BLUE PIGMENTS
5000 YEARS OF ART AND INDUSTRY

For Yves Rouchaleau

in memoriam

BLUE PIGMENTS
5000 YEARS OF ART AND INDUSTRY

François Delamare

Translated by Yves Rouchaleau

Archetype
Publications

First published 2013 by Archetype Publications Ltd
Original edition: Bleus en poudres, de l'art à l'industrie: 5000 ans d'innovations © Ecole des Mines de Paris, 2007

Archetype Publications Ltd
c/o International Academic Projects
1 Birdcage Walk
London SW1H 9JJ
www.archetype.co.uk

ISBN 978-1-904982-37-1

British Library Cataloguing in Publication Data
A catalogue record for this book is available from the British Library.

Cover illustration: Guimet's artificial ultramarine for laundry. Author's collection. Photographed by the author.

Typeset by Hannah Turk, London

Contents

Preface

The reader will not find here a history of the colour blue (others have already written it[1]), but a history of blue pigments.

What is a 'pigment'? It is a coloured powder which can be dispersed in a medium in which it is insoluble and to which it imparts its colour. It differs in this respect from 'dyes', which are soluble in the chosen medium.

Why write on blue pigments, rather than on brown, yellow or purple? When we observe the painter's palette, only their hue distinguishes blue pigments from others. They are found all over the globe, but once we probe the methods of production of these blue pigments, we find that, with very few exceptions, they are all found to be 'artificial', i.e. man-made.

In the natural world, blue rocks from which objects can be fashioned are rare: a few marbles, lapis-lazuli and related rocks, and minerals containing copper. However those which, once ground, can be used as pigments are exceptional. Only lapis-lazuli and azurite come to mind. The long absence of blues from the palettes of our distant ancestors is therefore easy to explain.

The primary goal of this book is to show how much ingenuity man has had to employ in order to produce blue materials. From Egyptian blue to copper phthalocyanine, to Maya and Han blues, smalt, blue ashes, Prussian blue and artificial ultramarine, we cannot help but be in awe of the variety of technical solutions found. Each civilization has produced its own solution, or sequence of solutions. Thus one can say that blue pigments can be considered as markers of civilizations.

Of course, because of their rarity, blue pigments have always been an expensive commodity. They therefore became the object of a very lucrative trade, spanning continents and seas. From recent analyses of ancient paint layers of known date and provenance, it has become possible to determine the extent of these ancient trades and their chronologies for Egyptian blue and smalt.

[1] M. Pastoureau has published several articles and books delving into this topic. Among them: 'Et puis vint le bleu' (1983), *Europe* 654: 43–50. *Couleurs, images, symbols* (1989). Paris: Le Léopard d'or. *Jésus chez le teinturier* (1997). Paris: Le Léopard d'or. *Bleu, histoire d'une couleur* (2000). Paris: Seui.

But blue pigments have another peculiarity which makes them unique and will, in fact, decide their destiny: their colour is complementary to that of orange-yellow. This remark would be of little import (every colour being complementary to another) were it not for the conjunction of two facts – the slightly yellow tinge exhibited by various widely used materials (textile or paper fibres, ceramic pastes, window glass panes) and the pronounced and permanent taste for the colour 'white' in our civilisation. In the case of natural or artificial textile fibres, this yellow tint, which tends to be accentuated with age or heat, interferes with our desire to wear body garments which are as white as possible. In the case of ceramic glazes and window panes, it is the ferric iron induced colour, from the iron traces in most minerals, which must be neutralised. The ability to rebalance these very pale yellow colours with a slight addition of blue pigment has been known since the sixteenth century, and possibly even by the Romans. For blue pigments, this has been an economic outlet of major importance, without equivalent for pigments of other colours. Like white and black, most blue pigments were made on a much larger scale than if they had been used solely by painters (including house painters and decorators).

Parallel to, and sometimes independent of the development of production processes, scientific enquiries were carried out to determine the origin of these diverse blue colours. While such enquiry may seem hopeless to us (in light of our current knowledge of the complexity of material studies), it bears witness to the continuing wish of man to understand nature. This eminent quality does not exclude rivalries between people and even between nations. It took until the beginning of the twenty-first century to obtain satisfactory answers to the question: what is the origin of the blue colours of these minerals? These scientific and industrial adventures are what I have set out to reconstitute on the basis of numerous documents, often of French origin. While the flavour of these ancient French texts is extremely hard to preserve in another language, it can be found, intact, in the French edition of this volume, published in 2007 in Paris by ParisTech Press under the title *Bleus en poudres*.

This book would have had a regrettable gap, had we not interested ourselves in the rediscovery of three blue pigments which have all but vanished from our memories – Egyptian blue, Maya blue and, the most recent, Han blue. Although the final answers may still elude us, the journey could be likened to the plot of a detective novel.

To get a better understanding of the atmosphere of the times, large quotations from original texts have been included. For texts written in foreign languages, contemporary translations are given, adhering to the original spelling.

Acknowledgements

Putting this book together took several years. This would not have been possible without the assistance of numerous persons. Let them find here the expression of my gratitude for their amicable support, which never wavered.

Delving in the archives, mostly French, could not have been done so efficiently without the competence and devotion of the librarians in charge of the ancient collections: at the library of the École des mines de Paris, Francine Masson and Marie-Noëlle Maisonneuve; at the Société d'Encouragement pour l'Industrie Nationale, Serge Benoît, and at the staff at the Egyptology libraries of the College de France and the Centre Jean Bérard in Naples.

For current publications, the library of the École des mines de Paris in Sophia Antipolis (Brigitte Hanot and Sylvie Michel) has proved an invaluable and constant help. In the same vein, I always have found help and support at the mineralogy museum of the École des mines de Paris. Lydie Touret and Amédée Djemaï are to be thanked for that.

I could not forget my researcher friends and colleagues from the Material Forming Centre at the École des mines de Paris (Monique Repoux, Bernard Monasse, Suzanne Jacomet, Gabriel Monge and Emmanuel Levrat) who so often let me benefit from their talent and competence during the research we conducted on pigments and dyes.

I am also indebted for a mass of first-hand information to various doctoral students I had the privilege of guiding in their work or having discussions with: Sandrine Pagès-Camagna, Marie-Pierre Etcheverry and Lætitia Cavassa concerning Egyptian blue; Bertrand Ledé, Cécyl Tarlier and Daisy Bonnard for artificial ultramarine; and very specially Sonia Ovarlez for Maya blue. Let them all of them be thanked.

I do not for a second forget the fruitful discussions I have had with colleagues and friends:

- Elisabeth Delange (Musée du Louvre, Curator for the Egyptian Antiquities Department), Pietro Baraldi (Professor at the Modena and Reggio Emilia University), Alix Barbet (CNRS) who so generously allowed me to pick from her vast photograph collection, André Tchernia (CNRS), Michael Tite (British Museum Research Laboratories) and Detlef Ulrich concerning Egyptian blue

- Hubert Guimet, Christian Duhayon (General Manager of Holliday Pigments) and Pr. Jean-Pierre Lelieur (LASIR) for ultramarines.
- Jacqueline Jacqué, Curator of the Musée des impressions sur étoffes (Cloth Printing Museum) in Mulhouse, France
- Bernard Jacqué, Curator of the Musée du papier peint (Wallpaper Museum) in Rixheim, France
- Gérard Quemeneur of Degussa France for Prussian blue, Sophie Norvez Hamel de Monchenault (ESPCI) for supplying cyanotypes and Tomoko Takesada for information concerning the introduction of iron blue in Japan
- Isabelle Roché, La maison du pastel in Paris
- Louise Wijnberg (Curator, Painting Restoration Workshop, Stedelijk Museum, Amsterdam).

not forgetting the colour encyclopaedists: François Perego, who so often berated me for limiting myself too much in my selection of blue pigments, Dominique Cardon and Michel Garcia.

I do not forget either my friends from the Institut de recherche sur les archéomatériaux of the CNRS (National Centre for Scientific Research) in Orleans, Bernard Guineau (another colour encyclopaedist), Bernard Gratuze (for the provenance of cobalt and smalt analysis), Maryse Blet and Patricia Roger (for the late use of Egyptian blue and natural ultramarine) for the kind authorisation to use documents supplied by them as illustrations.

It has never been easy to compute the price equivalents for ancient pigments, parsimoniously given in very diverse currencies, the value of which fluctuated along with political events. I often had to call on the extensive competence of Alain Weil and Cécile Morrisson, particularly when I was lost in the jungle of German Renaissance coinages. Let them find here the expression of my friendly gratitude.

For the translation of the texts dating back to the sixteenth and seventeenth centuries, while I took care of those in Latin (God knows how the *lingua* of seventeenth century chemists differs from that of Cicero!), I called upon the talents of Yves Rouchaleau for English, Martin von Hirsch for German, Christina de Villoutreys for Swedish and Maria-Vittoria Abba Legnazzi for Italian. Let each one be most sincerely thanked.

I am also in debt to various institutions (École des mines de Paris, Société d'encouragement pour l'industrie nationale, Banque de France, Bibliothèque Forney, Musée des arts et métiers, Musées de Grasse, Musée des impressions sur étoffes (Mulhouse), Musée du papier peint (Rixheim)), Centre Jean Bérard (Naples), The British Library, Musée de l'Ariana (Geneva), Het kinderen Alijnshospitaal Museum in Ghent, Kunsthistorische Museum in Vienna, companies (Holliday Pigments) or private individuals (H. Guimet, P. Gargiulo, D. Magaloni) for the gracious authorisation to photograph or use documents supplied by them as illustrations.

For the English edition, I am very grateful to James Black who, upon the mere description of the project, trusted me and agreed to publish this book. A bow to my friend Yves Rouchaleau who had the patience and skill to translate – and improve on – the original French text. A very long-term work. And how could I forget Jo Kirby Atkinson who not only was so helpful, in those cases where the company of dictionaries

proved fruitless, but who also agreed to read this text and enrich it with her pertinent comments. I also greatly appreciated the skill with which Hannah Turk at Archetype Publications has carefully reviewed the text and flushed out some remaining errors.

Last but not least, I cannot not overly thank my spouse and my family who have for so long suffered the invasion of the family space by an ever-rising tide of books, publications and samples, as well as the whims of the author, whom any titbits, when related to blue pigments, seem to overjoy.

And, for their precious help during the never ending fights with the computer or the communication networks, let Nicolas, Natalie, Cécile and Benoît be thanked.

1

Egyptian blue: the blue pigment of Mediterranean antiquity

Uncertain origins

No one knows where or when the invention of the blue material which we call 'Egyptian blue' took place. It is lost in the dawn of time. However, we do know today that Egyptian blue is in fact a *pâte-de-verre*[1], in which a double calcium and copper silicate $(CaCuSi_4O_{10})$[2] of a beautiful blue is dispersed in a soda-lime vitreous matrix, itself of a light blue colour due to the presence of copper.

A hypothesis was raised by J.E. Dayton (1981) who noticed the similarity between the impurities (mainly metallic elements) found in the Egyptian blues analysed and those found in ores from the Ore Mountains in central Europe, that the silicates coloured blue by copper and cobalt could be by-products of the treatment of silver ore found in the region of present day Schneeberg, in the Ore Mountains. These would have been exploited from the third millennium onwards. This hypothesis does not seem to have convinced very many, who were more drawn to the similarities existing between Egyptian blue and another synthetic material surfacing at the same time in the same region – glass.

Firstly, there is a similarity of ingredients between Egyptian blue and glass: quartz sand, lime, natron[3] and colour-inducing metallic oxides. Secondly, during manufacture, there is a similar need to maintain a high temperature for a long time – around 950°C

[1] *Pâte-de-verre*: vitreous matrix in which is dispersed another material of a different refraction index. Increasing the difference in refraction indices or the quantity dispersed diminishes the transparency of the paste which becomes first translucent, then opaline and finally opaque. It then becomes enamel.

[2] The corresponding mineral, extremely rare in nature, is cuprorivaite (see Chapter 9).

[3] Natron is a natural mixture of sodium salts (carbonates, sulphates and chloride) coming from the dried-out lakes of the present *wâdi-el-natrûn* (salt wadi), located 100 km northwest of Cairo. This exceptional source of an excellent flux made Egyptian glassmakers a fortune.

for one or two days – which requires rather specific furnaces. Added to this is the fact that, since its appearance in Egypt and for thousands of years thereafter, glass was neither transparent nor colourless but opaque and tinted.

By chance, due to its comparative inalterability, glass is well placed to survive as an archaeological witness. The oldest pieces retrieved should therefore enable us to pinpoint the date this man-made material appeared. Whether this was in Egypt or Mesopotamia, it is hard to decide, for material witnesses from these ancient times are very rare. The oldest glass objects found are Egyptian and date from around 3000 BC. They are coloured, opaque glass beads from tombs of the Predynastic era. Around 2500 BC, dark-coloured glass beads (containing iron, green or black, or cobalt blue) were made in Egypt, with an antimony-containing yellow on the surface. *Pâtes-de-verre* were also made to imitate semi-precious stones such as turquoise and cornelian that were used in small objects or jewellery.

A transparent glass cylinder dating from around 2500 BC was found in Tell Asmar, Mesopotamia. Colourless and without bubbles, this glass testifies to the control of the purity of raw materials, devoid of any colouring oxide, as well as to a refining technique implying higher temperatures than those reached in Egyptian furnaces. Unfortunately, Mesopotamian glass, too laden with fluxes, has poorly withstood the humid climate of the region. In Egypt, the much dryer climate led to the preservation of numerous telltale materials.

It is against this background that, in Mesopotamia and Egypt, three families of artificial blue materials appeared. The first is that of dark blue glass, coloured with cobalt oxide discussed in the following chapter. Next is that of glass, coloured by copper, of a rather turquoise colour. The third, of a more saturated blue, is that of copper-tinted *pâte-de-verre*, which Egyptian documents refer to as 'manufactured lapis lazuli', *hsbd iryt*, and which Mesopotamian documents call *uknû merku*, 'moulded lapis lazuli'.

uknû merku, the moulded lapis lazuli

While the excavations carried out in Mesopotamia turned up fewer turquoise blue *pâte-de-verre* objects than those in Egypt, at the same time they revealed a true treasure for the history of technology – actual recipes.

The oldest technical recipes in the world

Indeed, among the mass of clay tablets brought to light, two series of recipes for glass products have been identified so far, both kept at the British Museum, London. The first series consists of Babylonian tablets found at Tell'Umar, a site which became Seleucia upon the Tigris. One of them (British Museum number 120960) finishes with this colophon which allows us to date it:

> Property of Liballit-Marduk, son of Ussur-an-Marduk, priest of Marduk, man from Babylon. This the 24th day of the month of Tebet, in the year following that when Gulkishar became king.

Although the chronology of the Babylonian kings is rather uncertain around those times, the reign of Gulkishar is ascribed to the end of the seventeenth century BC. This tablet therefore would be contemporary with the Fourteenth Dynasty in Egypt. Recipes for glass and glazes for ceramics are recorded on these tablets. They are the oldest technical recipes known to us in any field, but they are unfortunately hard to understand as the meaning of some words still escapes the specialists. We do not know whether they belong to the technical vocabulary or are part of a coded language. The recipes are for soda-lime glass coloured blue by copper (Forbes 1966: 131–45) and give several base compositions or master-mixes such as *zukû* or *santu* glass. Modern glassmakers believe that their implementation requires a steady temperature of 800–1000°C (Gadd and Campbell Thompson 1936).

The tablet recipes from the second series are more recent by a thousand years. They are Assyrian, dating from around 640 BC, and originate from the library in the palace of Assurbanipal in Niniveh. *Stricto sensu*, they do not present deciphering problems. However, they have been a source of heated debate as to their technical value (Meissner 1925: 382–5; Zimmern 1925; Campbell Thompson 1925; Darmstaedter 1926; Ruska 1926). The texts they contain, probably of more ancient origin (estimated somewhere between the fifteenth and thirteenth century BC), tell how to build the three types of furnaces used by glassmakers and describe the manufacturing process. Experimentation has shown that in order to follow these glassmaking recipes the hottest furnace had to maintain a steady temperature of around 1000–1100°C. Eighteen recipes are given for soda or soda-lime glass: colourless or coloured blue, yellow, red and green. Only eight of these are complete. Just as those in the first series, these recipes show how to obtain a particular glass product from master mixes, to which some additions are made. Seven recipes deal with the manufacture of glass tinted blue with copper oxide. Their titles are: copper oxide coloured glass, *zukû* glass, *tersitu* glass (blue frit), *uknû* glass (lapis lazuli), *uknû merku* glass (moulded lapis lazuli), pale blue glass and *sipru* glass (sapphire). From copper-tinted blue glass to 'moulded lapis lazuli', we find here the whole range of Egyptian glass products with the exception of dark-blue cobalt glass.

The recipe for 'moulded lapis lazuli', **uknû merku**

The text of greatest interest to us here concerns the manufacture of *uknû merku*, the 'moulded lapis lazuli'. By chance it is complete, and not only does it give us the recipe but it also tells us its use: the manufacture of solid objects by moulding. Given the time needed to raise the temperature at the core of the object, we may assume that they were small objects.

The recipe uses two master mixes, the *tersitu* (a blue copper frit) and the *sirsu* (a colourless soda-lime glass):

> Thou shalt add to 1 mana of fine tersitu 1/3 mana of crushed sirsu glass, 1/3 mana of sand, 5 kisal of chalk, and thou shalt crush it again, thou shalt collect it into a mould, closing it with a duplicate mould; thou shalt place it evenly between the 'eyes' of the furnace and glow it and 'uknû merku' will come out. (Forbes 1966: 139–40)

A perfectly functional recipe, no ingredient is lacking, quantities are indicated and the temperature is roughly given by the colour of the light emitted. According to this English translation of the text on the tablet, the mix must be heated until it is red-hot, hence around 800–900°C.

What was the purpose of this material? It was used in jewellery and to make cylinder seals, vases or small animals. It was also used as an inlay to decorate furniture. A luxury material, it was used in place of Afghan lapis lazuli (*uknû*). Contrary to what we might think today, the fact that it was of artificial origin carried no negative connotation. The use of moulded lapis lazuli seems more frequent during the peak periods of Mesopotamian history, between the fourteenth and twelfth century BC in particular, and then between the ninth and fifth century BC. During other periods, when it was a vassal of Egypt, Mesopotamia paid part of its tribute money with *uknû merku*.

hsbd iryt, the Egyptian artificial lapis lazuli

In Egypt, as shown by the name *hsbd*[4] (lapis lazuli) *iryt* (manufactured), this blue material also served as a substitute for the very costly Afghan lapis lazuli. The latter was actually referred to for certain applications, such as the addition to mineral ointments, as 'true lapis lazuli'. There too, *hsbd iryt* is found as a decorative element enhancing clothing and funeral garb and as jewellery and luxurious objects such as the cylindrical seal of pharaoh Pepy I (Sixth Dynasty, 2250 BC) preserved at the Musée du Louvre, Paris.

As in Mesopotamia, this material was a product of great luxury. It was certainly very expensive and produced only in small amounts; the crucibles used at the time probably had a capacity of less than one pound weight. Yet we have no information on who actually made it. It was probably some authority protective of its control and therefore careful to keep the recipe strictly secret and to monitor its production. We know of a few references to 'lapis lazuli manufacturers' such as Semen, 'chief of the lapis lazuli manufacturers', who lived toward the end of the Thirteenth Dynasty (around 1300 BC) (Slitine 2005). However, if we bear in mind the similarity of its manufacturing technique to that of glass, we may conjecture that *hsbd iryt* manufacture was carried out in certain temples, for we know that glass manufacture was linked to major temples, such as those of Memphis and Thebes. We even know of a reference to a 'High Priest from Memphis, head of glassmaking' (Erman and Grapow 1927: 390, line 16). This use of *hsbd iryt* endured for millenia, attested to by the innumerable jewellery pieces found in tombs of all epochs, especially those of Tutankhamen (who died in 1326 BC). However, *hsbd iryt* also had another use, that of a blue pigment.

hsbd iryt, *the first synthetic pigment*
Why did the Egyptians (who exploited the copper in Sinai and imported some from Cyprus where seams of azurite existed) not use azurite, which is capable of supplying

[4]Or *khesebedj*.

a blue pigment of very satisfactory quality (for the time) just by crushing? There is no satisfactory explanation, which is puzzling when we consider that European painters made considerable use of it (see Chapter 4).

Figure 1.1 lets us compare the shades of 'manufactured lapis lazuli' and of azurite and ultramarine (see Appendix). We can see that the shades of *hsbd iryt* and azurite are nearly the same, corresponding to a dominant wavelength of 477 nm. They are perfectly distinguishable, on the other hand, from those of ultramarine with its dominant wavelength of 468 nm. Furthermore, the colouring strength and covering power of azurite and *hsbd iryt* are roughly the same – both are very low. This means they must be employed with a rather rough granulometry which makes them fairly difficult to use. Only their sensitivity to their chemical environment differs – azurite is highly sensitive, *hsbd iryt* not at all. However, Egyptian painters did not use azurite. 'Occurrences' have been occasionally noted and periodically referred to, but these are due to incomplete and poorly interpreted analyses, sometimes carried out on materials transformed and corroded through time (in particular copper glass).

Using natural lapis lazuli as a source of blue pigment was unthinkable, on the one hand because of its rarity (it was exchanged as gifts between royalty, hence the object of a trade among them), on the other hand because crushing this rock did not directly yield a powder of the same blue as the rock itself but instead a pale blue-grey powder with a very weak colouring power (see Figure 3.4). It would take several millenia before a technique was found to separate the blue grains of lazurite from those white, grey or golden of the minerals associated with it in the rock and to be able to obtain the precious natural ultramarine (see Chapter 3). This problem did not arise with *hsbd iryt*, which is made of blue and colourless grains only. It sufficed to crush the solid material and obtain a blue powder, which became lighter in colour as it was more finely crushed[5]. By taking the varied sizes of powdered granules and flushing with water, the finer and finer fractions that successively settled could be collected.

One of the first testimonies to the use of *hsbd iryt* as a pigment is the Mery stele from Saqqara, dating from the Forth Dynasty (2561–2450 BC), preserved at the Musée du Louvre. The excellent quality of this synthetic blue (i.e. the large proportion of calcium and copper double silicate contained in the vitreous matrix) presupposes an already well-established manufacturing technique, which must have been perfected at the time of the first dynasties if not earlier. Another circumstance confirms the ancient origin of the manufacture of *hsbd iryt* as a pigment. Around 2500 BC, Egypt was already exporting this blue pigment, to Minoan Crete in particular. We shall return to this issue later.

Under the Sixth Dynasty (2321–2140 BC), it was already an established habit to use *hsbd iryt* as a pigment for wall paintings in tombs and temples, although times of political turmoil occasionally corresponded to scarcity of this pigment. This is demonstrated

[5] The interaction of light with a pigment consists principally in the specific absorption of certain wavelengths and in the diffusion of the incident white light by the surface of the pigment grains. For a constant volume, crushing increases the total surface area of the grains; hence, the proportion of white light diffused increases and the eye perceives a colour which is paler, desaturated.

in certain tomb wall paintings in which water is depicted in white rather than in its customary blue.

The manufacture of hsbd̲ iryt

How was *hsbd̲ iryt* manufactured? No Egyptian recipe has reached us, most likely because the transmission of recipes was oral and extremely restricted. However, the stele of Irtysen the painter found in Abydos and dating from the Eleventh Dynasty (around 2030 BC) has this passage:

> I know the secret of the divine word [hieroglyphs] and the composition of the ceremonial rituals. Of all the magic formulae I have acquired the mastery, and they do not contain anything beyond my grasp. I am furthermore a craftsman who excels in his art, at the highest level of its body of knowledge. I know the 'roubagou', I can estimate dimensions, subtract and add until a body fits in its place. I know the stance of a male statue and the gait of a female, the attitude of the eleven birds, the convulsion of the isolated prisoner, how to make him cross-eyed, the look of fear on the face of the enemies from the South, the arm motion of he who hunts the hippopotamus and the leg motion of he who runs. I know how to make **pigments and products which melt without being burnt by the fire** [emphasis author's own] and which further cannot be dissolved in water. I shall reveal this to no one but myself and my elder son, the god having ordered that he should act as an initiate for I have noticed his ability as a foreman for all precious matters, from silver and gold to ivory and ebony. (See Andreu *et al.* 1997: 80–1, item no. 28)

'Pigments…which melt without being burnt by the fire…' – among all the pigments used by Egyptian painters, only vitreous materials seem to be concerned in this phrase, in particular cobalt tinted glass and 'manufactured lapis lazuli'. In the absence of any Egyptian recipe, and totally ignorant of an Assyrian recipe which would not be published and discussed until the years 1925–6 (Meissner 1925: 382–5; Zimmern 1925; Campbell Thompson 1925; Darmstaedter 1926; Ruska 1926), researchers from the nineteenth and twentieth century therefore compared the results from their experiments with analyses of ancient materials to reconstruct manufacturing techniques. We shall delve into this issue in more detail in Chapter 9.

We have stated that *hsbd̲ iryt* was a *pâte-de-verre* made of a calcium–copper double silicate dispersed in a soda-lime glass coloured blue by copper. Synthesis of the blue silicate was achieved by heating an intimate mixture of three components reduced to powders, contributing respectively copper, calcium and silicon as well as oxygen. A fourth one, containing an alkaline metal (sodium and/or potassium), played the role of a flux and sped up the operation by creating a vitreous phase.

What do we know of the raw materials used and the manner in which they were used? The results of analyses teach us little beyond the compounds which supplied the copper. The presence of small quantities of tin, arsenic, even zinc or lead points to the use not of copper salts (as researchers have used in their laboratories) but of metallic copper and copper alloys. From the Old Kingdom onwards, manufacturers have used scraps of arsenical copper. This practice endured until the accession of Thutmose III, around 1479 BC, from which time onwards manufacturers used scraps of tin-bronze

and, toward the end of the Nineteenth Dynasty, tin- and lead-bronze, a practice which would last until Roman times (Jaksch *et al.* 1983; Schiegl *et al.* 1990).

Such an evolution in the type of impurities present in *hsbd iryt*, the use of which is easy to date, is a boon for the history of Egyptian metallurgy since it is rarely possible to date metal objects. The composition of impurities in Egyptian blue mirrors the composition of the bronzes from which it is made; their sequence of appearance lets us date the use of these various types of bronzes. These changes in composition had no impact on *hsbd iryt* and its colour (i.e. the presence of these impurities had no influence on the quality of the final product). Zinc and arsenic vaporised while maintained at a high temperature. Tin was concentrated in separate phases, under the guise of small nodules of a double silicate of calcium and tin (malayaite) and stannous oxide (cassiterite) (see Figure 1.9). We should add that there was no shortage of copper in Egypt itself, especially during periods of prosperity when copper was imported in large quantities from Cyprus, Phoenicia and the Retenou (Syro-palestinian hinterland).

As for silica, the profusion of quartz in the *hsbd iryt* found in archaeological excavations points to the use of quartz sand, found in abundance in the desert. It has been formally identified through its impurities in at least one instance (Jaksch *et al.* 1983). However, the compound providing the calcium remains a mystery. The hypothesis generally accepted is that it came from limestone, but gypsum, very common in Egypt, might just as well have been used.

Reduced to fine powders, these various minerals were mixed with the metal chips to which was added an alkali flux – natron or plant ashes. Then after the mixture had been moistened to a paste it was shaped. In order to make solid objects, both halves of bivalve moulds were filled, then closed together and placed on the floor of a furnace heated to around 900–950°C, probably for two days. The resulting product, once cooled, was of a deep blue (on the surface at least). The object then was taken out of the mould, deburred and polished.

For pigment manufacture, cakes or balls were shaped and placed in a furnace heated to around 900–950°C, probably for one and a half days[6]. The pigment was then obtained by crushing. As the powder became finer, its colour became paler. The darker pigments, coarsely ground with a grain size around 0.1 mm, were employed in mural paintings for landscapes (skies and/or water) or to colour hieroglyphic wall inscriptions. They also were used to paint sarcophagi. Ground finer, they were used to colour the blue ink for cursive writing on papyrus[7]. The pigment thus obtained, a mixture of silicates, was chemically inert. It would not fade with light and was compatible with all

[6]Modern reconstitutions have shortened this time by taking the mixture out of the furnace after one night, letting it cool off and then grinding to homogenise it. The powder is then shaped into its definitive form. It is then returned to the furnace to undergo the same thermal cycle. It would be surprising if the ancients had not followed this practice, especially in countries where fuel was rare.

[7]The Egyptians invented ink around 3000 BC, long before the Chinese did. They first wrote on shards, then on papyrus. The ink colour most often used was black, which presents the best contrast with the support. It was made with carbon black, which, naturally hydrophobic, was dispersed in water with the help of a carbohydrate of high molecular mass, acacia gum. Faced

environments, both acidic and basic. Were it not for its particle size, this pigment would have had ideal qualities, both for its preservation through the centuries and for its use in mural paintings. We shall see later that, like many copper salts, it also has fungicidal properties (see Chapter 9).

A technical master stroke

Although the ingredients used in the recipe may seem fairly common, the manufacture of this blue silicate was actually rather delicate. A number of precautions were imperative and its manufacture imposed some technical constraints.

The first constraint had to do with the quantities of calcium to copper which had to be proportional to their atomic weights – hence 40 g of calcium for 63 g of copper, or, more practically, 100 g of calcium carbonate ($CaCO_3$) for 63 g of copper metal. This essential condition, which seems easy to fulfil, turned out to be particularly difficult to satisfy when the copper source was a copper alloy. The success of the operation most likely hinged upon preliminary trials. There was, on the other hand, a rather large amount of flexibility when it came to silica, provided it was in excess, i.e. at least four atoms of silicon per atom of calcium or copper (thus at least 240 g of quartz sand for the amounts considered above). The quantity of flux could also vary widely, and analyses confirm that it was high (15–20% in atomic percentage) in Egyptian productions. It would fall to a few percent in Roman productions in Italy and Gaul.

The second constraint concerned temperature. It was necessary to reach 950°C, a comparatively high temperature for the time, and to maintain it for at least thirty hours with a low rate of thermal drift (± 50°C). On either side, the resulting silicates would show different colours, in particular greens (Pagès-Camagna 1999). Such long stays at high temperature were more often seen in glass-related technologies than in metal working. The type of furnace used would not leave the issue in doubt. Such seems to have been the case; the Amarna excavations led by F. Petrie unearthed the remnants of a glassmaker's workshop containing crucibles that had been used to prepare hsbd iryt (Petrie 1894: 25–6 and plate 13; Spurrell 1895; Nicholson 1995).

As a third constraint, the atmosphere in which the reactants were placed had to be oxidising, for fear of obtaining a product to which copper oxide would impart a black colour. Hence the recommendation of Isidore of Seville to use calcined (i.e. already oxidised) copper filings (Isidore of Seville, Etymologiae XIX: 17.14; see also note 29).

We can see there were many constraints. That this blue silicate was manufactured in Egypt in various eras shows that an operational (i.e. quantitative) recipe did exist.

The expansion of Egyptian production

The volume of hsbd iryt production in Egypt seems to have remained low for a prolonged period, although we have proof of its export to the Minoan civilization as early as 2500 BC. One of its main uses was in jewellery, as a substitute for turquoise. Production increased with the advent of the Eighteenth Dynasty (1539–1293 BC), which

with the same difficulty, the Chinese would use the amino acids of fish glue as a dispersant (or surface active agent) for their 'Indian ink'. Egyptians also used red, blue and green inks.

corresponded with the period of greatest power for Egypt, particularly under pharaohs Thutmose III and Amenhotep II. Their authority having spread over the neighbouring areas, the wealth of vassal and allied countries poured into Egypt, provoking a veritable economic boom. At the same time there was an extremely active policy of monument and temple construction resulting in a large increase in decorated surfaces.

The dynamism of this period was accompanied by technical innovations, causing a sharp break with the practices and production rhythms of previous centuries. This can be seen in the production of glass as well as in that of *hsbd iryt*. In glassmaking, a major innovation occurred around 1450 BC, under the reign of Thutmose III. A new process was invented for manufacturing objects by coating a sand core, attached to a metal rod, with glass. For the first time it was possible to make hollow objects which glass craftsmen could turn into small vases and flasks. This opened a new market for glass, which until that point was confined to solid objects. A luxury industry for glass perfume containers grew, soon acquiring international fame. Glass production intensified considerably and likely became the province of independent craftsmen.

As for *hsbd iryt*, its use also expanded dramatically as a consequence of the proliferation of tomb and temple decoration in Luxor, Thebes and Amarna. We also know the form under which *hsbd iryt* was produced: cylindrical cakes of around 18 cm in diameter and 3 cm in height weighing over 1 kg. Seven cakes, five large and two small, weighing 7.86 kg in total were found in a chest in the tomb of Keruf, attendant of queen Tiyi, wife of Amenhotep III (around 1350 BC), in Thebes (Saleh *et al.* 1974). Their surface still bears impressions of the linen cloth which covered them before being placed in the furnace.

In 1894, the Egyptologist Flinders Petrie described a glassmaker's workshop in which *hsbd iryt* was also made in his account of excavations carried out at Tell el-Amarna, on the site of the Akhet-Aton city (abandoned around 1330 BC) (Petrie 1894: 25–6 and plate 13). Besides the description of the different ceramics used as crucibles or containers, Petrie clearly identified the origin of the quartz used – pebbles collected from the surroundings and subsequently ground down.

The workshop contained a furnace, grinding wheels and various pots. The scraps found suggest that the furnace was used for diverse purposes: heating pottery slips, making enamel, glass and *hsbd iryt*. On the floor of the furnace, where several pebbles of quartz were stained by copper silicate, rows of fired clay cylinders 20 cm in height and 12 cm in diameter were found. Turned upside down, they must have served as stilts. They supported vat-shaped crucibles in which was placed the mixture required to obtain *hsbd iryt*. The quantities manufactured were small as the volume of each crucible was less than 150 cm^3 (Figure 1.2). On some crucibles, the fluxes had reacted with the material of the crucible, thereby changing the composition of the mixture and decreasing the resulting amount of *hsbd iryt*. The latter, fused to the crucibles, made it impossible to reuse them. The crucibles were sufficiently deep for the reactive mixture to have been protected from unburnt gases which might have created a reductive atmosphere. Once the crucible was broken and the *hsbd iryt* recovered in the form of blue and green grains, it was ground. The powder thus obtained was returned to the furnace in round-bottomed cylindrical pots (15 to 20 cm in diameter, 5 to 25 cm in height). The

reaction resumed and the grains fused with each other by sintering. This resulted in a bluer, more homogeneous *hsbd iryt* shaped like a hard cake similar to those found in the chest of Keruf. This description was taken up and commented upon by Petrie's collaborator F.C. Spurrell (1895).

The data from the excavations directed by Petrie were criticised and reinterpreted by Nicholson (1995) in 1995, when he himself led an excavation on the workshops at Tell el-Amarna. It is probable that it was a place where both glass and *hsbd iryt* were made. It seems that the vat-shaped containers, which can be seen at the Petrie Museum, University College London, were crucibles in which *hsbd iryt* was made. We have various examples of the use of this *hsbd iryt*, such as in the decoration of earthenware vases (Figure 1.3).

Production of this blue pigment continued and increased until the Roman conquest. Its composition remained essentially the same during that time, and the production technique was fixed. Only the commercial shapes in which the raw product is still found varied. Before the Eighteenth Dynasty at least, *hsbd iryt* was produced in the shape of cakes of no more than a pound then, under that Dynasty, as cakes of over a kilogramme. Later it would be made in the shape of orange-sized balls or of flat disks, roughly 6 cm in diameter. Eventually, at an unknown date but prior to the fifth century BC, it would be made into small pellets 1 to 2 cm in diameter. The most satisfactory explanation one can offer for this reduction in volume comes from the need to achieve fuel economy in a process which requires a long heating at around 900–950°C. Decreasing the size of the pieces to be heated increases the surface to volume ratio and considerably improves the thermal exchange – the smaller the object, the easier and more thorough the firing.

hsbd iryt exports

Archaeological excavations unquestionably show that 'artificial lapis lazuli' was widely exported in spite of its high cost, although details of the price remain unknown to us. In our current state of knowledge, we are unable to differentiate between Egyptian, Mesopotamian and possibly even Phoenician productions. It became the habit to assign all of them to Egypt. We shall therefore employ the term *hsbd iryt*.

Like cobalt-coloured blue glass (see Chapter 2), *hsbd iryt* was exported from the Bronze Age onwards and is found as a blue pigment on the wall paintings of various Mediterranean civilisations. Fortunately for us, most ancient wall paintings from the Mediterranean were painted *a fresco*, i.e. by painting over a fresh lime mortar, the carbonation of which in the air progressively seals the painting under a transparent layer of calcite. This technique guarantees a long life to the decoration provided the pigments used do not react with the basic medium of the fresco.

This is where the perfect chemical inertia of *hsbd iryt* triumphs over azurite, which tends to turn into a green copper salt. This stability ensures that the traces of these decorations, usually found on fragments detached from walls, survive in archaeological contexts which can be dated. By gathering all possible data on such well-dated blue

decorations, we can therefore attempt broadly to reconstruct the salient contours of a history of *hsbd iryt* exports, one of the little-mentioned trades of antiquity.

Blue pigments from the Minoan civilisation

It seems that in the proto-historic Aegean world *hsbd iryt* was designated by the word *kuwano*; this at least is what seems to come out of the two Pylos tablets (Ta 642 and 714) and the five Oi tablets (701–705) from Mycenae (Halleux 1969). This blue material was used in solid form to decorate luxury furniture. Shaped as griffons or palms, it was inlaid with gold into tables, armchairs and stools, exactly as lapis lazuli was used for inlays in luxury furniture in Mesopotamia or in Syria, as witnessed by that found in Ras Shamra. This work of inlay was carried out by the *kuwanowokoi* and constituted a genuine specialisation since these craftsmen worked for both jewellers and cabinetmakers.

The first archaeological evidence of *kuwano* imports dates from the Minoan civilisation and relates to *kuwano* used as a pigment. From this point of view, the examination of a series of wall painting fragments found in Knossos proves particularly interesting. The samples come from excavations led by Sir Arthur Evans in the palaces and houses of Knossos. For four fresco fragments dating from 3000–2100 BC, 2000–1700 BC and 1800–1750 BC (the Prepalatial, c. 3000–1900 BC, and First Palaces, 1900–1750 BC, periods), the blue pigment employed was *hsbd iryt*, an imported pigment (Filippakis *et al.* 1976; Dandrau 1999). It would of course be interesting to verify the earliest date in the range, which would supply a *terminus post quem* for pigment exports and even manufacture, since we have seen that the first traces of its use in Egypt also date from 2500 BC. In any case, a fragment of a decorative scheme found on the island of Keros dated to 2500 BC confirms the use of 'artificial lapis lazuli' at that date. Analyses show that this *hsbd iryt* contains traces of tin, lead and arsenic; it was therefore made with salvaged bronze scraps (Filippakis *et al.* 1976).

In the period of the Second Palaces (1750–1500 BC), painters preferred to use two blue minerals of local origin, glaucophane (Figure 1.4) and riebeckite. The nature of blue pigments used in Crete and their evolution from 1750 BC is confirmed by analyses carried out on fragments of wall paintings from the island of Thera. We may conclude that the high price and/or scarcity of the blue pigment imported from Egypt (or Mesopotamia) led to the exploitation of these blue minerals available in Crete and Thera. Both are silicates; their chemical inertia is therefore good, but their slightly grey colour makes them appear dull. This may be why, although first employed pure, they were afterwards often mixed with the imported pigment, the colour of which was more sought after. However, during the Second Palaces period, *hsbd iryt* was not used in the pure form.

Around 1500 BC, during the period of the Third Palaces, Knossos was at the peak of its power. Trade with the Near and Middle East was very active. During this flourishing period, there is no evidence of glaucophane having been used in Knossos or in Thera. Painters again exclusively used imported *hsbd iryt*, indicating that it was more readily available and at a lower price. This does indeed match the increase in production we

had noted in Egypt around 1450 BC under the reign of Thutmose III. Furthermore, the conquest of Knossos by the Mycenaeans around 1400 BC did not alter this.

The kuanos *of Mycenaean civilisation*

Around 1600 BC, the Greeks, founders of the Mycenaean civilisation, arrived on the stage of history. They too decorated their walls with frescoes, and their painters needed the colour blue, which they would use until the ruin of their cities by the 'Sea Peoples' between 1220 and 1150 BC. Analyses carried out on wall painting samples and on unused pigments found during excavations on Mycenaean sites with dates ranging from 1400 BC to 1100 BC all yield the same result: the use of imported *hsbd iryt* but never glaucophane (Heaton 1910; Filippakis *et al.* 1976). Egypt therefore still exported *hsbd iryt* at this time.

The wreck of the Ulu Burun merchant vessel, sunk off Kaş, Turkey around 1300 BC, bears witness to this. This Mycenaean cargo ship had left Egypt carrying, among her rich cargo, 175 ingots of blue glass in three colours. The majority were of a cobalt-coloured dark blue, but there were twenty-one ingots of copper-coloured turquoise blue and one of purple (Bass *et al.* 1989; Pulak 1998; Pulak 2001). This wreck gives us an idea of the cargo carried by merchants between Egypt and, probably, Crete and Greece. In Crete, as we have seen, only *hsbd iryt* was still used in Knossos. The same was true in Thera and in Greece. Heinrich Schliemann[8] found some still unused during his excavations in Mycenae in 1876. These old discoveries were confirmed by more recent excavations carried out in the 'House of Idols' and at the temple by the British School of Athens. The same findings were made during excavations in the palace of Tiryns (*Epichosis, c.* 1300 BC) and in that of Nestor, in Pylos (1300–1200 BC) (Filippakis *et al.* 1976).

The Mycenaean civilisation left not only archaeological remains but also texts, tablets and Homeric poems which lead us to imagine the uses for this material and the name the Greeks gave it. Furthermore, since *hsbd iryt* was the only blue pigment or material used at the time, it follows that it is most likely the *kuanos* referred to in the texts as both a solid material and a pigment (Halleux 1969). In the world of Homer, this material is mentioned once in the Iliad when Nestor, King of Pylos, welcomes Machaon, who is returning from a bloody encounter:

> Then Hecamede, a captive with beautiful curls, prepares them a beverage. The old man won her in Tenedos, once, when that city was overcome by Achilles…In front of them, she first draws a table with *kuanos* plates, splendid and well polished, where she then lays a bronze salver, with foods which will accompany the beverage they take: onions, yellow honey and sacred flour bloom[9]. (Homer, *Iliad* 11.627–628)

[8]Schliemann, famous for having discovered the site of Troy, carried out his excavations with his own money. Only through the fortune he had amassed in the indigo trade was he able to achieve this.

[9]The term *kuanos* was restored here by R. Halleux (1969).

It is in the Odyssey that *kuanos* appears in its role as a pigment, in a wall decoration. Ulysses is ready to enter the palace of the Pheacian King:

> Ulysses was set to enter the noble abode of King Alkinoos; he paused for an instant. What turmoil in his heart, in front of the bronze threshold! For, under the high ceilings of the proud Alkinoos, it was like the sun and the moon shining! From the threshold all the way to the rear, two bronze walls ran unfurling their *kuanos* frieze. Golden doors opened in the thick walls: the risers, over the bronze threshold, were of silver; under the silver lintel, the raven was of gold, and the two dogs at the base, which the most clever art of Hephaestos had made to keep the house of the proud Alkinoos, were of gold and silver[10]. (Homer, *Odyssey* 7.86)

'*Prepared* kuanos' *throughout the Greek world*

After the Mycenaean civilisation, there is a gap of six centuries in the documentation concerning the use of blue pigments. It corresponds to a period of disassembly of the large political entities, Egyptian, Hittite and Mycenaean in particular, which preceded a new political reorganisation of the area. In this period of instability, cities attacked each other, if they were not under attack themselves from nomadic tribes. Ports were ruined, and international trade considerably pared down. Under these conditions, it would not be surprising if wall painting was not a priority. There were very few mandates, and from our point of view no archaeological traces of the use of *kuanos*.

It is not until the sixth century BC that we find it again, in the painted decoration on the façade of the Aphaia temple in Aegina (580–500 BC). It was then used by the artists living in Pella, the Macedonian capital (400–108 BC), and used in two different forms in the princely tombs and the (probably) regal tomb of Vergina in Macedonia (340–325 BC). It adorns the rosettes of a large gold casket as well as a gold diadem. In both instances, *kuanos* is the only material associated with gold, which clearly underlines its precious character. But it is also employed as a pigment in wall paintings, notably for the background of a frieze representing a chariot race. Furthermore, and this is quite exceptional, we can observe it adorning architectural elements. Thus the triglyphs in the façades of two of the three tombs, those said to be of 'Philip of Macedonia' and of 'the Prince', were painted in blue, the metopes remaining unpainted. Of the two colours used, blue and red, the blue by far predominates (Andronicos 1984).

At about the same time (around 320 BC) the Greek Theophrastus, who was a student of Aristotle, in his mineralogy treatise 'On stones', clearly distinguished between two *kuanoi* (Περί λιθων VIII: 55):

> Just as there is a natural and an artificial cinnabar[11], there is a natural *kuanos* and a prepared *kuanos*, as in Egypt...the Egyptian [blue] is prepared. Writers mention the name of

[10] The term *kuanos* was restored here by R. Halleux (1969).

[11] One would think that it is enough to grind natural cinnabar (rhombohedral HgS) to obtain a bright red powder usable as a pigment. Such is not the case. Natural cinnabar is variable in colour, ranging from dark red to purplish violet. If ground, it yields a dirty red, for a part changes into black metacinnabar (cubic HgS). The process therefore went as follows: natural cinnabar was decomposed into its elements, mercury and sulphur, by heating in air. Recombination of

the first king to produce prepared *kuanos* imitating natural *kuanos*. They also relate that the tributes were sent from Phoenicia under the guise of *kuanos*, part prepared, part not.

'Prepared *kuanos*' is obviously *hsbd iryt*. As to 'natural *kuanos*', most modern authors agree that it should be identified with azurite ($2CuCO_3.Cu(OH)_2$), the most important source of which was in Cyprus (*kuanos kuprios*). How is it that no trace of its use is found in Egypt? Purported occurrences have never been confirmed, and all too many cases are known where the mere presence of copper associated with a blue colour has led to an overhasty conclusion as to the presence of azurite (see Chapter 4).

The mention of 'prepared *kuanos*' in the tributes paid by Phoenicia to Egypt is remarkable. Of course, it accompanied the Afghan lapis lazuli as a luxury material, for which Phoenicia was one of the access roads to Egypt. However, this would mean that Egypt was no longer the only one to make this blue material and perhaps to export it. As time went by, the use of 'prepared *kuanos*' became more and more widespread. The Greeks soon employed it to paint scenes of modest size such as the scenes decorating funeral *stelai*, e.g. those of Demetrias dating from a long period stretching between the third and first century BC (Graeve and Helly 1987; Preusser *et al.* 1981). Painters also used 'prepared *kuanos*' to decorate the clay figures from Tanagra and even small vases such as *lekythoi*. It is clear that its production became more and more important and that its price came down considerably.

Blue pigments in pre-Roman Italy

Whether imported from Egypt or Phoenicia, this 'prepared *kuanos*' was used by Greek painters not only in Greece but also in the colonies of Magna Graecia and in those of the Greeks' allies in pre-Roman Italy. We know Etruscan paintings almost entirely through the wall paintings decorating their tombs. Their style suggests that the most famous, those from Tarquinia close to Civitavecchia (550–470 BC), were painted by artists originating from Eastern Greece, but at that time the Greeks had an *emporium* in the port of Gravisca, near Tarquinia. It was a private sanctuary where the *emporoi*, Greek ship owners and merchants, came to leave their offerings and celebrate the cult of their protective divinities. Among the offerings brought to light by the excavations of this Greek temple, bulk 'prepared *kuanos*' was found (Mortari and del Caldo 1971: 299). This confirms its import to Etruria by the Greeks and its use by their painters in wall paintings in Etruscan tombs, for example in the tomb of the Augurs, Tarquinia, where it was used to colour the leaves. This continued until the first century BC (Borelli-Vlad 1987; Gaetani *et al.* 2004: 17, note 3).

In Campania, Greek tombs of the same era were found at Paestum, the former Poseidonia. Dating from around 480 BC, the 'tomb of diver's', as it is known, also has evidence of the use of 'prepared *kuanos*'. This use survived the taking over of the city

mercury and sulphur was then provoked at a moderate temperature. This gave black microcrystalline metacinnabar (mineral ethiops). Heated above 580°C, this sulphide sublimated and its vapours condensed as cinnabar. An alkali wash got rid of excess sulphur. The resulting product, the 'artificial cinnabar' of Theophrastus, bright red, was ground to serve as pigment. This technique was used at the Roman cinnabar manufacture at the Quirinal at the time of Vitruvius.

by the Lucanians towards the end of the fifth century BC. 'Prepared *kuanos*' is also found, block shaped, in the Greek tombs of Tarento (third century BC).

Gaul, on the other hand, seems to have stayed away from this trend. True, the Celts cared little about wall paintings because the materials with which they built their dwellings and sanctuaries lent themselves poorly to this type of decoration. Furthermore, archaeological evidence dating from these times is rare in Gaul. According to our current state of knowledge, the Celts appear not to have used 'prepared *kuanos*'. This, at least, is what is shown in the analyses carried out on the traces of paint on the warriors of Roquepertuse (fifth century BC) (Delamare and Guineau 1991). An imported green earth is definitely present (a celadonite coming from the Monte Baldo, near Verona) but no blue pigment whatsoever. The presence of remnants of an object painted with 'prepared *kuanos*' in the tomb of the princess of Vix (Côte d'Or, Burgundy), dating from the sixth century BC, therefore seems exceptional (Rolley 2003). In addition, various objects in the funeral furnishings, the large bronze vase in particular, testify to trade links existing between Vix and Greece.

Exports of this blue pigment were not limited to the Greek world. In Africa, evidence of the use of 'manufactured lapis lazuli' by the Punic civilisation of the fourth and third century BC are the pellets found in many tombs in Carthage. These are also found in Malta from the third century BC.

Such a success in the export market implies a fruitful trade. Whether manufactured in Egypt, Mesopotamia or even in Phoenicia, a good deal of the 'manufactured lapis lazuli' exports were probably routed via the Phoenician ports of Tyre, Sidon and Byblos. Until, that is, the creation of the first true port of Egypt, Alexandria, during the fourth century BC[12]. We know that many industries soon developed in its suburbs. Among them, glass factories were famous for their production of luxury objects embodying a high technical virtuosity, such as the *millefiori*. Artisans specialised in ceramics and glass were numerous and skilled. Therefore, it is quite probable that Alexandria became an important centre for *hsbd iryt* production. This is implicitly confirmed by Vitruvius when he rather naively said that 'the manufacture of *caerulean* blue had been perfected in Alexandria' (*De architectura* VII: 11).

To summarise, 'artificial lapis lazuli' was a peerless product made in very few places (Egypt, Mesopotamia and probably Phoenicia). It was exported from there to the whole Mediterranean world and can thus be considered an indicator of trade in antiquity.

Caeruleum, the sole blue pigment of Roman civilisation

Imports of the first century BC
How could this blue pigment not have been adopted by Rome? It had no rival on the market and was already in use by the various Italic people that Roman armies conquered. The last Etruscan painted tombs date from this period. In Tarquinia, in the

[12] Alexandria in Egypt was founded by Alexander the Great on 20 January 331 BC, the date when he marked out the location of the future walls with barley flour.

'tomb of the Typhon' dating from the first century BC, one can see creatures with a human body whose wings and serpent tails are painted in blue.

In Rome, *hsbd iryt* was known as *caeruleum*[13]. We have no idea when it was used for the first time in a specifically Roman context; there are too few painted wall decorations from the early years of the Republic. The oldest testimonial to its use comes from Pompeii in the form of earthenware plaques painted in blue, red and yellow, which were re-used *c.* 140 B.C. to fill a gutter (Figure 1.5) (Tuffreau-Libre 2003).

It is well known that Julius Caesar led an urbanisation policy, which was actively pursued by his successor Augustus. The words of Suetonius, referring to the city of Rome, are well known (Suetonius, *The lives of the Twelve Caesars*, Augustus, 28, 3, Loeb edn., 1913):

> Since the city was not adorned as the dignity of the empire demanded, and was exposed to flood and fire, Augustus so beautified it that he could justly boast that he had found it built of brick and left it of marble.

It is clear that, due to the financial might concentrated in Imperial Rome, the market was of an altogether different magnitude from what it had been in Republican times. Clients were numerous and the frenzy for constructing public and private buildings naturally corresponded to a considerable increase in the demand for wall paintings and hence for pigments. Furthermore, the resolutely expansionist policy of the Empire led to the unprecedented enrichment of the higher strata of society. These were the ones who built luxurious villas in Campania, in Pompeii, Herculaneum, Stabiae or Oplontis. Not far away, in Baiae, the highest dignitaries had palaces built. There was therefore, during the first century BC, a true blossoming of projects which required pigments for the mural decorations, and the owners were not put off by the expense. We may even say that these '*nouveau-riches*' specifically requested expensive materials, which scandalised Vitruvius:

> When before works imposed through the delicacy of the artist's skill, it is now the amount spent by the owner which is the source of prestige. Who indeed, among the ancients, does not appear to have used cinnabar parsimoniously, as one does of a drug? Today whole walls are very often covered with it, indiscriminately. And the same goes for chrysocolla [malachite], purple, Armenia blue [azurite][14]. When a wall is faced with these colours, even if they have not been artistically laid, they blind the sight; and since they are costly, the contracts expressly stipulate that they be supplied by the owner and not by the contractor. (Vitruvius, *De architectura* VII: 5.7–8, according to the text established by B. Liou and M. Zuinghedau (1995))

Where did the market find its *caeruleum* supply? How did the flow of imports and prices evolve? We shall never know. Vitruvius, the only author from the first century BC who could help us, wrote around 30 BC. Although he gives us little to go on, what he

[13]Not to be confused with 'ceruleum blue', the commercial appellation of cobalt stannate, which appeared around 1860 (cf. Chapter 6).

[14]Vitruvius is in error. The blue pigment is in fact *caeruleum*.

does say is precious even if it is concise. In his chapter on 'artificial colours', Vitruvius (*De architectura* VII: 11.1) notes: 'The manufacture of *caeruleum* was perfected in Alexandria, and later Vestorius set up a production in Pozzuoli.' The whole history of this pigment is gathered in this short sentence. At first sight, we might think that it deals lightly with the tri-millennium past of *hsbd iryt*. Actually, it just sets the facts out in perspective. In Vitruvius' time, Italian production was the only known source, and it appeared that knowledge of the past production and exports from Alexandria (in fact for two centuries by that time) had been forgotten. However, the link between the blue pigment and the city of Alexandria is so strong that scholars from the nineteenth century did not hesitate to baptise this *hsbd iryt* turned *caeruleum*, 'Alexandria blue'.

If *caeruleum* was imported from Alexandria, it must have entered Italy at Pozzuoli, north of Naples. Before the creation of Ostia, it was the main port of the Republic, and it maintained numerous trade relations with Alexandria, a city with which Pozzuoli had many traits in common. Thus the port activities of Pozzuoli were supported by a very buoyant city surrounded by industrial suburbs. In particular, there was a mineral industry which processed alum, clay and *pozzolani*, besides sulphur and realgar[15] coming from the *solfatare* nearby. Lead based pigments, such as ceruse (lead white) and litharge (a yellow lead oxide), were also made there.

The caeruleum vestorianum

The geographical position of Pozzuoli was obviously ideal for supplying the Campania work sites, which were in full expansion. The flow of *caeruleum* imports was certainly growing fast. Perhaps they did not all come from Alexandria.

Around 70 BC, probably taking part in these imports and resale of *caeruleum,* an enterprising businessman, Vestorius, decided to compete with the foreign producers by setting up a *caeruleum* factory on Italian soil at Pozzuoli itself. As this is recorded by Vitruvius, whom we find was unaware of the ancient past of his topic, should we also doubt his reporting the location of this factory in Pozzuoli? It seems not, for it is corroborated not only by Pliny the Elder (*Naturalis historia* XXXIII: 57) who, a century later (around AD 77), wrote of a *caeruleum* from Pozzuoli, but also by the name *regio vici Vestoriani et Calpurniani* given in antiquity to one of the western quarters of Pozzuoli, an appellation which underlines the importance of the factories of Vestorius. This importance was confirmed by the archaeological excavations carried out during the nineteenth century in the area. The remnants of *caeruleum* manufacturing workshops or warehouses were unearthed, containing numerous fragments of clay vases covered on the inside with a layer of blue material as much as 30 mm thick. In places, the ground itself was completely blue in colour (De Criscio 1881: 16, and 20, *Dell' antico commercio di Pozzuoli*, quoted in Dubois 1907: 127–9).

The name of the industrialist mentioned by Vitruvius is very interesting, for Caius Vestorius is far from unknown. A friend of Cicero and Atticus, he was rich, cultured and spiritual, a banker and a wise businessman who invested anywhere money could

[15]Realgar: red-orange arsenic sulphide with formula As_2S_2, rather toxic, which could be used as a pigment. It entered in the composition of certain Gallo-Roman eyewashes.

be made be it commerce, estate management or manufacturing. The correspondence of Cicero, for whom he managed certain properties, tells us that he resided in Pozzuoli (Andreau 1983). Upon his death, his heirs set up in Pompeii and lived comfortably, as seen today in a wall painting depicting lavish silverware in the tomb of Vestorius Priscus.

One can hardly doubt that Vestorius was involved in the manufacture of this blue since Pliny a century later quoted a *lomentum vestorianum* and the *Maximum Price Edict*, promulgated in AD 301, quoted a *cyanus vestorianus*. The name of Vestorius therefore remained attached to the blue which he manufactured much longer than the name of Guimet would to his artificial ultramarine (see Chapter 7).

The factory of Vestorius and its exports

Everything leads us to think that Vestorius' factory soon became prosperous. Indeed, its existence corresponds to a remarkable expansion in the use of *caeruleum* in the years 50–40 BC in Rome and Campania. This is what F.B. Sear (1977) and H. Lavagne (1988) have shown, having studied the use of *caeruleum* in the decoration of grottoes and fountains. It was employed either as pellets simply broken in two (Figure 1.6), to form mosaic tesserae (*opus musivum*), or shaped as pearls, twirls or pendants. Its colour enabled the lines of the drawing to stand out in schemes where its dark blue was in stark contrast with the white of the shells and marble. Examining these monuments shows that, during the first century AD, *caeruleum* was progressively displaced by cobalt- or copper-tinted glass, which was probably cheaper. It is of interest to note that it was in Campania, the region closest to Pozzuoli, that *caeruleum* continued for a longer period of time in this particular role.

On the other hand, the fashion of using *caeruleum* as a blue pigment continued to increase. The mural paintings painted *a fresco* in and around Rome as well as in the cities of Campania still bear witness to this, and the eruption of Vesuvius, when it buried the Campanian cities in AD 79, found the colour merchants very well supplied in *caeruleum*.

The *caeruleum* workshop of Vestorius supplied not only local customers, but also those much farther away. Exports were made by sea – the numerous wrecks of Roman coastal vessels strewn over the rocks off the southern coast of Gaul bear witness to this. Two at least, the Madrague de Giens (Tchernia *et al.* 1978) and that more recently of Planier 3 (Tchernia 1968), contain *caeruleum* in the shape of pellets a few centimetres in diameter.

The cargo ship known as the Madrague de Giens was loaded mostly with wine amphorae. It sank around 70–50 BC. The *caeruleum* it contained is the oldest found raw in Gaul. Modern pilfering has prevented precise archaeological observations from being carried out on the pigments which had been present, but of the approximately fifteen pellets recovered three were analysed. They show a low alkali content (0.5%–4%) (Blet 1994).

It is likely that this cargo ship loaded her amphorae at Pozzuoli, for the volcanic sand which served as ballast and in which the amphorae were stuck is identical to that found in the Pozzuoli area. The *caeruleum* in this ship might well have been loaded

in Pozzuoli, in which case it would be the first evidence of the operation of Vestorius' factory.

The rocky islet of Planier, about 13 km offshore from Marseilles, proved fatal to many an embarkation. One of these failed voyages is of particular interest to us, the wreck known as Planier 3. This coastal vessel went under in 47 BC (some seventeen years before Vitruvius would write of Vestorius' factory) carrying a cargo of wine amphorae, and pigments in the free space above them. In spite of modern raids on the wreck, divers recovered some 40 kg of pigments: *caeruleum* (Figure 1.7), realgar and litharge.

The typology of the amphorae indicated that the boat first loaded wine in Brundisium (near modern Brindisi). Seals lead us to the identity of the owner of this cargo, a certain M. Tuccius Galeo, who appears in Cicero's correspondence. In it, we see that Galeo and Vestorius knew each other and even assisted each other in a lawsuit against a common rival, C. Sempronius Rufus. This establishes a link between the wreck and Vestorius.

The ship took on a cargo of Campanian amphorae, probably in the port of Pozzuoli. The probability that this stop-over took place is considerably reinforced by the presence of the pigments on board for two among them, *caeruleum* and litharge, were made in Pozzuoli and the third, realgar, could only have come from the *solfatare* of Pozzuoli. This gives us a second link between the wreck and Vestorius. Continuing on its journey toward the Narbonnaise (*Gallia Narbonensis*), the coastal vessel sank in view of Marseilles. Therefore, it is extremely probable that the pellets of *caeruleum* found in this wreck originated in a factory in Pozzuoli. Considering the links to Vestorius, it seems probable that the factory belonged to Vestorius himself. As a result, this wreck is an exceptional testimony to the ancient trade in pigments.

An examination and analysis of the *caeruleum* on Planier 3 showed that it has an exceptional cuprorivaite content, close to 95% (Figure 1.8). Such high contents are rare and have been observed in Gaul in decorative mural schemes dating from around AD 15. One comes from the ancient acropolis of Lero (St. Marguerite Island, across from Cannes) (Barbet *et al.* 1999a) and the other from the *rue des Farges* archaeological excavation in Lyon (Desbat 1984; Delamare, unpublished work, 1987). Furthermore, this *caeruleum* contains tin and not lead, which testifies to the use of a tin-bronze as a source of copper during its manufacture (Figure 1.9).

In summary, Vestorius' factory has now been located both in time (the first century BC) and space (Pozzuoli). We have reasons to believe it made a *caeruleum* much richer in cuprorivaite than traditional *hsbd iryt*. Yet a few questions remain: was this recipe peculiar to this factory and is this the famous 'vestorian blue' mentioned by Pliny and the *Maximum Price Edict*?

Vitruvius' recipe

Let us return to Vitruvius. The text continues with the recipe for the manufacture of *caeruleum* (Vitruvius, *De architectura* VII: 11.1):

This is a product quite amazing for the ingredients which went into its development. Sand indeed is ground with nitre flower, finely enough to obtain a sort of flour. And,

after having mixed copper turned into filings with large files, the whole is watered to make it hold together. Then, rolling it in one's hands, it is turned into pellets which are gathered and left to dry. Once dry, they are loaded into a clay pot, and the pots are taken into furnaces. Thus when copper and sand turned effervescent under the rage of the fire have melted together, giving to each other and receiving from each other their liquors, they abandon their individual characters, and their very self destroyed by the violence of the fire, they are reduced into a state of blue colour.

In spite of the detail which it gives us, this recipe is not quantitative. It therefore conceals the real difficulties in the manufacturing process and cannot be used in practice. But, even worse, this recipe is incomplete. Where did Vitruvius obtain it from? Common sense would indicate that it is uncommon for an industrialist manufacturing a high margin product to divulge his manufacturing secrets, especially when his interlocutor has told him of his intention to pass them on. Vitruvius may well have found himself in the position of those gourmets who have asked the chef for a recipe only to find that the sleight of hand on which the success of the operation depends has been omitted.

Let us first consider these ingredients, the nature of which surprised Vitruvius. The term *harena* in Latin is probably no more precise than that of 'sand' in English. Ambiguous, it denotes any rock reduced to a powder. The most common sands are formed of silica (in general, quartz) or lime stone (shell residues). The second ingredient is 'nitre flower', a purified mixture of sodium carbonate and potassium and sodium nitrates (Guineau and Vezin 1994). The third is copper filings, filings which Isidore of Seville specified should be roasted. That copper should be used finely divided is coherent with the grinding of the other elements – it is best to start with the most homogeneous mixture possible. But why use metallic copper rather than an ore as a source of copper? Most copper salts could, *a priori*, be used. In fact, in following the recipe, almost all researchers have successfully used copper carbonates. However a sulphide, which at high temperature changes into an oxide, would fill the same role. We shall suggest a reason later.

Vitruvius mentions that the mixture of reactants was shaped into pellets. Alexandria blue, and then its Italian, Gaulish and other imitations produced since the fifth century BC, are often found in excavations in the form of extremely hard pellets 1 to 2 cm in diameter. Thus, at first sight, Vitruvius gives us the recipe for a material answering perfectly to the current definition of a modern 'ceramic material': 'A solid artificial material made of crystallised anhydrous minerals, possibly associated with a vitreous phase, formed by synthesis and consolidated at high temperature.' (Lécrivain 1987)

The typical ceramic technology is that of sintering. It can be broken down into three phases: 1. preparation of the components in the form of a powder and in the case of reactive sintering, as is the case here, the mixing of these components (sand, nitre flower and oxidised copper filings); 2. shaping at ambient temperature (pellet forming). The production of this 'green' state often requires the addition of a binder to keep the powders together (in this case, water); 3. sintering *per se*, a high temperature (i.e. above 800°C) heating operation in which a major part of the constituents, if not the whole,

stays in a solid state, simultaneously causing the synthesis of the ceramic material and its consolidation[16].

The peculiarity of the operation described by Vitruvius is its purpose. In fact, neither the form of the resulting object (as opposed to the Egyptians and Mesopotamians during the first millennia of its use or to a modern ceramist–potter) nor the properties of the material most commonly aimed for, be they mechanical (hardness, resistance to wear, cutting ability) or thermal (refractory character), were of interest. The only element of interest was the colour.

What should we obtain at the end of the process described by Vitruvius? If the sand was limestone, the result is hard to forecast. But if it was a silicate, then we should obtain a sodium and copper double silicate ($Na_2CuSi_4O_{10}$), blue in colour, so-called 'Hubert blue' (Onoratini *et al.* 1987), which is not *caeruleum*. To obtain the latter, sodium should be replaced by calcium.

Let us note a fundamental difference between Vitruvius' recipe and the Mesopotamian recipe for *uknû merku*. A glassmakers' recipe, the latter drew upon two master mixtures, one of which, *tersitu*, brought in copper. The manufacture of *uknû merku* was therefore a by-product, which, according to Vitruvius, was not the case for *caeruleum*.

Inferences from the hsbḏ iryt *and* caerulea *found in excavations*

Over the last few dozen years, numerous analyses of *caerulea* have been carried out on objects, on pigments coming from paint layers and on raw pigments found on archaeological excavations. Analyses of the latter – cakes, pellets or powder – has revealed the actual proportions of the various ingredients entering into this blue material. What can be gleaned from this mass of results?

The first striking result is that there is a copper/calcium ratio always exactly adhered to by artisans. Figure 1.10 shows this for blues made in Egypt, Mesopotamia and Roman Gaul. On these diagrams, the vertices of the triangle represent the chemical composition (in atomic percentage) of each of the three oxides which we may consider make up manufactured lapis lazuli: pure CuO, CaO and SiO_2[17]. The composition of any calcium and copper silicate of any glass containing calcium and/or copper can therefore be represented by a point located in the triangle. We notice that, be it *hsbḏ iryt*, *uknû merku* or *caeruleum*, the points representing their composition lie on a line emanating from the point representing pure silica. This means that, even though the silica content may vary, the copper/calcium ratio stays fixed at a precise value.

These results confirm the existence of a quantitative recipe applied everywhere. We had direct proof in Mesopotamia with the tablet from Assurbanipal's library, but this recipe certainly existed in Egypt. As we saw, it crossed over to Italy during the first

[16]We may note that this technology differs from that of glass manufacture by the fact that forming takes place *before* the ceramic material is made rather than *after*.

[17]The summation formula for Egyptian blue, $CaCuSi_4O_{10}$, can also be written as: CaO, CuO, $4SiO_2$. Whichever way, the facts remain the same: these four elements are positioned in precise locations in the crystalline structure of cuprorivaite, in proportions close to those suggested by the formula. See Chapter 9.

century BC and then spread through Italy, Roman Gaul and the whole Roman Empire. This recipe called for a ratio between copper filings and 'calcium' to be adhered to scrupulously. It is therefore likely that this implied weighing both these ingredients separately. Thus the 'calcium' was not, as suggested, contained in silico-calcareous sand, the composition of which might vary[18]. This was a material that could be weighed, unlike quartz sand. This reasoning holds true for copper. Let us imagine that a copper ore had been used, such as one of these numerous sulphides, the composition of which varies with the geological layer it comes from. It would have been impossible to set the ratio of copper to calcium, yet, when starting from the metal itself, this could be achieved without difficulty. On the other hand, the problem would arise again if using a copper alloy of uncertain copper content. It was therefore imperative to know the composition of the copper alloys used.

The use of fluxes

The presence of a flux, i.e. a potassium or sodium salt, is not necessary to the success of the operation, but it fundamentally modifies the physical processes involved and acts as an accelerator for the chemical reactions. This contributes considerably to the commercial success of the operation. Mesopotamian and Egyptian (particularly during the Middle Empire) productions were made with a high flux content, reaching up to 20% in atomic percentage. Sodium dominated over potassium, which is a tell-tale sign for the use either of natron or of plants living by the sea, such as glasswort. At elevated temperatures, the flux attacks part of the silica to form a glass which dissolves the calcium and copper oxides. It is in the heart of this coloured vitreous matrix that, around 950°C, blue crystals of cuprorivaite form and grow (Figure 1.11).

Just as in a tumbler of effervescing water the bubbles form on the sides, so the nucleation of cuprorivaite crystals occurs preferentially at the interfaces. At that temperature the only possible interface is between quartz and the vitreous matrix[19]. Hence the practice of using quartz in excess (even in a large excess), since the presence of unmelted grains accelerates the nucleation reactions and therefore increases the production yield[20]. This freedom to select the ratio of silica is shown in the form of half-lines issuing from the point representing pure silica in Figure 1.10.

In the case of the unused *caerulea* found in Pompeii and that unearthed in Cumae and Liternum, their contemporaries in the first century AD (Cavassa *et al.* 2010) and

[18]That from the Volturno, the coastal river reaching the sea some 20 km north of Pozzuoli, contains 10% in weight of lime stone. Pliny said it was employed as a raw material by Roman glass factories.

[19]This fact had been noticed by Fouqué in his beautiful study: 'the ancients used a large excess of silica in their production; the blue matter, as it appeared, wrapped around the grains of sand used'. An idea he would express more aptly in a second note: 'when one uses, as the ancients did, an excess of silica under the form of quartz grains, the blue matter wraps as a sheath each grain of quartz which retains its action on polarised light and is attacked on its boundary only' (see Fouqué 1889b; also from the same author: Fouqué 1889a). See Chapter 9.

[20]We are therefore faced in this case with reactive sintering in the liquid phase, made of the vitreous matrix.

Gallo-Roman productions of the first centuries AD, the flux usually contains more sodium than potassium. But the flux content is much lower than that found in Egyptian productions. It stands at around 5% to 7% or less (taken as percentages by weight of sodium and potassium oxides). Thus the vitreous phase makes up a much lower share of the material, making the proportion of cuprorivaite higher and the blue colour more saturated. We thus tend toward a different manufacturing process, dominated by diffusion of elements in the solid state through contact areas existing between grains of differing kinds, a solid phase reactive sintering (Delamare 1997). The vitreous phase being reduced to a minimum, or even nonexistent, the excess silica has little or no purpose. Yet, strangely, in all these productions, the use of excess quartz (of around 30% to 60% by weight for the *caerulea* found in Pompeii) persisted.

Comparing *caerulea* with the *hsbd iryt* and *uknû merku* group therefore points to a similarity and a difference: a similar use of excess silica and a difference in the alkali contents. The result was a more intense, more saturated blue, at the price of a lengthening of the thermal treatment and a corresponding increase in production costs. These properties are obviously maximised when the vitreous phase is absent and the Egyptian blue made of cuprorivaite only, such as in the material that was found in the Planier 3 wreck.

Might this exceptional *caeruleum* not be the *caeruleum vestorianum, per se*? This leads us to formulate the question: were there not different types of *caerulea*? Which can be rephrased as: what could be bought at the *pigmentarius*, the colour merchant? We cannot answer this question for the first century BC, but we can attempt to do it for the following century.

Caerulea *available in the first century AD, according to the texts*

In spite of the numerous finds made during archaeological excavations all over the Roman Empire, it is hard to get an idea of the chromatic palette of the *caerulea* available to the painters, as well as of the different qualities of *caerulea* on the market. There is *a priori* no reason why the use of *caeruleum* was restricted solely to wall paintings, the only use to have survived to the present day. Easel painting and painting on stone also existed. Other applications could have included cosmetics, furniture decoration and even house painting (doors and windows).

In a (rather unclear) passage of *Natural History*, Pliny (*Naturalis historia* XXXIII: 57), writing around AD 77, wrote of the existence of various kinds of *caeruleum*. He quoted various origins, the old (Egypt and Scythia) and the new (Cyprus, Pozzuoli and Spain), origins about which he confused manufactured lapis lazuli (Egypt, Pozzuoli) and azurite (Cyprus). He also quoted prices and qualities, such as *lomentum*, the name of which suggests it might have been a 'laundry blue' and which 'does not support lime'. This remark is surprising. If it is being applied to true *caeruleum*, a pigment with remarkable chemical stability, which had been abundantly used for *a fresco* painting, this comment is false. If it is applied to azurite then it is correct, and would imply firstly that azurite was used for blueing laundry, and secondly that laundry products were not basic, unlike, for example, vegetal ashes. Another quality, made from the *caeruleum* from Pozzuoli (the *cylon*), would have been a blue 'for windows'.

As for prices[21], ordinary *caeruleum* cost 8 denarii per pound, then came this lighter coloured *lomentum* made from fine grounds, at 10 denarii a pound, as well as 'a *lomentum vestorianum* deriving its name from that of its inventor, made from the finest parts of Egyptian [blue]. Its price is 11 denarii per pound.' Another mortared *lomentum* of little value (5 asses, i.e. half a denarius per pound) completed the range. If one among them served for blueing laundry, then this would have been it. Let us note that, according to Pliny, apart from the last one quoted, the pigments with lower colouring strength are more expensive.

Table 1.1 The different qualities of *caerulea* according to Pliny.

Primary products	Derived products
Ordinary *caeruleum* (8 denarii)	Lighter *lomentum* (10 denarii)
	Lomentum vestorianum (11 denarii)
Caeruleum from Pozzuoli	Blue for windows (*cylon*)
	Ground *lomentum* (1/2 denarius)

From the general comparison between prices of the different pigments given by Pliny, it appears that at this time *caeruleum* was the next most expensive pigment after cinnabar. In comparison, white lead (synthetic also) cost between 6 and 10 denarii per pound, chrysocolla (malachite) from 3 to 7 denarii per pound and white clays and 'chalks' (calcite, aragonite, dolomite), around 0.3 denarius per pound.

We then need to jump forward two centuries to find other information on prices. In AD 301, the Emperor Diocletian signed into law in Nicomedia the *Maximum Price Edict*, which limited the price of *cyanus vestorianus* to a range of between 80 and 150 denarii per pound, confirming the existence of different qualities (Corbier 1985). The texts thus bring us two essential indications: there were different qualities of *caerulea* and there were a range of prices so that the highest quality could cost up to twice the price of the most inferior quality. We may suppose that such a range of prices did not just correspond to mere grinding followed by sorting according to particle size by levigation, a very inexpensive operation. Most likely the price difference was due to differences in the holding time at high temperature and possibly also to the qualities of the raw materials.

These various merchant qualities are probably present in the numerous *caerulea* found in excavations. However, the parcelling out of studies (a find of several pellets may be dispersed between various laboratories) probably prevented its being noticed. We are therefore forced to look for a collection of blue pigments found in excavations which are well-dated, well-localised and abundant enough to hope that these various merchant qualities can be identified. There seems to be no better selection than that provided by the rich towns of Campania buried under the ashes of the Vesuvius and, in particular, Pompeii.

[21] Prices for *caeruleum* quoted here are uncertain, since the manuscript is corrupted at this location. The manuscript of *De architectura* preserved in Bamberg gives different prices, but, although values differ, the relative rankings stay the same.

The caerulea *found in Pompeii*

The unused pigments found in Pompeii have been the object of numerous studies. The most famous among them are those of J.A. Chaptal (1809) and H. Davy (1815), which are among the first archaeometric works ever published (see Chapter 9). More recently, the monumental opus of S. Augusti (1967) covers all the pigments then unearthed but dates from an era when analytical techniques were less commonly used than today. Among the narrower but more recent studies, we can quote J. Vezin and B. Guineau (1988); A. Varone and H. Béarat (1997); A. Barbet *et al.* (1999b); D. Daniele (1999); and P. Baraldi *et al.* (2002a; 2002b). In general, these later studies aim only at identifying the pigments.

Augusti is probably one of the rare archaeologists to have had a comprehensive view of the pigments available in Pompeii in AD 79. Among the numbers of unused pigments of all colours discovered in the Campania towns which he examined, *caerulea* was the third most numerous (46) after yellows (49) and reds (51), but these three colours far outnumbered the finds of other colours. It was obvious to Augusti that there were several merchant qualities; however, he did not come up with criteria to distinguish between them.

We were lucky enough to be able to resume this study on all the pigments still preserved (Delamare *et al.* 2004), taking twenty-eight samples of dry blue pigments and seven white pigments from the finds stores in Pompeii. To complete this series, we also inspected the earlier finds which are in storage in the Naples archaeological museum. We retrieved eighteen items (pellets, powder or rocks) of raw blue pigments. Most of them were preserved in the earthen cups which originally contained them (Figure 1.12). Several were in storage pots containing around 1 kg of pigment. The analyses carried out show that, of the forty-six samples, forty-four are *caerulea*. The other two are simple copper-coloured glass, devoid of cuprorivaite. To bring out differing 'qualities' of *caerulea* from this collection implied forming subsets. But by which criteria would we distinguish them? Given the uncertainty we were in, we first selected external parameters – the pigment colour and its commercial form.

The colour of unused caerulea *from Pompeii*

We first examined the colour of the pigments. In Pompeii, as in Naples, we were not able to see the blue pigments all at the same time, as Augusti had done. Nevertheless, the existence of differences in colour catches the eye (Figure 1.12). It was therefore in the laboratory that we measured the trichromatic coordinates of these various *caerulea*. The measurement we are after is that which impresses the observer's eye and brain. This is why we do not plot here the absorption graph of visible light versus wavelength (as we shall do in Chapter 9) in order to identify this material. Figure 1.13 shows the distribution of points representing the colours of *caerulea* in the CIE 1931 colour space representing blues (see Appendix). The more saturated the colour (low x, y), the darker the shade (low reflectance). Whatever the origin of *uknû merku*, *hsbd iryt* and *kuanos*, the points representing the shades of other 'manufactured lapis lazuli' lay on this curve.

It is more usual to observe and interpret the projection of this curve in the xOy plane (Figure 1.14). Eliminating the uncertainties in the measurements of reflectance makes

the diagram more readable and the plot of the *caeruleum* tints more obvious. These points, for the most part, lie on a curve corresponding to the dominant wavelength, 477 nm. We may also note that, on the whole, these *caerulea* are of light or medium colour. Saturated, deep blues (low x,y) are rare.

Several points lie off the curve, particularly for high values of y. Analyses carried out show that they correspond to *caerulea* of atypical composition, for example simple coloured glass. The colour of this type of material turns out to be very sensitive to chemical composition. Colorimetry cannot displace analytical techniques, but it can draw attention to those samples particularly worthy of analysis.

Can we confirm these results? Figure 1.15 is similar to Figure 1.14, with the addition of the colour measurements of various *caerulea* retrieved in Gaul, at Lero, Soissons and Autun. The new points fall on the same curve and confirm also its split in the light blue area, where a parallel curve with a slightly higher ordinate appears. The dominance of lighter over darker colours is also confirmed.

This abundance of light blues (which matches Pliny's text on the various kinds of *caerulea*) is remarkable, as manufacturers had the ability to make *caerulea* of a more saturated colour. It may be explained by the use made of these pigments, for example skies and areas of water in wall paintings, or maybe eye-shadow in cosmetics. However, this abundance of light colours may also be explained by the possibility of obtaining dark colours more cheaply than by using a very saturated *caeruleum*, either by mixing light blue *caeruleum* with black or by using a light *caeruleum* over a black undercoat. The result is not identical to that which would be obtained with more saturated blues used alone, but it must have proved satisfactory at a lower cost.

The distribution of shades along this master curve does not occur in clusters, but is regularly spread. This prevents colour from being used as a discriminating criterion between various *caeruleum* qualities. An attempt at discriminating between shades in terms of the different commercial forms of *caerulea* (rocks, powder or pellets) also leads to regular distributions, all equivalent. Commercial form is therefore not a relevant ranking criterion either.

With both colour and commercial form having proved impossible to use as ranking criteria, we are forced to turn to others, such as the granulometry of powders and their chemical composition. By composition we mean the content of cuprorivaite and alkali elements as well as the nature of possible additives intended to modify, for example to desaturate, its colour.

Granulometry of blue pigments found in Pompeii

Most blue pigments studied were found in a powdery or weakly aggregated form. As to the pellets, they were made of a sintered powder, the original granulometry of which can be determined. To this end, we chose those images obtained by optical microscopy, a technique boasting the invaluable advantage of supplying images in real colour but which can only barely detect grains of a size below 1 μm (Figure 1.16). Where much more finely ground white pigments were present as an addition, scanning electron microscopy, equipped for elementary microanalysis, had to be used (Figure 1.17). These

images were used to determine the granulometry of the powder by the measurement of the dimensions of about two hundred grains.

The collection of measurements shows that, for 96% of these pigments, granulometry averaged around 100 µm (Figure 1.18). This is a very coarse granulometry for a pigment, but it was probably enforced by the low colouring power of this material and the use for which it was intended. A more thorough grinding would desaturate the colour far too much. The remaining 4% of the pigments were made of powders more roughly crushed. Their granulometry averaged around 200 µm. We shall see that they are not genuine *caerulea* but ordinary glasses tinted blue by copper. We further observed the presence of a much more finely ground *caeruleum*. Its granulometry is centred around 10–20 µm. We have never seen it on its own, but only in combination in roughly a quarter of the *caerulea* studied.

Granulometry therefore appears to be pertinent as a criterion to separate these subsets which would correspond to different 'qualities'. Let us recall that in the shops of colour merchants, in Pompeii notably, mortars were often found and even wheels to grind and reduce materials to a powder (Tuffreau-Libre 1999). These measurements of granulometric distributions show that half of these *caerulea* were intended to be used without any grinding. On the other hand, distributions with two (Figure 1.19), or even three modes, reveal a mixture with a *caeruleum* of another granulometry or the addition of a white pigment. The latter can often be detected only through an observation under higher magnification or by X-ray diffraction. From this point of view, an examination of the composition of these *caerulea* is therefore essential.

Composition of blue pigments found in Pompeii

Characterisation has thus been carried out both through X-ray diffraction to identify the minerals present and through EDX elementary microanalysis coupled with a scanning electron microscope to observe the minerals used as additives at higher magnification. Coupled with optical microscopy, these diverse methods were used to determine the proportions of the various minerals present (including cuprorivaite) (Delamare *et al.* 2004).

The first result showed that the blue pigments represented by points lying on the master curve in Figure 1.14 are all *caerulea*. On the other hand, points located on the curve shifted toward the top correspond not to *caerulea*, but to soda-potash-lime glass tinted blue with copper and devoid of any cuprorivaite. They are the ones roughly crushed, with a granulometry standing at around 200 µm.

The nature of the fluxes used to make all these blue pigments is rather instructive. For most *caerulea* studied, the ratio of sodium to potassium is around three, which probably points to an identical origin for flux. But there are exceptions such as the *caeruleum* added to one of the blue glasses which contains potassium only; also the *caeruleum* of the most saturated blue contains twice as much potassium as sodium. In these instances, the flux used was therefore different. Does this reveal the existence of different manufacturers or does it simply express a multiplicity of recipes?

Let us now return to the white pigments added. As we mentioned earlier, the abundance of light-blue shades (Figures 1.13–1.15) in this collection of blue pigments is quite

remarkable, most probably reflecting the taste of customers for this type of pigment. From a technical point of view, these light blues were made in three different manners, possibly indicating three different manufacturers.

The first method is a severe shortening of the high temperature holding time during the manufacture of a *caeruleum*, so that very little cuprorivaite is formed. This was a particular process carried out by the manufacturer. It was clearly an economical way to proceed.

The second method consists in using not a *caeruleum*, but a simple copper-tinted blue glass. As opposed to the manufacture of *caeruleum*, that of glass presented no particular technical problem. Fairly inexpensive, it had to come from classical glassmakers. These glassmakers were already supplying the opaque glass paste blue tesserae for mosaics which had driven *caeruleum* away from that market. This was therefore a logical extension of their competitive activity. Besides its very moderate production cost, this pigment had another asset – a much higher (40%) brightness[22] than that of *caerulea* (15–30%). This high value for brightness is probably due to the particles forming this pigment being scale shaped. Here again this was a special production. The composition of these glasses clearly differs from those which the Syro-Palestinian primary workshops exported throughout the Mediterranean basin particularly to Italy (Table 1.2).

Table 1.2 A comparison of the composition (in % weight) of blue glass used as a pigment in Pompeii with the typical composition of a Syro-Palestinian glass (B. Gratuze, private communication).

	SiO_2	Na_2O	K_2O	CaO	CuO	Al_2O_3	PbO	FeO
Pompeii	63	4.5	3.4	4.3	11	3.4	8.7	1.6
Syria-Palestine	69–74	15–20	< 1.5	6–8	1–3	2	–	–

The third method, which is the most commonly observed since it concerns three-quarters of the blue pigments examined, is to add a white pigment to a medium-blue *caeruleum*. Minerals used as white pigments were chalk (calcite and mostly aragonite), quartz and cerussite ($PbCO_3$). It was probably not the manufacturer but the colour merchant who prepared these mixtures, depending on the intended use for the pigment. Table 1.3 summarises the classification we suggest for the unused blue pigments found in Pompeii.

Table 1.3 A classification of the blue pigments from Pompeii which were studied.

Primary products	Derived products
caeruleum with 60–80% cuprorivaite (granulometry: 100 µm)	• addition of chalk • addition of cerussite • fine grinding (10/20 µm)
copper tinted glass (granulometry: 200 µm)	• addition of cerussite • addition of *caeruleum* 10/20 µm

[22] Brightness: proportion of the incident light reflected toward the observer.

Lead in blue

It is worth noticing the extraordinary abundance of *caerulea* containing cerussite among the *caerulea* we examined. While the literature mentions only three occurrences for ninety-seven Pompeii pigments analysed, all colours included (Varone and Béarat 1997; Baraldi *et al.* 2002a, 2002b), we identify it five times among the twenty-eight *caerulea* coming from the Pompeii storerooms. One of these occurrences actually is the only storage pot found. Cerussite was therefore mixed with *caerulea* more often than with other products.

Yet no ancient text mentions cerussite. On the other hand, several describe the manufacture of lead white (*cerussa* in Latin), our hydrocerussite ($2PbCO_3 \cdot Pb(OH)_2$) (Theophrastus, Περί λιθων VIII: 56; Vitruvius, *De architectura* VII: 12.1; Pliny, *Naturalis historia* XXXIV: 54). It was well known and manufactured at the time in several locations, including Pozzuoli. This was probably an additive used, which became carbonated with age.

According to Pliny, *cerussa* was forty times more expensive than the other white pigments, calcite or aragonite. It is therefore unlikely to have been used merely to desaturate the colour. It must have been used for a quality of its own – its siccative properties[23] as well as its high covering power due to its high refractive index. As a siccative pigment, it could be used for house painting. In this domain, the habit of using lead white for painting wood is ancient, be it as a primer or as a topcoat. This use is mentioned by Pliny (*Naturalis historia* XXXV: 19) himself with respect to boat painting. It has been observed in Herculaneum that doors and wood furniture were often painted. As a pigment with high covering power, we can think of a number of uses, for example as an ingredient in the realisation of cosmetics.

These *caerulea* combined with lead white could have then been the coloured mineral raw material available for the manufacture of eye-shadow. We know that lead white was the base of many make-up formulations. Pliny (*Naturalis historia* XXXIV: 54) writes of women's habit of whitening their complexions with white lead. The *caerulea* with the finest granulometry were not the ones containing cerussite, rather the ordinary quality with a granulometry centred around 100 μm. According to specialists in cosmetics, this granulometry is not an obstacle for such a use, the main issue being the covering power (i.e. non-transparency) of the product. This would be the role played by lead white, a pigment with a high refractive index, which remains opacifying in a greasy medium such as lanoline. As for *caerulea*, its use as make-up is vouched for by a text from the poet Propertius around 20 BC[24]: 'So what! That a woman makes her face up with *caeruleum* / Ensues it that is it beautiful?'

As for material witnesses, there have been numerous links made in museum exhibits between *caerulea* and make-up kits found during excavations (for example, for the third

[23] Siccative: that which accelerates the drying of the paint layer. For oil paint, lead makes soaps with the fatty acids of the oil, soaps which play an active part in the film polymerisation.

[24] *An si cœruleo quædam sua tempora fuco / tinxerit, idcirco cœrula forma bona est?* Propertius, elegy XVIII, verses 31–32 (quoted in Barbet *et al.* 1997).

century BC, in the Taranto area: see Lippolis 1986). But the connection between these objects is hypothetical and has not been proven.

What other use then? If we notice that some of these *caerulea* mixed with lead white, as well as a pot containing this white, were found in the *casa dei Casti Amanti*, which was not the shop of a colour merchant but a private residence in the process of being decorated by painters, we must look for a use in decoration. However, lead carbonates were not pigments which could be used for *a fresco* painting (C. Cennini, [*c*. 1420] 1991). They react with damp lime and darken. These may be the blues referred to in this sentence of Pliny's which surprised us: 'they cannot be mixed with lime'. But they can be used to overpaint *a secco* once the fresco has dried.

It is also known that lead white was much used by Greek painters to paint on stone, in particular on marble. Pure lead white was used to make the underlayer and to desaturate colours. Thus, in the so-called Eurydice tomb in Vergina (Macedonia) dating from the end of the fourth century BC, it is mixed with cinnabar (for the clothes of the Gods), *kuanos* (for the blue sky) and yellow ochre (the hairs) in the paintings covering the back of the marble throne (Brécoulaki 2000).

The multiplication of production during the first century AD

While the first century BC saw the *caeruleum* industry come to life and prosper on Italian soil in a single spot, Pozzuoli, the following century witnessed its diffusion in Italy, Gaul and Germany. The geographical dispersion of the *caerulea* dating from the first century AD analysed over the last few years speaks for itself (Table 1.4).

Table 1.4 A chronological list of *caerulea* analysed, whether unused or taken from paint layers, dating from the first century AD.

Date AD	Provenance
15	Lero (Ste Marguerite Island, France)*
15/20	Magdalensberg (Austria)*
0/25	Argenton-sur-Creuse (France)**
20/50	Magdalensberg*
25/50	Argenton-sur-Creuse**, Eysse** (Villeneuve-sur-Lot, France)
40	Vaison-la-Romaine*, Metz* (France)
50	Soissons*, Aix-en- Provence* (France)
79	Pompeii* (Italy)
80	Metz*, Paris (St Jacques street), (France)*
69/96	Liternum, Cumae* (Italy)

*Analyses by F. Delamare. **Analyses by M. Blet (1994). Pliny wrote his *Natural History* around AD 77.

One could think of course of an intensification of exports from the factory (or factories) in Pozzuoli, but we noted among the unused pigments found in Pompeii a certain amount of diversity in the fluxes employed. However, this does not amount to a chronological development of the practices of the very same workshop, since these pigments are contemporaneous. We might therefore be tempted to see them as variants of the same recipe produced by different manufacturers.

We reach the same conclusions when comparing the nature of impurities and minor components present in the various Gallo-Roman *caerulea* analysed (Delamare 1998). Their diversity shows that different raw materials were used. These products being generally of local origin, the conclusion cannot be avoided – new workshops appeared, farther and farther away from Pozzuoli. More proof of this comes directly from two archaeological finds made in Campania.

Recent excavations have brought to light on the site of Liternum, 20 km north of Pozzuoli (Figure 1.20), a storage location for *caerulea* dating from the Flavian times (AD 69–96), more or less contemporary with those coming from Pompeii (Gargiulo 1998). Numerous crucible fragments were found, most of them covered with a thick layer of blue pigment. A whole crucible was even found intact, having been used as a child's coffin (Figure 1.21). Cylindrical in shape, with a slight bulge in the middle, its dimensions (51 cm in height, 38 cm in diameter) give it a volume of 55 L. On display at the Baiae Museum, its capacity may be compared with the 0.1 L of the crucible found in Tell el-Amarna (see Figure 1.2).

In Cumae (7 km west of Pozzuoli), excavations led by the Centre Jean Bérard (Naples) have brought to light a ceramic dump, also of Flavian origin, containing numerous fragments of crucibles. They belong to one of two types. One, called 'open', more or less cylindrical, resembles that found in Liternum. The other, 'closed', has a neck much narrower than the waist (Figure 1.21). Unfortunately, it has not yet been possible to reconstruct the complete shape of these crucibles which had a minimum capacity of 12 L. In both cases, the fragments were covered with thick layers of a blue material (Figure 1.22) (Cavassa 2004).

The distribution in the CIE 1931 colour space of most points representing the colours of these pigments lies on the master curve of *caerulea* (Figure 1.23). Analyses carried out show that they are indeed *caerulea*, albeit rather poor in cuprorivaite. The other points lie slightly above this master curve, confirming once more the existence of a second curve parallel to the first with ordinate values slightly higher. The corresponding pigments show an abnormally high reflectance value. Analyses carried out show that we are dealing with *caerulea* abnormally rich in glassy matrix and very poor in cuprorivaite, very close to copper-tinted glass (Cavassa *et al.* 2010).

It is hard not to notice the geographic proximity of Liternum and Cumae to the main Italian source of sand at the mouth of the Volturno, which Pliny had recorded as having been used for glassmaking (Pliny, *Naturalis historia* XXXVI: 194; see also note 18):

> Today, we gather white sand coming from the Volturno, an Italian river, along a six mile stretch of coast between Cumae and Liternum, where it is most fine, and grind it in a mortar or with a wheel. It is then mixed with three parts of natron or by checking weight and volume; having been melted, it is put into other furnaces. There it turns into another material, called hammonitrum. The latter is melted anew and becomes then pure glass, a mass of clear glass. Sand is worked to-day in this manner in Gaul and Spain.

The multiplicity of manufacturing locations for *caerulea* during the first century AD is ascertained. This expansion paralleled the development of glass artisanship, and

was probably a part of it. The movement would continue to grow over the following centuries.

A universal blue from the second to the fourth century

Indeed, as Rome extended its conquests, it introduced the use of *caeruleum* where it had not existed before. Its production, which used only inexpensive raw materials but required a careful control of temperatures, spread throughout the Empire. As it spread, its price came down.

The archaeological excavations carried out during the last thirty years show that not only did the geographic area of *caeruleum* use increase considerably, but its use in wall paintings also became common. First limited to representing water (fountains, marine scenery) and the sky (paintings with a mythological topic), its use spread to the painting of larger and larger surfaces, such as plain backgrounds and whole panels. This is supported by an ever increasing body of archaeological evidence.

This evolution shows up particularly clearly in Gaul, where several hundred locations have yielded unused *caerulea,* or decorations containing *caerulea* in the blue paint layers (Figure 1.25) and sometimes also in the green (where *caeruleum* nuances a green earth) (Delamare *et al.* 1990; Figures 1.26 and 1.27) and purple (where *caeruleum* is mixed with haematite or madder lake) (Guichard and Guineau 1990). As for finds of unused *caerulea* in pellet form, the site of Bibracte (near Autun) has the greatest number of pellets found. Most Gallo-Roman villas have wall decorations, often rather stereotyped. Among the most remarkable from our point of view is one of the rooms of the large villa found in *rue des Magnans* in Aix-en-Provence, dating from the first half of the second century. This has exceptional wall décor of large panels with blue backgrounds.

The third century was the time when the use of *caeruleum* as a blue pigment was spread most widely, having travelled far beyond the boundaries of the Roman Empire to London, Libya, Uzbekistan[25] (Lapierre 1990) and even to Norway[26] (Rosenquist 1959; Chase 1971). In AD 301, the Emperor Diocletian enacted in Nicomedia the *Maximum Price Edict*, which set a ceiling price for some commercial products including pigments (Chapter 34, *De pigmentis*). Among them was *cyanus vestorianus*, for which the edict limits the price to a range of 80/150 denarii per pound. If we compare these prices with those given by Pliny 224 years earlier, taking inflation into account over the corresponding period, the price of *caerulea* had in fact gone down by 80% to 90% (Figure 1.28) (Corbier 1985). Since we know demand went up strongly during this period, these lower prices would tend to reflect the multiplication of production sites, as well as the considerable increase in the use of *caerulea* noted by archaeologists.

The third and fourth centuries AD left us with another iconographic source of great interest, the funeral paintings of Jewish and Christian catacombs dug around various big cities, Rome in particular. Decoration, more functional than luxurious, was *a fresco*

[25] Wall paintings of the Toprak Kala palace.
[26] The tomb of Bø, located near the Arctic Circle, dated from the middle of the third century AD, delivered a shield, the decoration of which contains *caeruleum*.

using a rather limited palette dominated by the warm tones of ochres on a white background. Green earths were little used[27] and blues were rare, as they were still comparatively expensive for use on inexpensive, functional decoration. However, the blue pigment used to render the transparency of glass, or to make shadow, was indeed *caeruleum*. Too few of these pigments have undergone analysis for comparisons to be made among them or with those preceding them. The use of *caeruleum* is also observed, sparingly again, in the wall paintings of the Coptic hermitages of the Kellia, a vast ensemble located halfway between Cairo and Alexandria. The date of these paintings is thought to be between the fourth and the eighth century AD.

The survival of caeruleum *during the Middle Ages*

Until recently, in the West, it was thought that the production of *caeruleum* disappeared during the fourth century with the downfall of the Western Roman Empire, whereas it continued in the Eastern Roman Empire[28]. Its use in a wall painting in Trier cathedral, dating from Constantine (fourth century), was thought to be an exceptional reuse of an ancient *caeruleum*. However, research carried out over the last twenty years has largely changed this somewhat simplistic point of view. For, in spite of the extreme rarity of wall paintings dating from these troubled times, the increasingly common practice of physicochemical analysis of wall paintings has indicated the later and later use of *caeruleum*.

Table 1.5 Currently known pre-Carolingian occurrences of medieval use of *caeruleum*.

Date AD	Provenance	Location	Type
5th century	catacombs	Naples	wall painting
7th–9th century	St Augustine's Abbey	Canterbury	wall painting
700–750	Church of S. Saba (Aventine hill)	Rome	wall paintings
before 850	St Germain, St Étienne oratory	Auxerre	wall painting

How is it distributed over the eight centuries constituting our Middle Ages? Table 1.5 shows that, for the earlier period, occurrences are very rare. During the fifth century AD, *caeruleum* was used in the frescoes of Neapolitan catacombs, cult locations where many honoured martyrs were buried. A more systematic examination of paintings made there during the sixth and seventh centuries may well bring more occurrences to light.

We have proof of its use at the S. Saba monastery, on the Aventine hill in Rome, during the first half of the eighth century. It was used together with ultramarine for the blues in two of the scenes of the life of Christ (*The healing of the paralytic* and *St Peter rescued from the waters* (Gaetani *et al.* 2004)) painted *a fresco* and discovered at the beginning of the last century. *Caeruleum* is also observed not as a pigment in a paint layer but dispersed in the carbonated lime underlayer of two Carolingian schemes in

[27]The same holds for prehistoric parietal paintings. The reason was likely the total obscurity of the surroundings requiring the very yellow light of oil or animal fat lamps, rather unfavourable to the colour of green earth.

[28]A study of the survival of *caeruleum* in the Eastern Roman Empire remains to be written.

the St. Étienne oratory, located in the crypt of the abbey of Saint-Germain d'Auxerre (France, *c.* AD 850) (F. Delamare and E. Cadet, unpublished work, 1998). One is a *trompe l'œil* capital painted during the Carolingian era (Figures 1.29–1.31) in the St. Étienne oratory (Sapin 1999); the other is an interlaced design painted during the four-teenth century. From the dispersion of a few *caeruleum* grains in the white undercoat, we can only conclude that the older paint layers containing *caeruleum* were scraped off in order to recover the carbonated lime below. Such a practice has been observed here at two different periods. Similarly, *caeruleum* traces were found on a polychromic capital in St Augustine's Abbey in Canterbury, of uncertain date (seventh to ninth century) (Braine and Welford 1991).

The rarity of archaeological evidence dating from this era may indicate that the use of *caeruleum* was restricted. What could these reasons have been? Could the recipe have disappeared? The Vitruvian recipe for *caeruleum* had not been lost, since Isidore of Seville recorded it around AD 630 in what would become one of the most famous medieval encyclopaedias, *Etymologiae*. Although there is a great similarity to Vitruvius' recipe (in particular the omission of the material supplying calcium), it also contains a piece of information which is not found in Vitruvius: copper must be used in an oxidised form (Isidore of Seville, *Etymologiae* XIX: 17.14[29]). The true recipe, that which could be successfully implemented and which had been so widely spread, could not have disappeared everywhere (this is borne out by the later uses of *caerulea*), and it would be almost impossible to restrict imports of the raw materials necessary to its manufacture as they were all very easy to procure anywhere. Hence, the fall in the use of *caeruleum* resulted more likely from a lack of demand. In the absence of a strong political power, all edifices which would have had wall paintings (palaces, rich dwell-ings, cathedrals, abbeys, churches) were no longer being built.

Caeruleum *and Carolingian Renaissance*

The reappearance of the use of *caeruleum* coinciding with the Carolingian Renaissance lends weight to this hypothesis (Table 1.6). It has been observed on an illumination in Carolus Magnus' Gospels representing a fountain of life surmounted by two blue-col-oured peacocks (Figure 1.32) (Roger 2007)[30]. At the abbey of Müstair in Switzerland, it was used in wall paintings for backgrounds, halos, mandorlas, folds in dresses and as an underlayer for flesh tones (*c.* AD 800) (Emmenegger 1986). It also appears on a wall painting of the beginning of the ninth century in the S. Vincenzo al Volturno church (Molise, central Italy) (Howard 2001).

[29]Here is this little known text: '*Caeruleum temperare primum Alexandria repperit. In Italia ex arenae pulvere et nitri flore idem faciunt. Sed Cyprium in fornace adustum huic permixtioni addes; Vestoriani similitudo erit.*' *Adustum* would be a corrupted form for *aes ustum*, corre-sponding to the Greek *chalcos cecaumenos*, roasted copper (Cu_2O) (see Guineau and Vezin 1994). From where did Isidore of Seville get this information, which is absent from the different versions of Vitruvius' text that have reached us?

[30]The manuscript is preserved under the reference 'Nouvelle acquisition latine 1203' at the Bibliothèque Nationale de France

Table 1.6 Currently known Carolingian occurrences of medieval use of *caeruleum*.

Date AD	Provenance	Location	Type
781–783	Carolus Magnus' Gospels	Aachen	illuminations
c. 800	Müstair	Switzerland	wall painting
early 9th century	S. Vincenzo al Volturno	Molise	wall painting
800–850	Sta Maria Foris Portas	Castelseprio	wall painting
800–850	Sta Maria Antiqua, atrium	Rome	wall painting
847–850	lower church of S. Clemente	Rome	wall painting
10th century	Winchcombe Abbey	Mercia	adorned letter

The first half of the ninth century brought us two new occurrences, wall paintings located in the Santa Maria Foris Portas church in Castelseprio in Lombardy, where it was used as an underlayer for flesh tones (Leveto 1985), as well as in the Santa Maria Antiqua atrium in Rome (Howard 2003: 39–40). In Rome, *caeruleum* was identified in an *Ascension* located in the lower church of the Basilica di San Clemente (AD 847–850) (Lazzarini 1982). It is therefore quite reasonable to presume the rebirth of production and demand sustained by a political power practising a vigorous policy of civil and religious building construction.

With the end of the Carolingian period (middle of the tenth century), demand dropped but seemed to continue in England, since the use of *caeruleum* was recently identified for the illumination of adorned letters on a sacramentary, a manuscript dating from the tenth century made at Winchcombe Abbey, one of the more important Benedictine abbeys of Mercia (Figure 1.33), as well as on another manuscript of the same period, also from southern England (Roger *et al.* 2004; Roger and Vezin 2007)[31].

From then on, the milestones become rarer (Table 1.7). The first occurrence signalled is remarkable – the use of *caeruleum* for an easel painting, a *Last Judgement* preserved in the *Pinacoteca Vaticana*. Painted *a tempera* over wood, it is attributed to Nicolò and Giovanni, painters working in Rome in the eleventh and twelfth centuries (Gaetani *et al.* 2004; see also Pozza *et al.* 2000). Then, more accurately dated (AD 1151–66), comes a polychrome statue discovered in the chapter house of St Albans Abbey in Hertfordshire, England (Kahn 1986). Definitely later are the wall paintings of the *loggia dei Cavalieri* in Treviso (thirteenth century) (Gaetani *et al.* 2004)[32].

Table 1.7 Known post-Carolingian occurrences of medieval use of *caeruleum*.

Date AD	Provenance	Location	Type
11th–12th century	The Last Judgment	Vatican	easel painting
1151–66	St Albans, chapter house	Hertfordshire	polychromic sculpture
13th century	loggia dei Cavalieri	Treviso	wall paintings

[31] Manuscript preserved at the Orleans municipal library under the reference BMO, MS 127.

[32] The presence of Egyptian blue in the remnants of blue paint layers on the polychrome sculptures in the window of the central portal of the Genoa cathedral (early thirteenth century) was the object of a publication. Analysis however could only detect azurite (Rotondi Terminiello 1978).

The areas where the use of *caeruleum* endures seem to be Italy (Müstair is very close to the Italian border) and England. In fact, it is probable that instances of *caeruleum* use could be traced in other countries such as France or Germany, if one were to look for them. For years Italy and England have indeed been the two countries most interested in identifying pigments in wall paintings. Therefore, the technique of *caeruleum* manufacture did not get lost in the world of occidental technique. On the other hand, in the learned world, the very memory of its existence disappeared. There may have been a few scholars toiling in the depths of monastic libraries who still knew there had been a quality blue pigment named *caeruleum*, but they would have been the exception.

The technical recipe books from the twelfth century reflect this state of affairs. The painting treatise of Eraclius[33], *On the Colours and Arts of the Romans*, was written around the millenary. It contains the Vitruvian recipe for manufacturing *caeruleum*. His earliest known manuscript dates from the twelfth century. It is currently preserved in the Avranches library in France but must have belonged to the library of Mont Saint-Michel. There we find the recipe for preparing *caeruleum*, but the word *caeruleum* was replaced by *cerussa* (white lead). The original version of the work, copied from Vitruvius' text, most certainly contained the word *caeruleum*, but this word was forgotten in the space of a few generations. During the act of copying the manuscript, the copyist monk, to whom the word *caeruleum* meant nothing anymore, corrected what appeared to him to be an earlier copyist's mistake, replacing it with the nearest word he knew, *cerussa* (Guineau and Vezin 1994).

A second example occurred around AD 1130 when the Benedictine monk Theophilus (who was not a theorist, but a practitioner) wrote the three tomes of his opus *De diversis artibus (On various Arts)* (Theophilus 1961)[34]. One of them was dedicated to the manufacture of pigments and another to that of glass, enamel and stained glass windows. Whilst, logically, the recipe for *caeruleum* should have found its place in one of them, the author kept silent on the topic.

Thus, while twelfth-century Europe was taken up in a real building frenzy of churches and cathedrals, which were decorated with paintings both inside and out, *caeruleum* turned up once more in the painter's palette. Even though the texts of Vitruvius and Isidore of Seville were still available and perpetuated the memory of this blue pigment which had been made for nearly four millennia, they would have to have been read, and understood! It would take until the beginning of the nineteenth century for interest in this blue pigment to pick up again, after its discovery during the first excavations in Pompeii, then its rediscovery during Bonaparte's expedition in Egypt.

[33] Italian painter born in Rome, remembered only for having written this *De coloribus et artibus Romanorum* toward the end of the tenth or the beginning of the eleventh century.

[34] It generally believed that Theophilus is the religious pseudonym of the German goldsmith Roger von Helmarshausen.

2

Zaffre, smalt, *bleu d'esmail* and azure
Tribulations of Saxon cobalt

For close to five thousand years – until the twentieth century – cobalt had no other use than to colour blue[1]. Yet the range of its applications was exceptionally broad, since it could be used at ambient as well as high temperatures (e.g. for cobalt-coloured glass as well as glazes and decoration on ceramics). Dissolved in a glassy material, it behaved like a dye. Blue glass, once crushed to a powder, could be used as a pigment by artists or by industry for paper or textile blueing.

General background

Cobalt-coloured glass: colour and transparency

In the ordinary sense of the term, glass is a mixture of oxides especially designed so as not to crystallize and to retain a consistency (viscosity) enabling it to be worked over a broad range of temperatures. One can say, more academically, that glass is a non-crystalline solid exhibiting the vitreous transition phenomenon (Zarzycki 1982). To achieve this result a glass lattice oxide is required (generally silica). Other oxides able to introduce a certain amount of disorder into this lattice are then added: lime, which

[1] The eighteenth century nevertheless saw attempts at using cobalt for metallurgy, as witnessed by Buffon (1783–1788, 3: 'Du cobalt' entry) quoting Baumé (1773): "M. Baumé, in his Experimental Chemistry, claims to have incorporated cobalt into an alloy for fountain taps, that this alloy could be perfectly moulded and was not subject to any kind of rust." This promising attempt does not seem to have had any sequel.

diminishes the solubility of glass in water, and alkalis (soda or potash salts), which lower the softening point of the mixture and are called fluxes. The proportions of these constituents varied little with location and era (Table 2.1).

Table 2.1 Typical glass composition (% by weight), outside colouring and opacifier compounds. A light blue is obtained with a cobalt oxide content of around 0.02%, 0.2% gives a medium-dark blue and 0.5% a very dark blue.

	silica	soda	potash	lime
Egypt eighteenth dynasty	76%	15%	2%	7%
Roman glass	70%	19%	1%	10%
window pane twelfth century	60%	4.5%	20%	15%
modern window pane	75%	17%	–	8%

Glass is usually coloured. This colour hinges on three factors: the nature of the colouring oxide, its concentration and the nature of the flux. When the colouring oxide is cobalt oxide (Co_3O_4, cobalt(II, III) oxide, or CoO, cobalt(II) oxide), the blue colour is a result of each Co^{2+} ion being surrounded by four oxygen atoms forming the extreme points of a tetrahedron of which it is the centre, the combination being made electrically neutral by two alkaline ions.

Cobalt is often not the only metal to be found in the ore used. It is almost always accompanied by nickel and iron, which also colour glass, but the colouring power of cobalt oxide is such that it determines the resulting colour. As glassmakers are wont to say, 'its colour eats all others'. It is therefore used at a very low concentration. This concentration determines the colour purity (chroma).

Less obvious is the role of the flux. Sodium or potassium in the flux modifies the shade previously obtained, the hue being considered more remarkable with potassium than with sodium. The discovery of this fact in the 1970s ended the dogma of the inimitable Chartres blue – the blue in the twelfth century stained glass windows of Chartres cathedral (France). The facts are simple. In a glass bay containing blues, one can tell perfectly easily, without analysis, those which are coloured with cobalt from those coloured with copper. When a twelfth century bay in the Chartres cathedral needed repair, light cobalt blue panes had to be made anew. However, it proved impossible to achieve the proper shade. Did the cobalt oxide of ancient generations contain impurities that had proved impossible to take into account? There had to be a lost secret.

As glass, the ultimate electrically insulating material, cannot be analysed using an electron microprobe, it was not until the invention of the ion microprobe that the 'secret' could be revealed. Most of the Chartres bays date from the thirteenth century, and the glass composing them contains a soda flux. This is why the master glassmaker in charge of restoring the twelfth century bay had selected as a base a soda-lime glass which he had coloured with cobalt oxide. Analyses showed that in the twelfth century glass was made with potash-based fluxes. Once the type of glass had been changed, the

desired shade could be reproduced. This was the reason – the physical origin of which is still poorly understood to this day – for the difference in shades between the light cobalt blue of the twelfth century bays and the deeper cobalt blue of those from the thirteenth century.

The transparency or opacity of glass also plays an important role in visual perception and this is not due to chance. Glass has the structure of a frozen liquid. If all of its components are perfectly dissolved, glass is transparent. However, if they are not, or if some insoluble material with a different refractive index is added (an opacifier), a portion of the light is diffused at the opacifier/vitreous matrix interface. Glass first becomes translucent. As the concentration of opacifier increases, glass turns opalescent, then, finally, into opaque enamel. Glass containing a notable proportion of a second phase is called *pâte-de-verre*.

The choice of opacifier is very wide. Analyses carried out on diverse families of objects show that the nature of the opacifier varies with time and location. Its identity can therefore contribute to the authentication of a glass object. In antiquity, Egyptian and Roman civilisations used calcium antimonate. In Limoges, France enamel makers used calcium and lead antimonates from the eleventh century until AD 1230. However, from 1230 onwards, for an unknown reason, they turned to lead stannate (Biron *et al.* 1995). During the eighteenth century in France, lead arsenate was generally used. During the following century, when opalines were the fashion in France, glassmakers used calcium phosphate, sometimes mixed with arsenious oxide (Vincendeau 1998). It follows from all of this that the use of impure raw materials leads to coloured and opaque glass.

Obtaining glass of a specific colour, or perfectly transparent, requires that the purity of all raw materials is controlled. The constraints are even more stringent if one wants to make a colourless glass. One is even sometimes forced to use discolouring oxides. Thus it would be discovered that manganese oxide (MnO_2, also called *glassmaker's soap*) corrects the colour given by the most common impurity, iron. We shall have the opportunity to return to this 'optical blueing' role of cobalt oxide later.

Cobalt ores

Cobalt deposits are rare. In Europe, most of the important veins are located in the quadrangle of the Ore Mountains in the Erzgebirge, famous for their very rich deposits of silver, which have been exploited since at least 1160. Cobalt is often found with silver. The most famous locations, the mines of Freiberg and Schneeberg on the northern edge of the quadrangle, belong to Saxony. Joachimstahl, now Jáchymov in Bohemia, is on the southern edge of the quadrangle. Cobalt is found also in Hungary.

The production dates of these locations are unknown. The earliest mention of zaffre and its German origin are to be found in a document from the *Fondaco dei Tedeschi*, the German merchants' warehouse in Venice, dating from 1328. However, most of the

documents available date from the end of the sixteenth and the beginning of the seventeenth centuries, when a series of mining towns appeared in the very heart of the mining districts in production: Schneeberg, founded in 1470, Annaberg in 1497, Joachimstahl in 1516 and Marienberg in 1521.

At the beginning of the eighteenth century, with the help of the craze for earthenware and china, a number of rulers of countries importing Saxon products promoted an active search for any cobalt veins which might exist on their own territory. Thus, in France, two medium-sized sites containing cobalt were found, one at Ste Marie-aux-Mines in Lorraine and, in 1767, another at Chalanches, near Bourg d'Oisans. In the Pyrenees, several sites were exploited on the Spanish side (Sage 1791). In Sweden, the very important deposits of Tunaberg and Hakansbø were discovered after 1750 and soon after, in Norway, those of Skutterud and, in 1770, that of Blaafarveværket. From 1823 until 1849, this last mentioned location was the largest smalt producer in the world. It employed 2,000 people and supplied three-quarters of the world market for cobalt blues. This market collapsed with the arrival of artificial ultramarine (see Chapter 7).

In 1864, Garnier discovered the rich lodes of New Caledonia, which came into production ten years later and made up the main resource for cobalt until 1904, when the Ontario mines joined them. The Katanga mines in Congo went on line in 1926 and very quickly ranked number one for production. Various sources of cobalt of secondary importance were later exploited in Germany, Morocco, Rhodesia and Pennsylvania. These productions coincided with the growth in the metallurgical uses of cobalt, which would open new and vast outlets.

The ancient sources of cobalt were therefore small in number and mostly outside France. Indeed, except possibly around 1786, France drew largely on foreign sources for its smalt supply, in particular from the Netherlands.

The most common cobalt ores are arsenides and sulpho-arsenides (Table 2.2). Cobalt is never present alone. Other metals accompany it, sometimes in comparable amounts, almost always nickel and often iron. The French chemist Thénard had already pointed out the similarities in chemical behaviour between these three metals, which still constitute 'the iron family'.

When analysis is taken further, traces of other metals are also found, the presence of which, linked to the particular genesis of each vein, constitutes a kind of signature for the vein. Thus, for the Egyptian cobalt alum from the oasis of Dakhla, analyses provide evidence for the presence of small quantities of manganese and zinc besides iron and nickel. In our current state of knowledge, this association of metals characterises this particular origin. In this way, one can thus attempt to determine the provenance of the cobalt used to colour an object.

Table 2.2 Main cobalt ores available in Europe.

Minerals	Formula	Occurrences
smaltite	$(Co, Ni)As_{3-x}$	Schneeberg (Saxony)
		Tunaberg (Sweden)
skutterudite	$(Co, Ni)As_3$	Schneeberg (Saxony)
		Jáchymov (Bohemia)
		Tunaberg (Sweden)
		Skutterud (Norway)
cobaltite	$(Co, Ni, Fe)AsS$	Schneeberg (Saxony)
		Tunaberg (Sweden)
		Hakansbø (Sweden)
		Vasturanland (Sweden)

Determining provenance

The accumulation of data resulting from the analyses recently carried out on cobalt-tinted objects, suitably dated and of known origin (glass, ceramics and glazes), allows a possible origin for the cobalt present in or on an object to be suggested, the cobalt coming from zaffre (we shall make this term more precise later)[2]. As a consequence, even in the absence of any archival document, one can, thanks to analysis, pinpoint the true production period of a mining location producing cobalt. The accuracy of the dates thus determined depends on that of the dating of the objects analysed.

Cobalt ores used to tint glass or ceramic decorations of Mediterranean antiquity and Western Europe from the Bronze Age to the nineteenth century are currently classified into nine families (see below). Each one has a signature based on not only its source, a vein, but also the way in which it has been treated:

Cobalt ores in the Near East:

- *Co-Ni-Zn-Mg-Al* in association. Middle and Late Bronze Ages, and the beginning of Hallstatt. The cobalt yielding ore came from alum deposits in Egypt. This cobalt is linked with soda glass made with plant ashes as a flux and with the first instances of glass made with natron as a flux (Egypt and Mesopotamia).
- *Co-As-Ni-Fe + Pb-Sb-Sn-Zn* in association. Palestine, from the end of the seventh century to the eleventh century AD. An occasional presence of chromium. The ore is likely to have come from the Kashan area, north of Esfahan (Iran).
- *Co-As-Fe* in association, sometimes with Cr and Zn. From the twelfth century to the fifteenth century AD. The ore also probably came from the Kashan area. This cobalt was used to decorate ceramics.

Cobalt Ores in Western Europe:

- *Co-Ni-As* in association. Late Bronze Age, from the eleventh to the eighth century BC. At that time, cobalt blue glass almost always contained copper. We can see

[2] Analyses are carried out via a mass spectrometry technique applied to matter vapourised via laser ablation (LA-ICP-MS) (see Gratuze *et al.* 1996; see also Gratuze and Blet-Lenormand 2002).

$CuFeS_2$ chalcopyrite particles through a binocular magnifier. The origin of this ore is as yet unknown (maybe the Ore Mountains).

- *Pure cobalt*, or binary pairings such as *Co-Sb, Co-Cu* or *Co-Mn*. From the eigth century BC until the twelfth century AD, cobalt was used almost pure, in particular for Gallo-Roman glassware. The origin is as yet unknown (possibly a Near East import).
- *Co-Zn-Pb-In-Fe* in association. Between the twelfth and fifteenth century. Ore Mountains and Freiberg provenance likely.
- *Co-Ni-Mo-Fe* in association. Around 1500, cobalt came from the Schneeberg *skutterudite* sufficiently roasted to eliminate arsenic. We shall designate this period as 'Schneeberg I'.
- *Co-As-Ni-Bi-W-Mo-U-Fe* in association. From the sixteenth until the eighteenth century, cobalt came from the same Schneeberg *skutterudite,* less roasted than previously however, hence the presence of arsenic and bismuth. This modification in the ore preparation was probably linked to the manufacture of *smalt*. We shall name this period 'Schneeberg II'.
- *Co-Ni-As* in association. During the nineteenth century, cobalt was accompanied only by nickel, with little arsenic. The provenance has not been formally identified. Potential cobalt sources are mentioned above.

Although cobalt is not widespread in the earth's crust, its use in obtaining glass of a blue colour is old – as ancient, it seems, as the invention of glass itself.

Antiquity

The first instances of cobalt-coloured glass

Invented around 3,000 years before our era in Mesopotamia or Egypt, glass, the first synthetic material, was opaque and coloured. Produced in very small quantities, it was used in jewellery only, in place of of lapis lazuli, turquoise or carnelian. Two kinds of blue were made. One was coloured with copper, this was the Egyptian blue we investigated in the first chapter. The other, darker blue derived its colour from cobalt. Where did the latter come from?

Such was the question long faced by Dayton, who carried out numerous analyses on blue, or blue-glazed, objects made in the Middle East during the third and second millenia. Dayton came up with an ingenious hypothesis (Dayton *et al.* 1978; Dayton 1981): this cobalt might be a by-product of silver production in the Ore Mountains, some kind of slag. After analytical techniques had become more sensitive, this hypothesis was dropped in favour of the use of a local source, the Dakhla oasis, where alums can be found containing 0.37% of their weight in cobalt (Kaczmarczyk 1986).

A technological and economic breakthrough occurred in Egypt during the reign of Thutmose III (around 1450 BC). Not only was glass (still opaque and coloured) no longer restricted to the field of jewellery, it was exported as raw glass ingots to the countries of the Mediterranean basin. From this time on, the production of raw material (glass) and the manufacture of the object were separate.

Glass *per se* was made in glass factories. They held the recipes; procured the raw materials, the flux, the colouring ingredients; and carried out fusion at around 1100°C. They, or rather their environment, bore the brunt of the terrible consumption of combustible matter which contributed to the deforestation of whole countries. These glass factories were first confined to Mesopotamia and Egypt but soon spread to the Syro-Palestinian coast around the mouth of the river Belus (now the Na'aman River), near modern Haifa. The amount of glass exported continued to grow and was sent to an ever-increasing number of glass workshops throughout the Mediterranean.

In these workshops, referred to as secondary workshops, glassmakers (often Jewish) reheated glass to around 800°C and turned it into objects. The system also implied organising the collection of the precious broken glass and sorting by colour. For cobalt-tinted blue glass, it seems that a frit was first made by heating pulverised pebbles of quartz with natron and cobalt laden alum at around 1100°C. Thus a blue material was formed, a master mix containing 0.2% by weight of cobalt oxide to be used for colouring glass (made with plant ash as flux), ceramic pastes or glazes (Tite and Shortland 2003).

It seems that blue glass, whether tinted by cobalt or copper, was much prized on the export market, demonstrated by that which was found in the Ulu Burun wreck, discovered and excavated off Kaş (Turkey). Around 1300 BC, this Cypriot or Levantine freighter contained among its rich cargo 175 ingots of blue glass in three different tints: dark blue ingots coloured with cobalt, turquoise blue coloured with copper and lavander blue (Pulak 1998, 2001).

After the appearance of the technique of moulding enabled the making of glass bowls, the invention of glassblowing in Palestine at the beginning of our era revolutionised the economy of glassmaking. This technique made it possible to obtain even larger objects which could be used as bottles or jugs and simultaneously increase production rates which reached such a level that glass objects could now be found in every house.

Cobalt glass was still around, but often in luxury items. It is found in marbled glass cups, or as the background of cameo glasses of which the white top layer was engraved. The most famous example is the Barberini-Portland vase, dating from the first century AD, currently preserved in the British Museum. Then came, during the third century AD in the Köln region, common glass vases highlighted with cobalt-tinted glass motifs. Some designs still existed under the Franks in the sixth century.

While cobalt-tinted glass is seldom found in the medieval objects that have reached us, we can at least be sure that glassmakers were using it for stained glass windows.

The medieval period

Theophilus and the glassmaker's art

The technical manual written around AD 1125 by the monk Theophilus describes how to build glassmakers' furnaces, set up a workshop and make stained glass windows (Theophilus 1961). Yet, no recipe is found in this book for the manufacture of coloured glass. Theophilus did not know them but mentions that certain colours were obtained by chance:

> Chap. 7. On yellow glass. Should you see one of the vessels assume a saffron colour, let it cook until the third hour, and you will obtain a light yellow; use as much as you like, following the processes indicated. If you wish, let it cook until the sixth hour and you will obtain a reddish yellow; there again, use it as you please.

> Chap. 8. On purplish glass. Should you recognise that one of your vessels turns into a fawn colour, nearing that of flesh, keep that glass for skin tones. Retaining what you want, cook the rest for two hours, between the first and the third, and you will obtain light purple; cook yet again, from the third till the sixth, and you will have a perfect, reddish purple.

For brighter colours, recycling ancient glass provided a solution:

> Chap. 12. On the various colours of glass. There are to be found in the ancient buildings of the pagans, among the mosaic works, various kinds of glass, to wit: white, black, green, yellow, sapphire, red and purple. It is not transparent, but opaque as marble. They are like small square stones inserted in gold, silver or copper: we shall revert to them in detail in the article concerning them.

> Various small vessels of these same colours are also to be found, which are recovered by the French, very clever at this type of work. They melt in their furnaces the sapphire, adding a little clear and white glass, and make precious sheets of sapphire, rather useful for windows. They do the same with purple and green.

The fame of French glassmakers for their knowledge and handicraft in the field of stained glass windows, which was to last until the seventeenth century, was therefore already established. However, Theophilus also knew that, as heirs to an uninterrupted tradition, Byzantine glassmakers made luxury items out of sapphire glass:

> Chap. 13. Of glass cups that Greeks decorate with gold and silver. The Greeks make out of the same sapphire stones precious drinking cups. Here is how they decorate them in gold (...)

The sapphirum vitreum *of Abbot Suger*

We know little of the beginning of the art of stained glass in France, but, by chance, the construction of the new abbey church in St Denis, near Paris, by Abbot Suger left us with indisputable and well-dated testimonies: first, a number of the original windows, currently dispersed (Cothren 1986; Lautier 2005), and then the writings of Suger

himself. Thus we know that, for him, the coloured light from the windows was to help with meditation (Suger [1142] 1867: chap. 33):

> When, besides the beauty of God's house, the beauty of the multicoloured stones draws me away from external worries and an honourable meditation leads me to reflect, transposing that which is material into that which is immaterial, on the diversity of sacred virtues, then do I believe seeing myself somehow in a strange region of the universe, existing not wholly in the mud of the earth nor in the purity of heaven. I believe I am transported anagogically through God's grace from this lower world to this higher world.

The blue colour was his preferred choice for it evokes better than any other 'the inaccessible light where God dwells' (Bur 1991). This was cobalt blue. This was why it was necessary that the stained glass windows of the new abbey contain a sizeable proportion of these blues (Figure 2.1). Around 1142, Suger ([1142] 1867: chap. 29) procured *sapphirum vitreum* for his worksite:

> The Lord with his infinite liberalities who, besides his assistance in the most difficult of cases, gave us also master glassworkers for the admirable stained glass windows as well as an abundant supply of sapphire glass (...), will not allow that funds lack for the completion of the project, He who is its beginning as well as its end.

However, we do not know from where this cobalt came. No analysis having ever been performed on Suger's windows, we are left with conjectures only. At that date, it might have originated from the first mines opened in the Erzgebirge, at Freiberg, but it could also have been the product of the old transparent sapphire glass recycling pointed out by Theophilus as a specialty of French glassmakers.

It is noticeable that there is something akin to an association of ideas between the blue colour imparted to glass by cobalt and luxury. Making sapphire glass did not, however, present any particular technical problem. There were no successive thermal treatments to carry out as was the case for red-coloured copper glass. Yet sapphire glass was expensive.

We have several witnesses to this high price, including a ledger dating to the years 1531–2 listing the expenses involved in equipping Saint Stephen's Chapel, Westminster with stained glass windows. For an identical, undefined surface 'unit', it cost six pence for 'white glass from Chiddingford' (one of the main glass centres in the Weald in Kent), two shillings and six pence for red glass and three shillings for blue glass (Brown and O'Connor 1991). Sapphire glass was indeed one of the, if not the most, expensive coloured glasses. The reason probably lies in the high price of the colouring material imported from Saxony, *zaffre*.

Zaffre and smalt

Zaffre and smalt, one or two different products?

Are the words zaffre (from the German *zaffer*) and smalt (also called in France *bleu d'esmail* or just *émail*) synonymous, or do they refer to different products? If this is the case, which products are they? The answer to this question is far from obvious because most authors make no distinction.

One of the earliest known texts concerning zaffre is that of Biringuccio (1540: book II, chap. 9):

> Zaffre is another mining product, heavy as metal, which will not melt alone, but, when accompanied by things approaching the nature of glass, it will turn into water, and colours in azure, so much so that those who want to tint glass or paint vases of glazed earth of azure colour put it to good use according to the craftsman's requests; but, if one adds more of the aforementioned Zaffre than is needed for said azure colour, it will yield black.

Kunckel is more precise in the commentary he gives on Chapter 12 of Antonio Neri's book (1612), entitled *Of the method for preparing the Zaffre to be employed for colours, in the Glassmaking Art,* in 1689. A descendant from a family of glassmakers, a glassmaker himself and an alchemist, he was a Gentleman of the Chamber and chemist for Johann Georg II, Elector of Saxony (Kunckel 1689[3]):

> I note that Merret and our author [Neri] went to great trouble to discover what zaffre might be. I therefore believe it necessary to describe it here in detail. Those who work in the mines at Schneeberg in Misnia[4], as well as in other locations, draw from earth a mineral they name Cobalt. (...)

Once the cobalt ore has been selected and roasted in two stages, each followed by grinding, it is then reduced to a fine powder which is sifted:

[3] *Ars vitraria experimentalis* is divided into two parts. The first is made up of the seven books of Antoine Neri, the notes of Merret on Neri, and the observations of Kunckel on both these authors. The second, published by Kunckel, is a collection of several operations related to the art of glassware. It seems that an English translation, which remained handwritten, was made by Hooke and read in session at the Royal Society as early as 1685 (cf. Harley 1982: 220, note 71). This book would not be published in French until 1752, in Paris, in a translation due to the Baron d'Holbach. The latter added on to it translations of a series of texts he deemed both interesting and related. Hence the rather long, but explicit title of the book: *Art de la verrerie, de Neri, Merret et Kunckel, auquel on a ajouté le "Sol sine veste" d'Orschall, l'"Helioscopium videndi sine veste solem chymicum", le "Sol non sine veste", le chapitre XI du "Flora saturnizans" de Henckel sur la vitrification des végétaux, un Mémoire sur la manière de faire le saffre, le Secret des vraies porcelaines de la Chine et de Saxe, ouvrages traduits de l'allemand par M. D****. It inspired the 'Saffre' entry in the *Encyclopédie* (1765), written up by d'Holbach.

[4] Misnia, the largest of the regions constituting Saxony, named after its original capital, Meissen.

Take a part of this cobalt [oxide] reduced to a powder; mix two parts, or even more, of pulverised rocks, or of well pounded & sifted quartz; wet this mixture & put it in barrels; it becomes compact and hardens as a stone, to the point where iron implements are required to break it. The matter thus prepared is sent to the Dutch and to the other Nations, which use it to paint their earthenware & tint their glasses. This is what many people call *Zafloer*, & what our Author and his Commentator Merret call *Zaffera* (in French *Zaffre*).

Sand is added in Misnia to prevent other countries from deriving or counterfeiting to their profit the starch blue which the Launderesses use, or the colour which Painters name *blue smalt*, or *bleu d'émail*; for it must be known that by mixing cobalt thus prepared with a certain amount of sand and potash, if this mixture is molten, there will result a dark blue glass which, when crushed in an especially designed mill, between two very hard stones, yields a powder of a very bright and very beautiful colour.

The Manufactures where these operations are attended to bring a very considerable income to the Elector of Saxony. Should the pure roasted cobalt, i.e., without addition of sand or crushed rocks, be sent abroad (which is forbidden to the workers, under the threat of very severe penalties), it would be easy to make elsewhere the starch blue and gain the corresponding advantage: zaffre is made in order to preserve this trade. Should one want to have a pure, unadulterated cobalt, of which a part would be more effective than three or four parts of zaffre, it would have to be obtained on the spot where it would be proportionately more expensive.

This text distinguishes unequivocally between zaffre and smalt. Zaffre is therefore a powdery mix of roasted cobalt ore and quartz sand. It is a greyish-red colour. Intended for the decoration of ceramics and the colouring of glass, it turns into glass and brings out the blue colour upon use only, through the action of the flux in the glaze or by dissolution into the glass. Its composition by weight is one part of roasted cobalt ore for one, two, three or four parts of quartz sand (Hartwig 2001).

What was the reason behind this addition of sand? Kunckel did offer an explanation, but why should adding quartz sand to cobalt oxide prevent the formation of smalt, and hence the colouring starch? Other reasons were put forth. According to some, this addition was intended to dilute the colouring product, so as not to sell too concentrated a product. For Beckman, this adjunction was meant to hide from the observer the true nature of the colouring product (Beckman 1846: 478–487, 'Cobalt', 'zaffer' and 'smalt' entries).

Practice shows that when cobalt oxide is used on its own, the blue colour obtained is rather dull. Yet, when silica is added, a cobalt silicate of a rather pleasing vivid blue is formed during heating. There probably lies the true reason behind this addition of sand to the roasted cobalt ore. However, the hue can be made even more beautiful by adding other mineral salts, such as a zinc salt. There are so many possibilities for improving the colour imparted by zaffre through these additions that one must conclude there was not a single zaffre but rather various kinds of zaffre, some probably more prized than others.

In any case, Baumé informed us about the easy measurement of the cobalt oxide content of zaffre (Baumé 1773: vol. 3, 402–5, *Essai des Mines de Cobalt* and *Lavage du safre*):

> As I could not obtain enough cobalt ore to procure a quantity of this semi-metal, able to supply the experiments I intended to carry, I treated zaffre as cobalt ore, & obtained through the use of fluxes a lot of this semi-metal; but, in order to have less useless matter to melt, I separated via rinsing as much I could of the sandy matter the Saxons mix with it.

> Water is poured into a large tureen, & three to four ounces of zaffre are put on a coffee cup saucer. This saucer is plunged in water, being held very straight with a single hand immersed up to the wrist joint: it is rapidly swung from right to left, ensuring it is always kept perfectly horizontal. This type of convulsive wrist motion drives the lighter sandy matters out of the saucer to gather at the bottom of the tureen, & constantly brings back to the centre the heavier mineral which, through this very simple operation, finds itself freed of the larger part of its sandy matter.

> I separated by this means up to six ounces of earthy matter not needing to be melted for each pound of zaffre [i.e. 50% by weight]. All the zaffres in the trade are not equally rich in cobalt. The proportion of sand discarded through rinsing varies much.

Smalt, on the other hand, is a potash glass coloured blue with cobalt and crushed to a powder. The question arising then is: why two products? Would a single one not have been enough? Zaffre is specifically designed to yield the blue colour either in glass or, using specific fluxes, in glazes. Smalt can colour a glass without problem but, due to its potassium content, would dangerously alter the chemical composition of the glaze on earthenware. Zaffre is used as a dye source; smalt, on the other hand, is used as a pigment.

In fact, zaffre and smalt have not always co-existed. Let us try to pinpoint the dates of appearance of these two products.

The beginnings of zaffre manufacture

The product described by Biringuccio under the name of zaffre is indeed that which we refer to under that name. Its applications prove this, as it is used to decorate ceramics and colour glass. Zaffre was therefore already manufactured in 1540, which has long been taken as the date of reference.

However, texts and material witnesses allow us to go back directly to the fourteenth century. The treatise on glass by Antonio da Pisa, written in 1395, mentions zaffre under the name *charafone,* as well as its German origin. It points out that zaffre was sold all over Europe in small leather bags and that it was very expensive (Gallo and Sandron 2008).

These pieces of information seem correct since during excavations in France floor tiles made around 1386 by Spanish earthenware manufacturers for the Valois Princes were found, many of which bear decorations made with a type of zaffre yielding a

blue-grey colour. In the oratory of Philippe le Hardi, Duke of Burgundy, in the Chartreuse de Champmol the tiles with heraldic décor depicting the lion of Flanders and the ancient Burgundy stripes can be listed (Quarré 1955; Jugie 2000). They were made between 1383 and 1389 by Jehan de Gironne, director of the Montot tile factory. The contemporary tiles of the castle at Mehun-sur-Yèvre were made in 1384 by Jehan de Valence for Jean, Duke of Berry (Rosen 2000). The very same Jehan de Valence, who also directed a workshop in Poitiers, ordered on 4 June 1386 for 16 sols (Gratuze *et al.* 1996): 'To Perrot Mehé for a pound of zaffre needed to paint tiles.'

During the fourteenth century, the Avignon *gabelle*, which levied taxes on all products brought into the city, mentionned the *saffre er colorar veyre*, which was taxed at 12 sous per hundredweight (cwt), hence twelve times more than soda or glass debris used in glass manufacture (Foy 1989). An older text referring to zaffre is a document from the *Fondaco dei Tedeschi*, the German merchants' warehouse in Venice. This text, dating from 1328, mentions the trade in *caffaranum*, one of the Italian terms designating zaffre (Stege 2004).

Excavations of glassmakers' workshops in Languedoc (La Seube) and Provence (Planier, Cadrix, Rougiers, Nans) allow us to go back even further. They have indeed brought to light numerous shards of clear glassware, goblets and cupellas, highlighted with appliqué beadings of cobalt blue glass. The oldest among these objects are, for the time being, dated to the second half or the end of the thirteenth century (Foy 1989). These objects, the oldest witnesses known to us of the use of cobalt in the medieval period, would appear to set a *terminus post quem* in the vicinity of 1270.

Let us recall that at the beginning of the twelfth century Theophilus the monk knew nothing about the glass colouring recipes (Foy 1989). He was content to accept the colour he found in his crucible and to give advice on an appropriate usage. Furthermore, although he knew of sapphire glass, he believed its source was the scraps of broken antique blue glass (small vases and tesserae). He knew the 'Greeks' used it, and tells us the French had become masters in the art of recovering it and turning it into stained glass windows. Zaffre was unknown to this Mosan glass specialist around 1125.

Zaffre production, therefore, began between 1125 and 1270. Could we narrow this time window down still further? The answer is *yes*, thanks to physico-chemical analyses. The analytical work carried out by Gratuze is from this point of view exemplary[5]. First carried out on ores and then on dated blue decorations, it suggests the twelfth century as a *terminus post quem* for the start of zaffre production and identifies the source of the cobalt: the Freiberg, one of the older mining sites of the Saxon area in the Erzgebirge.

The time window corresponding to the start of zaffre production is now narrowed down to the twelfth century. Theophilus might have belonged to the last generation

[5] See note 2

of glassmakers who ignored or who had no knowledge of zaffre. Thus, when in 1142 Abbot Suger congratulates himself on having succeeded in securing a sufficient quantity of *sapphirum vitreum* for the realisation of the stained glass windows in his new abbey church (Suger [1142] 1867: chap. 33), it may have owed its colour to this brand new source of colour, 'Saxon' zaffre.

The beginnings of smalt manufacture

Various texts mentioning smalt date back to the end of the sixteenth century. Thus in 1573 we read in *The Arte of Limning* (*A very proper treatise* 1573):

> To temper smalte or florrey[6]. Smalte or florrey being tempered in a shell with gum water make a blue, but not too perfect a color as azure or bice both make. The Apothecaries do put to it often times fine sand or chalk to multiply it to their profit. Therefore in choosing of it, take that which is bright of color, and not harsh, but soft between the fingers.

Only in 1580 was the first (and very scant) description of the manufacture of zaffre published. It can be found in the treatise of Lazarus Ercker (1580), who was the superintendent of mines for the Holy German Empire and the Kingdom of Bohemia, and who lived in Annaberg. At the end of the chapter concerning the recovery by fusion of the bismuth contained in the ore, we read:

> The nodular residue obtained through the two fusion processes [in the open or in a furnace] is used for the production of large quantities of zaffre blue pigment; it is used to colour glass blue. It is sold and sent to glassworks everywhere.

If it had been zaffre, as suggested by its use by glassmakers, this product would not have been blue, but grey. Yet Ecker explicitly refers to a 'blue pigment'. It is therefore likely that he confused both products under the appellation of zaffre, which would demonstrate the existence of smalt at that time.

Smalt is mentioned again in *Il Riposo*, the treatise on drawing by Borghini dating from 1584 (Borghini [1584] 1730: 173).

The text suggesting perhaps the earliest date for smalt production is fairly recent, published by Melzer (1684: 405) in 1684. It narrates a personal adventure which must have taken place in the sixteenth century:

> Peter Weidenhammer, from Franconia, arrived here [Schneeberg] a poor man. But, thanks to a colour he made from bismuth and of which he exported numerous hundredweights to Venice at a price of twenty-five thalers[7] a hundredweight, he soon made a

[6] *Florrey*, now flowers, is the scum that floats on the top of a healthy indigo dye vat. It has been used by artists as a blue pigment.

[7] A thaler (silver coin) is worth twenty-four groschen. Three Saxon florins (guilders) are worth two thalers.

fortune and built a beautiful house on the market place. His name is inscribed on the lower window of the choir in the big church, with the date 1520.

From this very short text we can still picture a trade mostly export related and very rewarding. But what was this colour exported by Weidenhammer? It was indeed cobalt, hence a cobalt blue, for – and we shall revert to this – cobalt was unknown at the time as a chemical element and its colouring properties were commonly attributed to bismuth. We shall see later on that the illusion of the blue colour being linked to the presence of bismuth was to last long after Brandt showed in 1742 that it was due to cobalt.

Was it zaffre for glassmakers, or smalt sold as pigment? Venice was already famous for its Murano glassworks, which made use of zaffre, but it was also renowned as an entrepôt in the trade of rare pigments (Matthew 2002).

However, a blue pigment is made to be used. What chronological information can we derive from observing the use of smalt by painters?

It has already been several dozen years since the conservation departments attached to the major museums began submitting the works entrusted to them to detailed examination using more and more sophisticated tools. Determining the pigments used is the easiest part of this painstaking work. A synthesis of these studies shows that the main period of the use of smalt by painters began around 1550, when the Turks invaded Hungary, which stopped the export of azurite of which that country was then a major producer (see Chapter 4). Having become rare and expensive, azurite – which already served as a cheaper substitute for ultramarine – was replaced by smalt. This lasted through the seventeenth century.

Yet we know that smalt had been used much earlier, in fact during the fifteenth century, by Flemish and German painters. It has long been thought that, among these works, its first occcurence was in the *Entombment* by Dieric Bouts the Elder, now in the National Gallery, London and dating from around 1450 (Mühlethaler and Thissen 1986). However, currently a *Carrying the Cross* painted around 1400 by an unidentified German painter is credited as having the oldest recognised occurrence of smalt. This painting is preserved in the Alte Pinacotheck, Munich (Stege 2004). Another painting shares in this privilege, but this is a wall painting, also dating from around 1400, located in the S[t] Johann and S[t] Salvador church in Donaustauf (Bavaria) (Stege 2004)[8]. Taking the large number of paintings and decorations studied into account, this date seems credible. Smalt therefore appeared in Western Europe at least two centuries after zaffre.

Saxon, Venetian or Byzantine innovations?

What lies behind the term 'appearance' when associated with the arrival of a product on the Western European market? Does this refer to Saxon 'innovations' or rather a

[8] Archives of the Doerner-Institut.

transfer of technology to Saxony, in which case which country might have been at the source of this transfer?

The currently accepted opinion is that the appearance of zaffre and then of smalt occurred in Saxony or Bohemia, in the immediate proximity of the European cobalt mines. There is certainly no shortage of sixteenth and seventeenth century texts suggesting the building of factories of zaffre and smalt in the Erzgebirge region. However there is no actual proof of the establishment of the technology in question.

Let us examine the hypothesis of technology transfer. The country which might have been the source of this transfer would be one where the glassmaking skills were at their zenith, and one which has access to a source of cobalt, used in manufacturing coloured glass, enamels and pigments.

Such a description would naturally apply to Venice. Settling in the first half of the seventh century at Torcello, the Venetian glassmakers made coloured glass for the tesserae destined for use in mosaic making. To make the dark blues, it is likely they imported the cobalt from a non-European source, such as Kashan in Persia, whilst the supply from Saxony was not available. Venice was well-known as the commercial hub of rare pigments and very early on was involved with the international trade in smalt and zaffre, the latter under a variety of names: *caffarum, chafarone, gafaro, saferina, saffra, zaffera, zaffra, zafro, zaffaro*, etc. However, once again, this hypothesis is seductive, and like the previous one has no tangible proof to substantiate this opinion.

There is another country which appears even more credible as a candidate: the Byzantine Empire, which, as in so many domains and in particular that of glass, has been a place of conserving and developing long held technical traditions. Even if the territory has undergone many changes over the centuries, we know that cobalt veins did and still do exist in modern day Turkey in Asia Minor, which although not big are numerous. Today, the Turkish mines office classes cobalt wealth as 'average', which may be translated as seams which are not commercially viable (Anaç and Tamzok 2007).

We cannot doubt that the Byzantine glassmakers produced dark-blue glass coloured with cobalt, given the evidence of Byzantine mosaics. We can take the example of those which cover the vaulted ceiling of the mausoleum of Galla Placidia at Ravenna. The abundance of cobalt blue glass tesserae bears witness not to the recuperation of antique glass, as supposed by Theophilus, but of a cobalt-coloured glass specifically made for the manufacture of mosaic tesserae. Furthermore, the use of smalt has been identified several times in Byzantine works particularly in two illuminated works (f. 76r and 190v) of a Byzantine Evangeliary (83.MB.69, MS Ludwig II.5) dating from the early part of the twelfth century preserved in the J. Paul Getty Museum, Malibu, California (M. Schilling, Getty Conservation Institute, unpublished work, 1987; N. Turner, Conservator, Department of Manuscripts, J. Paul Getty Museum, personal communication, 2010). It is therefore clear that the Byzantines were using smalt as a pigment at least one and a half centuries before it was detected in the West.

A transfer of Byzantine technology towards Saxony is therefore plausible. The link remains to be found. This might quite simply have been Venice given the direct continuous commercial links between Venice and the Byzantines and the great skill shown by those first involved in the 'Glass Arts' (Delamare 2009).

Old Recipes and reconstructions

Do zaffre and smalt have differing cobalt contents? A number of old recipes have come down to us, allowing for reconstructions, but they present some difficulties. For zaffre manufacturing recipes, the delicate issue is that while we know the weight of roasted ores to use, we do not know their cobalt content. Thus Kunckel (1689) indicated that to one part of roasted cobalt ore were added 'two parts or even more' quartz. For Hartwig (2001), the amount of pulverised quartz added to the roasted cobalt ores ranged from one to four times the weight of cobalt ore. From a roasted ore containing 80% cobalt oxide one would thus have obtained zaffres with contents ranging from 40% to 16% by weight of cobalt oxide. Let us recall that it takes only a 0.15% content for the colour to be dark blue.

In the case of the ancient smalt manufacturing recipes that have come down to us, it is the cobalt content of the zaffre used which is unknown, but it is clear that the cobalt proportion varied with the colour saturation achieved. Hartwig (2001) mentions smalts containing 2, 4, 6 or 8% of cobalt oxide by weight. Riederer (1968) quotes ancient recipes from which one can only estimate the zaffre content (Table 2.3). For an average cobalt oxide content of 23%, we would then reach an upper limit of around 5% and a lower limit between 1% and 0.3%, quite compatible with the desired colour range.

Table 2.3 A comparison between four smalt manufacturing recipes implemented from zaffre. According to Riederer. *(Milanesi 1864)

Recipe	Zaffre	Glass	Quartz	Potash	MnO_2	Zaffre content	Colour
Milanesi a	4 oz	12 oz			½ oz	24%	dark
Milanesi b	1 lb	25 lb				3.8%	light
Bolognese Ms	1 oz	84 oz				1.2%	very light
Montaubert	100/150 parts		300 parts	40 parts		23/31%	dark

Riederer quotes systematic attempts at smalt manufacturing carried out at the Doerner-Institut in Munich by mixing up various quantities of silica (SiO_2) and potassium (K_2O) and cobalt oxides (CoO) (Riederer 1968). According to purely physical criteria, the results are as follows:

- the potassium oxide content must lie between 5 and 40% by weight. Too low, it is insufficient to form a homogeneous glass; one gets a mixture of quartz and glass. Too high, it is the source of potassium hydroxide (KOH) formation when in contact with water. In practice, the cost of potash being ten times higher than that

of the silica supplied as quartz, as little potash as possible is used and one works with contents of between 5 and 10%.

- the cobalt oxide content must lie between 5 and 40 %. Below 5%, the blue glass would be too pale and could not be used as a pigment. Above 40%, the oxide would not dissolve into the glass, which would be saturated, and the resulting glass would be black. In practice, one tries to use the least cobalt oxide possible, and the contents are limited to 5–20% by weight.

Zaffre and smalt under analysis

We have very few analytical results concerning zaffres. There are barely more concerning smalts. Our conclusions will therefore be open to revision.

Table 2.4, due to Gratuze, brings together the analyses carried out on two grains belonging to different zaffres, as well as the hypothetical compositions computed on the basis of analyses carried out on blue decorations of ceramics.

Table 2.4 Mean composition of zaffres. Measured directly on grains for East and Limehouse. In the other instances, they are computed from the analysis of decorations. The samples from different origins (Barcelona, Lyon) are regrouped by impurity associations. According to Gratuze (see note 2).

	East 14th c.	13th–14th c.	14th c.	Late 14th–15th c.	Barcelona and Lyon 14th–17th c.	Limehouse (GB) 18th c.
SiO_2	50–62	50	35	44	70	69
K_2O	3	4	7	4	9	1.5
Na_2O	5	4	1	2	3.5	1.8
CaO	3.5	5	6	12	2–4	2.5
MgO	1	1	1	1	0.4	0.6
Al_2O_3	3	3	5	7	3.5	1
Fe_2O_3	12–20	18	34	23	4-6	0.8
CoO	3-7	3.7	7	7	2-3	3.1–4.4
BaO						10.3
ZnO		5.6	3	0.1	0.2	?
NiO	1–2	0.03	0.07	4.5	1	?
As	0.25	0.03	0.05	0.6	4–6	5.5
Cr	0.5–4					?
PbO		5.6	3			0.8
In	0.005	0.15	0.3			?
Mo	0.03			0.01	0.05	?
W					0.01	?
Bi				0.06	1–3	?
U					0.05	?
Associations	Co-As-Fe-Cr	Co-Zn-In-Pb	Co-Zn-In-Pb	Co-Ni-Mo-Fe	Co-As-Ni-Bi W-Mo-U-Fe	
Provenances	Kashan	Freiberg?	Freiberg	Schneeberg I	Schneeberg II	

Although highly variable (from 2 to 7%), the cobalt oxide content is high enough to justify the astonishing colouring power of zaffre. The nature of the fluxes was very

variable, but their global content of $(K_2O + Na_2O)$ is no higher than 8%. A remarkable fact is the high concentration of iron oxide during medieval times, a concentration which goes down spectacularly from the seventeenth century onwards. As for the rest, we find metals in association with other metals, the particular details of which are signatures for the provenances.

What about smalts? Spring *et al.* (2005) analysed smalts from seven paintings of the sixteenth century Italian and Flemish schools. Their cobalt oxide content ranged from 3 to 9% by weight. A smalt used by Gainsborough (*c.* 1752) reveals potassium oxide contents varying between 12 and 15% for well preserved, still blue smalt grains. It goes down to 1% for grains having suffered the impact of time and having lost their colour. One of these smalts – rather exceptionally it would seem – is high in sodium oxide (7–11%), which makes up for a comparative dearth of potassium oxide (4–5%).

Gratuze carried out analyses on smalt grains coming from whitened paper, paint layers or pigment as yet unused. Although his analytical technique differs, it was shown that the results obtained matched well with that used by Spring. The smalt grains extracted from eighteenth century Dutch-made paper (Figures 2.2 and 2.8) have rather low cobalt oxide content (0.3–2% by weight) and are high in potassium (Gratuze *et al.* 1996).

Analyses were carried out on two smalts manufactured in the eighteenth century (B. Gratuze, unpublished results, 2006). One came from S[te] Marie-aux-Mines, the other from blued Dutch papers (Figure 2.2). Table 2.5, from which most of the minor elements and traces which indicate provenance have been deliberatly omitted, summarises the results.

There is no significant difference between the compositions of S[te] Marie-aux-Mines and Dutch smalts. The 'Dutch secret', should there be one, therefore does not lie – as it has been written – in 'additions of matter which are still trade secrets of the manufacture' (Landois 1751a). The flux is indeed potassium, which of all common alkalis is the one giving the most beautiful blue colour. Its content is three times higher than in zaffres, which is normal to reach a vitreous state.

Interestingly, these smalts, which contain little calcium oxide, have a not neglige-able content of barium oxide (up to 6–8%). We know that barium plays the same role as calcium in glass, but it is a much rarer element. Is the presence of this oxide characteristic of smalt? Probably not, since it is found in Limehouse zaffre. Is it characteristic of eighteenth century productions, or of some of them? Future analyses may tell. We can only point out that it is not rare to find baryte $(BaSO_4)$ in veins containing cobalt ore, whether in the Ore Mountains (in Freiberg in particular) or at Chalanches and S[te] Marie-aux-Mines.

In summary, zaffre and smalt differ mostly in their flux content (potassium oxide). It is purposely low in the case of zaffre, so that its use did not overly modify the

compositions of glazes used for ceramics. It was purposely high in the case of smalts, since the goal was to make glass.

Table 2.5 Composition of smalts (as a percentage of weight). Average composition in the first column, according to Gauld Bearn (1923). In the other two, results of analyses carried out on two eighteenth century smalts, determined by LA-ICPS-MS. Courtesy of B. Gratuze, CNRS, Orleans.

Oxides	Smalt	Ste Marie-aux-Mines	Dutch paper
Glass constituents			
SiO$_2$	60%	63%	65%
K$_2$O	17	17	13
Na$_2$O		0.3	0.65
CaO		2	2.3
BaO		6–10	0–8 (average of 2.2)
Al$_2$O$_3$	15		
Colouring oxides			
Fe$_2$O$_3$		1.5	2.4
CoO	0.8	1.3	1.1
NiO		2	0.53
As$_2$O$_3$		2	5.1
Bi		?	1.1

From a chronological point of view, zaffre manufacture appeared in Saxony during the twelfth century and expanded as new cobalt veins were discovered. This zaffre was used to colour glass or glazes. A new product was invented during the first half of the fifteenth century, smalt, a potash glass tinted with cobalt then ground up. It was first used as a blue pigment by artists, then for blueing textiles and paper. It appeared under various appellations: Flanders blue, Dutch blue, Prussian blue, Saxony blue, and even, for the better quality, Electoral Saxony blue.

The time difference separating the inventions of these two products had been completely obliterated from memory by the time the sixteenth century technical texts were written.

The cobalt industry in Saxony in the sixteenth and seventeenth centuries

The mining rush of the sixteenth century
Toward the end of the fifteenth century, Saxony was the scene of a veritable mining rush. By 1474, 176 mines were active in the Schneeberg (Bruchmüller [1897] 1913). Probably only a score of them produced cobalt. In 1492, cobalt-containing veins were discovered in Annaberg. This brought renewed activity to an area in which silver veins were becoming exhausted. Four years later, six cobalt mines were paying dividends (*Cobalt monograph* 1960).

Mining towns were built in rapid succession: Schneeberg (1470), Annaberg (1497), Joachimstahl (1516) and Marienberg (1521). The capital invested in shares in the mines was not only that of the local aristocracy, but also came from the South and West of Germany. Soon mining legislation was passed in Schreckenberg (1500), Annaberg (1509), Joachimstahl (1518) and Hohenstein (1526) (Halleux and Yans 1990[9]). This was the time when Peter Weidenhammer acquired a fortune in Schneeberg.

A plethora of technical works also date from the middle of the sixteenth century. We have already mentioned Biringuccio (1540). In his *Bermannus* (The Miner), written in German and published in 1530, Georg Bauer, better known under the name of Agricola, talked of *kobelt*, an ore found in the silver mines of the Ore Mountains (Bauer 1530). In his *De re metallica* written in Latin and published in 1556, he points out that the miners working in the mines containing *cobaltus* and arsenic had to wear leather masks, gloves and boots to fend off the corrosive effects of arsenic (Bauer 1556). He described also the work of glassmakers (Figure 2.3). We have already noted that in 1580 Lazarus Ercker published an important treatise on ores (Ercker 1580).

Smalt, a Dutch specialty

Let us leap forward a century. The papers of Lehman published by Klotzsch provide an interesting source of documentation on the cobalt industry in Schneeberg (Lehman 1770: 363–367). Christian Lehman was a priest in Scheibenberg, where he died in 1688. He carried out research on the history of mines in Misnia, and wrote some notes at the beginning of the Thirty Years' War. According to these, the colour mills would have been around 100 years old at that time, which would have dated their establishment to the years 1540–60. Let us read his words (Beckmann 1846: 483):

> Christopher Schurer, a glass-maker at Platten, a place which belongs still to Bohemia, retired to Neudeck, where he established his business. Being once at Schneeberg, he collected some of the beautiful coloured pieces of cobalt which were found there, tried them in his furnace; and finding that they melted, he mixed some cobalt with the vitreous mass, and obtained fine blue glass. At first he prepared it only for the use of potters; but in the course of time it was carried as an article of merchandise to Nuremberg, and then to Holland. As painting on glass was then much cultivated in the latter, the artists there knew better how to appreciate this invention. Some Dutchmen therefore repaired to Neudeck, in order that they might learn the process used in preparing this new colour. By great promises they persuaded the inventor to remove to Magdeburg, where he also made glass from the cobalt of Schneeberg.

Prepared for potters and glass painters, it is more likely that it was zaffre that he is writing about, but then mills appear for grinding blue glass. This is therefore now smalt:

[9] Includes a bibliography on the history of Saxon mines (p. xiii, note 2).

But he again returned to his former residence, where he constructed a handmill to grind his glass, and afterwards erected one driven by water. At that period, the colour was worth seven dollars [thalers] and a half per cwt., and in Holland from fifty to sixty florins. Eight colour-mills of the same kind, for which roasted cobalt was procured in casks from Schneeberg, were soon constructed in Holland; and it appears that the Dutch must have been much better acquainted with the art of preparing, and particularly with that of grinding it, than the Saxons; for the elector Johann Georg sent for two colour-makers from Holland, and gave a thousand florins towards enabling them to improve the art [in his States]. He was induced to make this advance chiefly by a remark of the people of Schneeberg, that the part of the cobalt which dropped down while it was roasting contained more colour than the roasted cobalt itself. In a little time, other colour-mills were erected around Schneeberg. Hans Burghard, a merchant and chamberlain of Schneeberg, built one by which the eleven mills at Platten were much affected. Paul Nordhoff, a Frieslander, a man of great ingenuity, who lived at the Zwitter-mill, made a great many experiments in order to improve the colour, by which he was reduced to so much poverty that he was at length forced to abandon that place, where he has been employed for ten years in the colour factory. He went to Annaberg, to a colour factory established there in 1649 and with the assistance of a merchant at Leipsic he was appointed the director; and by these means the Annaberg cobalt became useable. The consumption of this material however must have decreased in the course of time; for in the year 1659, when there were mills of the same kind at more towns in the neighbourhood of the mines, he had on hand more than 8,000 quintals.

The story is anecdotal and of uncertain chronology. However, it does clearly provide evidence for the very special role which the Dutch were to hold in this domain. They left it to the Saxons to treat cobalt ore at a great expense of wood and noxious fumes (for a ton of cobalt oxide two to three tons of arsenic were produced), and concentrated their energy on manufacturing high added value materials, in this case smalt. It seems that for over a century, until around 1568, the Dutch were the sole manufacturers of this blue powder.

How did they do it? To make smalt is to make potash glass. One must therefore add to the roasted ore a large quantity of a vitrifiable oxide (quartz) and flux (plant ash), then bring the mixture to melting in a glassmaker's furnace and mix. The thick glass is then cast into very cold water where it 'shivers' and cracks. It is then ground and turned into a powder in purpose built mills, then sifted and sorted by colour and degree of fineness (a glassmaker's job followed by a grinder's job). From a technical point of view, it would appear that it was in the latter part, the art of grinding smalt – which is very hard – between stone millstones, in mills specialised for this type of work, that the Dutch became masters; hence, the efforts of the Saxony Elector to implant this technique in his states.

It was at that time, under the governorship of the Duke of Alba (1567–73), that Protestants were expelled from the Spanish Netherlands. A number of them, manufacturers or traders, settled in Germany in Protestant areas (or at least areas tolerant toward the Reformed religion) such as Saxony. Some in particular settled in Leipzig. They were

to play an active role in the privileged commercial ties which would be established between both countries, and if there is a domain in which the Dutch excel, it is indeed that of commerce. During this century long monopoly for the manufacture and sale of smalt as a pigment for artists, the Dutch would set up sales networks in Flanders, Italy, Germany, England and France.

Princely monopoly versus foreign interests: the management of mines in Saxony during the seventeenth century

We shall here summarise Bruchmüller's study ([1897] 1913). As mentioned above, during the sixteenth century the production of roasted cobalt ore, zaffre and smalt in Schneeberg was in the hands of numerous small enterprises. Intermediaries would come to buy and export. It seems that the first smalt manufacture set up in Saxony was that of Christopher Stahl in 1568. This entrepreneur is briefly mentioned as having installed in Schneeberg a small blue colour factory, with its furnace and colour mill. Producing for artists, it was probably a modest establishment. It disappeared in 1573 after a flood.

The first attempt at large scale manufacture dates from 1575, when Harrer and Jenitz applied to the Elector August for the grant of ten year exclusive rights in the purchase of cobalt oxide produced in the Schneeberg. Their argument went as follows: the roasted ore was currently bought by foreign agents who sent it to Nüremberg, and thence to Venice and elsewhere. The blue colour was prepared in foreign countries, and sold at a higher price. Through extensive research, they managed to discover the secret leading to the preparation of this blue colour; they needed these exclusive rights to achieve a return on their investment. The concession requested was granted. However, the expected results did not materialise: the two partners were not able to set up a sales network on a par with that which they wanted to supplant. In 1579, they lodged a complaint against the score of factories which, in spite of their concession, competed with them in the Schneeberg by making blue colour. The Elector renewed the concession. The ore roasted in the various factories surrounding the town could only be sold to the holders, and at a price of 10 groschen a hundredweight. However, nothing changed, and in 1589 bankruptcy followed.

Then, around that time, concessions multiplied – for mines, the treatment of ores and the manufacture of colour. Inaugurating a new policy, the Elector authorised foreign merchants to invest, which brought an influx of capital. In 1603, a decree required every transaction concerning cobalt ore to go through the Mining Office. Then, on the basis that over the course of one quarter Dutch merchants had bought 4,000 cwt of cobalt which they resold in Holland, England and Spain without paying any tax to the Elector, a special tax was created on the sale of cobalt to Holland. It came on top of those the Elector collected at every stage of production.

The same year, as a reaction against this situation, a man named Berckau, from Joachimstahl, made an offer to the Elector to take charge of smalt manufacture by

himself. The argument was still the same: the ore was currently exported to Hamburg and Holland where smalt was made, and its trade brought large profits. Since all the raw materials were in Saxony, he boasted of being able, with an associate, to make 2 to 3,000 cwt of smalt per year in Schneeberg. His provisional manufacturing costs in Saxony were broken down as follows for 100 cwt of smalt:

For roasting:

100 hundredweight of raw cobalt ore	300 guilders
Wood for roasting the ore	9
2 workers for 14 days	9
Waste 3 hundredweight	9

For smalt manufacture:

50 hundredweight of flux (ashes and sand)	400
Wood for melting	42
4 workers for 4 weeks	36
Sundries	25

Hence a total cost of 830 guilders, of which the price of flux (potash) is the dominant factor. However, at that time, the cost of Dutch manufacture came to 1,000 guilders for 100 cwt, and this smalt was sold in Hamburg for 2,000 guilders. Berckau asked for 5,000 guilders in advance and 20% of the profits. He foresaw a trip to Holland and England to establish the necessary commercial connections. Probably mindful of the Harrer and Jenitz precedent, the Elector turned him down.

In 1609, a decree made it compulsory for companies producing cobalt in Schneeberg and for warehouses to sell their cobalt to the Elector exclusively. Purchases would from then on go through the tax collector. Trade in Schneeberg cobalt had become a state business.

The consequences of this decision were beneficial at first. The new, less fragmented organization and the availability of more important financial means, supplied mostly by Dutch businessmen, translated into an increase in price and sales volume. The purchase of ore and the sale of zaffre were conceded in 1610 to a German, Kreifinger, for six years. The onus was on him to supply the needs of the Elector as a priority, and to purchase roasted ore at a price of 6 guilders and 10 groschen. Two Leipzig merchants provided collateral for Kreifinger. The contract was renewed around 1614. The Elector Johann Georg made a commitment to supply him annually with 3,000 cwt of top quality roasted ore at a price of 8 guilders a hundredweight, and 500 of lesser quality at 6 guilders.

The impact of the Thirty Years' War
The Thirty Years' War (1618–48) caused this industry serious damage. Between 1620 and 1639, the ore production went down from 8,000 to 2,000 baskets. Moreover,

during that period, cobalt extraction and utilisation industries were shaken by conflicts between the financial interests of mine operators and of miners and those of the Elector, as well as the financial backers. The last would usually be the ones to win. Thus Dutch merchants were able for a time to limit their purchases to the 3,500 cwt they needed, when the Elector wanted to sell them more. In 1620, a twelve-year contract was entered into for the supply of 6,000 cwt of prime quality and 1,000 of a lesser grade, at a price of 8 and 6 guilders per hundredweight respectively. Payment was to be made in 'good French currency'[10].

However, by the autumn of the same year, the Elector requested a loan of 50,000 guilders from these sleeping partners. They jumped at the opportunity and made him a surprising offer. They agreed to lend the amount at 7% interest, under the condition that, irrevocably and in perpetuity, they held a monopoly on the purchase of cobalt and trade in the oxide, directly, without going through the tax collector. Yearly fees of 4,000 guilders would be paid to the Elector. Probably facing a pressing need for cash-flow, the Elector agreed to the proposition, but he had to rescind his decision when confronted by his Mining Officer who showed him how such an agreement would be detrimental to the miner's rights, who would leave Schneeberg, and also not beneficial to the Elector himself, since the mines brought in 6,000 guilders annually. The *status quo* therefore persisted.

But so did the Elector's financial difficulties. The following year, the cobalt ore producers claimed the overdue payment of 17,000 guilders for previously delivered ore, to be paid in good Saxon currency, and not in the copper coins from Brunswick which nobody wanted. Furthermore, the price of all goods had trebled and caused the departure of many a miner; they requested an increase of half a guilder per basket, which was granted.

This did not suit the consortium of financial backers, who cried ruin and complained about the poor quality of the ores. Eventually they were able to persuade the Elector to agree that of one of them, Brandenstein, one of the Elector's major creditors, should be the sole person entitled to manage the purchases and trade in cobalt ore and its derivatives – tasks which were, therefore, withdrawn from the prince's tax collector – for a twelve-year, renewable duration. The Elector left Brandenstein the onus of the backpayments for already delivered ore, which amounted to 30,000 guilders. The new contractor displayed all his skills in arguing and not paying. The result was a new series of violent conflicts, the mining operators pointing out the deprivation of their miners, some of whom left while others died of hunger. Brandenstein himself ended up tearing up his contract. The Elector then granted the mining operators the right to transform the ore into oxide and to trade it themselves, in exchange for an extra tax of 1 guilder

[10] The onslaught of the Thirty Years' War freed the official Saxon monetary workshops from Imperial oversight. In 1620, the Saxon thaler, worth 24 groschen, was tariffed at 40 groschen. Hence the rejection by the Dutch of this weakened currency.

per basket of ore. However, the evidence was there: business was not getting any better. War had considerably diminished the customers' buying power, and the trade in blue colour, which was not a necessity, suffered particularly.

Thereupon an offer to take charge of the purchase of ore and the sale of oxide turned up once more. It originated from two German dealers, Hans Friese, from Hamburg, and Daniel de Briers, from Frankfurt. In short, they were offering to buy 3,000 baskets of ore annually and to pay the Elector a fee of 1,000 guilders. It was specified that, of the four grades of ore, only the top three would be paid for, at prices of 3, 2½ and 1½ thalers respectively. The mining operators vehemently opposed this project, claiming it would lead to their ruin. The project was amended, with a purchase guarantee increased to 4,000 baskets. The result was a split between the operators. The issue was settled by a vote: thirty individuals representing eighty-seven mines voted in favour of the contract; forty-three individuals standing for the 132 other mines chose the *status quo.*

During the year 1623, the number of mines producing cobalt was therefore 219 at Schneeberg. A production of 4,000 baskets per year would thus have amounted to an average of 18.3 baskets per mine, sold for about 45 thalers. These figures look completely unrealistic: the number of mines should be divided by ten at least. It is likely that all the mines, be they of silver or cobalt, or all cobalt mines, either currently in production or exhausted, each owning the right to a share in the vote, were included in the count (Daubuisson 1801–1802).

The harder part was to come. A report, dating from 1631, from the Director of the Mining Office states that since 1628 no sale had taken place, due to the war. All the mountain passes were blocked off by the military: it was impossible to transport goods. The Dutch, who had been the major customers (Figure 2.4), had given up this area of industry. Because of the lack of currency, business was done by barter. Miners were paid in ore, which they went on to sell in Bohemia at rock bottom prices to avoid starvation. To add insult to injury, the Croatian troops sacked the town of Schneeberg in 1632 and caused the ruin of most mines, which from then on were not kept up and were flooded by water. Only three mines remained workable. A basket of ore, which cost (including taxes) 1 guilder to extract, was sold for just 25 groschen.

In spite of another sacking of the town in 1642, by Swedish troops this time, Elector Johann Georg I applied himself to restarting the cobalt blue industry. He had the hardest time finding contractors willing to take charge of the purchase and treatment of ore. A contract with three German merchants, Hans Friese, Hans Burkhardt and Hans Schnorr, was finally signed in 1642. Each agreed to buy 800 cwt of ore graded by the Mining Office in three qualities, to be paid in good currency at 3 thalers 18 groschen, 2 thalers 18 groschen, and 2 thalers respectively. Friese was granted the right to export his cobalt. The other two were allowed to set up a workshop and colour mill in the area of Schneeberg. In exchange, they were forbidden to export ore to Bohemia. Indeed, the exhaustion of the cobalt mines in that country made its smalt factories totally dependent

on the supply of ore from Saxony. The Elector fully intended to gain the upper hand against his competitors. It was at that time that Brandt carried out and published his work on metallic cobalt.

Elsewhere, China had suffered economic decline at the end of the Ming dynasty; the conquest of the country by the Manchus in 1647 brought European trade with China to a halt. As blue-decorated chinaware no longer arrived in Holland via the Dutch East India Company, the Delft potters attempted to produce a makeshift substitute, and were successful in imitating it with a thin earthenware, glazed white with a blue decoration: Delftware. Their success was so great that the Delft pottery itself was soon imitated in France and in England. This large increase in European demand contributed to zaffre production starting anew.

Recovery, stability and prosperity of the Saxon cobalt industries

In 1649, the contract binding the Elector to the German merchants was renewed. This time, a fourth contractor, Sebastian Oehme, joined them. The price for the best quality ore went up to 4.6 thalers per hundredweight. The prohibition against supplying Bohemia was renewed, as well as the obligation to reserve pearl ash (a flux rich in potassium carbonate) made in Saxony for the contracted companies.

Aside from the supply of cobalt, a major concern of smalt manufacturers was to procure the necessary potash flux. At that time, the pearl ash from Saxony covered only a third of the needs of the Schneeberg contractors; the other two-thirds had to be imported from Bohemia. The price of this product was far from negligible in the production cost of smalt: we saw that, for an equal weight, it cost more than twice as much as the ore.

In 1651 Burckhardt died heirless and bequeathed his four cobalt mines and his large factory to the Elector who therefore became directly involved in this industry as a contractor.

The system had, in any case, found a stable equilibrium point, and the exclusivity contract would be renewed several times with the contractors. Four factories and four only would make smalt in Saxony. As the ducal company, located in Oberschelma, was twice as large as the others, however, there would always be not four shares but five, three being in private hands and two belonging to the sovereign of Saxony.

In 1659, an agreement was entered into by the contractors. It laid down:
1. A pricing agreement. Smalt would be sold between 5 and 10 thalers per hundredweight for the two extreme qualities. Due to the need for transport, there would be an extra half thaler for smalt going to Leipzig, and more depending on distance.
2. No manufacturer was allowed to make more than 24 cwt of smalt per week.
3. Each manufacturer had to brand the barrels containing its production with its own mark.

Five manufacturers producing 24 cwt each weekly amounted to a yearly production of around 6,000 cwt (each equivalent to 100 lb) of smalt.

Smalt manufacturing according to Zimmermann

A century later, in 1746, the book of Carl Friedrich Zimmermann dedicated to the mining sciences appeared. It was divided into several treatises. One of them dealt with the manufacture of zaffre and smalt (Zimmerman 1746):

> One used to hide the ways to make zaffre or the colour blue under a great shroud of mystery: but it is of very little use to be so secretive in this matter, for although there are various operations & skills contributing to the purity & fineness of this colour; it nevertheless is the cobalt & bismuth earth, *Wismuth graupen*, which lies at the source, & anywhere these two materials are found, there will be no lack of people able to extract the blue colour. Choose Glassmakers who have already worked with glass of differing colours, & they will soon find the necessary manipulations to bring the endeavour to fruition. These manipulations vary with the various kinds of cobalt to be treated; often-times the process which is advantageous for one type of cobalt is not for another, & in some location a mystery is made of an operation which sometimes cannot take place in another.

In twelve pages the various stages in the manufacture and controls required for the proper manufacture of smalt were set out:

- appraisal of the quality of the ore, sorting and crushing to the size of a hen's egg.
- light roasting of the ore in the open air to melt the bismuth.
- assay of the ores to determine the mix required to achieve the desired colour. 'For each assay the Assay Master was paid three guilders, and one guilder for whom-ever made the colour inspection.'
- once a quarter, the mine owners sent samples of the cobalt ores they had extracted to the Grand Council of Mines as controls. The ore was weighed and distributed in fifths between the four smalt manufacturers (the princely company was allotted two-fifths). Officially identified samples were retained for testing.
- tests of the cobalt content (the nature of which was never made explicit)[11]. Once the cobalt content was known it was possible to determine the amount of tax owed to the Elector (taxes on the tenth, on the ninth and others), taxes which were levied on the owners of the mines, then on the manufacturers of blue colour.

[11] The Baron d'Holbach tells us of the nature of these tests: 'A quick method to determine whether a *cobalt* mine will yield a beautiful blue is to melt it in a crucible with two to three times its weight in borax, which will turn a beautiful blue if the *cobalt* is of good quality.' (Holbach 1753). Baumé, in his treatise *Chymie expérimentale et raisonnée* (1773: vol. 3, 402, *Essai des Mines de Cobalt*) described another kind of test, a quantitative one, consisting of weighing the cobalt obtained from 4 oz of ore.

- the ore was transported to the blue factories where it was crushed in a stamping mill and sifted. The powder then underwent an oxidative roasting in a reverbatory furnace. 'In these shops was burnt only excellent very hard wood.' During the roasting, which lasted from five to nine hours, the ore would lose from 20 to 30% of its weight. It was then sifted.
- in parallel, potash was prepared from the ashes of trees burnt in the forest. The ash was washed in water, and this solution was then evaporated in boilers. The residue (pearl ash) was calcined in reverbatory furnaces. The resulting salt, i.e. potash, was then sifted.
- silica was also prepared from white stones gathered in the fields or from the quartz gangue accompanying the cobalt ore. These materials, extremely hard, were first calcined, thrown into cold water to shatter and then taken to the stamping mill and sifted.
- equal parts (by weight) of these three powders, cobalt oxide, potash and silica, were mixed in a crate, then used to fill crucibles which were placed in a glass furnace[12].
- these crucibles, made of Bohemian clay, were expensive and required special care. When new, they were carefully brought up to temperature. When in use, they never left the hottest area of the furnace. Iron ladles were used to charge and discharge them. There were six crucibles in the furnace.
- heating was carried out at the highest possible temperature. To that effect, the dryest possible wood was used. After six hours, the mixture in process of vitrification had to be stirred every fifteen minutes (there was a clock in the workshop by which to set these operations). The longer the heating period, the better the blue. When the process was considered finished, the operator gathered glass with an iron spoon and 'threw it into a vessel full of water, in order to shatter the glass, make it more brittle & easier to pestle & grind in the mill.'
- the shards of blue glass were carried to the stamping mill in wheelbarrows, then sifted in a brass sieve, to avoid the rust from an iron sieve. The crushed glass was then taken to the mill.
- for six hours it underwent the action of a double grinding wheel crushing it in water against a very hard flat stone. The resulting powder was flushed in a stream of water, ending up being graded by grain size. The colour fell to the bottom of the vats.
- this powder was then washed several times in water to rid it of its last impurities and sifted in a horsehair sieve. 'The Director of the factory took a sample and let it dry, took it through a small horsehair sieve to assess its goodness, & see if its colour matched the specimen or model with which it was to be compared.'

[12] Of all the smalt cobalt oxide contents encountered here, this is the greatest (33% by weight).

- the smalt was spread in layers two inches thick on boards and carried to the drying kiln, where it would remain for one day and one night.
- the smalt was sifted, and then put in large vats in which it was stirred and its colour homogeneised. An inspector made sure its colour was appropriate, or made necessary alterations to modify the colour.
- the smalt was weighed and packed in barrels, large or small. Once sealed, they were branded with a hot iron with the name of the manufacturer, then, with a red pencil, marked with letters indicating the colour and fineness.
- the barrels were sent to Schneeberg, 'where all the barrels were probed for sample taking: a mark was inscribed on the barrel; the Prince's duties were paid; a passport was taken, & this colour was sent to Foreign Countries.'

These various operations were the topic of a series of engravings by August Fürchtegott Winckler around 1790 (Winckler 1959).

But while the nature of the industrial operations had now been published, the raw material still remained just as rare. Let us read Baumé (1773: vol. 3, 404, *Essai des Mines de Cobalt*):

> The cobalt mines [ores] are very common; but the Chemists can procure but with great difficulty fragments of this mineral, because the Saxons who own it prevent its export. Samples can only be found in Cabinets of Curiosities.

The cobalt blue industry was by then well organised and stabilised in Saxony. It would nevertheless undergo a few setbacks, such as the onslaught of the Seven Years' War, which began in 1756 with the conquest of Saxony by Frederic II. It would then flourish again.

However, what took place in other countries? We already have an idea of the Dutch activity in this field: investors, ore buyers and smalt producers are frequently encountered. Sharp dealers, they would export zaffre from Saxony all the way to China, the prodigiously active source of porcelain production, because the local cobalt mines were becoming exhausted (Figure 2.5). These exports to China lasted a long time. They were confirmed by Hellot (1740) in 1737, by Holbach (1765c) in 1765 and by Dietrich (1786: 297–304) in 1786. During this time, what happened in England and France, countries producing barely any cobalt?

The smalt industry in England and France during the seventeenth and eighteenth centuries

Smalt in England during the seventeenth century

Let us turn the clock back a little. England was one of the largest outlets (possibly the most important due to the textile industry) for smalt made in Holland. We shall follow here Harley's account (1982: appendix III, 197–201).

Intent on developing English industry and fighting against the costlier imports, King James I granted in 1605 a trio of entrepreneurs, W. Twynyho, A. Baker and J. Artogh, a patent for the manufacture of smalt in England. Smalt was described as (Taylor 1977): 'A certain blew stuff called Smault, commonly used by Paynters and Lymmers.' The patent was valid for twenty-one years. In exchange, they would pay annual royalties and commit themselves to selling smalt at the market price, to be determined on the basis of an average over the previous seven years (i.e. on the price of imported Dutch smalt). In fact, as we have seen for the contracts from Saxony, this patent is tantamount to a monopoly. It forbids anyone else from manufacturing smalt on English soil, and prevents English traders from importing Dutch smalt. Granting this patent had two consequences.

One consequence, much to historians' advantage, consisted in a series of lawsuits, which left traces in the archives. One case had the purpose of stifling a competitor, Christian Wilhelm, who had already been manufacturing smalt in England since 1604. Supplying proof of the earlier date of his roasted ore imports and smalt sales did not help his cause: he had to turn his works over to the patent holders at a rock-bottom price. Other actions were brought in court by the Dutch manufacturers from the important glassmaking centre of Middleburg, then the capital of the province of Holland, intent on not losing their English market but to no avail. Or nearly so, for it may have been that Twynyho, soon to part with Baker (who continued on his own), had played the role of a Trojan horse for the Dutch manufacturers in England.

The other consequence turned out to be catastrophic for this fledgling English industry. In spite of the vast captive market offered to him, not only was Baker unable to satisfy demand in its entirety, but he also had to sell his production at a loss. For, during these inflationary times, the set price determined from the average over the previous seven years did not yield sufficient returns. To make matters worse, in spite of the ordinances affirming his monopoly, the manufacturer had to face an influx of contraband smalt sold at a low price by the Dutch. In spite of fresh instructions being given to the officers of the Cinque Ports, to redouble their efforts against the smuggling of smalt, Baker declared bankruptcy in 1623.

In theory, no one else had the right to import smalt until 1650. But an examination of the books of the Port of London shows that, as early as 1630, smalt was openly imported by the ton by various dealers. This was at the height of the Thirty Years' War in Europe

when production in Saxony was nil. Dutch dealers were therefore running down their inventory of smalt that had been intended for England but which remained unsold since 1605. A short note by Turquet de Mayerne ([c. 1620] 1974) informs us of the purchase price for four qualities of smalt in England, probably in London: 'Smalte – a pound 6. 8. 12. 15. depending on goodness.' Unfortunately, Mayerne did not specify the monetary unit: penny or shilling? We shall see later that it was probably a penny. We can only take note of the failure of governmental policy in this domain.

English dissatisfaction during the eighteenth century

With the increasing popularity of blue-coloured tableware with customers and with the development of the smalt-consuming textile and paper industries, zaffre and smalt imports kept growing. In the middle of the century, they grew from 180,000 lb in 1748 to 286,000 lb in 1754 (Taylor 1977). Then after a pause due to the occupation of Saxony by the Prussians in 1756, at the start of the Seven Years' War, which interrupted production, imports took off again with renewed vigour. Time had come for the English industry to fight back. Reaction took place under the guise of a search for cobalt deposits over the British territory, which would obviate the need to import zaffre.

From its inception in 1754, the Society for the Encouragement of Arts, Manufactures and Commerce of London offered a prize to he who could locate an exploitable cobalt vein on British soil and prove that its ore could yield zaffre and smalt (*Summary abstracts* 1789). A first deposit was very quickly found in 1755 in Truro, Cornwall. But, as it was very small, it could not be exploited. Its presence still had beneficial effects, however, enabling miners, assayers and chemists to become familiar with these ores and to perfect their treatment. Other veins were then recognised in Cornwall, as well as in Devon and Scotland. Although exploitable, none was of real importance.

There were, nevertheless, entrepreneurs adventurous and skilled enough to exploit them, since the accounts of the smalt manufacturer in Wittichen, in the Black Forest, show for the years 1768–71 an entry for the purchase of English roasted cobalt ore at a price of 70 guilders per hundredweight. England, which was desperately lacking cobalt, still exported part of its own.

One of these entrepreneurs was William Cookworthy, a most enterprising Plymouth Quaker who discovered China clay in Cornwall and began porcelain production in Plymouth (1767). Desirous to have his porcelain decorated at the lowest price, he exploited the cobalt-rich veins of Cornwall and set up a zaffre manufacture for his own use. Being simultaneously in control of raw materials, the manufacture of the object and its decoration, Cookworthy was ideally positioned to implement all desirable improvements, including the additions to be made to zaffre in order to obtain those vivid blue hues so prized by customers. Indeed, products coming out of his factory were equally famed for the quality of the porcelain and the beauty of their blue decoration.

Yet, this English production was grossly insufficient to match the ever increasing needs of industry and household consumption. In 1783, the Society for the Encouragement of Arts, Manufactures and Commerce again raised the alarm over the fact that most of the zaffre and smalt used in England was imported. Unfortunately, its quality left much to be desired, for these products underwent adulterations. Consequently, colours obtained *in fine* for decorating ceramics, or as pigments for artists, were not satisfactory. In another domain, the outlet of cloth blueing had become very important, for which smalt was used under the name of Powder Blue. During that year, which saw the fourth Anglo-Dutch war (1780–84) turn to the advantage of the English, and while the Dutch East India Company was moribund, to its English rival's greater profit the Society emphasised how zaffre export to China, still in the hands of the Dutch, offered an enviable market which could not be neglected.

For all of these reasons, it would therefore have been extremely useful to discover exploitable cobalt ores on British soil, for the process to make an English smalt was known. Only the raw material was missing. The total control of the production chain would enable a quality product to be made which would be well suited to internal as well as external markets. This is probably why the Society offered a prize in this domain in 1812. Here is the announcement (*Premiums offered in the Year 1812* 1813: 12)[13]:

> 91. COBALT, ZAFFRE, AND SMALT. For the discovery of a mine of cobalt in Great Britain or Ireland, that will produce a sufficient quantity of the mineral, of good quality, to supply a manufacture of Zaffre or Smalt; the gold medal, or thirty guineas.
>
> Certificates that at least one ton of the ore has been raised; and five pounds of Zaffre, and ten pounds of Smalt made therefrom, to be produced to the Society on or before the last Tuesday in March, 1814.
>
> N.B. It appears from the minutes of the Society, in 1755, that a discovery of cobalt was made at or near Truro in Cornwall, but not a sufficient quantity of ore found to answer the desired purpose.

As the prize was not awarded, the offer was renewed each year until 1816 in the list of prizes offered. It disappeared thereafter.

Smalt manufacture in France during the eighteenth century

The problem in France was of an identical nature: the territory seemed to lack the precious mineral, which is most of the time paired with silver – another reason to prospect for it. Documents concerning mining activity over what was then French territory during the seveenth century are few in number. If mining research was active in this domain, it left few traces. In the meantime, France was totally at the mercy of Saxon cobalt, whether bought from German or Dutch merchants. The latter appeared to enjoy

[13] The author was not able to consult the volumes of the *Transactions of the Society for Encouragement of Arts, Manufactures and Commerce* corresponding to the years 1799–1811.

a reputation for quality summarised in the text below concerning zaffre production in Saxony (Landois 1751a):

> It is sometimes withdrawn in this semi-molten state to be transported to Holland, where vitrification is completed & colour perfected through the addition of products which are still production secrets (…).

> Thus *powdered azure is* nothing else, as we can see, than rock *azure* or powdered smalt. Some comes from Germany or Holland; the latter is the more expensive, & its colour blue more nearly approaches that of ultramarine. It is thus called *Dutch ultramarine,* or *common ultramarine.* The belief runs, in the trade & in the workshops, that the German variety must be grainy, sandy & dark to be good; that, on the contrary, that from Holland is good only if pale & fine.

During the eighteenth century in France a real enthusiasm for the Earth Sciences, as well for the mining industry, developed. This enthusiasm led to tangible results in the field of mine exploitation that concerns us here. On another level, it led to the development of technical information sources which will be invaluable to us. They deal with three sites. The first is Ste Marie-aux-Mines, in the Vosges.

Production at Ste Marie-aux-Mines

The history of zaffre production in Ste Marie-aux-Mines still remains to be written. It is generally accepted that it began at the start of the eighteenth century with the discovery of the Chretien well, which supplied enough cobalt ore for a zaffre and smalt manufacture to be set up. Yet, the account books of a Nurernberg merchant, Lorenz Meder, mention for the year 1558 the shipping into Antwerp of *safflor* coming from Alsace (Kellenbenz 1974). However, no other occurrence of cobalt in Alsace is known apart from the one in Ste Marie-aux-Mines. At the beginning of the eighteenth century, the mining area of Ste Marie-aux-Mines belonged to the Duke of Zweibrücken and produced silver. Cobalt ore suitable for the manufacture of smalt was discovered in the Rauenthal valley. A factory was erected next to the Chretien pit head, which would produce smalt (see Table 2.5) but failed toward the end of the century.

The survey of French natural resources carried out from 1716 at the behest of Regent Philippe d'Orléans throws some light on this production. Superintendants were in charge of collecting data in every province, and of synthesising this data in the guise of memoirs addressed to the Regent. The latter had them forwarded to the Académie des Sciences and to Réaumur in particular. These memoirs contain some information concerning smalt manufacture in Ste Marie (Demeulenaere-Douyère and Sturdy 2008: 142–4, plates 4–8a).

In March of 1716 Réaumur wrote to the Alsace Superintendant, d'Angervilliers, concerning the mines in Ste Marie-aux-Mines:

> (…) We learnt that the mines in Sainte Marie have been worked for some time, and that various individuals from Strasbourg have made it their business. We have heard those

mines mentioned in a way which made us wish at the extreme to have detailed memoirs on everything concerning them, and which would tell:

1° what are the various mines in the vicinity of Sainte Marie. We were assured that there are some for lead, for bismuth, that zaffre and azure [smalt] are extracted from those of bismuth, and finally that there is silver.

2° In what manner are each of these different mines worked. We should not wish that just a rough idea of the processes be given; we should wish that trouble be taken to go down to the tiniest minutiae, that the fear should always be to be on the short side rather than overly long, that even the names workers give to each step are not forgotten. That which concerns the preparation of azure most excites our curiosity.

3° We should also be charmed to see samples from each of these different mines, samples from these mines [ores] in the states they are in after each preparation, of the scoriae separated from them, of the foreign bodies found in the mines, and finally of matter in its state of perfection. (…) If the trouble is taken to supply us with these samples, it would also be necessary to take that of wrapping each item in a paper carrying a label advising of the contents of the paper.

4° Would there be someone at hand able to draw the designs of the machines, tools, furnaces, we should be put in an even better position to profit from the memoirs one has been willing to forward us. We should not request drawings to be finished, but rather exact, made to a scale which would show with accuracy the sizes of each part of the drawing.

There followed various specific questions on Réaumur's part. Unfortunately, they emanated more from a scientist's thirst for knowledge of things from nature and industrial processes than from an economist's desire to know the quantities produced, their production costs and sale prices. We may nevertheless note that, although Réaumur mentioned zaffre manufacture in passing, his real interest lay with that of smalt ('That which concerns the preparation of azure most excites our curiosity'), the manufacture of which he seemed to know in principle since he asked only about points of detail.

The answer arrived in Paris in 1717 in the form of a crate containing a memoir, accompanied by the drawings and samples requested. Five wash drawings concerned the preparation of azure. They dealt with the situation of the cobalt-supplying mine, 'the layouts and profiles of the building and furnaces built in the Rauenthal valley, half a league above Ste Marie, to serve for the preparation of azure', two layouts of the ground floor housing the mills, and the details of the 'Tools for the azure foundry'. (Figure 2.6). Réaumur then sent back a batch of additional questions:

We should also have to ask for five to six pounds weight of cobalt or azure ore such as it comes from the mine. We have experiments to carry out on that matter. One forgot to mention in the memoir how much pulverised cobalt is introduced into the furnace where it is roasted at a time. There was no mention either of how long the rocks are roasted, or of how many are roasted at a time.

Hence a new shipment from the Superintendant:

We include here in the parcel n°19 six pound weight of cobalt or azure ore such as it is drawn from the mine, as desired in the article here included.

There does not appear to be a set amount of pulverised cobalt introduced at a time in the furnace where it is roasted. Attention is only paid to lay it on the surface of the furnace hearth up to an inch and a half high, else it would prove hard to stir it well and roast it evenly. The master who is in charge of azure preparation knows by the colour when it is time to take it out of the furnace and the poison has evaporated enough. The master holds this knowledge for a secret which he will not share with anyone. (…)

Here included as n°20 will be found a sample of potash used for azure. It comes in two fashions, one common and the other fine. The quality is marked on each bottle marked of the same number.

The ashes of fir wood give the best potash. Six hundredweights of these ashes yield a hundredweight of fine potash. When the ashes come from some other wood, it takes up to eight hundredweights to make a hundredweight of common potash. : (…)

Azure is made of different manner and of different quality, as can be seen from the three samples here included. The most beautiful, n°21, is obtained by putting a pound of roasted cobalt with six pounds of roasted rock powder. The next, n°22, is made with a pound of cobalt and eight pounds of rock powder. The third, of a pound of cobalt and ten pounds of rock powder. Following this arithmetical proportion, one can make several grades of it, but only the three qualities mentioned above are used.

The result of all this was that, in 1716, the mine located in the Rauenthal valley produced a cobalt ore used to make zaffre and smalt on the spot. This latter production made use of potash probably prepared on location from fir tree ash. Smalts came in three commercial grades. The production size and the ongoing prices remain unknown to us. However, referring to the mining establishments of Ste Marie-aux-Mines as a whole, Réaumur adds: 'The annoying part is that we are assured that all these new establishments are in trouble'. Effectively, this factory producing zaffre and smalt collapsed at the end of the century.

The cobalt mine in Chalanches

In 1767, silver veins were discovered at Chalanches, near Allemont (Isère). The mine was exploited on behalf of the King until 1776, the date at which his brother, the Comte de Provence, acquired its concession. He hired a Saxon engineer named Schreiber, under whose impetus the mine expanded considerably. Access to the mine being extremely difficult, particularly in winter, the ore was not treated on the spot, but rather in the mining town of Allemont. Production reached 600 kg of silver per year in 1784 and 1785 with 90 workers.

Although some deposits contained cobalt under various guises (one of which was then referred to as 'goose excrement'), it was not exploited for azure production. Schreiber (1784) gave us the reason:

The arsenical grey cobalt ore is the only one among our ores to be low in silver, and it could advantageously be used for zaffre and azure production; but it is even rarer than the other kinds. One will always err when judging the Allemont production from cabinet samples and believing cobalt to be plentiful. Of one hundred hundredweight of silver ore extracted, there are barely twenty pounds of cobalt of the type I just mentionned; which is very different from the assertion attributed to me, that out of a hundred pounds of silver ore there were twenty pounds of cobalt. There is no doubt that were this ore to be found in such proportions I should advise that a zaffre manufacture should be set up in Allemont immediately.

The mine remained active during the period of the revolution, then survived with difficulty on the proceeds from silver production during the first twenty years of the nineteenth century. It would become profitable by exploiting cobalt and nickel from 1835 onwards. Sorted cobalt ore sold then for 300 francs per 100 kg (Gueymard 1838–40).

The Spanish cobalt mine in Gistain valley

The beginnings of the St Mamet zaffre and smalt manufacture, near Bagnères-de-Luchon, are very poorly known. Its history is linked to that of the cobalt mine located on the other side of the Pyrenees, in Spain, in the Gistain valley[14]. The early days of this mine were mentioned by the Irish naturalist William Bowles, who, having entered the service of the Spanish king as a mineralogist in charge of making an inventory of mineral resources, visited it in 1753 (Bowles 1776):

> At the turn of the century, a peasant in this valley felt that the stones on the high mountain facing Plan from the North-east were weightier than ordinary stones; he suspected this was a silver mine. He took one to Zaragoza, to an individual he thought knowledgeable about mines. This individual carried out all imaginable tests to discover the silver he hoped to find; but, at the end, he recognised it for a cobalt mine. He sent several samples to the Azur factory in Germany, where they were tested. The Germans, finding it perfect, attempted to profit from the wealth of the mine without unveiling to the Spaniards either its worth or its secret; to that end they sent a German commissary charged with negotiating with Aragoneses the concession of the mines in the Gistau valley, offering to deliver each year to the king a certain amount of lead at a good price. The Court granted his request, without suspecting there could be any other metal in this mine. The German and Spaniard then entered a secret understanding, by which the latter committed to deliver the former all the cobalt that could be drawn from the mine for thirty five pounds per raw hundredweight.

> Since local people had barely any understanding of mine exploitation, several persons in the know were brought over from Germany to train them, and cobalt began being extracted.(...)

> The Germans drew out for a long time five to six hundredweight of cobalt per year. This cobalt was sent through the port of Plan to Toulouse, where it was boarded onto the Languedoc canal, and from Languedoc it was forwarded to the [German] factory through Lyon and Strasbourg. When these said Germans had, so to speak, creamed our

[14] 30 km directly south of St Mamet.

mine, from which they had extracted the easier part, not being able to turn a profit from its exploitation anymore, they abandoned it and left in 1753, shortly prior to my arrival. (...)

I then examined these pits and found there several chunks of good cobalt, which was of a finer grain and a lighter grey-blue than that from Saxony.(...)

I was not able to pay closer attention to the lode, for, as the particular administration I mentioned still perdured, these farmers jealously resented my search. I therefore had to be content with what I could see without digging, and I then left Spain, desperate at seeing thus abandoned advantages presented by nature, which only served to enrich foreigners who were let carry away half a mine, one thousand times rarer than gold and silver mine, the metal of which could be used for centuries to paint of the most beautiful blue the faience and porcelain in the kingdom, and procure much money through its export.

Several projects aimed at reopening the mine would be conceived. The first was that of a French industrialist, M. de Gensanne, in 1766. Yet nothing happened, and the following year, much to his disappointment, Guillaume de Malesherbes, who had made a special trip to Plan to visit this cobalt mine, found it abandoned (Malesherbes n.d.; Bart 2008).

Thus when Baumé wrote in 1773 (1773: vol. 3, 347–8, *Mines de cobalt*) that 'A cobalt mine was discovered in the Pyrenees on the Spanish border. I examined it & found it of an excellent quality; it also contains bismuth. It would be of interest to trade that it be exploited. (...)' and seized the opportunity to study cobalt, comparing the Archimedean forces on cobalt reguli[15] 'drawn from a mine six leagues from Bagnères in the Pyrenees and drawn from a zafre originating from Saxony' (Baumé 1773: vol. 2, 257, *Sur le régule de cobalt*) his samples came from old gatherings and not from an active mine.

A second attempt at reopening the mine took place in 1776 when Don Mathias Estevan, from Zaragossa, secured the privilege to exploit all of the mines of the Aragon Pyrenees for twenty years, a privilege he ceded in 1780 to baron Charles de Beust, chamberlain to the Elector of Saxony. This cession having been confirmed by the Spanish court in 1782 (and the privilege extended until 1804), Beust set up a company to exploit the Mines de cobalt des Pyrénées, a company with capital split into 60 shares of 9000 livres each. He was the majority owner, the others being an Aragon native living in Paris and three Parisians. The Gistain valley cobalt mine reopened in April 1784; the ore was shipped to France by mule to be treated in the factory which M. de Beust had built in St Mamet (Marsan 1929; Lamicq 1990).

The St Mamet factory

Originating from an old family with close ties to the Saxon court, de Beust lived between Dresden and Paris and was well acquainted with Parisian society. He was not averse to

[15] *Regulus*: metallic substance extracted from a mineral.

addressing his requests to the highest echelon of the kingdom. He had a factory built for azure blue production in St Mamet, near Bagnères-de-Luchon, and was actively involved in the production line. At the same time, he solicited from the French court the permits and privileges which ought to have insured his business success. And it was a success indeed. A King's Council decree dated 17 April 1784 granted his Company 'permission exclusively to exploit during twenty five years (...) all cobalt mines currently existing and to be discovered in the French Pyrenees'[16]. The same decree granted the Company exclusive privilege 'in the production of blue colours derived from cobalt over the spread of such concession and foresaw an exemption of import duties for the supplies needed for colour manufacture' (i.e. Spanish cobalt ore and potash). The factory essentially treated Spanish ore, but also some of French origin which Beust had discovered in Juzet, near Luchon.

Luckily for us, it was around that time that Philippe-Frédéric de Dietrich, manufacturer, future Mayor of Strasbourg[17] and an accomplished mineralogist, toured France to visit ore deposits. He visited the Beust factory in the Pyrenees in 1785, a visit that would lead to a publication in 1786 (Dietrich 1786: 297–304). The first draft of this report, a more loquacious manuscript, can be found in the National Archives. Here it is *in extenso*, unedited (Dietrich n.d.):

> The most considerable of the establishments I have seen around Bagnères de Luchon is probably that of M le Comte[18] de Beust, set in St Mamet on the basis of a decree from the Council on April the 27th, 1784. It was built to manufacture Cobalt which M le Comte de Beust procures from Spain, and from any source he may discover in the whole French Pyrenees, wherein I indicated to him several locations where he can find this mineral, and he himself inquired in that part of these mountains under the King's sovereignty.

> The zaffre & azure factory is located on the river Pique, in the territory & parish of St Mamet, 1100 fathoms [toises] to the South of Bagnères de Luchon, & some hundred fathoms above the tower of Castel-Viel: the amount of water is more than enough for this factory, which consists of:

> 1°. A large foundry, 48 feet in length, 34 feet in width, & 44 feet in height, of which 14 feet in masonry & 30 feet in woodwork. This building houses the roasting kilns, the sublimation chambers, the melting and fusing furnaces; and finally a chamber 24 feet in length, by 12 in width & 14 in height to set up the first colour manufacturing master.

> 2°. A large building, located on the bank of a canal, drawing water from the river Pique to supply the various machines. This building is 114 feet in length, 33 feet in width, 30 feet in height, of which ten in masonry & twenty in woodwork. It contains a stamping mill with eight stampers, a grinding mill with four wheels, a mixing chamber, a crushing

[16] Archives nationales, Paris, shelf-mark E 1619 B.

[17] It was he who, six years later, during the course of a dinner given at his residence in the honour of the officers of the Strasbourg garrison, would ask the Captain in the Corps of Engineers, Rouget de Lisle, to write a *Chant de l'armée du Rhin*, to later become the *Marseillaise*, from then on the French national anthem.

[18] A 'baron' in Spanish documents, Charles de Beust has the status of 'comte' in French archives.

& washing chamber, a drying chamber & a potash roasting kiln. The buddle [a shallow inclined trough for washing ore] is composed of three slightly slanted tables positioned in steps one above the other; their purpose is to isolate the regulus which may be contained in the glass before the latter is taken to the grinding wheels.

3°. A storage area for the mineral and the manufactured goods, of 33 feet in length, 25 feet in width & 20 feet in height.

4°. A laboratory equipped with all the kilns needed for tests, 25 feet long, 20 feet wide, & 18 feet high, including the roof.

5°. A house as living quarters for master workers & others such as need to be on location night & day: this building is 48 feet long, 22 feet wide & 34 feet high, of which 18 feet are in masonry & 16 feet in woodwork.

I found there the following employees, to wit:

Three master colour makers, Messrs Chalaker the father and his two sons, all three skilful artists known in Germany. The younger son is better than his father and elder brother, the father is also a good mineralogist.

A bookkeeper, named Bernard Ruffin, very intelligent and active.

Finally, at the time when manufacturing would begin, one had to have constantly on hand thirty workers, spread between the roasting kiln, the melting or fusing furnaces, the mill, the grinding wheels and washing, among which were five more artists, or principal workers, which means in the end that Monsieur le Comte de Beust had been able to attract five major artists from Germany.

This interesting factory is currently in activity; superb colours were made, samples of which the Comte de Beust handed to us, which generally met with approbation and which will be made in sufficient quantity to supply the whole kingdom, and even export a considerable amount. Indeed, the supply of his mineral obtained from Spain was so considerable that, due to its true value, the price of shares, which had originally been 4,000 livres, and then 5,000 livres, has been raised to 10,000 livres. And this product can only be increased through the indications of cobalt in France which I gave M le Comte de Beust, and which he already is acting upon.

The major difficulties encountered by the Comte de Beust stem from the ill will of the inhabitants of the country where he set his establishment. He had a hard time procuring the wood needed for the construction and operation of his factory, even by paying, and he has to apply to the water and forest management administration to be authorised to draw from the forests of Bagnères and St Mamet the wood needed for his important manufacture, at a price it will please the administration to set. The high cost of potash, which he is obliged to obtain from Germany at a prohibitive price, is an obstacle to the development of his factory; he could procure some at a low cost by picking up, in the woods among which he is settled, the lying trees which the inhabitants leave to die[19].

[19] The archives retain a *Demande du comte de Beust de prendre dans la forêt de Bagnères-de-Luchon le bois nécessaire à ses fabriques de potasse et de cobalt* dated from 1785. Centre historique des Archives nationales, Paris, série K, Monuments historiques, titre VII: législation, économie, finances, shelf mark 909, 35 à 40. We also find in the same inventory a *Note sur les dégradations des bois de Saint-Mamet et de Bagnères-de-Luchon,* dated from 1785 (K 904, 55).

The various dispositions of the ordinances concerning privileges granted to factories of this type, which he will append to his request, add to the consideration of the importance of his establishment to engage the administration in treating it favourably.

I must here observe that the Comte de Beust positioned his establishment far away from any dwelling, and that he had a 160 feet long chimney built in his foundry to ensure no one would be inconvenienced by the arsenical vapours released during production. The inhabitants from Bagnères de Luchon wanted it built on their territory: he felt that the vapours might alarm the patients coming for the baths in Bagnères. He moved so far away that those with the most vivid imagination could not fear them.

The Comte de Beust intends to have cobalts dug for around St Lazy, by St Gaudens, and near Lus à Barregat; he even discovered a very interesting deposit near Brunet, a description of which he sent me after my visit.

The Comte de Beust used to be Chamberlain for the Elector of Saxony, assigned to the department of commerce. A journey he made to France and Spain introduced him to the Pyrenees cobalt, which had so far always been sold to Germans who carried it back home as best they could to turn it into blue.

The Comte de Beust, who was not without knowing that this production was, so to speak, a Saxony preserve, did not wish to set the Establishment up abroad without making due offers to his master in this respect. He even entrusted me with the original correspondence, and only after meeting with constant refusals to all his offers did he determine to take over to France an establishment which would more naturally have been created in Spain, where the Cobalt mines were, had not the inducements promised by our government through the order, the dispositions of which I transcribed, decided him to settle in the French Pyrenees. No sooner was this establishment being born that the court in Saxony withdrew from his author the charge of Chamberlain, that which attached him to the chamber of commerce, and along with it, the 4,000 livres stipend attached. The Comte de Beust, now that he has brought this establishment up to perfection, to-day asks that the administration compensate him for the loss of this income by granting him an allowance of the same amount.

The Comte de Beust is, as of now, in a position to manufacture over 4,000 hundredweight[20] of blue, which already by far exceeds the needs of the Kingdom; and, being able to take the level of production up to 6,000 hundredweight, he solicits the Council to prohibit, or at least heavily tax, the entry of foreign zaffre and azure, a request which should not harm the public, since his colours are at least as beautiful, and further the prices of the Bagnères de Luchon factory are so much lower than all products of this colour introduced so far in the Kingdom.

The Comte de Beust also requests, as a consequence of his franchise order, an exemption of all entry rights for the raw materials needed for the manufacture of azure, such as cobalt and potash.

He finally begs the Council to promote his manufacture to the status of Royal Manufacture, that he may have a Swiss guard in the King's livery and the option of marking his colours on the King's crest with the inscription *Manufacture d'azur*.

[20] This refers to hundredweights of the French pound weight of 425 g. 4,000 cwt therefore make 170 tonnes. This evaluation of French consumption appears to agree with the figures given *supra* for the mid-century English imports.

The Comte de Beust's manufacture being unique and the first in the Kingdom[21], I believe it warrants the prerogatives sought by its owner.

The Council granted the Comte de Beust free circulation for these manufactured goods throughout the Kingdom, as well as exemption from all export duties. The *Ferme Générale* however, through particular decisions sent its directors, put to this franchise limits not intended by the Council by restricting the duty exemption to the first destination only. The Comte de Beust rightfully desires that the new order he solicited has the title of Royal Manufacturer, in a way that will shelter him from any difficulty, the terms of the Exemption he has been granted for the Kingdom as well as for the provinces deemed foreign.

With the creation of this factory – and contrary to the assertions of Zimmermann, for whom any glassmaker procuring cobalt can manufacture smalt – it was indeed a technique from Saxony which settled in France. The supervisory staff was also imported from Germany.

The first of the three volumes of Dietrich's monumental opus, *A description of the ore lodes of the Pyrenees forges and salt mines*, appeared in 1786. In the fifth memoir of this work, the author described Beust's zaffre and azure factory. This text differs noticeably from the handwritten document. Indeed, after the same description of the factory buildings, one reads (Dietrich 1786):

This interesting factory is currently in production. M. the General Comptroller intends to grant it the title of Royal Manufacturer. Superb colours are produced there in quantities sufficient to supply all the needs of the Kingdom, & even export considerably. These colours have met with general approval, & though as beautiful as those from abroad, if not even more so, their price has been set lower; the Minister therefore seems to be in favour of imposing duties on foreign azures. One may find it opportune to read here a few points concerning the use of & trade in zaffres & azures.

Cobalt is known to be a semi-metal wont to turn under a vitrifying fire into a blue glass, when mixed with vitrifiable substances such as sand, quartz, &c.

Through various processes following the vitrification of cobalt, it is turned into an impalpable powder of varying degrees of fineness & of varying nuances, darker or lighter, depending on the proportions of those vitrifiable substances added; these powders are named smalt, zaffre, azure, royal blue: trade has branded them variously.

Samples bearing the letter E correspond to the name Esmalte, *Eschel* in German, or Smalt, given to the finest among these powders.

The letter C refers to colour; samples bearing this mark are not as fine as smalts.

The letter S, meaning sand, marks the coarsest powders. To each of these letters is added an O, to indicate that the merchandise is of an ordinary quality. An M, for medium quality. And, finally, an F, when of fine quality; &, as there are five degrees of fineness and beauty, so there are marks from a single F up to five to distinguish between them.

[21] Alsace in its totality having been part of France since 1678, we may conclude from this Strasbourg resident's comment that zaffre and smalt were no more in production in S^{te} Marie-aux-Mines.

Azures marked with an E, or smalts, are mostly employed to give finish to toiles, batistes, lawns, muslins and threads. The use of smalts is surprising within this class of manufactures, by which they are indispensably needed; Flanders, the Netherlands, England, Germany, namely Silesia & Lusatia, consume very large amounts.

Azures marked with a C, or colours, are mixed with starch & dressing to stiffen cloth after it has been whitened. It is easy to conceive how much is used in this way. It is also used to paint earthenware, ordinary porcelain and other fine paste ceramics. In glass factories, to correct the colour of glass, & to make blue coloured glasses, & in a fresco painting: all drysalters deliver large amounts for these various uses. The Dutch export a large quantity of smalt and colours to the Great Indies & China.

Azures marked with an S, or sands, are used by confectioners[22] and officers to dust trays: they are much used in Germany to powder writings.

Independently of these three different kinds of cobalt products, it is also turned into zaffre, which is but cobalt [ore] torrefied or roasted, thereby stripped of the arsenical parts with which it is usually soiled: it is reduced to a powder which is, mostly, of a reddish grey, & is mixed in suitable proportions with the necessary substances so that they can enter into fusion & yield blues of variable intensity when used to paint fine porcelain, earthenware, glasses and enamels. This detail shows that zaffre differs from other cobalt preparations, in that in the latter this mineral is vitrified before use, while zaffre is changed into glass only with the covers [glaze] and varnishes of the porcelains & enamels over which it is applied. It imparts these materials with a very beautiful blue colour. But there is very little cobalt suited for making zaffre. The better it withstands a very bright fire, the better it is deemed to be; & one of its most essential properties must be not to [dif]fuse and spread under fire beyond the limits in which the painter circumscribed it.

The consumption of smalts, colours, sands and zaffres in France is estimated to be 4,000 hundredweight at most, which sell for from 72 livres up to 600 livres per hundred.

M. le comte de Beust has just discovered, together with me, a process of which the Dutch had up to now been the sole proprietors, to obtain at will, through a secondary operation, the pale superfine smalt, for which the demand is prodigious, and which the Dutch manufactured in a single location, in the middle of the woods, ten or twelve leagues away from any major city, to better preserve the secret.

[22] For confectionery and pastry ornamentation, the practice of using a 'pigment' to get a blue colour, rather than a 'dye' as was done for other colours, lasted until the end of the nineteenth century in the most elevated circles. Around 1880, at the court of Prussian Emperor Wilhelm I, Urbain Dubois and Émile Bernard were still using scale blue (smalt) for decorative preparations and ultramarine to colour culinary preparations. For the former, a coating of powdered sugar hid the material (metal, paste board or wood) out of which the architecture of set pieces was made. The purpose was 'to charm the eyes of the gourmets before satisfying their taste buds'.

Method for dusting with coloured sugar. The tiers, the drums or just simple undercrusts of dry dough or wood are ordinarily dusted. The desired amount of coloured sugar is taken for the operation. Egg whites are half whipped, mixed with a little sugar and a pinch of flour; those parts destined to be dusted are wetted with this liquid with a brush. The sugar is liberally dusted over this moist layer, so that there remains a smooth layer against the wood or the dough. The sugar is left to dry out in the air. (see Dubois and Bernard 1881: vol. 2, 327, *Ornementation*)

The various grades as well as their use are summarised in Table 2.6.

Table 2.6 Marks and use of the various qualities of azure made at the St Mamet manufacture in 1786. The coded letters respect German custom: S for Streublau (blue strewing smalt), C for Couleur and E for Eschel; O is for Ordinary, M for Medium and F for Fine.

Granulometry			Colour quality	Uses
Coarse (*Sand*)	Medium (*Couleur*)	Fine (*Eschel*)		
OS	OC	OE	Ordinary	plate sanding drying written documents
MS	MC	ME	Medium	added to starch: blueing (laundry)
FS	FC	FE		
FFS	FFC	FFE		
FFFS	FFFC	FFFC	Fine	cotton fabric finishing
FFFFS	FFFFC	FFFFE		
FFFFFS	FFFFFC	FFFFFE		

One may assume that the overwhelming marjority of the production was fine or medium granulometry, hence blueing. Its use as pigment for artists was not even mentioned.

In 1787, on his first trip to France, Arthur Young visited the St Mamet factory with the Duke of La Rochefoucauld. Being first and foremost an agronomist, Young was as little interested in the industrial process as in the manufactured products and their market. He nevertheless left us several interesting remarks showing the factory was still fully active (Young 1792: vol. 3, 542–5):

Bagneres-de-Luchon – At half a league from this place is a cobalt factory. It is said to be the only one in the whole kingdom, which was all supplied, before the establishment of this fabric, by a Saxon gentleman, from the works in Saxony; and what is now made here is used at home and exported as Saxon cobalt. The ore is brought from Spain at a very high price, from a mine in the Pyrenees, not more distant in a straight line than six leagues, but the road is so rocky that the ore is brought by the valley of Larbouste, which takes up a day and a half. The ore is not found in veins, but in lumps (*rognons*), so that it is often lost and found again.

A remarkable circumstance, and hardly credible, is their employing ore also from Styria, which is shipped at Trieste for Bordeaux and brought by the Garonne to Toulouse, and hither by land, at the expence of 45 liv. the quintal. They use also some from Piedmont; of these different ores that from Styria is the worst and the Spanish the best; they cost at the factory, one with another, 300 liv. to 360 liv. the quintal. (...)

Vicinity to the Spanish mine, and cheapness of wood, were the inducements to establish this factory here; they now make pot-ash, which was formely imported from the Baltic, and cost 40 liv. the quintal, but they can make it here for 12 liv.

It was probably in that year that the Spanish government, reneging on its word, withdrew the exploitation privilege for the Aragon Pyrenees mines from the company and began exploiting the Gistain mine itself. This must have been a very hard blow for

the company, which was forced to get its ore from elsewhere. From then on, a large part came from France, from Juzet and then from a vein discovered by Dietrich in St Lary (Ariège). The balance was imported at great expense from Styria and Piedmont, as told by Young.

An official document may testify to the activity of the factory that year. An *Extrait exact de la balance du commerce de la France pour l'année 1787* [An exact abstract of the trade balance of France for the year 1787] tells us that smalt imports contributed 207,563 French livres towards the thirty-six million livres deficit of France under the chapter of trade in 'mineral substances' (*Apperçu de l'extraction* 1794). It also shows that France exported smalt, thus confirming Young's report. Unless it re-exported mostly imported smalt, it had to export that from St Mamet. The detail of this balance is given in Table 2.7.

Table 2.7 Balance of French smalt imports and exports for the year 1787. Weight is given in hundred-weight (cwt; 100 lb amounted to 49 of our kilogrammes). Prices are in French livres.

Smalt imports			[St Mamet?] Smalt exports		
Total weight (cwt)	Amount (livres)	Unit price (livres/cwt)	Total weight (cwt)	Amount (livres)	Unit price (livres/cwt)
2825	238,967	84.6	389	40,188	103.3
29	8,784	302.9			

France therefore imported only two qualities of smalt (unless the customs recognised only two qualities). The most widely imported, the least expensive, must have been that used to blue cloth and paper. It was referred to in this document as 'azure, smalt or cobalt glass'. Top quality smalt was called 'blue ash' or 'powdered smalt', which is rather inaccurate. It was probably used as a pigment by artists as well as for construction work. This would explain the faulty use of the term 'blue ashes', normally reserved for synthetic copper carbonates (see Chapter 4). Unfortunately, we are not informed of the origins of these imported smalts.

What happened? Why did the smalt imports reach such a high level – at three quarters of the estimated consumption by the kingdom? Two hypotheses may be tabled. The first is that the deficient output of the St Mamet factory may have turned out to be well below predictions. This explanation is not very satisfactory since, according to Dietrich, this factory was well managed and its activity full of promise. The second hypothesis is that the estimate of the smalt needs of the kingdom turned out to have been unrealistic since demand exploded due to the increasing practice of textile and paper blueing, and to the rapid growth of the textile and paper industries at the time. The St Mamet factory supplied a normal amount, but there still was a need to import.

In 1791, most likely at the request of the manufacturer, the chemist Sage (1791) analysed cobalt ores coming from the Gistain valley. However, in 1792, the French Revolution caused the factory to close and the exploitation of the Gistain mines to

stop (Navas 2003), a situation confirmed by this text evaluating the cobalt resources of France in 1794 (*Apperçu de l'extraction* 1794):

> These substances [zaffre and smalt] are of great value; they are mostly drawn from Saxony and Bohemia. The Tunaberg mine, in Sweden, supplies all the cobalt used at Sèvres. This metal has been recognised in several French mines, in the Pyrenees, in the Vosges and in Allemont, where it accompanies silver ore. Yet it has not yet been found in any part of the Republic in sufficient abundance to deserve a separate treatment. A rather important smalt manufacture which had been set up in Bagnères de Luchon drew the cobalt it used from mines exploited by Spaniards in the Gistain valley in Arragon, on the opposite side of our mountains.

The revolutionary whirlwinds having dispersed the shareholders, neither the exploitation of the mine nor the azure factory resumed (Dralet 1813: vol. 2, 152–3). A traveller, Charpentier, having visited the mining site around 1808, told of it being abandoned and of collapsed rooves having made the mine galleries impracticable (Charpentier 1823: 368). In 1820, another traveller visiting the St Mamet factory site, Dufour, estimated it was 'abandoned for at least thirty years. (…) All that remains of this factory are the walls and roof' (Dufour 1820). The St Mamet factory was still referenced under the 'azur' entry written by Le Normand in the *Dictionnaire technologique* (1822). However, by 1867, it was not listed in P. Larousse's *Grand Dictionnaire Universel* (1866–79).

The smalt industry during the nineteenth century

The situation in France

The end of the eighteenth century was a productive period for research on cobalt (Gerhard 1781; Marggraf 1783). In 1780, Bergman (1787) demonstrated that cobalt, isolated by Brandt, was a chemical element. Then Kapff published a book gathering together all that was known of this metal and its compounds (Kapff 1792). Soon would follow the works of Thenard (1803–1804) [cf. Chapter 6], Proust (1806) and Berzelius (1812), to mention but the more salient.

During the nineteenth century, in spite of the optimistic prognosis made concerning the St Mamet production, France continued to import smalt. In 1805, it imported 606 tonnes of 'azure in powder or stone' for an amount of 1,212,158 francs (hence an average price of 2 francs per kilogramme, i.e. 98 francs per hundredweight), 8% in custom duties being paid on azure (Collin 1806). Smalt consuming industries, particularly the paper industry, grew in an extraordinary fashion, while the French smalt production remained stagnant.

The dependency on imported smalt facing France was a cause for concern. Thus, among the list of prizes offered by the Chemical Arts committee of the French Société

d'Encouragement pour l'Industrie Nationale was to be found[23]: '7° A 2,000 francs prize for the discovery of the means to colour in blue glasses, enamels, etc., by any substance other than cobalt and its preparations.' This prize was not awarded.

In 1822, France still imported 600 tonnes of smalt (Le Normand 1822). It probably came from Germany, as can be gathered from this text from Guimet (1831):

> Experience has already shown that ultramarine blue could advantageously and economically replace not only cobalt blue [Thenard blue] intended for painting, but also azure or glass coloured with cobalt oxide [smalt], which is used in enormous quantities for blueing papers, toiles, calicos, muslins, etc., and with which Germany is in a position to supply all of Europe. As concerns paint, I never doubted the result; but for blueing, I had in a sense no hope, because of the low price of cobalt blue [smalt], the best quality of which costs but from 2fr.75c. to 3 fr per pound, and I was unable to set such a low price for my ultramarine, when an attempt at blueing paper changed all my ideas on this topic.

The situation did not fundamentally differ in Great Britain where, for the year 1853, Muspratt gave the figures: 2,274 cwt (115.5 tonnes) for zaffre imports and 287,623 lb (130.5 tonnes) for those of smalt (Taylor 1977).

Industry of smalt in Germany

The German smalt industry seemed to flourish at the end of the eighteenth century. In 1779, Gerhard evaluates the result of the yearly sales of Saxon smalt at 200,000 French écus[24], and that of the manufacture set up in Silesia by the Count of Schaffgorsch at 4,000 écus. Around 1810, five manufacturers of enamel blue were listed in Köln (Dufraisse 1971).

As for the activity of the Saxony mines, they were reported upon by a Frenchman, Bonnard (1815: 368), Chief Engineer in the Royal Corps of Mines in 1815:

> The Schneeberg mines are, in general, flourishing. They are remarkable for the beauty of the interior terraces they contain in numerous locations. They are also famous for the prohibition forbidding any foreigner to be let into their administration. One can never enter except by some kind of fraud, and therefore one probably sees them incompletely. Having secured from H. M. the King of Saxony official permission to visit them down to the last detail, as well as the Royal factories where smalt is made, a permission which, I stand assured by Messrs the mining officers, had never been granted to any stranger, not even to any native of Saxony from outside the mining administration, I can vouch that I have seen nothing to justify the mystery with which the exploitation methods and manufacturing details are shrouded; a mystery which was probably intended to prevent the stealing of ore and the guessing of manufacturing processes when the Schneeberg mines and factory were the only ones of their kind, but which has no real purpose to-day when other cobalt mines and other smalt factories exist, not far from Schneeberg, in Saxony

[23] *Bulletin de la Société d'Encouragement pour l'Industrie Nationale* (1816) (1st series, 15th year) 148: 236.

[24] In France, the écu is a silver coin worth 6 livres (accounting currency). In 1779, 200,000 écus corresponded to 4,000 guineas. 4,000 écus corresponded to 970 guineas.

and Bohemia, and which still probably endures as an ancient custom which no one sees fit to change. There is nothing special to the Schneeberg establishments, other than the beauty of the ores offered here by nature. There is no secret other than the practical skill of the employees and workers in the factory, to achieve the mixes most appropriate to obtain such and such a nuance of blue, a skill which is the natural result of a long habit and an even longer tradition. (...)

The fact is that there was no lack of legislation surrounding the various installations composing the cobalt blue factories. A decree from the Elector dated from 1724 forbade any foreigner from entering the colour mills (Gerber 1864). Entering the blue manufacturing premises without authorization was deemed an act of espionage. Students at the Mining Academy of Freiberg themselves were subjected to these authorisation requirements. In 1831, the Konsberg burgmeister Böbert, from Norway, did not obtain permission to visit the Schindler factory in Schneeberg: he clandestinely visited with the complicity of one of the foremen. Betrayed, he was condemned, together with his accomplices, to pay a fine (Hammer 2004).

While Guimet was getting ready to conquer the blueing markets which were the main outlets for smalt (see Chapter 7), the Royal company exploiting the rich veins of Norwegian cobalt in Blaafarveværket was privatised (in 1823). It was exploited by two entrepreneurs from Schneeberg, Benecke and Wagner, who built a large smalt factory on the spot.

Simultaneously, the search for better purification and preparation processes was resumed. Thus, in 1830, Liebig published a process for the large scale preparation of a purer cobalt oxide (Liebig 1830a, 1830b). This was probably what enabled these factories to come up with a new cobalt blue, cobalt aluminate or Thenard's blue (see Chapter 6).

In 1845, the three private Schneeberg factories merged and, in alliance with the Royal manufacturer, created a cobalt blue trust. In 1849, the latter, which also exploited Norwegian cobalt, was the world's leading producer of cobalt blue under all three guises: zaffre, smalt (1,200 to 1,400 tonnes per year) and Thenard's blue. It employed 2,000 workers and supplied 80% of the market at the time.

Evolution of the price of smalt

The texts from which we have quoted contain prices for zaffres and smalts, but they are particularly hard to comprehend. For a price given in florins or thalers per hundredweight, there are three types of uncertainties. The first has to do with the value of money in Saxony, sometimes much disturbed by political events such as the Thirty Years' War. The second is linked to the unit hiding behind the hundredweight; does it refer to baskets, pound weights (and, if so, of what value?) or to another unit of weight? The third uncertainty is that we rarely know to which point in the commercial chain this price corresponds; it is hard to be sure that it is indeed a retail price for the end user.

By chance, we have two sources for prices at the end of the eighteenth century. The first is the smalt factory at Wittichen, in the Black Forest, in Bade-Württemberg, set up in the vicinity of a medium-sized deposit of cobalt (Riederer 1968). For the period 1768–71, we know the distribution of costs and production (Tables 2.8 and 2.9). The mineral raw materials amounted to 81% of the total cost, wood to 10.8% and labour to 5.8%. These figures are in broad agreement with the provisional costs in Berckau in 1603 (respectively 84%, 6.1% and 5.4%).

The cost of potash is twice that of locally produced cobalt ore. To the cost of the raw materials must be added that of their transportation, which was quite high. It was therefore advantageous to use local ore. Ore imported from Austria or Siegerland cost 20 guilders per hundredweight; from Bohemia it cost 35 guilders per hundredweight; from Spain (Gistain valley) or from Piedmont, 45 guilders/hundredweight and from Cornwall, 70 guilders/hundredweight.

Table 2.8 Distribution of smalt manufacturing costs at the Wittichen manufacture during the 1768-71 period. According to Riederer.

Ingredients	Weight (cwt)	Cost (guilders)	Unit price (gld/cwt)
local cobalt	1 474	10 024	6.8
imported cobalt	192	10 067	52.4
smalt slurry	766	6 940	9.0
quartz	1 917	1 917	1.0
potash	1 206	15 505	12.9
arsenic	63	351	5.6
speiss	1.4	8.4	5.8
Total	**5 620**	**4 4812**	
wood	4 263 steres	5 968	1.4 gld/stere
expenses			
salaries	-	3 207	-
miscellaneous	-	1 022	-
expenses			

Table 2.9 Distribution of smalt manufacture during the 1768–71 period, according to Riederer. The letters represent: S for Streublau (blue strewing smalt), C for Couleur and E for Eschel; O is for Ordinary, M for Medium and F for Fine.

Granulometry			Colour quality
Coarse	Medium (*Couleur*)	Fine (*Eschel*)	
OS	OC	OE	Ordinary
MS	MC 873.75 cwt - 14.5 gld/cwt	ME 250 cwt – 14.5 gld/cwt	Medium
FS	FC 1003 cwt – 19/21 gld/cwt	FE 155 cwt – 21/25 gld/cwt	Fine
FFS	FFC	FFE 0.25 cwt – 29 gld/cwt	
FFFS	FFFC	FFFE	
FFFFS	FFFFC	FFFFE *royal blue*	
FFFFFS	FFFFFC	FFFFFE	

Data concerning production at this factory during the same period are given in Table 2.9, which lists the various grades of smalt being manufactured (see Table 2.6). Production focussed on four grades: the medium grade being the most popular.

The second source for prices comes from France at the same time. It is Baumé's Chemistry treatise, in which he tells us how the prices were fixed (Baumé 1773: vol. 3, 438, *Bleu d'azur*):

> This is how the price for this merchandise is established. In all establishments where azure is made, there are samples of various nuances & differing beauty with set prices, which are kept by the Director of the factory. The azure blue just made is compared with these samples; & having recognised that to which it most resembles, it is set at the same price as that of the selected sample. Various letters designating its quality, & the price for a hundredweight are branded on a barrel with a red hot iron as follows: O.H. 36 livres (French currency), F.H. 62 livres, F.F.F.F. 158 livres, O.C. 34 livres, O.E. 42 livres, M.E. 50 livres, F.E. 70 livres, F.F.E. 94 livres, M.C. 42 livres, F.C. 62 livres, F.F.C. 90 livres, F.F.F.C. from 140 to 160 livres.

This can be displayed as a table very similar to Table 2.6, replacing the letter S (Streublau) with H (Table 2.10). The letter S is reserved here for zaffre (*saffre*, in French).

Table 2.10 Price of the various qualities of smalt and zaffre in French livres per hundredweight, according to Baumé (1773). H is for Streublau (blue strewing smalt), C for Couleur and E for Eschel; O for Ordinary, M for Medium and F for Fine. S is for Zaffre.

Zaffre	Smalt granulometry			Colour quality
	Coarse	Medium (*Couleur*)	Fine (*Eschel*)	
OS 28	OH 36	OC 34	OE 42	Ordinary
MS 52	MH	MC 42	ME 50	Medium
FS 96	FH 62	FC 62	FE 70	Fine
FFS 124	FFH	FFC 90	FFE 94	
	FFFH	FFFC 140	FFFE	
	FFFF[H] 158	[FFFFC] 160	FFFFE	

Prices as indicated by Baumé are 50% higher than those of the Wittichen factory[25]. It seems that, in both cases, they refer to a wholesale price established by the manufacturer. The same author quoted several prices for zaffre (Baumé 1773: vol. 3, 437, *Safre*):

> We brand on the barrel with a red hot iron different letters referring to the quality of zaffre & the price for a hundredweight, as follows: F.F.S. 124 livres (French currency), F.S. 96 livres, M.S. 52 livres, O.S. 28 livres.

It therefore seems that the same lettering system was applied to classify both zaffres and smalts.

[25] In 1770, the guilder contained 9.744 g of pure silver. In France, the *livre tournois* corresponded to 4.507 g of pure silver. A guilder was therefore worth 2.162 *livres tournois*.

A question arises: what was the source for the information given by Baumé, whose book was published in 1773? Was his source Ste Marie-aux-Mines? But why would this factory, which was the twin of that of Wittichen, adopt such high prices?

The result of our calculations is shown in Figure 2.7. The distribution of these prices is, to say the least, unusual. Three among them stand out from the others. One of them (for 1550) was given by Lehman as a sale price practiced by the Dutch (4.40 g of gold per kilogramme). However, around 1634, Mayerne gave the London sale prices for four grades of smalt. They ranged from 0.5 to 1.2 g of gold per kilogramme if the monetary unit is the penny, and from 6 to 14.4 g of gold per kilogramme if it is the shilling. It does appear that prices set by the Dutch for their higher quality smalt were much higher than those corresponding to Saxony blues.

So Hughes reports that during the seventeenth century, the price of the Dutch smalt (Dutch ultramarine) in England, recognised to be of the highest quality, was ten times the price of blue from Saxony (Hughes 1954). For the latter, we can draw a curve through the lower values which seem to correspond to superior quality of Saxon smalt. A curve with a much steeper slope could still probably be drawn in the high price region, had we a sufficient number of data points.

This pricing development contrasts with that generally observed for other blue pigments, which decreases as competition and industrial production intensify. The price uncertainties mentioned above do not explain this inversion in the slope of the curve. We should rather remark that the production of these cobalt blues hardly ever gave rise to serious competition, the price cartel in Saxony being established as early as 1659.

The various uses of smalt

Smalt, a pigment for artists

We wrote earlier of the first use of smalt as a pigment by artists. In his *Entombment* (1455), Dieric Bouts used three blue pigments together: smalt, azurite and ultramarine. At that date, the cobalt may have originated from Freiberg, and the smalt may have been made in Holland. We can track by analyses carried out on paintings undergoing restoration the extent of the use of smalt by Italian, Flemish, German, French and English painters (Mühlethaler and Thissen 1986). It was in general use during the sixteenth and seventeenth centuries, when Van Dyck, Velasquez, Hals, Rembrandt, Vermeer and Rubens, among others, used it. It would be strongly challenged during the eighteenth century by the appearance of Prussian blue, and abandoned during the nineteenth century. In his treatise *Of Oil Painting,* Mérimée does not even mention it among the blue pigments (Mérimée 1830)[26].

[26] Concerning Mérimée, see chapter 5, note 106.

Smalt is referred to in the Colour Index as 'Blue Pigment 32 CI77 365' and is of a purplish-blue colour: its dominant wavelength is 473 nanometres. The colour darkens as the cobalt content is increased. It was actually by varying this content that manufacturers could offer their clients different shades, since the nature of the flux was always the same. The shape of the reflectance spectrum explains why the author of the entry 'Blue Ashes' in the *Encyclopédie* (Landois 1751b) pointed out that smalt did not have an appealing colour in the yellow light of candles: '(…) the enamel which is so vivid in day-time, & seems grey under lighting.'

The colouring power of smalt is very low, its hiding power also: the low value of its refractive index (around 1.5) makes it transparent in oil. Its chemical stability – like all potassium glasses in fact – leaves much to be desired. Potassium tends to dissolve: in weakly acid media, such as the oils used in painting, potassium diffuses into the fatty binder (Spring *et al.* 2005). This results in a progressive loss of colour of the pigment, and an accelerated yellowing of the binder due to the oxidation of oils.

Being very hard, smalt is difficult to grind. Its grains generally adopt a scale-like shape often showing conchoidal fractures. The use of smalt for oil painting is fraught with a number of difficulties arising from the large size of the particles as well as from their much flattened scale-like shape.

An oil paint made from a pigment of rather large grain size requires a lot of oil, which it cannot retain since its specific surface area is so small. In such a medium, the smalt suspension tends to separate and form a sediment; it is then surmounted by oil, which causes drying problems. This is, indeed, what is observed in a still fresh paint layer made with pure smalt. So says Turquet de Mayerne ([*c.* 1620] 1974: f. 9v):

> The death of colours arises when the oyl, lying on top, dries and forms a skin, which turns black in the air. There are certain colours, and enamels [smalt] in particular, which do not mix easily with the oyl and are always drawn to the bottom to bind, and thus die easily, i.e. turn black.

A number of recipes circulated among the workshops to allay this inconvenience. The first consists in adding a finely ground siccative pigment, such as white lead. But adding white is impossible when attempting to create dark blue shades, as in drapery. What to do? La Fontaine advises blotting (La Fontaine 1679: vol. 2, 16–17):

> To prevent it from running. When your drapery has been done, you will lay your painting on the ground, or on a table, you will take then used paper, such as grey trade paper, break it into small pieces, and let them drop over your drapery, mostly over the shadows, then the paper will draw out all the oyl, and when the blue will be as if dry, which we refer to as imbue or *enbus*, although the colour is not dry yet, the paper will keep the colour from running. To remove the paper, you must drop the painting on its corner, and all the paper will come off. Note that it must not be left to dry, else you could not remove it anymore. Large pieces must not be applied, for they would leave marks on the drapery.

Another trick consists in using smalt for 'powdering', a particular technique applied only with large size grains, those of 'parting azures', which the Sᵗ Mamet factory calls 'sands'. This is what La Hire tells of them ([1694] 1730: 672–3):

> The *Parting azure & Enamel* is the most common blue; it is a powder of a very bright colour, & they differ only in that the azure has a much coarser grain than the enamel, for they are the very same matter. The coarser the grain of the enamel, the brighter the colour is, & the more it tends toward purple like azure, but the enamel is of a more beautiful celestial blue. The grain of the powdering azure is so large that it can be used but with great difficulty, & only in *tempera* or *a fresco*, or to put in starch paste or starch with which it binds very well. It is named *Parting azure,* for, to achieve a beautiful *bleu Turquin* background, it is dusted over an oil white laid of a mediocre thickness & as fat as possible; it is then immediately spread with a feather, but it must have been well dried out previously on a paper above the fire; it is laid on thick enough, & left until the background is well dried out, & thus the white has taken up all it can. It is then shaken up, & all that does not hold on to the white is taken off by rubbing it gently with a feather or soft brush. It is a very bright colour & very long lasting, though exposed to air & rain.

> The enamel, which is the very same matter, only finer, gets all the paler as it gets finer, it is a powder used in *tempera* & *a fresco*: but it is seldom used with oil because it turns black, unless mixed with much white. This colour is but a glass coloured with Zaffre, being melted together & then turned into a powder.

To cut it short, smalt, a rather expensive pigment, was found by painters to be hard to apply. Furthermore, it ages poorly. It is therefore far from constituting the ideal blue pigment for artists. These defects are not important in blueing applications.

Smalt, a blueing agent

Whitening and blueing

Most white materials of an organic origin, such as animal fibres (wool, silk) or vegetable fibres (cotton, linen) are actually slightly yellowish, which means that they absorb more blue light than other wavelengths. They are said to give the yellow 'eye'. Furthermore, these materials tend to yellow with ageing or when heated, for example during ironing. This very general phenomenon applies to both textiles and paper, a non-woven array of vegetable fibres. Man has long confronted this phenomenon by either whitening or azuring (or blueing).

Whitening includes all processes aimed at the destruction of coloured molecules. The oldest, and most economical method, consisted of a simple exposure to sunlight and dew. Many organic molecules are susceptible to modification by near ultraviolet rays, thereby losing the ability to absorb light in the visible range. The inconvenience lies in the need for space (to lay out the textile pieces for the exposure) and time (as the process is very slow).

Next came the use of three families of bleach, all with oxidising properties. Until the end of the eighteenth century, textiles or paper were exposed to the vapours of sulphur dioxide (SO_2) resulting from the combustion of sulphur, which discoloured them. Then, following the work of the French chemist Berthollet (1789a), the use of chlorinated products would spread. 'Berthollet water', made at the chemical product factory of the Comte d'Artois located in Javel near Paris, would become *'eau de Javel'* (chlorine bleach)[27]. Progress was significant as a result of time saving as well as convenience (a water-based solution is easier to handle than sulphur vapours). Furthermore, this new process freed huge tracts of land on the outskirts of towns to the benefit of market gardening. This process was so easy to use that the 'berthollisation' of textiles is still current practice in households today. The more recent families of oxidisers put to use were the peroxidised products, such as perborates or hydrogen peroxide.

Optical blueing draws upon another philosophy. It consists in slightly colouring in blue a material having a yellow tone, so as to rebalance light absorption. The whole skill consists in measuring the amount of blue added so as to obtain not a pale blue, but a white support (in fact, a very light grey since there is absorption of light in the blue and yellow regions). Optical blueing is carried out with either pigments or dyes.

Textile blueing

The history of cloth blueing remains to be written. The first mention of such a practice could lie with Pliny the Elder, who talked of various *caerulea*. A particular grade of one of these *caerulea* (our Egyptian blue, cf. Chapter 1), consisting of its finest fraction, hence of a very light colour, was called *lomentum* (the name of a kind of soap), which allows one to think that this grade might have been reserved for laundering. This *lomentum* cost 10 denarii per pound (Pliny the Elder, *Naturalis historia* XXXIII: 57).

We must jump some fourteen or fifteen centuries to notice that the male as well as female habit of wearing a ruff around the neck, and the female one of wearing a coif, can hardly be conceived without stiffening. This was done with starch paste, a product which presents the peculiarity of yellowing slightly under the heat of the gophering or pressing iron. It is therefore very possible that an optical blueing agent may have been added to the starch.

During the request for the patent-monopoly for the manufacture of smalt in England made in 1605 by the trio of Twynyho, Baker and Arthog discussed above, the pale blue variety of smalt ('blue starch') used for the optical blueing of textiles was mentioned (Harley 1982: appendix III, 198).

[27] The product manufactured in Javel in the eighteenth century was a solution of potassium hypochlorite in water. Our current chlorine bleach (*eau de Javel*) is a solution of sodium hypochlorite.

From then on, this use of smalt mixed with starch was regularly mentioned in treatises. We saw that Kunckel (1689) in his *Ars vitraria experimentalis* remarked concerning Saxony-made zaffre:

> Sand is mixed with it in Misnia for the sole purpose of preventing other Countries from extracting or counterfeiting with profit the blue starch used by Laundresses, or the colour Painters call blue smalt, or enamel blue.

In his *Traité pratique de la Peinture* written in 1694, Philippe de La Hire ([1694] 1730) points out:

> Powdering azure is so coarse that it can be used but with great difficulty, & only for *tempera* or *a fresco*, or to add to starch paste or starch with which it binds very well.

Guineau presents us with a number of examples dating from the eighteenth century of the application of blueing to the finishing of textiles at the end of the manufacturing process (Guineau 1993). Indigo was used, whether coming from the West Indies or elsewhere, as for example in this recipe drawn from a compendium first published in 1740 (*Secrets concernant les Arts et Métiers* 1819: 204):

> Very excellent method for whitening silk. Take for five pounds of silk two and a half pounds of hard, white soap, let it dissolve in clear water; add the size of three large hazelnuts of powdered gatimalo [from Guatemala] indigo, mix everything up, let the silk boil in it, then wash it in a tub, then wash it again, and thereafter the silk will be most white, and will have a slight blue aspect, ever so slight as nothing really.

An analogous, but more detailed recipe can be found in Chomel's dictionary (1743a):

> The way to whiten silke, & which is done so; the silke still all raw is put in a pouch or bag of light cloth, which is thrown into a boiler full of boiling river water, in which has been dissolved good Genoa or Toulon soap. After the silke has been boiled in this water the space of two to three hours & the bag in which it is contained has been turned & agitated several times, it is pulled out to be beaten & washed in cold water, & when it has thus been washed & beaten, it is lightly spun, then thrown a second time into the boiler full of cold water, mixed with soap & a little indigo. It is this indigo which gives the blueish aspect, which is usually noticed in white silkes. After the silke has been withdrawn from this second boiler, it is spun very hard with a wooden peg, to expel all the water & the soap, then it is shaken to unspin it, & separate the strands, & it is suspended in the air, in a sort of drying furnace especially made, which is called a sulphuring chamber because of the sulphur burnt there; it is the mineral vapour which brings the last degree of whiteness to the silke.

Indigo blueing was therefore associated there with sulphur whitening. For cloth other than silk, recipes constantly mention the use of smalt mixed with starch. Let us read Chomel (1743b):

We call Dutch azure the enamel prepared in Amsterdam, & in several other locations in the United-Provinces; it is more appropriate for linen than for painting. (…) The launderers of fine cloth say they give blue to a cloth, to mean they draw it through a water, in which they have dissolved a little starch with Dutch enamel or azure. Two blues are usually given to batistes, one which is the blue of whitening by the launderers, & the other the finishing blue by the Merchants.

The detail of the procedure was given by Chomel in the article *'Blanchi'* (whitened):

Manners of different preparations to whiten the fine linen cloths,
and finish them as is done in Picardy.

Many operations enter in this whitening of cloths, two kinds of lye baths are used, the ones strong & able to cleanse, the others light to impart softness to toiles. These baths are either cold or hot. One washes as many times as baths are given; the bathed & washed cloths are grassed, or spread & exposed to the air, & are there sprinkled; from there on they go to receive various finishes, meaning that these cloths go from the whitener to the finisher, & these finishes are different according to the various qualities of cloth. They are finally beaten with a mallet to even them. They are folded, they are marked, after which the Merchant presents them for sale & sends them to the various whereabouts of his correspondents: such are the manner and order of all these baths and washes.

The first bath is thus treated, the cloths still all *écru*, that is, recently pulled off the loom, are left to soak in clear water the space of one day, & after they have been well washed and cleansed of all their rubbish, they are thrown into a vat full of cold lye, at the exit of which they are rinsed again in clear water & spread on the meadow where they are sprinkled from time to time with clear water, which runs in little ditches along the meadows, through the means of scoops or long handled hollow shovels, that the Dutch name *Gieter*.

The second bath, after the cloths have remained for some time on the meadow, they are taken through a fresh lye bath, which is drawn quite hot, like the ordinary baths, & this bath is composed differently, according to the condition the cloths are in, after which the same cloths are washed in clear water, they are grassed or spread back on the meadow, & all those things are reiterated until the cloths are perceived to have acquired the desired degree of whiteness.

The third & last type of bath, is a soft & light bath, to induce the cloths to take back the softness the other more acrid & harsher baths might have deprived them of; they are then well washed in clear water, the rubbing and milking of cloths following the three baths. This rubbing consists in soaping them with black soap, which begins by degreasing them somewhat & finishes by whitening the edges, which could not become perfectly white without the help of soap. After having washed them & made them neat & unloaded them of their soap, they are left to soak in cow's milk, which has been skimmed, which finishes to whiten & degrease them, imparts them with great softness, & lets them throw a little wool. After the milk, they are washed again in clear water, for the last time. After which the cloths are blued, which means the cloths are drawn through a water in which a little starch & Dutch enamel or azure has been soaked, of which the fatter & paler is the best, for the cloths must not show too apparent a blue.

Finishing follows, once the cloths have been whitened in the manner indicated, the whiteners turn them into the hands of the merchants they belong to, & it is then that they are given the proper finishes. These finishes differ, depending on the qualities of the various

cloths, for there are some among them for which some strength must be preserved, & others for which it must be diminished to make them lighter.

The finish for cambrics is given with starch & pale enamel, soaked in clear water. A few other drugs are added, the quality & quantity of which depends on the knowledge and skills of the finisher. Cambrics having received their finish & being dry up to three quarters & a half, they are hammered, which means they are beaten with smooth mallets of a hard wood over blocks or marble stones, which is done to break the grain & give them a finer eye. After they have been suitably beaten, they are folded into small square pieces which are put in a press, & at the output of this press, the merchants affix their numbers over small parchment fragments attached to the edge of the cloth, on the heading side with silke of differing colour, according to the merchants'inclination, who call this silke their livery, each merchant having his particular colour which stays constant; they are then properly wrapped in a brown paper from Rouen, well hammered & beaten, tied with small string, & from then on the cloths are in a condition to be sold, crated & forwarded to those locations where they must be consumed.

Around 1785, Buffon talks of the blueing of cloth with laundry starch (*bleu d'empois*), a mixture of starch and smalt. As for Chaptal, he teaches that (Chaptal 1790: vol. 2, 213):

Smalts are used to give to stiffen cloths, cambrics, lawn, muslins, threads, etc. Azures mix with starch to form a dressing, the uses of which for stiffening cloth are well known.

We have hardly any documentation concerning domestic laundry. After the continental embargo decreed by England, no West Indian indigo came to France, and the blueing of cloth was of necessity achieved through pigments. The cheapest among them was smalt, the price of which Guimet gave us for 1831: from 2.75 to 3 francs per pound (Guimet 1831). However, the use of Prussian blue was just as common under the name of 'starch blue' (*bleu fécule*) (Desalme and Pierron 1910) or 'Basel blue'[28], although it presented the inconvenience of taking a rusty colour in a basic environment, which was that of the lyes, rich in alkali carbonates.

At the time, adding starch to the rinsing water was common practice. Starch stiffened fronts or cuffs on shirts or blouses during ironing. It gave body to the fabrics.

Paper blueing

The first instance of paper blueing in the Western world was observed on papers dating from 1550, using a pigment, smalt, finely ground and dispersed on the surface of the paper (Hunter 1978: 478). At that date, cobalt, from Schneeberg II, and smalt had already been used by painters for more than a century. This practice must have gone through highs and lows, for a study of Dutch papers made between 1650 and 1810 shows a resurgence of this practice in 1746 (Barrandon and Irigouin 1979). Why at such a date? A century had already passed since the end of the Thirty Years' War, and order and prosperity had returned to Saxony smalt production.

[28] A mixture of Prussian blue, gypsum, a little barium sulphate and starch (see Colinart 1988).

Observing the smalt grains used (Figures 2.8 and 2.9) shows a granulometry averaging about 100 μm. Their analysis reveals a cobalt oxide content ranging from 0.5 to 2% by weight. The nature of the impurities corresponds to the so-called Schneeberg II period (B. Gratuze, unpublished work, 2006).

The Dutch papermakers kept their process secret, and did not even share it with the Angoumois paper mills in France, even though they purchased their products made with their own watermarks on a regular basis (Barrandon and Irigouin 1979).

During the eighteenth century, Italian papermakers used another method: they added several rags dyed with indigo to the mass of white rags used for paper manufacture. Fulling guaranteed that blue fibres were dispersed among the white (Guineau 1993) (Figure 2.10). At the same time, in France, paper was often directly dyed with indigo. Low quality paper, poorly blued, resulted in a light blue.

The blueing of ceramic paste and glass

Animal or vegetable fibres were not the only things whitened by blueing; mineral media also benefited industrially from such a treatment. For example, most of the clays used in the ceramic industry contain a little iron which, after baking, in the ferric state imparts a slightly yellow tint to them. In order to obtain a white paste, the tint is balanced with a little cobalt oxide. The cobalt oxide proportion does not exceed 0.5% by weight. To avoid the problem of blue spots due to the difficulty of grinding the oxide, cobalt chloride or sulphate are sometimes used.

In ordinary sodalime glass (window panes), iron is still a source of colour. Indeed, the silica sands used always contain traces of iron sufficient to impart a slight tint to the glass: oxidised iron in the ferrous (Fe II) state causes a light green tinge. With iron oxidised in the ferric (Fe III) state, the tinge is yellow. The goal here is to obtain a transparent, yet colourless glass. This problem is not new, witness this text dating from 1773 (Macquer 1773):

> Two kinds of window glass are made, one which has a light hue, & the other which is perfectly white [colourless] (…) The white glass is used in beautiful apartments & to put over paintings, pastels & prints; the coloured one is used in buildings for the panes. (…)
>
> In several glass factories a small amount of azure blue [zaffre] is added to the composition of the glass intended for wine bottles in order to impart to the glass a slight blueish tinge which makes it more appealing to the eye than if it were black or yellowish.

In the 1920s, people 'discoloured' ferrous glass in the traditional manner, by adding a little manganese dioxide (MnO_2), which caused its oxidation into a ferric iron. A more recent technique consists of provoking oxidation by adding a mixture of sodium nitrate and arsenic oxide. Ferrous iron turns to the ferric form, but does not tint the glass.

The most recent technique for glass decoloration consists in adding a little selenium. But, in this case, the ferric iron gives the glass a slightly yellow colour, a tinge which

can be corrected by the addition of a very slight amount of cobalt oxide. A weight content of 0.00015% of cobalt oxide is enough to decolourise a glass containing 0.05% of iron in ferric form.

Is cobalt really the source of the blue colour?

As with other blue pigments, the origin of the colour caused much ink to flow. It was first associated with the presence of bismuth, as is shown clearly in the text of Melzer, dating from 1684, which we reviewed above (Melzer 1684: 405):

> Peter Weidenhammer, from Franconia, arrived here [Schneeberg] a pauper. Yet, due to a colour he made from bismuth, of which he exported many a hundredweight to Venice at a price of twenty five thalers a hundredweight, he soon amassed a fortune and built a beautiful house on the market place.

We saw that in 1746 Zimmermann still shared this opinion (1746: 589):

> (...) for although there are various operations and skills contributing to the purity and fineness of this colour, it nevertheless is the cobalt and bismuth earths, *Wismuth graupen*, which lie at the source, and, anywhere these two materials are found, there will be no lack of people able to extract the blue colour (...)

In 1735, the Swedish chemist Georg Brandt succeeded in wresting 'cobalt' (i.e. cobalt ore) from the bismuth it contained, and isolated an unknown 'semi-metal' (Brandt 1735). He meant by 'semi-metal' a body which had the look, the colour and the density of a metal, but 'which did not perfectly spread under the hammer'[29]. Holbach gave us a summary of his arguments (1753):

> M Brandt, a learned Swedish chemist, has shown in a memoire inserted in the proceedings of the Upsala academy, that it should be ranked among the semi-metals: here are the reasons on which he based his sentiment:
>
> First, cobalt offers from the outside the same outlook as a metal. Second, it has a metallic heaviness. Third it enters fusion in fire, & assumes in cooling a convex surface, which is a distinctive character of metallic substances. Fourth, cobalt dissolves in *aqua fortis* [nitric acid], & gives the solvent a yellowish-green colour; fixed alkali salts[30] precipitate this solution with a black colour, & alkali precipitates it with a very vivid red; if we edulcorate this precipitated matter & add to it a flammable material, by melting this mixture we obtain cobalt as a regulus, as is done with precipitates of other metallic substances of which we attempt a reduction.

In 1742, Brandt demonstrated that the blue colour of smalt was due to this 'semi-metal' alone (Brandt 1742):

[29] *Per semi-metallum intelligibitur corpus quodcumque, quod formam metalli habet, & colore ac pondere ad metalla proxime accedit; sub malleo vero perfecte extendi non potest.*
[30] Potassium salts.

> Those who say that arsenic must be present in the cobalt [ore] for smalt to be obtained hold opinions that experiment does not verify. In fact, it is from a pure cobalt regulus [the metal] that, on their own, or through the addition of transparent bodies, are born smalt and the blue colour in glass mixed over fire. Not arsenic, not iron, not steel, not bismuth will give this result.

It is hard to be any clearer. He underlined afterwards how difficult it was to separate iron, almost always present in the ore, from cobalt.

However, many chemists remained convinced that these results were erroneous, and that the colour was due to bismuth, often present in the cobalt ore, or more probably to iron. Behind this last hypothesis probably hid the desire for a unifying concept. Iron was responsible for the blue colour in Prussian blue (see Chapter 5). The chemist Marggraff had just proved it was responsible for the colour of lapis (which was erroneous). Would it not make sense, if it were also responsible for that of zaffre tinted glass?

This latter opinion was the one favoured by Diderot, who was then interested in painting over enamel. He had just published the treatise on this subject written by his friend, the chemist Montamy, close to the Regent (Arclais de Montamy 1765). The same year, in a little known text, Diderot expressed doubts on cobalt being responsible for the colour of blue glass coloured by zaffre, and what he proposed to get to the bottom of the issue was tantamount to a true research plan (Diderot [1765] 1970):

> In spite of the details entered into by our author on the blue derived from cobalt, there are still many things left wanting in this article; and we know that M. de Montamy intended to carry out a series of experiments to settle the true nature of cobalt, which to-day constitutes a source of arguments among chemists; some view it as a semi-metal, based on the regulus obtained; others view this regulus as a particular combination of iron with arsenic. Several experiments carried out by very skilled chemists seem to confirm both these opinions equally. M. Rouelle, whose talents are known all over Europe, persists in seeing cobalt as a particular semi-metal since this famous chemist has derived what is called cobalt regulus from smalt itself, or from this vitrified and pulverised blue coloured matter coming to us from Saxony; on the other hand, M. Henckel tells us that, letting reverberate a third of a drachma of iron filings during a quarter of an hour, he gave it a dark purple colour; and having mixed these reverberated filings with a quarter of a drachma of pulverised white pebbles [quartz] and the purest alkali salt, and having placed this mixture in a luted crucible, exposed to a violent fire, he obtained a sapphire blue coloured glass.

> Assuming this experiment is true, which can hardly be doubted, it appears that the property of imparting a glass with a blue colour belongs to iron, and would suggest the presence of this metal in what we call cobalt regulus, which might perhaps just be an intimate combination of iron with arsenic at the saturation point; which makes their union very strong, and capable of resisting the action of fire up to a certain point.

> Another experiment from M. Henckel seems to confirm this idea (...).

> Were it allowed to chance here a conjecture shared with M. de Montamy, but which he has not been able to verify, we should be led to believe that, by mixing iron filings with arsenic, adapting the proportions by trial and error, and treating it in the same

manner as M. de Montamy did for marine salt, hence putting a certain amount of very finely divided iron, as obtained through the operation giving iron or *l'oethips martial*[31]; this iron thus divided and mixed through trituration with a fourth its weight in arsenic, placed in a fragment of a well sealed gun barrel and exposed for some time to a coal fire, might combine intimately with it and yield a substance similar to what is called cobalt regulus, and susceptible like it to make blue colour.

This method, were it successful, would prove very advantageous since it would spare the inconvenience of procuring good cobalt, which is not very easy; in fact, it would enable the manufacture of zaffre in all countries, since the chemist, in his laboratory, would imitate what nature does in Saxony or Spain inside the earth. One dares think that this conjecture deserves checking several times over before being rejected. (...)

In another direction, M. Marggraf has proved that the blue colour found in lapis-lazuli was due to iron only, and not to copper, as heretofore believed. Maybe this blue colour would be faster and not disappear in fire, if the iron causing it intimately combined with arsenic, as it is wont to be in the speiss of Germans, or in what is called cobalt regulus. All these things come to buttress our conjectures, and must urge us to examine whether artificial cobalt could really be made; this would greatly facilitate the work of those who paint, whether on enamel or on porcelain. (...).

Valmont de Bomare, editor of a dictionary of Natural History, was completely in agreement with this point of view (1767–1768: vol. 2, 'cobalt'):

According to the new clarifications we have over the colouring principle of *lapis lazuli* (see this entry [where Marggraf's work is alluded to]) & according to several particular experiments we have attempted, we do not despair that cobalt eventually will be recognised as a mere combination of iron, arsenic, &c.

Modern science would nevertheless prove Brandt right.

[31] Black iron oxide Fe_3O_4.

3
Natural ultramarine
The essence of the blue pigment

Lapis lazuli, a much sought after stone

Lapis lazuli is a hard rock, of a deep blue, which is only found in a very few rare spots on the terrestrial globe (Da Cunha 1989). For millennia, the Sar-e-Sang mines, in Badakhshan, a province of north-eastern Afghanistan, have supplied the Far and Near East, the Mediterranean world and the Occident with this precious mineral. An extraordinary example of continuity, the mines are still in operation. During the Afghan wars of the 1990s, their production was one of the sources of finance for Commander Massoud's forces.

These mines long held an air of mystery for Europeans. The first travel account to describe them seems to have been that of John Wood (1841), who visited them around 1837. In this extremely mountainous area of the Hindu Kush, exploiting the deposits of lapis lazuli is exceedingly difficult as they are found in very hard calcite or marble. The rock was to be heated in a wood fire, then quickly cooled with water. The main difficulty was to procure wood and water, which had to be brought from far away. The blocks of lapis lazuli were taken away on the backs of donkeys, thereby limiting the weight of each block. Recent visits by geologists show that exploitation has become somewhat modernised by the use of dynamite (Wyart *et al.* 1972). The amount of lapis lazuli extracted can be up to one tonne per year (due to the climate, the mines can be exploited for only four months each year). It takes nine days for the rocks to reach Kabul, where the Ministry of Mines divides them between Afghan lapidaries (20%) and the export market. In times of war, the rocks are taken to Pakistan, from where they

are exported. Defect-free blocks, i.e. those of a dark blue colour destined for jewellery, without inclusions or cracks, make up 16% by weight of this lapis lazuli.

The origins of the exploitation of these mines and of the trade in lapis lazuli are lost in the dawn of time. There is talk of rough blocks and objects, such as cylindrical seals, found in the cities of the Indus valley (Mehrgarh), which could date from 7000 BC. Amongst the people of the Near East, lapis lazuli was held in no less esteem than in predynastic Egypt (as witnessed by the Standard of Ur (Figure 3.1)). Not only did Egypt import Afghan lapis lazuli, but, when it defeated its neighbours, it demanded from them (Assyria and Babylon in particular) a tribute in the form of lapis lazuli (Lalouette 1986: 304, 306). Dark in colour, lapis lazuli probably served as a male blue as opposed to the light, hence female, blue of turquoise. The first was associated with male sexuality, the second with fertility (Aufrère 1991: 320). Lapis lazuli is also found among the treasures of Troy brought to light by Schliemann and housed today in the Pushkin Museum in Moscow. A hammer-axe, weighing 1.34 kg, made of a lapis lazuli rich in pyrite, constitutes proof of a trade in Afghan lapis lazuli during the Bronze Age (Tolstikov and Treister 1996; see also Herrmann 1968). Accompanying silk over the various routes known as the Silk Road, lapis lazuli never ceased to travel toward the Occident for the pleasure of the dignitaries of the western world. Numerous objects in museums testify to this. But lapis lazuli was also credited with many and varied therapeutic virtues as claimed in the treatise of Boece de Boot (1644: chapter CXXI):

- the azul Stone is good for melancholic illnesses
- the azul Stone purges without drawback
- the azul Stone shows admirable possibilities against quartan fever.

From lapis lazuli to lazurite

Lapis lazuli is a rock. It is therefore made of various minerals, in particular calcite, lazurite, iron pyrite, mica, pyroxene, phlogopite, plagioclases etc. (Figure 3.2). Among these, only one is blue, lazurite[1]. This mineral was to have an ephemeral destiny: described and named in 1890 by Brœgger 'lazurite', it only existed for 115 years. Now, thanks to sophisticated analytical techniques, lazurite has lost its status as a mineral (Ledé 2005). It is a sodalite, a sodium alumino-silicate with empirical formula $(Na_6Al_6Si_6O_{24})2NaCl$, heavily contaminated with sulphur. Let us try to explain this. The structure of sodalite consists of a compact assembly of alumino-silicate 'cages', corresponding to the $Al_6Si_6O_{24}$ in the empirical formula – small cell able to take in 'guests' provided they are not overly large. In pure sodalite (which is white), these cages are home to Na^+ and Cl^- ions (they make up the Na_6 and NaCl of the empirical formula above, which can be very misleading). The progressive exchange of Cl^- anions for sulphur-containing anions

[1] The terms 'lazulite' or 'lazuli' were also used at the beginning of the nineteenth century.

gives sodalite a blue colour. At higher concentrations of 'encaged' sulphurised anions, it is known as lazurite.

Coloured sulphur-containing anions (the chromophores) come in three types. The first is the S_3^- anion, which gives a beautiful blue and has a high colouring power. The second is the S_2^- anion, which is yellow. Its colouring power is much weaker. The third is pink in colour. Electrically neutral, its formula would appear to be S_4. These coloured species cannot exist in the free state but need a host structure which protects them from the outside world.

The lazurite tint depends on the respective concentrations of these three types of chromophores and on those of other colourless sulphur species, the presence of which depends on the chemical environment during synthesis. It also depends on the total thermal history of the compound as well as on the final water rinsing. The basic shade is a purplish-blue due to S_3^-, as can be seen from the visible light absorption spectrum (Figure 3.3). The presence of S_2^- shifts it toward the green; that of the pink chromophore, toward the violet.

If we replace sulphur with elements that have similar chemical properties, such as selenium or tellurium, we obtain results analogous to lazurite: red in the case of selenium; yellow, blue or green in the case of tellurium (Guimet 1877, 1878; Plicque 1878; Reinen and Lindner 1999).

All this was, of course, far from being known at the period of interest to us, and the path to learning it would be a long one.

Of the nature of ultramarine and the reasons behind its colour

Let us limit ourselves to setting back the clock two centuries. During the eighteenth century, some mineralogists classified lapis lazuli among the jaspers, due to its hardness and colour. Others, seeing it bubble in the presence of acids (due to the presence of calcite), would put it in the marble family. Indeed, blue marbles do exist, such as Portugal blue, *bleu fleuri* or Turkish blue. In 1777, the chemist Sage (1777), docimasy[2] professor at the *École Publique* set up at the Paris Royal Mint, classified lapis lazuli among the zeolites (minerals which seem to boil under the influence of heat). This classification, confirmed by Romé de Lisle, still remains valid (Romé de Lisle 1783). However, there still remained the determination of the composition of lazurite, and an explanation for its colour. The first difficulty lay in the fact that pure lazurite was not on hand, only lapis lazuli. Still combined with the lazurite were calcite ($CaCO_3$) and iron pyrite (FeS) with its golden aspect, and also other minerals (e.g. augite, mica, hauynite, wollastonite). This, therefore, was a composite from which it was important to separate the constituents. Yet, the traditional preparation of ultramarine, regardless of the care taken, always left impurities which interfered with analyses.

[2] Docimasy: science of the assay of metallic minerals, with the goal of determining the nature and proportions of the constituent elements.

The second difficulty arose from the fact that chemists had not yet recognised the basic concepts related to crystalline structure, concepts which have been developed separately by mineralogists. It followed that, in the chemists' minds, colour could only be due to chemical composition, which is only a half-truth. Until then, as far as was known, colour was related to the presence of a very small number of metals. For the blue colour, the first explanation was the presence of copper, but, since 1724, the presence of iron was another possibility, following the work of John Brown on Prussian blue (cf. Chapter 5). Then in 1742 Brandt claimed that cobalt was the source of the blue colour of smalt; this provided a third possibility.

The beginning of the article 'lapis lazuli' in the *Encyclopédie* gives us an echo of the first of these explanations applied to lapis lazuli: 'One cannot doubt that it is to a copper dissolution that lapis owes its blue colour, & it must be looked at as a real copper mine[3] containing a proportion of it, sometimes higher, sometimes lower' (Holbach 1765a). However, this was an inherited idea which had already had its time. As Holbach reported in detail on the recent research of the Prussian chemist Marggraf:

> The famous M. Marggraf has just published, in the collection of his chemical works, printed in Berlin in 1761, the exact analysis he made of lapis. The experiments of this learned chemist show that most of those who discussed this stone have erred so far.

These researches show that lapis lazuli does not contain any copper but a small amount of iron (not that in pyrite), which he demonstrates by provoking the formation of Prussian blue. It is therefore 'certainly' to this iron that lapis lazuli owes its colour (Marggraf 1758, 1762: 305).

This was also the opinion of Buffon (1783–1788, 4: 'Lapis lazuli' entry, 180–85), who, besides, opposed the classification proposal of Sage:

> Recent Naturalists have placed Lapis lazuli among the zeolites, although it differs in many more ways than it resembles them; but when one becomes persuaded, following the sad and sterile labour of Nomenclaturists, that Natural History consists of creating classes and genres, one does not remain content with putting together things of the same genre, and one often ill-advisedly throws in other things having little relationship to them, often having very different essential characteristics, even opposite to those of the genre they are to be included under. Several chemists have defined lapis as a zeolite, blue, mixed with silver (Cronstedt 1771, p. 157 and following), while this rock is not a zeolite, and it is highly doubtful that it could yield silver: others have assured that it yielded gold, which is very doubtful too, etc.

> Lapis does not swell, like zeolites, when it enters into fusion; its substance and texture are all different: lapis is not organised, like zeolites, along rays from the centre to the circumference; it presents a tight grain, as fine as that of jasper, and it would with reason be regarded as a jasper if it had the hardness, and took as beautiful a polish; it is nevertheless harder than zeolites: it is not mixed with gold and silver, but with pyrite-rich parts

[3] 'Stony substance containing a metal' (see Holbach 1765b)

which show as gold coloured points, spots or streaks: the background of the stone is of a beautiful blue, often spotted with white; sometimes this blue colour verges on violet. The white spots are lime inclusions, and sometimes present the texture and sheen of gypsum: these white parts, hit against steel, do not give out sparks, while the rest of the stone fires like jasper: the only link this stone lapis has with zeolites is that they both are composed of vitreous parts and calcareous parts; for dipping lapis in acids shows that some of its parts bubble up like zeolites.

The opinion of modern Naturalists was that the blue of lapis came from copper; but the famous chemist Marggraf, having selected the blue parts, and having separated them from the white and gold coloured pyrite ones, recognised that the blue parts did not contain an atom of copper, and that it was to iron that their colour must be attributed: he observed at the same time that the white spots were of the same nature as gypsum rocks.

Around 1790, the Prussian chemist Klaproth analysed lapis lazuli and gave the following composition by weight (quoted by Haüy 1801): silica 46.0%, alumina 14.5%, carbonated lime 28.0%, sulphated lime 6.5%, iron oxide 3.0% and water 2.0%. The absence of copper was confirmed, as well as the presence of iron. Sulphur was detected for the first time and assigned to the presence of a calcium sulphate.

In 1806, Desormes and Clément (1806)[4], in their laboratory at the *École Polytechnique* in Paris, confronted the problem again, after having taken the utmost care to purify the ultramarine extracted from lapis lazuli:

We have used, throughout our research, ultramarine of varying quality; but that which entered in our experiments, wherefrom we concluded as to the approximate proportions of its main constituents, was of the highest beauty; only 2 to 3% can be recovered from a beautiful lazuli; still, it was not yet absolutely pure, but at least fifteen to twenty times more so than the lazuli from which we had extracted it.

The composition by weight that they determined was the following: silica 35.8%, alumina 34.8%, soda 23.2%, calcium carbonate 3.2% and sulphur 3.1%.

There were two surprises: the first was a high proportion of soda; the second was the absence of iron, which proved that this element was an impurity (indeed, it came from pyrite) and that it was not part of the composition of ultramarine. The presence of sulphur was confirmed.

[4] The constant collaboration of these two scientists (although of the same age, Desormes was Clément's son-in-law), and their common realisation of the so-called 'Clément-Desormes' experiment which allowed them to measure the specific heat of gases under constant pressure or volume, ended up by turning them into a single person of uncertain birth date. Thus does this mythical N. Clément-Desormes appear in various publications as well as in the *Grand dictionnaire universel du XIXᵉ siècle* of P. Larousse (1866–1879) and in the *Dictionnaire universel d'histoire et de géographie* of Bouillet (1864).

Considering the absence of copper[5], iron and cobalt, the origin of the blue colouration of lapis lazuli was to remain a mystery until 1822 when C.G. Gmelin, a Wurttenberger chemist, and his colleague Breithaupt studied, named and described a blue-coloured fossil found near Kaiserstuhl-im-Breisgau. From the results of the analysis, they concluded that it was made of a mineral matter similar to sodalite or lapis lazuli and determined that its colouring principle must have been sulphur (Gmelin 1822[6]).

From lapis lazuli to ultramarine

Ultramarine is lazurite ground and reduced to a fine powder. There is a problem in that pure lazurite is never available, only lapis lazuli. Grinding this rock results in a blue-grey powder useless as a pigment (Figure 3.4).

Where and when was the technique perfected to extract lazurite powder from this blue-grey powder? Nobody knows. Compared with the long history of lapis lazuli exploitation, the date of this innovation seems to be recent. Yet, it escapes us. One assumes that this technique first appeared in those countries closest to the production site, countries where the raw material, lapis lazuli, was affordable. We are therefore forced to make do with the proven occurrences of ultramarine use: 'proven' meaning that analyses have shown without ambiguity the presence of lazurite. For there was a time, not that long ago, when the analytical method – inherited in a direct line from the eighteenth century – consisted in identifying in a blue paint layer the metal from which it must have derived its colour (copper, cobalt or iron). Were these metals not detected, attention would then turn to the presence of aluminium, silicon and sulphur with a view to diagnosing ultramarine. Since these elements were almost always present (the sample containing or being soiled with clay), the conclusion, almost always erroneous, was unavoidable: this was ultramarine. These methodological aberrations endured in some laboratories until the 1970s. Currently, various physical analytical methods, such as Raman spectrometry, are able to characterize lazurite without ambiguity. This said, let us revert to proven occurrences.

Gettens (1937–1938) noted the use of ultramarine in wall paintings in the temples of Bamiyan (Afghanistan), the oldest of which are dated to the sixth century AD. In Afrasiab, a city predating modern Samarkand (Uzbekistan), located on the Silk Road, wall paintings dating from around AD 660 were painted with ultramarine blue backgrounds. But the oldest, published example of the use of ultramarine as a pigment is to be found in Central Asia, in Turkmenistan, in the wall paintings of Mansur Depe, dated from the second century BC (Lapierre 1990: note 94). This date constitutes currently the *terminus ante quem* for the emergence of this technique.

[5] This did not stop H. Davy from thinking, in 1815, that Egyptian blue (which he showed contains copper oxide) was a species of lapis lazuli (see Chapter 9).
[6] Cited in the commentary of C.G. Gmelin (1828c: 367).

The manufacture of ultramarine seemed to appear later in the Mediterranean regions, around the start of our era. Was it an independent discovery taking place in the wake of the Alexandrian alchemists or was it rather the slow diffusion of the Asian recipe along the Silk Road? No one knows. The first definite occurrence of the use of ultramarine in the Occident was observed in Gaul: it is a painted terracotta Gallo-Roman statuette dating from the second century AD, found on the Argentomagus (Argenton-sur-Creuse) site, not far from Châteauroux (Guineau, unpublished work, 1993[7]). This is exceptional, for the use of ultramarine seems to have been very rare during antiquity. In fact, no technical text mentions it. The arrival of this new pigment in the Occident, long attributed to the Arab invasions of the eighth century, was therefore much older. But how was ultramarine actually prepared?

The manufacture of ultramarine azure

The oldest recipes, that we know of, for extracting ultramarine from ground lapis lazuli in the Western world date from the twelfth century. They appeared simultaneously in the Muslim and Christian worlds. Many variations are known, many of them dating from the fourteenth and fifteenth centuries. A given volume of recipes may contain several. Thus, we find ten in the *Experimenta de coloribus* one of the famous *Livres des couleurs* of Jean Lebègue, compiled in Paris in a manuscript dating from 1431 (Villela-Petit 1995). Their titles can be translated as:

n°10 – To make perfect ultramarine azure
n°111 – To make ultramarine azure
n°112 – To make a paste from which azure is prepared
n°113 – To extract azure from the paste
n°114 – To make a paste from which ultramarine azure is prepared
n°115 – To extract a perfect azure
n°116 – To obtain not as perfect a blue
n°117 – Thus is azure made
n°118 – To clean, refine and make ultramarine azure from a paste, or make it from a powder of lapis lazuli reduced to a powder and purify the powder with a paste
n°349 – To make fine azure

Rather short, they constitute variants of the same recipe. We shall quote two, to give an idea of the common background and the degree of variation. First, recipe number 10 (Lebègue 1431: *Experimenta de coloribus, n°10*)[8]:

10. To make perfect ultramarine azure – Take some lapis lazuli at will and grind it finely on a porphyry wheel, then, make a mass or a paste of the following ingredients: for a pound of lapis, take six ounces of Greek pitch, two of mastic, two of wax, two of

[7] It concerns a statuette analysed very shortly after its discovery in a dig, and which we are sure is not a later retouching.
[8] Recipe translated from Latin by M.P. Merrifield (1849: 49).

black pitch, two of gum from the pine, one of spike or linseed oil and half an ounce of turpentine, boil the whole in a pan until nearly melted, then filter and gather the product in cold water, stir and mix well with the lapis lazuli powder until fully incorporated, and let rest for eight days; the longer they rest, the better and the finer the blue will be; then knead the paste with the hands while sprinkling with hot water, the blue will then come out with the water; the first, second, third waters should be kept separately. And when you see the blue having descended to the bottom of the container, throw out the water and retain the blue.

Then recipe number 349 from the *Alcherius de coloribus diversis*, originating from the same *Livres des couleurs* of Jean Lebègue[9]:

349. To make fine azure - You must take the Indian or Persian azure stone which comes from beyond the sea, and which is kept by the apothecaries, who use it in some of their medicines. That which has white veins is better than that which has gold veins, and if you heat it over the fire on a hot plate of iron and when cool find it of the same colour as before, it is good. If you buy the same stone in powder, you must prove it in this manner, and then pound and grind it well on a flat piece of porphyry or other hard stone; then make a cement of turpentine and to a quarter of a pound of the said powder by weight add 4½ ounces of turpentine, and mix and incorporate together the powder and turpentine in a well-glazed earthen vessel, the turpentine being tepid before the powder is put into it. You must leave them in this state for the space of sixteen hours or thereabouts; then heat some water until it is tepid, throw it into the pot until the said mixture is covered with it, and stir the whole well together quickly and for a long time with a stick; then take the water, which will be rendered opaque by the blue colour, let it clear, and throw it into another well-glazed earthen vessel, and let it settle, when the blue will fall to the bottom; then pour some more water on the mixture and stir it harder than before, and throw the water, which will thus be full of the blue colour, into another clean glazed vessel, and let it settle, when the blue will fall to the bottom. Then pour in tepid water for the third time, and stir the said mixture of turpentine and blue; pour off the water into another pot and let it settle, then pour the water off all three vessels, dry the blue and keep it. The first will be worth its weight in gold, the second its weight in silver, and the third is good for making grounds. For this reason each sort should be kept apart.

The principle behind the operation consists in using the hydrophilic character of the surface of lazurite, a character which is much more marked for this mineral than for the others from which it must be separated. A malleable fatty (hence hydrophobic) paste is made, into which is dispersed the lapis lazuli ground as finely as possible. Grinding finely meets two requirements. The operation increases the surface/volume ratio of the material, which makes the treatment all the more efficient. It also makes it possible to obtain the very fine granulometry which will turn lazurite powder into a pigment usable, for instance, with a brush. The rest periods give the interface reactions a chance to develop. The surfaces of calcite, iron pyrite and most of the minerals present set up bonds with the fatty medium; weak bonds, but numerous enough to create a difference

[9] Recipe written in French. Text translated by M.P. Merrifield (1849: 316–18).

with lazurite which does not create any. Washing with hot water then selectively carries away the lazurite grains, which are gathered with the utmost care.

Most recipes insisted on the need to carry out at least three consecutive extractions, and especially not to mix the resulting ultramarines, which, becoming less and less coloured, are of decreasing quality. The first extraction probably corresponded to grains of pure lazurite. The following extraction permitted the recovery of mixed grains, in which the proportion of lazurite decreased in favour of other minerals as the washing operations multiplied. The last extraction supplied the ultramarine ashes, not a very commercial material, but appreciated as a quality grey-blue pigment.

Properties of ultramarine

Ultramarine presents an array of qualities which make it an exceptional blue pigment. Lazurite has a density of around 2.4, and a refractive index of 1.50. Dispersed in an oil medium, it is therefore a transparent pigment. Its visible light absorption spectrum (Figure 3.3) fully reflects its blue colour with its purplish component: the dominant wavelength is 468 nm. Its colouring power is mediocre, but higher than that of its competitors (Egyptian blue, smalt and azurite). Ultramarine has excellent lasting qualities. Very stable thermally, it can withstand being heated to red heat, which sometimes even brightens its tint. It is completely insensitive to light, and its chemical stability would be ranked as very good were it not sensitive to acid environments which decompose it. Apart from this effect in acidic media therefore, it is a blue pigment with perfect stability. It does not fade like smalt nor does it turn greenish like azurite or Prussian blue. Only Egyptian blue may rival it for permanence. Hydrophilic, ultramarine disperses easily in aqueous media, with more difficulty in oil-containing media. However, these slightly unappealing physicochemical properties must not distract us from the enthusiasm mixed with awe which gripped painters – at least those who were privileged to use it – when they wrote about it:

> Ultramarine blue is a noble colour, beautiful, truly perfect, more so than any other; it surpasses anything one might say of it. (Cennini [*c.* 1420] 1991: chapter LXII, 128–35)

> Ultramarine supplies the most beautiful colour known; but as it is very expensive, painters make use of it only for works that deserve it. (Le Pileur d'Apligny 1779)

> Ultramarine, one of the most brilliant colours on our palette, is at the same time the most resilient. (Mérimée[10] 1830)

The oldest attested usages are still to be found in preserved manuscripts, so little explored to date.

[10] Concerning Mérimée, see Chapter 5, note 27.

The presence of ultramarine in medieval manuscripts

We are forced to admit that we know next to nothing of the use of ultramarine during the first centuries of our era. Laurie (1935) claims to have observed some on the illuminations of Byzantine manuscripts dating from the seventh century. It seems to have appeared in the Occident with the Carolingian Renaissance. At that time, when patrons and scriptoria multiplied, it could be found in the decoration of various manuscripts, including the *De laudibus sanctæ crucis* (*Praises to the Holy Cross*) and one from the scriptorium of l'abbaye de Corbie (Guineau and Vezin 1990).

Dulin (1994) studied the pigments and dyes used in the making of seven of the preserved specimens of the *Louanges à la sainte Croix*, a work famous in its time. Its author, Rabanus Maurus, a learned encyclopaedist, was abbot of Fulda (near Mainz, Germany) between 822 and 842, then Archbishop of Mainz. He was part of the third generation of well-read Carolingians who began their careers at the time the Empire was coming apart[11]. He finished the *De laudibus* in 810 while in Fulda. This treatise on spirituality presents a very peculiar graphic form: each page was set out as what would later be known as a 'concrete poetry' (*calligramme*), in which text and coloured illustrations were intimately linked in subtle graphic games (Rabanus Maurus 1988). The oldest of these manuscripts were made in the Fulda monastery scriptorium at the beginning of the ninth century. The most recent is dated from around 1060. They all have numerous illuminations which include areas of blue.

Dulin carried out a series of analyses on each one to identify the pigments and dyes present in the paint layer. The first three specimens, copied in the Fulda scriptorium and dating from the ninth century, contain indigo blues. We do not know whether it was local indigo coming from woad (*Isatis tinctoria L.*) or from *indicum*, coming from *Indigofera tinctoria L.*, imported from the East Indies. Only one of them, copied around 840, shows the simultaneous use of indigo and ultramarine[12]. Among the others, dated from the tenth and eleventh centuries, only that kept in Orleans and one of the three preserved in Paris, at the Bibliothèque Nationale de France, indicate the use of ultramarine[13].

Guineau analysed the blue colours used by copyists and limners of six manuscripts, which were produced in the scriptorium of the abbey of St Pierre de Corbie during the twelfth century (Guineau *et al.* 1986). For large, historiated letters (i.e. letters adorned with filigree, animals or grotesque creatures), all the blues (whether the shades be bright, light or greyish) were ultramarine.

[11] He wrote numerous works of piety (he would be the *Veni Creator* author), pedagogy and culture. He wrote an encyclopaedia (*De universo*) in twenty-two volumes meant to replace that of Isidore of Seville.

[12] That kept in the Vatican library, referenced Regina lat. 124.

[13] Orleans, M 145 (122). Paris, BnF, MS BN Latin 11685. This is the copy written around 1060 for the St Germain-des-Prés Abbey near Paris.

In much more recent and luxurious manuscripts, such as *les Heures du Maréchal de Boucicaut* (the Boucicaut Hours), illustrated around 1407, the blues were indigo or ultramarine, the latter being rather abundant. A careful examination reveals the use within the same illumination of three different ultramarine qualities, varying in colour saturation and fineness of grain (Guineau *et al.* 1998; Villela-Petit and Guineau 2003). This, of course, brings to mind the recipes calling for the separation of extracted ultramarine into several fractions of differing qualities (Figures 3.5 and 3.6).

The price of ultramarine

As the lapis lazuli moved further away from the mines from which it was extracted and journeyed at the slow pace of caravans, its price increased. Having reached the merchant towns of the Levant (Aleppo, Beirut, Acre, Alexandria), it was then shipped to Venice and, eventually, distributed to other cities. Its higher cost prohibited its use except on limited surfaces and in exceptional circumstances. A number of documents quote prices, generally the price for higher quality ultramarine. These prices were not given per pound, but per ounce, a much smaller unit. This unit of weight remained fairly stable between countries, but varied in definition from place to place[14]. We shall take it to be 31 g in the paragraphs that follow.

Around 1400, Jean Lebègue mentioned the three grades of ultramarine in recipe number 349 (which we saw above) and said: 'The first is worth its weight in gold, the second its weight in silver, and the third is good for making grounds.' The first grade was therefore worth 31 gold grammes an ounce. Since at the time the ratio of gold/silver values was around 12, the second grade would have been worth around 2.6 g of gold, which might have suited a third grade, but seems rather low for a second. It is likely that the phrase copied by Lebègue must be viewed more as an image to capture the imagination than as evidence of the actual price.

Around 1420, in Florence, Cennini ([*c.* 1420] 1991: 132) said:

> But remember that, if you have lapis-lazuli of good quality, the blue from the first two extractions will be worth eight ducats per ounce. The last two are worse than ash; so let your eye learn not to spoil the blues of good quality because of the bad.

The ducat (used here for florin) was struck at 3.50 g and assayed at 23 2/3 carats of pure gold. This ounce of ultramarine was therefore worth 27.9 g of gold.

[14] Initially and etymologically the twelfth part of the Roman pound, the ounce was, in France, the twelfth part of weak pounds such as that of Troyes (which gives it a value of 31.103 g), or the sixteenth part of strong pounds such as that of Paris (which gives it a value of 30.594 g). In England, the apothecaries' ounce (and also the Troy ounce, used for gold) were twelve to the pound and these were equivalent to about 30 g. The avoirdupois ounce, used for general purposes, was a little over 28 g and there were 16 to the pound. What is not clear at all is whether or not the weight used for ultramarine in the shops was the apothecaries' ounce or the avoirdupois ounce.

In a letter to Jacob Heller from Dürer sent from Nuremberg and dated 4 November 1508, Dürer (1987: 21) wrote:

> Know that I use the most beautiful colours I can find. Ultramarine alone cost me twenty ducats, not to mention the other expenses. (…) Had you had to acquire a pound of ultramarine, one hundred florins would hardly have been enough. For I cannot find any at less than ten or twelve ducats per ounce.

Therefore, it was indeed top grade ultramarine. In Nuremberg, at that time, the florin which Dürer called 'Rhenan' contained about 2.83 g of gold. The price of an ounce was therefore within a range of 28 to 34 g of gold.

Twelve years later, in Dürer's travel log, we read for 14 December 1521, a date at which he was in Antwerp (Goris and Marlier 1970: 86): 'I paid 3 florins to Jan Türcken for Italian art. I gave him art for twelve ducats in exchange for an ounce of good ultramarine blue.'

Throughout this journal, Dürer keeps his accounts with a minuteness which amuses, and then annoys, the reader, soon disappointed with the very down-to-earth preoccupations of the Master. We may therefore assume that the latter was not guilty of any largesse, and that he paid the just price for his ultramarine. In 1521, in Antwerp, in Brabant, Charles V was on the throne. Until 1520, the gold currency was the 'Philippus florin' which Dürer talked about in his letter, worth 25 sols[15]. In 1521, there was a switch to the 'Karolus florin', worth 20 sols. The coin weighed 2.914 g and assayed at only 14 carats of pure gold[16]. Dürer therefore paid 20.4 g of gold for his ounce of ultramarine. He made a good deal.

According to the *Dialogo* of Paolo Pino, in 1548 in Venice, ultramarine would have sold for 60 scudi an ounce (Merrifield 1849: ccxiii). At 3.097 g of pure gold per scudo, the price for an ounce of ultramarine would have come out at 186 g of gold, which seems hard to believe, especially in the city which was the centre of the trade in lapis lazuli and ultramarine.

Around 1600 in England, Hilliard (1981)[17] reported prices of £11 10s and £7 10s an ounce for the best and cheapest qualities of ultramarine. This would have put them at 110 g and 72 g of gold an ounce respectively, prices which would seem rather in line with those cited previously. But soon after, in 1609, in his *Le parfait joalllier*, Boece de Boot (1644: chapter CXXXVIII), talking of lapis lazuli, wrote:

[15] The 'sol', or 'sou' (the name of which derives from the Latin *solidus*) was a French accounting money equal to the twentieth part of the pound. It was therefore, in principle, equivalent to the English shilling.

[16] The ducat is equivalent to the florin. We may note that Dürer does not talk in Antwerp money (gold florin, *real* [3 sols], *patard* [1 sol], silver groschen [1/2 sol] and bullion *mite*), but in German money (ducat, deniers).

[17] Quoted in Harley (1982).

> The pound of rock sells ordinarily for eight or ten Thalers, which, if it was good, will yield at least ten ounces of colours (...). From a perfectly good rock you will draw five and a half ounces of the first colour, an ounce of which will be worth twenty Thalers. The ounce of the second colour will be worth five or six Thalers, and of the third, one, or one and a half.

The best grade of ultramarine went, therefore, for 52 g of gold an ounce, the second for about 14.3 g of gold and the third in the vicinity of 3 g of gold.

Established in London in 1641, the Dutch painter Peter Lely paid £4 10s for an ounce of first quality ultramarine, and £2 10s for an ounce of second quality ultramarine[18]. The pound corresponded then to 8.345 g of pure gold. Lely therefore paid 37.5 and 20.9 g of gold respectively for an ounce of his ultramarines, which was rather expensive.

In the 1679 edition of Boutet's work, we read that in Paris (Boutet 1679):

> These colours can all be found ground at M. Foubert's, rue Grenéta, at the sign of the Bagpipe. They each cost eight sols an ounce, with the exception of Carmine, the most beautiful grade of which is sold for ten francs per gros. There is also some for eight, six and four. The Ultramarine, six and eight francs per gros.

A 'gros' being an eighth of an ounce, the ounce of ultramarine was worth here 4.91 and 6.14 g of gold respectively, very low prices. If they are correct, it was not top quality ultramarine.

In his *Art du peintre, doreur, vernisseur, et du fabricant de couleurs*, Watin (1773) gives prices for the various pigments available in France. For a sixteen ounce pound of pigment, one had to pay:

Ultramarine	1536 livres
Ultramarine ashes	48 livres

This prices the ounce of ultramarine at 29.92 g of gold and the ashes at 0.935 g.

In 1788 in Paris, ultramarine of the best quality sold for 100 livres (or francs) an ounce, i.e. 31.2 g of gold an ounce (Chaperon 1788). This price of 100 francs an ounce was still quoted in 1803 by Thenard (1803–1804).

On the other hand, around 1785 in London, the best quality ultramarine cost 10 guineas (hence 76.6 g of gold) an ounce, and ultramarine ashes £2 (14.6 g of gold) an ounce (*The Artist's Repository and Drawing Magazine* 1784–1786[19]). This confirms the very high price of ultramarine in England, during the eighteenth century at least, until a colour maker, Middleton, imported lapis lazuli from the Ural mines, which had recently become available. In 1809 Middleton sold his best quality for 6 guineas (43.9 g of gold). The fall in price was spectacular (Harley 1982: 45).

[18] Merrifield (1849) quoting *Walpole's Anecdotes*, vol. 3, 130–32.
[19] Quoted in Harley (1982).

Published in 1823, the *Dictionnaire Technologique* reports that (Payen 1823a: 'Bleu d'outremer' entry, 225–30):

> One still finds in Italy very beautiful ultramarine for 110 francs [31.9 g of gold] an ounce; blue ashes for 1 to 2 francs [0.29 or 0.58 g of gold], and intermediate qualities at prices ranging between these two limits.

The entry for 'Guimet' in the *Grand Dictionnaire Universel du 19ᵉ siècle* relates that at the time of the Guimet blue invention, i.e. around 1830, a kilogramme of natural ultramarine cost, on average, 3,000 francs and that, on account of its high price, less than 3 kg were used each year in France (Larousse 1866–1879, 8: 'Guimet' entry). An ounce of ultramarine therefore cost 93 francs, or 27.0 g of gold. From this date onwards, data concerning the price of natural ultramarine disappeared, probably due to the arrival on the market of the artificial ultramarine manufactured by Guimet (cf. Chapter 7).

In 2007 the German firm *Kremer Pigmente* was selling natural ultramarine, mostly from Chile and the remainder from Afghanistan. For most qualities, ultramarine is separated via a process well known to the mineral industry: flotation[20]. The price of the top grade obtained by this method was 380 euros for 50 g, which puts the ounce at 14.9 g of gold. But for ultramarine produced by the traditional method, the price was 977 euros for 50 g, hence 38.3 g of gold an ounce. In spite of improved transport facilities and multiple sources of lapis lazuli, the price for this ultramarine is 23% more expensive than the same weight of gold.

Table 3.1 A comparison of the prices in grammes of gold for an ounce of top quality ultramarine between England and France. Prices seem lower and more stable in France.

France			England		
Date	Reference	Price (in grammes of gold)	Date	Reference	Price (in grammes of gold)
1400	Lebègue	31.0	1600	Hilliard	110
1773	Wattin	29.9	1650	Lely	37.5
1788	Chaperon	31.2	1785	Artist's Rep.	76.6
1803	Thénard	31.2	1809	Middleton	43.9
1823	Dic. Tech.	31.9			
1830	Larousse	27.0			

Figure 3.7 gathers all these results. We often read that natural ultramarine was sold for its weight in gold. We notice that this was true, but corresponded rather to a floor price. A number of prices were much higher. Apart from the 186 g of gold which Pino was dubious about, we note that the higher prices were found in England. Table 3.1 demonstrates this, and also throws light on the great instability in prices in this country. On

[20] Flotation: A process for separating solid particles in an aqueous environment, using the difference between wetting properties by water. The addition of a suitable surface active agent allows one of the powders to be recovered on the surface of the tank when injecting air via the bottom.

the other hand, in France the price remained stable and equal to that of gold. Whether this is true or a result of the small number of prices reported, we shall probably find out in the future.

Such high prices are unique for a pigment. This was why ultramarine was sold by the ounce and not by the pound. The remarkable stability of its price over six centuries was, as we shall see, a singular instance among blue pigments. It is nevertheless likely that prices did fluctuate as a result of political interference on imports.

Consequences of the cost of ultramarine

One consequence of the high cost of ultramarine was that numerous painters turned away from ultramarine, replacing it, for example, with azurite. Also, if those painters who decided to use it (and had to pay for it themselves) had miscalculated their costs, they may have had to renegotiate the sale price for their painting. An example was given by Dürer (indeed if there is one painter whose price-related complaints have reached us, Dürer is the one). The complaints related to the painting of a triptych representing the Assumption of the Virgin, ordered by the draper Jacob Heller for the S^t Thomas altar of the Dominican church in Frankfurt-am-Main. For this painting, lost today, eighteen wonderful preparatory drawings on blue paper exist, showing details (in particular the joined hands and feet of apostles). There is a copy painted during the eighteenth century by Jobst Harrich, and nine letters written by Dürer to the patron. In these letters, dating from the years 1508–9, Dürer apologised for the delay in honouring his order, then negotiated a substantial revision of the price initially agreed upon for executing the triptych. His request was based in part on the cost of ultramarine used to paint the triptych:

-Ultramarine alone cost me twenty ducats, without mentioning other expenses (...) (Dürer 1987: 4 November 1508)

-Do not worry about colours, for I spent over twenty-four florins on them. And should they not be beautiful, I believe you will not find any more beautiful elsewhere (...) (Dürer 1987: 21 March 1509)

-So, I pray you, be satisfied that I ask you one hundred florins less than what I could have obtained for this painting [i.e. 200 florins, new price, instead of the 300 Dürer estimates his work at]. And I am telling you that it was nearly taken from me by force. For I painted it with great zeal, as you will be able to see. I also made it with the best colours I could obtain. For the five or six layers, from the first to the last, I used a good quality ultramarine. And while it was already finished, I went over it with another two coats, to make it last longer. I know that if you take care of it, it will be clean and fresh five hundred years hence. For it is not done as is customary. Make sure it stays clean, no one touches it and is not sprayed with holy water (...) (Dürer 1987: 26 August 1509)

Even taking into account the revised sale price of the painting (200 florins), the cost of ultramarine alone still represents at least 10% of the total.

The third consequence of the high cost of ultramarine was the risk of the retail product being adulterated. The ultramarine manufacturing process is long and involved, and it seems that, very early on, some merchants specialised in this production. The abundance of recipes for testing the quality of ultramarine suggests the existence of fraudulent practices of extending ultramarine by the addition of other blue powders, azurite, smalt, Prussian blue, even indigo-dyed powder: the painters had a legitimate distrust of the authenticity of a pigment they bought for the price of gold.

The test – which had to be easy to implement – was long carried out by bringing the blue pigment to red heat on a knife blade, an operation to which true ultramarine remains insensitive. This test was often mentioned at the beginning of recipes. Thus, in recipe number 349 of the *Alcherius de coloribus diversis* from the *Livres des couleurs* of Jean Lebègue (around 1400) already quoted:

> 349. To make fine azure - You must take the Indian or Persian azure stone (...) and if you heat it over the fire on a hot plate of iron and when cool find it of the same colour as before, it is good. If you buy the same stone in powder, you must prove it in this manner (...)

Two centuries later, the recipe was still current, as witnessed by *Le parfait joaillier* (Boece de Boot 1644: chapter CXX):

> [Of the Azul stone] There are only two kinds, that which is fast in fire and that which is not. The fast Azul stone: this means that being placed over fire, its colour does not change (for that is the proof of its legitimacy), is almost always brought from the Orient. The non-fast is found in Germany [azurite], & is commonly called *lasurstein* (...). From the fast is separated the ultramarine colour, from the non-fast that which is called *Asurblau*.

More recent is the test of resistance to a strong acid (Mérimée 1830: 182):

> Although ultramarine withstands the action of fire, to the point of reddening without losing its colour, this colour is destroyed by acids; this supplies a means of recognizing its purity. One puts a pinch of ultramarine in a small glass or porcelain vessel, and pours a little nitric acid over it. The blue colour is destroyed in an instant, and there remains only an earthy matter, of a yellowish grey, which gels up.

> Neither cobalt blue, nor Prussian blue are altered by acids: this is why, in the event that ultramarine had been falsified by mixing with one of these colours, the fraud would be easily discovered. An indigo dissolution would not be bright enough to tempt one to use it to falsify ultramarine. If nevertheless some had been mixed in to bring up the hue of ultramarine, it would be discovered by means of sulphuric acid which does not destroy the colour of indigo.

This test has also long been used to check the quality of a Maya blue (cf. Chapter 11).

Legal steps to guarantee quality

A consequence of the elevated price of ultramarine was the distrust of those commissioning the work, to whom the ultramarine was billed, who wanted to be sure that what they were paying for at the price of gold was indeed true ultramarine.

A testimonial is found in the '*prix-faits*' (set prices), those contracts established before a notary between the patron and the painter (or the illuminator). The archives of Jean Morel, notary in Avignon at the middle of the fifteenth century, contain two of interest to us. The most famous is that established with Enguerrand Quarton for the commission of the *Couronnement de la Vierge* currently in the Villeneuve-lès-Avignon Museum.

The text describes minutely the different scenes to be portrayed, the characters composing them, their comparative sizes and even their garments, the whole constituting a true theological programme[21]. But it also fixes the nature of blues and golds. Here is an abstract (Chobaut 1977)[22]:

> *Prix-fait* concerning the painting of a retable for messire Jehan de Montagnac, priest
>
> On this 23rd of April [1453], maistre Enguerrand Quarton, from the diocese of Laon, painter, residing in Avignon, entered into a pact and an understanding with messire Jean de Montagnac, in the presence, upon the request, and with the accord of the latter, concerning the painting of a retable according to the norms and dimensions contained and specified in the articles of the treatise they submitted to me, written in the Roman language, the contents of which follow*:
>
> Follows the general disposition of the retable which messire Jehan de Montagnac, priest, has maistre Enguerrand, painter, execute to set in the church of the Chartreux of Villeneuve lès Avignon by the Altar of the Holy Trinity.
>
> First must be the representation of Paradise, and in this paradise must be the Holy Trinity, with no difference from Father to Son, and the Holy Spirit in the shape of a dove, Our Lady to the front, as said maistre Enguerrand will deem best; upon said Our Lady's head the Holy Trinity will lay the crown;
>
> Item, the clothes must be rich; those of Our Lady must be of white, figured Damask cloth following the advice of said maistre Enguerrand, and around the Holy Trinity must be cherubs and seraphs;
>
> Item, by the side of Our Lady must be the angel Gabriel with a number of angels, with on the other side Saint Michael, together with any number of angels too that said maistre Enguerrand will deem best; (…)

[21] In line with the text promulgated by the Church's Fathers at the second Nicaean Council, in 787: The composition of religious images is not left to the artist's interpretation; it reverts to the principles laid down by the Catholic Church and the religious tradition. Art alone belongs to the artist, and composition to the Fathers.

[22] Departmental archives of Vaucluse (shelf mark E *Notaires, fond Martin*, short notes from J. Morel, notary in Avignon, 1453, f. 48–51). Paragraphs marked by an asterisk were translated from Latin.

Item, in the second mountain will be Moses with his sheep and a young son bringing his bag and there appeared to said Moses Our Lord in the shape of fire in the midst of a bush, and shall say Our Lord: Moses, Moses; and Moses shall answer: Assum;

Item, to the right hand side will be Purgatory where souls will show great joy seeing depart for Paradise, which the Devils will show great sadness for;

Item, to the left will be Hell, and in between Purgatory and Hell will be a mountain, and on the side of Purgatory above the mountain there will be an angel comforting the souls in Purgatory, and on the side of Hell a devil on the mountain, much disfigured turning its back to the angel and getting certain souls into Hell, which are turned over to him by other devils;

Item, in Purgatory and Hell will be of all venues, following the advice of said Maistre Enguerrand;

Item, said retable will be entirely made with fine oil colours, and azure must be pure azure from Acre [ultramarine], except for that which will be put on the border, which must be of pure azure from Germany [azurite], and the gold which will enter in the border as well as around the retable must be pure gold, burnished; (...)

Consequently, maitre Enguerrand commits to working in the manner described above and with the utmost accuracy, conforming to the preceding indications; further, he commits to have finished his work within one year following next Michaelmas, this for the price of one hundred and twenty florins, which is equivalent to twenty-four sous in Avignon currency from which will be withheld what said painter recognizes having received from messire Jean, i.e. forty florins, of which he declared himself satisfied, and the same messire Jean gave him receipt in full*(...).

Considering that painters knew how to obtain the same deep blues with azurite as with ultramarine, by superimposing layers of different types over coloured undercoats, there was therefore clearly the will on the part of the commissioner to use the most expensive pigment, as expensive as gold, for the greater glory of God. Still, he did not use it everywhere. However, precise as the instructions may have been, it did not follow that confidence reigned, as appears from this second contract entered into in 1448 in Avignon between Cardinal Jean Rolin, Bishop of Autun, son of Nicolas Rolin, Chancellor to the Duke of Burgundy and an *illuminator librorum* from Uzes, for the illumination of a missal intended probably for the chapel erected by the Rolins in the convent of the Celestins in Avignon. The terms of fraud and falsification turned up repeatedly (Perrat 1995: 139)[23]:

On March 20th, 1448, Maitre Jean de Planis d'Uzes, book limner, promised said Lord Bishop to illuminate a missal belonging to the Lord Bishop himself, which he had written by Dominique Cousserius, Celestine, with appropriate histories [scenes with characters] and capital letters of pure and fine gold over a field comparted in Acre blue [ultramarine] and red, with tokens, most faithfully, decently and honestly, without any fraud nor falsification, and to execute each history, well drawn, in pure gold, lapis and purple, following

[23] Departmental archives of Vaucluse (shelf mark E *Notaires, fond Martin*, short notes from J. Morel, notary in Avignon, f. 105).

the agreed upon form and personages, according to the instructions of said Lord Bishop, at the price of fifteen gros each history and one gold *écu* per one hundred above mentioned initials; and to accomplish said work with great care and faithfully, as well and as quickly as possible, without any fraud; and to not set aside said work for some other, nor interrupt it for any reason whatever.

In this very place, the nobleman Henri Tegrini, banker and citizen of Avignon, answering in the name of said Lord Bishop, and giving his own guarantee, promised said Jean to pay him the agreed upon price, in proportion to the accomplished work, and according to his need for money; and said Jean promised to accomplish said work in the present city of Avignon, and to well and faithfully keep said missal and return it thus illuminated and completely finished to the same Lord Bishop of Autun.

It was hard to take more guarantees.

Concerning this fear of fraud with respect to the quality of ultramarine, Vasari ([*c.* 1550] 1996: 159–61) cited an amusing anecdote in his 'life' of the painter Pietro Vanucci, called Perugino:

> The works of Pietro being thus held in much esteem by Florentines, a prior of this Jesuit convent, who appreciated works of art, had him paint, on a wall of the first cloister, a Nativity scene with the Wise Men, treated in a rather minute manner, but very carefully detailed; and, in the second cloister, above the door to the refectory, Pope Boniface confirming the order of the blessed Giovanni Colombini. Above this fresco, one could see the Nativity of Christ with angels and shepherds in very fresh colours. On the door of the oratory, he added still, within an arc, the three half-figures of the Virgin, Saint Jerome and the blessed Giovanni, in such a beautiful manner that this fresco was considered one of the best he had ever produced.

> From what I heard told long ago, said prior excelled at ultramarine blue manufacture, and, as he possessed a certain amount, he willed Pietro to use a lot in all the above mentioned work; but the poor man was so distrustful that, not having confidence in Pietro, he always wanted to be present when the latter used blue in his work. Thus Pietro, who was a good man, with a straight heart, and desired nothing but the reward for his labours, harboured a heavy heart at seeing the prior's defiance, and imagined to make him blush over it.

> Having taken a small basin full of water, when he had done the underneath of his draperies or of other things he wanted to paint in blue or white, he asked in rapid succession for ultramarine from the prior, who would put reluctantly his hand to the bag, and had him put it in the phial full of water for distemper. Moving next to execution, after two strokes of the brush, Pietro would dip his brush in the basin so there remained more ultramarine in the water than he laid on the painting. The prior, seeing the bag empty and the work not come out, did not cease to repeat: 'God! Does that coating absorb ultramarine!' – "You can see for yourself!' would answer Pietro.

> Then, when the prior had left, Pietro would take out the ultramarine left at the bottom of the basin; and, when he deemed the time right, he gave it back to the prior and told him: 'Father, this belongs to you; learn to trust good men, who never cheat those who trust in them, but who would know how to cheat, should they want to, distrustful beings such as you.'

4

German azurite and English blue verditer
Favourite pigments of European painters

In Italy, the Renaissance was a period of intense activity for pictorial arts, but which blue pigments did the Florentine or Siennese painters of the *Trecento* and *Quattrocento* use for their wall paintings and easel paintings? One thinks first of ultramarine (*azzuro oltramarino*) imported by the Venetian merchants. But the remarkable qualities of this pigment were unfortunately counterbalanced by an exorbitant price (see Chapter 3). Since, in the Occident, it was worth its weight in gold, it was used with the utmost parsimony, and no one would have considered using it to paint the blue backgrounds in wall paintings.

Fortunately, there was another blue pigment which could be bought much more cheaply: the *azzuro della Magna*, also called *azzuro citramarina* in Italy, *azur d'Allemagne* or *azur des montagnes* in France, *blew* (blue) *bice* or *bice* in England, *Bergblau* or just *blo* in Germany. This was a pigment obtained by crushing a particular copper ore, which had a beautiful dark blue colour, our present day azurite[1].

Kuanos from Cyprus and Armenian stone, ghost azurites

Azurite was already known and used during the Neolithic period; we have proof in a find made during the excavations of a fifth millennium settlement located in the gardens of the Giribaldi villa in Nice (Binder 2004). Among the various blocks of material likely to have been used as pigments (yellow and red ochres and bauxites of various colours), lay a block of azurite. Given the particular environment in which it was found, there is

[1] Not to be confused with lazurite, a mineral constituting the blue component of lapis lazuli.

little doubt that it was used as a pigment. Although azurite was known in antiquity, it is mentioned in very few texts. For Theophrastus (Περι Λιθων VIII: 55), it was natural *kuanos* from the copper mines of the island of Cyprus (*kuanos kuprios*). Its high price was a consequence of its rarity. Three centuries later, for Vitruvius (*De architectura* VII: 5.8), *armenium* (Armenian blue) was an expensive colour, one of those which had to be supplied by the patrons. As for Pliny the Elder (*Naturalis historia* XXXV: 28), he pointed out that the colour had been worth 300 sesterces (i.e. 75 denarii) a pound, but that its price had gone down to 6 denarii as a consequence of the discovery of a lode in Spain.

Three authors, three periods and already three different origins. As for prices, each of our three authors went to great lengths to mention that this mineral was expensive. How was the price of azurite placed compared to that of the various *caeruleum* grades? For the latter, Pliny (as we saw in Chapter 1) gave a spread of 8 to 11 denarii per pound, depending on quality. Even after the spectacular fall in price following the discovery of the Spanish source, azurite remained an expensive colour, costing barely less than *caeruleum*.

Despite having been known since antiquity no one knows quite how azurite was used. Lapidaries[2] or medical treatises (Dioscoride[3], Celse[4], Galen[5]) did not mention any therapeutic properties specific to it. Yet azurite was found in a Gallo-Roman second century AD eye-doctor's box discovered during excavations in Lyon (Boyer *et al.* 1990; Guineau 1989). This box[6] contained twenty oblong blocks and cylindrical sticks of dry eyewash to be diluted. Eighteen different compositions were identified. From the different analytical techniques applied to identify the various components in these mixtures it was apparent that these eyewashes were made from medicinal plant extracts and finely ground minerals bound by gum arabic. Of these eighteen formulae, fourteen contained between 4% and 27% by weight of various copper salts (tenorite, cuprite, brochantite and malachite) and two contained azurite, 4% and 10% by weight respectively.

The use of azurite in the pharmacopoeia is therefore confirmed. On the other hand, its use as a pigment, often taken for granted, is extremely doubtful. In Egypt, in spite of what may have been published, no trace of its use has ever been found. In the Minoan and Mycenaean civilisations and then in Greece, as we saw in the previous chapter, painters used only prepared *kuanos* (Egyptian blue) and glaucophane. Among the Etruscans and

[2] Lapidary: Treatise detailing the properties (therapeutic in particular) of stones.

[3] Greek physician, author, around AD 90, of a work 'Universal medicine' (*De universa medicina*) describing plants and minerals endowed with pharmacological properties.

[4] Roman encyclopaedist from the first century AD of whom a single work has reached us, his *De medicina*.

[5] Greek physician (AD 130–199).

[6] Similar boxes have in the past been taken for paint boxes (Santrot and Corson 2012). The confusion arose because of the nature of the minerals identified (earths, clays, white lead) which have also been used as pigments.

Samnites, painters (who were actually Greek) also used prepared *kuanos*. Rome exclusively used the same blue (which it named *caeruleum*), as did the people conquered by the Romans. The only time the use of azurite was recorded in Roman Gaul, it was later shown to have resulted from the poorly interpreted analysis of a *caeruleum*.

One might think that these results concerned only wallpaintings, and that they were justifiable in that this was carried out *a fresco*, a technique in which the pigments were applied in a basic medium which azurite could not withstand. One would then deduce that we know nothing about the pigments used in other domains, such as easel painting, polychromy of stone statues or in cosmetics. But excavations at Pompeii lead us to significant findings concerning the nature of pigments found at various colour merchants. Of the fifty or so pots containing blue-coloured unused pigments found there, none contained azurite: all contained *caerulea* (cf. Chapter 1). In addition, archaeological excavations have not revealed any objects testifying to the use of azurite in antiquity.

A carbonate dedicated to the arts

What is azurite? It is a mineral which owes its blue colour to copper. It is found in the guise of beautiful transparent crystals or opaque blue budding concretions in scarce, modest veins in copper mines (Figure 4.1). It is often accompanied by the other copper carbonate, green malachite. Azurite is an exception in the collection of blue materials used as pigments, in that it does not belong to the family of silicates, but to that of carbonates. The formula describing its composition is $2CuCO_3.Cu(OH)_2$ or $Cu_3(CO_3)_2(OH)_2$. It crystallizes in the monoclinic system (Belokoneva *et al.* 2001).

As with all carbonates, azurite is extremely sensitive to its chemical environment. It is immediately destroyed by acidic media. It is slowly modified by basic environments, which turn it into green copper salts. Furthermore, many pictorial layers executed with azurite have blackened with age. It suffices to compare the two versions of *St. Sebastian ministered to by Irene* by Georges de la Tour. The coif of the praying figure and Irene's cloak were executed with ultramarine in the Louvre painting, and with azurite in the painting in the Staatliche Museen, Berlin. Ultramarine remained blue; azurite blackened. It was deduced that azurite was a pigment unstable over time, one which did not age well. This is not correct, for if the pictorial layer did indeed darken, this would not be due to azurite, but to the organic binder used to coat each grain and make it adhere to its neighbours and to the support (Gettens and West Fitzhugh 1993). The binder has darkened.

The pigment manufacture and its usage particularities

The preparation of the pigment, in principle, is simple. Native azurite is generally ensconced in a sandstone matrix. Theoretically, it is possible to extract the azurite by crushing the ore to separate it from the sandstone and other minerals, achieving separation through moderate grinding followed by sedimentation in water. Although, in

principle, the difference in density between azurite (d = 3.8) and sandstone (d = 2.6) is enough for the operation, in fact, azurite and sandstone adhere very tightly, which makes this separation difficult. The particles are then sorted by size. Powders are thus obtained with colours ranging from dark blue for the coarser grains (Figures 4.2 and 4.3) to a slightly greenish light blue for the finer.

Medieval taste, which was to endure through the Renaissance, favoured above all deep blues, that is, simultaneously saturated and dark, even blues tending toward purple. There was little appreciation for blues tending toward green. The powder with the higher grain size was therefore the most sought after. It still had to be able to be used on a brush. To obtain blues rivalling those obtained with ultramarine, painters used 'German azure' roughly ground ('as sand', said recipes), i.e. with a granulometry around 0.1 mm.

Some recipes advised washing with lye, a solution having either vegetal ashes (hence rich in potassium carbonates), ammonia solutions (fermented urine) or sal ammoniac (ammonium chloride). In the latter two cases the blue cupro-ammonium ion must have been formed on the surface, which would help to reinforce the colour. Indeed, reconstructing the operation shows that this wash in lye sharply brightens the colour of azurite (Fuchs and Oltrogge 1990).

The refractive index of azurite is low (n = 1.76), which makes it a pigment with low covering power. It therefore had to be used in thick layers (0.1 to 0.3 mm) if the support had to be hidden. Indeed, to obtain a beautiful blue, azurite was used in thick coats bound with egg yolk or hide glue. This was a real technical achievement as the pigment consisted of large grains, hard to pick up with a brush. Furthermore, painters superimposed several coats, the first being sometimes laid over a dark-coloured background. The blue shade obtained was superb, and seemed illuminated by the shimmering of light on the shiny surfaces of the blue grains. This shimmering aspect disappeared when the pictorial layer was varnished.

The beginnings of the use of azurite as a pigment

Although azurite was not used as a pigment in antiquity, it was certainly used as one in the medieval period. When did this innovation occur? This question is hard to answer, for vestiges dating back to Late Antiquity or the High Middle Ages are rare, and those which have been analysed are rarer still. In wall painting, the rare remnants from Carolingian times testify to the use not of azurite, but of *caeruleum*. In the crypt of the abbey of S[t] Germain in Auxerre, where wall paintings from different periods currently co-exist, the oldest dating back to AD 850, azurite appears in decorations dating from the twelfth century (Coupry 1999). Howard (2003) mentions that it was in common usage in English wall paintings of the thirteenth century.

If we direct our attention to the most abundant source of medieval documents at our disposal, manuscripts with illuminations, the study by Dulin brings a semblance of an

answer (Dulin 1994). This study involved seven manuscripts of the same work, the *De laudibus Sanctae Crucis* of Rabanus Maurus (1988). Only one of these manuscripts reveals the use of azurite: the one which might have been produced near Paris, at the abbey of St Germain-des-Prés around 1060. Up to folio 22v, all blues are ultramarine. From this folio onwards, the page borders, and these borders alone, were painted with azurite.

During the fourteenth and fifteenth centuries, azurite was commonly used by French limners. In the famous book of hours made for Maréchal de Boucicaut (a very luxurious manuscript made around 1407), preserved in the Jacquemart-André Museum in Paris, azurite is used specifically for initial letters, while ultramarine and indigo are used for illuminations (Guineau *et al.* 1998). In another example, in the *Geographica* of Strabo, illustrated in Florence in 1464, Antonio del Chierico used ultramarine or pure azurite blues, as well as azurite with a little ultramarine added for the reliefs (Guineau *et al.* 1993). Of course, the suppleness of the substrate, parchment, did not allow for thick coats of large-grained azurite. The latter had to be finely ground, and the corresponding shades were light blue.

The azzurro della Magna *at the time of Giotto*

Let us revert to painting, and turn our attention to Italy at the start of the fourteenth century, when painters such as Cimabue, Duccio, Giotto and Simone Martini were at work. They used *azzurro della Magna* as well as ultramarine as blue pigments. Their choice probably depended on the commissioner of the work, its destination and the availability of these two pigments, both imported. Another constraint was the size of the work. When it was large, as were wall decorations, a blue background could not, of course, be done in ultramarine. The wall decorations in the Scrovegni Chapel in Padua, painted by Giotto around 1305, constitute a good example. Who has not been struck, when seeing them, by the abundance and magnificence of the blues? They are due to the good quality *azzuro della Magna* applied with mastery.

We may calculate an order of magnitude for the amount of azurite used by Giotto to decorate the nave alone, which is 20.5 m long, 8.5 m wide and 12.8 m high. Assuming an average thickness of 0.2 mm for the blue pictorial layer, calculation shows that it took 200 kg to paint the barrel vault. And, assuming that the skies and other blue areas occupy 25% of the scenes depicted on the side walls, we reach a total figure of 340 kg (i.e. 710 lb, where 1 lb = 477 g).

Giotto painted *a fresco*, i.e. onto fresh lime mortar. He mastered to perfection this difficult art, recently rediscovered after an interruption of close to a millennium. This is evident in the painted decoration of the S. Francesco basilica in Assisi, where various fresco painters worked. Like the ancients, he used the whole palette of earths, yellow and red ochres, green and burnt earths as well as lime white. But he had a problem with the blues. He did not have *caeruleum* at his disposal, the very memory of that pigment

having disappeared. On the other hand, *azzuro della Magna* was available. But he knew he could not use it *a fresco* in the basic environment of the fresco mortar. So he used it *a secco*, applying his blue colours on the hardened calcite surface of the dried fresco[7]. And in order to get his blue colour to adhere to this surface he used a binder of his own invention. Unfortunately, the latter did not retain its properties over time, and the result is only too visible: many blue paint layers have peeled off and detached from the wall.

The treatise on painting and drawing techniques written in Padua a century later by the painter Cennino Cennini ([*c*. 1420] 1991), *Il libro dell'arte*, probably reflects the teachings received by Cennini from his master and possibly even from Giotto himself, the father of Cennini's master, Taddeo, having worked for twenty-four years in his workshop. As for blue colours, Cennini treated *azzurro della Magna* and ultramarine on an equal footing, but indigo is more rarely mentioned. Unfortunately, the chapter dealing with the characteristics and properties of azurite is limited to a few lines, but in several other chapters we learn that *azzurro della Magna* was among those colours which must not be used *a fresco*, but rather *a secco*. Consequently, to lighten it, lead white was used and not lime (chapter LXXII). Lead-yellow or tin-yellow (*giallorino*) would be chosen to lighten this blue as well as to change it into green. The green shade thus obtained would be brightened with *arzika* (weld lake) (chapter LIV). Several paragraphs deal with the preparation of this *azzuro*, which Cennini recommends should be ground with care. Thus in chapter LX:

> When with this blue thou must backgrounds make, must thou grind it with water, very little and most lightly, for it does not in the least like the stone. Willst thou use it for garments or to obtain greens, as I erstwhile told thou, it must be ground some more.

By grinding it more, the spread in grain size thus obtained would allow it to be divided into several grades, from dark blue to light blue, thus enabling the representation of shades and highlights, and, as mentioned, the finer grade had a slightly greenish tinge. These three or four grades would allow for the rendering of relief in draperies, an academic exercise which Cennini obviously held close to his heart. Cennini indicated two or three ways to produce the tonal values (often at least three) allowing relief to be given to the drapery. The first consisted in selecting a dark blue, and mixing it in dishes with increasing quantities of lead white. This is what Cennini called the 'three dish' technique. The second consisted in selecting a medium blue with which to paint, say, the Virgin's cloak. Folds were then darkened with a mixture of indigo and black, and the strokes of light were obtained on reliefs by thinning the *azzuro* layer through scraping with a brush handle (chapter LXXXIII).

[7] During its 'curing' the fresh lime mortar reacts with the carbon dioxide in the air to form calcite $CaCO_3$. This forms on the surface a hard transparent layer, about 100 μm thick, which protects the paint layer. This explains the excellent preservation of frescoes over time.

The author also advises us that, from cuttings of kid or sheep skin parchment, he made a transparent, very light-coloured hide glue which he deemed ideal to serve as a binder for blue colours. It could be spread *prior quo ante* on the support, mixed with the pigment itself or spread over the paint layer already in place (chapter CXI). If this was the binder used by Giotto in Assisi, however, we can make but a negative judgment as to its longevity.

Azzuro *or* oltramare*? The blues of the* Quattrocento

Italian painters from the *Quattrocento* knew how to achieve deep blues with azurite very similar to those that can be obtained with ultramarine. This makes it difficult for today's experts to identify which pigment was used and why. Two types of sources of information are available, archival documents and physicochemical analyses carried out on the works during restoration.

Archival documents come in rather diverse forms: contracts entered between the order-giver and the painter, books of recipes, and tariffs for customs and duties. In the contract entered into in 1453 in Avignon by the painter Enguerrand Quarton and Jehan de Montagnac (the priest who acted for the Chartreux of Villeneuve-lès-Avignon for the supply of a retable representing the *Crowning of the Virgin*, discussed in the previous chapter), only one paragraph dealt with the pigments to be used. It concerned the most expensive items, gold and the blue pigments. For the latter, it specified their nature and areas where each should be used; to azurite was assigned the least visible area, the border of the frame[8] (Chobaut 1977):

> Item, said retable will be entirely made with fine oil colours, and azure must be pure azure from Acre [ultramarine], except for that which will be put on the border, which must be of pure azure from Germany [azurite] (…)

This contract is not a unique instance: others are known, explicitly mentioning azurite. Thus, on 10 August 1453, in Padua, Mantegna (only twenty-two years old) signed the following contract (Merrifield 1849: cxcix):

> Agreement made between the monastery of Sta. Giustina and me, Andrea Mantegna, painter, relative to the painting of an altar-piece to be placed over the altar of S. Luca in the church of Sta. Giustina, by which I, Andrea Mantegna, agree to paint all the figures at my own expense, including the colours, for the price of 50 ducats in Venitian gold, and to inlay with azzurro Todesco all the carvings and ornaments of the said altar-piece. (…)

In 1462, King René d'Anjou ordered a painting for a church in Arles. The contract stipulated the blue should be of *azur bonum de allemagna*. In February 1474, Giacomo Filipo, painter in Ferrara, entered into a contract with Brother Ludovico da Forli, prior

[8] Departmental archives from the Vaucluse (shelf mark E *Notaires, fond Martin*, short notes from J. Morel, notary in Avignon, 1453, f. 48-51).

of the old S. Salvatore church in Bologna to paint works 'of good colours well matched with each other' over a background of *azurro todesco* costing ten *bolognini* per ounce (Merrifield 1849)[9]. As we can see, examples are not lacking for the *Quattrocento*.

Of a very different nature are recipe books. More often copied from competitors or from older editions than originating from a practitioner's experience, these books of 'safe and well-tried secrets' must always be viewed with a critical eye. Words belonging to a technical vocabulary ill understood by the copyist may be altered; fancy ingredients may have been added to make the writer look more knowledgeable; recipes can be displaced and no longer match their title or the chapter in which they are found. Therefore each recipe has its own history which only the specialist knows how to reconstruct.

Once this work is done, these recipes can bring back to us completely forgotten shop practices and tricks, as is the case with the anonymous 'Bolognese manuscript' entitled *Segretti per colori*, which may have been written around 1420 and which dedicates its first three chapters 'to the various azures'. The first chapter is concerned with the natural mineral pigments, ultramarine and *azzurro della Magna*, and the manner by which to tell them apart, and especially of the preparation of these pigments. Twenty-one recipes deal with the preparation of ultramarine and only two with that of *azuro de lamagna*, also named *azurro thodesco* or *vero azurro spagnolo*. One of them, very detailed, describes the grinding of the rock containing azurite, its rinsing with an ash decoction, its mixture with honey to prepare for another grinding, followed by a succession of sequences of rinsing in lye and grinding. Next came an overnight immersion in strong vinegar (rather surprising for a carbonate). One then had to separate the various grades of azurite as a function of their particle size. To that end, the resulting blue powder was agitated in soapy water. The froth carried the finer particles, which were recovered separately. The operation was repeated several times. The preparation ended with a treatment in boiled urine with gum Arabic added. 'Thus is an azure-like ultramarine obtained'.

The other source of information comes from the results of physicochemical analyses carried out on the paint layers during the restoration of painted objects, statues and paintings. In this domain, we shall take a single example, that of a study purporting to identify the nature of the blue pigments used for the mantle of the Virgin in some forty 'primitive' Italian paintings in the Campana collection (Martin and Bergeon 1996). The collection comprises 600 paintings and covers the fourteenth and fifteenth centuries. The Florentine and Siennese schools are particularly well represented.

During a recent restoration campaign, forty-three of these paintings, painted on wood panels between 1310 and 1490, were examined and their paint layers analysed. The blue pigments turned out to be sometimes azurite, sometimes ultramarine. Let us look at the details.

[9] Two types of coins stuck at the Bologna mint carry the name of *bolognino*. The reference is probably here to gold *bolognin*o, equivalent to sequin.

The Campana collection

In Rome, in the middle of the nineteenth century, Giampietro Campana, marchese di Cavelli, Director of the *Monte di Pietà*, a papal charitable trust that operated as a pawnbroker, is an enlightened amateur of ancient art. He leads excavations to find art objects, which he collects relentlessly. He also buys with passion. His taste is very eclectic. For classical Antiquity (Greek, Etruscan or Roman), he hunts down vases, marble and bronze statues. For the Medieval and Renaissance period, he seeks furniture, paintings and majolica. From all over Italy, objects are offered to him. His collections soon number thousands of objects which he generously leaves at the disposal of scholars in the Campana Museum, located in his Roman residence, the *Palazzo Campana*.

However, Campana purchases so much that he ruins himself. He then deposits his collection at the *Monte di Pietà* he directs, and, on the basis of this security, borrows four million scudi. But, from purchase to purchase, he lets himself be carried away again. His expenses have exceeded nine million scudi when, in 1859, the scandal erupts. It is earth-shattering. The Marquis barely avoids being sent to the gallows, but has to agree to a settlement. The Pontifical Government, more in need of ready cash than of objects of art, proposes to Napoleon III the block purchase of the Campana Museum. In France, the antique style is at its height. The Emperor is passionate about ancient history and archaeology. The author of a *Life of Caesar*, he entertains the idea of creating a museum of national antiquities at St Germain-en-Laye (1861) and of starting excavations which will lead to the identification of the antique site of Alesia at Alise-Ste Reine in the Côte d'Or (1861).

The Emperor involves himself personally in this acquisition which took two years, a delay during which some of the better pieces will be bought by Russia and England. Eventually, the French government adopts a budget for the 1861 project which contained a special credit of 4,800,000 francs earmarked for the purchase of the remnants of the Campana collection. The transaction went through, and these treasures (around 10,000 items) arrived in Paris. They were exhibited immediately in the Palais de l'Industrie et des Beaux-Arts erected on the Champs-Élysées for the Universal Exhibition of 1855. Their popularity was enormous. Soon Campana jewellery appeared, while the 'Etruscan' and neo-Greek styles inspired the decorative arts. In 1863, the objects from the Campana collection were divided between the Musée du Louvre (where they formed the 'Musée Napoléon III') and provincial museums. The 600 paintings by Italian 'primitives', a school of painting little in fashion then, are entrusted to the Petit Palais in Avignon, and are today the reason for its fame.

For the earlier period (1310–30), only four paintings were examined. Their blues are *azzuro della Magna*. Then comes a more extended period (1340–1430) where, of twenty-two paintings, twenty have ultramarine blues (two of them over layers of *azzuro della Magna*) and two only *azzuro della Magna* blues. On the other hand, for the period 1450–90, of the sixteen paintings examined, all sixteen have *azzuro* blues, without any ultramarine. This distribution, very homogeneous over each period, is particularly clear for the twenty paintings belonging to the Florentine school. They were painted over two periods: ten between 1360 and 1410; the ten others between 1450 and 1490. For the earlier group, all blues are ultramarine applied in a thick paint coat over a grey underlayer. For the latter group, all blues are *azzurro della Magna* spread in thick or medium

coats over a grey or blue underlayer. We shall note that these results are chronologically in good accordance with the contracts between commissioners and painters quoted above. Dating from 1453 to 1474, they fit well into the 'azurite period'. *A contrario*, we must also note the presence of ultramarine in the 1453 contract concerning the painter Enguerrand Quarton.

How can we explain this curious distribution? The choice of pigment is not only due to the vagaries of contracts between patrons and painters: could it not be linked first and foremost to cyclical procurement difficulties for one or other of the pigments? It seems that, in the first half of the fourteenth century, the use of lapis lazuli was reserved for prestigious works, such as the *Maesta* of Duccio. On the other hand, between 1340 and 1430, particularly in Florence, the use of ultramarine became the rule – it even eventually became used for run-of-the-mill paintings. Simultaneously, we notice the use of ultramarines of lower quality. It was suggested that this systematic use of ultramarine could be linked with the new forms of devotion which appeared during the Black Death which hit Tuscany in 1348. But what would then have been the reason for the recovery of *azzuro della Magna* in the Italian market in the years around 1440? Was the temporary disappearance of ultramarine due to the fall of the Byzantine Empire?

One thing is sure: during the *Quattrocento*, Italian painters strove to obtain with azurite the same deep blue shades which were more easily obtained with ultramarine, by varying the particle size, the thickness of layers, their superposition and the colour of the underpaint. And they were successful. We shall see later on that, at this time, azurite production was mostly German. Did this influence the choice of blue pigments by German painters?

The blues of Albrecht Dürer

On his way through Antwerp, Dürer bought ultramarine. But how did he use this precious material? A recent study presents the results obtained through physicochemical analyses of the pictorial layers in the eleven works of Dürer preserved in the Alte Pinakothek in Munich, and the two at the Metropolitan Museum of Art in New York (Burmester and Krekel 1998). In these thirteen works, painted between 1495 and 1526, Dürer used very little ultramarine and no smalt at all. On the other hand, he used a lot of excellent quality azurite. To modify its tint, he lightened it with ceruse or darkened it with bone black and made purples by mixing it with cinnabar[10] or with a red lake[11]. He used it for oil, and water-colour paints.

Where did this azurite come from? A poem by Kaspar Scheit dated 1522 contains a stanza which leads one to think that Dürer procured *Bergblau* (mountain blue) in Saarland (Burmester and Krekel 1998):

[10] Mercury sulphide HgS (cf. Chapter 1, note 11).
[11] Pigment made by colouring a mineral support (generally alumina based) with a dye of vegetal (madder) or animal (kermes, cochineal) origin.

After several days
They crossed the river Saar.
Not far from the blue mountain
Where the colour of Dürer's paintings
Was taken before he died.

We shall return to this Saarland mine later.

The blues of the fifteenth and sixteenth century German painters

The use of ultramarine by Dürer, though parsimonious, seems exceptional in the practice of German painters of the time. For of the sixty or so German works painted between 1450 and 1550 analysed at the Dœrner-Institut in Munich, only one reveals the use of ultramarine. All the others contain only azurite. It is very tempting to link this fact with the dominant position held by the German states in the production of azurite. But how could this assertion be verified?

The lists of prices of products sold in pharmacies form a series of archive documents which has been little exploited from the point of view of the history of painters' colours (Burmester and Krekel 1998). In Germany, the materials needed by painters (colours, binders, varnishes) were on sale at the grocers or in pharmacies. At the time of Dürer, a city like Nuremberg had ten pharmacies. Fortunately for us, these were obliged to keep up to date records of available goods. An examination of these lists shows that the colours used by painters of the period, including azurite, were present. It was among the more expensive pigments, and was available in three grades: raw azurite, *lazurum* and *lazurum di optime*, the better quality. Prices given by the *Münchner Taxe* of 1488 and 1505 are identical, respectively 10, 16 and 64 pfennig[12] an ounce for these three grades. The highest quality of these was still forty-five times less expensive than ultramarine.

The vocabulary used in these lists is in itself revealing. While true lapis lazuli imported from Afghanistan and the ultramarine which derives from it are systematically absent, the nomenclature used to designate the various grades of azurite (nomenclature which varies from one list to another) contains terms such as lapidis lazuli and lapis lazuli, names which could not have been used in the international trade of the times as they would have been misleading. They were therefore reserved strictly for German use. The German states, the main producers of azurite, therefore seem to have constituted a particular area in which true ultramarine did not enter, and where it was not even mentioned. This does indeed correlate with the fact that German painters did not use ultramarine, and that Dürer did not buy it in Germany but in the Netherlands.

It therefore seems that two geographical areas may be identified, each with its own use of blue pigments. Germany, a producer of quality azurite, used it extensively and almost exclusively. The use of imported ultramarine was very rare.

[12] 'Pfennig' is the German name for denarius.

Italy did not produce azurite[13]: *azurro Lombardo* and *azzurro di Ragusa* were but trade names intended to disguise, as was often done, the true source of the pigment, Germany. Ultramarine, which followed the Silk Road, came naturally to Venice. Italian painters therefore had at their disposal the two types of pigment, both imported, but one was considerably more expensive than the other. France found itself in the same situation as Italy. It imported both pigments and used them both for small size works, be it in the field of easel painting or of illumination.

What is known of azurite production?

Azurite production

We don't know very much about azurite production in that period. It seems that it took place in France, in Saarland, in Saxony, in Tyrol and in Hungary. Hungary, where there were numerous copper mines, particularly in the Banat province (Dognaczka, Orawicza, Szaska and Moldawa (Born 1780)), was then a major azurite producer. But the exports of azurite stopped around 1550, when the Turks invaded the country. Harley (1982: 47) signals the existence of a production in Central America, vouched for by several authors, that was exported to Spain. Deposits in each area were few in number, generally of mediocre size, and it is not easy to tell which deposits were used for copper metal production, and which were used for the manufacture of pigments.

In France, the Chessy mine, near Lyon, the only copper mine extant in France, had been abandoned until Jacques Cœur, High Treasurer to Charles VII, was granted its concession in 1455. He set up a company to exploit it with traders from Lyon, and imported the expertise and miners from Germany. The prime purpose of this exploitation was very probably copper production. In the eighteenth century, around 200 miners produced about 50 tonnes of copper per year. The mine consisted of various veins rich in assorted copper ores (Raby 1833). The vein rich in carbonates, and in particular in azurite, which would become world famous under the name of *mine bleue,* was discovered in 1811. It was an azurite vein located in Triassic sandstone and clay (Cordier 1819). The larger veins were 150 m long and 0.50 m wide. Haüy supplied Vauquelin (1813) with samples of blue and green carbonated copper for the latter to analyse, for scientists were at a loss to understand the cause of this difference in colour. This mine was so famous for the beauty of the blue crystals found there that two Englishmen, Brooke and Miller, suggested in 1852 that this mineral be given the name of 'chessylite'. But the Frenchman Beurdant had previously suggested 'azurite' in 1824, and this was the name that was retained. Except for the more spectacular specimens, which are the pride of mineralogy collections the world over, this azurite was exploited as copper ore.

Like every mining lode, that of Chessy went through several high periods. It played an important role in French copper production, particularly during the Continental

[13] Some authors claim that it did produce some in the Sienna region.

System (1806–14). But, to our knowledge, no document testifies to azurite extraction at Chessy before the nineteenth century, and, in particular, there is no reference to it during the fifteenth century. This was not the case for the mines in Saxony (Goldberg), Tyrol (Schwaz) and Saarland (Blauberg, at Wallerfangen[14]), which, in 1500, were all in production. This of course explains the terms *azur d'Allemagne, azzurro della Magna* and others of the same kind. It is of the Saarland production that we have, for the moment, the most information.

Wallerfangen azurite

As with all mining production in his fiefdom, the production of 'mountain blue' was taxed by the Duke of Lorraine, on whose land Wallerfangen lay. Tax collectors are not usually a highly praised group, but, in this case, their documents have proved very useful to recent research[15]. These documents contain the figures for the Wallerfangen production from 1493 to 1626, that is for the period immediately following the works in the Campana collection (Figure 4.4). Over this length of time, we successively witness the mine coming on line, its full exploitation and its decline and closure. As in Chessy, azurite was located in veins of sandstone or clay. That which is found in clay has a much deeper colour than the other. It makes for first grade azurite. During the first phase of its activity, which lasted from 1490 to 1508, extraction was controlled by a foreman directing six to ten miners. The annual azurite production was about 700 lb. It is interesting to compare this output with our calculation of the amount of azurite (approximately 700 lb) required two centuries earlier to decorate the Scrovegni chapel.

The opening of this mine coincided with the beginning of a golden period for mining exploitation in the German provinces. Perfected mining techniques allied with the access to large amounts of capital enabled the exploitation of veins which were not on the surface, but went deep underground. As would be expected, it was silver mines which first sustained the extraordinary development of international commerce, with mines in Bohemia, the Harz, Tyrol and Lower Hungary. This was the time (1556) when Agricola wrote his soon-to-be-famous treatise *De re metallica*, in which he depicted modern mining techniques. From 1509 to 1543, the Wallerfangen mine increased output to between 2,500 and 4,500 lb of azurite per year, with peaks reaching 5,000 and even 6,000 lb (Figure 4.4), by expanding its workforce (a score of workers now worked on extraction), applying various technical improvements and bringing new veins on line. The demand for azurite had, therefore, sharply increased.

Let us take an example. Around 1510, the painted interior decoration of the Cathédrale Ste Cécile d'Albi (France) was completed; the blue colour is omnipresent and dominant on the vaults as well as on the side walls. Analyses have shown that the pigment used was azurite. Given the size of the building, and using the same assumptions as before,

[14] Located some 10 km west of Saarlouis.
[15] They are preserved in the Meurthe archives in Nancy (cf. Engel 1996, 1997)

i.e. that blue paint layers are 0.2 mm thick on average, it would have required no less than 3,000 lb of German azurite to supply the work site: the main part of the annual production of the Wallerfangen mine at the time. The multiplication of such projects may have been behind the strong increase in demand and hence the production of this mine.

In what form was azurite sold? Once separated from its parent rock, or clay, azurite was ground in a mill and sorted by colour and particle size. This 'refined azure' was sold in leather bags in weights of one pound. Three merchant grades (the best, the medium, the lesser) were available, which could have been delivered as such for 'water' colours (probably for *a tempera* paint) or mixed with undefined oil for oil paint. The average sale price, one franc per pound, remained nominally stable from 1500 till 1586. In fact, devaluation must be accounted for. And, if that of the Lorraine currency followed that of France, the price of a pound of azurite went from 1.22 to 0.99 g of fine gold, which corresponded to a 19% drop in price. At the beginning of the sixteenth century, refined Wallerfangen azurite was therefore 400 times cheaper than Afghan imported ultramarine. Around 1600, the price of ultramarine having remained stable, azurite was therefore 500 times less expensive. Such a difference in price would clearly affect painters' choice in the selection of a blue pigment.

Where did this azurite go once extracted? We saw that it was used in Germany, but was also exported to France, the Netherlands and Italy. A document relates that, while campaigning in northern Italy, Duke Antoine de Lorraine met Germans conveying 'a large quantity' of 'azure' coming from Wallerfangen (Engel 1996). There is therefore no doubt that Wallerfangen exported a large part of its production to Italy. The appellation *azzurro della Magna* was well deserved.

This golden age of Saarland azurite production came to an end around 1565. At first sight, the reasons seem to be of a technical nature. A fire destroyed the equipment. Epidemics then interfered with the mining process. However, demand had already started to fall. Exports diminished, and then came to a halt. Simultaneously, the circle of German clients became smaller and smaller. Trade in this azurite went into decline. The richer veins were by then exhausted; the veins exploited were narrow, often only one cubit wide, only allowing one man space to work. Conditions were so hard that the last two miners worked underground for only two hours in the morning, and two hours in the afternoon. Yet, in spite of the fact that production costs increased, the average sale price went down. Five grades were available as 'water colours' at the time, and four as 'oil colours'. Around 1600, sales stopped altogether. Refined or raw, azurite remained at the mine. According to contemporary accounts, in 1601, the inventory was of 21 tons and 4 bichets[16] of raw azurite and 215 bags of refined azurite. In the absence of an uptake in the market, this stock was sold in 1620 and 1621 as ordinary copper ore at a price of a quarter of a franc per pound.

[16] Depending on the region, the 'bichet', a measure of volume used mainly for grain, amounted to 20 to 40 of our litres.

The slump in Wallerfangen azurite might have been due to competition from other mining sites with lower production costs. However, it was more likely the consequence of competition from a synthetic product made in England, blue verditer.

The appearance of verditer

The sixteenth century witnessed the appearance in England of a new blue pigment, artificial and sold under the name of 'blue verditer'. The birth of this pigment and the perfecting of its production mode are shrouded in mystery. Harley (1982: 50–53) and MacTaggart and MacTaggart (1980) help to trace its first appearance. Harley leans toward the end of the sixteenth century; however, Apted and Hannabuss (1978: 148) located a mention of verditer purchase in the accounts of the Lord High Treasurer of Scotland for 1506 and 1507[17].

But there existed two varieties of verditer: the green and the blue. If one is to believe this generic name given to both varieties, the green would have appeared first. Derived from the French *vert de terre* (green from earth), 'earth' probably having to be taken with its chemical meaning[18], this verditer had nothing to do with green earths. Even if this green verditer was used as a pigment, it is the blue verditer, the most sought after and the most profitable which is of interest to us here. The mentions of *verditer grene* in the 1551–2 accounts of Edward VI and of *verditer bis* among the colours bought to decorate the hall of Falkland Palace in 1537–8 suggest the nature of verditer already had to be specified, and that therefore the blue already existed (MacTaggart and MacTaggart 1980).

Upon the circumstances of its discovery, sources are silent. It seems it was indeed due to chance, which was cleverly exploited. Mayerne claims it occurred in a workshop for refining silver from copper alloys (Turquet de Mayerne [*c.* 1620] 1974: f. 22v). Others mention the refining of gold. At the time, in the first case, silver bearing copper was dissolved in a nitric acid bath[19]. Silver soon formed a black deposit in the bottom of the tank, covered by a green solution of copper nitrate. To refine gold, the process involved two stages. A first etching of the gold and silver alloy by *aqua fortis* preferentially dissolved silver. The silver nitrate solution was then put in contact with copper. Silver precipitated and copper entered the solution. In both cases, there resulted a green solution of copper nitrate. Someone must have poured this solution over chalk, noticed

[17] *The Lord High Treasurer's accounts for Scotland*, quoted by M.R. Apted and S. Hannabuss (1978: 148).

[18] 'Earth, in chemical terminology, signifies that which remains the most earthly of a body of which the salts, the spirits, the oils have been drawn' (*Dictionnaire de l'Académie Françoise* 1694). In fact, 'earth' globally refers to oxides, hydroxides and carbonates.

[19] Nitric acid, *aqua fortis*, is obtained by distilling a mixture of saltpetre (KNO_3) and sulphuric acid. On this refining process, called in France in the eighteenth century '*départ*' (departure), see Abot de Bazinghen (1764: 'Départ' entry).

the greenish or blue-greenish precipitate forming at the end of twenty-four hours and taken advantage of the situation.

What does seem certain is that one or both verditers became a by-product of the production of precious metals, soon being carried out not at the artisan level, but on an industrial scale.

The whims of blue verditer

The production of blue verditer was, of course, more profitable than that of green verditers, but although they appear identical, it seems that the manufacturers had a hard time mastering these processes and obtained green more often than they desired. These problems must have been sufficiently worrying for various chemists to have been called in for help. Among them, Merret (1662: 292) echoed their perplexity:

> Tis a strange and great mystery to see how small and undiscernable a nicety (…) makes the one and the other colour, as is daily discovered by the refiners in making their *Verditers*, who sometimes with the same materials, and quantities of them for their *Aqua-fortis*, and with the same Copper-Plates, and Whiting make a very fair Blew *Verditer*, otherwhiles a fairer or more dirty-green. Whereof they can assign no reason, nor can they hit on a certain rule to make constantly their *Verditer* of a fair Blew, to their great disprofit, the Blew being of manifold greater value than the Green.

Consulted shortly before, Boyle ([1661] 1764)[20] reported that:

> (…) Sometimes the Refiners cannot make this Verditer for a great while together, and yet cannot tell whence their disability to make it proceeds. Of which Contingency I remember I lately heard one of the most eminent and richest of them sadly complain, affirming, that neither he, nor divers others of his Profession, have been able not long since to make Verditer for divers months together (…) [He however had] found a Remedy for it, namely, to warm the Menstruum[21] well before it be poured on the Whiting (…)

Experiments by MacTaggart and MacTaggart (1980) show that the manufacturing secret lies in the control of three factors: the concentration of the copper nitrate solution, the temperature and agitation of the deposit which forms. The best results are obtained with a concentration of 15 g of nitrate in 200 mL of water, a temperature no higher than 12°C, and stirring the deposit formed every twenty minutes. Forty-eight hours are enough to obtain a quality blue verditer which, observed under optical microscopy, presents the same characteristics as those taken from period paint layers.

[20] Quoted by MacTaggart and MacTaggart (1980).

[21] '*Menstruum* is a liquor used to draw and extract all sorts of spirits, essences, tinctures, salts, to digest and corrupt all things which need humidity. It comes of several kinds; depending on the nature of the thing to be extracted or corrupted, one use wine spirit, dew spirit, *aqua fortis*, lemon juce, distilled vinegar, common water or distilled water as the Artist sees fit.' (Meurdrac 1666)

Temperature is therefore a key factor for success. It is very likely that the unfavourable periods to obtain blue were summers, particularly warm summers as the MacTaggarts themselves pointed out. It is unlikely that the manufacturers themselves had not noticed that fact. The 'Remedy' reported by Boyle, consisted of heating the copper nitrate solution. This was the complete opposite of the reality and was therefore probably a lure intended, using a publication by the eminent chemist, to lead the competition astray. It is not like an industrialist to give his production secrets away! The fact is that this manufacturing secret was well kept.

Blue verditer and azurite

What relationship was there between blue verditer and natural azurite? As can easily be seen by comparing their X-ray diffraction spectra, blue verditer and azurite are close relatives. In fact, blue verditer is mainly composed of azurite and the remainding material has no crystalline structure, i.e. it is 'amorphous'. Analyses suggest it is composed of a mixture of copper carbonate and hydroxide. Blue verditer and azurite differ, therefore, in composition and the presence of amorphous matter in the former. However, the difference in the processes giving birth to these two compounds is not without influence on their morphological characteristics. Blue verditer is made of minuscule crystals compounded into rounded grains with a diameter of a few micrometres. Their shape is therefore very different from that of natural azurite, which results from grinding and displays sharp edges (Figure 4.2). They also differ in colour, the very fine grain size of the blue verditer conferring on it a slightly greenish light-blue colour, whilst the grains of German azurite, with dimensions between 20 and 100 μm, are of a more saturated and darker blue.

For painters, this difference in morphology is not without consequences. With its fine granulometry, blue verditer is certainly easier to use, to pick up with a brush than azurite composed of much larger grains. But, on the other hand, the greater surface area and the consequential increased surface exchange between the grains and the outside world makes blue verditer more sensitive to the environment, and liable to veer toward green shades. It is sensitive to acidic media, oils and resins, as well as to sulphur, which makes it turn brown. Ceruse (lead white) stabilizes it in oily media, which allows it to be used for the rendition of skies.

We can therefore differentiate German azurite from blue verditer in a paint layer, but this ability is fairly recent. There is little doubt that, with the number of analyses undertaken being constantly on the rise, the use of blue verditer will turn out to have been pervasive in England. This pigment was produced by English manufacturers at a price which let it displace imported azurite. It was also successfully exported. We saw that it was probably the cause for the decline in demand for Wallerfangen azurite from 1570 onwards. How did it fare in France?

Blue ashes in France

The new pigment very soon became known and used in France under the names of *cendrée* and *cendres bleues*, a term which, curiously enough, would come back to England as Sanders blue. The small number of proven identifications means that it has been impossible to date the earliest occurrence. Various qualities were imported. The least expensive were used to paint wallpaper. The more expensive were used by artists.

In 1773, in his shop in rue S[te] Apoline in Paris, Watin sold 'blue ashes powder' for 9 livres a pound, a price which was in the lower range of Prussian blue prices (Table 4.1). Azurite is not mentioned.

Table 4.1 List and price of blues for painters sold by Watin in 1773. Prices are to be understood by the 16 ounce pound, except for ultramarine. (Watin 1773: 395)

Blue for painters	livres	sols
Azur [smalt]	1	10
Four fire enamel powder [very fine smalt]	1	4
Blue ashes powder	9	–
Indigo pieces	12	–
Prussian blue pieces, from Berlin	40	–
Various Prussian blues of diverse nuances, at 8, 10, 12, 18, livres	–	–
Ultramarine, per ounce	96	–
Ultramarine ash	48	–

J.-H. Fragonard, like other painters, used blue ashes. At the Villa Fragonard in Grasse (France), a wooden box housing eighteen labelled glass phials containing pigments is preserved. Family tradition attributes this paint box to J.-H. Fragonard, who would have used it during his stay in Grasse in the years 1790–91. Three of these phials contain blue pigments. Their contents were analysed (Delamare and Guineau 2006). The medium blue, labelled *bleu cendré*, does indeed contain blue ashes, a mixture of azurite and amorphous copper hydroxide (Figure 4.5).

It seems that neither the painters nor the dealers worried about the exact nature of this pigment. At first they imported azurite from Germany. This supply failed and/or it became much more economical to import blue ashes from England. That is all there was to it. But while the dealers knew or suspected the origin of the pigment, the public probably did not, particularly in France.

A French problem: what are blue ashes?

Information from documentary sources was confused, mixing at will references directing the reader either to a particular mineral, or to an artificial product, and the suggested locations of origin were also varied. French readers wishing to inform themselves on the topic of blue ashes by first reading the *Encyclopédie* (1751–1765, 1: 'bleu' entry) would find:

Blue (Ashes) – (…) They are found as soft stone in those places where there are copper or rosette mines, & one only has to grind them with water to reduce them to a fine powder.

Such a definition would suit azurite well.

Valmont de Bomare (1767–1768: 'Cendres bleues' entry) stated in his dictionary:

Blue ashes. This name is given to a blue & soft stone, grained, almost reduced to a powder, which is found in the copper mines, in Poland and in a particular terrain of Auvergne called Puy-de-mur. This matter is ground with water to make it finer, & great use is made of it for distemper painting. It is this that most often forms the beautiful and vivacious blue colour one notices on theatre decorations: it cannot be employed with oil for it darkens.(…)

A text which the colour merchant Watin did not hesitate to make his own (without quoting his source), adding his own touch on top (Watin 1773: 31–2):

Blue ashes. This name is given to soft & blue stone, grained, almost reduced to a powder, which is found in copper mines, in Poland and in a particular terrain in Auvergne (1); it is of great beauty, & much used in distemper, especially for theatre decorations to make beautiful sky backgrounds. Mixed with yellow Avignon berries, it serves Fan makers and scenery Painters, & gives them beautiful greens. It is worthless with oil.

The (1) inserted in the text refers to a note present in the 1808 edition, but not in the 1772 original. Here it is (Watin 1808: 31):

Chemistry also composes blue ashes, by mixing together three parts of good crystallised white sand, well dried by the fire, two parts of nitre, a part of copper filings, one of decrepit common salt, and an eighth of a part of sal ammoniac. The mixture is melted in a crucible, the matter is poured in cold water, washed, sifted; the water once decanted, the blue powder is dried, then reduced to an impalpable powder.

Watin recognizes the existence of artificial blue ashes, but gives an extravagant recipe for it, which, instead of having to do with aqueous solutions, is carried out in a dry environment and at high temperature. If, as is probable, the term 'sand' designates a quartz sand, we have here an unexpected resurgence of Vitruvius' recipe for *caeruleum* manufacture, slightly modified by the addition of sodium and ammonium chlorides.

In 1792, the chemist B. Pelletier (1798) presented us with good documentary evidence:

Lemery, mentioning blue ash, says it is a blue composition [i.e. an artificial blue], or ground rock, coming from Poland.

Pomet also tells us that blue ash is a composition which we draw from England or from Rouen, to where it is brought by the Swedes, Hamburgers or Danes. The most part, also says Pomet, comes to us from Dantzig in Poland, and he adds that he was not able to find out what blue ash was, but that he had been assured it was a composition, and that some was made in Rouen.

These ideas are very confused. This is in contrast with those of Pelletier:

> No one doubts to-day that blue ashes are but a product of the art; we also know, rather vaguely however, that those who prepare it in England are people who refine gold and silver materials. We also know of a native blue which, being ground, delivers a colour much superior to the most beautiful blue ashes. This blue is the copper mine [ore] designated as mountain blue, azure crystals and blue chrysocolla [azurite].

But old ideas can survive a long time. Thus could one read in 1823, from the chemist Payen's pen (Payen 1823a: 'Bleu de montagne' entry, 203–11):

> Blue copper or copper carbonate is found in all copper mines in the guise of grains, small blades, crystals (...). The earths it colours in blue are known as *cendre bleues cuivrées*, and, when it turns up in grains or in bulk form, it takes the name of *bleu de montagne*.

A challenge: counterfeiting the English blue verditer

Exploitation of natural resources alone does not encourage competition between countries: the same natural resources are rarely available to neighbouring countries, and each country tries to obtain the greatest possible advantage from those it has. The situation is very different when technique and human knowledge come into play. If a new blue pigment had been created in England, a pigment which turned out to be well suited to the market and sold quite well, why could others not have succeeded as well?

The question arose with particular acuity in France in the seventeenth century, at a time when Colbert set up a long term policy intended to limit imports as much as possible, and when the first elements of a new discipline, chemistry, came into being. We shall see in Chapter 9 that nothing stood in the way of a rediscovery of *caeruleum*, which would have been, from every point of view, a very satisfying substitute for azurite (cf. Chapter 1, Figure 1.1). It is within this context that various chemists attempted to reconstitute the manufacturing process of English verditers, all in vain. Many different methods for precipitating various copper salts with lime wash were tried. The precipitates thus obtained were either greenish (and would stay that way), or of a nasty blue tending toward green or brown. When they were truly blue, they turned out to have little stability, or else were too expensive to produce. But the economic context was becoming pressing.

The increasing vogue for painted wallpapers in seventeenth century England created a new and very important market for blue verditer. Artists were no longer the only consumers. This fashion soon arrived in France with flocked papers, imported from England, which simulated velvets and silk. France then became the scene of an outburst of wallpaper factories, one of the more famous was Réveillon in Paris. One thus saw the motif of an early eighteenth century silk brocade decoration on English paper being copied by Réveillon (Velut 2005). As early as 1780, in France, refined interiors were decorated with naturalistic panels and door mantels of painted paper (Figure 4.6). In

Rixheim near Mulhouse, the Zuber factory became famous for the quality of its products (Figure 4.7) (Jacqué *et al.* 2002).

The painted paper industry clamoured for larger and larger quantities of cheap colours, which only had to last a few years. Various copper blues were used, among which the sulphate ($CuSO_4.5H_2O$), but the manufacturers had a hard time guaranteeing the consistency of its colour. This was why blue ashes in paste, which completely satisfied these requirements, were popular.

The chemists who attempted to solve the problem were numerous. In 1788, Berthollet (1791) remarked in passing that:

> When lime is mixed with a greenish copper precipitate recently obtained and a sufficient amount of water, this precipitate assumes over time a blue colour, which closely approaches the blue colour of blue ash, which is used in the art.

Various recipes were suggested, but when tested, they rarely turned out to be satisfactory.

The first good French recipe

This is why, as soon as a renowned chemist managed to solve the problem, he was immediately besieged by wallpaper manufacturers. This is what happened to B. Pelletier, as told by his son (C. Pelletier 1798: 19–20):

> Blue ashes, used for painting and in great demand in wallpaper manufactures, were coming in from England. Their preparation method was not known in France, or at least had ceased to be. This merchandise had become rare and expensive. Pelletier undertook to carry out a series of experiments on the blue ashes which led him to discover that they were composed of copper oxides and lime, both saturated by carbonic acid; and, after much work, he was able to prepare some at little expense.

> A wallpaper manufacturer (Arthur[22]) heard of his achievements; he approached him to secure the sale of the secret of this discovery at very advantageous conditions. Pelletier's answer is contained in the memoir on blue ashes he read in front of the Academy of Sciences shortly thereafter: 'I could have, said he, turned this work into an object of speculation; the moment was propitious; but other interests are driving me. To contribute to the progress of the Arts, such is my ambition.'

Indeed, on 19 March 1792, the very day when he was elected *membre associé chimiste* of the Académie des Sciences, Pelletier read to that assembly the account of the important work he had dedicated to the investigation of the nature of blue ashes and

[22] Arthur and Grenard were then, in Paris, one of the more ancient and renowned wallpaper manufacturers. It bore a very special interest for the manufacture of colours, and had invented a yellow, the composition of which it held secret (Velut 2005: 153).

their preparation (Pelletier 1792[23]). He supplied us in passing with some precious information showing that French productions of mediocre quality already existed:

> I also knew that a copper blue much inferior to blue ashes was prepared in Paris, by precipitating copper sulphate with potash and turning this precipitate to blue by means of lime and sal ammoniac: but this precipitate turns a little green as it dries.

He then went on to detail his recipe, which is often alluded to, but of which the original text is hard to find. Here it is *in extenso* (B. Pelletier 1798):

> Preparation of blue ashes – I let copper dissolve at room temperature in weakened nitric acid, in order to have a copper dissolution akin to that obtained in gold and silver refining. I then add to this liquor powdered lime, and take care to stir this mixture to facilitate the decomposition of the copper nitrate; I also take care to include a little excess copper nitrate so that all the lime be absorbed and the precipitate resulting (in the very instant of the mix) be a pure copper precipitate; I let the precipitate settle, I decant the liquor above it (which is lime nitrate), I wash it several times over, until it is at last well edulcorated; I then lay everything over a cloth, so that the precipitate may drip dry. It is with this precipitate, of a tender green colour, that I prepare the blue ashes.
>
> To that end, I take a certain amount that I lay on a grinding stone or in a large mortar; I add a little quick-lime powder: by working this mixture, it takes right away a very bright blue colour. If the precipitate was too dry or even completely dry, I add a very small amount of water so that the mixture takes the consistency of a paste, slightly liquid and easy to grind. The amount of lime I use is of seven to ten per cent of the precipitate; but I have a sure method to ascertain I did not add in excess, which is to let dry a very small amount of the mixture, either in the sun or in a warm location, during the same time grinding goes on; and if through desiccation it turns too light in colour, then a little copper precipitate may be added, making sure the vivaciousness of the blue does not diminish; I then let everything dry; and, as I have used but little water, desiccation is quick.
>
> This is how I obtain blue ashes absolutely similar and even superior to those we are sent from England: treated in the same way by acids, they totally dissolve with effervescence, and give carbonic acid (...)

Indeed, this recipe is one of the rare French recipes which do not attempt to 'improve' the colour by forming the ammoniacal copper complex resulting from the addition of sal ammoniac.

Considerations follow as to the origin of the colour, which are not without interest:

> I am content, for now, to point out that light does not in any way influence the colour they [the blue ashes] take, as several chemists were wont to believe: the fact is instantaneous, it occurs in the dark, and it is even so fast that one cannot suppose light could contribute anything to it.

[23] Due to the fact that the *Mémoires de l'Académie Royale des Sciences* (dissolved in 1793) did not appear from 1791 to 1806, the text of Pelletier can only be found in his collected works edited by his son (B. Pelletier 1798).

Pelletier then undertakes an exercise in possible future prospects which, at first sight, appears full of common sense:

> It will be deemed now that it is possible to establish blue ashes competitively, even if one has to prepare copper nitrate on purpose; and if the exclusive privilege of refining granted to a single establishment cannot last under the new regime [the French Revolution], individuals who will then be free to refine gold and silver matters will find it possible to take a useful and lucrative advantage of the copper nitrate dissolution by using it to make blue ashes. This process will be all the more advantageous for them, that when refining is in the hands of several, it will not be possible to consider treating the copper nitrate dissolution through the process now followed in Paris, which consists in distilling it to recover the copper and nitrous acid in part; which requires expenses which individual establishments would not be able to bear.

For what reasons did these suggestions fall on deaf ears? For what reasons did the French, who needed blue ashes, not succeed in associating this production with the refining of gold and silver as was done in England? Very simply because, at that time, refining of gold and silver was not carried out on any scale in France. Gold and silver had fled France, or else gone into hiding. The minting of coins was replaced by increasing amounts of paper money, the *assignats*. In March 1792, when Pelletier presented his work to the Académie des Sciences, the authorised ceiling for *assignats* in circulation had already reached 1.6 billion livres. Copper was scarce, and notes were even printed with a face value as low as 5 sols to buy bread! With paper money, there was no need for *aqua forte* refining and therefore no copper nitrate solution. Absorbed in his research, Pelletier probably had little contact with the problems of everyday life.

Patents and recipes

Other recipes of a more confidential nature were the objects of patents, as witnessed by the *Journal des Mines*, which published abstracts from the Imperial decrees containing the proclamation of patents of inventions[24]:

> Abstract from the Consuls' decree; from Messidor the 27th, year 10 (July the 15th, 1802):
>
> This same day was delivered a certificate of request for an invention patent with a five year term, to the Cit. William Story, chemist, living in Fontenay-sous-Bois near Vincennes, for the manufacture of a *celestial English blue*.

Story's recipe was reported on in detail by Le normand (1822). It essentially consisted in preparing indigo carmine which was used to colour potassium soap to which was finally added a little alum. In spite of its name of 'Celestial English', this was therefore not a recipe for blue ashes.

And nine years later[25]:

[24] Journal des Mines (an XI [1802–1803]) 13(77): 417.
[25] Journal des Mines (1811) 30(180): 449.

Were definitively patented, during the first three months of 1811, the individuals there-after mentioned (…):

3°. The Sire Pierre Estève, domiciled in Flessingue, Department of the *Bouches de l'Escaut*, to whom was delivered on March 25, 1811, the certificate for his five year invention patent request for a means to manufacture the blue known as English blue.

Was this really a recipe for blue ashes?

In 1823, considering that Pelletier's recipe did not yield satisfactory results (was that yet another manifestation of the influence of temperature?), the French chemist Payen (1823a: 'Bleu de montagne' entry, 203–11) perfected another recipe which he published together with quantitative details and tricks of the trade. First, calcium chloride was made to react with copper sulphate. Calcium sulphate precipitated, and attention turned to the clear liquor which contained copper chloride. The minimum amount of lime slurry was added to precipitate all of the copper as carbonates. Thus was gathered a green paste to which was added first a little potash, then a little ammonium chloride and copper sulphate. A blue paste resulted which was left to decant and dry. Depending on the amounts of lime slurry added, three qualities of blue pastes could be obtained to align with commercial practice. Once dried, the better two would sell as blue ashes. The pastes were used as such for wallpaper, the lowest quality being used for solid backgrounds. Blue ashes, much more concentrated and expensive, were used by artists. Payen also indicated the prices paid by the trade for these different qualities (Table 4.2):

Table 4.2 Price (in francs per kilogramme) for the different qualities of paste blues and blue ashes in France on the eve of the arrival on the market of the Guimet blue. The pastes could contain up to 75% by weight of water. According to Payen (1823a).

Blue paste		Blue ashes pieces	
superfine blue n°3	2.25 F/kg	dark superfine blue	23–25 F/kg
fine blue n°2	1.80	fine blue	16–20
blue n°1	1.25	–	–

It was against these tariffs that, around 1830, both d'Arcet and Guimet struggled to introduce their pigments to the wallpaper pigment market – the former his 'blue in the imitation of Egyptian blue' (cf. Chapter 9), the latter his artificial ultramarine (cf. Chapter 7). Blue ashes did not have much longer to live. The growth in ultramarine production, with the accompanying decrease in price, would progressively chase them away from wallpaper, their main market. Thus one could see in 1835 (cf. Chapter 9) the famous wallpaper manufacturer Zuber adopt this ultramarine in his factory in Rixheim.

English and French blue ashes

In 1855, while the French and English production was declining rapidly, Lefort wrote an article on blue ashes in which he insisted on the differences found between English and French blue ashes (Lefort 1855):

> ### Azurite in Persia under the reign of Shah Abbas II
> ### (1642–1666) (Tavernier [1679] 1964: 205)
>
> The athemat-doulet [Mahamet-Beg] not having succeeded in the search for gold and silver mines, applied himself to that of copper, the discovery of which proved most useful to the whole kingdom. For in these copper mines were found veins of azure, of which a large quantity is used in Persia to paint all the Moorish designs on the panelling and arches of houses. Before this discovery, true azure was used, which comes from Grand Tartary and is very expensive [ultramarine]. That from Persia is a sort of copper mine [ore], and the stone, being ground and passed through cement[26] as is done for true azure, ends up reduced to a very fine powder, of a beautiful colour surprising the eyes. Persia being able to do without azure from Tartary, Mahamet-Beg had forbidden painters to use foreign azure, and instructed them to only employ that from Persia. But this prohibition did not last long, for Persian azure did not withstand exposure to air like true azure, ending up as a dark and sombre colour. As it peals off and it cannot withstand the delicate application of a brush tip in miniatures, it was soon abandoned as a coloured earth and artists reverted to azure from Tartary.

Several English manufacturers only hold the secret of this production, and the product they deliver presents, within a few hundredths, the same composition as that found in nature, while the French mountain blue, called *blue ashes, lime blue, copper blue*, always contains a variable proportion of caustic lime and lime sulphate. (…)

English blue ashes go for a higher price than French blue ashes, first because they possess a more beautiful hue, and then because they are faster.

He pointed out that French end products always contain ammoniacal copper (the copper ammoniated complex), which is of a

> blue of very great beauty, but of a more than doubtful fastness. It is obviously to the presence of this substance in the blue ashes intended for painting on [wall]paper that must be attributed the lack of fastness generally enjoyed by the blue colour of our apartment papers, especially when the n°1 blue is used, or the inferior quality also named lime blue.

From Lefort's point of view, he pretended that Pelletier's recipe had not been used. He confirmed then that essentially all of the production had been used in a paste for the wallpaper industry. He then indicated a simple test to distinguish between English and French blue ashes:

> The artist and retailer may benefit from distinguishing French blue ashes from English blue ashes. To that end it suffices, when they are in the paste state, to desiccate them completely at a low temperature, and then to heat them in a tube with a small amount of potash or caustic soda reduced to a powder. The sense of smell will easily perceive in the

[26] 'Cement' is to be understood as purification by kneading with waxes and assorted fatty bodies. Persian painters therefore prepared azurite in the same manner they prepared ultramarine. The process worked because the surface of azurite, like that of ultramarine, is hydrophilic.

former the presence of alkali volatile [ammonia], a phenomenon which does not occur with ashes of English origin.

It was too late, and it is likely that none of his readers had the opportunity to attempt this test. The time of blue ashes had, in turn, definitively passed, and, in 1858, when the French chemist Péligot discovered a copper hydroxide based blue able to serve as a pigment, there was no industrial demand for the product. At that date, this blue (Péligot blue) was therefore of little interest.

5
Prussian blue
An unexpected destiny

At the beginning of the eighteenth century, only blue ashes were available. However, painters were not happy with such a chemically unstable blue pigment and, with azurite no longer on the market, the need to find a true substitute for ultramarine became all too real. The ideal blue pigment should have a dominant wavelength close to 468 nm, be as saturated as possible to impart a very good colouring power and as insensitive as possible to the chemical environment imposed by the paint layer, be it acid (oil painting) or basic (*a fresco* painting). It would be non-toxic, of not too high a density, disperse easily in the various common media and would not change colour under artificial light, nor turn greenish or fade under the influence of light. For its refractive index, there could be some leeway – if it were low, as with natural ultramarine, it would be a transparent pigment; if it were higher, it would have more covering power. It would preferably be a siccative, cost little and be easy to obtain. Such was the challenge which had to be faced at the dawn of the eighteenth century.

Did men of the arts have sufficient knowledge to succeed in their quest? Indeed, it was the body of knowledge accumulated by a declining alchemy and an infant chemistry in this early Age of Enlightenment that gave the impetus for a rational search for this substitute for ultramarine. But today, knowing the complexity of the problems to be solved, we would not place odds on the success of this endeavour. Having been much preoccupied with combustion and the calcination of metals during the seventeenth century, chemists were discovering the all new phlogiston theory (Stahl, *c.* 1718). Still to come was the identification of chemical elements essential to our field, such as cobalt (Brandt, 1735), nitrogen (D. Rutherford, 1722), oxygen (Scheele, Priestley and Lavoisier, *c.* 1774), chlorine (Scheele, 1774) and cyanhydric acid (HCN; Scheele, 1782). This was

probably why, in 1751, in his *Figurative system of human knowledge* with which the first volume of the *Encyclopédie* (1751–1765, 1) begins, Father Mallet still ranked chemistry with alchemy and 'natural magic'. Such was the context in which *Berlinerblau* (Berlin blue), better known under the name of Prussian blue or iron blue, appeared at the turn of the century.

What is Prussian blue?

In 1773, Baumé (1773: vol. 2, 'Bleu de Prusse' entry, 592–606) defined this pigment: 'Prussian blue is iron precipitate & coloured blue by a phlogistic matter.' However, knowledge progressed, and today we can say that Prussian blue is a compound containing ferrous (Fe^{II}) and ferric (Fe^{III}) ions, cyanide (CN^-) ions and water. It is classically assigned the formula $Fe^{III}_4[Fe^{II}(CN)_6]_3 \cdot nH_2O$ and called ferric ferrocyanide or iron(III) hexaferrocyanate(II), a formula and its corresponding names which date back to a time when coordination complexes were unknown. A compound had to be a salt, i.e. the result of a reaction between an acid and a base.

Prussian blue crystallises easily, but the determination of its complete crystalline structure has been fairly recent (Ludi 1988). It is a coordination complex in which ferrous and ferric ions play analogous roles within a cubic mesh structure. Both are at the centre of octahedra. The former are surrounded with carbon and the latter with nitrogen atoms (Figure 5.1). Prussian blue is thus a cyanocomplex of iron (II) and iron (III) ions. The uncertainty concerning the amount of water actually present is due to the fact that although a well defined part of the water belongs to the structure (coordinated water) there is also a variable amount of weakly linked zeolitic water which is only, so to speak, 'accommodated'. Prussian blues therefore belong to the class of zeolites, nanoporous materials.

This highly coloured compound, insoluble in water, is the 'insoluble Prussian blue'. It is '77510 Pigment Blue 27' in the Colour Index. Its refractive index (n = 1.56) is very close to those of the organic media used in painting. Used pure and mixed with some oil, Prussian blue is therefore transparent.

Prussian blue possesses four unusual properties. The first is its intense colour and prodigious colouring power, at least ten times that of ultramarine. All colours included, it is, historically, the first pigment with such a high ability to colour a medium. This simple fact was deemed extremely remarkable. This colour is due to the easy electron-transfer between the ferrous ion and the ferric cyanide when Prussian blue is excited by light. The process absorbs light at a wavelength of 620 nm. This transfer of electrons is balanced by the opposite transfer, which occurs without visible light absorption. This very intense absorption in the yellow range explains the blue colour (dominant wavelength 470 nm) and its intensity.

The second peculiarity is that the cyanide ions (CN⁻) are so involved in the chemical bonds that they relinquish their personality and become hidden from the outside world. Although, when isolated, these ions are highly toxic, Prussian blue is not at all.

The third property is that, in spite of the stability of Prussian blue, the iron ions have a tendency to switch with other metals. Prussian blue is therefore the prototype of a set of compounds of analogous structure in which the metal ions can be substituted. In medicine, this property has long been used to treat the after-effects of poisoning by heavy metals or radioactive metal isotopes[1]: the undesirable metal is thus chemically hidden, then evacuated. Some Prussian blues substituted with cobalt exhibit super paramagnetic transitions which are currently much studied as possible information storage materials for future computers. Others show interesting catalytic properties.

The fourth property is the rather peculiar structure of this complex compound which allows it to take in monovalent cations within its crystal structure. Two of these cations are of particular interest to us: ammonium ions (NH_4^+) for the Prussian blues manufactured today and potassium ions for many ancient preparations where the result is what is improperly called a hexacyanoferrate (II) of iron (III) and potassium, represented as $Fe^{III}K[Fe^{II}(CN)_6].nH_2O$. This compound is the (water) 'soluble Prussian blue', referred to as '77520 Pigment Blue 27' in the Colour Index. The presence of these cations modifies a number of properties such as the hue, the stability of the pigment, its solubility in various media (water, an aqueous solution of oxalic acid) and ease of crushing. This is what led, until the 1960s, to the belief in the existence of numerous varieties of iron and cyanide ion complexes (Duval 1959).

The composition of Prussian blue is therefore variable, and extremely sensitive to the way in which it is prepared. It is easy to imagine how small-scale productions may have accidentally yielded different products under the same name. 'Under the same name' is actually a manner of speaking, for rarely has a pigment received more varied names as this one. Some of the names indicating the origin: Berlin blue, Prussian blue, Paris blue, Antwerp blue, Basle blue, Hamburg blue; others named after the manufacturer: Milori blue, Monthiers blue; and still others recalling some aspect of its colour: iron blue, steel blue, bronzing blue (Guineau 2005: 'Bleu de Prusse' entry; Perego 2005: 'Bleu de Prusse' entry). An international agreement settled on 'iron blue'.

Numerous methods have been used to make Prussian blue. The most straightforward consisted of adding ferric ions to a water-based solution of ferrocyanide ions $Fe^{II}(CN)_6^{4-}$, an extremely stable compound. The presence of potash led to soluble blue, a compound which seems to have been the one most used from 1820 onwards. The complexity of ancient processes led to the formation of this potassium prussiate $K_4[Fe^{II}(CN)_6]$.

Historically, Prussian blue was the first blue pigment where appearance on the market has been reasonably well documented.

[1] In particular the 134 and 137 radioactive isotopes of caesium.

Berlin blue, a last gift from alchemy

Like many others, the discovery of *Berlinerblau* resulted from a cleverly exploited accident (which in the realm of blue pigments is almost always the case). We know of the circumstances surrounding this discovery from a very small number of sources. The first is a short account from the chemist Georg Ernst Stahl (1731: 280–83), the phlogiston theorist, who had lived in Berlin since 1716 and was writing in 1731, twenty years after the events (cf. Fritz 1954). According to him, the discovery took place in Berlin. Heinrich Diesbach, a colour maker, was going through one of his usual preparations in the laboratory of Johann Konrad Dippel, who had just arrived in Berlin. Dippel was a curious character, part physician, part alchemist, and a very knowledgeable one at that. His name remains tied to the study of distillation, a process to which he devoted a book in 1729, and to an animal oil (obtained by distilling stag's horn powder), Dippel's oil, then part of the Pharmacopoeia. This oil was a complex mixture containing in particular nitrous (aniline, pyridine) and aromatic products (Petit *et al.* 1999: 'Bleu de Prusse' entry). But Dippel led a double life, and the part which was hidden from view led him into trouble with the law wherever he was, forcing him to lead a nomadic life (Hoefer 1852–1866, 14: 'Dippel' entry).

Diesbach was preparing a 'Florentine lake', i.e. a cochineal carmine, by taking an aqueous solution of cochineal containing alum and ferrous sulphate[2] and adding a base (potash) to precipitate the metal hydroxides. The dye (carminic acid) then reacts with the nascent aluminium hydroxide yielding the desired precipitate, the coloured lake, which is then gathered, washed and dried. Short of potash, Diesbach turned to Dippel, who offered the use of recycled potash. It had been used several times to purify his animal oil and could not be used for that purpose anymore. Diesbach used it, and, for the first time, did not obtain the expected tint but a greenish precipitate, which veered towards blue. He sought Dippel's advice, who suggested it was a consequence of the animal matter present in the recycled potash, which had reacted with the iron vitriol. Experiments immediately carried out confirmed this hypothesis. This is therefore the first recipe for manufacturing *Berlinerblau*: letting ferrous sulphate interact with potash which had had prolonged contact with Dippel's oil.

The date of these events was not mentioned, but must have been between 1704 and 1707, the only period during which Diesbach and Dippel could have rubbed shoulders in Berlin (Harley 1982: 70–74, *Prussian Blue*). This date was confirmed and narrowed down by Berger (n.d.), our second source of information, who claimed that *Berlinerblau*

[2] No one seems to have pointed out how incongruous it is to find ferrous sulphate used in the production of carmine lacquer. The carmine red colour is that of the complexes formed by carminic acid on aluminium. But this acid forms complexes with many other metals, each having its own colour. While those formed with tin were of a much prized colour (scarlet), such was not the case of those formed with iron, of a purplish colour sometimes tending toward black. Thus the use of iron utensils was advised against in the preparation of carmine lake.

was invented by Diesbach in 1706. We do not know how both men came to realise that this product could make a very remarkable blue pigment, but perhaps it was due to Diesbach's role as a colour maker.

To make it in large quantities, it was imperative to get rid of the dependence on Dippel's oil, a product hard to make and therefore expensive. It was probably Dippel who thought of using ox blood as a source of cheap animal matter to react with potash. The process, made public by Woodward in 1724, was perfected fairly rapidly as Dippel had to flee Berlin for Holland in 1707 to avoid prison. It consisted of concentrating the ox blood by boiling until a powder was obtained, which was then heated at red heat with highly concentrated potash (in fact, a potassium oxide obtained by roasting a mixture of saltpetre and potassium tartrate). The amino-acids contained in the animal matter probably produced a reduction reaction between ammonia (from the amino-acids) and the red hot coal, yielding cyanhydric acid according to the formula: $NH_3 + C \rightarrow HCN + H_2$

The product was washed in water. Following filtration, the resultant solution, which contained $K_4Fe(CN)_6$, was added to a solution of alum and green vitriol (ferrous sulphate). A greenish precipitate appeared which, when treated with hydrochloric acid, would turn blue, almost black, the Berlin blue. Derived from reaction with potash, this was a potassium-containing 'soluble blue'. This process was based on indigenous raw materials and cheap chemical products. It required large amounts of blood and wood for combustion, as well as an iron apparatus specifically dedicated to this process that had no copper parts (to avoid ion exchanges). Such a manufacturing process was surely not easy to keep secret.

We do have some idea of the manner in which the discovery was exploited thanks to Frisch, our third source of information. In his correspondence with Leibniz, he recounted the role he had played (or claimed to have played) in the development of the pigment and bringing it to the market in Prussia and the rest of Europe (Frisch 1896). The first mention of this new blue pigment is found in a letter dated 31 March 1708. The name *Berlinisch Blau* appeared in November 1709.

Having improved the finishing treatment with hydrochloric acid, to which Berlin blue owes its colour, Frisch devoted himself to publicising the new pigment worldwide, leaving its production to Diesbach. First he had it tested by various artists, among whom was Werner, the Director of the Berlin Academy of Arts (1709). Toward the end of that same year, assured of the positive result of these tests, he wrote a note.

The Note on a Berlin blue, recently invented

In 1710, a note written in Latin appeared in the first volume of the *Miscellanea Berolinensia* (Frisch 1710), the memoirs of the then named *Societas Regia Scientiarum*, of which this is the *in extenso* translation (English translation: Kirby 1993: 70–71):

> Painters who mix oil with their colours have few that represent blue, and those such that, rightly, they wish for [some] more satisfactory. Of the common [blues], certainly,

one does not reject mixture with the oil, but does not last for a long time in the work: it becomes greenish, somewhat pale, rust-coloured or distinctly dirty. Another is indeed constant and beautiful enough, but sandy; and this defect, which is inconvenient to the fine work of a skilled master, cannot be removed if the space of a year were to be consumed in grinding it. The best of all, which ordinarily they call Ultramarine or Azure, which is produced from lapis lazuli, not only deters many by its price, but also does not freely permit the addition of other colours; and this last is able to show its beauty only in the light parts: it is useless in the shadows.

This just desire of craftsmen, the blue colour, which was invented here in Berlin several years ago and [which] now, after different, most careful considerations, appears boldly in the public eye, can certainly alleviate, if not satisfy. For instance, it has none of these inconveniences. In oil it shows its chief splendour. In truth everywhere, in water, oil and other liquids with which one can paint, it is found to be durable in the highest degree. That nitric acid [aqua fortis], as it is called by chemists, which erodes or dissolves everything, does not change it so much, far less destroy it, as render it brighter. And as certain blue colours can be employed in encaustic painting [enamel] and, so it is said, are not destroyed by drying by fire, so this new colour strongly resists caustic liquids (which name those acids and all destructive agents can rightly be given); which difficulty it, out of all types of colours, can endure. This [colour] fears even less the more common investigations of painters: for example, the juice squeezed from citrus fruits, etc. It is not changed [when] in place either by the air or by change in the weather. It survives in quick lime and in that white which distinguishes gold from a gem. Just as it was formed out of the most finely divided materials, so it can be ground into the finest powder. And where it is not sufficiently reduced by the first stage [in the process], it may be completed by a second or a third; however, by these separate stages having thus been made dry, it can be wetted again by pure water. Indeed, for that reason, by these means only, it is usual to complete this work in that art of painting in the smallest degree, which they call miniature, the more skilfully, as they wish. Or other painters, who mix colours on a board, can reduce it with a knife with little trouble. Because of this [aforementioned] fineness, it covers wonderfully areas that are spread with a brush and it can be extended by other colours. Besides, not only is it able to be covered over by less obscuring colours of its kind and is able to set off things that stand out more, but also it can shade in folds, hollows and the greater depths of the picture.

This [colour] is of two kinds: the one dark and more suited to expressing shadow; the other light, not mixed with ceruse or with another white, but being in this state at once, at its first appearance. The darker type of this colour is made from the lighter and becomes as if reduced, or, as they say, becomes concentrated. Painters of lesser kinds, who customarily measure [out] this colour for the purpose of common mixing, rarely desire the lighter variety: [they] search for the darker alone and, mixing white with it, add light by degrees. Those whose eyes are more discerning in fact immediately perceive [that] a colour, which rises to a lighter grade out of its darkness by the admixture of white, has not produced so much light and attractiveness in its being as that which Nature has produced in a weaker form.

For the rest, it is harmless: nothing here is arsenical; nothing contrary to health, but rather a medicine. Without danger, those things which are made from sugar can be painted in this colour and eaten. Beginners of painting can safely draw through their lips the brushes with which they spread their panels; which they will do with other paints not without danger to life. The price, finally, by which it is procured, scarcely approaches a

tenth part of [that of] the dearest Ultramarine[3]. And the supply of this, which in Berlin can be had at the Bookseller of the Royal Society of Sciences, is as much as the prodigal hand of craftsmen can desire for the purposes of adorning their work.

A very curious text indeed for publication in the memoirs of the young Royal Society of Berlin. At first reading, it gives the impression of having been written by a painter, a man of the trade, since it is so rich in technical details. But a closer reading brings out so many incongruities that it is more likely that it was written by someone foreign to the world of painting, who poorly transcribed that which he had been told. Thus is it hard to identify those blue pigments, the defects of which are exposed in detail. They are probably smalt and azurite (or blue ashes), but they are hard to recognise precisely. The third blue pigment available, indigo, has actually been forgotten. Furthermore, the qualities of the new pigment have been clearly exaggerated. If it does resist acids, it is destroyed by bases, and can therefore not be mixed with quick-lime. Furthermore, it is sensitive to light and its colour turns green, and then fades. As to what we are told of the links between the two qualities, even if this seems strange knowing that the colouring strength of the pigment was such that it was often sold mixed with white pigments, we might assume that the lighter quality corresponded to the impure product obtained before treatment with hydrochloric acid, since this acid must get rid of the undesirable by-products, such as iron oxides and aluminium hydroxide formed in the reaction which would act as an extender.

This text is therefore more akin to a simple advertisement, but it is valuable, since it proves that in 1710, three years after Dippel left Berlin, Berlin blue did exist, that it was manufactured in sufficient quantities to meet artists' needs and that it was available for sale. Yet where was it manufactured? By whom? Why is Diesbach's name not mentioned? This remains a mystery. Publication in the *Miscellanea Berolinensia* probably forbade too many details.

The price of Berlin blue made it an expensive pigment by weight, more so than azurite, for example. But, for the user, the high price was compensated for by both its low density (d = 1.83) and by its extraordinary colouring power, not counting the specific virtues – indeed very real – of the new pigment.

The obscure years

The introduction to the market by Frisch must have been convincing, for success seems to have come immediately to this new blue (Bartoll *et al.* 2007). The first canvas currently known in which Berlin blue is observed to have been used is an *Entombment* by the Van der Werff brothers dated 1709. The pigment was used for the Virgin's mantel and the sky.

[3] Berlin blue was therefore sold for almost one tenth its weight in gold.

It seems that the court painters very soon tried the new pigment. As early as 1709, Frisch was sending Berlin blue to various European cities including Wolfenbüttel (where Leibniz resided), Leipzig, Basle and Saint Petersburg. In 1714, 100 lb went to Paris. But at that date, in Paris, Watteau had already been using Berlin blue for several years, employing it as an underlayer in *La mariée de village*, painted around 1710–12, while ultramarine was used for the sky and the figures. Watteau got more daring, and Berlin blue is found in his *La récréation italienne* (1715–16, Berlin, Charlottenburg), in the sky of his *Gilles* (1718–19, Paris, Louvre), and in his *Comédiens italiens* probably painted in London in 1719–20 (Washington, National Gallery of Art).

His students Lancret, and especially Pater, would use Berlin blue more freely, often in preference to the other blue pigments available. Pater went so far as to use it exclusively. The use of Berlin blue can even be used as a way of distinguishing between the various painters of these *Fêtes champêtres*, which all appear to have come from the same hand.

Berlin blue is found to have been used: in Holland in 1720 by Adriaen van der Werff in *Jacob blessing the sons of Joseph;* in Italy, Berlin blue is found on two canvases from Canaletto, *Veduta del Rio dei Menicanti* and *Veduta del canal Grande da Palazzo Balbi* dating from the years 1719–23 (Berrie 1997); and in the USA, Berlin blue was used as early as 1723 for one of the wall decorations in Trinity Church in Boston. Its use would continue to increase.

During this time, small scale manufacturers multiplied in Germany and in other countries. Thus in 1722, the Dutch painter Eikelenberg noted:

> Joan George Collazius, portrait painter, announces that he sells the veritable Berlin blue made by M. Mack, in Leipzig; 40 gulden a pound, and 52 for the best quality. He lives in Nieuwe Turfmarckt, the tenth house of Vijselstraat, above the Red Lion, in Amsterdam[4].

In England, around 1730, artists who used water colours and gouache were wary of Berlin blue: it was viewed as a secondary alternative, like smalt, by Smith (1730: 'Alter [ultra]-marine, for a fine Piece, otherwise Blue-Smalt, or Prussian-Blue, will do as well.'). Similarly, it was considered 'difficult' because of its 'oily quality' in *The Art of Drawing* (1731). Yet at the same time, it was used to paint the doors of buildings. In 1738, we have a testimonial to its use in an ink in Paris where Le Blon used a Berlin blue ink for the blue plate destined for the three colour portrait of Cardinal Fleury, a mezzotint print from the portrait by Rigaud (Rodari 1996: 74). The stage was set. The vogue for Berlin blue would grow, and this strange and remarkable product would intrigue chemists more and more.

[4] S. Eikelenberg, *Aantekeningen over schilderkunst,* unpublished manuscript preserved in the Alkmaar archives, collection n°390-394 (cf. A. van Schendel, Studies in Conservation, vol. 3, 3 (1958) pp. 125-131 and Buck 1949).

An exciting research topic for chemistry in its infancy

Woodward and Brown

Around 1723, the recipe for Berlin blue manufacture reached London. A former member of the Royal Society, the geologist John Woodward, had it sent from Germany. He forwarded it to one of his colleagues in the Society, the chemist John Brown, for experiments to be carried out. Since they turned out positively, Woodward and Brown made a joint communication in the journal of the Society, the *Philosophical Transactions*. In two pages, in Latin, Woodward (1724) published the recipe without introduction or commentary. The article title referred to this blue as '*Cæruleum Prussiacum*', an appellation which matched that of 'Prussian blue' used by Brown in the article. This appellation appears to have been that commonly used in England and in France, while in Italy reference was made to *azzurro di Berlin*.

In his article, written in English, Brown (1724) detailed the *modus operandi,* indicating the heating times and detailing the gains and losses of weight of the various products in every operation. In his opinion, the delicate points were the calcination of the ox blood and the alum/vitriol proportion – 50/50 by weight seemed to him to yield the most beautiful blue. He made sure that every ingredient in the recipe was indeed necessary. Then he checked whether this property of iron extended to other metals such as silver, mercury, copper, bismuth and lead. These attempts did not meet with success. He concluded: 'May we not therefore hence conclude, that Iron is the Metal, that is the subject of this beautiful Colour produced by Means of the *Lixivium* with Blood?'

Geoffroy the Elder

Brown's experiments intrigued one of his colleagues of the Royal Society, the French chemist Étienne François Geoffroy (known as 'the Elder' to differentiate him from his brother), who was also a member of the Académie Royale des Sciences de Paris. He published the results of his work in two long memoirs in 1725. In the first, he quotes almost *in extenso* the contents of the 1710 announcement, together with this commentary (Geoffroy 1727a):

> These are the praises that the Gentlemen from Berlin made of their Blue in this announcement, without telling us of its preparation. They kept this secret well hidden as long as they could. But it is difficult for so useful a preparation, and in the hands of several persons working on it, to stay hidden for long.

> The curious Mr. Woodward, illustrious Member of the Royal Society in London, found a way to secure the manner in which this Blue is prepared and made it public in the Philosophical Transactions, the Journals of the Royal Society of London for the months of January and February 1724; this Blue is even much prepared in London currently; & either the way it is prepared differs from that in Berlin, or the Gentlemen from Berlin, assured of their throughput, are getting neglectful in this preparation, but that from London appears more brilliant and sparkling than that from Berlin.

He goes on to translate the recipe, which is then published in French, and summarizes the work of Brown. He then relates the difficulties he himself encountered duplicating the experiment and presents his thoughts:

> Having thought about this operation, all that occurs there appears very unusual & worthy of attention. I believe, like Mr Brown, that it is the Iron which supplies the basis for the Blue. I believe that it is the bituminous part of the Iron, which (as is known) is found in great quantity in this metal, which gives this colour. Several things convince me thereof. 1.° The blue colour which polished Steel assumes when exposed to a moderate fire, where this bitumen rarefied by the heat of the fire is slightly raised to the surface of this metal[5]. 2.° The blue colour of the Ink made with the Vitriol & the Gall-Nut, & of which the black is but an obscure & very dark blue[6]. 3.° The blue colour which subsumes with Gall-Nut the ferruginous Waters, particularly those from Passy[7] which are highly laden with Iron. 4.° The blue dye which some Chemists draw from Iron through Sal Ammoniac[8]. (...)

> It is true that in Iron this bitumen seems too compact & too condensed to give a beautiful blue colour. Of its own it is obscure, & even black. It is tied & too closely immersed within the gross earth of the Iron to be rid of easily. It needs a similar matter, sulphurous, to unite with it, to withdraw it from this earth, spread it, divide it & rarefy it.

> Oils are the natural solvents for bituminous matters. But as all Oils are not apt to dissolve indifferently all matters sulphurous & bituminous, so I have recognised that most Oils derived from Plants are not apt to dissolve this bitumen & develop the blue colour.

> The Gentlemen from Berlin usefully employed in this occasion Ox blood, and their experiment let it be known that the oil from this blood is most appropriate therefore. Mr Brown recognised the same property in Ox flesh; and I have found that most oils contained in animal matters yielded the same result. (...)

Indeed, he attempted the experiment, replacing the ox blood with wool and, curiously reverting to the original, using grated stag horn, but this seemed to give him a smaller amount of the pigment. He had better success with distilled oil from stag horn. Geoffroy's theory is clear: the goal was to extract, using an appropriate solvent, the blue fraction contained in iron, a fraction which is revealed in the various experiments detailed above. Using the essential oils studied by his brother, he extended his investigations to oils of vegetal origin, without result: only dry truffles gave a precipitate of a beautiful blue colour, unfortunately of short duration. Sponge, on the other hand, gave a beautiful blue, which appeared to him to weigh heavily in favour of classifying the

[5] The colour is due to the light interferences caused by the particular thickness of the oxide layer formed during thermal treatment.

[6] This black colour is due to the chemical reaction of tannins with ferrous ions, which gives ferrogallic complexes, found in all the black writing inks used at this time (see Delamare and Repoux 2005).

[7] The village of Passy, near Paris, famous for the quality of its springs. Nowadays part of the 16th arrondissement of Paris.

[8] The blue colour is probably due here to the presence of copper in the green vitriol (ferrous sulphate).

sponges within the animal rather than the plant realm, leading to controversy in the scientific world. He then attempted to dilute ferro-gallic ink, which only yielded a dirty violet. On the other hand, adding safflower or cochineal did not change the blue hue but doubled the output of the operation. This is the article which, twenty-five years later, served as the basis for the article '*Bleu de Prusse*' in the *Encyclopédie* (Malouin 1751).

Six months later, Geoffroy (1727b) wrote a second memoir in which he presents the complementary experiments undertaken. He proved that Prussian blue can also be made by replacing the ox blood with plant products such as charcoal or guaiac wood; he attributed this to the presence of iron in the various charcoals. We shall see that they contain nitrogenous compounds.

Geoffroy the Younger

Close to twenty years later, in 1743, a long memoir appeared from Claude Joseph Geoffroy (1746), the younger brother of the previous writer, now deceased, also dedicated to the study of Prussian blue. Beyond fraternal feelings, his work was motivated by the need to meet a growing demand for inexpensive quality products:

> This colour has become an object of commerce since the taste for Varnish in apartments, for Camaieu in carriages, & several other reasons to use it have multiplied. To avoid obtaining too much from abroad, I felt I had to take this subject up again, to examine it anew, try to perfect its colour, make its preparation easier and contrive to lower its price. (…)

He compares the manufacture of Prussian blue (which, when pure, is almost black) with indigo dyeing through repeated baths to obtain very dark, almost black blues (inferno blue). But he does not go further on this point. We shall see that this *rapprochement* with dyeing would later play an essential role and would take Prussian blue production to an industrial scale. His purpose was to find a recipe for Prussian blue dispensing with the need for the reaction of the greenish precipitate with spirit of salt (hydrochloric acid) which required careful rinsing in water over periods as long as a month. Poorly washed blues were often a cause for incidents in painting:

> I dare hope that the experience Painters will gather with it will show that it does not destroy colours close to it, or mixed with it, as other Prussian Blues prepared by ordinary methods do.

Geoffroy then quoted five variants of the initial manufacturing process: the older process from England, the one which was currently in use in England, the process used in Berlin and another two. They all included an acid wash of the greenish precipitate. Four of them washed with spirit of salt, while the fifth used spirit of nitre (nitric acid). What use was the acid wash? For Geoffroy, it dissolved the yellow matter, the 'martial earth' (a kind of ochre-containing, non-transformed iron) which yellowed the

green precipitate. His reasoning can therefore be summarised by the following 'colour equation':

green precipitate - yellow martial earth = Prussian blue

After two years of research, he perfected two processes he deemed very satisfactory. The innovation consisted in minimizing the excess of yellow matter. Geoffroy also indicated, and this was new, the possibility of replacing potash with soda, this latter alkali yielding other nuances of Prussian blue.

His enthusiasm even led Geoffroy to suggest the use of Prussian blue in medicine under the guise of sweet pills. In order not to turn the customers off with an ox blood preparation, he reverts to stag's horn oil and assures them that these pills have appetite-stimulating properties and that they induce perspiration.

Ménon

In 1747, a memoir from Father Ménon (1750a) on Prussian blue was read at the Académie Royale des Sciences. With reasoning based on the blue colour 'which is specific to iron', he imagined numerous experiments to back up his ideas. In fact, he appeared mostly intent on distinguishing himself from his predecessors on this topic. An impressive number of his experiments led to the precipitation of blue products which he claimed were Prussian blues.

His second memoir, submitted on 23 March 1749, presented two original research ideas (Ménon 1750b). One of them, based on the fact that the colour of antimony strongly resembled that of iron, consisted in attempting to make Prussian blue with antimony. He thus precipitated a number of blue salts, the colour of which he could not really assign to antimony or to the traces of iron he could not remove from his antimony. He commented:

> There would be much to be wished that my conjectures not be true, that Prussian blue be realisable with antimony, & that the blue that can be obtained be due to that mineral only; paint would benefit, and find an excellent colour there. (...) Advantages would be found in antimony blue, that cannot be with ordinary Prussian blue; no matter how well it is made, it can be destroyed by fixed alkali, or altered by acids which, after having progressively removed the coating covering the molecules of metal, change part of them into rust, which happens all too often when Painters match this colour with lead based preparations (...).[9]

The second idea consisted in dyeing cloth with Prussian blue. Since cloth can be mordanted with iron and dyed black with iron gallate, a black which can be weakened into dark blue, one should be able to dye with Prussian blue. His attempts failed with

[9] There is probably an ion exchange between the iron in Prussian blue and the lead in lead white.

cotton, and worked fairly well with wool even though the hues obtained were not very uniform. Dyeing with Prussian blue turned out to be much easier with silk.

> One can anyway make Prussian blue at little expense, & derive a colour as much above ordinary blues as crimson is over madder dye. These benefits may well stimulate the emulation of those who work for the public good and the progress of the Arts.

Macquer

Simultaneously a memoir by Macquer (1753) appeared (it was submitted on the 16 April 1749) entitled 'On a new type of blue Dye, in which goes neither woad nor indigo'. Pierre Joseph Macquer held the chemistry chair at the *Jardin du Roi* in Paris and was a member of the Académie Royale des Sciences. Like his colleague Jean Hellot, who had been chosen by this 'Illustre Compagnie' to lay the grounds for a *Tinctorial Chemistry* (and who had recently begun publishing his work (Hellot 1742, 1744, 1750)), he also chose this branch of applied chemistry and published a book on the topic (Macquer 1763). For the time being, thinking along the same lines as Ménon, he was considering a broader question: could one dye with a pigment?

> I first examined whether Painting could not communicate to our art [dyeing] some of these beautiful colours that it parades in to such advantage, and I worked in this direction all the more readily than I knew that, were this thing possible, I should be committing against Painting some kind of larceny without causing it the slightest harm, the arts being able to give each other the most beautiful presents without the donor getting poorer in the least.
>
> Going down the list of the various colours, my eyes settled principally on Prussian blue, a sparkling colour with which Chemistry enriched Painting a few years ago, & that we see every day so happily a second ultramarine in our most beautiful paintings.
>
> The conclusions I drew on the operations by which this colour is made led me to see in it all the qualities of a true fast dye, such as M. Hellot described in his theory; the dissolution of alum and vitriol seemed to be able to act as an excellent mordant by which the pores & fibres of the fabric would be disposed to receive and snare the colouring atoms, & I believed the matter which precipitates when the salt solution is mixed with the sulphurous & alkaline wash most apt to be applied to the fabric because of the fineness of its parts.

Macquer was therefore struck by the similarity between the manufacture of Prussian blue and the operations of dyeing with a mordant. He not only noticed, as Geoffroy and Ménon had, the similarity in the use of iron or green vitriol in both processes, but also that of alum, which is one of the better mordants used for dyeing (cf. Delamare and Monasse 2005) (except in the case of indigo considered by Geoffroy). The vision he had of the dyeing mechanism was that of Hellot: filling the pores in the fibres with coloured matter, followed by the astringent (we should say compressive) action of alum. Macquer proceeded simply, at first, like a dyer. Having chosen skeins of different fibres, he mordanted them in alum and vitriol solution, and then dipped them in a prussiate mixture.

The results were very positive for linen, cotton and silk. For woven wool, the colour was uneven and the cloth had become 'rough to the touch'. Very professional, he submitted his specimens to the tests of boiling with alum or soap, and ascertained that the colour was fast. However, he found fault with the evenness of the colour and the somewhat rough touch.

He would try different variations, changing the order of operations, the concentrations or durations. He also attempted to lower the cost of the operation, in particular by adopting the soda based process suggested by Geoffroy. Macquer obtained beautiful shades of blue, which required however an acid brightening. Here is the judgement he proffered on his discovery:

> Let me finally summarize the main properties of the new dye:
>
> First of all, it is as superior for beauty & sparkle to woad and indigo blue as scarlet is to madder red. This colour, compared with the most beautiful blues made according to the ordinary method, leaves them so far behind that it is hard to believe the latter are dyed in blue.
>
> Next, the ordinary blue only dyes the surface of the beaten fabric, & does not penetrate inside, whence it happens that blue cloth shows a whitish warp when it gets worn: since the new dye penetrates the fabric in all of its parts, it will not have this inconvenience & the cloth so dyed will wear through without showing this disagreeable look.
>
> Third, it is colourfast for wool & silk, &, as I stated, withstands very well the boiling test with alum. Crimson dye does not stand any better than ours the boiling test in soap. The most stringent test for dyes being the action of air and sun, I exposed specimens of the new dye in the outdoors to the ardour of the sun during the full months of September and October last year, when the days were almost all serene, and these specimens did not fade (...)
>
> Finally, it does not in any way alter the goodness of the cloth, provided the precautions I mentioned are taken; to convince myself, I hung from yarns dyed in this manner weights that I kept increasing until the yarn would break, and the yarn in this experience did not break until it got to hold a weight which broke the same yarn before it was dyed. (...)

One cannot help noting the similarities between the works of Ménon and Macquer: the identity of topics, and even of some sentences, such as those where the superiority of Prussian blue over indigo is compared to that of crimson over madder. Or the remark on the wool dyed in Prussian blue, which is 'rough to the touch'. What should we make of this?

Reading both memoirs leaves no doubt. The article of Ménon is sketchy, mentioning Prussian blue dyeing only in the last two pages, and gives no experimental detail. However, the memoir of Macquer has eleven pages entirely dedicated to perfecting this dye, with great clarity and admirably shows the method used by this chemist throughout his research. Macquer certainly did not draw his inspiration from Ménon, but there was undoubtedly some communication between them, and Ménon used Macquer's results

without acknowledging him. Posterity, which forgot all about Ménon, made no mistake, nor did his contemporaries.

Macquer seems rather optimistic about the applications of his discovery. Indeed, Hellot advised him to show his results to the Contrôleur Général des Finances[10] before submitting them to any learned publication. Macquer therefore went to Fontainebleau to submit samples of his dye to the Contrôleur Général, who showed them to Rouillé, counsellor to the Conseil Royal du Commerce. He sent them back to Hellot, who wrote a report which was handed to this Counsel on 22 October 1748, certifying the date of the process discovered by Macquer. The administrative path followed by these specimens is proof of the interest the monarchy took in the problems of dyeing (Pinault 1987: 158, ref. 170). In fact this very novel process did not evince any interest from the dyers, as at this time enormous quantities of a very inexpensive indigo had arrived in France from the French colonies of Saint-Domingo and Guadeloupe. Imports of this indigo through Nantes, Bordeaux and La Rochelle ranked third in value with cotton, after sugar and coffee. Macquer's innovation came sixty years too soon: when it reappeared under the name of *bleu Raymond*, it would have undergone a few improvements.

Undeterred, three years later Macquer (1756) published a second memoir dedicated to the analysis of Prussian blue. He was particularly interested this time in the reactivity of this compound with bases, according to the now classical reaction occurring in an aqueous solution:

Prussian blue + potash \rightarrow iron hydroxide + potassium yellow prussiate

$$Fe_4[Fe(CN)_6]_3 + 12\ KOH \rightarrow 4\ Fe(OH)_3 + 3\ K_4[Fe(CN)_6]$$

Progressively saturating potash with Prussian blue, he showed that it gradually lost its alkalinity. Simultaneously there appeared a rusty yellow precipitate while the solution took a lemon-yellow colour. He identified the precipitate through evaporation by heat, for the powder thus obtained was attracted to a magnet. But his attention focused on the yellow liqueur which, in contact with a green vitriol solution, regenerated Prussian blue. For the first time, a Prussian blue had been manufactured cold from very few ingredients:

> These experiments demonstrate that the matter which the alkali dissolve from the Prussian blue on which they are left to digest is precisely the same with which they are laden when calcinated with animal matters. (...)

The nature of this matter remained a mystery which Macquer promised to examine, but this was a promise he would not keep. He also demonstrated that alum is not necessary for the manufacture of Prussian blue, its presence simply increases the acidity of the bath. This remarkable study was a landmark in the understanding of the

[10] The minister in charge of Finances of France from 1661 to 1791. At the time, J.-B. Machault d'Arnouville.

manufacturing processes for Prussian blue. It proved the existence of a compound, later to be known as potash yellow prussiate, $K_4[Fe^{II}(CN)_6].3H_2O$ in its crystalline form, which would prove extremely important when the time came to dye textile fibres with Prussian blue on an industrial scale.

Prussian blue during the second half of the eighteenth century

This last work of Macquer indicates the starting point, in France and particularly in Paris, for the manufacture of Prussian blues of very high quality, that is, of high purity and little acidity. Such products quickly became a standard for quality in Prussia and England under the name of 'Paris blue', a name which was not used in France where one continued to use *bleu de Prusse*. But Macquer was not the only person, even within the Académie Royale des Sciences, working to improve the efficiency of the process of manufacturing Prussian blue. In 1756, a bibliographical synthesis of the French stud- ies carried out on Prussian blue appeared. It ended with the presentation of a study by Hellot, a veritable benchmark, in which he compared the blues obtained by six variants of the manufacturing process (*Sur la préparation du bleu de Prusse* 1762):

> We shall now communicate several processes which contribute to make the operation more secure & easy, & which were presented to the Academy by M. Hellot.

> This academician, having assisted, by order of the Court, to the experiments of an indi- vidual who knew how to prepare the most beautiful Prussian blue one could use, & having learnt that the poor behaviour of this man had forced him to leave the kingdom, did not see fit to abandon to Foreigners a body of knowledge which could be most useful to the trade of the kingdom, & he described to the Academy the following processes, which he had seen him employ; we shall relate them here such as he gave them.

There followed six recipes using desiccated ox blood, summarised here in Table 5.1. The first, 'First process for the most common blue, as is always followed in Berlin', uses potash as alkali. The product obtained is of a quality considered to be ordinary. The yield by weight, computed with respect to the amount of blood used, is 45%. The second recipe replaces potash with pearl ashes[11]. The Prussian blue obtained is of a lower qual- ity, but the yield of the operation doubled. Each of the other four 'processes' uses quick lime as a base – one gives a Prussian blue of ordinary quality, but the other three give higher quality blues. For the third process, the yield of which was particularly low, the author commented:

> This operation will yield but seven ounces of precipitate, which will not require bright- ening, but its beauty will make up for the small quantity obtained, it surpasses on this point all Prussian blues made by other methods. M. Hellot saw it used to glaze[12] blue

[11] Ashes obtained by burning desiccated wine sediments, rich in potassium carbonate K_2CO_3.
[12] To glaze: 'to deposit a colour with little body or a dye which lets the background on which it is laid show through.' According to J.-F. Watin (1808).

skies & draperies, it was as impressive as the most beautiful ultramarine, & it further-more had the advantage of resisting the effect of the air.

Table 5.1 Comparison of the nature and weight (in pounds) of the reactants used for three pounds of desiccated ox blood in the six processes described by J. Hellot. *Acid potassium tartrate deposited in the casks during the fermentation of red wines. The colour is due to anthocyanins colouring the wine.

Process	Alkali	Red tartar*	Saltpetre	Alum	Green vitriol	Blue quality	Yield
1-Berlin	potash 3	3	1 ½	8	2	ordinary	45%
2	pearl ashes 3	2	1 ½	8	2	low	83%
3	quick lime 3	2	1 ½	6	1 ½	high	15%
4	quick lime 3	2	nitre 2	4	1	ordinary	-
5	quick lime 4 ½	2	1 ½	4	1	high	18%
6	quick lime 6	2	nitre 1 ½	4	1	high	54%

The last of these processes is remarkable, since it supplies a very high quality Prussian blue with a yield higher than the Berlin process. Here it is:

> Take three pounds of desiccated ox blood, six pounds of quick lime, two pounds of red tartar, one pound, eight ounces of nitre[13]. Calcinate & wash as in the previous processes; pour this wash, still warm, in a solution of four pounds of alum & one pound of green vitriol, there will precipitate after the effervescence a blue matter as beautiful as that from the third process, but in a quantity very much larger, as one obtains thus twenty six ounces.

There is no doubt that a lot of research was been carried out in this domain – the memoirs drawn upon here probably form only the tip of the iceberg (Lehman 2012). Various persons were probably working in secret in a race to make commercial gains from this pigment, e.g. the unknown person mentioned above who fled the kingdom before 1756, yet whose knowledge one did not disdain to recover through a member of the Académie Royale des Sciences.

It was around this time that Prussian blue became the most used blue pigment for artistic oil painting. Remarks casting doubts on the quality, such as that from Robert Dossie (1758: vol. 1, 77–8) who advised whoever wanted a permanent Prussian blue to make it by himself according to the recipe he gave[14], became rarer and rarer. In the paint box of Jean-Honoré Fragonard, mentioned in the previous chapter, two phials contained Prussian blue. The dark blue labelled *Bleu de Prusse* contains a potassium based solu-ble Prussian blue, totally pure (Figure 5.2). The light blue, labelled *Bleu*, contains the same Prussian blue, cut with a large quantity of kaolin, a white filler not often found with this pigment (Delamare and Guineau 2006).

[13] A 16-ounce pound weighs 489 g here.

[14] This recipe was followed, and the resulting Prussian blue studied in detail (cf. Kirby and Saunders 2004).

As for prices, we are advised by the colour manufacturer and paint contractor Jean Félix Watin who, in his *l'Art du peintre*, gave the price of the various pigments he was selling in 1773[15]. Prices in French *livres tournois* were given for a weight of a 16-ounce pound of pigment. He offered Prussian blues in five different qualities:

Prussian blue, from Berlin, in lumps	40 livres
Different Prussian blues of assorted hues	8, 10, 12 and 18 livres

and four mixtures with increasing quantities of ceruse (lead white), colours 'prepared with oil, ready for use':

Turkish Blue	2 livres 10 sols
Royal Blue	2 livres
Sky Blue	1 livres 10 sols
Tender Blue	4 livres

These prices can be compared with those of the other blue pigments from the same list (see chapter 4, table 4.1). Compared with the price for the better quality ultramarine, which we know remained remarkably constant, the price of the better quality Prussian blue therefore fell from 10% of the ultramarine price in 1710 to 2.6% in 1773. It was still high, as witnessed by the contracts entered into for painting the French warships.

In 1778, the paints commonly used by the French navy were based on ochre and carbon black. A single blue pigment, azure (i.e. blue ashes) was used, parsimoniously, for decorative purposes, e.g. for officers' apartments. It cost 10 livres a pound (Boudriot 1973–1977, 3: 269). Its price, coherent with that given by Watin, was already twenty times that of ochre. Prussian blue, which was four times more expensive for the same weight, but much more economical for a given colouring power, had not yet penetrated this market. On the other hand, it had penetrated the wallpaper market, in Paris at least. It was supplied by various Parisian manufacturers including Dheur, whose Prussian blue factory was located at 4 rue Fer-à-Moulin, and who had supplied the wallpaper manufacturers Arthur & Grenard since 1770[16]. Gohin appears to have been in production since 1760. Jacquemart & Bénard got going much later, around 1795[17].

Due to the increase in the number of factories and of improvements, the price of Prussian blue kept coming down. From then on, not only was it used by all artists, but it displaced the other blues used previously. In England, it was the only blue mentioned by W. Williams (1787) in 1787. In France, in the 1808 edition of the *l'Art du peintre*, Watin

[15] J.-F. Watin 1773, additional pages 2 and 3: *État et Détail Des principales Marchandises & autres objets (...) qui se trouvent en grand nombre & bien assorties au magasin dudit Sieur Watin, carré de la Porte Saint-Martin, à Paris, à la Renommée des couleurs, Dorures et Vernis.*
[16] Archives Nationales, F[30] 159-160.
[17] Archives Nationales, F[12] 2281, dossier VII-2.

fils, a colour merchant also, offered artists but a single blue, Prussian blue. However, he sold it for many other uses, such as house painting (Watin 1808: 129)[18]:

> It can be used with oil or tempera; only the quantity needed for the purpose should be ground, for it is highly susceptible to becoming greasy when kept. I make some just as beautiful as those from London or Berlin, and I keep some common, in the solid as well as the liquid form.

These Prussian blues were used to make various colours. Watin's volume catalogued the following mixtures:

- mixed with increasing quantities of ceruse, we have seen that we got four nuances of blue, always in fashion: Turkish blue, Royal blue, Sky blue and Tender blue. 'You can mix one or the other with water, use it with paste. But the colour will be nicer if you grind it with poppy seed oil and mix it with turpentine spirits to dilute it.'
- his 'violet' was a mixture of carmine lake, ceruse and Prussian blue.
- 'the *vert de composition* for apartments, is made with a pound of ceruse white, two ounces of Dutch pink and half an ounce of Prussian blue.' A different mixture of the same ingredients would yield 'sea green'.
- 'linen grey is made of ceruse, lake, and very little Prussian blue, ground separately, and which, mixed in the required amounts, give the desired linen grey.' This grey, made with walnut oil, was recommended for doors, casements, and outside shutters.
- He also made a colour 'steel grey' with ceruse, Prussian blue, fine lake and crystallised verdigris.

French worries

Contradicting the approval given to the Parisian production by various authors, German as well as English (Harley 1982: 72), French official documents considered that France did not produce Prussian blues of sufficient quality and that something had to be done to remedy this situation. A surprising contradiction, the origin of which may lie in the high esteem in which French products were held abroad, while German products often carried a pejorative connotation. Research was resumed in the 1780s, as indicated by the large number of publications.

In 1778, an apothecary at the Metz military hospital, Baunach (1778), published a two part study. In the first part he described in detail two processes used in Germany to industrially prepare Prussian blue from horns, oxen hooves and leather scraps:

[18] In his *État de ce qui compose l'assortiment nécessaire au Peintre,* describing the box of colours and accessories which he sells for 48 livres.

Prussian blue is prepared in several German Factories, whence it is distributed every-where at a very modest price; the most renowned are in Swabia, near Augsburg; there are also some in the Hesse-Ranau [Hanau] Principality, at a short distance from Francfurt.

The second part was dedicated to personal observations made in the laboratory, tending to prove that Prussian blue was not just a compound of iron specifically, but could be obtained using all metals or semi-metals. Starting from the hypothesis that Prussian blue was a salt resulting from the action of an acid contained in the blood ('animal acid', as Sage would say) on an alkali, potash, Baunach precipitated metal hydroxides, some of which were – or went through a stage – of dark or blue-black colour.

Of much greater interest was the report made to the Société libre d'Émulation (predecessor of the Société d'Encouragement pour l'Industrie Nationale – Society for the Promotion of National Industry) that same year (Cadet de Gassicourt *et al.* 1778). Its aim was to evaluate the Prussian blue wool and silk dyeing process suggested by Le Pileur d'Apligny (1770, 1776a, 1776b, 1776c, 1779), a specialist of dyeing processes, and the author of various well-considered works on the topic.

The reviewers explained that indigo dyeing suffered, from an industrial point of view, from three major drawbacks. With the classical process, the vat blues exhibited very fast but somewhat dull hues. Also vats were difficult to control and could deteriorate, thereby increasing costs. When indigo was dissolved in sulphuric acid, one obtained brighter colours known as *bleus de Saxe* (Saxe blues), but these were not as fast and aged poorly. In any case, indigo was imported from overseas, and its price varied considerably depending on the international situation – hence the advantage of perfecting locally made fast dye yielding beautiful blues. These comments would turn out to be prophetic.

When comparing Le Pileur's process with that suggested thirty years earlier by Macquer, the reviewers noted several improvements, the most salient being the use of potash much more saturated with the colouring agent since it was combined directly with Prussian blue rather than blood. However, they pointed out several weaknesses and suggested a simplified and improved process.

The cost of this Prussian blue dye seems, for the time being, to have been equivalent to that of Saxe blue, but 'the price of Prussian blue comes down everyday due to the large increase in the number of factories established for its manufacture, principally in Paris (…)' (Cadet de Gassicourt *et al.* 1778).

This new dye was not really colourfast, but it was far from being the only one. Experience had shown that improvements were always possible. For the time being unable to resist an alkaline environment, Prussian blue could only be used for fabrics which were not washed, such as wool, silk and, for cotton based fabrics, velvets. However this dye gave superb colours, which aged well. As opposed to indigo, it enabled nuances to be varied. The reviewers' opinion was therefore very favourable. But, as Macquer had been the true inventor of this process, they showed him the work of Le

Pileur and the improvements that they had suggested. 'It is after M. Macquer's opinion, & with him jointly, that we request the support of the Society in favour of M. Le Pileur d'Apligny' (Cadet de Gassicourt *et al.* 1778).

In 1781, Chaptal (1781b: 57, 76, 102) published his study on 'The colouring part of Prussian blue'. Soon thereafter the Italian Landriani (1783), a member of the Royal Society of Berlin, published a personal contribution coupled with a bibliography (an unusual occurrence at the time) (Achard 1784). But the work of Scheele (1782, 1783) was the most remarkable. In particular, letting Prussian blue interact with sulphuric acid, he studied the resulting gas emanation and its characteristic smell. He recognised that this gas – which behaved like a weak acid – 'results from the union of ammonia with a coal-like substance made subtle by a high heat'. One cannot help but think of the current I.G. Farben and Degussa synthesis processes for prussic acid (Andrussow 1935; Endter 1958):

$$2\ CH_4 + 2\ NH_3 + 3\ O_2 \rightarrow 2\ HCN + 6\ H_2O \qquad \text{at } 1200°C, \text{ with a catalyst}$$
$$CH_4 + NH_3 \qquad \rightarrow \quad HCN + 3\ H_2$$

This gas, which Scheele named 'colouring principle', would be studied by Guyton de Morveau *et al.* (1787) who baptised it 'prussic acid', a name it carries to this day.

In 1786, Hassenfratz, Professor of Physics at the École Royale des Mines in Paris, began publishing his quarrel with a German apothecary, Westrumb, who held phosphorus to be responsible for the blue colour (Crell 1786). Backed by Berthollet, Hassenfratz (1786, 1788, 1789) proved the proposition to be false. However, in which direction should one search, when the body of knowledge in chemistry was still so imperfect? With the goal of better understanding the nature of iron prussiate (in other words, Prussian blue) Berthollet (1789b) studied the properties of mercury, potassium, sodium and ammonium prussiates. While studying the action of light, he discovered ammoniacal Prussian blue. Going further than Bergman for whom 'prussic acid is composed of carbonic acid, volatile alkali & phlogemon' (Bergman 1787), he deduced from his experiments that:

> It therefore appears to me that there is nothing doubtful about the composition of prussic acid, beyond the proportion of its principles which I have not yet been able to determine. It is a combination of nitrogen, hydrogen, and pure coal or carbon.

> (...) From these data, it is easy to see why animal substances intervene in the formation of prussic acid; they supply the nitrogen entering its composition. Still, coals from vegetal substances can produce a small amount of prussic acid, because these charcoals always contain a small quantity of coal from animal origin, as I pointed out elsewhere. Several species of coal yield a larger quantity of prussic acid, as observed by Mr Hassenfratz: but we know we can extract ammonia from these coals, and they therefore contain nitrogen.

He then wondered about the wisdom of classifying prussic acid among acids.

The Irishman Peter Woulfe, a member of the Royal Society, discovered picric acid and also turned his attention to Prussian blue. However, his intent was to use it to make

test liquors in order to show evidence of iron. Apparently, he too discovered ammonia-cal Prussian blues under the name 'Prussian ammoniac salt' (Woulfe 1788, 1789). It then was Sage's (1789) turn to make several observations of little interest.

Ten years later, Proust (1799), then Professor of Chemistry in Madrid, published a veritable textbook on the nature of Prussian blue. Starting from the assumption that this blue was a product of oxidation, he intended to demonstrate that, just as there were two distinct oxidation states for iron (ferrous and ferric), so there were two distinct Prussian blues – one ferrous, one ferric. The question was not without interest, since we know that both these iron oxidation states coexist within the same crystalline structure. Proust also demonstrated that Prussian blue contained water.

Of the virtues of annexation

There is documentary evidence that in 1787 French imports and exports of Prussian blue or iron prussiate balanced out (*Aperçu de l'extraction* 1794). They added up to 17,838 and 14,330 French livres respectively. It is unfortunately impossible to deduce either the importance of French production or the origin of the imports from these figures. The average price for imported Prussian blue was 396.4 livres per hundredweight, hence 2.48 g of gold for a kilogramme. This price was higher than that of the best quality of smalt imported that same year. There is of course no competition between the colouring power of these two pigments, which lies very much in favour of Prussian blue. But the times were politically unstable, and, fourteen years later (1801), the Treaty of Lunéville recognised that the French Republic should have the rights over the territories located on the left bank of the Rhine. This eased the situation. A memoir from Citizen Duhamel (1801: 488), Mining Inspector, written in 1801, bears witness:

> The conquest of four departments on the left bank of the Rhine has secured for us several establishments we were lacking, the beautiful mercury mines known as the Mines du Palatinat and the Zweibrücken region supply beyond our needs; the interesting manufac-ture of the beautiful Prussian blue from Sultzbach, in the Saar department, will free us from the tribute we pay Germany.[19]

This was the *Berlinerblau* factory set up in 1786 in Sulzbach (Saarland), a factory which came to be of great importance, adapting to technical developments and not closing its doors until 1938. During the years 1796–1806, it used coal as a fuel which it purchased from the French administration at a favourable price. In 1806, it consumed 4,500 metric quintals of coal (Maret 1807). We should note that if the French inspec-tor had reasons to rejoice over the annexation of these territories by France, he was not

[19] It would be a shame not to quote the last paragraph of the Memoir, so typical of the enthusiasm of the time: 'May all factories have at their helm such enlightened people, and may ignorance, always so mysterious, soon be forced to flee in front of the noble enthusiasm of artists who, rivalling only in talents, rush to carry forth into the arts the flame of useful knowledge.'

the only one: the German industrialists who, until then, were corseted by a mesh of borders and constraining customs legislations, saw them suddenly disappear, and the vast French market opened up for their products. They took advantage of it to such an extent that, around 1810, 'the Roër [Ruhr] department had become the first in terms of industry, ahead of all others in France' (Dufraisse 1971).

The intervention of the Société d'Encouragement

This annexation did not slow the efforts made to master the process. As soon as it had been founded under the instigation of Chaptal, the Minister of Interior, the infant Société d'Encouragement pour l'Industrie Nationale (SEIN) placed the manufacture of Prussian blue among the five topics up for competition in 1802 (*Annonces concernant les Mines* 1801):

> The Société d'Encouragement offers a prize to whomever will reveal a process to regularly obtain, at the trade price, a Prussian blue of a beauty and shade equal to those of the qualities most sought after in the arts.
>
> This prize will consist of a medal and six hundred francs.
>
> Depending on the degree of perfection the process will present, the Society will extend to the artist the amount needed to pay for a patent for the next ten years.

This was, let us note, the most modest prize on offer, since the others were between 1,000 and 2,000 francs.

On the given day the contestants were not ranked as the jury was not sure that they had assembled the most beautiful qualities of Prussian blue as reference material or that they knew the prices. The jury therefore ordered these reference blues from 'abroad', from England in fact, and extended the deadline by some months (Mérimée 1803).

In the meantime, a memoir from Citizen Curaudau (1803a, 1803b) appeared in which the author drew a parallel between gallic acid and prussic acid, since both turned a dark colour when left in the presence of red iron oxide. He advised against the presence of steam during the roasting of animal matters with potash. Then came the great day when the Société d'Encouragement judged the Prussian blues. Referring to the postponement (*Rapport sur le Prix du Bleu de Prusse* 1803):

> It is true that it prolonged for a while the impatience you must have felt to learn that France could dispense with paying foreign industry a tax for the manufacture of beautiful Prussian blue (…). Of the competitors who entered, only two drew our attention.

The first competitor was a foreigner who offered the German processes, but could be competitive in price only in those countries where potash was cheap, which was not the case in France. The second competitor was the company belonging to 'citizens' Michel and Pierre Gohin, located at 8 rue du Faubourg Saint-Martin, Paris. They made prussiate which was then turned into a Prussian blue of top quality. The commission

vouched that these products were as beautiful as the best of the foreign competition. Unfortunately, like the others, they turned slightly greenish under sunlight. Prices – unfortunately not quoted – were found to be comparable. The Société awarded its prize to the Gohin brothers. We shall see, however, that this would end in disappointment.

In the meantime, imports were necessary. During the regnal year XIII (1804–5), France imported 3,754 half-kilogrammes of Prussian blue for a total of 56,325 francs. Duties paid amounted to 4%. Averaged across all qualities, the price of these imported blues therefore came out at 15 francs per half-kilogramme (Collin 1806). Comparing this price with those of the market (see Figure 5.10) shows that this was the price of the best quality[20]. This confirms the fact that France did not manufacture quality Prussian blues, or at least not in sufficient quantity.

From pigment to dye: dyeing with Prussian blue

The wars fought by France after the Revolution had made the import of cotton and the trade in indigo between French ports and the West Indies very difficult. The Continental System (1806) stopped it totally. France had previously been importing thirty million francs worth of indigo per year (between 1,000 and 1,500 tonnes). This dye (the most solid and least soiling blue dye, of universal use) had been supplied cheaply; but where could it be procured now? Where could the 150 tonnes of indigo needed to dye the uniforms of the 600,000 soldiers of the Grande Armée be found? With what could it be replaced? The bounties from the corsairs[21], even contraband[22], could not suffice.

Aware of this problem, Napoleon instituted in June 1810, at the instigation of Chaptal, three prizes of extraordinarily high value (*Programme d'un Prix* 1810). The first, of 100,000 francs, was to reward 'he who will find a way to extract from an indigenous plant, easily cultivated, a matter capable of replacing indigo in terms of price, use, shine and fastness of colour.' (Art. 1). A second prize of the same amount was destined for 'he who will find a process apt to fix an indigenous plant colour onto wool, cotton, linen and silk, so as to replace indigo under the conditions of article 1.' (Art. 2). Intermediate prizes were offered – in case the process would still need the use of indigo, the value of the prizes would be proportional to the amount of indigo saved.

The third prize, worth 25,000 francs, would go to 'he who will reveal a process, to dye wool and silk with Prussian blue so as to obtain a colour even, shiny, constant and resistant to friction and washing in water.'

[20] Travelling through time and land, we can compare prices through their gold value only. The 20 francs gold coin struck in 1805 weighs 6.45 g, and assays 900 thousandths in gold. The price of this Prussian blue therefore stands at 8.70 gold grammes per kilogramme. See Figure 5.10.
[21] The French privateer *Le héros du Nord* proved particularly efficient in this domain by intercepting Dutch ships in 1810–11 (see Pinault 1987: 159, ref. 176).
[22] In 1810, following a large scale police operation led in Frankfurt against the contraband of English products, Meyer Amshel Rothschild had to pay 20,000 francs in duties over his hoard of contraband indigo (Bouvier 1960: 32).

One can imagine the incentive this imperial decree gave to the world of chemists (to Roard and the very young Chevreul in particular), and to the dyers and developers of processes, as well as the peasantry. At the same time, the administration sent woad seeds (*Isatis tinctoria L.*) (which originated in Northern Italy) throughout the whole Empire, with subsidies paid to the peasants to restore its cultivation. In 1811, 14,000 hectares were thus returned to cultivation and a woad school opened in Albi (France). Woad indigo factories were set up in Toulouse, Turin, Florence and Borgo San Sepolcro. Unfortunately, time was against them. The fall of the Empire in 1814, which brought the return of cheap indigo imports (English this time, from North and South Carolina) spelt their doom.

These efforts did not lead to a durable contribution, except for Prussian blue. Two processes for dyeing silk with Prussian blue, very similar to each other, were put forward. The first was by the chemist J.L. Roard, but since he was a member of the commission awarding the prize, he withdrew from the competition (Pinault 1987). The second was by a former chemistry professor from the École Polytechnique in Paris, J.-M. Raymond, who held the Industrial Chemistry chair created by Napoleon in Lyon to support the Lyon dyers. Thus the silk dyeing process with Prussian blue invented long ago by Macquer, perfected and improved by Le Pileur d'Apligny and the reviewers of his work, was rediscovered. Sixty years had gone by since Macquer's publication, and thirty-three since that of Le Pileur's process. This may explain why no one referred to them. Yet Raymond was probably aware of them, since he quoted Macquer's second work on Prussian blue.

The Raymond process consisted in mordanting silk with iron, then dipping it in an acid solution of potash yellow prussiate ($K_4[Fe^{II}(CN)_6].3H_2O$). A succession of baths interspersed with washes got rid of residual impurities and acidity. A last brightening with ammoniated water darkened the colour. Raymond admitted that his process experienced more difficulties with wool, from which the colour rubbed off. The innovation which set this process apart from its predecessors was the use of potassium prussiate as the complexing agent. Macquer had used blood, while Le Pileur used Prussian blue itself. This time, the process addressed powerful industrial needs. For his *bleu Raymond* which only dyed silk, Raymond received part of the prize, i.e. 8,000 francs in 1811. Jean Michel Haussmann, the great manufacturer of printed calico, deemed 'the first dyer in France', always on the lookout for innovations, was the first to put it to use on an industrial scale. This did not take place without a few inconveniences for him and for others, as shown by the judgment passed by an inspector from the Administration of the Imperial Furniture on a piece of lampas dyed by Lacostat according to the Raymond process. The inspector reproached them for 'not guaranteeing the unity of tone, hue, colour of a whole piece of furniture. Here shade varies, one finds a Warning in the middle of a bolt letting the upholsterer know of a change in hue, which is pitiful' (Coural 1980, 1987).

These difficulties must have been fairly quickly overcome, since the Imperial administration took care to spread the process to all parts of the Empire where silk dye works were to be found. Brochures were printed to this effect in Paris, Lyon, Tours, Turin, Genoa, Florence and Krefeld. Prefects were in charge of distribution, as demonstrated by this letter kept in the National Archives[23]:

> Aachen, September the 18th, 1811
>
> My Lord,
>
> I received, together with the letter your Excellency honoured me with on the 7th of this month, the 60 copies concerning the process discovered by M. Raymond for dyeing silk with Prussian blue. I made haste to disseminate them among the dye works in the Department of the Roër.
>
> I respectfully Remain, my Lord, Of Your Excellency, The very humble & very obedient Servant.
>
> The Prefect from the Roër,
>
> To His Excellency the Minister of Interior, Empire Count

The process was simultaneously published in detail by Raymond in various brochures. The main points were taken up in the Bulletin of the Société d'Encouragement (J.-M. Raymond 1811, 1814).

The future of the process, therefore, rested on the possibility of procuring prussiate of potash, the production of which would grow with the success of *bleu Raymond* dyeing. From being considered as a fake indigo (which had no reason to exist from 1814 on), *bleu Raymond* soon acquired an excellent reputation within the textile industry. Prestigious orders included the silk velvet screen embroidered and brocaded in gold, currently decorating the King's bedroom at the Louvre (Figure 5.3).

This state of affairs was not ignored by the *Dictionnaire technologique* (Robiquet 1823: 'Bleu Raymond' entry, 231–2):

> *Bleu Raymond* is a discovery all the more precious for dyeing as heretofore no means were known to obtain this shade on silk; for it is known that beautiful dark blues are made in a vat, and never show any brilliance, while sky blues, which are obtained from an indigo solution, can never achieve the tone of Prussian blue.

As for dyeing wool cloth, the Raymond process was used (in spite of its imperfections) to dye the uniforms of the draftees of 1814 and 1815, called to arms in 1813. Known by the nickname of 'Marie-Louise' (for, in the absence of the Emperor, the draft decree had been signed by the Empress Marie-Louise), the name spread to this new blue tint which became, for a time, *bleu Marie-Louise*[24].

[23] Archives Nationales, F12-2252.

[24] This blue will remain known as *bleu Raymond* for posterity.

The problem of dyeing wool, and especially wool cloth, with Prussian blue would be studied by Roard, then Director of Dyes at the Gobelins Factory in Paris, but it was Raymond *fils* who developed the first viable industrial process. He communicated it to the Société d'Encouragement in 1822 and showed his first specimens of dyed cloth at the 1823 Exhibition in Paris (*Coup-d'œil* 1825). He was awarded a silver medal. A full memoir describing the application of the process to cloth, in addition to fleeces, appeared in 1828 (P. Raymond 1828a[25]). When applied to wool, Prussian blue dye would be known in France as *bleu de France* (French blue).

Of what did this process consist? The main difficulty to overcome was to attach ferric iron onto the wool fibres while preserving their qualities. The use of a simple acidic ferric salt bath allowed efficient Prussian blue dyeing, but made the wool rough to the touch. The addition of a 'chlorine bath' (probably bleach) to the ferric salt solution yielded a soft wool after dyeing, but the latter would prove impossible to felt. The addition of tartaric acid to the ferric bath was finally adopted in the industrial process. A second innovation consisted of adding the cyanide ions in two consecutive baths: one of prussiate of potassium, and the other of cyanhydric acid (HCN) which was brought to the boil. This was followed by fulling of the cloth with soap and a process to revive the colour.

If one was to consider five shades of blue, equally distant from one another in terms of saturation, in order to dye one kilogramme of wool, it took approximately 15 g of prussiate to get a nascent blue (*bleu naissant*), 40 g for a celestial blue (*bleu céleste*), 65 for a Turkish blue (*bleu turquin*), 85 for *bleu pers*, and 100 for the most saturated shade, *bleu d'enfer* (P. Raymond 1828a)[26].

A last difficulty to be overcome was the monitoring of the shade obtained. In practice, it was very hard to obtain the desired shades in Prussian blue dyeing. However, the new Director of Dyes at the Gobelins, Michel-Eugène Chevreul (1826), showed that the key of the problem was the accurate control of the amount of iron used for mordanting the silk fibre by using suitably proportioned solutions.

In continuous progress, Raymond blue dyeing would, for the next forty years, use up the better part of the production of prussiate of potash. All the more so since a process for printing fabrics with Prussian blue would soon be perfected (Figures 5.4 and 5.5).

[25] An abstract of this memoir also was published (P. Raymond 1828b). In addition, an account was published in England that same year (P. Raymond 1828c). Raymond perfected his process by working with Seguin and Co., a company which wove and dyed wool cloth in Annonay, a small industrial city South of Lyon (cf. Cotte 2007: 48–9).

[26] This scale of saturations is but a simplification of the scale of thirteen blue shades as determined by Colbert's Dyeing instructions (1669).

Prussian blue manufacture in France during the Consulate and the Empire

How can one pinpoint the industrial production of Prussian blue in France and its evolution? Various sources are available. Between 1798 and 1849, *Expositions des produits de l'industrie nationale* were organised in Paris, at first at irregular intervals, then every five years. The reports from the juries enable us today to retrieve the identities of the winners of medals or honourable mentions, for manufacturers of colours, of blues (no details given), of blue balls for laundry and finally of Prussian blue, with which is often associated prussiate of potash. The bulletin of the Société d'Encouragement pour l'Industrie Nationale is also an interesting source, as are requests for patents, but only the best were identified in this manner, and only if they entered the competition at the *Expositions*. In spite of its location on French territory, the Sulzbach factory does not appear in any of the exhibitions. What was then the ratio of the number of medal winners to the actual number of factories? Should their number be multiplied by three, by ten? And what was their actual production?

On the list of prize-winners for the first Paris Exhibitions, drawn up in 1819, we find:

- for 1798: no manufacturer of Prussian blue.
- for 1801: the brothers Gohin, colour merchants in Paris, whom we know received the prize from the Société d'Encouragement in 1803.
- for 1802: the brothers Gohin, and Marchais, from Paris, both rewarded for a *bleu français* (French blue) which was probably Prussian blue mixed with alumina.
- for 1806: in Paris, the colour merchants Lambertye, Marchais, Paeytavin and Prieur, as well as the widow Wuy for her colour balls. For the provinces, Aymard and Boyer, both in Avignon, Charbonnier in Menesbes, Guibeaux in Orleans and Lançon in the Jura. For the annexed *départments*, two Prussian blue manufacturers appeared: Lochrs in Metternich and Rethel in Aix-la-Chapelle (Aachen).

The requests for letters patent complete this data. Thus, in 1814, an English manufacturer named Steigen Berger requested a licence to enjoy the property rights granted to the authors of discoveries and inventions, and to obtain a patent for five years to import the manufacturing processes for indigo and Prussian blue. He made four types of blues. The 'England stone' and the 'indigo stone' were intended for cotton factories and washerwomen; the 'indigo flora' and 'Prussian flora' were suitable for manufacture of white paper (Pinault 1987: 161–2, ref. 178). His Prussian blues were therefore intended for colour correction and optical blueing. The letters of patent were granted. Soon thereafter, Gay-Lussac (1815) published, in a long article, the results of his work on prussic acid and a new gas formed of carbon and nitrogen to which we assign the formula $(CN)_2$. He established the elementary composition of these compounds, and then, meticulously and exactly, their quantitative composition by weight. He pointed out that prussic acid is a hydracid, comparable to hydrochloric acid. He inferred that the carbon-nitrogen radical played the role of chlorine. He confirmed this similarity by studying

the action of prussic acid on potassium. He pointed out that, from a systematic point of view, this acid should be called 'hydroprussic acid', but that, since the qualifying term 'prussic' was not used in Germany, a new name should be found. He suggested 'cyanogen' (i.e. 'which generates blue' in Greek) for the gas formed of carbon-nitrogen $(CN)_2$. HCN would be the 'hydrocyanic' acid, and its salts, the 'hydrocyanates' and 'cyanides'. Gay-Lussac studied their reactions, as well as those of the former 'prussiates'. He finally reached Prussian blue, which he showed to be an iron hydrocyanate or cyanide. He accepted its hydration, and reflected on its reactivity toward the various cyanides.

In summary, the Consulate and Empire formed a key period in the development of Prussian blue manufacturing in France. This is indeed what appeared in the *Rapport historique sur les progrès des Sciences naturelles depuis 1789 et sur leur état actuel* (Historical Report on the Progress of Natural Sciences since 1789 and their current status) ordered by Napoleon from the Institut, i.e. the Académie des Sciences of Paris (Cuvier 1810):

> We have already discussed the new colours delivered by chemistry to oil painting and enamel painting, such as Mr Thénard's cobalt blue; chromium red; the same metal green applied to china by Mr Brongniart. We could have added the introduction in France of the manufacture of Prussian blue and English blue, which is but a Prussian blue mixed with alumina.

Prussian blue manufacture and the environment

Such a proliferation of Prussian blue factories, most of them located in urban areas, was not without environmental problems. Risk of fire, foul odours and the spread of blue colour outside the factory gave problems to the surrounding neighbourhood. Complaints were therefore numerous. How should the rights of the residents be reconciled with the necessary development of French industry backed by Napoleon?

In 1804, the Class of Physical Sciences and Mathematics from the Institut had, indeed, written a report dated from *26 Frimaire an XIII* (17 December 1804), a report which examined the whole manufacturing industry (*Extrait des Registres* n.d.):

> The minister of Interior [Chaptal] has consulted the class on a question, the solution to which essentially concerns our manufacturing industry.

> It is to be decided whether the proximity of certain factories can be detrimental to health.

> The solution to this problem must appear all the more important as, due to the natural trust deserved by the decisions from the Institute, it will from now on form the basis for the judgments of the magistrate, when he has to adjudicate between the fate of a factory and the health of the citizens.

> This solution is all the more urgent, it has become all the more necessary, as the fate of the most useful establishments, even more, the very existence of several arts have lain with simple police regulations, and that some, relegated far from supplies, man-power or consumption by prejudices, ignorance or jealousy, keep fighting at a disadvantage against innumerable obstacles laid in the path of their development. Thus have we seen

in succession factories for acid, ammoniated salts, Prussian blue, beer, and leather prepa-
rations be relegated outside the walls of the cities, and each day these very same estab-
lishments still denounced to the authority by worried neighbours or jealous competitors.

As long as the fate of these factories is not assured; as long as purely arbitrary legisla-
tion will have the right to interrupt, suspend, disturb the due course of a production; in
a word, as long as a simple police magistrate will hold in his hands the fortune or ruin
of the manufacturer, how can it be conceived that he will push imprudence to the point
of entering such endeavours? How could it be hoped that the manufacturing industry
be established on such fragile bases? This state of uncertainty, this continual struggle
between the manufacturer and his neighbours, this eternal indecision as to the fate of
an establishment paralyse, restrain the efforts of the manufacturer and slowly dim his
courage and his abilities.

It is therefore of prime necessity for the prosperity of the arts, that limits be at last set
which leave nothing to the arbitrariness of the magistrate anymore; which draw for the
manufacturer the circle within which he can exert his industry freely and securely, and
guarantee the neighbouring owner that there his no danger to his health or to the prod-
ucts of his soil. (…)

The production of Prussian blue, the extraction of ammonium carbonate by distilling
animal matter in the new factories of ammoniated salts, let loose a large quantity of
noxious vapours or fumes. To tell the truth, these fumes are not dangerous for health;
yet, since to be a good neighbour it does not suffice not to be dangerous, but also requires
not to be inconvenient, the promoters of these types of establishments, when they decide
on their location, must prefer one which is remote from any dwelling. But when the
establishment is already formed, we shall refrain from advising a magistrate to order its
relocation; it is enough in this case to order the manufacturer to build very high chim-
neys, so as to drown into the air the disagreeable fumes resulting from these operations:
this method is mostly of use for the production of Prussian blue, and it is through its
application that one of us maintained in the centre of Paris one of the most important
factories of this kind, against which the neighbours and the authority had already formed
an alliance. (…)

The magistrate must watch for the initiative of a worried or jealous neighbour; he must
carefully distinguish between that which is merely inconvenient or disagreeable, and
that which is harmful or dangerous; he must remember that for a long time the use of coal
was proscribed, under the frivolous pretext that it was unhealthy; he must, in a word,
penetrate himself with this truth, that by accepting complaints of this kind, not only
should we prevent the establishment in France of several useful arts, but we should also
imperceptibly remove away from the cities the blacksmiths, the carpenters, the wood-
workers, the sheet metal workers, the coopers, the founders, the weavers and in general,
all those whose profession is more or less inconvenient for some neighbour. To be sure,
the arts we just mentioned make more inconvenient neighbours than the factories we
had talked about; the only advantage they hold over the latter is their long established
presence. Their right to their location was formed with time and need: let us not doubt
that when our factories get older and better known, they will peacefully enjoy the same
advantage in society. In the mean time, we believe that the class should take this oppor-
tunity to bring them, in a special manner, under the protection of the Government, and
declare that manufactures of acids, ammoniated salts, Prussian blue, Saturn [lead] salts,

white lead, starch, butcheries, tanneries, breweries, do not constitute an environment detrimental to health, when they are properly conducted. (...)

On these questions, the Class of Physical Sciences and Mathematics of the Institut requested the opinion of the chemistry section. The latter wrote a more technical report, in which this opinion could be found (*Rapport fait à la Classe des Sciences physiques et mathématiques* n.d.):

It is already known to this day that in some factories of soda and Prussian blue, the proximity of which is so fearsome when ordinary processes are employed, one begins to use new operations by means of which the muriatic acid and hydrogen sulphide gas are so well coerced [condensed], absorbed or diluted, that they are hardly sensed within the factories; but it remains to be seen whether these operations conducted on a large scale will be successful, and if their use itself will not present some draw-backs.

An 1810 decree classified industrial establishments in terms of their environmental harm (odours, noise and fire hazard). The covering letter justified its need (Saint-Jean-d'Angely 1810):

Sire,

There have arisen, at various times, very sharp complaints against the establishments where tallow is melt, leathers are tanned and where glue, Prussian blue, vitriol, lead salt, ammoniated salts, starch, lime, soda, mineral acids, etc. are made. It is claimed that their exploitation causes fumes detrimental to the vegetation of plants and the health of men. These complaints were directed in the year 13, to the class of Physical Sciences and Mathematics from the Institut, which wrote a work that my predecessors have constantly made their rule, each time they have had the opportunity to adjudge requests for the suppression of factories. Everything would therefore be settled, if new protests had not been lodged. They have mostly originated with soda factories. I stand assured that the fumes caused by these factories destroy vegetation in the neighbourhood, and oxidise in very little time the iron on which they set. Such a state cannot be looked upon with indifference. While it is just that everyone should be free to exploit his industry, the Government cannot, on the other hand, tolerate that, for the advantage of an individual, a whole neighbourhood breathe a noxious air, or a person suffer damages in his property. I will admit that most establishments facing complaints do not cause fumes contrary to public health; but, undoubtedly, one cannot but admit that these fumes are most disa-greeable, and thereby cause prejudice to the owners of houses nearby, preventing them from renting these houses, or forcing them, should they be able to rent, to lower the price of their leases. The solicitude of Government embraces all classes from Society, and it is within his justice that the interests of these proprietors not be lost from sight any more than those of the manufacturers. (...)

In Paris in 1812 an *Instruction concerning the Prussian blue factories* was pub-lished by the municipal authorities (*Extrait d'une instruction* 1814). It proposed a number of proven technical solutions to protect the surroundings from foul-smelling or corro-sive vapours. The first phase concerned the roasting of animal matters in a reverbera-tory furnace (as practiced by the Gohin establishment), the gathering and burning of

deleterious fumes, or the distillation and safeguarding of ammonium carbonate. For the second phase, the idea was to fix the hydrogen sulphide emanating during production. The apparatus described was operational at the Broustrom establishment, petite rue Saint-Nicolas, faubourg Saint-Martin.

In 1814, a new decree split the Prussian blue factories into two classes. In the first class were establishments:

> where fumes and hydrogen sulphide gas are not burnt. (…) Establishments and Works which will not be set up anymore in the vicinity of private homes, and for the creation of which it will be necessary to secure the authorisation of His Majesty in his Council of State.

Factories which burned fumes and hydrogen sulphide gas belonged to the second class (*Nomenclature des manufactures* 1814):

> Establishments and Works which need not absolutely be relegated from dwellings, but which will not be allowed to set up until it has been established with certainty that the operations to be performed will be carried out in such a manner as not to inconvenience the neighbouring owners, nor cause them any damage. In order to set up such establishments, authorisation from the Prefect will be required, unless an appeal is lodged with the Council of State.

Thanks to these regulations, the archives have retained a number of applications for permission to open Prussian blue manufactures, such as that of M. Léro (*Rapport, projet de décret et projet d'avis* n.d.):

> REPORT from the minister of manufactures and commerce on December the 9th, 1812
>
> Sire,
>
> Mr Léro, colour merchant, operates a Prussian blue factory currently located at 36 rue Neuve-Saint-Nicolas, quartier de la porte Saint-Martin. Complaints having arisen against this factory because of its location, Mr Léro has requested authorisation to transfer it to 8 rue d'Aligre in the Saint-Antoine outskirts. The *commodo et incommodo* inquiry which the préfet directed gave rise to some opposition, mostly based on the fact that in general Prussian blue factories may exhale an inconvenient odour. But the *préfet de police* and the *conseil de préfecture* have made sure that M Léro used processes which alleviated such an inconvenience. This is indeed what the *conseil de salubrité* observed, in the presence of which he operated. Also, the *architecte-inspecteur de la petite voirie* visited the locality; he found it suitably arranged. The *préfet de police* and the *conseil de préfecture* therefore believed that the authorisation requested must all the more willingly be granted, as it gives the factory of M Léro a much more suitable site, from a public sanitation point of view, than that it currently occupies; anyway, in the Manufacture of Prussian blue, obligation will be made for him to use the disinfecting processes indicated in the *conseil de salubrité* report. I wrote to that effect the Imperial decree project herewith enclosed; I have the honour of submitting it for your Majesty's approbation.

I am with the deepest respect, Sire, Of your Imperial and Royal Majesty the very-humble, very-obedient and very-devoted servant and very-faithful subject,

le comte de SUSSY.

Or that of M Chastel (*Rapport, projet de décret et projet d'avis* 1813):

REPORT from the minister of manufactures and commerce on April the 7th, 1813

Sire,

M Antoine Chastel requests permission to establish a Prussian blue factory in a house belonging to him, located at 10 Paris at rue des Bourguignons, faubourg Saint-Jacques. Establishments of this kind being included in the first class of the nomenclature appended to the Imperial decree of October, the 15th, 1810, the préfet de police had the request posted in the quartiers of Observatoire, Saint-Jacques and Saint-Marcel. No opposition surfaced. The *architecte-inspecteurde la petite voirie* visited the site and found it well suited for its intended use. The *conseil de salubrité* advising the *préfet de police* saw no inconvenience to the realisation of the establishment under the project. Finally, the *préfet de police* believes that permission should be all the more easily granted as the house of Mr Chastel is located at the extremity of the faubourg Saint-Jacques and isolated from any other habitation. As a result of these considerations, I do not hesitate, Sire, to submit to your Majesty the imperial decree project herewith enclosed.

Le comte de SUSSY

These two authorisations were granted. It seems that the productions from these two establishments were never distinguished in the Parisian *Expositions des produits de l'industrie nationale*.

The expansion of production under the Restoration

The fall of the Empire did not stop the growth in the number of Prussian blue factories. In 1818 the following report from Mérimée (1818)[27] appeared concerning the Drouet establishments:

Gentlemen, there exist in Paris and France several manufactures where Prussian blue is prepared; but they mostly make paste blues, which are sold moist. Our colour merchants still obtain from abroad almost all of the blue which is used in oil painting and wash.

These considerations persuaded you, fifteen years ago, to offer a prize for the preparation of Prussian blue of first quality.

[27] Jean François Léonor Mérimée (1757–1836), painter and chemist. He was the father of the author Prosper Mérimée (*Carmen*) and the uncle of the physicist Augustin Fresnel. He spent his whole life researching colours and varnishes used by painters, attempting to rediscover the old recipes. In 1802, he was named a member of the body in charge of pronouncing on the objects admitted to the *Exhibition of Products from the Industry* organised by Chaptal in Paris. He would play a large role in creating the Société d'Encouragement pour l'Industrie Nationale of which he would become one of the Secretaries. He published in 1830, in Paris, a synthesis of his research work: *De la peinture à l'huile.* See P. Larousse (1866–1879: 'Mérimée (J.-F.-L.)' entry) and G. Pinet (1913).

One of the competitors [Gohin] prepared, in front of your commissioners, a large quantity of blue, which, when compared with the most beautiful specimens which could be procured in England, was found to be equally brilliant in colour. The conditions for the programme having been fulfilled, the prize was handed out; but the goal of our Society has not been reached; for none of our manufacturers has supplied the trade with blues more beautiful than before.

The success of the experiment which decided you to award the prize depended on the use of crystallised prussiate of potash, which at that time was expensive. Your commissioners objected that the high price of this salt precluded its use in a factory. Their retort was that it could be prepared very economically. One had to be content with this answer; but the proof of its inaccuracy lies in the fact that the process was abandoned straight away.

At this moment a former trader, M. Drouet, considers establishing in Paris a manufacture of superfine blue; and, in order to prove that he is in a position to deliver to the trade blues perfectly similar to the most beautiful blues obtained from Germany or England, he sent you several specimens which you charged us to examine.

Before anything else, we had to acquire proof that this blue had been made by the sender. We therefore invited M. Drouet to prepare a small quantity before us. He agreed without hesitation to our request, and the blue we saw him make seemed perfectly similar to the specimens.

We did not attempt in any way to know the process of M. Drouet, but it was impossible that we should not see that he uses crystallised prussiate of potash: a condition which must yield as a result perfectly beautiful Prussian blue.

Thus his process is the same as was used fifteen years ago and abandoned; but the circumstances are very different. It was then very expensive, it is not anymore today. The discovery of blue dye with prussiate of potash has oriented the research of several chemists toward the means to prepare this salt economically. Success was achieved, and, now that it can be had for 6 francs a pound, there must be some benefit to be found in using it.

We therefore think that the establishment envisioned by M. Drouet can be a success. It would even more, probably, if it were tied to a factory which would supply the raw materials without any expense other than that of gathering them. This will happen some day, and he who first gets wise to it will derive considerable profit; for, even though Prussian blue is not a fast colour, it is brilliant and is very much used in paper mills, wall-paper manufacture and decorative painting.

The blues from M. Drouet, tried out with gum and oil, appeared to us as brilliant in colour and as intense as any we have used, and we think the author cannot fail to arouse the interest of the Society if he manages to put up a factory which delivers to French consumers a colour we have to procure from foreign factories.

We have here, in a nutshell, a picture of the problems of Prussian blue production in France and of the identity of the industrial customers. As opposed to England, France produces this pigment only by the German processes which yielded second quality products. Processes using prussiate (based on the work of Macquer) were too expensive. On the other hand, a large part of the industrial customers consumed low quality blues, for wallpaper, painting and paper blueing, where Prussian blue is a substitute for blue ashes and smalt respectively.

At the 1819 National Exhibition in Paris, out of the seventy-two establishments presenting their products in the 'Chemical Industry' section, twelve made pigments and, among these, only three manufactured Prussian blue (Le Normand and Moléon 1824: 199–200):

- Gohin, 'colour producer in Paris, 3 rue Neuve-Saint-Jean, faubourg Saint-Martin, well-known for his colour manufacture, which ranks among the first in France, showed Prussian blues of different qualities, which he delivers at a price below that of the most beautiful foreign blues of the same grade. The colours are prepared in his manufacture with the utmost care.'
- Drouet, 'in Paris, 188 rue Saint-Denis. The Prussian blues of this manufacturer have been recognised, by the Société d'Encouragement, as superior to any other in the trade.'
- Desétables, 'paper manufacturer in Vaux-de-Vire (Calvados). The price of his Prussian blues varies according to quality. Pure, it sells for 16 francs a pound; mixed with alumina, for 5.50 F a pound; as a paste for the paper industry, for 1 F a pound.'

Among the cohorts of colour makers, a number of whom probably made Prussian blue on a small scale, the following were to be found in Paris: Bergeron (colour balls), Colcomb, Didier, Ferlier (blue, in balls) and the widow Wuy.

At the Paris National Exhibition of 1823 awards were made to (Héricart de Thury 1824):

- Vincent and Co., in Vaugirard near Paris, for prussiates of potash and soda, as well as for Prussian blues. Thus Vincent benefited from a glowing report from Payen concerning the quality of his yellow prussiates (Payen 1823b).
- Cartier *fils* and Grieu, in Pontoise, for Prussian blues.
- Souchon, pharmacist in Lyon, for prussiates of potash and soda.
- Raymond *fils* received a silver medal for his Prussian blue wool cloth dyeing process.

Yet the problem of French production quality seems not to have evolved very much as, in the same year, one reads from the pen of the chemist Pierre Robiquet (1823: 'Bleu de Prusse' entry, 211–25), concerning French productions of Prussian blue:

All producers are successful with paste blues, for, as long as these blues remain wet they retain their beautiful shade; but they rather often turn greenish when dried, and such is unfortunately the case of almost all of those made in France. The beautiful blues from Berlin do not present this defect. I have no doubt however that, when there will be the will to study and follow this operation with a modicum of perseverance, one will be able to get to the bottom of all the circumstances and master them. It has to be admitted, however, that this will require sagacity for the very reason that, as I stated, theory is not advanced enough yet to serve as a guide.

Four years later, the 1827 Paris National Exhibition cited (Héricart de Thury 1828):

- Vincent and Co., in Vaugirard (Seine), for 'a very beautiful assortment of Prussian blues'.
- Roux and Co., in Paris, '22 rue Saint-Maur, who receive a bronze medal for Prussian blue specimens of great beauty.'
- Souchon, in Paris, 19 rue Bleue, for his dyeing wool cloth blue with prussiate of iron.

Let us for a moment focus our attention on this 'rue Bleue', located in the faubourg Montmartre. In 1789, rue Bleue received its name and, for many years, played host to the laundry blue balls factory of Messrs Story and Wuy, soon headed by the widow Wuy. This is where the Lyon-originating Souchon (a prussiate manufacturer) sited his factory and although his attempts at dyeing wool cloths with prussiate had not reached a significant level of quality by 1825 (a report from the Société d'Encouragement states that 'the colour had well penetrated through the cloth, but that, from the point of view of brightness, there was something wanting' (*Coup d'œil* 1825: 190)), he would soon improve his production. At number 25 rue Bleue, the wallpaper manufacturer Leclaire, probably a large user of pigments, and blues particularly, would set up his factory in 1826.

Prussian blue in Japan

It seems that it was the Dutch who introduced Japan to Prussian blue. It was known by a family of painters practising in the Western style since 1763 at the latest, at which date it was mentioned in a text of the scholar Hiraga Gennai.

But it was mostly from 1826 onwards that surplus Prussian blue exported by Great Britain to China would arrive in Japan. Its price would progressively come down.

In the *Masaki no Katsura* of the editor Seisôdô Tôho, Prussian blue was referred to as the 'blue imported from China' the Western name of which was *berorin* (a deformation of the Dutch *Berlyns blaauw*). He declared that he had used it since 1829 to print poems, but stated that, at the time, this blue was not yet used for colour prints (*nishiki-e*).

Prices became radically lower in 1830, which explains the change in the situation. The first known occurrence dates from 1830. It is a monochrome sheet in shades of Prussian blue due to the fan maker Iseya Sôbei; it shows a view of the Sumida River by Keisai Eisen.

There followed then from 1831 onwards, the publication of the 'Thirty six views from Mount Fuji' by Hokusai. Upon this occasion, its editor, Nishimura Eijudô, brought out in 1831 an advertisement announcing the availability of:

'Thirty six views of Mount Fuji by the Master Hokusai
Sheets printed in Prussian blue
One scene per sheet
Issued one by one
Showing the different forms of the Fuji according to the view point
The series may go beyond the planned thirty six views.'

One of the most famous of these prints was named 'Under a Wave, off Kanagawa' (Figure 5.6). Out of the eight engraved woodblocks needed for its printing, four were set apart for shades of Prussian blue. This series met with such success that the use of Prussian blue in prints became common.

One cannot readily discard the notion that these factories for blue pigments with a high colouring power must have imparted this colour to their immediate vicinity. Thus the tract of land of Épluches, near Pontoise, where the Prussian blue factory of Cartier *fils* and Grieu was established would soon be referred to as 'The blue earths' on maps (Linquette 2002: 52). In the 1970s, children playing on the site of the manufacture would become blue.

As we have seen, pollution due to these factories was not only coloured, but also the gases produced were foul smelling and corrosive. This is shown by the evaluation carried out in 1827 in Bouxwiller (Bas-Rhin), which designates the Prussian blue factory adjacent to the Roman Catholic Church as responsible for the accelerated corrosion of the metal components of the works and the reeds of the organ. Already applying the principle 'the polluter pays', the Bouxwiller mines, owner of the factory, contributed part of the restoration expenses.

Production development

We have reached a period when Prussian blue was under attack in its traditional markets of paper and textile blueing from Guimet's artificial ultramarine. Both of these markets would be progressively lost. Yet its production would continue to grow. This can be seen through the rewards bestowed on the manufacturers at the National Exhibitions. Thus at the Paris National Exhibition of 1834 awards (Dupin 1836: vol. 3, 340 and 345):

- Ducoudré, in Paris, 27 rue du Roi-de-Sicile, who for five years had been making 'prussiate of potash and Prussian blue of high quality'.
- Pluvinet and Co., in Clichy, Pitay in Ivry-sur-Seine and Kesler in Boulay (Moselle), all three for their prussiate of potash.

The Mining Administration from Bouxwiller (Bas-Rhin), which had begun producing Prussian blue a few years earlier, was not present.

It is noticeable that, due to the development of Prussian blue dyeing, prussiate of potash now supplanted Prussian blue as a product of merchandise. As for dyes, medals were awarded to:

- Souchon, in Paris, '19 rue Bleue, prussiate of iron dyeing of cloth and merinos'.
- Merle and Malartic, in St Denis, 'prussiate of iron dyeing workshop. They present two cuts of casimir[28], one of them light blue, the other dark blue, of a superb sheen, even though dyed without indigo.'

These latter industrialists were enterprising people. They managed to convince Baron Thénard, President of the Committee for Chemical Arts of the Société d'Encouragement as well as various other members on the Committee to wear suits cut from a wool cloth dyed by them with Prussian blue. This was a masterly coup. Testimonials started to arrive: 'this dye withstands wear at least as well as indigo, and seams and other parts

[28] Casimir: light cloth of thin wool almost exclusively used for men's clothes.

of the garments exposed to friction do not whiten, even though the cloths experimented with were piece dyed.' A visit to the Merle establishment convinced the commissioners from the Société of the quality of the dyes and the volume of the trade involved, but these industrialists wished to keep their process a secret (Bussy 1837).

Five years later the following received awards at the 1839 Paris National Exhibition (Darcet 1839: 393–6):

- Ducoudré, in Paris, 5 rue du Coq-Saint-Jean, who 'occupies one of the top ranks among the producers of prussiate of potash and Prussian blue; he was the one who maintained production of prussiate of potash in France, even though it generated only losses for those manufacturers who attempted it; through a remarkable activity and a strict economy in its operations, by studying better than previously done the raw materials he could use, and even organising on a large scale the preparation of animal matters, M. Ducoudré reached his happy results, which contributed no little to the development of prussiate of potash manufacture at a time when the use of this salt for dyeing required large quantities.'

- Tilloy-Bérard, in Marsannay-le-Bois (Côte d'Or). 'The crystallised prussiate of potash which was sent to the 1839 Exhibition by M. Tilloy-Bérard is pure and always made without ropes through the centre of the masses of crystals and without any foreign salts being mixed. He delivers to the trade each month 700 kg of prussiate of potash of first quality, and always sells this salt at slightly below the going rate.'

- Mérolhon d'Anchel, in Médine near Nevers (Nièvre). 'He is the only manufacturer who exploits in Nevers the remnants of animals and busies himself with the preparation of fertilizers. This establishment is of great importance locally, for it uses up all the blood from the slaughter houses in the city, and gives a living to the poor of the area, who are employed to pick up the bones, horns and other animal remnants. M. Merolhon d'Anchel makes animal black, ivory black, animalised coal and Prussian blue.'

As a consequence of the raw material used, all these industrialists simultaneously made other products, in particular animal black[29] and ammoniacal salts. These products were of good market value too. Since this value remained stable while the price of Prussian blue kept coming down, it ended up with the blue being considered a by-product of ammoniacal salts preparation. Concerning Prussian blue dyeing, we find:

- Merle, Malartic and Poncet, Société du bleu de France, in St Denis (Seine), along with this comment: 'the application of Prussian blue to cotton and silk has presented much less difficulty than the application made of it to wool; even to-day, there is not a dyer of mediocre skills who does not know how to dye in blue the

[29] Animal black is used to purify molasses imported from the Western Indies during the production of cane sugar.

first two fabrics, while there is but a small number to dye wool well with this colouring matter, and we are referring particularly to felted wool cloth. (...)'

In 1860, the daughter of this Merle claimed from the Administration the 25,000 francs reward which, according to her, her father had deserved, 'who perfected the application of the prussiate of iron to the dyeing of wool'. This was probably the share not handed out to Raymond *père* of the 25,000 francs prize from 1811, amounting to 17,000 francs. Logically, it should have reverted to Raymond *fils*, but times had changed. The claimant was turned down following a negative report from Chevreul (Rufino 1991: 154).

In Lyon, the Guinon and Chabaud Works used a blue dye using a double cyanide of iron and tin. Taking advantage of the fervour accompanying the return of Napoleon's ashes to France (1840), they christened this particular shade of blue, 'Napoleon blue'. They would take part in the Paris Exhibitions until 1863.

Among the colour producers honoured for the first time was Milori, in Paris, (4 rue Barre-du-Bec) and in Montreuil, (261 rue de Paris). He was 'highly commended for his Prussian blues of very high colouring power'.

An altogether different domain appeared three years after the invention of the daguerreotype (1839) – a process for printing on paper with potassium ferricyanide called 'cyanotype', invented by Sir J.F. Herschel (1842). The process relied on the sensitivity of iron salts to light. On exposure to light, the salts turn from the ferric to the ferrous state. In the dark, an ordinary sheet of paper was covered with a mixture of ammoniacal iron citrate and potassium ferricyanide, and then dried. For printing, it was exposed to daylight for a few minutes in contact with a negative. Light changed the ferricyanide into ferrocyanide, which interacted with the ferric salt to form Prussian blue (Figure 5.7). This process, very economical, would survive mostly only for printing plans, for that reason named 'blueprints'.

A time for change

Whereas an earlier generation of authorities had rejoiced at seeing the Prussian blue industry use animal waste, thereby sanitising the slaughterhouses present in every city, the new generation wanted to see these by-products made into fertilizer, which agriculture desperately needed. It therefore became urgent to find new sources of nitrogen which could be used to make prussiates. England and France rivalled each other in ingenuity in this domain. The great interest which the French took in the English industry at this time probably is a reflection of the English advances in the field.

In 1838, a Frenchman, Delaunay, patented in England an improvement to the standard manufacturing process consisting in recovering the gases containing the nitrogenous products resulting from the ox-blood-based production, and directing them onto a mix of charcoal, iron and potash to recombine them into cyanides (*Procédé de fabrication* 1842). The same year, an Englishman, Thompson (1837–1838, 1840), revolutionised the production technology by suggesting Prussian blue be prepared not from ox blood

anymore, but directly from nitrogen in the atmosphere. The initial mix to be heated red to make Prussian blue or prussiates consisted then of potash coke and iron turnings. If it used coal rather than coke, one might think that it actually was the source of nitrogen since coal contains up to 10% of nitrogen by volume. But such could not be the case with coke, which had already been roasted, driving off the gases. Thompson presented his process to the 'Society, Instituted at London, for the Encouragement of Arts, Manufactures, and Commerce' (the future Royal Society of Arts) and submitted a sample. This was so interesting an innovation that the Society rewarded it with a Gold Medal. Soon thereafter, Swindells suggested a variant of the same process (*Fabrication perfectionnée* 1840).

The idea of using nitrogen from the air was really appealing. It would tempt other researchers – Fownes (1841) in England, who attempted the first experiments, as well as Possoz and Boissière in France. In 1843, in the former Payen factory located in Grenelle near Paris, Possoz and Boissière set up a pilot plant for the manufacture of prussiate of potash based on this principle. The reaction requires much higher temperatures: a white heat must be reached. This caused numerous technical difficulties, in particular the refractory materials used could not withstand high temperatures and the presence of potash. And the price of prussiate was highly dependent on the amount of fuel consumed. Furthermore, the savings made by not using nitrogenous materials were counterbalanced by the cost of deoxygenating the air. In 1843, the factory turned out 15 tonnes of prussiate. However, the high cost of fuels in Paris led the inventors to look for a more favourable location. They found it in 1844 in England, in Newcastle upon Tyne, where they erected a factory on behalf of an English company. It started producing 1 ton of prussiate of the best quality daily, which retailed for slightly under 2 francs a kilogramme (*Sur la fabrication des cyanures* 1848). In Germany, Bunsen too considered this problem (Bunsen and Lyon Playfair 1846).

In 1845, in London, Laming patented a process using ammonia as the nitrogen source, whatever its origin – urine, black from bones or animal matters, ammonium salts or even guano (*Perfectionnements* 1847). The idea was excellent, for this process did not require extreme temperatures, and the concentration of reactants could easily be controlled.

At the 1844 National Exhibition in Paris, two manufacturers, now classified under 'Chemical Products', were rewarded with Gold Medals (Péligot 1844: vol 2, 726–47):

- The Mining Administration of Bouxwiller (Bas-Rhin), 'the Prussian blue of which enjoys in the trade a long established and deserved reputation'.
- Ducoudré, in Paris, '5 bis, rue Saint-Maur. The yellow prussiate of potash exhibited by M. Ducoudré is of remarkable beauty; after the Mining Administration of Bouxwiller, the factory of M Ducoudré is the oldest. It is the only one apart from that of Bouxwiller to have worked without interruption for fifteen years, during the good as well as the bad times of this difficult production. By adding

blood and other animal waste to the charred residues resulting from calcination of the nitrogenous matter with potash, M. Ducoudré produces a fertilizer which, according to the analysis carried out by M. Payen, is classified by its nitrogen content as of being of better quality than the black from the refineries. Over the last three years, 30,000 hectolitres of this fertilizer have left the works of M. Ducoudré: the most honourable testimonials attest to its efficiency. M. Ducoudré also makes Prussian blues esteemed by the trade.'

Then came:

- Delondre, of Nogent-sur-Marne (Seine) and in Paris, 19 rue Vieille-du-Temple. Red prussiate of potash in crystal form. Within two months, he had sold 1,000 kg at 10.50 francs per kilogramme for dyeing silk and wool.
- Bergeron *fils* and Couput, in Vaugirard and in Paris, 9 rue Ste Croix-de-la-Bretonnerie. Prussiate of potash and Prussian blue for painting. As a technical innovation, the company uses the 'process adapted for manufacturing by MM. Possoz and Boissière', which consists in using nitrogen from the air instead of animal matters to act on coal and potash. If this process developed, 'it will enable the return to agriculture of the animal matters of which the ever increasing production of prussiates deprives it of in such large quantity; it will create for industry an everlasting source of cyanogen products. (…)'
- Ringaud the younger, in Paris, 73 rue-de-la-Roquette. Prussiate of potash and various kinds of Prussian blues.
- Martin de Saint-Semmera, in Paris, 11 rue des Francs-Bourgeois-Saint-Marcel. Prussian blues. 'This start-up factory deserves the jury's attention.'
- Wuy and Butet, in Paris, 54 rue de la Verrerie. For laundry blues and for Prussian blue in tablets.
- Darcel and Co., in Rouen (Seine Inférieure), prussiate of potash.
- Chevallier-Vuillier, in Dôle (Jura). Indigo blues for blueing and Prussian blues.

The following were distinguished among the 'colour manufacturers':

- Lefranc brothers, in Paris, 23 rue du Four-Saint-Germain. The factory, located in Grenelle, employed seventy-two workers and produced Prussian blue among various other colours for artists.
- Milori, in Paris, 4 rue Barre-du-Bec, and in Montreuil, 261 rue de Paris. Already internationally known for his Prussian blues, this manufacturer created a range of synthetic greens, based on Prussian blue to which he added chromium yellow and barium sulphate, the 'Milori greens', a range which would also become famous.

What can be derived from this listing of prize-winning companies? The impression of a very vital industry, having gone through a difficult period, but which, revitalised by *bleu Raymond* dyeing, had reached an important point in its development. Of the

companies created each year, the weaker had disappeared. The others had reached a size assuring them of a substantial position in the market.

It is hard to form an opinion as to their production. Fortunately, a text published in 1848 puts the annual consumption of animal matters intended for prussiate production at 3,000 tonnes (*Sur la fabrication des cyanures* 1848). Assuming an efficiency ratio of 50% in weight with respect to these matters, the annual production of Prussian blue and *bleu Raymond* would be of the order of 1,500 tonnes in France.

The Paris World Fair

In 1855 the first *Exposition Universelle* took place in Paris. The final report of the jury of the Chemical Arts opened with a synthesis, a paragraph of which dealt with prussiate of potash, distinguished as the basic product in this domain (*Exposition universelle de 1855* 1856: X, 471):

> The production of yellow prussiate of potash by calcination of animal matters with potash, in the presence of iron, was introduced in France in 1822 by the Administration des Mines de Bouxwiller, so cleverly headed by M. Schattenmann. Although the manufacturing processes have remained, in the main, identical since that time, several improvements in the way the process is led have much increased the prussiate yield with respect to the decomposed organic matter over what it originally was, and prices have gone down in proportion. Around 1825, the price of yellow prussiate was in the range of 12 to 13 francs per kilogramme; some ten years ago, this salt was still worth 7 francs, and it is now sold for 2 fr. 80 cent. a kilogramme.

> Several years ago a new process for the preparation of prussiate of potash emerged in England. It rests on the property inherent to a mixture of potash carbonate and coal to absorb at high temperature nitrogen from the air to form potassium cyanide, which, in the presence of iron, can easily be transformed into ferrocyanide. This process dispensed with the use of animal matters, a large part of which was wasted in the preparation of prussiate of potash, and thus promised to bring serious economies to this production. The expectations it bred have not materialised yet. The Exhibition hardly contained several rare specimens of prussiate prepared via this process, and furthermore their external appearance seemed to demonstrate that they did not come from a regular production established on a large scale.

> A certain amount of yellow potash prussiate is turned into red prussiate which has seen several applications since 1842 to calico printing and wool dyeing. M. King (Hurlet and Campsie) has shown the most beautiful specimens of this salt.

What should be made of the remark concerning the Possoz process? It seems indeed that this production floundered, probably because of the technical problems presented by the high temperatures required for its operation. The only further mention of this process regrets that it did not reach the industrial production stage. The same thing would happen to the attempts to produce prussiate of potash of Oedenwald near Fedenstadt (Black Forest) in 1858.

Among the exhibitors with awards we note:

- The Mining Administration of Bouxwiller (Bas-Rhin), 'which delivers yearly to the trade 400 metric tons of yellow prussiate of potash, 30 tons of red prussiate and ten tons of superfine Berlin blue'. This plant produced therefore around a third of the total French production.
- Coignet in Lyon, at the Guillotière. Prussiate of potash.
- King (Hurlet and Campsie Alum Works) in Glasgow, the main prussiate producer in the United Kingdom
- Zoeppritz, Württemberg. Prussiate of potash.

One would have expected a large increase in the number of citations of award winners. In fact, their numbers were very restricted. In particular, no mention is to be found of the works in Sulzbach (Germany) and Boskovice (Moravia, then a part of Austria). There were so many exhibitors that it became impossible to list the awards in spite of the increase in the size of the reports (which went from three to fifty volumes). Also, the Chemical Arts changed into the Chemical Industries and the reports only mentioned a selected number of syntheses putting forth the technical innovations, mainly concentrating on the major basic industries, linked to sulphuric acid, soda and chlorinated products.

At this time, the use of Prussian blue reached all the way to the Far East. Thus around 1857, it was commonly found in China for adulterating teas intended for England. The producers explained that they themselves never drink artificially coloured teas, but that foreigners seem to prefer them. Since Prussian blue was cheap, they saw no objection to its use, especially for the more expensive varieties of tea (Hassal 1855: 296; Hassal 1876: 123).

The coal gas revolution

The years 1850–70 witnessed the development of a new generation of processes which, once more, would revolutionise the manufacture of Prussian blues and prussiates. This is probably the reason why a treatise was published in 1858 by Kamrodt (1858), head of the assay laboratory for the Rhine provinces, detailing the various processes for the production of Prussian blue and prussiates from ox blood, the technical problems they presented, and solutions to overcome them and increase the yields. In fact, this was a technical evaluation of processes which were on their way out.

The new production techniques were linked to the prodigious development in the use of coal gas for heating and lighting, in both the domestic and urban sphere. This gas, particularly foul smelling, had to be purged of the ammoniacal and sulphurous products it contained. To that effect, it was pushed through cheap reactive matter, used as a 'scrubber', which became progressively loaded with ammoniated salts and cyanides. In 1850, Krafft patented in Paris the use of lime which had been used to scrub coal gas as a source of cyanides. This was revolutionary. There was no need to heat up the mixtures anymore to carry out the synthesis of prussiate. Serial washes would enable

the separate recovery of ammoniacal salts and ammonium prussiates, which would then be transformed into ammoniacal Prussian blues. A tonne of scrubbing lime would have supplied from 12 to 15 kg of this new type of Prussian blue (Krafft 1855).

It behove the Gauthier-Bouchard Works in Aubervilliers, near Paris, to perfect an economically sound industrial process around 1860. They used the second generation of scrubbing materials developed by Mallet (1891) in France in 1847. It consisted in a mixture of calcium sulphate and hydrated iron sesquioxide, aerated with sawdust. The calcium sulphate fixes ammonia, and the iron oxide fixes hydrogen sulphide and cyanides. These masses were washed and treated to obtain potassium cyanide to be used in prussiate manufacturing.

Prussian blue was obtained directly from the least concentrated washes through precipitation in the presence of ferrous sulphate in an acidic medium. The production cost of prussiate of potash was 2.75 francs per kilogramme. The sale price for these Prussian blues ranged from 3 francs per kilogramme for the lower quality to 5.57 francs for Prussian blue and 6.80 francs for *Berlin-flor blue* (Chandelon 1864).

> The blue thus directly obtained as a paste or undergoing desiccation finds itself endowed with a remarkable intensity of hue, roughly twice that of ordinary English blues for an equal quantity of dry substance. (...) With the help of the treatment described above, the inventor obtains from one cubic metre of residues from the works, 15 kilograms of Prussian blue. At the time of the Exhibition opening, the 1,500 cubic metres delivered by the Paris Gas Co. had produced 22,500 kilograms of Prussian blue. (Payen 1862)

Confronted by this process which would soon be adopted everywhere, many other suggestions were put forward for using ammonia as a nitrogen source. The principle was not new, but there were many technical difficulties that needed to be overcome. Still in pilot form at the International Exhibition in London in 1862, the process put forward by A. Gélis used carbon sulphide as the intermediary in a series of reactions between ammonium sulphides and thiocarbonates which eventually produced prussiate of potash (Payen 1862). According to the inventor, it would deliver prussiate for roughly 1.66 francs per kilogramme for a yearly production of 30 tonnes (Chandelon 1864).

A more classical approach could be found in the Kamrodt process (Kamrodt 1857), for which a patent had been taken by Johnson (1859). The Brunquel process would use ammonia to catalyse the formation at high temperature of cyanides from nitrogen in the air. As to the Margueritte and Sourdeval process, patented in France in 1860 and in England in 1861, it consisted in replacing potash with barium hydroxide, which greatly improved the yields (Margueritte and Sourdeval 1860). The resulting barium cyanide was converted into potassium cyanide (Payen 1862).

The Gauthier-Bouchard process worked very well. Indeed, in 1877, the Aubervilliers works produced 150 tonnes of paste blue intended for paper blueing (Laboulaye 1891: 'Bleu de Prusse' entry. In the Report on the Universal Exhibition of Paris in 1878 one could read (Lauth 1881):

Messrs Levainville and Rambaud (formerly Gauthier-Bouchard Works) have exhibited Prussian blue obtained by the process discovered by this Company in 1867 and which has since seen a wide-spread expansion. It consists, as is well known, in using used gas scrubbing material treated with lime and air. After several months of oxidation, the transformation takes place; the prussiate of lime thus obtained is treated with carbonate of potash, and the prussiate of potash is brought to crystallisation: the mother liquor serves to prepare Prussian blue.

Numerous plants would convert to this process, including that of Sulzbach. The cost of *bleu Raymond* dyeing would never cease to come down. Yet it would soon be abandoned.

The end of bleu Raymond

This period also underwent another major upheaval: the appearance of synthetic dyes. Indeed, it was in 1860 that the blue dyeing of silk with a synthetic dye, azuline, was started in France. The first establishment to practise it was the Guinon, Marnas and Bonnet Works in Lyon, the very same which had invented Napoleon blue based on iron and tin cyanides.

Azuline would soon be displaced by the Lyon blue discovered by Girard and de Laire, thereafter by a long sequence of synthetic dyes, each more efficient and easier to use than the one before. In 1865, at Guinon, Marnas and Bonnet, *bleu Raymond* dyeing was but a memory (Turgan 1865). Silk dyeing plants would quickly adapt. The disaffection for *bleu Raymond* was quick and almost total. It remained in use (particularly in Lyon) for dyeing silk black, a role in which it was appreciated for giving weight and facilitating the take-up of tannins (Moyret 1880). Tannins probably reacted with the ferrous ions of Prussian blue to yield black coloured compounds belonging to the ferrogallic complex family.

As the demand for prussiates had decreased considerably, cyanide production underwent a prolonged eclipse. It would find a new outlet with the growth in the use of 'carbon paper'. Perfected in the year 1860 by L.H. Rogers in the United States, these copying papers constituted the best solution to the thorny problem of duplicating administrative, commercial or banking documents, following the appearance of the typewriter in 1867 in the United States. Copies were made in black or in blue. In the latter case, the very fine paper was coated with a mixture of Prussian blue (21%), paraffin (20%), Vaseline (20%), mineral oil (15%), carnauba wax (10%), mountain wax (4%) and kaolin (10%).

In a rather similar vein, Prussian blue was used to colour inks, in particular printing inks (Figures 5.8 and 5.9). For inks intended for writing, soluble Prussian blue was used, with the addition of one eighth of its weight in oxalic acid. Marks made with these inks resist oxidising erasers (based on potassium permanganate for example) perfectly as well as the action of water and light. They are destroyed by alkali, but regenerated by an acid wash (Casey 1940). They are, in other words, safety inks.

Above all, it was the development of gold ore treatment by lixiviation with alkali cyanide solutions in 1887, which got production going again. Let us look at a German example. In 1870, Zimmermann worked for the Kunheim firm which made Prussian blue. He perfected a process for recovering cyanides from the coal gas scrubbers. In 1880, he took off on his own, and created with his brother a Prussian blue factory in Wesseling, on the Rhine. Timing was, of course, poorly chosen, and things did not go too well. In 1889, Roessler, from Frankfurt am Main, which refined gold and silver, took a share of the company in order to cheaply secure the potassium cyanide it needed. After several mergers, in particular with Vossen (which made *Vossen blau* in Neuss) and Manox Ltd. (which made Manox blue in Manchester), in 1959 the resulting firm became part of the Degussa AG group, where it is in charge of Prussian blue production.

Evolution of the price of Prussian blue

Figure 5.10 summarizes the change in the price of Prussian blue over two centuries. It is based on the prices previously cited. In order to compare prices given in such diverse currencies, we used their gold equivalent. On a given date, the distribution of points matches the differing qualities sold. For example, in 1819, in the range sold by the Desétables Works, the lowest price corresponds to the paste intended for blueing paper; the highest, to pure blue of the best quality.

Besides an exponential decrease in price, we observe that between 1820 and 1860, due to the importance of *bleu Raymond* dyeing, the price of yellow prussiate was of paramount importance.

Prussian blue today

Prussian blue is still used by artists, for pastels and oil or water colour paints, but not in acrylic paint. Today, as before, this use corresponds to a very small percentage of its total production. In 2006, the worldwide use of Prussian blue amounted to 12,000 tons. It was spread over three main items (by weight percentage): inks at 70%, agriculture at 20% and paints at 10% (Degussa AG data).

The high proportion of use of Prussian blue used to colour printing ink is a result not only of the increased use in colour printing but also to two qualities peculiar to this pigment. First of all, this pigment colour is quite close to the theoretical cyan colour. Second, Prussian blue is transparent in fatty media, which facilitates superpositions during colour printing.

In agriculture, Prussian blue is used to colour fungicides used in vineyards. The habit of colouring the grape leaves blue seems to be specifically French and dates back to the nineteenth century. Vine growers treated their grapes with copper sulphate to avoid them being stolen. The dramatic mildew epidemic of 1882 showed that sulphated vines were spared. Hence the generalisation of such treatments and later of those with Bordeaux mixture. The toxic character of such salts raised alarms, and they were

replaced in the 1930s by zinc (or manganese) ethylene-bis-dithiocarbamates. These salts, judged particularly efficient against fungi and red spiders during tests, met with a certain amount of resistance on the growers' part. First, they were not blue; they should therefore be less efficient. Worse, they were colourless. As these treatments were not carried out by the growers themselves, but by contractors, it became impossible to know whether a particular vineyard had been treated or not, and whether the treatment had been properly administered.

It was therefore decided the new fungicides should be coloured, and the choice fell on blue out of respect for old habits. After consideration of the various pigments and dyes available, Prussian blue was chosen. It was applied together with fungicide in ratios of between 2% to 8% by weight. With use this Prussian blue deposit on the leaves was seen to have a biological effect. Probably exchanging part of its iron with the leaf on which it had been deposited, it stopped chlorosis and increased the leaf chlorophyll content (*Bleu Vossen* 1986).

The use of Prussian blue as a specific medication for internal radionucleide contamination (caesium, thallium and indium) in the case of a nuclear or radiological event was also planned. It was its ability to exchange its iron ions with heavy metals which came into play here. The product is not yet used generally in France for that purpose. It is used in French military hospitals and medical facilities at nuclear installations.

Was Prussian blue the much awaited substitute for ultramarine?

The question does not really arise, except in the eighteenth century. The qualities of this pigment are remarkable. In terms of its colour, the dominant wavelength is almost the same as that for ultramarine (470 nm), and its saturation is extraordinarily high, of a level as yet unknown at the time. The result is that Prussian blue displays an astonishing colouring power. As with ultramarine, its low refractive index makes it transparent in organic binders. Furthermore, it is a siccative, which means it helps with the drying of oils, hence of the paint layer. Its strengths are therefore considerable. Among its weaknesses, we note that it is discoloured by sunlight and looks greenish under artificial light. Furthermore, it is far from being perfectly inert chemically, since it reacts in a basic environment. With its qualities and defects, being already considered as a possible substitute for indigo, could Prussian blue have taken the place of ultramarine? It would seem not.

We saw that in 1749 Macquer (1753) wrote: 'Prussian blue, shining colour with which Chemistry has enriched Painting in these last few years, and which we see everyday complementing so happily ultramarine in our best paintings. (...)' 'Complementing' ultramarine, not 'replacing' it.

This notion of substitution does not even come to the mind of the author of the article on 'lapis-lazuli' in the *Encyclopédie* (1751–1765, 9: 'lapis-lazuli' entry), who, more than

fifty years after the beginning of the use of Prussian blue for painting, is of the opinion that:

> It is from pulverised lapis that is drawn the precious colour of ultramarine blue, so dearly paid for by Painters, and for which one could only hope that Chemistry could substitute some preparation which would have the same resilience and the same beauty, without being of an excessive price.

The chemist Thenard, searching for new blue pigments in liaison with the painters Vincent[30] and Mérimée, was much more critical. Talking of replacing ultramarine, so expensive that its use was at the time confined to miniatures, he wrote (Thenard 1803–4: 130):

> In any other circumstance, one is almost always forced to use Prussian blue. True, this blue is indeed exempt of most of the drawbacks presented by azure [azurite]; it is truly celestial and so intense that it appears black; it is easily reduced to a powder; it can be mixed with oil as well as with gum; it gathers at last all of these qualities, except for one, fastness. But this failure is the one most to be feared, since it cannot be remedied. Cast the eyes on a modern painting; the sky, at first admirable, soon loses its vividness; it becomes altered, promptly turns green, and thence one cannot recognize in it that of nature.

Mérimée (1830: 178) expressed himself on his own thus:

> This colour would be one of the more precious, if it had fastness: it is most intense, is easily painted, dries quickly; but it loses its sheen, turns greenish, and grey when exposed to a strong light.

The case was therefore closed. It is probably for this lack of durability that Prussian blue did not displace ultramarine in artistic painting.

However, the link between these two pigments remained in the minds of many. Witness the prize offer written up between 1789 and 1812 by the Society for the Encouragement of Arts, Manufactures and Commerce of London (*Premiums offered in the Year 1812* 1813: 12)[31]:

> 82 – BLUE PIGMENT FROM IRON – To the person who shall invent, and discover to the Society, the best blue pigment from iron, superior to Antwerp or Prussian blue in colour and durability, fit for use in oil or water, which may be afforded at a cheap rate; the gold medal, or thirty guineas.

> One pound weight of the colour, and a full disclosure of its preparation, to be produced to the Society on or before the first Tuesday in February, 1813.

[30] François André Vincent (1746–1816). A student of Vien, he was a historical painter who built his career in Paris. J.-F.L. Mérimée and Horace Vernet were his students.
[31] This offer was maintained in 1813 and 1814.

This offer evidently concerned an improved Prussian blue, but let us read the rest:

> N.B. It appears from the analysis of lapis lazuli by Klaproth, and the experiments of Guyton, (related in the *Annales de Chimie*) that ultramarine is a blue sulphurate of iron, and that a blue substance much resembling it is constantly found amongst the scoriae of blast furnaces where iron is reduced. The Society by offering the above premium wishes to call the attention of persons to these facts, and encourage them to make experiments, in the hope of producing a blue pigment which may be substituted for ultramarine.

The discovery of the presence of iron in lapis lazuli – quite correct, but due to the presence of pyrite and not the blue mineral, the lazurite (cf. Chapter 3) – led to a totally erroneous link between Prussian blue and lapis lazuli, very symptomatic of a mindset. We are therefore still at the starting point: the search for a substitute for ultramarine.

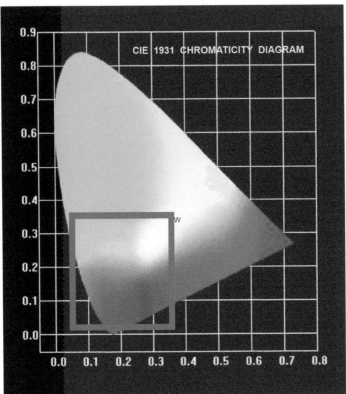

Figure 1.1 Colorimetry.

Upper graph: classical representation of the two-dimensional CIE 1931 chromaticity diagram or colour space (see Appendix). The rectangle delineates that area of blue shades of interest to us, which will be represented in the lower graph.

Lower graph: a comparison between the shades of an artificial ultramarine (OM32 from Holliday Pigments) mixed with increasing quantity of white pigment (solid circles), of the caerulea found in Pompeii, a Roman version of *hsbd iryt* (solid squares), and of crushed azurite (triangles). As the concentration in ultramarine increases, the tints of white and ultramarine combinations evolve from white (0.31; 0.31) to the most saturated blue (0.17; 0.09). The colours of Egyptian blue and azurite are indistinguishable. They are greener than ultramarine.

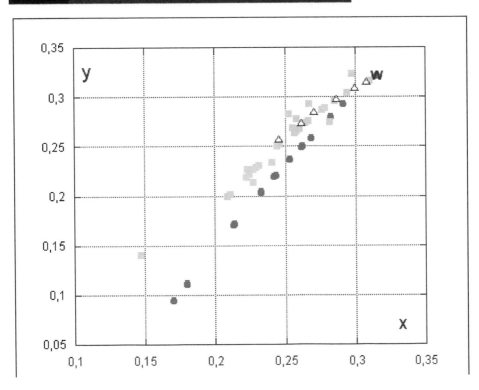

Figure 1.2 Tell el-Amarna. Flinders Petrie's excavations. Pot used as crucible intended for *hsbd iryt* manufacture. Some *hsbd iryt* remains, stuck to the clay. Height 5.5 cm; rim external diameter: 8.1 cm. The volume of the crucible is around 120 cm³. UC 8986. Courtesy of the Petrie Museum of Egyptian Archaeology, University College London.

Figure 1.3 Tell el-Amarna. Vases decorated using *hsbd iryt*. Around 1350 BC. Courtesy of the Kunsthistorische Museum, Vienna.

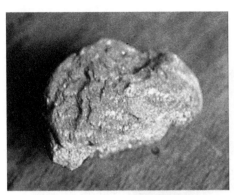

Figure 1.4 Glaucophane. Mineralogy Museum of the École des Mines de Paris.

Figure 1.5 The oldest testimonial to the use of *caeruleum* by Roman painters comes from Pompeii, with the polychromy of this earthenware plaque, which was re-used *c.* 140 BC to fill a gutter. Courtesy of and photograph by: M. Tuffreau-Libre.

Figure 1.6 Detail from a mosaic made from pellets of *caeruleum*, broken in two, used as tesserae. Used in this manner, the colour of *caeruleum* seems particularly saturated. Pompeii, house of the golden bracelet. Triclinium, the nymphæum's fountain (AD 40). Photograph: A. Barbet.

Figure 1.7 *Caeruleum* taken from one of the pellets found on the wreck of Planier 3. Courtesy of A. Tchernia. Photograph: the author.

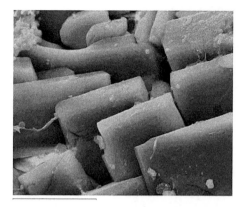
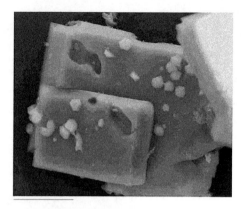

Figure 1.8 *Caeruleum* taken from one of the pellets found on the wreck of Planier 3. It is made of well-formed cuprorivaite crystals, without a glassy phase. The spherules spread over the surface contain tin from the bronzes used as raw material. The holes – characteristic of cuprorivaite from antique wrecks – were drilled by marine animals. Scanning electron microscopy. The bar, corresponding to a length of 10 μm, gives the scale of magnification. According to Delamare (2003).

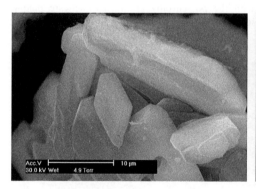

Figure 1.9

To the left: a grain of caeruleum from the wreck of Planier 3. One can see the glassy matrix behind the cuprorivaite crystals. The bar under the photograph corresponds to a length of 10 μm. As in the previous picture, the use of bronze as a source of copper is revealed through the presence at the surface of the cuprorivaite of spherules rich in tin.

To the right: an enlargement of one of these spherules. Scanning electron microscopy. According to Delamare (2003).

Figure 1.10 Global composition of various manufactured lapis lazuli.
Upper figure: productions from Egypt (fourteenth century BC) and from Mesopotamia (ninth–seventh century BC). Analyses performed via atomic absorption (Tite *et al.* 1984).
Lower figure: productions from Italy (Giens madrague, c. 60 BC) and Roman Gaul (first–third century). Analyses performed via neutron activation (Blet *et al.* 1997).

Figure 1.11 Polished slice of an *uknû merku* fragment found in Nimrud (*c.* 500 BC). *To the left*: in light grey, the cuprorivaite crystals ensconced in the vitreous matrix [in grey] where they were born; in black, quartz crystals, and, to the centre, a round hole. *To the right*: a detail showing how newly formed cuprorivaite crystals are located at the interface quartz [black]/vitreous matrix [in grey]. Scanning electron microscopy. According to Etcheverry (1998).

Figure 1.12 Pompeii. Pots containing unused *caerulea*, as pellets, powder or rocks. Note the differences in the tints. Photographs: the author.

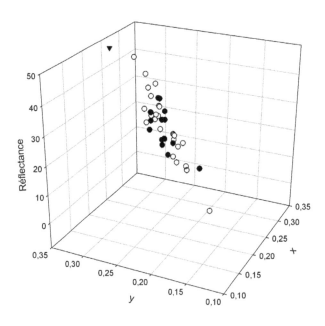

Figure 1.13 Colorimetry. Distribution in the CIE 1931 colour space (see Appendix) of points representing the colours of unused caerulea found in Pompeii. The point located toward the reader is the deepest and most saturated blue. The points farther away are lighter and more luminous. Due to the measurement technique, the curve is somewhat noisy along the reflectance (vertical) axis. According to Delamare *et al.* (2004).

Figure 1.14 Colorimetry. Same data as in the previous figure, projected on the xOy basal plane. Points group around a curve (geodesic) which materializes the fact that all these tints correspond only to a unique wavelength close to 477 nm. Compare to Figure 1.1. 'W' represents the achromatic point (white). According to Delamare et al. (2004).

Figure 1.15 Colorimetry. CIE 1931 colour space. A comparison of the colours of *caerulea* from Pompeii with those found in Gaul. All are grouped around the same curve. According to Delamare *et al.* (2004) (□) and Blet *et al.* (1997) (○).

Figure 1.16 Ref. 9555 *caeruleum* found in Pompeii observed through optical microscopy. We can distinguish the intense blue grains of cuprorivaite, the transparent grains of quartz and the grains intermediate in colour, quartz undergoing transformation or cupro-wollastonite. Granulometry seems unimodal, and centred at around 100 µm. However, X-ray diffraction shows the addition of aragonite. Consisting of particles one hundred times smaller, they can be seen only with a scanning electron microscope. Granulometry is therefore actually bi-modal. According to Delamare *et al.* (2004).

Figure 1.17 Ref. 10106A *caeruleum* seen through a scanning electron microscope. Colours disappear, but important magnifications and EDX elementary analysis are possible. Among these grains which clearly result from grinding and seem similar, EDX identifies cuprorivaite (grains 2, 11, 12, 14), cuprowollastonite (10), the vitreous matrix (3, 4, 5, 7, 8, 9, 13), silica (1) and a zircon surrounded by cuprorivaite (6). According to Delamare *et al.* (2004).

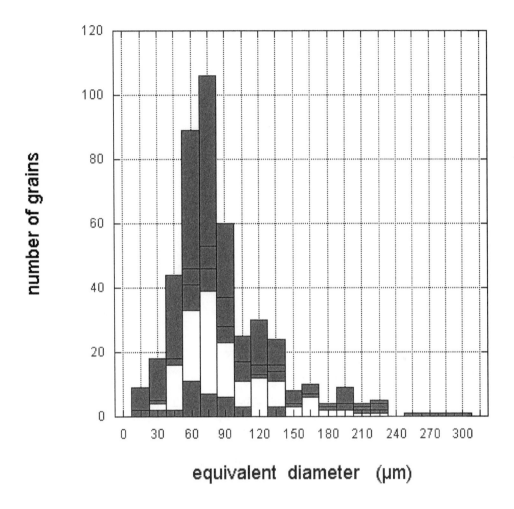

Figure 1.18 Typical granulometric distribution of a *caeruleum* found in Pompeii as measured on photographs similar to Figure 1.16. The asymmetry of the distribution is due to the difficulty in observing by optical microscopy particles, the dimensions of which are less than five μm. The areas shaded grey represent cuprorivaite and glassy matrix grains; the white areas, quartz grains. According to Delamare *et al.* (2004).

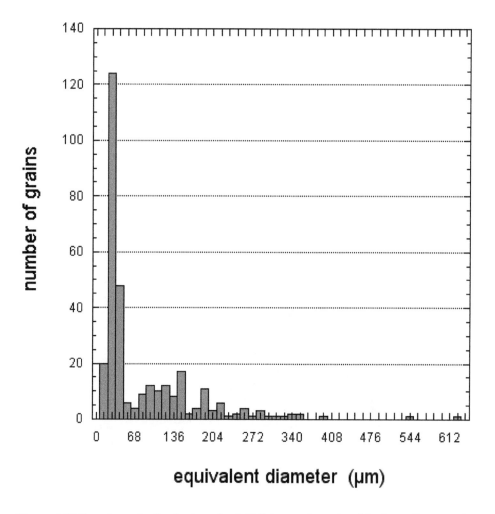

Figure 1.19 Granulometric distribution of ref. 3991A *caeruleum* found in Pompeii. It reveals a mixture of two powders of different granulometry. Examination by X-ray diffraction shows the rough powder to be a copper-tinted blue glass and the fine powder to be a *caeruleum*. According to Delamare *et al.* (2004).

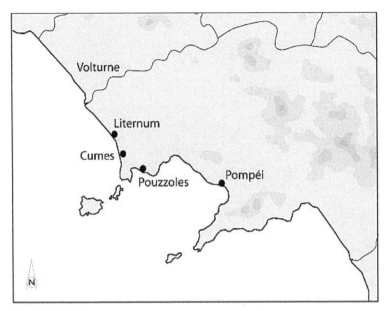

Figure 1.20 Campania (Italy). Cities manufacturing or using *caeruleum*. Courtesy of L. Cavassa. (Cavassa *et al.* 2010).

Figure 1.21 Roman crucibles used in Campania for the manufacture of *caeruleum*. *Left*: the only whole crucible unearthed from the Liternum site. Exceptionally, it was not used as a crucible, but as an enchytrismos burial for a child. Height: 51 cm (courtesy of the Dr P. Gargiulo).
Right: one of the two types of crucibles found in Cumae, of the shape called 'closed'. Unknown height. The other type ('open') is very close to the crucible shown on the left. Courtesy of the Jean Bérard Center (Naples).
Drawings by L. Cavassa. (Cavassa *et al.* 2010).

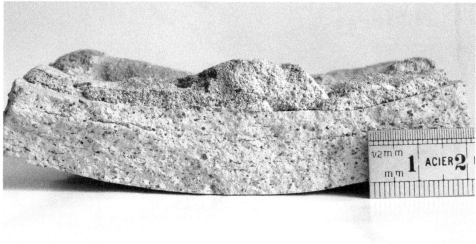

Figure 1.22 Cumae. Crucible fragment covered with a residual *caeruleum* layer, as seen from the top and the edge. It comes from a dump from the Flavian times (AD 69–96). The ceramic paste, containing volcanic inclusions, was of local origin. Courtesy of the Jean Bérard Center (Naples) and of L. Cavassa. Photographs: the author.

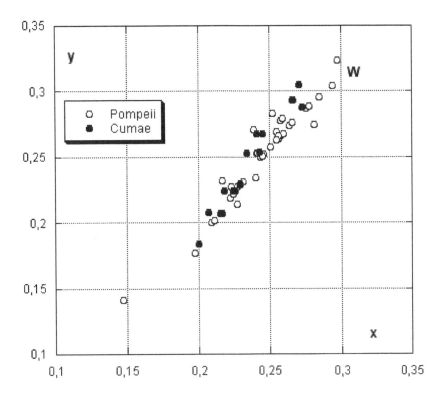

Figure 1.23 Colorimetry. CIE 1931 colour space. A comparison of the colours of blue pigments found in Pompeii and Cumae. (Cavassa *et al.* 2010).

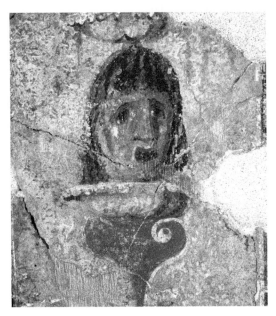

Figure 1.24 Aix-en-Provence, France. Detail from the décor of a house. Parking Pasteur excavations. Second half of the first century AD (influence from the 4th Pompeian style). Photograph: A. Barbet.

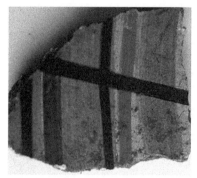

Figure 1.25 Glanum (St Rémy de Provence, France).
Left: fragment of a 'baroque' marble imitation from the XXXII portico, 2nd Pompeian style, dating from the years 40–30 BC.
Right: macrophotograph of the same fragment showing that the blue paint layer consists in a *caeruleum* dispersion in a white medium, calcite here.
Courtesy of A. Barbet. Photographs: the author.

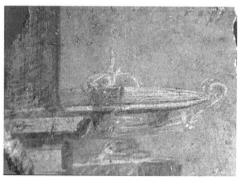

Figure 1.26 Lero (Ste Marguerite island, Alpes-Maritimes, France).
Left: restitution of the black and celadon green décor of the sweat room (laconicum) [around AD 15] as a model (Sea museum, Îles de Lérins, France), according to Barbet *et al.* (1999a).
Right: a fragment of this décor.
Photographs: A. Barbet and the author.

Figure 1.27
Left: a macrophotograph of the green paint layer showing the presence of *caeruleum* grains mixed with green earths (celadonite and glauconite).
Right: *caeruleum* extracted from this layer. One can distinguish blue grains (cuprorivaite and glassy matrix) and colourless grains (quartz).
Photographs: the author.

Figure 1.28 Evolution of *caerulea* prices according to Pliny and the Maximum Price Edict. The two dots materialize the price range, depending on the quality of the pigment. In order to facilitate their comparison their prices are given in 'grammes of gold per kilogramme'.

Figure 1.29 Auxerre, France. *Trompe l'œil* capital in the Carolingian decoration n°12 (*c.* 850) of the St Etienne oratory, located in the crypt of the St Germain Abbey (Auxerre, France). Pigments used were a yellow ochre (kaolinite + goethite), probably of local origin, and a sandy red ochre (quartz + kaolinite + haematite). Photograph: the author.

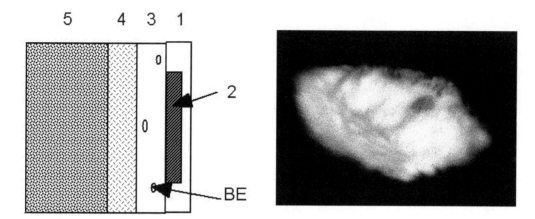

Figure 1.30 Auxerre, *trompe l'œil* capital from decoration n°12.
Left: stratigraphy of layers in a red area: (5) wall, (4) grey primer, (3) whitewash containing a few *caeruleum* grains (BE), (2) lacunary red paint layer, (1) modern polymer protective film (Paraloid B). *Right*: micro sample showing a grain of *caeruleum* ensconced in an undercoat of carbonated lime. According to Delamare and Cadet, unpublished work, 1998.

Figure 1.31 Scanning electron microscope observation of the *caeruleum* grain shown in the Figure 1.30. It is a cuprorivaite crystal, still partially ensconced in its calcite sheath (top). If the grinding it underwent deprived it of its crystal equilibrium shape, in table form, it revealed the sheet structure of this silicate. Another aspect of the crystal structure is revealed by the etching holes present on its surface, all oriented the same way (bottom). According to Delamare and Cadet, unpublished work, 1998.

Figure 1.32 Carolingian occurrence of medieval use of *caeruleum*. Head of a peacock near a fountain of life. Carolus Magnus' Gospels. (Bibliothèque Nationale de France, nal. 1203) dated from 781–783, folio 3, verso. Photograph: P. Roger (CNRS, Orleans).

Figure 1.33 Carolingian occurrence of medieval use of *caeruleum*. Adorned letter 'P' from the Winchcombe Sacramentary (Orleans municipal library, MS 127) end of the tenth century, folio 41. The high granulometry of the pigment is clearly visible in the enlargement. Photographs: P. Roger (CNRS, Orleans).

Figure 2.1 St Denis Abbey. Infancy of Christ window. Annunciation. Mid-twelfth century. Cobalt blue and vivid copper red. Abbott Suger (Sugerius AB[bas]) is shown fallen down at the Virgin's feet. Photograph: the author.

Figure 2.2 Smalt grain within the sheet of Dutch paper that it azures (eighteenth century). Its cobalt content is 2.0% in weight. The circular shapes are traces left by the laser ablation analytical method. Optical microscopy. Courtesy of B. Gratuze (CNRS, Orleans).

DE RE METALLICA

Sed qui carent prima fornace, hi, cùm munus diurnū perfecerint, uefperi

Figure 2.3 Glassmakers' ovens. According to Agricola's *De re metallica* (1556). Courtesy of the library of the École des mines de Paris.

Figure 2.4 A major part of the *azulejos*, these scenes realised with majolica tiles, decorated with zaffre, which decorated Portuguese palaces and monasteries during the seventeenth and eighteenth centuries, were made in Holland. Porto, cathedral. Photograph: J. Delamare.

Figure 2.5 European earthenware (Delft and Moustiers) and Chinese porcelain (bottles from the Kang Hi period) decorated with zaffre. Private collection. Photograph: the author.

Figure 2.6 S^te Marie-aux-Mines. Smalt manufacture. Layout of the ground floor housing the mills. Archives of the Académie des Sciences, 'Investigation of the Regent'. Courtesy of the Académie des Sciences de l'Institut de France. Photograph: Mr Plouvier.

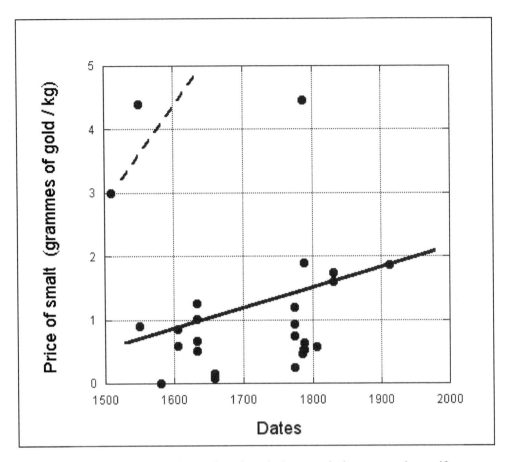

Figure 2.7 Evolution of the price of smalt. In general, the texts rarely specify whether they deal with production or sale prices. In 1550, the lower price was the sale price in Saxony; the higher price, the sale price in Holland. The very low prices of 1659 correspond to the worst moment immediately following the Thirty Years' War. The lower curve shows the progression in price for first quality Saxon smalt. The upper curve sketches the evolution of the price for high quality Dutch smalt.

Figure 2.8 Smalt blued paper made in Holland (second half of the eighteenth century) seen through a binocular magnifier with two magnifications. The smalt grains can be seen between the cellulose fibres. The grain on the right is roughly 50 μm long. Courtesy of B. Gratuze (CNRS, Orleans).

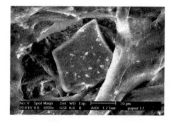

Figure 2.9 Same paper observed by scanning electron microscope. A smalt grain set in cellulose fibres. Courtesy of M. Blet-Lenormand (CNRS, Orleans).

Figure 2.10 Observation through a binocular magnifier of an Italian white paper containing blue fibres dyed with indigo (c. 1790). Photograph: the author.

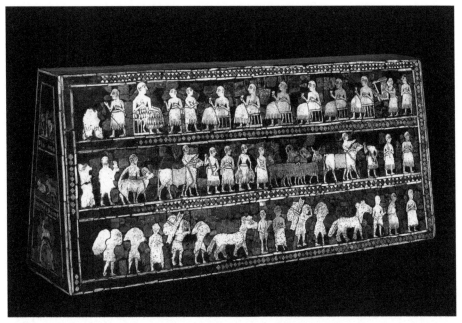

Figure 3.1 Standard of Ur, 'Peace' panel. This Sumerian artifact excavated from the ancient city of Ur (2550 BC) depicts Sumerian people bringing animals, fish and other goods in procession to a banquet. This mosaic is made of lapis lazuli, red limestone and shell fragments glued to a wood panel by bitumen. Courtesy of the Trustees of the British Museum.

 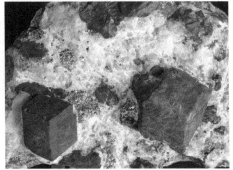

Figure 3.2 Streaks and crystals of lazurite in their calcite gangue. Golden iron pyrite is visible. Sar-e-Sang (Afghanistan) origin. Courtesy of the Mineralogy Museum of the École des mines de Paris.

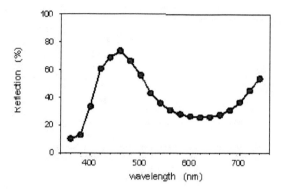

Figure 3.3 Visible light reflection spectrum of lazurite. The very high reflection of blues around 460 nm is accompanied by a weaker reflection of reds around 700 nm. This is what gives strictly S3- ultramarine the purplish component constantly attributed to Guimet ultramarine. According to Ledé (2005).

Figure 3.4 A comparison of the colours of an average quality lapis lazuli as a block, sawn and polished (to the right), and of the same reduced to a powder. The powder obtained is of too pale a colour to be of use as a pigment (cf. Figures 3.5 and 3.6). Courtesy of A. Djemaï, Mineralogy Museum of the École des mines de Paris. Photograph: the author.

Figure 3.5 Use of ultramarine in camaieu for illuminations. The Châteauroux breviary (between 1417 and 1422), folio 106, Municipal Library of Châteauroux, shelf mark 2. Courtesy of P. Roger (CNRS, Orleans).

Figure 3.6 Use of ultramarine for illuminations. The Châteauroux breviary, folio 254, Municipal Library of Châteauroux, shelf mark 2. Courtesy of P. Roger (CNRS, Orleans).

Figure 3.7 Evolution of the price for an ounce of top quality ultramarine (●) over the last six centuries. The price remained fairly constant, and close to that of an equivalent weight of gold (31 g). We notice the extent to which the price indicated in 1548 by Pino (186 g of gold) was unrealistic. Ultramarines of second and third qualities (□); ultramarine ashes (○).

Figure 4.1
Top: crystallised azurite from Chessy (France);
Bottom: a mono crystal of azurite from Chessy (France).
Mineralogy Museum of the École des mines de Paris. Photographs: the author.

Figure 4.2 Ground azurite prepared according to the recipe in the Bologna manuscript by S. Ovarlez. This azurite is very pure, but yellow-orange coloured impurities are visible. The coarse granulometry is centred on 85 μm. Observation under a binocular magnifier. Courtesy of B. Monasse, École des mines de Paris.

Figure 4.3 A non-ground azurite grain observed under a higher magnification via optical microscopy. Courtesy of B. Monasse, École des mines de Paris.

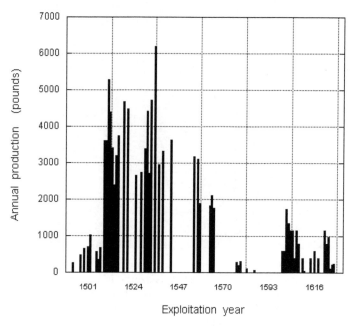

Figure 4.4 Commercialised production of azurite from the Saarland mine of Wallerfangen between 1493 and 1626, counted in pounds of 477 g equivalent. Four years without any production (1503, 1508, 1526 and 1534) are attributed to the plagues. For the other years, zero values correspond to a lack of data. The graph covers the infancy, full production and the decline of the mine. After 1593, data correspond to available azurite production. According to data from N. Engel (1997).

Figure 4.5 Phial of 'bleu cendré' from the paint box of J.-H. Fragonard preserved at the Villa Fragonard, in Grasse (France). Courtesy of musées de Grasse.

Figure 4.6 Eighteenth century wallpapers with a blue background.
Left: 'Domino'. Unknown workshop (Paris?) c. 1770. The colour turned green over time.
Right: wallpaper panel with arabesques (detail from the lower part). Jacquemart & Bénard Manufacture, formerly Réveillon, Paris, 1794.
Courtesy of the Musée du Papier Peint (the Wallpaper Museum) in Rixheim (France).

Figure 4.7 Panoramic wallpaper 'the Eldorado' (strips 1 to 6). From a model of Joseph Fuchs, in collaboration with Eugène Ehrmann and Georges Zipélius, Jean Zuber and Co. manufacture, Rixheim, 1849 (modern printing). Courtesy of the École des mines de Paris. Photograph: the author.

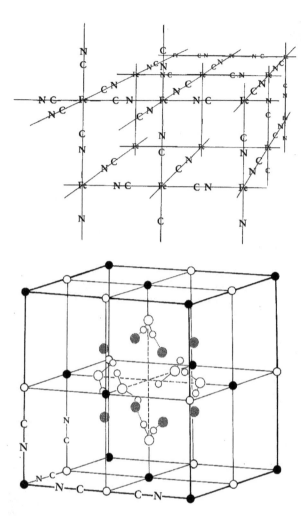

Figure 5.1

Top: Prussian blue crystal mesh. According to Ludi (1988).

Bottom, at the mesh nodes: ferrous (FII) ions (black dots) and ferric (FeIII) ions (white dots). Inside, coordinated (white dots) and zeolitic water molecules (the latter represented by its oxygen atom, in grey).

Figure 5.2 One of the two Prussian blue phials in Fragonard's box. Villa Fragonard, in Grasse, France. Courtesy of musées de Grasse.

Figure 5.3 Hangings and bed decoration from the Grand Brothers house in Lyon, made between 1817 and 1819 from a design by Saint-Ange. It is of Raymond blue dyed silk velvet embroidered and brocaded in gold. Paris, Musée du Louvre, King's bedroom. Photograph: N. Delamare.

Figure 5.4 *Bleu de France* (French blue). 'Prussian blue background with white and yellow print, discharging with a Scottish press, from Mr. Muir Brown and C° in Glasgow'. According to Persoz (1846). Photograph: the author.

Figure 5.5 An exemple of *Bleu de France* print. Woolmuslin with cashmere motive with a reserve under the blue. Kœchlin Brothers (?), Mulhouse, *c.* 1850. Courtesy of the Musée de l'Impression sur Étoffes, Mulhouse (France).

Figure 5.6 Hokusai. 'Under a wave off Kanagawa'. The most famous print from the 'Thirty six views of Mount Fuji' volume (*c.* 1831), printed with four Prussian blue based inks. Private collection. Photograph: the author.

Figure 5.7 Cyanotype. A technique supplying monochromatic photographic proofs. The scale of tones is expressed in Prussian blue. Ghent (Belgium), a street in a *béguinage*. Cyanotype by S. Norvez Hamel de Monchenault (ESPCI, Paris). Photograph: the author.

Figure 5.8 A detail from the *Tableau des principales monnaies du monde* (Paris, *c.* 1860). Gold coins are represented in yellow, and silver coins in a light blue obtained from a Prussian blue ink. Private collection. Photograph: the author.

Figure 5.9 France. The 'Prussian blue' 1 centime (1877). Private collection. Photograph: the author.

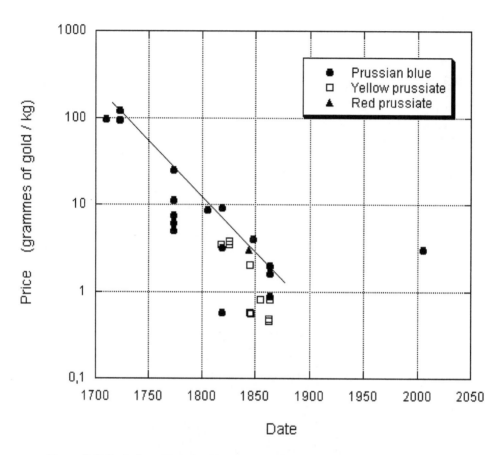

Figure 5.10 Evolution of Prussian blue and prussiate prices. In order to compare prices given at different times in different countries, they were recomputed on the basis of a gold weight per kilogram of matter, taking into account the various weights of the local pound. For the same date, the price spread corresponds to the different qualities of the product. The fact that the price of prussiates appears as early as 1820 is a sign of their increasing importance on the market.

Figure 6.1 Sèvres manufacture. *Bleu du Roy* set-piece treated in a lapis blue background (1778–9). J.-J. Dieu and N. Schradre painters, A. Pepin repareur and Vincent gilder. © Musée Ariana, Ville de Genève. Vases AR 10618 to 10620. Photograph: J. Pugin.

Figure 6.2 Sèvres manufacture. A detail from the vase on the left showing the lapis lazuli imitation realised by mixing pastes, as well as the clouds of points and the gold threads left by the brush in the imitation of iron pyrite.
© Musée Ariana, Ville de Genève. Photograph: J. Pugin.

Figure 6.3 The baron Louis Jacques Thénard, *c.* 1825, by an unidentified artist. Private collection. Courtesy of G. Emptoz.

Figure 6.4 Palette of colours produced by the Colville Establishment. The three shades of cobalt blue are numbered 10, 11 and 12. Courtesy of the Musée des Arts et Métiers, Paris. Photograph: the author.

Figure 6.5 Banque de France. Proof of the 100 F (type 1848) note, Paris outlet. Black ink printing. Former Delamare collection. Photograph: the author.

Figure 6.6 Banque de France. 1000 F (type 1862) note, the first note to be printed in 'celestial blue' with an ink coloured by cobalt aluminate. Due to the orthochromatic emulsion available at the time, this note was impossible to photograph; no line would have appeared on the picture, which would have been nearly white. Courtesy of the Banque de France.

Figure 6.7 Banque de France. Proof of the 1000 F type 1897 note, the first French note to be printed by the four-colour process. The blue ink contains Prussian blue and Thenard's blue. This note would in fact be issued with a 5000 F face value. It would be made with other colours in 1918, and not circulated until 1938. Former Delamare collection. Photograph: the author.

Figure 7.1 'Elevation of the Society's House, designed by Robert Adam Esq.' From Transactions of the Society Instituted at London for the Encouragement of Arts, Manufactures and Commerce, vol VIII, 1790.

Figure 7.2 Headquarters of the Société d'Encouragement pour l'Industrie Nationale, at 4 place St Germain des Prés, Paris. Photograph: the author.

Figure 7.3 Plaque surmounting the entrance door to the hotel of the Société d'Encouragement pour l'Industrie Nationale. Photograph: the author.

Figure 7.4 Guimet ultramarine. Box of laundry balls posterior to 1910 and bag of blue. Author's collection. Photographs: the author.

Figure 7.5 The use of ultramarine in the wallpaper industry. Here, for the background and printed details. Block printed wallpaper (detail), unknown manufacture, France, *c.* 1860. Courtesy of the Musée du Papier Peint (Wallpaper Museum) in Rixheim (France).

Figure 7.6 The use of ultramarine in the wallpaper industry. Here, for the printed motives. Courtesy of the Musée du Papier Peint in Rixheim (France).

Figure 7.7 International Exhibition, London, 1862. Report from the international juries, London, 1863. Courtesy SEIN. Photograph: the author.

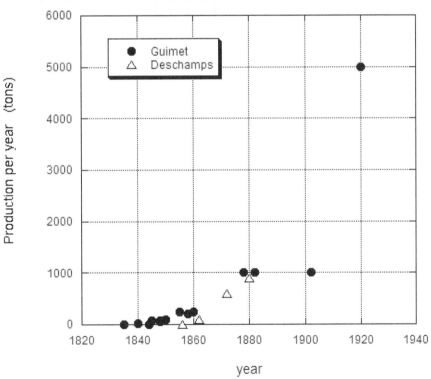

Figure 7.8 Comparative production of the Guimet and Deschamps establishments. Source: private archives of the Guimet family (Tarlier 2007).

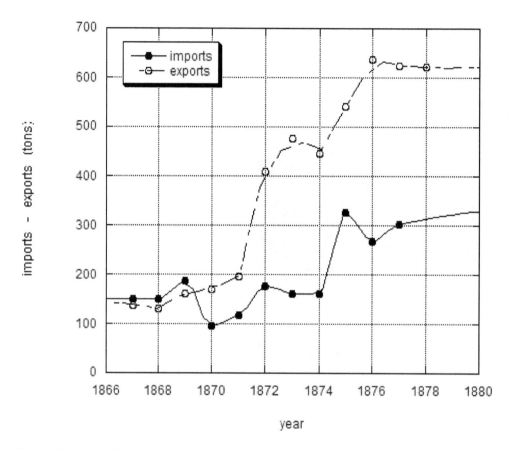

Figure 7.9 France. Ultramarine imports and exports evolution. We note that the 1870 war affected only imports (essentially from Germany). According to Lauth (1882).

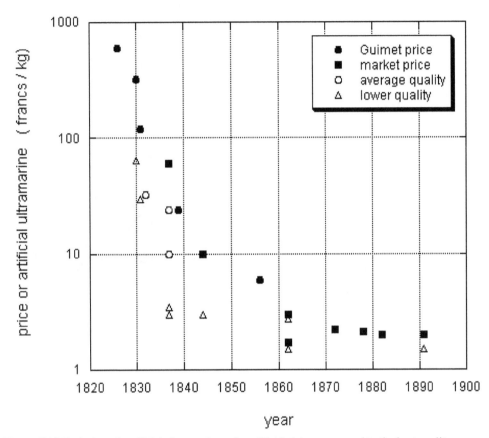

Figure 7.10 Evolution of artificial ultramarine prices. Black dots correspond to the best quality.

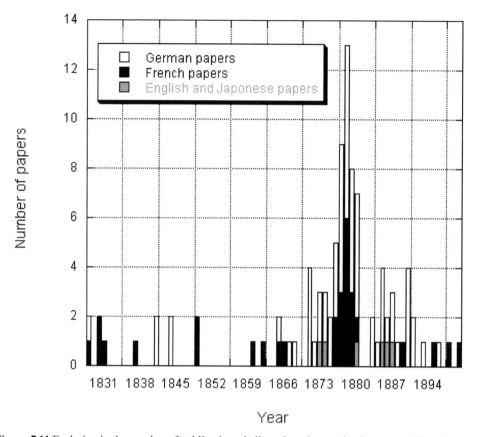

Figure 7.11 Evolution in the number of publications dedicated to ultramarine between 1828 and 1900.

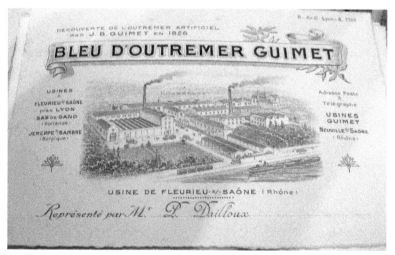

Figure 7.12 Business card of a trade representative from the Guimet Est. After 1919. Courtesy of H. Guimet.

Figure 7.13 Crucible in use at the Fleurieu factory at the end of the nineteenth century. Private archives of the Guimet family. Courtesy of C. Tarlier.

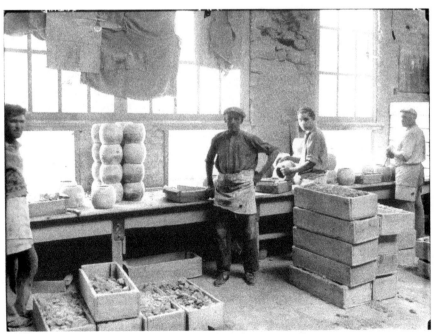

Figure 7.14 Fleurieu factory, ultramarine sorting shop. Crucible piles can be seen. Private archives of the Guimet family. Courtesy of D. Bonnard.

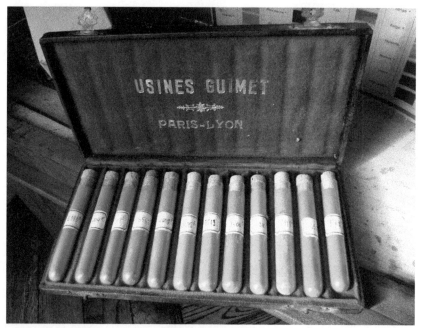

Figure 7.15 Sampler of various qualities of Guimet ultramarine. Courtesy of H. Guimet.

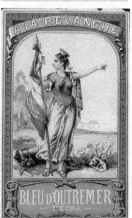

Figure 7.16 Laundry blue labels.

The 'A la laveuse' blue label (bottom right-hand corner) mentions: Factory print shop, Fleurieu. It therefore was one of the trade marks under which Guimet sold.

The 'Au colporteur' Fast Blue label (top right-hand corner) simultaneously mentions its Dole origin, as well as Neuville s/ Saône, a community adjacent to Fleurieu. It therefore was another brand purchased by Guimet.

'A la Revanche' (till Revenge) (bottom left-hand corner) alludes to the Franco-Prussian 1870 war. France shows the way to the reconquest of Alsace and Lorraine. Courtesy of the Forney Library in Paris.

Figure 7.17 The Balois Frères Establishment was founded in Dole (Jura, France) in 1800. At that time, their laundry blue was probably colored by indigo carmine. In 1889, E. Guimet purchased Balois Frères. Therefore, the Balois laundry blue becomes Guimet ultramarine. This packaging, a wooden box, dates from this period.

Figure 7.18 The factories of Destrée in Haren (Belgium) and Leverkus in Riga, the two aborted takeover attempts studied by the Guimets. Labels (top and bottom). Courtesy of H. Guimet.

Figure 7.19 Reckitt blue cylinders sold in Belgium. 1950's (?). Courtesy of the Her kinderen Alijnshospitaal Museum in Ghent. Photographs: the author.

Figure 7.20 Guimet blue cylinders. Around 1950 (?). Courtesy of the Marquisat, in Pont-Croix (France). Photograph: the author.

Figure 7.21

Top left: Reckitt blue sold in Belgium. Label placed on top of the box in Figure 7.19 proving production by the Destrée Est. Courtesy of the Her kinderen Alijnhospitaal Museum in Ghent.

Bottom left: crucible used for ultramarine manufacture at Destrée in Comines. Courtesy of Holliday Pigments. Photograph: the author.

Figure 7.22

Left: plastic household objects coloured with ultramarine. Courtesy of Holliday Pigments. Photograph: Ch. Debosschère.

Right: box for tracing powder for masons. The powder is pure ultramarine. However, the whiteness of the box polymer is due to ultramarine blueing. Photograph: the author.

Figure 7.23 Several ultramarine nuances for Henri Roché pastels. Courtesy of La maison du Pastel, in Paris. Photograph: the author.

Figure 7.24 Barnett Newman's 'Cathedra'. A blue 'monochrome' composed of multiple juxtapositions and superpositions of small blue surfaces painted blue, with ultramarine of different shades. The macrophotograph, taken during restoration, shows the bleeding of the blues. Courtesy of the Painting Restoration Workshop, Stedelijk Museum, Amsterdam.

Figure 7.25 Barnett Newman's 'Cathedra'. Edge protected from the paint by a paper strip during the realisation of the work. Macrophotograph taken during restoration. Courtesy of the Painting Restoration Workshop, Stedelijk Museum, Amsterdam.

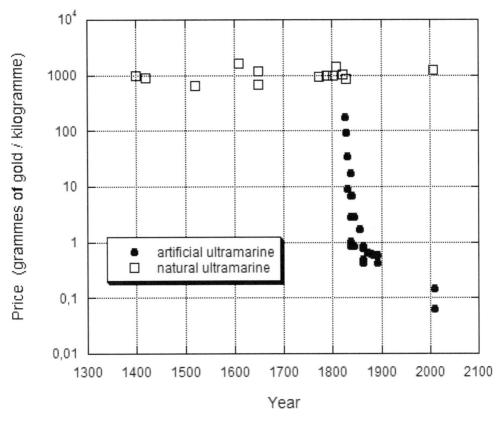

Figure 7.26 Comparison between the evolution of prices for natural and artificial best quality ultramarines.

Figure 8.1 Structural formula for phtalonitrile.

Figure 8.2
To the left: the structural formula for phtalic anhydride.
To the right: phtalimide.

Figure 8.3 Three remarkable porphyrines.
Left is the A and B chlorophylls (for A, R = CH3; for B, R = CHO).
Right is heme.

Figure 8.4 Monophthalocyanines.
Left: hydrogen phthalocyanine.
Right: metallo-phthalocyanine. 'M' designates an atom from a metal element (Cu, Ni etc.).

Figure 8.5 Use of phthalocyanine blue in house painting. House façade in Ghent (Belgium).
Photograph: the author.

Figure 8.6 Use of phthalocyanine blue in industrial painting. Douarnenez harbour (France). Fuel tanks. Photograph: the author.

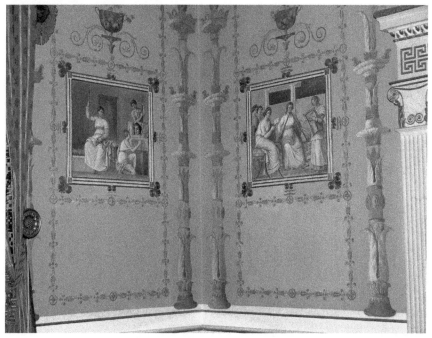

Figure 9.1 The fashion for Pompeii style décor during the eighteenth. Salon with candelabra decoration over a blue background. Palazzo of Capodimonte, near Naples. Photograph: A. Barbet.

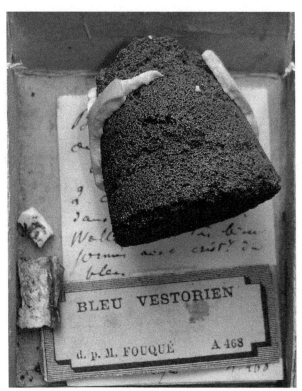

Figure 9.2 One of the samples of Egyptian blue made by Fouqué, still located in its porcelain crucible. The label, from the hand of Fouqué, states: 'Egyptian or Vestorian blue. CaO. CuO. 4 SiO2. 2 crucibles. In one, very well formed wollastonite crystals with cryst. of the blue'. Mineralogy Museum of the École des mines de Paris. Photograph: the author.

Figure 9.3 Typical shape of cuprorivaite crystals. The numbers are the Miller indices characterizing the three families of lattice planes bounding the crystal. According to Pabst (1959).

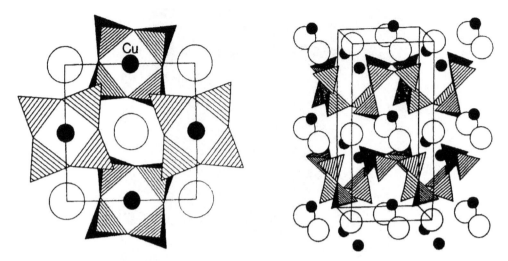

Figure 9.4 Crystalline structure of cuprorivaite. The tetrahedral represent SiO4. According to Finger *et al.* (1989).
Left: view from above along the [001] direction. The half-mesh is shown darker.
Right: axonometric view of the cell, axis c being vertical. The small black circles stand for copper, and the large white ones for calcium.

Figure 9.5 Kinetics of Egyptian blue formation in the presence of 10% alkali. Along the ordinate axis, the fraction (as a percentage by weight) of the initial mixture transformed into cuprorivaite. According to the data in Ullrich (1979).

Figure 9.6 A detail of the preceding figure evidencing the incubation periods, which are all the more visible as temperature is lower (850 and 900°C). According to the data in Ullrich (1979).

Figure 9.7 Light absorption spectrum in the visible range. The measurement was made on the *caeruleum* grain visible in Figure 1.31 by B. Guineau (unpublished result, 1999).

Figure 10.1 Han purple. Representation of the BaCuSi2O6 crystalline mesh. According to Finger *et al.* (1989).
Left: projection according to (001).
Right: front view with vertical c axis. The silica tetrahedra are coloured grey; barium is represented by white circles, copper by black circles.

Figure 10.2 Han blue. Representation of the crystalline mesh of BaCuSi4O10. According to Chakoumakos *et al.* (1993).
Left: projection along (001).
Right: front view with vertical c axis. The silica tetrahedra are coloured in grey. Barium is represented by the large circles, copper by the small ones.

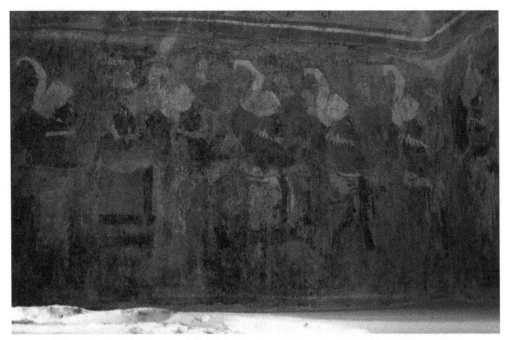

Figure 11.1 Bonampak. Structure 1. Procession of King Chan Muán and the notabilities from his court. Around AD 790. Photograph: D. Magaloni.

Figure 11.2 A historical Raman spectrum: this was the first, all methods combined, to show the presence of indigo in an ancient Maya blue. These Raman spectra were obtained: A – on a Maya blue coming from a Dzibilnocac wall painting and B – on an indigo sample. According to Guineau (1987).

Figure 11.3 Mexican indigo bush (*indigofera suffructicosa Miller*) in the tinctorial plant garden of the Couleur Garance Association, at the Lauris castle (Vaucluse, France). Courtesy of M. Garcia. Photograph: by S. Ovarlez.

Figure 11.4 Metztitlan convent (Hidalgo, Mexico). Maya blue painting of a vault (end of the sixteenth century). Photograph: S. Ovarlez.

Figure 11.5 Palenque (Mexico). Incense burner from the temple 15 (n°5). Three shades of blue are clearly visible. Photograph: S. Ovarlez.

Figure 11.6 Observation through a binocular magnifying glass of the polished surface of cross-section made from a blue paint layer from chamber 10 of Chacmultun (late classical). Average thickness of the blue layer: 15 μm. Photograph: S. Ovarlez.

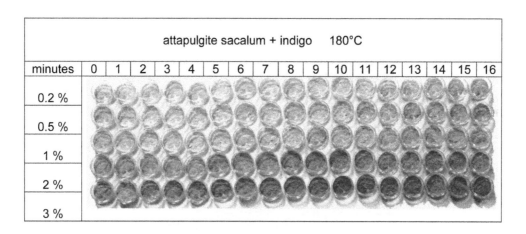

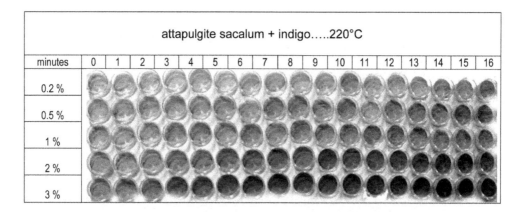

Figures 11.7 and 11.8 Sequences of boxes containing a mixture of *sacalum* clay and pure indigo. They embody the kinetics of Maya blue colour apparition (in abscissa, length of stay at temperature, in minutes) as a function of the initial indigo content (in ordinate, initial indigo concentration, in percent weight) and of temperature (above, 180°C ; below, 220°C). According to Ovarlez (2003b).

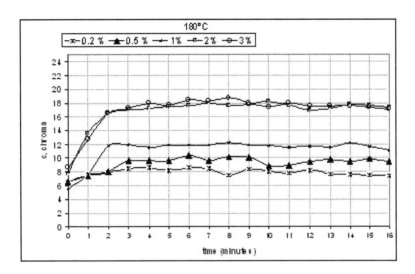

Figure 11.9 Evolution of chroma (c) with time for the five sequences of samples shown in Figure 11.8. Colour is measured here in the colour space Lch. We notice that reaching maximum chroma takes a few dozen minutes, and not tens of hours. Furthermore, for given clay, there is indigo saturation: 3% gives the same results as 2%. According to Ovarlez (2003b).

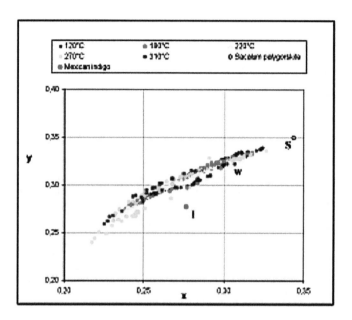

Figure 11.10 Colorimetry. Representation in the xOy plane of the CIE 1931 colour space of the palette of yax obtained with sacalum clay by playing on the length and temperature of treatment. According to Ovarlez (2003b).

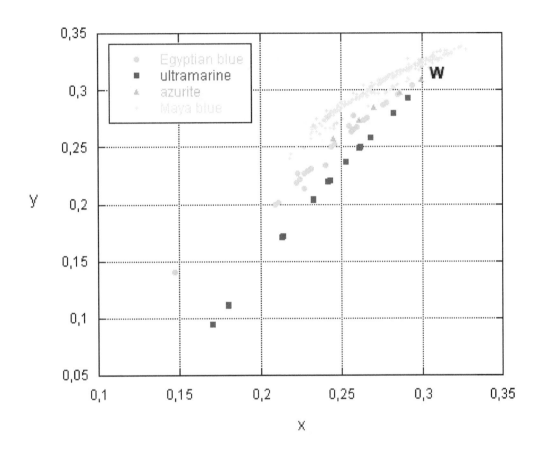

Figure 11.11 Colorimetry. Representation in the xOy plane of the CIE 1931 colour space of the hues measured on various ancient blue pigments. The range of *yax* obtained with *sacalum* clay (here, 'Maya blue') is the greener (high y) and the least saturated (high x).

Figure 11.12 Atomic model of Maya blue. Crystal mesh of attapulgite seen along axis c. The crystal is seen facing the aperatures of the nanochannels. The large spheres represent aluminium atoms. The two continuous lines represent the chains –Si–O–Si–O. Water molecules occupy the free space in the hydrated attapulgite channels (*top*). They are replaced by indigo molecules during the Maya blue formation at around 120°C (*bottom*). According to Giustetto *et al.* (2005).

Figure 11.13 Atomic model of Maya blue after heating at around 150°C. Representation of a portion of a monoclinic attapulgite nanochannel with the indigo molecules in a stable position. According to Giustetto *et al.* (2005).

Figure 11.14 Atomic model of Maya blue. Space occupied by two indigotin molecules in a sepiolite nanotube at low temperature. Seen from the front (right) and slightly slanted (above). Colour code: turquoise blue, carbon atoms; red, oxygen; yellow, magnesium; blue, silicon. We clearly see the two coordinated water molecules bonded to magnesium. According to B. Monasse, École des mines de Paris, unpublished results, 2007.

Figure A.1 Spectral power distribution (or visible light reflection spectrum) of lazurite (ultramarine). According to Ledé (2005).

Figure A.2 The CIE standard observer colour matching functions. λ is the wavelength of the equivalent monochromatic light, measured in nanometres. According to Guineau (1993).

6

The discovery of Thenard's (cobalt) blue
A time for scientists

Vincennes: from beau bleu *to lapis blue*

During the eighteenth century, chemists working in soft or hard paste porcelain factories aimed to perfect cobalt-based blue colours which had sufficiently high saturation to be able to imitate lapis lazuli. This meant, of course, colours able to withstand temperatures in excess of 800°C imposed by the firings.

Thus in France, as early as 1740, the Vincennes factory, with its *beau bleu* ('beautiful blue'), made soft paste items to imitate lapis. But the *bleu lapis* ('lapis blue'), or *bleu de M. de Gagny*, was finally perfected only in 1752. The colour, based on cobalt frit, was applied before the glaze, fired once at 800°C, then, when the glaze had been applied, fired again at 900°C (Albis 2003).

However, it proved technically difficult to produce a satisfactory colour for hard paste porcelain when the factory moved from Vincennes to Sèvres as the firing sequence, as well as the nature of the glaze, was different. It was not until the years 1770–80, and even then with difficulty, that the chemists at the factory were able to emulate lapis with new colours, based on Swedish cobalt, which were applied over the glaze and withstood firing at 1350°C. These colours were used either for simple surface decoration – *fond bleu* ('blue background'), *bleu royal* ('royal blue'), *bleu du Roy* ('King's blue'), lapis – or for colouring the ceramic paste itself. In either case, the imitation of lapis lazuli involved producing not only the blue colour, but also that of the main associated minerals – white and also gold to imitate (for once) iron pyrite (see Chapter 3).

An excellent example of these lapis-like glazes is the wonderful centrepiece in lapis blue background and gold made for the King Louis XVI of France, currently located at the Ariana Museum in Geneva (Figures 6.1 and 6.2).

Archives of the Sèvres factory give recipes for coloured pastes with their proportions by weight:

Celestial blue paste: Saint-Yrieix earth, 66; spath for the ordinary glaze, 18; nickel calx [oxide], 12; Swedish cobalt calx, 1.

Paste to imitate lapis lazuli: Saint-Yrieix earth, 4; prefired Aumont sand, 1; cobalt calx, 1.

When one wants to imitate veined lapis lazuli, one takes ordinary white paste arranged in small rolls, celestial blue paste (…) likewise shaped in small rolls, one roughly kneads these rolls, and there results a paste in which one notices irregular and bizarre veins such as those in natural stones[1].

While cobalt oxide was used in ceramics to imitate lapis lazuli, the idea of using it for colours for easel painting was not entertained. These were two cloistered worlds, separated by the need for high temperature firing for the ceramicists. Yet scientists may have stumbled across cobalt aluminate in the course of their research. In Vienna, it is possible that, around 1775, Leithner could have prepared a cobalt aluminate from a cobalt arsenate, a colour which would later assume the name of 'Leithner blue'. On the other hand, some authors think that cobalt aluminate had already been identified by a Swedish mineralogist, J.G. Gahn, around 1770, and also by C.F. Wenzel (future head of the Freiberg cobalt mines in Saxony) in 1777 (Harley 1982: 56). What is certain is that these discoveries had no impact on the artistic world.

The invention of Thenard's blue

The 1790s saw an influx into Paris of innumerable works of art, the result of the victorious French Republican army's plundering of Church and Princes' property in Italy and Belgium.

The French people, called the 'Freedom people', having become the recipients of these treasures, had to show them as fast as possible for they felt invested with an essential mission: their display at everyone's disposal. (Bergeon 1988)

Hence the resurgence of the already ancient idea of creating a museum in the Palais du Louvre (Hautecœur 1953). But many of the paintings had suffered during transport and had often arrived damaged from the journey. A *Conservatoire du Museum des Arts* was therefore set-up, under the direction of the painter J.-H. Fragonard and with the advice of the restorer Picaud, which established the grounds for a State painting

[1] Régnier, minutes from 2 June 1781, archives from the Sèvres Manufacture (quoted in Albis 1999: 86).

restoration policy, a policy which would be dynamically pursued by J.-B. Le Brun[2] (Le Brun 1798–99; *Notice des principaux tableaux* 1798–1799).

In 1800, Bonaparte appointed Chaptal to the post of *ministre de l'Intérieur* (what is now *ministre de l'Industrie*). A remarkable personality and a distinguished chemist, he was well aware of the weaknesses of the young French industries (especially the chemical industry) and decided to remedy them. It was in such a frame of mind that he took an active part in the foundation of the Société d'Encouragement pour l'Industrie Nationale. Highly interested in applied chemistry, having himself set up factories near Montpellier to exploit his discoveries, Chaptal (1781a, 1781b) had addressed the issue of colour production for artists as well as for house painters[3].

In line with this new movement in paintings restoration, he would have directed Vincent, Mérimée and Thenard to synthesise colours capable of replacing the pigments used by the masters that had since become either unobtainable, such as azurite, or too expensive, such as ultramarine.

In 1802 or 1803, Chaptal put the young Thenard to work on this topic. P. Larousse (1866–1879, 15: 'Thenard (Louis-Jacques)' entry) offers us the following savoury account:

> One day Chaptal, *ministre de l'Intérieur*, summoned him to his cabinet and, without any further ado, told him: 'We are short of ultramarine blue, always a particularly rare and particularly expensive product, and Sèvres requires a blue able to withstand high firing. Here are 1,500 francs, go and find a blue which fits the requirements which I have indicated.' – 'But…', Thenard tried to say, 'I…' – 'I have no time to waste,' resumed Chaptal, 'go away and bring back my blue as soon as possible.' One month later, Thenard had solved the problem[4].

Let us forget 'Sèvres requires a blue able to withstand high firing', which we know to be totally untrue. It has been shown that this phrase was added by Thenard *fils*, in a clumsy attempt to enhance his father's claim for the Sèvres blue, probably to further his glory (Déré and Emptoz 2000). Once put right, the anecdote rings true. It is amusing to compare it with the official version handed down by each of the protagonists, Chaptal (which we shall read further down) and this from Thenard (1803–1804: 129):

> It behoved a Minister, patron of the Sciences, the boundaries of which he knocked down, even while embroiled in the care of public affairs, to want that which should be done for painting as he had done for several other arts; that chemistry should throw a light on the processes it employed in colour production; that some should be put right, that others should be proscribed; that new ones should be created, and that all be ascribed a constant

[2] This Le Brun, art dealer, collector and indefatigable advocate of the creation of the national museum in Paris (Le Brun 1793, 1794), was the husband of the painter Elisabeth Vigée.

[3] Chaptal, in 1782, set up in Alès a manufacture to apply his roasting process for yellow ochres. See Péronnet (1988: 289).

[4] This anecdote is quoted by Thenard *fils*, and can be found in almost identical form in P. Flourens, *Éloge historique de Louis-Jacques Thenard* (1860).

and certain advance. He has entrusted me with this important task. (…) Of all the colours painting was lacking, none was more necessary than blue.

Thenard himself admitted to having had little difficulty in finding his blue[5]. A student of Vauquelin, he had one of the most abundant collections of chemical compounds ever prepared at his disposal, in his mentor's laboratory. He would find his inspiration at the well of Sèvres blues. Let us once again listen to him (Thenard 1803–1804: 130):

> I had therefore to begin by searching for a blue that could substitute for ultramarine. To find it was a problem, the solution to which seemed to me only difficult, and not impossible. I found it much earlier than I had hoped; I had observed that the beautiful blue decorating the vase from the Sèvres factory was made from cobalt arsenate; I thought that by making an exact mixture of this salt with recently precipitated alumina, we might conceivably get the same result. I carried out the experiment, and it met with total success; several times repeated, it was constantly successful; it was even more so with cobalt phosphate, and I obtained a beautiful colour by using borate too.

He then expands on the range of colours he could obtain depending on the initial cobalt salt and the alumina/cobalt salt ratio. He remarks that the most intense blue shades obtained 'are less than ultramarine at a hundred francs an ounce'[6]. He then gives an estimate of the production costs of his blues. In the case of the most saturated blue, cobalt arsenate based, a pure bright blue would cost 23 francs 'for five hectogrammes', making it barely more expensive than a Prussian blue (Figure 5.10), and seventy times less expensive than natural ultramarine. With a higher alumina charge, a light blue would cost 20 francs to make.

These cobalt aluminates were then to be tested as colours for oil paint (Thenard 1803–1804: 135):

> My research would have been almost to no avail were these colours, beautiful in appearance, not of a perfect blue and easy to use as well as having the property of being unalterable. Citizens Vincent and Mérimée, whose advice proved so useful, have been willing to carry out a large number of trials, with gum or with oil; all succeeded beyond their expectations: their beauty can be judged by those I have had the honour of bringing in front of the eyes of the Class[7]. One of these trials, which is of prime quality ultramarine, differs so little from the others that it is almost impossible to recognise it [1]. I do not know whether their fastness will be as high as their brightness is striking; time only can tell; but everything seems to bring us that promise. Having faced for the last two months a bright light, they have not undergone the least alteration; their colour in its purity is attacked at the atmospheric temperature neither by oxymuriatic acid[8] and any other known acid, nor by alkali and hydrogen sulphide. (…)

[5] Thenard had done an extensive bibliographical search on this topic, as witnessed by his *Traité de chimie élémentaire théorique et pratique*, the first edition of which appeared in Paris in 1813.

[6] An ounce weighs around 31 g, which puts the price of this ultramarine at 29 g of pure gold per ounce, or 121 guineas per kilogramme.

[7] Class: Physics and Mathematics class of the Académie des Sciences.

[8] Oxymuriatic acid, i.e. chlorine.

[1] Oil trials with ultramarine at 100 francs an ounce, and with phosphate- and arsenate-based blue, cannot be told apart: but if instead of oil one uses gum, they become less difficult to recognise; the ultramarine is then slightly more intense than the others.

A cobalt aluminate

Once called 'cobalt aluminate' or just 'cobalt blue', Thenard's blue is a mixed oxide, a spinel, of empirical formula $CoO.Al_2O_3$ or $CoAl_2O_4$. It crystallises in the cubic system, and turns out to be perfectly stable chemically. Its colour (dominant wavelength 470 nm) is close to that of natural ultramarine. Due to a refractive index of 1.74, its covering power is slightly better than that of ultramarine. It is a siccative. Only in its colouring power is it inferior to ultramarine. It is referenced in the Colour Index as Pigment Blue 28 CI 77346.

This new blue was the first real success for chemistry in this field. While the invention of Prussian blue was due to chance, that of Thenard's blue came from reasoning. Perfectly suited to artistic painting, it therefore looked like a very serious candidate to displace ultramarine. Such was, of course, Chaptal's opinion (1807: vol. 3, 372):

> M. Thenard, whom I had entrusted during my Ministry with some research on colours, jointly with M. Mérimée, has found a cobalt composition which advantageously replaces ultramarine. (…) [It] forms a composition of a beautiful blue, equal to ultramarine, and which can, as the latter, be used with oil. Experience has justified this assertion, and this cobalt blue has already become a branch of trade.

A blue rapidly adopted by painters

Obtained by roasting cobalt arsenate in the first case, phosphate in the second in the presence of alumina gel, Leithner's Viennese and Thenard's Parisian blues did not have exactly the same colour. This fact was generally attributed to the presence of arsenic or phosphorous traces in the final product. But fairly quickly variants would be developed using other cobalt salts such as nitrate.

Because they were made for artists only, and therefore in small quantities, cobalt aluminates suffer from an almost entirely undocumented history of production. In France, as we have seen, Thenard's blue was already traded in 1807. Chaptal (1819: 290) indicated that a 'M. Dumont has perfected this discovery, and supplies today this beautiful blue colour to all of our porcelain decorators'. Since the Saxony Mines Authority jealously made sure that the totality of the cobalt ore extracted was treated on the spot, could the ore have come from Sweden? (see Chapter 2). In France, Thenard's blue was unanimously appreciated for its qualities and its use spread quickly, not only in the field of painting on porcelain, but also in that of oil painting. Thus did Thenard's blue appear as early as 1807 on the canvasses of J.A. Vallin (1760–1831) in France and as early as 1808 on those of F.H. Füger (1751–1818) in Germany. In the 1820s, the French colour manufacturer Bourgeois explained (Watin 1823: 45):

Cobalt blue is a colour of a pure, brilliant and fast shade which, seeing the reasonableness of its price compared with that of ultramarine, now replaces the latter in very many instances. It could even be employed to as much advantage as ultramarine, were it not for the defect, and this is the only one, of appearing, when seen in the evening under candle light, of a shade tending toward purple; an inconvenience which of necessity then changes the relation between tones that the artist wanted to impart.

In England, 'Thenard's blue' is known as 'cobalt blue' and according to the latest identification of it made while a work was being conserved, Turner would have been the first painter to have used it as early as 1806–7 (Roy 2007). However, written evidence of this blue came at a later date. The first mention of cobalt blue seems to date from 1815. Field claimed to have procured cobalt blue from Bollmann, a known colour merchant. It had been made according to Berzelius' method (a process known to us only through that single reference) and cost a guinea an ounce[9]. Cobalt blue appeared in 1816 in *J. Varley's List of colours* (Harley 1982: 57), which recommended it as a substitute for ultramarine. In spite of several criticisms and unavoidable doubts as to the lasting quality of this newcomer, cobalt blue was adopted by artists.

In Saxony, Sweden and Norway the manufacture of cobalt aluminate would eventually be added to the traditional productions of zaffre and smalt carried out by the cobalt trust dominated by the Royal factory of Saxony (see Chapter 2).

An expensive pigment

We have very little data on the price at which cobalt blue was sold, but it was an expensive pigment. We have seen that Thenard in 1804 estimated its cost at between 40 and 46 francs (1.5 to 1.7 guineas) per kilogramme (1.3 to 1.5 francs per ounce). We do not know what happened in reality. However, it seems that Thenard had probably been overly optimistic. Chaptal, in 1807, said that: '(…) this cobalt blue has already become a branch of trade', but did not give any details. In 1815, in England, cobalt blue retailed for a guinea per ounce (i.e. 26.4 francs), hence almost twenty times more. A report from Mérimée (1834) gives us a price of the same magnitude:

The price of M. Colville's blue [Figure 6.4] is 10 francs [0.4 guinea] an ounce. This price is higher than that of M. Guimet's ultramarine[10], and the specific weight of cobalt is higher than that of ultramarine, which also adds to the price increase: thus, admitting that the fastness of both colours is the same, cobalt blue manufacture will never expand as much as that of ultramarine. Anyhow, this colour is sought after for water-colours and is the object of foreign export.

Cobalt blue was therefore an expensive pigment. In fact, it was among those for which the price was quoted per ounce, and not per pound or kilogramme. Its trade was

[9] The price of this pigment is only three times lower than that of ultramarine.
[10] At the time, 6 francs (0.2 guinea) per kilogramme, or 20 centimes per ounce (see chapter 7). The ratio is 1 in 50.

therefore prone to various types of fraud. Artificial ultramarine was used to falsify it. The main reason why this pigment was so expensive was the quasi monopoly of the producer countries, Saxony and Sweden.

It seems that France did not pay much attention to the production of this blue, a fact which would soon, under circumstances tragic for the country, assume strategic importance.

A strategic blue ink

In 1803, Napoleon granted a private bank, the Banque de France, the exclusive privilege of issuing bearer notes within Paris. With the 1848 revolution, this privilege would be extended to the whole country. The banknotes which would circulate henceforth, with high nominal values, were printed in black on white or chamois paper (Figure 6.5). Security was insured by identical printings on both sides of the banknote. The exactness of superpositions, extremely hard to achieve, guaranteed to the bearer the authenticity of the banknote. The advent of photography in the years 1840–50 gave birth in France to fears of counterfeiting; not in England, however, where the issuing banks put their faith not in the printing process, but in safety papers embedded with sophisticated watermarks, with degrees of shading (Bank of England, 1855) (Hewitt and Keyworth 1987: 111). Only the Bank of Scotland, which had experimented with the colour printing of notes very early on, showed concerns about photographic counterfeiting toward the end of the century (Douglas 1986: 46).

The Banque de France turned to the Académie des Sciences for advice. It had grounds for its fears when in 1850 a photographic counterfeit of the 1848 type 100 francs (Figure 6.5) note turned up in Lyon. It was the product of a daguerreotype portrait maker.

But what was feared above all was the invention of the transfer of a photograph onto a steel plate, a technique which would allow large scale forgery. Such a process was developed by Talbot in England in 1852. When the physicist Pouillet, who worked with the Banque de France, learned of it, he immediately informed the Governor (Guitard[11] 1963):

Epinay (Seine), May the 3rd, 1853

Mr. GOVERNOR,

Yesterday, at l'Académie des Sciences, our colleague, M. Biot, presented us with a memoir he had just received from Mr. Talbot, a member of the Royal Society in London. Mr. Talbot was able to engrave onto steel by the means of photography; M. Biot was kind enough to let me choose two which seemed to me the most interesting for the Bank. I shall tomorrow Wednesday take the liberty to come and show them to you, for this new photographic discovery is, I believe, of a still more menacing nature than the one we knew of. We were informed that at the same time, in Paris, M. Meple de Saint Victor had

[11] Guitard directed the production of banknotes at the Banque de France from 1939 until 1961.

obtained similar results, for steel engraving also, and that very soon we should be able to examine his results, no less remarkable than those of Mr. Talbot.

It appears to me that these twin discoveries come too close to the interests of the Bank not to rush to inform you, begging for permission to insist again on the paper experiments, since the special characteristics that the Bank paper must have are becoming more and more essential.

Please accept, Mr. Governor, the homage of my feelings of respect and devotion.

POUILLET

In 1862, the decision was reached to issue a 1000 F note printed in colour, but in monochrome. The following anecdote was told in this respect (Eudel 1908: 111):

One day, one of the censors of the Banque [de France] placed in front of the eyes of the Empress Eugénie a fake 100 F note [type 1848, Figure 6.5] reproduced via the new processes [photography]. 'I want to play a trick on Louis', she said, seeing the perfection of the imitation. And she put the pseudo-note in a drawer of the Imperial table.

During the day, a cadger showed up. Napoléon III, wont to welcome his former companions of misfortune, opens the drawer, takes out the first note to fall under his hand and gives it to the poor devil. The latter thanks him profusely, and happy as can be, runs to a changer to cash this paper which represents an incalculable number of sweet felicities. The note is recognised as false at first sight. The bearer is accompanied to the nearest police station, and the commissioner asks him where the note comes from: 'The Emperor gave it to me'. He was taken for mad. But, seeing that he persisted in his statement, additional information was sought and the evidence had to be faced.

This was not the end of the matter. The incident had per force to be brought to Napoléon III's attention, who did not take it well. The governor of the Banque de France was informed and the Council resolved to adopt a colour photograph-proof for printing.

There remained to choose the colour of the ink. Pouillet studied the photogenic qualities of colours, studied the 'cochineal', 'madder' and 'red lead' tones, and in the end recommended a light blue be chosen. The photographic plates of the time, orthochromatic and not panchromatic, were effectively insensitive to blues. To choose a suitable blue pigment, the alteration of various blue pigments by chemical reactants were studied by Rivot (head of the Assay Office of the École des mines de Paris[12]; Guitard 1963: 52), in collaboration with the curator of the Arts et Métiers museum and the manufacturer of colours and typographic inks, Lefranc[13]. It led to the selection of a single pigment, the most stable, cobalt aluminate. It would be the one used to produce the chosen shade,

[12] No trace of these experiments seems to have survived in the archives of the École des mines de Paris.

[13] 'Messrs Lefranc and Co., in Paris, as for their colours, rank at the top for their printing inks; these clever manufacturers make on their own blacks of the most beautiful shade for their fine inks; their reputation is without equal for their black inks for cut-outs and their coloured inks.' (*Exposition Universelle de 1855* 1856: 541).

referred to as *bleu céleste* ('celestial blue'). This pigment would be supplied by the Royal factory of Schneeberg (Saxony).

The banknote, created on 4 December 1862, was the 'type 1862' 1,000 F, the first French note printed in blue (Figure 6.6). This note proved nearly impossible to photograph. The bank decided to abandon the identical printing in black and to use celestial blue printing for the rest of its range of notes.

This reliance on Saxony proved extremely troublesome in 1870. Indeed, from the start of the Franco-German war, the Banque was obliged to urgently issue a very large number of small denominations (50, 20 and 5 franc notes) to replace the gold and silver coins hoarded away. All these notes had to be printed with celestial blue ink. How could the necessary ink be procured from a country with which one was at war? The answer was simple: by going through the intermediation of Swiss traders (Lafaurie 1953). The situation was nevertheless shocking, and the Banque continually tried to extricate itself from this constraint. In 1872, Pouillet having died, Berthelot was named *Conseiller (scientifique) de la Banque de France*. He was mostly concerned with the chemistry of colours for use in the printing inks. His first report dealt with the replacement of cobalt aluminate imported from Saxony with a French product, which was achieved that same year, as shown by this report on cobalt blue (Lauth 1882: 166)[14]:

> Before 1868, the *Manufacture Royale des Bleus de Saxe* had, so to speak, a monopoly on this product; since that time, M. Marquet [de Vasselot] in Paris has attempted such a production which he has brought to a high degree of perfection with the assistance of a distinguished chemist, M. Jourdin. Although its consumption is perforce limited, due to the high price of the metal, cobalt blue is now ranked in the list of truly useful colours: commonly used in fine painting and artificial flowers, but its main outlet is for the printing of banknotes. The Banks of France and Belgium use it exclusively: it appears that they may use 80,000 francs worth of it every year.

> Cobalt blue is prepared by the calcination, under well defined conditions, of a mixture of alum and cobalt oxide. Certain shades required for fine painting are obtained by letting dry thin layers of a paste of alumina and cobalt oxide, which are then fired.

Where did the cobalt come from? Did it come from Sweden or Norway? No one knows. But it might well have come from the New Caledonia lodes recently discovered and which began production in 1874 (cf. Chapter 2). Such an origin would perfectly match this desire for independence from any product of foreign, and particularly German, origin. This text received confirmation from the account of the World's

[14] The same text goes on: 'Mr Pinondel has also shown cobalt blues obtained through a combination of alumina and cobalt phosphate; his purplish blues are obtained with a muffled fire, his pure blues are heated white.'

Fair held in Chicago in 1893, where one may read, concerning the production of the Establishments of Marquet de Vasselot (Adrian 1894: 250)[15]:

> His blues deserve special mention. Indeed, prior to 1870, the Manufacture Royale des bleus de Saxe had a monopoly on cobalt blues. At that time, M. Marquet set up production to supply the Banque de France with the blue it needed to print its banknotes. Since then, this blue has been adopted successively for printing the notes of the Belgian, Italian and Romanian banks. (…) M. Marquet de Vasselot set up his factory in 1892 for the large-scale manufacture of writing inks, both stable and communicative[16], liquid glues, inks for rubber stamps and duplication. (…) M. Marquet de Vasselot, grateful to two of his devoted collaborators, recognises M. Jourdin, attached to his Establishment since 1864, and also M. Bruère, his second chemist, as having been a powerful help in the pursuit of his useful discoveries.

The Banque de France would long stay faithful to cobalt blue, as witnessed by the minutes of the monthly meetings of the Comité des Billets et Essais. On 15 April 1896 the production of the 1,000 F note (future type 1897) established on the basis of the painter François Flameng's design (Figure 6.7) was discussed. This was the first banknote to be printed in four colours by the Banque. The composition settled upon for the inks was as follows (Peyret 1994: 90):

Yellow	pure chloramine yellow,
Red	a mix of chloramine yellow and paranitraniline red,
Blue	a mix of alizarin S blue, Prussian blue, and cobalt aluminate,
Sepia	a mix of nitroso β naphtol red cobalt and carbon black.

Blue was the only colour for which mineral pigments were still used; all the others were of organic origin.

Van Gogh and 'cobalt'

The correspondence of Vincent Van Gogh preserves for us the excitement for 'cobalt' which overtook him in 1885, at the very beginning of his Antwerp period. It also reflects his concerns at its high price:

> It is a true joy for me to work with better quality brushes, and to have cobalt, carmine, brilliant yellow and vermillion.

[15] The countries which adopted banknote printing with celestial blue belonged, like France, to the Latin Monetary Union, an international monetary convention signed in 1865 at the initiative of Napoléon III.

[16] Communicative ink: copying ink which, used with a special thin paper, diffuses through the original sheet of paper to give multiples copies in a letter copying press.

It is often advantageous to buy that which is the most expensive, especially cobalt – no other shade of blue matches it to obtain subtle shades. Though the quality of colours does not give all of its worth to a canvas, yet it brings the breath of life to it[17].

And nine days later:

I have acquired new ideas and learnt new means of expressing what I want: better quality brushes help me and I have gone wild over two colours, carmine and cobalt. Cobalt is a divine colour, and there is nothing as beautiful to create space around objects[18].

This is indeed what he did, for example in both specimens of Doctor Gachet's portrait[19]:

I am working at his portrait, the head with a white cap, very fair, very light, the hands also a light flesh tint, a blue frock coat and a cobalt blue background, leaning on a red table, on which are a yellow book and a foxglove plant with purple flowers.

or in the canvas featuring the church of Auvers[20]:

I have a larger painting of the village church, where the building appears purplish against a deep and simple blue sky of pure cobalt, the stained glass windows show like ultramarine blue spots, the roof is purple and part orange.

These claims are fully supported by the analysis carried out on these canvasses (*LRMF* 1999).

The same correspondence includes the orders for colours he sent to his brother Theo several years later, during his stay in St Rémy (1888–90). As far as blues are concerned, he ordered only Prussian blue in 1888. From 24 March 1889 onwards, he ordered cobalt and ultramarine and would renew the orders until the eve of his death in July 1890[21].

The other cobalt blues: cerulean blue and cobalt turquoise

In 1860, the English firm Rowney introduced a cobalt stannate to the artists' colours market under the name of '*caeruleum* blue'. It was again a mixed oxide of formula CoO, n SnO_2 with n \geq 1. It was offered for use in watercolour and oil paint. In spite of its name, it should not be confused with Egyptian blue (cf. Chapters 1 and 8), called *caeruleum* in the Roman world.

[17] Letter to Theo 441N on 19 December 1885, in Van Gogh (1960).

[18] Letter to Theo 442N on 28 December 1885, in Van Gogh (1960).

[19] Letter to Theo 638F on 4 June 1890, in Van Gogh (1960). These paintings are kept in the Ryoei Saito collection in Tokyo and at the Musée d'Orsay in Paris.

[20] Letter to Wilhelmine W22F at the beginning of June 1890, in Van Gogh (1960). The painting is kept at the Musée d'Orsay in Paris.

[21] Letters to Theo 475F, 541F, 541aF, 551F, 581F, 584F, 585F, 592F, 594F, 604F, 608F, 629F, in Van Gogh (1960).

This *caeruleum*, soon renamed cerulean blue, is a light blue pigment. Its tint varies a little depending on its production. The dominant wavelength of its tones lies between 479 and 483 nm. Its colour does not change with artificial lighting. It is referenced as Pigment Blue 35 CI 77368 in the Colour Index. Cerulean blue has a lot of the assets of Thenard's blue: great chemical stability in the most diverse chemical environments, and great stability to light. But its colouring power is low, and it was expensive.

It was often replaced by another cobalt blue, cobalt turquoise, brought onto the market in the 1920s. Like Thenard's and cerulean blues, it is a mixed oxide, a spinel, but part of the alumina (Al_2O_3) is replaced with chromium oxide (Cr_2O_3). It is represented by the empirical formula: $Co(Al, Cr)_2O_4$. This blue possesses a better covering power and tinting strength than Thenard's blue, but it presents the same shortcomings under artificial light. Like cobalt aluminate, this blue is remarkably stable. Its chemical inertia is perfect: it withstands acids, bases and solvents. It is therefore not toxic. It can withstand temperatures up to 500°C, and light and time have no influence over it. It is referenced in the Colour Index as Pigment Blue 36 CI 77343.

7
Guimet blue and artificial ultramarines
The dream comes true

After so many disappointments, how could one not be convinced that only material of the same composition, even if it were artificial, could replace natural ultramarine? The problem, which turned out to be particularly difficult (see Chapter 3), was that nobody had any idea exactly what natural ultramarine was, or the reasons behind its colour.

The time of Encouragements: *London*

The analysis of lapis lazuli carried out by Clément and Desormes laid the ground for a future synthesis. Such was the opinion of the authors, who concluded: 'That this first attempt with a substance as little known and as singular be followed by its artificial production!' (Desormes and Clément 1806). It was also the opinion of the Society for the Encouragement of Arts, Manufactures and Commerce of London (Figure 7.1), which offered two prizes in 1801. Two prizes, but both seemingly directed toward a single goal: the manufacture of an artificial ultramarine or something closely resembling it. The first offer of a prize was written thus (*Premiums offered in the Year 1801* 1801: 34, n°77):

> 77. ULTRAMARINE. To the person who shall prepare an artificial ultramarine, equal in colour, brilliancy, and durability, to the best prepared from lapis lazuli, and which may be afforded at a cheap rate; the gold medal, or thirty guineas.[1]
>
> One pound weight of such colour, and a full disclosure of its preparation, to be produced to the Society on or before the first Tuesday in February [1802].

As had happened with the great majority of prizes offered by this society, the offer was not taken up. The society continued with its yearly prizes until 1831, by which point

[1] Depending on the importance attached to the issue, the prizes on offer were of 15, 30, 50 or 100 guineas.

Guimet blue was widely available. The second proposal for a prize (already quoted in Chapter 5) contained a *nota bene* which, as we mentioned, could only lead the candidates astray (*Premiums offered in the Year 1812* 1813: 12, n°82)[2]. That offer was not taken up either.

Goethe and Vauquelin

In 1787, during his travels in Sicily, Goethe became interested in the variety of coloured stone, marble and agate traditionally used to decorate the churches of Palermo. He visited the artisans who cut and polished them. Referring to the latter, he noted in his *Journal* for 13 April (Goethe [1786] 1962: 246):

> They are also showing great skill in handling another material which is a by-product from their lime kilns. Among the calcined lime they find lumps of a sort of glass paste, varying in colour from a very light to a very dark or almost black blue. These, like other minerals, are cut into thin sheets and priced according to their purity and brilliance of colour. They can be used as successful substitutes for lapis lazuli in the veneering of altars, tombs and other church ornaments.

Was it really artificial ultramarine? No one can answer that question today. But if the answer were positive, the limestone stuffed into those lime kilns would have been very impure, or otherwise only lime would have come out of these kilns. What is definite is that they were not Leblanc soda kilns as the process had only been published that very year, 1787. We shall see later that two types of blue materials may form in the kiln, ultramarine when there is enough sulphur, and Egyptian blue when copper is present (see Chapter 9). The existence and use of this Palermo blue substance seems to have remained very localised and discreet. It took twenty-seven years for a similar observation to be made again. But, this time, it happened within a scientific context which lent itself to analyses and reflection.

The French chemist Vauquelin (1814), in a note dated 1814, recounted that one Tassaert, in charge of the sulphuric acid and soda workshops at the S^t Gobain mirrors and glass factory, had noticed the presence of a blue material resembling lapis lazuli in the soda kilns. These were kilns where soda ash was made, the flux indispensable to the industrial production of glass, our current neutral sodium carbonate (Na_2CO_3). The process utilised was the Leblanc process, the principle of which might usefully be recalled: a first reaction transforms sea salt into sodium sulphate; and a second operation, held in a 'soda kiln' around 900°C, carries out the reduction of this sulphate by charcoal to yield sodium sulphide, which then reacts with calcium carbonate to produce sodium carbonate:

$$Na_2SO_4 + 4\,C \rightarrow Na_2S + 4\,CO \quad (1)$$
$$Na_2S + CaCO_3 \rightarrow Na_2CO_3 + CaS \quad (2)$$

It was in such soda kilns that the solid blue material formed on the interior walls of the kilns. Tassaert gave Vauquelin a sample, pointing out that this material began

[2] This offer was maintained for 1813 and 1814 only.

forming from the day the floor of the kilns were made of sandstone rather than brick. Sandstones are rocks formed from silica grains held together by a 'cement' which may contain alumina.

Vauquelin's note (1814), published under the promising title *Note on an artificial blue colour analogous to ultramarine*, is a study of the chemical reactivity of this blue material with the usual chemical reagents. He compared the reactions of this unknown blue material with those of lapis. He noted obvious similarities (resistance to heat and bases, attack by acids), but a difference too: there was much more sand in the sample supplied by Tassaert than in natural ultramarine. He did not reach a definitive conclusion. Only by rereading the title of the Note as well as its conclusion can the reader conclude that Vauquelin believed he was dealing with an ultramarine soiled by impurities:

> If I am not mistaken in the connection I have made between the colour of the factitious material and that of the lapis, we may hope to be able to emulate nature in the formation of this precious colour someday. I intend to attempt a few experiments on this subject.

He does not seem to have brought this project to fruition, possibly because he was working on so many other topics. None of the numerous publications he produced until his death in 1829 dealt with lapis or ultramarine (Poggendorff 1858: 'Vauquelin' entry). Had he been able to continue further on this project, he would undoubtedly have had a large audience; as what he had already achieved proved pivotal. Ultramarine synthesis was possible; it seemed within the reach of a good chemist.

The time of Encouragements: *Paris*

In 1824, the Société d'Encouragement pour l'Industrie Nationale[3] (SEIN), with headquarters in Paris (Figures 7.2 and 7.3), picked up the idea of its elder London sister. More generous than its English counterpart, but also more demanding, it offered a 6000 francs prize to the first person, of whatever nationality, to perfect the production of an artificial ultramarine at a cost not exceeding 300 francs per kilogramme. The programme (*Programme des prix* 1824) was drawn up by the chemist Gay-Lussac (Laboulaye 1891: vol. 3, 'Outremer' entry):

CHEMICAL ARTS

V. Prize for the discovery of a factitious ultramarine

Ultramarine, one of the more vivid colours, is also the most durable, but its excessive price limits its use to precious paintings.

Skilful chemists do not doubt that it is possible to make an artificial ultramarine having all the qualities of that which is derived from lapis lazuli.

It had been believed for a long time that iron was one of the major colouring agents in ultramarine; but Messrs Clément and Desormes, having had the advantage of working with considerable amounts of lazulite, have managed to extract from it ultramarine with no iron.

[3]Concerning the origins of this society, see the article *Société d'Encouragement pour l'Industrie Nationale* (Laboulaye 1891: 'SEIN' entry).

Their analysis showed that while iron sulphide is always found in lazulite, it does not seem to be one of the elements of the blue colour.

But soda, a substance which had not been expected, was found in much too large a proportion for it not to be considered a constitutive part of the colour.

When the analysis of Messrs Clément and Desormes was published, soda and potash were not expected to be classified among the metallic oxides, and when these two alkalis, having first been transformed into metals[4], were seen then, in their first degree of oxidation, to assume a blue colour, sodium could be considered one of the colouring principles of lazulite.

New facts have turned up to support this conjecture.

In 1814 M. Tassaert, director of the St Gobain mirror and glass factory, found, upon demolishing the hearth of a soda kiln, several fragments of sandstone impregnated with a very vivid blue colour. He handed them over to M. Vauquelin who, struck by the similarity of this colour with that of ultramarine, carried out several experiments on this material and found that it behaved with reactants exactly like lapis lazuli.

Since then, numerous attempts were made to check whether soda, in its ultimate state of purity, could not be substituted for potash and produce a colourless glass, and proof was obtained that the purer the soda, the bluer the colour of the resulting glass[5].

Based on these facts, as well as others which need not be brought out here, we are entitled to consider artificial production of ultramarine as possible; and if we go by the elements discovered by analysis, this colour would be of so moderate a price that not only could it be employed for decorative paintings, but also for the various uses to which cobalt azure [smalt] and Prussian blue are put.

With the hope of procuring this advantage to the arts, the Société d'Encouragement offers a prize of six thousand francs[6] for the discovery of an economical process by which could be made an ultramarine identical in quality to that which is extracted from lazulite.

The Société will view the process as 'economical' when a kilogramme of this colour can be delivered direct to the trade for 300 francs at most, and if they can be convinced that future manufacturing improvements will considerably lower its price.

The memoirs will have to be sent by May the 1st, 1825.

Happy times, when the prize programme supplied all of the bibliography necessary for the research! Strangely, no one (including Clément, Desormes and Vauquelin) seemed to have been interested by the announcement, and, once the year was up, the reporter for the various competitions proposed by the Société had no grounds for triumph. Rather, it was a time for reflection and perseverance (Gérando 1825):

[4] Allusion to the work of H. Davy, who in 1807 isolated by electrolysis sodium and metallic potassium from the corresponding bases.

[5] This rather strange remark follows perhaps from the fact that the colour of glass depends not only on the nature of the metal oxide supposed to colour it (cobalt oxide for instance), but also on that of the alkaline flux used, sodium or potassium (see Chapter 2). The glass alluded to must have contained a little copper or cobalt.

[6] 6000 francs amount to 227 guineas; 300 francs, to 11.4 guineas.

The various competitions run by the Société and upon which you had to pronounce during this session have not delivered, this we admit with a deep sense of regret, everything that we were justified to expect when considering the importance and variety of the topics on offer, the awards promised, and the indications supplied to the competitors to facilitate their research. These competitors were very few in number, and many among them remained very far from the goal. This is all the more surprising, that the motion of industry makes new progress amidst us everyday, and that it is everyday better seconded, either by the favour of public opinion, or by the discoveries in the sciences and the applications they obtain. (…)

Having set upon selecting those problems which present the highest degree of interest, and of which the solution is not surrounded with discouraging difficulties, the Société must therefore not tire of proposing again those it adopted, so that its perseverance draws the attention of the clever artists and supports them in their attempts. By reporting here on those of the attempts which proved fruitless, or which, at least, did not entirely fulfil the goal, we must seize the opportunity to recall the motives which should excite the zeal of competitors, to set anew the light on the conditions the Société intends to prescribe; but we must at the same time avoid getting into the details which might expose them to having the property of their processes purloined from them, or which would, at least, supply their rivals with the opportunity to profit from their experiments: we shall furthermore hasten to communicate directly to those who so wish all the observations [from the commission] to which gave rise the works they let us know of, so that they can pursue them and add to their perfection. We could not also too much recommend those who compete to ensure themselves of the results they think they have obtained, by proofing them through repeated positive experiments, made with the appropriate care.(…)

Such is also that which had for goal the *manufacture of an artificial ultramarine* (n°5 of the programme).

Of the two competitors who chose to enter the fray, neither seems to have consulted your programme, or understood the true meaning of the question you had put forth.

What had you asked for, indeed? A true ultramarine, made up entirely, having all the qualities of that which comes from lapis lazuli. The competitors, on the contrary, without bothering to find out, by analysis, the elements in ultramarine, in order to recompose it afterwards, sent preparations drawn from Prussian blue and cobalt, which more or less weakly imitate the colour to be produced, but which the alumina phosphate discovered by our colleague M. Thénard already approached much better.

Proposition. Your administrative Board, persisting in thinking the discovery possible, proposes you also persist in stimulating it through competition.

The amount of 6,000 francs you have attached to it proves the importance you attach to seeing a very rare and very high priced substance replaced by an artificial composition.

An interesting text, which reveals in particular the position of the Société d'Encouragement toward the inventor's property, a position which would change with time. The prize programme for 1826 was absolutely identical (*Programme, Arts chimiques* 1825).

This policy of perseverance was a good choice, for a new candidate emerged who started work on determining the process of making artificial ultramarine. As recommended by the programme, he based his considerations on the works of Clément and

Desormes as well as on the observations of Tassaert and Vauquelin. The latter suggested reproducing interfering reactions occurring around 900°C between the compounds involved in the Leblanc process and the silica-clay material of the sole of the kiln. Although he had none of the knowledge which we currently have to understand the reactions involved in this synthesis, our candidate was somehow heading in the right direction. This candidate was French. His name was Jean-Baptiste Guimet.

Guimet and the pigments

Guimet was born in 1795. He was a graduate of the École Polytechnique (class of 1813). His admission file contained the following description[7]: 'Chestnut hair; clear brow; straight nose; chestnut eyes; nondescript mouth; round chin; full face; 165 high; distinctive signs: pock marks.' Among his classmates can be found names which were to become famous. Prosper Enfantin, future *Père Suprême* of the Saint-Simonians, was part of the same class. The former class also included the future physicist Jacques Babinet, thermodynamicist Nicolas Carnot and geometrician Michel Chasles. In addition, Auguste Comte was a member of the following class.

The siege of Paris in 1814 by the Austrian, Prussian and Russian allied troops brought a little of the unexpected. Guimet was a gunner at the Trône barrier and came close to getting himself killed (Mulsant 1893). At the time of the Restoration, in 1816, the École Polytechnique was dissolved as were the other Grandes Écoles stemming from the Revolution. Guimet found himself without a diploma, and faced with the obligation of making a living. He sat for the entrance exam for the Civil Service. Admitted sixth out of seventy-two, he chose the administration of powder and saltpetre. He first worked for the Paris arsenal. It was in that city that he met Rosalie Bidauld, daughter of a known painter settled in Lyon, a talented artist herself, whom he would marry. This certainly influenced Guimet's subsequent interest in the manufacture of pigments. Nominated as supplementary adjunct commissioner in Esquerdes (near St Omer) in 1821–2, he discovered the manufacturing processes for the English 'red gunpowder'. He then relocated again to Paris in 1823. In January 1824, he set up a business to exploit a new process of his own for the manufacture of lead white[8]. He would soon have to entrust this business to his partner after he took the position of adjunct commissioner for powders and saltpetre in Toulouse in 1825[9]:

> My manufacture of white lead is more or less organised and I have been very satisfied with the first products. It is a very good business which must be expanded as much as possible. We began on the small side to show caution. Now that everything has met our expectations, my partner and I shall busy ourselves with securing the finances necessary to operate on a larger scale.

[7] In the archives of the École Polytechnique.
[8] Lead white was the most important of white pigments. It was used as a basis for industrial paints. In spite of its own production, France was at the time a net importer of lead white.
[9] Letter from J.-B. Guimet to his aunt, Madame de Voiron, dated 8 January 1825. Private archives of the Guimet family. Quoted in Tarlier (2007: 41).

'He then considers uniting with a companion capable of embellishing and charming his life' (Mulsant 1893: 7), and, on 19 May 1824, he marries Rosalie Bidauld in Paris.

Posted in Toulouse where he was separated from his young wife, who remained in Paris, he prepared fine colours for her[10]:

> And, my good friend, I too make paint. I bought 6 pounds of yellow ochre which I busy myself washing with care so as to retain but two pounds of well washed and very fine colour. I also washed several different red ochres. While waiting for your coming, I amuse myself preparing for you an assortment of colours which will be as beautiful as those you use in Paris. There are but two or three which will have to be bought in Paris. Washing ochres is a long process, but I believe it indispensable for their beauty. The difference is very large.

And, a few days later[11]:

> I am beginning to know how to prepare certain colours. You take care of painting, and I shall take care of colours. You will never run out of them.

Guimet and ultramarine

When he made the decision to compete for the prize offered by the Société d'Encouragement, Guimet was, therefore, not on a trial run. He knew what pigments were; he had already studied at least one manufacturing process. The company which he had set up caused him problems and would be liquidated in 1830. This was probably the reason why he would take the utmost care in setting up his future blue pigment company. He already had a rather precise view of the markets to be conquered[12]:

> Ultramarine being the fastest and most beautiful of all colours, it must, on an equal cost basis, be preferred to all other blues. Thus, besides replacing cobalt blue for painting pictures, it could advantageously be substituted in wallpaper manufacture [i.e. for blue ashes], in Prussian blue print imaging [on textiles], for blue ashes, and I shall keep working and hope in my next letter to announce to you something more precise. (...)

He thus initiated research in this field. We know from his experiment notebooks that, as early as July 1826, he succeeded in synthesising ultramarines by heating clay with sodium carbonate and sulphur. In August 1826, he was studying the effect of variations in proportions. Counting in weight percentage of anhydrous matter, he tried the following initial proportions of soda/clay/sulphur: 33/33/33, 27/37/37 and 20/45/35. Other than for the addition of sulphur, all the ingredients for the manufacture of Leblanc soda were

[10]Letter from J.-B. Guimet to his spouse, dated 15 March 1826. Private archives of the Guimet family. Quoted in Tarlier (2007: 45).

[11]Letter from J.-B. Guimet to his spouse, dated 28 March 1826. Private archives of the Guimet family. Quoted in Tarlier (2007: 47).

[12]Letter from J.-B. Guimet to his spouse, dated 11 August 1826. Private archives of the Guimet family. Quoted in Tarlier (2007: 48)

present and ready to react with the clay. He kept his wife regularly informed of these developments, and recommended she be discreet[13]:

> In the meantime, do not communicate the details I am giving you. I waste no time sharing them with you for your pleasure, but it would be very annoying were it to be known the thing is possible before I took out a patent because all the chemists would set upon it, being assured that, with patience, they would succeed.
>
> Furthermore, the Société d'Encouragement has offered a 6000 F prize for this object I am sure I can enter the competition and we must not arouse anyone's attention. So I recommend that you tell absolutely no one the result I just obtained.

The secret must have been well kept as this original Guimet process is not known to us. It is likely that he started from kaolin and a mixture of sodium carbonate and sulphate, sulphur and a reducing agent such as charcoal. These ingredients were reduced to fine powders and mixed. Production must have been achieved in a single heating, divided into two stages: first a roasting around 800°C excluding air, then during cooling allowing oxidation at about 450°C. The whole process lasted several days, depending on the size of the kilns. The success of the operation was difficult to control as the temperature and oxido-reductive nature of the atmosphere during the whole process was critical. Another difficulty: the materials used needed to be very pure and anhydrous. On the mastery of these numerous parameters hinged the end colour (hue and saturation) of the resulting ultramarine, as well as the efficiency of the reaction.

In October 1826, in Toulouse, Guimet was already producing artificial ultramarine on a pilot scale. As evidence we have his laboratory notebook for the year 1826, where between the 28th and 29th October can be found the draft of the following order (Loir 1879a, 1879b):

> To Monsieur Barthélemy Bérard in Marseilles,
>
> Gentleman,
>
> Be good enough to have sent to Mr Journot, saltpetre maker in Toulouse, 1 barrel of soda sulphate from your factory, of a weight of 4 to 500 kil. as well as a small barrel of soda salt of around 100 kil. only.

This document indicates the scale at which the trials were made – Guimet had indeed reached the pilot scale – but it also indicates where the trials were made: at a saltpetre works in Toulouse. As the manufacture of saltpetre involves a succession of dissolutions and evaporations, it is likely there were no kilns available which were capable of reaching the high temperatures Guimet needed. The saltpetre maker supplied the space, and, possibly, the manpower. But Guimet probably had to have the kilns built.

In 1827, having learnt that, once more, no one had met the conditions of the programme and that the prize was, for the third time, put up for competition (*Programmes,*

[13] Letter from J.-B. Guimet to his spouse, dated 11 August 1826. Private archives of the Guimet family. Quoted in Tarlier (2007: 49)

Arts chimiques 1826)[14], Guimet, prudent and perfectionist, decided again to defer the presentation of his process and take advantage of this extra year to perfect it.

1827, the critical year

Guimet's deferment turned out to be a mistake. For that year another chemist, Christian Gottlieb Gmelin, decided to confront the problem. A Württemberger, hailing from a lineage of known physicians, botanists and chemists, at thirty-five he was a chemistry professor at the University of Tübingen. Following the recommendation of the Société d'Encouragement, he too built on the results of Clément and Desormes, as well as on the observations of Tassaert and the work of Vauquelin. We saw in Chapter 3 that he had already given some thought to the problem, for, several years earlier, he had studied a blue-coloured fossil found in the neighbourhood of Kaiserstuhl-im-Breisgau. From the results of the analysis, he concluded that it was made of a mineral matter similar to lapis lazuli and determined that its colouring principle must have been sulphur (Gmelin 1822). During the spring of 1827, Gmelin visited a number of French colleagues in Paris and announced to them, among other things, that he had begun work on the synthesis of ultramarine.

During that time, in Toulouse, Guimet was improving his process and succeeded in preparing an ultramarine he felt was of first quality, worthy of being offered to artists to prepare their colours with. He had some sent to artists so that they could try it. Probably making use of his wife's network of relations, he selected those more in public view, such as Ingres and Horace Vernet (Gay-Lussac 1828):

> I then had to engage in very long lasting research to make my process economical and suitable to the Arts; yet as early as the month of July, 1827 my blue was already used by several distinguished painters, by M. Ingres in particular, who used it to paint one of the most beautiful ceilings in the Charles X Museum [in the Palais du Louvre]. I may even add that M. Ingres, who is an excellent judge in this matter, repeated several times to me that my ultramarine left nothing to be desired, and that he favoured it over all those in the trade.

Ingres' painting was *The Apotheosis of Homer*. This canvas, signed and dated 1827, was replaced in 1855 in its original location by a copy by J.-B. Balze. The original is still in the Musée du Louvre – in the nineteenth-century French painting section, the Daru room. Guimet's artificial ultramarine was used to paint the tunic of Sappho, the only woman present in the painting[15]. As to Horace Vernet's painting, it was *The Battle of Fontenoy*, which takes place under a blue sky (Bouvier and Fossier, 2006: 171):

> M. Horace Vernet who has just used the same [ultramarine] colour over his whole ceiling depicting the Battle of Fontenoy, gave an account himself to the Academy of an experi-ment which admirably proves the intensity of this new ultramarine. This artist made a

[14]The text remains identical; only the date changes.

[15]Taking the size of the painting into account (5.12 x 3.86 m), Sappho's tunic has a surface of about .6 m^2. One can estimate at 40 g the amount of ultramarine used. Had it been of natural origin, it would therefore have set the painter back 5½ guineas (140 francs).

sky blue colour with lazulite [natural ultramarine] and white lead. The factitious ultramarine [Guimet ultramarine] with the same amount of white produced a much darker tint. He progressively increased the amount of white and he required five or six times the amount of it to get the tone of his first mix. One can judge by this the intensity of M. Guimet's ultramarine, something which gives the user an immense advantage, that of economy.

Encouraged by the painters' reception to his ultramarine, Guimet set up 'an ultramarine outlet, at Messrs Tardy and Blanchet's, 7 rue du cimetière Saint-Nicolas, Paris' (Gay-Lussac 1828: 415). The best quality retailed for 600 francs a kilogramme, which was six to seven times less than natural ultramarine. During that time, for the fourth consecutive year, the Société d'Encouragement postponed its 'prize for the discovery of a factitious ultramarine' (*Programmes, Arts chimiques* 1827)[16]. Considering his manufacturing process proven on a pilot scale, Guimet decided to compete for the 1828 prize. In mid-December 1827, he contacted Gay-Lussac, told him of his successful research, sent him a sample of his ultramarine and asked him to announce his discovery to the Académie des Sciences. Gay-Lussac agreed, and announced this on 4 February 1828. The proceedings relate it as follows:

> M. Gay-Lussac announces that M. Guimet, assistant commissioner for Powders and Saltpetres, succeeded in manufacturing ultramarine from basic components, bringing together the principles that Messrs Clément and Desormes had found through the analysis of natural lapis. This new product is richer in colours and brighter than natural lapis.

A member of the audience reports (Pelouze 1828: 53):

> During the last session of the Académie des Sciences (February 1828) a report was presented announcing that M. [blank] has totally succeeded in this production [artificial ultramarine]. He is still keeping his process secret.

The same day, Guimet presented his samples and research work to the Société d'Encouragement, while refraining from divulging the essential points. Gmelin read the news in the *Schwabischer Mercur* of 28 February 1828 and immediately reacted.

Gmelin's reaction and publications

Gmelin did not consider for even a moment that Guimet's research might have evolved independently of his own. He felt that his work had obviously been copied, pirated. He very quickly published a first article in *Hesperus*, a German magazine (Gmelin 1828b), a translation of which Liebig communicated to Gay-Lussac, whom he suspected was directly implicated. This translation, as well as two replies, were rapidly published in the *Annales de Chimie et de Physique* (Gmelin 1828a). In Gmelin's text, while the beginning was dedicated to the presentation of his approach as a chemist, the remainder was more controversial and intended to take issue with what he considered to be outright plagiarism:

[16] The text is still identical; however, the limit date is pushed from May 1827 to July 1828.

Several circumstances had long convinced me that the colouring principle of ultramarine was sulphur. The formation of this colour, noticed by M. Tassaert (Annales de Chimie, 89, p. 88)[17] in a kiln used for soda manufacture and having a sandstone floor, evidently proved the possibility of doing it artificially. For this colour possessed indeed all the characteristics of true ultramarine, particularly that of being destroyed by potent acids with a production of hydrogen sulphide. I wanted above all to learn, through the comparative and exact analysis of different kinds of ultramarine, which proportion of its elements would be most favourable for the production of a beautiful shade. To this end, I procured eighteen months ago lapis-lazuli from Saint Petersburg and ultramarine from Paris (at the Palette de Rubens, Saint-Martin, 6 rue de Seine) through the agency of Captain Baer and Professor Hofalker, and I submitted to the latter a rigorous analysis.

However, the famous painter, M. Seybold, in Stuttgart, having assured me that the ultramarine I had purchased in Paris was not of the best quality, I turned to Professor Carpi, in Rome, to get some of all kinds and in sufficient quantities for the analysis of this colour.

Spending a few weeks in Paris during the spring of 1827, I committed an indiscretion by sharing with several chemists, and in particular with M. Gay-Lussac, the conviction I had achieved the possibility of manufacturing ultramarine artificially, and that I was busy with this problem; it is therefore possibly my fault that another prevailed upon me in this discovery, for each has the incontrovertible right to carry out research on objects of interest to others.

Also do I recount these circumstances only to divert from me the suspicion that I did not begin my experiments until after having learnt of the happy result of some other work. Many a person, and M. Gay-Lussac himself, will no doubt willingly testify that I talked about it, and that he did not tell me at the time that someone was busy, in Paris, with similar research.(…)

The remainder of the note was devoted to the description of his process.

Gay-Lussac most courteously replied in a comment published at the end of this note (Gay-Lussac 1828):

Although M. Gmelin uses there the word *indiscretion*, I need not attempt to justify myself. I even declare, according to his desire, that he told me last year, during his stay in Paris, that he believed in the possibility of making ultramarine; and if I did not tell him on that occasion that someone was working at it in Paris, there was a very good reason; I knew nothing about it. I only learnt of the research of M Guimet, which was done in Toulouse, 200 leagues from Paris, when he sent me a sample of the ultramarine he had made, some six weeks before the announcement to the Institut of his beautiful discovery. (…)

This taste for polemics and claim for precedence is typical of the period, and scientific journals willingly served as sounding boards. Thus, in the very same issue of the *Annales de Chimie et de Physique* where Gmelin made his accusations, the article preceding his was a vigorous defence of the inventions of the Frenchman Fresnel against the unfriendly attacks of the Briton Brewster ('To swell one's titles, to diminish those of

[17]This was in fact Vauquelin's note (1814).

others, has always been the tactics of complainers. I should therefore not be surprised that it be followed by M. Brewster...' (Arago 1828)). As to the corresponding article, it dealt with a complaint concerning the manufacture of a sodium borate!

The Gmelin process

As opposed to Guimet, Gmelin did not start from clay, but by wet chemistry using a mixture of certain proportions of aluminium hydroxide, silica gel and soda. This mixture was desiccated, and then reduced to a powder. As he mentioned, with reason: 'This combination of silica, alumina and soda is the basis for ultramarine, which must now be coloured with sodium sulphide' (Gmelin 1828a). The purpose was to form the cage-like atomic lattice structure peculiar to sodalite. He then went to a dry process. In a crucible heated to red heat in which the decomposition of sodium carbonate in the presence of sulphur had yielded sodium sulphide, he carefully added the previously prepared mixture. This mixture remained at a red heat for no more than an hour. 'In case all parts of the ultramarine be not equally coloured, one can separate the nicer parts, once they have been reduced to a very fine powder, by washing in water'.

This process differs from what we assume was Guimet's on at least two points: the base silico-aluminate (natural, but unknown, for Guimet; artificial for Gmelin), and the scale at which manufacturing was conducted (pilot scale for Guimet; laboratory process for Gmelin). The scant attention lavished by Gmelin on controlling the oxidising or reducing character of the atmosphere is striking, as is the speed of the operation, when compared with the several days of high temperature heating required by Guimet's process.

This claim for precedence was echoed in July 1828 at the Société d'Encouragement (Daclin 1828):

> (...) M. *Gmelin*, a professor in Tübingen, claimed, in a German paper, priority for the discovery of the preparation of an artificial ultramarine, which was recently presented to the Académie des Sciences by M. *Ch* [sic] *Guimet*: this claim appears unfounded; but since the Société attaches a great importance to the question, which it put up for competition, being resolved in accordance with the conditions set in its programme, we shall let M. *Gmelin*'s process be known. (...)

Then followed the text of Liebig's translation:

> Such is M. Gmelin's process, which could usefully be repeated, to ensure that it does indeed offer the advantages promised by the author.

Several months later another article by Gmelin (1828c) appeared on the same topic, still written in German. The author this time described (in minute detail) his attempts to obtain artificial ultramarine. He described various types of crucibles and compared their respective advantages, and also his studies on the influence of iron as an impurity. And above all he insisted (and we know this was essential) on the importance of oxidising the reactants during the heating process in order to produce the sulphur oxides which, according to him, led to the blue colour. To this end, he devised various

laboratory methods, and ended up by using bellows. He published in passing the following composition (in weight percentage) for natural ultramarine:

silica 47.306%; alumina 22.000%; soda 12.063%; lime 1.546%;
sulphur oxides 4.679%; sulphur 0.188%; water,
sap based substances (due to the preparation method), sulphur and waste 12.218%.

He compared this composition with that published twenty-two years before by Clément and Desormes. The precision of the results obtained was remarkable, but for a material with so poorly defined a composition as ultramarine, it may lead to a smile. The last paragraph of the article was manifestly intended for Guimet:

> And now, I wish that others also share their experiments without restraint, that things may proceed forward. If an invention yields important profits, it is normal that one should keep one's discoveries to oneself in order to remain independent. For independence is the greatest possession of a sensible man. On the other hand, one must regret those secrets made by people who die without having shared their discoveries. This delays Art.

The six pages written by Gmelin (1828c: 366–80) were followed by fourteen pages of commentaries by a prolific editor who seemed to pursue two goals. The principal aim was to give a maximum of additional experimental details. These details came, of course, from Gmelin, but the writer did not quote his source for the ultramarine analysis and the experimental technique used to reach these results. He then insisted on the importance of distinguishing non-oxidised sulphur from oxidised sulphur. Clément and Desormes 'had not been able to find evidence' of oxidised sulphur. The editor vigorously emphasised the need to have an oxidising atmosphere. To finish, he reported that Gmelin, in comparing the ultramarine he obtained after washing in boiling water with natural ultramarine of high quality, found his to be more greenish and greyish; it lacked the red sheen characteristic of ultramarine. The attempts at preparing oil paints only emphasised the difference.

The second goal pursued by the editor was clearly to establish that the German scientist's research preceded that of the Frenchman, as well as to gloss over the very 'laboratory' character of Gmelin's study. Regarding this latter point, he indicated that Gmelin had prospected for the raw materials with which the industrial production of ultramarine could be attempted. The Neuhausen clay was not suitable, for it contained too much iron (5%). On the other hand, the St Yvrieux earth (probably the French St Yrieix kaolin) was perfectly suitable. As for precedence, he recalled the study of the blue fossil, which dated from 1822. And then, in an important final note, the work of a certain Döbereiner (1823: 213) who, in 1823, also attributed the reason for the colour of ultramarine to sulphur. He concluded:

> One cannot doubt that the first knowledge of the fact that sulphur is the colouring principle of ultramarine occurred, not on French soil, but on German soil, at least from a scientific point of view. Even if the technical aspects of the manufacture of this valuable product were found by M. Guimet in Paris at the same time as M. Gmelin and independently, as can be seen from the letter of M. Gay-Lussac of April, 1828. It may interest the

readers to learn that M. Guimet has established an outlet for his ultramarine at Messrs Tardy and Blanchet, at 7 rue du cimetière Saint-Nicolas.

Thus was Guimet cleared (for a time) of the accusation of plagiarism, but sentenced to simultaneously.

Comparing Gmelin's two consecutive articles is rather instructive. All polemic is absent from the second, which is purely and simply the text of a meticulous experimenter, sharing his secrets and thoughts. As a result, as far as the process for obtaining artificial ultramarine is concerned, Liebig's French text is purged of many essential operational details, in particular the need to use (at least during the final phase) an oxidising atmosphere.

It seems likely that Gmelin's process delivered ultramarine of rather mediocre quality, probably due to too short a duration at high temperature for sulphur to have time to diffuse sufficiently through the sodalite and impart to it a beautiful blue colour. We saw that Gmelin admitted that all parts of his ultramarine might not be coloured equally, and that the general shade obtained was greenish or greyish, without a red sheen. However, he was not the only one to point this out. In 1830, Mérimée (1830: 186), reporting *in extenso* the French version (due to Liebig) of Gmelin's process in his book *De la peinture à l'huile*, remarked:

> This process was repeated by several of our chemists, and they did indeed obtain ultramarine; but the colour of that ultramarine was not as bright as it should be. The sintered mass retrieved from the crucible was not of an even shade: some parts were pale; others, more or less intense, were of different shades, veering toward green, or toward violet. This process therefore needs to be modified.

In any case, the publication of this second version of Gmelin's process was to have considerable repercussions over the manufacture of artificial ultramarine in Europe.

The verdict from the Société d'Encouragement
Toward the end of 1828, the Société d'Encouragement pour l'Industrie Nationale could finally award its 'Prize for the discovery of a factitious ultramarine' (which afterwards then become 'artificial ultramarine'). This it did after having mulled over the report from the Chemical Arts Committee[18], dated November 1828 and written by Mérimée (1828), secretary for life of the École royale des Beaux-Arts, a report which we include below:

> Gentlemen, in 1824 you offered a 6,000 franc prize for the manufacture of an artificial ultramarine endowed with all the qualities of that obtained from lapis lazuli. This problem, which you deemed highly important, is completely solved, and four years were enough to deliver to the arts this happy result.

[18]This committee was composed of Bréant (Chemist and Assayer at the Mint of Paris), d'Arcet (member of the Institut), Gaultier de Claubry, Mérimée, Payen (manufacturing chemist), Pelletier (pharmacist), Roard (chemist, owner of the white lead manufacture in Clichy), Robiquet (Chemistry Professor at the School of Pharmacy) and Thénard. Dartigues and Vauquelin were honorary members.

Most discoveries occur when least expected; however, this one owes nothing to chance: encouraged by you, it was seen as the natural product of the current state of our knowledge.

Had your confidence been less securely based, it might have been shaken by the attempts sent to you the previous years. None of the competitors seemed to have understood your programme. This year, M. Guimet, a former student from École Polytechnique and now commissioner for Powders and Saltpetres, is the only one to have entered. His natural taste for the arts and his union with a woman possessing to a high degree the talent for painting probably focussed his attention on your programme, and his knowledge of chemistry led him to find the road to his research goal.

Last year he had already obtained results which you would no doubt have applauded; but he judged his task not fulfilled as long as he could hope for new improvements.

At that time, several artists tried out his ultramarine and found it equal to that which they drew from Italy. One can see a very large scale demonstration of it in the ceiling representing Homer's apotheosis, as painted by M. Ingres, in a room of the Charles X Museum. The drapery of one of the main figures is painted with artificial ultramarine, and in no painting is a brighter blue to be seen.

For its part, your Committee for chemical arts did not neglect experiments through which it could check that the qualities of the new colour were identical with that extracted from lazulite. It verified that this colour does not decompose under a red heat, is not altered by caustic alkali and that it is entirely destroyed by concentrated acids and converted into gels: it is through these characteristics that the purity of ultramarine is recognised.

Most artists have no idea of the creative power of chemistry, some may refuse to put their trust in the new ultramarine; but they will then be very embarrassed in trying to distinguish it from that of lapis: for chemical analysis lets no difference appear. Actually, this diffidence, which will never be shared by the majority, will grow weaker by the day.

There are times when certain discoveries are, so to speak, ripe, and for that reason take place simultaneously in several locations: this circumstance occurred again with respect to artificial ultramarine. At the same time M. Guimet was making its discovery, a chemistry professor from Tübingen, M. Gmelin, found a process to make this beautiful colour.

The announcement of the success obtained by the French chemist having been made at the Institut this last February soon reached Germany. M. Gmelin, disappointed by an event taking away from him the precedence for an invention on which he was counting, believed he could retrieve it through publication of his process and insinuation that the discovery which France was priding itself in might have been brought about through the indiscretion he had committed when announcing the previous year in Paris that he was convinced of the possibility of making ultramarine entirely from first principles.

It is surprising that M. Gmelin would have persuaded himself that none of our chemists could harbour the same conviction. He nevertheless declares that his own rested mostly on the formation of a beautiful blue colour in the hearth of a kiln where soda was manufactured. M. Vauquelin, who analysed it, found that it in no way differed from ultramarine. The memoir which our chemical scientist published ends on this remarkable sentence: 'One must hope to be able to imitate nature in the production of this precious colour'. It is no less surprising that M. Gmelin had not been aware of your programme, published four years ago; scientific journals in Germany must have mentioned it.

Anyhow, we do not contest M. Gmelin his discovery; we even wish that he perfect his process to the point where he can derive from it products as beautiful as those obtained by our compatriot. We flatter ourselves that, on his side, he will disown the rather disobliging insinuations he let himself proffer (1).

Two conditions were set in your programme:

Through the first (and that was the essential one), you required that the artificial ultramarine be in all points similar to that from the trade. It is the opinion of your Committee that this condition is fully fulfilled.

The second requested that the colour be prepared via a process economical enough to be delivered to the trade at a price of 300 francs per kilogramme.

Gentlemen, your Committee did not believe that this condition should be followed to the letter; it accepted the motives asserted by M. Guimet to justify having raised the price of his colour to twice that which you had set. His ultramarine has consistently more than twice the intensity of that which is generally used in the trade, and half as much is required to obtain with white the same shades: the condition is thus sufficiently met. It is impossible that more practice in the preparation of this colour will not bring improvements which will allow its price to come down, and in this manner and as the result of competition (for M. Guimet's process will be found), your economic goal will soon be reached.

There still remained to verify that the ultramarine entered for the competition and already spread in large quantity through the trade was all manufactured. No member of your committee had the slightest doubt in this respect; but, given the circumstances, since it was in charge of establishing the rights to your award, it believed it could not be content with a moral proof.

Consequently, it asked M. Guimet to entrust (but under the seal of secrecy) someone of his choice with his process, who would have held both your confidence and his and could attest in front of you of his conviction that the blues entered and those that M. Guimet has for several months sold to the trade are artificially prepared.

M. Guimet agreed to it: M. Vauquelin received a confidential communication about the process, and he imparts to you his intimate conviction that this ultramarine is entirely manufactured.

Gentlemen, this discovery will be epoch making in the history of painting; it is one of those the chemical arts may most justly draw glory from. Such is the unanimous opinion of your Committee: it judges the prize well deserved.

I consequently have the honour of proposing to you, in its name, to award this prize to M. Guimet.

(1) We hear that he has disowned them.

These conclusions were adopted on 3 December 1828 during the general session presided over by Chaptal. Guimet therefore won the Prize. Vauquelin died the following year, leaving Guimet sole master of his manufacturing secret.

Kuhlman's note
A few years later, Kuhlman (1829) published a note *On the production of artificial ultramarine*:

One finally recognised the possibility of artificially preparing ultramarine when M. Vauquelin published in the *Annales de Chimie*, vol. 89, that a blue matter, found in the soda kiln by M. Tassaert, had presented him with the physical properties belonging to this precious colour. Recently, the research of M. Guimet and that of M. Gmelin have met with the most satisfying results. However, due to the complex nature of the manufacturing processes published so far the price of artificial ultramarine has remained very high. With the desire to simplify such methods, I believe it useful to let you know of a production mode remarkable for its simplicity.

When having reverbatory furnaces, that were used for roasting sulphate of soda, repaired, I sometimes notice that the brick dam separating the product from the hearth is covered in various places with an ultramarine layer. It appears that, prior to the formation of ultramarine, sodium sulphide is formed; for the blue layers are surrounded with small bright crystals, of a brownish red, formed by this sulphide.

Did sulphate of soda decompose through the sole action of heat, or through the combined action of heat and coal from the fire, or did it finally decompose under the influence of the silica and alumina in the clay? These are questions which I cannot answer yet. However what I do know is that it is possible to make ultramarine with sulphate of soda and clay. (…)

Kuhlman therefore states that the ultramarine forming during the production of Leblanc soda is not due to the reaction:

$$Na_2S + CaCO_3 \rightarrow Na_2CO_3 + CaS$$

but to:

$$Na_2SO_4 + 4\,C \rightarrow Na_2S + 4\,CO$$

No need for sodium carbonate; sodium sulphate will do. This was yet another step toward the optimal solution.

Guimet in search of a market

In 1830, Guimet was made Commissioner for Powders and Saltpetres in Lyon. He directed the powder factory. When the first rebellion of *canuts* (silk workers) occurred, he succeeded in preventing the insurgents, who had taken control of the guns, from doing the same with the powder inventory of which he was in charge. With the help of his brother-in-law, Louis Bidauld, also a graduate from the École Polytechnique (class of 1826) and also a chemist and student of Gay-Lussac, he continued to produce artificial ultramarine for artists in Toulouse. A note to the Société d'Encouragement, dating from July 1830, confirms (*Séance du 14 juillet 1830* 1830):

M. Guimet recalls that the Société d'Encouragement, when awarding him the 6,000 fr. prize it had offered for the manufacture of ultramarine blue, expressed the wish that the price of this colour, first set at 25 fr. an ounce[19], be reduced later on. He announces that

[19] Within the text of the *Société d'Encouragement* mandating a price of 300 francs per kilogramme, there seems to have been a computational error which would take an ounce to 83 g, instead of around 31 g as usual.

very important improvements, by him obtained, in the preparation of this substance, enable him as of now to satisfy the wishes of the Société, and that his prices are to-day established as follows:

N°1 ultramarine: superfine	160 francs per pound	15 francs per ounce
N°3 ultramarine.	64 francs per pound	6 francs per ounce

It is available in Paris, from Messrs Tardy and Blanchet, 7 Rue du cimetière Saint-Nicolas.

However, Guimet realised how limited the market for artists' colours was. Due to its price (between 2000 and 5000 francs per kilogramme depending on quality), the French consumption of natural ultramarine did not even reach 3 kg per year (Larousse 1866–1879, 8: 'Guimet' entry). Assuming that a reduction in price would occur and that exports to other countries would multiply the use by one hundred, there would just be enough to offer an outlet for his current production at the pilot scale. But he was counting on moving to an industrial scale, and producing one hundred times more without any major difficulties. It was therefore high time to examine the markets for 'the various uses to which cobalt azure and Prussian blue are put' as suggested by the Société d'Encouragement, i.e. paper and cloth blueing.

Good fortune intervened, for just then, Montgolfier, the famous paper manufacturer, decided to try artificial ultramarine for blueing his luxury paper, and got in touch with Guimet. The brilliant success of this attempt was to change the destiny of artificial ultramarine manufacture.

The birth of the Guimet company

Simultaneously, and without abandoning his position with the Administration des Poudres et Salpêtres, Guimet created a new company dedicated to the manufacture of artificial ultramarine. The founding act and statutes have not been found, but they date from April 1831 (Tarlier 2007: 51). Guimet surrounded himself with men whose competence he had long appreciated. He took on, as associates, his brother-in-law Louis Bidauld as technical director, and his wife's half-brother Jean-Louis Lambert as commercial director. The premonition that competition would not be far behind made him move fast. Due to a new assignment to Lyon, he searched for a piece of land close to a waterway in the Lyon area. In March 1831, this was settled[20]:

I found after many a chase a perfectly suitable location. It is a domain situated in Fleurieu, on the banks of the Saône, completely isolated and meeting all the conditions that may be desired for an industrial establishment. The place is named the Red House.

Authorisation to open an ultramarine blue factory was applied for in May 1831, and granted in September of the same year. Production began forthwith but breaking into the national market would soon hit two sizeable obstacles. The first infrastructural obstacle was the absence of a means of transportation to link the Lyon area to the rest of France. The railway was only in its infancy in France, and transport took place by river

[20]Letter from J.-B. Guimet to Lambert, dated 30 March 1831. Private archives of the Guimet family. Quoted in Tarlier (2007: 52).

or by road. In order to fulfill the orders rapidly, Guimet set up a network of ultramarine depots covering the whole territory. Within three years, he had set up two depots in Paris, Tardy and Blanchet, and Lacoste the elder at 23 rue du Granitier for British orders. In the provinces, there were two depots in Rouen, and one each at Le Havre, Angoulême, Troyes, Lyon, Toulouse and Geneva. Soon there was also one at Mulhouse, held by Zuber, whom Guimet would entrust with the mission of selling in New York, as well as a few others. These warehouses were intended to satisfy the future needs of paper manufacturers for ultramarine blue for blueing.

The second obstacle was of an administrative nature. It was due to the high levels of duty which were imposed on artificial ultramarine during its travels. Classified in the same category as natural ultramarine, it was treated as a luxury product, and charged prohibitive railway freight tariffs. Turgan (1882) would point out that the duty had not changed since Guimet ultramarine sold for 200 francs per kilogramme, i.e. since 1830. Yet, its price had gone down spectacularly, and would go down to 2 francs, 1 franc or 50 centimes per **kilogramme** depending on quality. But it was still classified as 1st category merchandise (liable to a tariff of 20% of its sale price for its transport), and not as 4th category merchandise as it should be. On the other hand, numerous countries (England, Germany, Austria etc.) had set up duties of a protectionist nature. Guimet, who had a hard time exporting in spite of his tariff advantage over the competition, would be forced to ship his ultramarine under false names:

> If you favour me with some order, it would be important to know if, at the English customs, ultramarine is not taxed with very high duties. We could then ship the blue under the appellation royal blue as I do in Austria[21].

> I must warn you of a very important fact ignored by Lambert, which is that ultramarine blue is hit upon its entry into England with an exorbitant duty. Consequently, I did not affix the ordinary labels on the bags. I wrote azure blue, in order to avoid paying duties which would be equivalent to a prohibition. For the same reason, the bags are not accompanied by a printed instruction as I am in the habit of[22].

> I have the honour to warn you that I have just sent you the order on the count of M. L. Dambock, tulle manufacturer in Vienna, a small packet containing three pounds of ultramarine blue, under the name of royal blue, a qualification that you will be careful to state to customs[23].

Guimet refused to set up factories abroad. A letter shows that Clément and Desormes had acted in vain as intermediaries trying to persuade him to set one up in Glasgow[24].

[21] Letter from J.-B. Guimet to Balston and Co. in London, dated 21 December 1831. Private archives of the Guimet family. Quoted in Tarlier (2007: 56).

[22] Letter from J.-B. Guimet. Private archives of the Guimet family. Quoted in Tarlier (2007: 94).

[23] Letter from J.-B. Guimet to M.M. Ottmann and son in Strasbourg (1831). Private archives of the Guimet family. Quoted in Tarlier (2007: 95).

[24] From the private archives of the Guimet family. Quoted in Tarlier (2007: 96).

The conquest of the market for quality paper blueing

We shall not revisit here paper azuring or blueing (see Chapter 2). As the whiteness of luxury paper depended on the use of an inexpensive blue pigment, one can imagine the battle which the pigment manufacturers had to fight. At the time of the trials carried out by Montgolfier, smalt (purchased directly from Saxony) was favoured by French paper makers. The open letter from Guimet to Gay-Lussac, dated 25 May 1831, is particularly revealing as to the future industrialist's approach (Guimet 1831). After having underlined his efforts to improve the quality of his ultramarine while lowering its production cost (indeed, less than three years after having won the prize of the Société d'Encouragement, the price is much lower than the initial price of 600 francs per kilogramme):

(…) Experience has already demonstrated that ultramarine blue could advantageously and economically replace, not only the cobalt blue [Thenard's blue] intended for painting, but still azure or glass coloured by cobalt oxide [smalt], which is used in enormous quantities for blueing paper, linen cloth, calico, muslin, etc., and with which Germany is in a position to supply all Europe. As far as painting is concerned, the result never seemed in doubt to me; but for blueing I had somehow no hope, because of the low price of cobalt azure, the best quality of which costs but 2.75 to 3 francs per pound, and it was impossible for me to set my ultramarine at such a low price, when an attempt at blueing paper changed all my ideas on the topic.

It was nearly a year ago that M. Elie Montgolfier, a distinguished paper manufacturer, having seen a sample of my blue, conceived the idea of using it to replace cobalt for paper blueing, and, at his request, I put at his disposal a quantity of ultramarine sufficient for a full scale trial in the beautiful paper manufacture of Messrs Canson brothers in Annonay. The letter paper, blued thus, had as beautiful a hue as with cobalt, and the shade obtained was more even; but the most important result, from an industrial point of view, is that a pound of ultramarine, due to its intensity and extreme division, blues as much paper as ten pounds of the most beautiful and most fine cobalt. To make this fact even more obvious, I ceded to various paper mills in the Lyon area two hundred pounds of ultramarine at a price of 20 francs per pound; and when the nine month experiment showed that at that price my blue was less costly than cobalt, I decided to expand my production greatly and, in order to favour the manufacturers further away from Lyon, I set the price at 16 francs a pound.

Ultramarine intended for painters who require a particular purification, and having been selected during the whole preparation,...its price is 60 francs a pound for the higher and superfine quality. The second quality sells but for 20 francs only.

What has been obtained for blueing paper applies equally to calico, muslin, etc. Several finishers from Tarare already employ it for this latter use, and, as we give these results publicity, so do new orders come to us, some so considerable that I decided to manufacture ultramarine on a very large scale. I just purchased, three leagues from Lyon, a property to set up an establishment able to satisfy all of the demand. My brother in law, who assisted me in a distinguished manner, will direct the new production, for the success of which I am ready to make all the necessary sacrifices. We shall have great difficulties to surmount in the beginning, but we hope to succeed with perseverance and the protection of enlightened persons.

I have the conviction that, in a time not far away, France will be entirely free of the tribute it pays abroad for the cobalt blue used in painting and blueing, and that we may even, in case of success, force the foreigners to obtain from us the blueing colours. Cobalt would have no use other than glazing and blueing earthenware. Ultramarine being impervious to caustic alkali[25], it is easy to conceive how this property is favourable for blueing linens.

Ultramarine can furthermore be employed in wallpapers, the painting of artificial flowers, in every manner of oil paint, and I have even applied it to the dyeing of some cloths[26]. Crêpe dyes perfectly with ultramarine, and gives a beautiful blue, the colour of which is of an extraordinary richness and fast to the test. (...)

Guimet had found his first large market, that of blueing a staple product, paper. He would displace Saxon smalt from this market. For the first time, a pigment until then reserved for luxury artistic painting would be produced in the hundreds of tonnes. This was the task devolved to the Fleurieu factory. In a note read on 6 April 1831 to the Board of Governors of the Société d'Encouragement, Mérimée (1831), picking up most of the elements contained in the preceding note, explained:

(...) He consequently made a trip to Annonay, and an experiment carried out at M. *Canson*'s demonstrated that a pound of second quality ultramarine, which he could sell for 20 francs, blued as much paper as 10 pounds of cobalt [smalt], which, purchased wholesale, came to 26 francs: it meant therefore considerable savings, without mentioning another very important advantage resulting from the lightness of the colour, which uniformly spreads through the paper, while cobalt, due to its weight, sinks to the underside of the sheet[27].

The experiment, repeated with 30 pounds of ultramarine, confirmed the first results. Similar trials were then carried out in Rives, in the factory of Messrs Blanchet and Kleber, where over a hundredweight of this colour was used: so these manufacturers wanted to put money down for everything M. Guimet could manufacture.

These interesting improvements were announced to me as early as this last December, and from this moment on I should have kept you informed; but M. Guimet asked me to defer until a large establishment brought him to a position to satisfy the numerous orders from manufacturers. He is today in a position to meet the needs of the trade, and he desires that you be informed of what he has done to justify your expectations. (...)

A problem still remained to be solved. A sheet of paper is a non-woven intertwinement of cellulose fibres. However, without treatment this paper would be like blotting paper, on which it is impossible to write. To make it able to receive ink, paper undergoes various coatings and sizings which fill the pores and make the surface white, smooth and hard. These coatings often contain alum ($KAl(SO_4)_2.12H_2O$), a salt which

[25] The detergent used at that time for the household laundry was soda ash (our sodium carbonate Na_2CO_3). Its presence turned laundry water slightly basic.

[26] It was not dyeing *stricto sensu*, but rather printing on cloth. See *infra*.

[27] The density of artificial ultramarine is 2.34. Depending on its cobalt content, that of smalt varies between 2.5 and 2.8.

acidifies this medium. But, in an acid environment, ultramarine decomposes. The current remedy consists in treating the ultramarine surface, and covering it with a thin protective layer of silica. Guimet could only warn his customers[28]:

> If your azure is altered during sizing, this solely comes from the alum which you introduce into the sizing liquor. It is indispensable that the dose of this salt be decreased until you perceive no difference between the sheet of paper before and after sizing. Lime has no influence on ultramarine.

In spite of Guimet's remarks, this sensitivity to acid environments remained one of the few defects of artificial ultramarine, and manufacturers would soon see that there was a technological barrier to be broken. For the time being, production from the Fleurieu factory – the first in the world to produce artificial ultramarine on an industrial scale – would rapidly conquer the French market for paper blueing.

The market for laundry blue

There is little documentary evidence as to how Guimet opened up another huge market, that of blueing white linen, turning his artificial ultramarine into a 'laundry blue'. The eighteenth century saw the appearance of a real concern for hygiene, which was manifested by more frequent changes of body garments and bed sheets. Both had to come out of the wash as white as possible, for the colour white was inseparable from the notion of cleanliness. During the following century, in cities, the majority of family washes were entrusted to laundries – specialised establishments of varying size (Ungerer 1990; Bardiot 2001). It was through these establishments that Guimet would first commercialise his blue[29]: 'I sent through the mail leaflets to all paper mills and laundries of which the addresses can be found in the almanac of trade.'

The laundry market would turn out to be much harder to penetrate than that of paper mills. Prices had to fall below four francs per pound in order to get it started. But for Guimet, as later on for his emulators and competitors, this market would prove gigantic and soon became the premier market in its importance. The form in which ultramarine should be sold was soon found: balls about 1 cm in diameter (Figure 7.4), as was traditionnally done with other blues (smalt and indigo). Later came bags containing round bars (Figure 7.19). Finding the machines that performed best in producing them was hardly a problem for engineers[30]: 'The machine of M. Tillion *fils* can deliver balls like gum balls. (...) While trying out that machine, I was led to another means, extremely simple, which can give us 600 kg of balls per day with the same personnel.'

In 1834, considering the good development prospects for the artificial ultramarine market, Guimet decided to devote all of his time to such a promising industry. As a

[28] Commercial correspondence of the firm from the time of J.-B. Guimet (1832). Private archives of the Guimet family. Quoted in Tarlier (2007: 70).

[29] Letter from J.-B. Guimet to Lacoste, Guimet blue salesman in Paris, dated 26 May 1832. Private archives of the Guimet family. Quoted in Tarlier (2007: 70).

[30] Letter from Bidauld to J.-B. Guimet. Private archives of the Guimet family. Quoted in Tarlier (2007: 116).

consequence, he resigned from the Administration des Poudres et Salpêtres. That same year, his artificial ultramarine was displayed at the *Exposition de l'Industrie Française* held in Paris at the place de la Concorde. He presented 'three large vases containing several kilogrammes of ultramarine' (Moléon 1835–1838)[31]. His invention gave him the *Légion d'Honneur* as 'the inventor of the factitious ultramarine blue' (Dupin 1836), as well as a gold medal. This medal was the first of a long series: Paris in 1839 and 1849, Council Medal in London in 1851, Prize Medal in New York in 1853 etc. Guimet's exemplary success would soon inspire others to follow in his footsteps, abroad as well as in France.

Production development, other than Guimet's (1830–60)

The Gmelin process for making ultramarine on the laboratory scale had been published in 1828, in French and in German, the latter version containing important technical details. It still had to be developed as a production process, and the laboratory process supplied an ultramarine of very mediocre quality. It therefore had to be brought up to pilot scale, then to industrial scale.

The first production, which seemed to have been only at a pilot level, was carried out by Köttig in Meissen. Let us read Guimet[32]: 'The first factory to have produced ultramarine after mine was the Royal Saxon China Manufactory at Meissen, near Dresden. In 1831, it already produced some very beautiful products; but to my great surprise, its output never reached a very large scale.'

In 1832, the Society for the Encouragement of Arts, Manufacture and Commerce of London made a new prize proposition, in addition to the one for ultramarine (Transactions 1832): '26. For a precise report on the methods used by the chemists of France and Germany for the production of the new blue pigment used as a substitute for ultramarine; the Isis gold medal.' News of the manufacture of artificial ultramarine had, therefore, reached England, and aroused some interest, but not as much as in France. Indeed, various chemists attempted very small scale production of Gmelin ultramarine for artists. Thus did Mérimée relate on 31 December 1832 (Arsenne [1833] 1986: 237): 'M. Delaire, chemist, announced a siccative and fixed ultramarine blue, superior to all the factitious ultramarine known, at a price of 10 fr an ounce (…).'

This was a high price when compared to that of Guimet ultramarines which, at that time, sold for between 30 and 40 francs per kilogramme for the best quality. This confirms that production must have been at the laboratory scale. But Delaire was not the only one. A professor from the École de Pharmacie in Paris, Robiquet, who was very active in the new field of extracting colouring principles from tinctorial plants (he had already at that date isolated alizarin and purpurin from madder roots, as well as orcinol from orchil), proposed a process for ultramarine manufacture consisting of roasting a mixture of kaolin, sulphur and sodium carbonate (Robiquet 1832; Stas 1856: 601). The

[31] The visual effect must have been very close to that produced by certain accumulations of powdered ultramarine presented in exhibitions dedicated to Yves Klein.

[32] Letter from J.-B. Guimet to Messrs Zuber and Co., in Rixheim, dated 25 January 1856. Quoted Loir (1879a).

use of this last component shows that Robiquet had not paid attention to Kuhlman's note. Still talking of artificial ultramarine production, Mérimée went on (Arsenne [1833] 1986: 237): 'M. Robiquet shows the way to obtain it for a low price. (…) [But his blue] lacks in intensity and does not have that azure sheen found in M. Guimet's.'

A major event occurred in 1834 – the first German production on an industrial scale at Wermelskirchen, near Köln (Prussian Rhenany), by Dr. Leverkus. The Belgian chemist Stas would say (*Exposition Universelle de 1855* 1856: 606–7):

> By initiating production at a time when all indications to do such a thing were to the contrary, Dr. Leverkus did a real service to Germany and the other states; indeed he freed them of the monopoly which M. Guimet brought to bear on general consumption, by keeping his manufacturing processes secret.

The second competition from the Société d'Encouragement de Paris

Germany was not the only place where the *de facto* monopoly Guimet had over the production of artificial ultramarine was frustrating. It was the same in France too, and at the very heart of the Société d'Encouragement pour l'Industrie Nationale. In 1836, following, so it would seem, a change in policy of this society concerning industrial property (an issue which had always been the subject of debate there), the Committee for Chemical Arts spoke in favour of reopening the competition for artificial ultramarine. The report from Payen (1836) states:

> PRIZE OFFERED FOR THE YEAR 1837 - 1°. For the exact description of ultramarine preparation.
>
> It was as the consequence of the call from the Société d'Encouragement that the preparation of artificial ultramarine appeared in France; the author of this beautiful discovery deserved and received the prize endowed by us.
>
> One of our learned colleagues, *Vauquelin*, whose loss we all deplored, alone was, in your name witness to the operations through which the competitor made the brilliant and fast colour which we previously obtained from lapis lazuli at a very high price.
>
> At that time, we did not take the useful precaution imposed since, to have deposited in a sealed envelope the description of the process solving the problem, and the secret was, for us, buried with *Vauquelin*.
>
> The Société d'Encouragement does not, therefore, have in its own archives the guarantee that such a beautiful industrial invention will not itself be lost when its author ceases exploiting it.
>
> We also know that some very beautiful results have been obtained in the same direction by several chemists, although none of them has been able, to our knowledge, to make his process effective.
>
> It is therefore very likely that a new competition will bring us the certainty of acquiring, in the public interest, a process useful to our industry and to our fine arts; it is not impossible even that improvements be obtained, in the economy of the operation at least.
>
> As a consequence, the Société d'Encouragement opens a competition and endows a prize of 2,000 francs for the exact description of a manufacturing process by which one could economically prepare as beautiful an ultramarine as M. *Guimet*'s, and deliver it to the

trade at the current market prices for the various shades while realising a profit of at least 10 percent.

As a basis for comparison, commercial samples in sealed jars shall be deposited with the Société's secretary prior to next July the 1st. Competitors will be able to retain for ten years the secret of their operations; but, in that case, they will have to communicate and demonstrate them to one of the members of the Committee for chemical arts, mandated by this Committee, and who will deposit under a sealed envelope the description made by the competitor after having carefully checked its exactness; the seal on the envelope will not be broken until the ten years have expired.

There was a curious convergence between the desires of both societies for *encouragement*, that of London and that of Paris. The official programme took this text up and fixed the closing date as 1 July 1837 (*Programme XIII* 1836). The Société d'Encouragement therefore encouraged French competition against its laureate Guimet, without the latter having contravened the rules in any way. It did not take more than one year for a laureate to be found (Dumas 1837):

The Société d'Encouragement, which may derive glory from having thought possible and having brought to birth the artificial preparation of ultramarine, did not want to leave its work unfinished. M. *Guimet*, whom it crowned in 1828, remained the master of his process. The Société thought it useful that a suitable process for this manufacture be known, or at least may be known at a given time.

It understood, indeed, that after having obtained an almost undreamt of success by having ultramarine made at a moderate price, it had to go beyond and prepare for the future a large and economical production of a substance which, by the nature of its ingredients, promises to become the least expensive blue colour of all, as it is the most beautiful and the most durable.

A blue colour which is obtained, indeed, by means of clay, sulphur and soda must become, sooner or later, a colour with a price as low as Prussian red [roasted yellow ochre];one just needs to adjust the manufacturing process over several years of full scale practice.

These motivations determined the Société to offer a new 2,000 francs prize in favour of he who would give an exact and complete description of a manufacturing process suitable for ultramarine production. It has determined that the ultramarine be as beautiful as that of M. Guimet, and that it be deliverable to the trade whilst realising a 10% profit. Under these conditions, it allowed that the author should preserve for ten years the secret to his process, the description of which would remain under seal in the archives of the Société.

A single competitor came forth, M. Ferrand, well known in the colour trade for the cadmium yellow he has been preparing for several years with success. The ultramarine submitted by him presents the following variants:

For painting, the n°1, which is the most beautiful 60 francs per kilogram
For blueing linen or papers, the n°2 24 francs per kilogram
For wallpapers, the n°3, in paste form 3 fr. 50 c. per kilogram

All these samples are, as far as the beauty of the colour, below the analogous samples of M. *Guimet*. From this point of view, the conditions of your programme were therefore not satisfied. Nevertheless, your Committee for chemical arts remained convinced that

the process of M. *Ferrand,* which, according to this manufacturer, is nothing else than the process of M. *Robiquet,* improved, should suffice to meet the purpose the Société had elected. It judged that this manufacturer's ultramarine was sufficient for most commercial uses; that it could be perfected over time; that the recipe leading to it would always be an excellent starting point for any one wanting later to improve this product. For these motives, your Committee judged that it was proper to award the prize to M. *Ferrand.*

I have consequently been charged with becoming acquainted with the description submitted by this manufacturer and to check its exactness in his workshops. I had the operation carried out under my eyes, and was able to convince myself that this description was perfectly in accordance with the process employed by M. *Ferrand.*

The essential conditions of the programme having been satisfied, we have the honour to propose the Société award M. *Ferrand* the 2,000 francs offered, and to preserve until the end of 1847 the description of his process, which will be publishable at that time if the Société sees fit.

Signed *DUMAS*, referee Approved in plenary session, 17 January 1838.

Thus Ferrand, colour manufacturer at 7 rue Mongalet, Paris became the second laureate of the Société d'Encouragement on this theme. The same year, his products, which included ultramarine, would earn him a bronze medal at the *Exposition des produits de l'industrie nationale* held in Paris.

The development of ultramarine manufacture in France

Ferrand was not the only one in France to work on this subject, and research was making good progress. Another specialist in organic chemistry, Persoz, Professor of 'dyeing, whitening and starching' at the Conservatoire impérial des Arts et Métiers devised a process he kept secret (Stas 1856: 601) while a certain Capitaine de Tiremois (1842a) published his laboratory process. His raw materials were (weight proportions):

Raw clay (ground and sieved) from Abondant, near Dreux: 100
Alumina in gel form, representing anhydrous alumina: 7
Desiccated sodium carbonate: 400, or crystallised: 1075
Flower of sulphur: 221
Arsenic sulphide: 5

Obviously, Tiremois had not mused over Kuhlman's note either. The detailed operating scheme revealed a production process in two stages. The first heating yielded a first material 'of a beautiful tender green, already bluish'. A second oxygen free heating, in a closed crucible, led to ultramarine. This process does not seem to have been used industrially.

During that time, Courtial set up an ultramarine factory in Besançon, and began production. In 1844, the daily production was of 25 kg of good quality ultramarine which sold for 10 francs per kilogramme, and the same quantity of ultramarine ash which sold for 3 francs per kilogramme (Dumas 1844). In 1845, the following note appeared in the bulletin of the Société d'Encouragement (Payen 1845):

Gentlemen, two years ago, M. *Courtial* sent you from Besançon samples of artificial ultramarine of remarkable beauty.

At that time, this manufacturer intended to relocate the industry he had created in the department of Doubs to near Paris . He has now carried this project out. Taking advantage of the experience acquired, M. *Courtial* has perfected his methods.

In his factory, set up in Grenelle, a steam engine develops all the mechanical power necessary to his operations; daily production amounts to 80 kilogrammes, and the ultramarine thus obtained, on a larger scale, presents a richer and more brilliant shade than the products sent from Besançon: comparable, actually, from a fastness point of view, to the most highly esteemed ultramarines in the trade, they seemed to us to leave nothing to be desired. (…)

Ultramarine (…) enhances the brightness of our wallpapers, can be affixed, via printing processes, to luxury cloth; it is used for blueing white paper as well as whitened threads and linens; it is used for the solid backgrounds of inscriptions and exterior paintings which multiply everyday, to decorate shop fronts. (…)

The following year (1846), the Société awarded its gold medal to M. Courtial 'for having, through the creation of a new factory, developed this production further' (*Médailles d'or* 1846). In 1847, at the end of the ten years elapsed since Ferrand had deposited the envelope containing his process, the Société d'Encouragement did not see the need to publish the process. It judged – with reason – that the multiplication of ultramarine factories in Europe was such that this measure was no longer justified.

In 1848, Guimet's factory employed 80 workers and produced 80 tonnes of ultramarine[33]. By 1855, its production had gone up to 250 tonnes (55% of national production as its six competitors together produced only 200 tonnes).

The development of ultramarine manufacturers in Germany

The production of artificial ultramarine took off quite remarkably in Germany, presenting its customers with more and more different qualities of ultramarine.

Although Gmelin had published his laboratory process, each manufacturer worked in the greatest secrecy to create an operation on an industrial scale. Some processes were written up in publications (e.g. Weger (1845), Brunner (1846) and Dippel (1854)), but none detailed enough to give away an industrial secret. As an exception to the rule, Prückner (1844), a German businessman linked to the Leykauf and Heine Company (Nuremberg) but having his own factory in Hoff (Bavaria), presented in detail the manufacturing process of Leykauf and Heine 'which supplies to the trade factitious ultramarines of all qualities and at all prices'. According to him, the process was widely used industrially. However, by the time he had written this, the factory had already been closed down: the workers were overcome by sulphurous vapours. Prückner leads one to believe that he used a modified version in his factory.

According to him, the raw materials were iron-free white clay; the soda sulphate resulting from hydrochloric acid production; sulphur; coal; and, curiously, an iron salt, e.g. ferrous (Iron II) sulphate, 'completely devoid of any copper'. The article details

[33] Private archives of the Guimet family. Quoted in Tarlier (2007: 83).

the crucibles, muffles and reverbatory furnaces used; the purification of the various reagents; and the sodium sulphide preparation. Mixing the ingredients was done as follows: to a 50 kg syrupy solution of sodium sulphide were added wet clay in the amount corresponding to 12.5 kg of dry aluminous clay, as well as 0.25 kg of ferrous sulphate. This was stirred and dried. The mixture was ground, and then put into muffle furnaces with capacities between 15 and 20 kg. It was heated initially to red heat for about an hour, while turning over the products in the air. The product thus obtained was washed in water to remove the excess sulphurous reactants. The green or blue-black residue was dried, ground and sieved. Placed in crucibles in batches of 7 kg, it was heated again 'to a light red' for about half an hour, during which time it was again turned over in the presence of air. After cooling, the ultramarine was then 'of a beautiful pure blue'. It was ground, and ranked by fineness. As described, this process seems to depart on many points from the optimal production. This is probably the reason why it was published.

Behind this smoke screen, German factories grew like mushrooms. In 1855, Germany was the top producer of ultramarine in the world: its forty factories produced 1,650 tonnes. France produced 450 tonnes, and England 400.[34]. Such large scale production had an influence on the manufacture of ultramarine in other countries including England and France.

The Great Exhibition of the Works of Industry of All Nations

This exhibition (Crystal Palace Exhibition) was held in London in 1851. It led to the publication of a catalog of exhibitors, reports by the Juries and comments that take stock of the artificial ultramarine made in England at that time.

Thus, in his commentary on the exhibition, Tomlinson (1852: cxxxvii) writes:

> (...) The manufacture has very recently been introduced into England, but it is in the hands of foreigners. At the Great Exhibition, the artificial ultramarine on the English side was by Kurtz and Schmersahl, of Manchester; by Picciotto, as manufactured in London by Hochstätter's process; and by Dauptain & Co., of the City Road, London. Guimet has not published his process: the Germans have been more liberal, they having published, at different times, a number of recipes in detail, some of which fail in practice, others are too expensive, and one or two depend, to a certain extent, upon the skilful application of the materials furnished by the locality of the manufacture. (...)

For its part, the Report by the Juries (Graham 1852: 44–50) gives us a list of the rewarded exhibitors with short comments:

For the United Kingdom

Dauptain, Gorton and Co., exhibitors of ultramarine had the Prize Medal accorded to them for the beautiful samples of their manufacture.

Schmersahl A. E., exhibited different varieties of ultramarine of fine quality, for which a Prize Medal was awarded to him.

Picciotto M. H., is not awarded for its ultramarine, but for another product, gum-arabic.

[34] Private archives of the Guimet family. Quoted in Tarlier (2007: 93).

For France

Guimet J. –B, 'Lyon, had the Council Medal awarded to him as the original discoverer of artificial ultramarine in 1828, and as being still one of the most successful manufacturers of this substance.'

Courtial, 'of Grenelle, near Paris, had the Prize Medal awarded to him for his assortment of ultramarine, which fully maintain, by their superior quality, the high reputation of the French manufacture.'

Zuber J. and Co., 'of Rixheim (Haut Rhin) had the Prize Medal awarded to them for their ultramarine, which is remarkable for its fine division and beautiful violet tint. They also supply a green variety of ultramarine, and a collection of paints.'

For the *Zollverein* Germany

Gademann H., 'of Schweinfurt, Bavaria, is one of the German exhibitors of ultramarine to whom the Prize Medal was awarded.'

Schruck and Uhlich, 'of Bamberg, in Bavaria, received Honourable Mention for ultramarine of superior quality.'

Büchner W., 'of Pfungstadt near Darmstadt, [Hesse] had the Prize Medal awarded to him for ultramarine, of which he exhibited the greatest variety.'

The Electoral Blue Colour Works, 'of Hesse, Schwarzenfels, received Honourable Mention for beautiful samples of smalt, accompanied by other preparations of cobalt, and for ultramarine.'

Curtius J., 'of Duisburg, (Prussia), was one of the exhibitors of ultramarine distinguished by a Prize Medal.'

Leverkus C., 'of Wermels-Kirchen (Prussia), stood high as an exhibitor of ultramarine, and had the Prize Medal awarded to him for that substance.

Röhr F., of Wiesbaden, Nassau, was an exhibitor of ultramarine distinguish by a Prize Medal.

The Royal Saxon China Manufactory, at Meissen, first prepared ultramarine in Germany; and has exhibited samples of remarkable beauty, for which a Prize Medal has been awarded.

Bremiger, of Kirchheim is also mentioned as having contributed a great display of ultramarine from Germany.

For Austria and Bohemia

Kutzer and Lehrer, of Prague, obtained Honourable Mention for the ultramarine which they exhibited. They also presented chrome-orange and chrome-yellow of fair quality.

Setzer J., of Weitenegg, on the Danube, represented the manufacture of ultramarine in Austria. He also exhibited the yellow sulphide of cadmium of great purity and intensity; with a collection of madder colours. An Honourable Mention has been awarded to him.

Beyond the reporter's comments, which seem a little Francophile and Germanophobe, two points seem noteworthy. Exhibitors can be classified into two categories. Those who have specialized in the production of ultramarine (Guimet, Courtial, Curtius, Leverkus etc.) and those for whom this new production (ultramarine) in addition to those they already do (Electoral Blue Colour Works, Setzer, Pitticcio etc.). Such firms are less

rewarded for their ultramarine than the first category. They will be the first to abandon this production when the competition becomes tougher.

The second point concerns 'The Electoral Blue Colour Works', i. e. the Schwarzenfels factory of smalt located in the Hanau county (Héron de Villefosse 1819: 158). Smalt being driven out of its markets by ultramarine, we have here an example of attempted industrial conversion of the manufacture of smalt to that of ultramarine. They at least had a point in common, both taking place at high temperatures. However, this conversion did not succeed.

The impact of German production on France

The case of the expansion of German factories and the variety of products they brought to the market could not help but impress prospective French manufacturers in their choice of process. This was certainly the case with Zuber. This famous wallpaper manufacturer located in Rixheim, near Mulhouse, was a large consumer of ultramarine which was used for the skies and blue backgrounds in his wallpaper scenes (Figure 4.7). He had used it since 1835, the date at which it appeared in the company inventory under 'drugs and colours'[35]:

1½ kg superfine ultramarine in paste form [at] 30 francs	45 francs
10 kg mixed ultramarine for rolling [at] 4 francs	40 francs

At the time this corresponded to ultramarines of medium and low quality respectively (Figure 7.10). These entries keep recurring without any reference to the origin until 1847, when the origins are mentioned:

80 kg of Guimet ultramarine [at] 9 francs	720 francs
40 kg of Leverkus ultramarine [at] 7.70 francs	308 francs

As far as Guimet ultramarine is concerned, the price corresponded, at the time, to the best quality. We shall later see Guimet's comment concerning the difference in price.

In 1846, Jean Zuber (2003) wrote to his son Ivan[36]:

Ultramarine (…) is a product of which we make great use, the manufacture of which is liable to a large development, able still to deliver good profits, in France especially where this colour is still worth twice as much as abroad, and the manufacture of which finally is of so recent a date and kept in so few hands as to probably still be able to undergo large growth and great improvements.

[35] Archives of the Jean Zuber and Co. manufacture, shelf mark MPP Z 195. Quoted in Jacqué (2005: 3).

[36] Archives of the Jean Zuber and Co. manufacture, shelf mark MPP Z 195. Quoted in Jacqué (2005: 10).

He decided to manufacture his own ultramarine. To this end, he halted the studies of his son at the École Centrale in Paris, in order to send him to Wermelskirchen to be trained in the Leverkus process. His mission was to get ready to set up a production facility in Rixheim. There, Ivan had the hardest time finding the shade of Guimet blue. He went to London to study the Dauptain process. Difficulties having been overcome, production began in 1849, and went according to plan.

Jean Zuber was determined to publicise it (*Procès verbal* 1849):

Messrs *Zuber* and Co., of Rixheim (Haut-Rhin), state that the manufacture of artificial ultramarine is one of the more beautiful conquests of modern chemistry; the Société d'Encouragement being in a position to claim, quite justly, the glory of having provoked and encouraged it, they hope it will welcome with interest the announcement of an establishment they have just created for the manufacture of this colour through improved processes.

Until now only two ultramarine factories existed in France, that of M. *Guimet*, inventor of the processes whose products occupy the top rank, and that of M. *Courtial*, established just a few years ago.

In Germany, on the other hand, this industry has recently undergone a certain development; its manufacturing processes seem to differ from those used in France, and its products are, in a number of ways, preferable to the French ones.

Desirous to preserve for France its superiority in this branch of industry, Messrs *Zuber* and Co. have adopted the German manufacturing processes in the factory they just founded, and they submit samples of their product for the Société d'Encouragement to examine.

Here are the advantages that their production method presents: 1° a larger variety of hues, either lighter or darker than the French ultramarines which generally present a single hue only; 2° a greater vividness in tone; 3° shades of a pure blue exempt from the pinkish sheen characterising French [Guimet] ultramarine. This circumstance enables these kinds to be used for mixtures in which the pinkish shade would only produce sullen tones, in particular for very light blues and greens.

The samples sent by Messrs *Zuber* and Co. are composed of their more common kinds.

They note that their establishment already employs some thirty workers and the motive force of six horses: it is set up to allow production to be increased to 30,000 kilogr. of ultramarine per year, and they have good grounds to expect to reach this figure soon.

From this collection of information and an examination of the samples, Messrs *Zuber* hope the Société will conclude that, for having imported into France, by submitting to enormous sacrifices, the manufacture of ultramarine from the best methods known in Germany, they have brought progress to this interesting industry. Such is, actually, the opinion of M. *Guimet* himself, who sent Messrs *Zuber* the following letter this April the 2nd:

'I have received, together with your letter of March the 28th, the samples of ultramarine of your making that you were kind enough to send me; I find them quite beautiful, and most sincerely congratulate you on this result which honours you. I see with pleasure the progress of an industry, the development of which interests me greatly, not preoccupying myself with my interests as a manufacturer, though they may suffer. Competition within

reasonable limits increases consumption by creating new buyers, and the result is more or less the same for the manufacturers.'

In August of the same year, there appeared in the same bulletin of the Société d'Encouragement a report on Zuber's ultramarine (Bussy 1849). It reproduced to a large extent the above text, but also added:

(...) But the numerous and recent applications ultramarine has received in a great number of industries and the resulting consumption have led to the creation of rival factories abroad.

Germany distinguished itself in this type of production, particularly, in Nuremberg, where a considerable establishment marketed its products not only in Germany, but even threatened to introduce them into French markets, in spite of the onerous import duties they would have to bear.

These German products, inferior in price, are rather commendable in terms of quality and stand out mostly by the variety of shades which suit the multiple uses of ultramarine.

This is the state of production in which Messrs *Zuber* and Co. intervene.

They had been the first manufacturer to use ultramarine on a large scale for wallpaper and received, in 1832, a second class gold medal for the improvements they introduced to the manufacture of wallpaper; but the requirements peculiar to this type of application, the obligation to have very varied hues appropriate for all blends of colours required by wallpaper preparation soon inspired in them the desire to establish a production of their own. (...)

To appreciate the importance of the modifications Messrs *Zuber* and Co. made to the manufacture of ultramarine, one must not forget that the uses for this product acquire more importance every day. It is used not only to print on cloth or paper, for paint, to blue paper and linen, but also to colour wax, candles, soap, starch, and even sugar. Messrs *Zuber* and Co. have given it a domestic use of sorts, substituting it, in the guise of tablets or balls, for the various blues which are used to blue laundry.

Independently of the beauty of the hue it imparts to the laundry, it does not present, like Prussian blue, the inconvenience of turning red under the influence of the detergents to which household linen is submitted.

From the motives expressed in this report and the examination of the products addressed to the Société, the committee is of the opinion that Messrs *Zuber* and Co., through the import to France and the large scale exploitation of the best processes applied in Germany for the preparation of ultramarine, have delivered a veritable service to this interesting industry. (...)

This was too much for Guimet who, abandoning his usual reserve, let it be known to the Société in a letter dated 5 September 1849 (Guimet 1849):

(...) The minutes of the meetings of the Société d'Encouragement for the month of July contain a notice from Messrs *Zuber* and Co., from Rixheim, concerning a factory for ultramarine blue which they have just set up in Alsace where they have taken advantage of developments realised in Germany in the production of this colour, which has assumed a major importance in that country over the last few years.

I applauded that industrial result, and expressed it in a letter addressed to Messrs *Zuber* and Co. this last April the 2nd; but while paying justice to their efforts, I cannot refrain from contradicting their assertion that the production of ultramarine would be more advanced in Germany than in France where it was born.

Messrs *Zuber* and Co. base their opinion on the Germans having brought to the trade a larger number of shades than me, whence they conclude that this operating manner constitutes some inferiority on my part to which they have come and brought remedy.

This large variety of samples, which barely differ from one another, far from being an advantage, only serves to bring to the ultramarine trade a confusion from which unscrupulous dealers know very well how to profit by substituting one quality for another. If I did not follow this path, it was not because of the difficulty of producing all these shades, but rather because it was unnecessary and made the market for this colour very complicated.

Indeed, for the most important uses of ultramarine, paper blueing, cloth blueing and printing, it is enough for me to have two qualities to satisfy the consumers. For painting, just three shades meet all the artists' needs.

A much more essential condition to consider in the value of ultramarine is its colouring richness and fineness which make its use more or less economical. From this point of view, my blue is recognised everywhere as far superior to those from Germany, which, for an apparently equal shade, colour roughly half as much as mine. Consumers know perfectly how to appreciate this advantage, important for all uses.

Through numerous analyses of different ultramarines, I found that those from the main German manufacturers contain at most 4 to 5 per cent of combined sulphur, while in my ultramarine I combine 8 to 10 per cent of this combustible. The colouring richness is proportional to the combined quantity of colouring principle[37] .

The best proof I can give of the preference granted to my ultramarine is the considerable sales I make in foreign countries in competition with the German blues; I export annually over 20,000 kilog., which, due to their great colouring richness, are equivalent to nearly 40,000 kilog. of German ultramarines.

Furthermore, my manufacture has kept on progressing. Since the 1844 exhibition, my yearly production has gone up from 10,000 to 60,000 kilog., and prices have reduced by over a half. Recent improvements allow me to increase my production and bring it up to 200,000 kilog. per year, should consumption needs require it. I have just set up, to that effect, a new steam engine with the force of 30 horsepower for grinding ultramarine.

Signed *GUIMET*

One may very well understand the interest of Zuber for a wider ultramarine chromatic palette. But, for the rest, Guimet's arguments carry weight, and the man knew his business. It is indeed no easy task to judge by the naked eye the saturation of a colour, or to evaluate the colouring power of a pigment without carrying out trials. The committee, manifestly with little competence in this domain, let itself be duped over the quality of German ultramarines

[37] This relation is confirmed by recent research. For blue ultramarines, the colouring power of the pigment is proportional to the concentration in S_3^- chromophores (cf. Ledé 2005: 231).

Figures 7.5 and 7.6 offer an illustration of the use of ultramarine in the wallpaper industry.

We shall note that, in this text, Guimet mentions printing on cloth amongst the most important uses of ultramarine.

Ultramarine printing on cloth

When planning to make a pigment, one would not perhaps think of the textile market. Yet, in 1831, Guimet ended his open letter to Gay-Lussac by saying (Guimet 1831):

> One can use ultramarine in wallpapers, painting artificial flowers, in all kinds of oil paintings, and I have even applied it to dyeing certain cloths. Crêpe dyes perfectly with ultramarine, and gives a blue colour the sheen of which is of an extraordinary richness and fastness against anything (...)

'Dye' certainly has to be understood in a very particular sense since a pigment could in no way be employed for dyeing. Prussian blue dyeing (see Chapter 5) was an exception, since it consists in forming the coloured matter directly on the fibre, rather than dispersing powdered blue onto the cloth. By 'dyeing', in this letter, we must therefore understand 'printing on cloth'. This is anyway what the following text leads us to understand (Persoz 1854):

> M. Guimet, in discovering ultramarine blue, believed he was serving exclusively the needs of painting; however so brilliant a colour would mostly serve printers on cloth. In 1834, Messrs Blondin, printers at la Glacière [in Paris], began applying it by making it adhere to the cloth using egg white. For ten years that is until 1844, they were the sole printers using the very secret process of printing ultramarine blue on a multitude of objects: ties, handkerchiefs and novelties which became very popular at the time.

> Among the products of the 1844 Exhibition were to be found several cuts of muslin printed in ultramarine blue by M. Broquette, which sharply drew the connoisseurs' attention through their nuance and printing method, from which emerged remarkable effects of contrasting tones.

> Messrs Dollfus-Mieg immediately took up this production, and, thanks to the important means at their disposal, they were able to print in a few months a considerable number of bolts of white background muslin and jaconet[38] with admirable ultramarine blue designs which they sold throughout the world markets. From this time on, ultramarine blue, successively introduced in the printing of all kinds of cloths, never ceased being employed and its use gave birth in France to several industries for the purpose of either extracting albumen from egg white and serum from blood, on a large scale, or treating through various processes milk, gluten, fish cartilage, all matters actually capable of displacing albumen for mechanically fixing colours onto cloth.

[38] Jaconet: 'cotton cloth, fine, light, but tightly woven, which holds the middle ground between muslin and percale, and which is used either white or printed to make dresses (...).' In France, the main production centres for jaconet were Tarare, Mulhouse (where the Dollfus-Mieg manufacture was located) and Saint-Quentin (Larousse 1866–1879, 9: 'Jaconas' entry, 867).

It therefore did indeed refer to pigment printing, a type of printing which is not used with dyes, but only with pigments which attach to the fibre surface thanks to polymers which cross-link after application. During the nineteenth century, natural polymers were employed (egg white in the present case). Synthetic polymers are used nowadays. The colours produced are brilliant and generally fast (*Dictionary of Fiber and Textile Technology* 1990: 'printing' entry).

The 1855 Universal Exhibition in Paris

A last and vast experiment remained to be attempted. France, for the last half-century lead the world in its national exhibitions, France, now lays its hand on the sceptre of Universal Exhibitions; and in what circumstances!

With a foresight which judges the chance of success to be high and a powerful will which makes it certain, the Emperor hastily fixes a time, premature in the eyes of the meek. As early as 1853, he decrees 1st May 1855 as the date for the Paris Universal Exhibition and the Nations get to work.

In vain do battles and giant sieges take place[39] which keep the world in expectation; our weapons, instead of stopping it, protect the work of all peoples.

France erects an immense palace for its Industry, which, for the world, becomes a temple to Peace and Concorde.(...) (Dupin 1856: 137)

In other words, the first Universal Exhibition organised in France took place in Paris in 1855. Facing the Palais de l'Élysée, the entrance portal to the gigantic Palace of Industry built on the Champs-Elysées was symbolically surmounted by the statue of *France crowning with gold Art and Industry.* For his artificial ultramarine, Guimet received his 'crown' in the guise of the highest award, the Grand Medal of Honour, ahead of the thirty-three other competing manufacturers. The jury's report concerning the artificial ultramarine section was by the Belgian chemist Stas (1856: 600–7). It gives us a snapshot of the ultramarine production in Western Europe through the eyes of the manufacturers who saw fit to compete. The great news in this domain was the discovery of green ultramarines, some of which were described as 'of a very pure green'. Some German manufacturers, like Röhr, specialised in the production of a range of blue-greens and entered a series of samples containing no less than thirty-six shades in the competition, obtained by favouring the formation of the yellow chromophore, S^{2-} (see Chapter 3).

All the manufacturing processes consisted in allowing sodium sulphide laced with sodium carbonate to react with finely pulverised white clay at a dull red heat for forty-eight hours. Taking place in a reducing atmosphere, the reaction resulted in a green ultramarine. Contact with air transformed green ultramarine into blue ultramarine. It only remained to wash the product once cooled to rid it of surplus unreacted sulphurous products.

Some manufacturers had already noticed that the addition of silica to the initial mix increased the resistance of ultramarine to an acidic environment.

[39] At the time the French and English troops were fighting against the Russians at the battle of Alma, and the siege of Sevastopol had failed.

Lauth (1882: 163) recorded the number of ultramarine factories per nation in 1855 as: seven in France; forty in Germany (Germany produced 66% of the world's ultramarine); and only four in England (producing 400 tons). Of the fifty-one manufacturers recorded, only thirty-four presented their ultramarine at the exhibition. Sixteen of these received awards. Ranked by nation and merit, they were (Stas 1856: 604):

For France

Guimet J.-B., Lyon, established in 1830–31, Grand medal of honour.

Zuber & Co. in Rixheim (Mulhouse), ultramarine manufacturer since 1849, medal of honour.

Chapus & Richter, in Wazemmes (Lille), since 1849, 1st class medal.

Armet de Lisle J., Nogent-sur-Marne, recent, second in importance in France after Guimet, 2nd class medal.

Bonzel Frères, in Haubourdin (Lille), honourable mention.

For Germany

Fries C.-A., in Heidelberg (Baden), 1849, 1st class medal.

Büchner W., in Pfungstadt near Darmstadt (Hesse), 1842, 1st class medal.

Von Plonnies and Co., in Marienberg near Darmstadt (Hesse), recent, 2nd class medal.

Dr. Leverkus E., in Wermelskirchen (Prussian-Rhenany), 1834, 1st class medal.

Curtius J., in Duisburg, (Prussian-Rhenany), 1849, 2nd class medal.

Stinnes G.-G., in Ruhrort (Prussian-Rhenany), 1852, honourable mention.

Röhr F., in Clarenthal near Wiesbaden (Nassau), recent, 2nd class medal.

Bartels and Mohrhardt, in Alexandrinenthal (Coburg), 1852, honourable mention.

Breuninger and sons, in Kirckheim-under-Tech (Wurttemberg), honourable mention.

For Austria

Kutzer, in Prague (Bohemia), very recent, honourable mention.

For Belgium

Brasseur E., in Ghent, 1851, 1st class medal. Its production, 300 tonnes/year, is mostly exported to America, England and Spain. Qualities for printing cloth, blueing paper and balls for blueing linen. Brasseur also produces red and white lead. He is the first manufacturer to produce ultramarine in Belgium.

We do not know the identity of the eighteen manufacturers who were also at the Exhibition, but absent from this list. Among them might have been the following (the dates are those of their creation):

Courtial, in Besançon, 1843. Transferred to Grenelle near Paris in 1845.

Royal porcelain manufacture in Meissen, near Dresden (Saxony), 1831.

Leykauf and Heine, in Nuremberg, 1841, which became *Zeltner and Heine* in 1845.

Prückner C.P., in Hoff (Bavaria).

Setzer, in Weitenegg (Lower Austria)

Dauptain, in London, 1845.

Kohnstamm H. and Co., in New York, 1851.

Can one identify the manufacturing processes employed? It is clear that the great majority of them derived from the Gmelin process, brought up to pilot scale in Meissen, then to an industrial scale by Leverkus. But which modifications did each bring to it? Were there as many variants as manufacturers? These questions currently have no answers. Similarly, it is very difficult to know whether a French manufacturer used the Ferrand process. Among the six French producers identified, the only two established facts are that Guimet used his own process and Zuber had bought the right to use the Leverkus process, with improvements due to the C.A. Fries firm from Heidelberg. Courtial may have used the Ferrand process. The others probably used German processes. This is certainly what allowed Stas to write in his report:

> (...) it has to be admitted, the processes used in France were borrowed from German factories.(...)

Then, in the conclusion (Stas 1856: 603, *outremer artificiel* section):

> (...) the jury believes it must, through a solemn vote, recognise the eminent service the Société d'Encouragement has in this circumstance rendered the industry and fine arts of all countries. It also thinks that the same vote should include the names of M. Christian Gmelin, in Tübingen, and M. Guimet, in Lyon: M. Christian Gmelin, for having discovered in Germany and made known, as of 1828, a process for artificial ultramarine production; M. Guimet, for having discovered in France, at the same time, and having produced on a large scale pure blue artificial ultramarine. (...)

In line with the claims of the editor of Gmelin's article, written in German, Guimet was again convicted of simultaneity here. In a later report, Loir (1879b: 1), probably tongue-in-cheek, would write: '(...) the jury's report, although written with much care and great impartiality by M. Stas, offers a glimpse of German influence having circumvented the honourable reporter.' J.-B. Guimet did not protest, but it was upon this occasion that he published his letter 'to the Zuber gentlemen' dated 25 January 1856, a letter in which he listed in chronological order the first establishments to make ultramarine[40].

One Guimet may hide another

In 1855, Jean-Baptiste Guimet took a major holding in Henry Merle & Co., a soda manufacturer. That same year, following the purchase of an area of salt marshes, he changed it into the Compagnie des Produits Chimiques d'Allais et de la Camargue (PCAC), of which he became Chairman of the Board. Under his guidance, this company gained in dynamism. In 1860, at the age of 65, Jean-Baptiste Guimet relinquished the direction of the Fleurieu factory to his son Émile, aged 24. He died in 1871. The story of his career was the topic of a communication by Mulsant, a member of the Académie de Lyon and

[40] Letter from J.-B. Guimet to M.M. Zuber and Co., in Rixheim, dated 25 January 1856. Quoted in Loir (1879b: 3).

assistant librarian of the city of Lyon, who read it before this assembly on 19 March 1872. It was then published as a booklet (Mulsant 1893).

Unlike his father, Émile Guimet had no scientific background. He had a pronounced taste for the arts and philosophy. Nevertheless he took over the business, and managed, with obvious success, to lead two very different careers simultaneously. The most well-known to the public is that of an impassioned amateur of Far Eastern arts, who assembled very remarkable collections that his travels gave him the opportunity to build, and his fortune the possibility to acquire (Omoto and Macouin 1990). The desire to put them at the public's disposal pushed Émile to set up a museum in the Tête d'Or area in Lyon, a museum which was inaugurated in September 1879 by Jules Ferry, *ministre de l'Instruction Publique*. But dissatisfied with the apathy of the Lyon cultural life, Émile Guimet decided to donate his collections to the French state, provided the latter supplied him in Paris with a suitable tract of land where he could build, at his own expense, a second museum, larger than the first. The Guimet museum, the current Musée National des Arts Asiatiques, would be inaugurated by the President of the Republic Sadi Carnot in November 1889.

In parallel, Émile Guimet led the career of an industrialist who continued to develop the Fleurieu factory, and the range of ultramarines made there. He showed himself to be a boss in the vanguard of social activism, which did not always go down well with the Lyon establishment. He also took an active interest in the PCAC Company, the name of which was extended to include the name of one of its managers, Pechiney. He became Chairman of the Board in 1887. It was he who would orient its activities toward the production of aluminium. An exceptional personality no doubt, but his expenditures on his cultural activities would end up restricting the financial leeway of the Guimet business.

The London International Exhibition

In 1863, the International Exhibition took place in London. In the chemical products section, the report (Figure 7.7) concerning ultramarines was written by the Hesse chemist A.W. Hofmann, one of the founding fathers of organic chemistry, who at the time presided over the Royal Chemical Society of London and directed the Royal College of Chemistry. He had read the Stas report on the 1855 Paris Exhibition and recommended its reading. We therefore find once again the repeat of the legend of the simultaneous discoveries by Guimet and Gmelin. However the interest in his text is, of course, that it gives us a review of artificial ultramarine production in 1862 (Hofmann 1863).

The processes were split into three groups, according to the nature of the reactants:

1. Initial mix: kaolin + sodium sulphate + coal

This was the oldest process. It required the highest temperatures, and supplied a slightly sintered product green in colour. Once reheated in the presence of sulphur and air, it changed into blue ultramarine containing from 6% to 8% sulphur by weight serving as chromophores.

2. Kaolin + sodium sulphate and carbonate + sulphur + coal

This type of production could proceed at lower temperatures. By playing on the proportions of sulphate and carbonate, one could obtain ultramarine which was blue enough

to be sold as such. However, it was by the addition of sulphur and a second heating that one obtained a dark blue ultramarine containing 10% to 12% sulphur. The ultramarines produced according to either of the above processes lacked resistance to acid attack, such as that by alum, which played a role in paper manufacture.

3. Kaolin + sodium carbonate + sulphur + carbon + silica

In this third process, the addition of silica offers a certain amount of chemical protection to ultramarines against the acidity of the environment, but the process is hard to control due to the tendency of silica to sinter. The resulting ultramarine had a reddish lustre.

The following businesses, listed in alphabetical order, were rewarded by identical medals (asterisks mark the 'honourable mentions'; the new establishments having appeared since 1855 are in bold) (*Medals* 1862; Hofmann 1863):

For France

Armet de Lisle J., Nogent-sur-Marne (Seine), for 'ultramarine of good quality'

Deschamps Frères, Vieux-Jean-d'heures Saudrupt (Meuse), 'for the great beauty of their blue ultramarine, employed for staining paper and dyeing cotton yearn'

Dornemann G.W., Lille, 'fine specimens of ultramarine.'

Guimet J.-B., Lyon, 'for the creation of the ultramarine industry; for the excellence of the products which he continues to manufacture'

Richter B. et F., Lille, 'for the good quality of his ultramarine manufactured on a large scale'

Bertrand et Co.*, Dijon, 'for the good quality of ultramarine'

*Chapus A.**, Lille, 'for ultramarine of good quality'

For the *Zollverein* Germany

Blaufarbwerk, Marienberg (Hesse-Darmstadt), 'for excellence of ultramarine manufactured on a large scale'

Büchner W., Pfungstadt (Hesse-Darmstadt), 'for the excellent quality of ultramarine'

Curtius J., Duisburg, (Prusse), 'for the variety and excellence of ultramarine'

Ultramarine Manufactory of Kaiserslautern, Kaiserslautern (Bavaria), 'for the good quality of ultramarine, manufactured on a large scale'

Dr. Leverkus C., Wermelskirchen (Prussia), 'for the beauty of ultramarine'

Ultramarine Manufactory, Heidelberg (Baden), 'for the superior quality of ultramarines'

Theunert and son*, Chemnitz (Saxony), 'for the good quality of their ultramarine'

For Austria

Lehrer A., Türnitz (Bohemia), 'elegant collection of ultramarines, blue and green, resisting the action of alum'

Setzer J., Weitenegg-on-the-Danube, 'ultramarines, blue and green; specimens of the raw materials used in their manufacture'

*Kutzer J.**, Prague (Bohemia), 'for ultramarine of good quality'

For Belgium

Brasseur E., 'for white lead and ultramarine excelling in quality and cheapness'

Hofmann quoted less than half as many manufacturers as Stas. Were there really fewer exhibitors? The fall in the price of ultramarine on the markets forced the manufacturers to invest heavily if they wanted to remain profitable and a number of them gave up. In France, this was the case for Zuber who had been losing money since 1856 and stopped ultramarine manufacture in 1860 (Jacqué 2005: 8). There were still no English manufacturers represented, but the very same year Reckitt decided to enter this field of activity.

In contrast, one notes the presence of a Belgian manufacturer whose products were of high quality, if we believe Chandelon, who described them as comparable to those of Deschamps (Table 7.1):

Table 7.1 Comparison of the Parisian prices (in francs per kilogramme) of the various qualities of ultramarines sold by the Establishments Deschamps in Vieux-Jean-d'Heures (Meuse, France) and Brasseur in Ghent (Belgium) (Chandelon 1864: 268–70).

	Pure blue ultramarine	Pink-purple ultramarine
Establishments Deschamps	1.50 to 1.70 francs	1.90 to 2.00 francs
Establishments Brasseur	2.75 to 3.00 francs	1.50 to 5.00 francs

Since their creation in 1856 by Jules Deschamps, an *Ingénieur des Arts et Manufactures*, the Establishments Deschamps had grown in importance and had come to challenge Guimet for first place among French manufacturers (Figure 7.8). Producing 95 tonnes in 1862 with 25 workers, ten years later they were producing 600 tonnes (a third of which was for export) with 120 workers. This rapid success was due in part to having perfected an ultramarine which was less sensitive to acidic environments, and therefore enabled paper manufacturers to use it for sizing with alum without taking particular precautions. Consequently, Deschamps ultramarine progressively displaced Guimet ultramarine for this use.

The Franco-German quarrels of the years 1860–80

The years preceding the Franco-Prussian war marked an increase in German claims concerning the manufacture of ultramarine, even though, in both countries, opinions were split. Thus in a memoir on the manufacture of ultramarine by Fürstenau, published in Coburg in 1864, one may read (Fürstenau 1864):

> Based on these observations and the work of Clément-Desormes[41], the Société d'Encouragement de Paris established a prize for the artificial production of ultramarine, which was won by M. Guimet from Lyon, whose factory is still today the most important in France.

> Soon thereafter Gmelin had his process for producing ultramarine published.

[41] See Chapter 3, note 4.

However, the following year, G.-E. Lichtenberger (1865) published in Weimar a large work on the manufacture of ultramarine. This recounted another tale.

Principally and exclusively, the Germans and the French are the ones who have been occupied with the subject, and, without belittling the merits of the latter, we must nevertheless secure for our compatriots the glory of having set to work in a deeper scientific manner and of having sought and used more varied means. As to the time from which the first individual work dates, it was that of Marggraf, in Berlin, in 1758, who published the result of his research on natural ultramarine in the *History of the Berlin Academy*.

Gmelin was the one to discover the artificial preparation method in Tübingen, around the year 1827, and in reality through a purely theoretical approach, by mixing and roasting the amounts of pure components computed after analysis. (...)

The French attempts at ultramarine manufacture, as opposed to those of Germany, were less effective. Dumas however mentioned that, in France, preparation of the colour was achieved at the beginning of the 18th century, yet he doubted it himself. The first scientific research to appear was due to Clément-Desormes in 1806; it contained an analysis of natural ultramarine; yet no attempt at imitating it was to be found. This was first mentioned when Tassaert and Kuhlman pointed out on several instances that ultramarine might be formed in the kilns for the preparation of raw soda. The proof that this was indeed the desired product was indicated by Vauquelin from the results of analysis.

Since the possibility of an imitation was explicitly pointed out, the Société d'Encouragement endowed, in 1824, a 6,000 franc prize for the inventor of a preparation method matching the goal. It fell to Guimet, from Toulouse, to be awarded the prize in 1828; his name garnered much notoriety and his production was the source of much wealth; but, from the accounts by men of his time, such as W. Büchner, it appears that the knowledge of the work of Gmelin, who communicated his results during his stay in Paris, was the cause for Guimet's reputation; however, although his products were much sought after and employed in many guises, his method was so costly that the value it reached can only be attributed to the novelty and to its supposed invention in France. Büchner also indicates that the colours of Guimet themselves left a lot to be desired and that a comparison of the first products obtained in Germany with soda could not be made. The accounts are not definite over the continuation of the Guimet system, for the Société d'Encouragement at the time had not made sure of the exact description of the system; a prize had to be instituted again in the same direction in 1837; nevertheless, some notion of that system may have endured in France and spread later, for a Belgian manufacturer upheld a few years ago that his system matched that of Guimet. (...)

In general, as is well known, production in France is rather low and there are but few places supplying some products, their name even is barely known in Germany, even Laboulaye's technological dictionary [Laboulaye 1891: 'outremer' entry[42]], published in 1857, only contains for the ultramarine entry a description already given of Pruckner (with a natrium [sodium] sulphide solution); on the other hand, no indication as to the French methods.

The latest account, and the most complete, concerning the French production, is found in the Bulletin de la Société d'Encouragement, 1849, July, p. 325, and in that of 1849,

[42] The seventh edition of 1891 dedicates a good part of the *outremer* entry to the Guimet process and the researches carried out under the leadership of Émile Guimet.

September, p. 386, in which Bussy tells the Société of an ultramarine factory founded by Zuber and Comp. in Rixheim (Haut-Rhin, Alsace).

He pointed out that there existed so far only two ultramarine factories in France, that of Guimet and Courtial (no indication as to its whereabouts) and that of Zuber and company, with 30 workers and 6 horses, having an annual production of 600 hundredweights, aiming to satisfy the needs of their wallpaper factory. (…)

This text does not call for any comments. In this atmosphere of disinformation, Loir (1879b: 6) also quotes a certain Dippel (1854):

Dippel indicates in his book (and mentions in the literary indications, at the beginning and at the end) that Guimet possessed a factory in Toulouse to exploit his invention, and, further, Laboulaye mentions, that he was an associate of Courtial from Grenelle. With his death and that of Vauquelin, his only collaborator, many of the details must have been lost; yet the principal processes must have been maintained, otherwise there would only remain in France one factory of this nature. How all this meshes together cannot be indicated exactly and one cannot give any information about it. (...)

Another possible symptom of the Franco-German quarrel was that fact that, in 1872, the *Grand Dictionnaire Universel du XIX^e siècle* by Pierre Larousse dedicated an article to Jean-Baptiste Guimet but made absolutely no mention of Christian Gmelin among the various Gmelins to whom he dedicated articles. Thirteen years later, by which time J.-B. Guimet and C. Gmelin were both deceased, Dr. E. Büchner, son of one of the first ultramarine producers in Germany, again took up the thread in an article in the Chemiker Zeitung on 12 April 1878 (Loir 1879a):

Gmelin, in Tübingen, was the first to become interested in the production of ultramarine the artificial way, and his efforts were crowned with success; he managed, in 1827, to produce ultramarine, although still in a very costly manner and in very low quantities and qualities.

The French claim that the rights for the invention of artificial ultramarine production belong to M. Guimet, from Toulouse, and the Société d'Encouragement awarded him, in 1828, the 6,000 franc prize it had endowed in 1824. As it is an established fact that Gmelin, in 1828, during his presence in Paris, gave communication of his discovery to the Paris chemists, and as it was only in 1828 that the prize was granted to M. Guimet, there is no doubt that the latter appropriated Gmelin's discovery. One can without reservation attribute to Gmelin the discovery of artificial ultramarine, and to Guimet the rights of production. Guimet, in a short time, produced large quantities and soon acquired a name and colossal fortune. He was for a long time the only one to produce artificial ultramarine, which must seem all the more astonishing since the discovery *per se* came from a famous German scientist.

We see here once more how, due to its lack of zeal and self belief, German industry had its own inventions pillaged by other nations. Today, one could still find similar examples, especially in the chemical field.

The following 1 June, Émile Guimet responded to this article in the following letter (Loir 1879b: 8):

In an article of M. Büchner, published in the 15th issue of your journal (12 April 1878), an assertion can be found which only rests on an inexactitude.

According to the author, it would be following communications made in 1827 to chemists in Paris by Gmelin, that J.-B. Guimet would have appropriated his discovery of artificial ultramarine and M. Büchner adds it is impossible to doubt it. Yet, in July 1826, J.-B. Guimet had already discovered artificial ultramarine and his attempts at manufacturing had gone so far that, in order to further them, he was obliged, on 28 October 1826, to have 600 kilos of soda salts sent to him by Barthélemy Bérard, from Marseilles.

The argument drawn from Gmelin's stay in Paris can therefore no longer be invoked to prove the anteriority one wants to attribute to him in this discovery.

What may have caused this confusion is the fact that J.-B. Guimet did not publish his discovery until 1828; he had spent over two years perfecting his processes, not wanting to divulge his secrets until he was able to present industrially made products and not simple laboratory observations. (…)

This letter was not published.

É. Guimet, who had his father's laboratory notebooks in his possession, then had pages 24 and 25 from the 1826 notebook autolithographed[43], which proved that it was in July of that year that ultramarine synthesis was achieved. He also had page 39 autolithographed, where the draft of the order for soda salts from the house of Bérard could be found. He then contacted Loir, a chemistry professor at the University of Lyon, and gave him this collection of documents and asked him to write up a memoir on the discovery of artificial ultramarine. Loir presented his memoir on 23 May 1879, to the Société d'Encouragement, then presided over by the chemist J.-B. Dumas. After the publication of this memoir in the bulletin of the Société d'Encouragement (Loir 1879a), the quarrel finally settled down.

Thus, in the compendium of *Chemical Technology* published in 1880 by Dr. Wagner, professor at the University of Wurtzburg, one reads (Turgan 1882: 8):

Following the scrupulous study I made of the items M. E. Guimet communicated to me, I acquired the conviction that J.-B. Guimet was the first to manufacture ultramarine and that it was he who for the first time attempted to reproduce it artificially. It is impossible that he would have been aware at that time of the research in Gmelin's laboratory.

The industrial underpinning of the quarrel: the French situation

These Franco-German nationalistic quarrels mirrored an industrial reality. The ultramarine manufacturing industry was growing at full speed – artificial ultramarine had conquered the market for blueing in all of Europe. There followed an increase in the number of factories, as well as an increase in the production capacity of the older ones. Yet, while the ultramarine industries in Germany and France, then Belgium and Russia, were in a good state of health, in England, on the other hand, this industry was in the process of collapsing. Reckitt was an exception.

[43] A process rather similar to lithography, which, before the invention of photography, would let a page written in ink be reproduced.

In France, in spite of the 1870 war, the ultramarine industry had progressed remarkably (Figures 7.8 and 7.9). French exports leapt forward after the 1870 war. The private archives of the Guimet family preserve for us the market shares of the seven main French producers for 1872[44]:

Guimet (Fleurieu)	34%	Balois (Dole)	7%
Deschamps (Meuse)	31%	Robelin (Dijon)	6%
Armet de Lisle (Paris)	9%	Richter (Lille)	6%
Dorneman (Lille)	7%		

Table 7.2 compares the development of the various French firms, and underlines the dynamism of Deschamps.

Table 7.2 Production of the main French manufacturers of artificial ultramarine in 1862 and 1872 (in tonnes)[45].

Date of origin	Manufacturer	1862	1872	% change
1831	Guimet	300	650?	+120% ?
?	Balois frères	?	112	?
1847	Dorneman	52	116	+120%
1849	Armet de Lisle	150	150	0%
1856	Deschamps frères	95	600	+530%
1857	Robelin	30	90	+200%
?	Richter	100	100	0%
	Production total	> 727 tonnes	1818 tonnes	140% ?

In 1872, a count of ultramarine factories carried out by Lauth (1882) established that there were twenty-three in Germany, six in France, two in Austria, one in Belgium and none in England. In 1878, Lauth records twenty-five factories in Germany, eight in France, six in Austria, three in the Netherlands, several in Russia, but still none in England. That year, prices had fallen so far (the prime quality was traded at around 2.20 francs per kilogramme (Figure 7.10)) that production was only profitable on a very large scale, and under well-controlled conditions. This was a time ripe for mergers.

That same year the Paris International Universal Exhibition took place, on the Champ de Mars and at the Trocadéro Palace newly built on the Chaillot hill[46]. This was the opportunity for a rather detailed account written up by Lauth. He attempted to list the innovations that had occurred, and to obtain an idea about ultramarine production and export and import flows. He compared the various industrial practices stage by stage. The selection of raw materials happened in diverse ways, taking into account local mineral resources and the desired ultramarine colour. To obtain pinkish-blue ultramarines, one started from silica rich kaolin, to which Guimet added pegmatite, silica sand, crushed flint stone or diatomite. To make pure blues, a more aluminous rich kaolin was selected, and soda sulphate added to the soda carbonate. Heating times and

[44] Private archives of the Guimet family. Quoted in Tarlier (2007: 165).
[45] Private archives of the Guimet family. Quoted in Tarlier (2007: 158).
[46] This palace was replaced by the current Palais de Chaillot, built for the 1937 *Exposition Universelle*.

temperatures varied greatly between factories. Although most manufacturers put raw materials in crucibles which, by dividing the matter, better spread the heat and saved fuel, others preferred to heat large masses in muffle furnaces, thus saving on the price of crucibles. We now know that the reactions took place in two stages, the first in a reducing atmosphere and the second in an oxidising atmosphere. Some, like Guimet, were in favour of a single roasting carried out under both types of atmosphere. Others practiced two successive roastings. The importance of very fine grinding was underlined.

In summary, the general quality of the products brought to market had clearly increased, the average price had decreased and their resistance to the mildly acidic environment of alum treated paper was definitely better. As for the improvement in methods of manufacture, the displacement of manual labour by mechanical labour had been generalised and labour conditions were much more hygienic. However, the manufacture of ultramarines was accompanied by a large production of sulphurous compounds, either gaseous or in solution, which was not without concern. The discharge of soda sulphate-saturated waters into the rivers 'gave rise to numerous complaints'. In 1869, a process was suggested to recover the sulphurous compounds present in the ultramarine wash waters by using them to precipitate barium sulphate, used as a white pigment called 'permanent white' *(blanc fixe)* (Haustein 1869).

Lauth also indicated an increasing interest for ultramarine purple, isolated by J.-B. Guimet as early as 1840, manufactured for the first time by Zeltner in Nuremberg in 1873, and displayed at the exhibition on several stands, including those of Guimet, Deschamps and the Belgian Botelberge. He then made a rather detailed bibliographical analysis of the state of knowledge concerning the composition of the various types of ultramarines.

The industrial underpinning of the quarrel: the German dominance

German dominance of the artificial ultramarine industry during the period 1860–90 is beyond doubt (compare Tables 7.2 and 7.3). Of the thirty or so active German manufacturers, the Guimets deemed it necessary to gather quantified information on sixteen. Note the presence of a factory in Schneeberg, another witness to the industrial conversion of smalt manufacture to that of ultramarine. The German ultramarine output was three times the French production. What were the reasons for this dominance?

In 1880–81, a chemical engineer of the Guimet Establishment, Morel, visited the Palatinate factories and according to him four factors explained the remarkable dynamism of the artificial ultramarine industry in Germany during that period (Tarlier 2007). The first was probably the existence of the customs union (*Zollverein*) implemented by Prussia from 1834 onwards between most German states. To protect German industry, it set high duties on all foreign products. The second was the support manufacturers received from the banks, which was not the case in France, even in a premier banking city like Lyon. Émile Guimet would complain about it. The third factor was the presence within the German territory of better quality kaolin more suitable for ultramarine manufacture than that from St Yrieix. Thus Leykauf used aluminous kaolin with which he prepared his celebrated light blues. Palatinate kaolin, on the other hand, rich in silica, led to ultramarines that could withstand acidic environments better. The

German manufacturers generally were located next to kaolin deposits. The final factor was probably a more dynamic research programme than that in France.

Table 7.3 Output of the main German artificial ultramarine factories (in tonnes). From the Guimet family private archives and Tarlier (2007: 168).

Origin date	Manufacturer	1862	1872	% change
1834	Leverkus (Cologne)	250	751	+200%
1838	Leykauf (Nuremberg)	750	1135	+50%
1842	W.Büchner (Darmstadt)	184	642	+250%
1843	von Waitzsche-Erben (Hirschberg-Cassel)	160	195	+22%
1848	J. Curtius (Duisburg)	350	750	+114%
1850	C. A. Meier (Hanover)	?	150	
1852	Blaufarbenwerke Marienberg (Bensheim-Hesse)	79	243	+210%
1854	Forkel and Wassermann (Coburg)	90	112.5	+25%
1855	Sophienau (Coburg)	80	182.5	+130%
1856	Hannöver'sche (Linden)	300	800	+170%
1856	Theunert and Gechter (Chemnitz)	50	150	+200%
1856	Schneeberg	80	133	+66%
1857	Kaiserslauternwerke	200	500	+150%
1862	G. Eggestorff (Linden-Hanover)	20	250	+1150%
1866	S. F. Holtzapfel (Coburg)	0	75	
?	Jordan and Hecht (Ocker- Braunschweig)		40	
	Production total	2593 tonnes	6109 tonnes	+135 %

The progress of knowledge

In the 1870s, there was a boom in the number of publications related to ultramarines (Figure 7.11). Of the fifty-five articles observed between 1870 and 1880, 67% were of German origin (including Alsace and Austria) and 27% of French origin (Garçon 1901: 'outremer' entry). Between 1870 and 1900, of the eighty publications listed, these percentages did not vary much: 69% and 24%, respectively.

Research attempts intended to elicit the true nature of ultramarine prevailed. Due to the communication policy of Émile Guimet, the research carried out in the laboratory at the Fleurieu factory became more widely known. Thus in the years 1875–7, studies concerning the influence of an oxidising or reducing environment on the succession of various colourations (brown, green, blue, purple, pink and white) of ultramarines, observed long ago by J.-B. Guimet, were resumed and pursued. Laboratory productions were also attempted, *a priori* deemed easier to interpret. In Fleurieu, Plicque synthesised ultramarine by heating a pure sodium silico-aluminate (of empirical formula $3SiO_2 \cdot Al_2O_3 \cdot Na_2O$) with carbon sulphide for 90 hours at 750°C. He then treated it with sulphur dioxide (SO_2) for ten hours. He obtained a mixture of blue ultramarine and sodium sulphate. This production process was simpler than the industrial process, but its interpretation remained just as hazardous. In parallel, still with the intent of getting a clearer view of the role played by the various constituents of ultramarine, T. Morel synthesised and studied the analogous compounds obtained by replacing sulphur with the chemically similar elements selenium and tellurium (Plicque 1878).

As opposed to his father, Émile Guimet intended to give the maximum publicity to these works. What might be compared to a communications stunt began at the regional level on 12 November 1877 with a presentation delivered to the Académie des Sciences, Belles-lettres et Arts of Lyon, the text of which he published without delay as a booklet (É. Guimet 1877[47]). On a national level, he gave a lecture to the Académie des Sciences in Paris on 3 December 1877. His text was picked up and published in 1878 in the Bulletin de la Société d'Encouragement (É. Guimet 1878). This article itself was lifted *in extenso* from the 'ultramarine' article in the Laboulaye's *Dictionnaire des Arts et Manufactures*. It was simply and anonymously appended to the original article (Laboulaye 1891: 'outremer' entry). Thus the shortcomings of this article by P. Debette (which had given rise in 1865 to the ill-intentioned interpretations of Lichtenberger) were repaired.

The Fleurieu model factory toward the end of the century

Eighty artificial ultramarine factories existed in Europe around 1890. Most were German. The global production was over 10,000 tonnes per year, which, at an average price of 2 francs per kilogramme, amounted to over 20 millions francs in value. Germany controlled roughly two thirds of this production, and France the remaining one third. The Guimet factory in Fleurieu, with its 1,000 tonnes annually, produced one tenth of the world output and one third of the French. Ever improved and perfected, this factory was, in 1882 (fifty years after its establishment), construed by Turgan (1882) as the ultramarine factory worthy of being described in his monumental work *Les grandes usines, études industrielles en France et à l'étranger*. According to this description, the buildings (Figure 7.12) occupied an area of 6,000 m^2 distributed over three floors. Some housed the reagent storage, grinding and mixing installations. A workshop manufactured crucibles (Figure 7.13). From this workshop led a railway track taking the crucibles to the automated filling station for the reagent mix[48], then to the kilns. After roasting, the crucibles would go in the same way to the sorting shop where ultramarines would be classified by colour, and then to the washing shops. This would be followed by the drying, grinding and sifting operations. Ultramarine was then examined (Figure 7.14), classified and stored in large crates containing no less than 20 tonnes of pigment, in order to ensure homogeneity and continuity for the various qualities (Figure 7.15). Production amounted to around 3 tonnes per day. Stocks of pure ultramarine stood at around 400 to 500 tonnes. Guimet ultramarine was delivered to the final consumer in powder, paste, ball (for blueing) or pellet form. Workshops shaped the ultramarine into balls or pellets. For wholesale delivery, it was packed in barrels, crates or bags, and for the retail trade, in boxes or packets.

From a social point of view, Guimet was rather progressive, supplying his workers and their families with housing, their children with schooling and free medical assistance in case of illness.

[47] This booklet would be reprinted in 1889.

[48] i.e. (as weight percentages) kaolin 37%, sodium carbonate 22%, sodium sulphate 15%, sulphur 18% and charcoal 8%.

Being a prophet in one's own country

Everyone knows how difficult this is. The Germans would therefore not be the only ones to try to deprive Jean-Baptiste Guimet of his invention. Other people would bring their contributions to this difficult task. As a note to his historical study published in 1879, Loir (1879b: 18) related an anecdote. This was the attempt from a would-be chemist to defraud the Paris colour merchant, A. Giraud, from whom he attempted to borrow a few thousand francs to exploit lapis lazuli deposits he claimed to have discovered in Russia to obtain ultramarine. Mérimée, from whom Giraud took advice, replied that the would-be chemist was only a con-man. Some time later, a 'Paris artistic journal' published a large article on ultramarine. The author wondered why such a colour, formerly so rare and expensive, could now be found so plentifully and for so low a price on the market. Exploring all avenues except the right one, he eventually stumbled across the answer from Mérimée to Giraud. Getting it all wrong, he concluded that it was the exploitation of the Russian lapis mines which had made ultramarine so common!

Of an altogether different kind was the contribution of an anonymous admirer of the French chemist Marcelin Berthelot who, in 1908, gave him credit for the discovery of Guimet blue. Praising his disinterest, he wrote (Jacques 1987: 99):

> He always refused to draw for himself the slightest profit of his discoveries, the benefits of which he abandoned to the community. (...) Enormous fortunes, such as that of Guimet blue, were built on a single scientific memoir of his. (...)

Dole, French capital of laundry blue

Laundry blue factories had existed in France for a long time. One may cite, for example, in Lille, the ultramarine factory at 23 rue des Robleds of C. Henry the elder, who also manufactured 'Turnsole, Cobalt, Starches, Pencil leads and white Soaps' (Pitoiset and Grichois 2002: 191), or that of Ghesquière & Renier, and similarly, in Dijon, that of Robelin. The number of laundry blue factories was particularly high in Dole, in the Jura. It is said that the confectioners in the city were famous, and that the blue manufacturers drew on their expertise in the making of balls. The production of laundry blue in Dole goes back to at least 1800, at which date the firm of Roux Lecoynet was producing a blue soluble paste, coloured by indigo carmine[49]. Later on, several factories were set up to make indigo carmine, either to compete in the linen blueing market, or to penetrate the ink and dye market. Thus, in 1882, the Boilley and Passier blues enjoyed a very good reputation with both dyers and printers (Lauth 1882: 143–4).

The 'Dole blues' were, therefore, originally indigo carmines, but this term would soon be applied to other blue dyes or pigments. Thus, in 1882, while there were several factories preparing laundry blues shaped as tablets or balls, these blues were at that time

[49] Indigo is not soluble in water or in the usual solvents. Indigo carmine (indigo disulphonic acid) was discovered by Barth in 1740 while treating indigo with sulphuric acid. It is the result of attaching two sulphonate groups onto each indigo molecule, making it soluble in water. Indigo carmine was rather quickly employed for the optical blueing of textiles, in conjunction with gypsum or starch. The Dole manufactures used carmine made from natural indigo, since the synthesis of indigo did not take place until around 1890 (cf. Guineau 2005).

coloured not only by the traditional indigo carmine, but also by Prussian blue, aniline blue or ultramarine. This was the time when E. Daloz sold his *A la Justice* blue and his *Bleu parfumé aux fleurs de Nice* (blue perfumed with Nice flowers) (Figure 7.16). Balois Frères sold his *Bleu fixe* (fast blue) under the brands *'Au colporteur'* (pedlar), *'A la fortune'* and *'A la colombine'* (Columbine). Neither merchant cited the nature of their pigment, which was probably not ultramarine, as many competing firms (of now unknown location) took great care to emphasise on the box label that they used ultramarine (Pitoiset and Grichois 2002: 190–93):

> Ultramarine blue in balls for blueing linen. N°1 quality.
> *'A la revanche'* [Until revenge], Extra ultramarine blue
> *'Vendre bon pour vendre beaucoup'* [Sell well to sell a lot]. Ultramarine blue.

Guimet ultramarine was sold under multiple labels, more or less explicit:

> Guimet ultramarine. Lyon. For blueing linen. J.B. Guimet, inventor in 1826.
> Linen blueing. Extra ultramarine. *'A la laveuse'* [To the laundress].

The caption 'Factory print shop. Fleurieu' written in small characters leaves no ambiguity as to its provenance.

In 1889, Émile Guimet purchased the Balois Frères factory in Dole. This is the reason why the *Bleu fixe 'Au colporteur'* also mentions *Balois Frères, maison fondée en 1800 à Dole (Jura). Neuville s/Saône, Rhône*. Neuville was close to Fleurieu. We may wonder exactly how the roles were distributed between these two locations, and whether, as is generally said, Guimet ultramarine was truly manufactured in Dole.

The slow growth of laundry ultramarine in England

We shall consider this growth on the basis of the activity of Reckitt, for Reckitt is typical of those industrialists of laundry blueing for whom adopting artificial ultramarine was but one development among others, but one which would be able to endure. Set up in 1840 by Isaac Reckitt in Hull (Yorkshire), the firm manufactured and marketed a range of laundry products, among them starch sizing, an essential product for dressing clothes. Since starch yellows a little under the heat of the iron, it had long had a blue pigment added to it. At Reckitt's, smalt was used. The 'Reckitt blue' was sold as tablets obtained by compressing a mixture of sodium carbonate, starch and a little smalt. It was added to the rinse water of the laundry, starch would swell and the tablet would fall apart, freeing pigment and starch to weave among the fibres. In 1852, Reckitt gave up smalt in favour of artificial ultramarine, which he purchased in France or in Germany. This was a very late switch, since artificial ultramarine had been on the market for over twenty years! A good Quaker, Isaac did not much appreciate novelties, but it became obvious that by adopting artificial ultramarine he would finally have a superior quality laundry blue.

Upon his death in 1862, Isaac Reckitt's sons decided it would be more profitable to manufacture the ultramarine they needed than to buy it. To this end they hired a German, Joachim Eggestorff, 'who had learned ultramarine production in his country' (*Ultramarines* 1964). This was the same year that G. Eggestorff set up his firm in Linden (Hanover). This Joachim was probably a relative. They must have learned their

trade in one of the established German factories (see Table 7.3). Thus began, not without its own set of problems, the production of artificial ultramarine in Hull. This production would continue, and Reckitt succeeded through a clever policy of internal and external growth not only in remaining active in England, but also in extending its production into France and Germany (*Ultramarines* 1964).

This same Joachim Eggestorff oversaw the birth of another ultramarine factory in England. His peregrinations illuminate how some businessmen attempted to compensate for the collapse of the artificial ultramarine industry in that country. In 1880, Eggestorff had picked up his pilgrim's staff again and convinced a new set of businessmen of the opportunities which artificial ultramarine production would present. They were chemical industrialists, wholesale suppliers of chemical products established in Backbarrow (Cumbria). The project consisted in organising production on the site of a former cotton mill. Attempts began in 1890, and were for a long time fruitless. The products turned out blackish, greenish or barely blue. Then, when blue was successfully obtained, its colour would vary with each production run. Through perseverance and constant improvements in the quality of its raw materials and its processes, the Blue Mill in Backbarrow finally succeeded in supplying quality ultramarine to the paint, linoleum, ink and wallpaper manufacturers around 1895 (Mein n.d.).

In spite of these efforts, the output in England was not able to satisfy its own internal market, which then became a battleground for German and French exports. The Germans held around 90% of the market and even set up factories in England, e.g. Leverkus in London.

Ultramarine production during the twentieth century

In 1910, aged seventy-four, Émile Guimet handed over his business affairs to his son Jean. In contrast to his father, the latter devoted himself entirely to the company, intending to develop markets in England and Russia, which had both been ignored by his father (in 1901, Émile had refused to take over the Destrée factory in Haren, Belgium (Figure 7.18), a factory which would have enabled him, via Antwerp, to seize an important position in the English market).

Immediately after taking over the business, Jean Guimet bought an ultramarine production factory in Sas-de-Gand, Holland. Then, right in the middle of World War I, in 1916, he was offered the Leverkus factory in Riga, which had been sequestered as a German possession and which supplied 48% of the Russian market[50] (Figure 7.18). This was a wonderful opportunity to gain first-hand information on the Leverkus techniques. Having visited the factory (where he was particularly interested by the kiln filling technique using crucibles), and convinced of the viability of the business, Guimet carried out the necessary financial engineering. In June 1917, production started again, and the ultramarine was distributed all over Eastern Europe via warehouses located in Moscow, Tiflis (Tbilisi), Baku, Kiev and Berdychiv (Ukraine). However, in October 1917, the

[50] A third of the market (37%) was in the hands of the German Vege, which manufactured on the spot. The remaining 15% was imported.

Russian revolution broke out and ruined the project[51]. In 1919, Jean Guimet purchased a Belgian factory in Jemeppe-sur-Sambre. In ten years, the Guimet production had quadrupled (Figure 7.8). Unfortunately, Jean Guimet died in a car accident in 1920, but business went on. After World War II, as new fluorescent blues were taking over the laundry market, exports to the French colonies became more and more important.

In 1926, Destrée built an ultramarine factory under the name Outremer Destrée S.A. in Comines, the ribbon making capital, near Lille. At the same time, Deschamps Frères made ultramarine in Bar-le-Duc, where there was a large paper mill. In 1928, both the Destrée group and the Lancashire Ultramarine Co (i.e. the Blackbarrow mill) were acquired by Reckitt & Colman. Ultramarine production kept growing (Figures 7.19 and 7.20), but for the Guimet Co. (Figure 7.21) ultramarine production would follow a downward trend. French decolonisation from 1954 (Indochina) to 1956 (Morocco and Tunisia) and 1962 (Algeria) dealt a severe blow to its exports to these countries.

In 1962, Reckitt took over Guimet. In 1963, Outremer Destrée S.A. was the top French producer. In 1967, Reckitt closed the Fleurieu factory. Three years later, Reckitt took over the German manufacturer Blaufarbenwerke, and the following year the group settled in all six of the Common Market countries. In 1980, it changed its name to Reckitt's Colours S.A. In 1985, the firm was the top European producer for ultramarine, and made 70% of its turnover from exports. In 1994, the group was taken over by Holliday Chemical Holdings. The Comines factory became Holliday Pigments S.A. In 1998, Holliday Chemical Holdings was bought by the British group Yule Catto. Corporate names changed, but the factories remained. At the very beginning of the twenty-first century, in Western Europe, ultramarine was only produced in two Holliday Pigments factories (one in Hull, England and the other at Comines, France) and in factories of the Spanish group Nubiola (in Spain and in Romania). The Hull factory has since been closed, and Holliday Pigments S.A. was bought in 2008 by the U.S. group Rockwood Holdings, to be merged into Rockwood Pigments.

The world ultramarine production is currently around 45,000 tons annually, which amounts to an one hundred million euro market. It is split into 22,000 tons for ultramarine of lower quality, and 23,000 tons for ultramarines of the higher qualities, which are very closely controlled. Ultramarines of inferior quality are used as linen blue. They are made in India and Japan, for use mostly by developing countries (India, China, Africa and Latin America). Production is traditional, without any particular precautions against sulphur dioxide emissions. Under attack from modern fluorescent blueing compounds, this market for family laundry, once huge, is decreasing by 3% to 5% each year. In developed countries, ultramarine was chased away from its traditional markets, domestic linen and paper blueing. For blueing linen, it was displaced by fluorescent blueing agents as early as the 1950s. The latter absorb light in the near ultraviolet and reemit it in the blue, thus increasing surface brightness while the use of a blue pigment

[51] From the private archives of the Guimet family. Quoted in Tarlier (2007: 235–49).

decreases it slightly[52]. This is the famous 'whiter than white' so vaunted by washing powder advertisements.

Ultramarine was very well positioned in the field of paper blueing until the advent of the paper crisis due to worldwide overcapacity of production. Prices became so tight that the manufacturers selected a dye as a blueing agent for coated paper, and a cheap one at that. It was just added to the solution bringing the coating mineral charge onto the paper. This blueing did not stand up to light, but it was deemed sufficient for news-papers, which, in most instances, would be thrown away by the end of the week. Thus ultramarine became excluded from a market once opened up by Montgolfier.

In developed countries, spurred by the need to find new outlets for the production, ultramarine manufacture has been constantly improved. At this stage, the distinction between Guimet and Gmelin processes makes no sense, of course. There is a unique optimal process toward which everyone aims. However, a new technical constraint has appeared, and a crucial one at that: to reduce sulphur dioxide emissions linked to the manufacturing process, drastic standards have been imposed by the European environ-mental protection rules. The optimal manufacture of one tonne of ultramarine releases around 600 kg of sulphur dioxide, which results in the formation in the atmosphere of one tonne of sulphuric acid – the source of acid rain.

Not having been able to solve this problem in an economically viable manner, since 1970 eight European ultramarine producers have had to stop production. Alone remain Holliday Pigments. In their factories, fumes containing sulphurous products are cleansed of 99.5% of that sulphur. The sulphur dioxide recovered is oxidised, then transformed into very pure, concentrated sulphuric acid which is sold as a by-product.

In these factories, manufacturing is automated. The initial mixture of kaolin, sul-phur, a sodium salt and a reducing agent is shaped into bricks and piled up criss-crossed in the kiln. These bricks are heated up to 750°C sealed off from air. They are then left to cool in a controlled atmosphere. Once taken out they undergo a succession of washing, suspension and filtration, then grinding, flotation, classification (yielding blues with different saturation levels), drying, possible blending with other colours and finally packaging.

A number of precautions enable the preparation of special grades, such as 'anhy-drous ultramarine', or 'dust free' (with very fine granulometry to colour polymer fibres to the core) or with a very low heavy metal content (as impurities) for cosmetic use. Surface treatments (silica) can protect the ultramarine particles from ambient acidity. Other treatments can change the nature of the surface of ultramarine, which is naturally hydrophilic, to be hydrophobic.

[52] The difference in blueing practices between developed and developing countries was illus-trated during the 2003 Iraq War. In order to avoid its soldiers being spotted at night by ultra-violet lighting, the American army forbade the use of fluorescent blueing for laundry for the duration of its operations in Iraq.

Current markets for ultramarines

If industrial ultramarine production in developed countries was to survive, new outlets had once more to be found. This was achieved by trying out the specific qualities of ultramarines, and remedying their defects. Let us review their qualities. Ultramarines are characterised by:

- a reddish-blue colour which cannot be duplicated. It can therefore be used for safety inks for travel, concert or sporting event tickets;
- light absorption in the yellow region of the spectrum (ideal for optical blueing);
- an excellent resistance to ultraviolet rays and light (ideal for plastic objects intended for outdoor use, such as stadium seats);
- a better thermal resistance (up to 400°C) than the other blue pigments, invaluable during the forming of polymers, which is carried out hot;
- a lack of any tendency to diffuse or provoke the swelling of polyethylene and poly-propylene (widely used polymers) as occurs with the other blue pigments;
- a lack of toxicity (no heavy metals, no halogens), together with the fact that ultra-marines are non-irritant and non-mutating. They are therefore suitable for food packaging, toy manufacture and cosmetics. Particularly for eye-shadow and mascara, a domain for which ultramarine is the only blue pigment authorised by European, American and Japanese legislation for the eye area.

As for defects, the only one of note is the sensitivity of ultramarines to acids. Qualities of ultramarine coated with silica currently stand up to acid environments down to pH=2.

In practice, the majority of quality ultramarines produced (70%) is used to colour plastics blue or to blue them to obtain true whites (household product packaging (Figure 7.22)). The remainder is split between artists' colours (8%) (Figures 7.23 to 7.25), inks (7%), linen blue (6%), paints (5%) and cosmetics (2%). The market for these quality ultramarines is increasing by around 5% per year.

Artists mad about blue

As we have seen, artistic painting represents a not insignificant market for ultramarines. There are artists who become infatuated, for a while at least, with the colour blue. Such was the case of Barnett Newman when he painted his large monochrome blue, *Cathedra,* by juxtaposing innumerable small squares of alternating shades of ultrama-rine (Figures 7.24 and 7.25). This canvas, hung at the Stedelijk Museum in Amsterdam, was lacerated one day with a razor by a jealous colleague worried about having his name associated with that of Newman. The several seconds sufficient to slash a canvas of large dimensions with a large 'Z' were matched by the three years of painstaking work by the restorer Louise Winjberg and her team to reconstitute thread by thread the continuity of the cut canvas (Glanzer *et al.* 2001).

Geneviève Asse also often painted blues, and Jean Verame modified desert land-scapes from Morocco by painting monumental rock formations in blue. But there are others who have fallen in love with the pigment and its powdery aspect. Anish Kapoor is one of them. Many of his sculptures are not painted, but sprinkled with pure pigment. For example, *At the hub of things,* the large egg powdered with Prussian blue at the

Hirschhorn Museum in Washington, named and described as a symbol of the goddess Kali, centre of the cosmos, with her blue skin.

Yves Klein was also an ardent admirer of blue. He was a monomaniac as far as ultramarine blue was concerned or, more precisely, of a special ultramarine shade (ref 1311) which he procured directly from Destrée at Comines (Nord). Klein was a painter. In order to try and retain the velvety quality of the raw pigment (a quality which disappears when the pigment is mixed with a binder), he would have required a binding medium with the refractive index of air. This does not exist. Klein worked for five years on this problem with colour merchant in Paris, Adam (2011: 78–84). He tried numerous binder formulas, and eventually selected one of them. He did not file a patent; instead he filed a 'Soleau envelope' with the *I*nstitut National de la Propriété Industrielle. It is thus labelled:

Soleau envelope n°63471 of May 19th 1960 on IKB (International Klein Blue)

The International Klein Blue was perfected by Yves Klein the monochrome during the years 1954 – 55 – 56 – 57 – 58. The current chemical formula is exactly:

For 700 kg of ref. 1311 ultramarine

Medium – IKB fixative:

> 1 kilo. 200 Rhodopas (paste product) MA (Rhône Poulenc) [vinyl chloride]
>
> 2 kilo. 200 Ethyl alcohol 95 % of industrial grade
>
> 0 kilo. 600 Ethyl acetate

4 kg. 00 in all. Blend cold while stirring and never heat straight. The pure ultramarine blue reference 1311 is then mixed cold with the fixative medium in the proportion of 50% if one adds 1/10 of the whole of pure acetone and 40 % if one adds pure alcohol.

To be applied with a paint roller, brush or spray gun over a support of wood, plywood or masonite armed with wooden ribs in the rear and covered with a film.

Made in Nemours, May the 19th, 1960, at 21 h.

It was with paint so formulated that he painted most of his monochromes. It is clear that as the formula ceased to be a secret a long time ago, it would be extremely difficult to separate a work painted by Klein from a fake through physico-chemical analysis.

One might have thought, with the low cost of production (Figure 7.26) of this excellent pigment long viewed as ideal, that the market for these colours would have reached a stable state. This state did last for nearly a century, before being thrown into upheaval by the arrival of newcomers, copper phthalocyanines. But that's another story.

8

Copper phthalocyanines
A chance happily exploited

Many experiments lead to unexpected results, but, as Pasteur pointed out, the experimenter needs to have an alert mind for them to turn into discoveries. After that of Prussian blue, a perfect example is the discovery of copper phthalocyanines.

A Scottish molecule

The story began in 1907. Two German chemists, Braun and Tcherniac, obtained an intensely blue-green compound while heating o-cyanobenzamide. It would be determined later that it was a hydrogen phthalocyanine (Braun and Tcherniac 1907). This observation did not lead to any further studies. In 1927, two Swiss chemists, Diesbach and his student Weid, published their observations on a blue compound which had formed during the synthesis of phthalonitrile in the presence of copper. The compound contained copper, which could not be extracted by any means, due to its great chemical stability (Diesbach and Weid 1927).

The following year, at Grangemouth, Scotland, in the laboratories of Scottish Dyes Ltd., three researchers – Dandridge, Drescher and Thomas – were perfecting the industrial synthesis of phthalimide from phthalic anhydride. The reaction took place in an enamelled iron reactor, in the presence of ammonia and heated under pressure. However, the phthalimide obtained was of a greenish-blue colour. The reason for this colour was understood when a coloured compound was found to have formed where the enamel of the reactor had been chipped and bare iron was visible.

The team soon synthesised this product. It came in the form of a very dark powder, with a purple lustre. Rubbed over paper, it left a trace of the colour of Prussian blue. The team foresaw the possibility of using this compound as a colouring material, but as it was insoluble in most solvents, they thought of turning it not into a dye but into a pigment. They studied several variants. In particular, replacing iron by copper yielded

a product of an intense blue. A patent for this blue was taken out the same year[1]. It was at that time that Scottish Dyes was absorbed into Imperial Chemical Industries (ICI).

A new molecule for Linstead

In 1929, Dandridge sent a sample of the compound containing iron to Sir Jocelyn Field Thorpe, director of organic chemistry research at Imperial College of Science and Technology, London. Feeling that 'it appeared that the substance might prove of academic interest' (Barton *et al.* 1968: 320), the latter entrusted a young doctor, Reginald Patrick Linstead, with a study which continued for several years (Barton *et al.* 1968). Convinced that he was dealing with a new molecule, Linstead baptised it 'phthalocyanine'. 'Phthalo' was short for 'naphthalo', and 'cyanine' referred to its blue colour.

The results were published in 1934 in the form of a six-article series which appeared in sequence in the same issue of the *Journal of the Chemical Society*. The first was devoted to the study of iron phthalocyanine, its composition, its thermal stability and its solubility in various solvents (Linstead 1934). The second dealt with the preparation of magnesium phthalocyanine from various nitrogenous molecules (Byrne *et al.* 1934). In the third article, Linstead pointed out that magnesium phthalocyanine was exceptional for its ease of formation, and that synthesizing the other phthalocyanines was not nearly as easy. This was when the works of Diesbach and Wied were pointed out to him. He then turned to a synthesis starting from phthalonitrile and producing numerous metallic salts. The synthesis of copper phthalocyanine was easy: it was sufficient to heat phthalonitrile in the presence of metallic copper at around 200°C. The reaction produced a good yield (Linstead and Lowe 1934a).

The fourth article was devoted to a comparison between syntheses of copper phthalocyanine starting from various copper salts, in particular chlorides. The more easily the salt provides its copper ions, the easier the synthesis is. Linstead noticed that the reaction used four nitrile molecules for every copper atom (Dent and Linstead 1934). The fifth article studied magnesium phthalocyanine (Linstead and Lowe 1934b). Once prepared and purified, a quantitative study of its combustion in oxygen gave access to the relative proportions of its elementary constituents, carbon, hydrogen, nitrogen and magnesium, which can be summarised by the empirical formula $(C_{32}H_{16}N_8Mg.2H_2O)_n$. The molecular mass was then determined by ebullioscopy (i.e. by measuring how much it alters the boiling point of a particular solvent); close to 572, it corresponded to the empirical formula where n = 1, and not one of its multiples. Taking the initial compound into account, Linstead hypothesised that the molecule of magnesium phthalocyanine resulted from regrouping four molecules of isoindole around the magnesium atom. The determination of the molecular weights of copper, nickel and platinum phthalocyanines was the subject of a short note in *Nature* (Robertson *et al.* 1935).

Determining the structure of the molecule was the topic for the sixth article (Dent *et al.* 1934). This was carried out by purely chemical means, with a series of syntheses from various carefully selected nitrogenous molecules. The result showed that the structure of phthalocyanine is formed by the condensation of isoindole molecules

[1] English patent no. 322169 (1928)

around a space which may harbour a metallic atom. Studying magnesium phthalocyanine showed that these molecules numbered four, which also seemed true for copper phthalocyanine. This was, therefore, a genuine new type of structure. The researchers' intuitions were correct, and this structure would be confirmed through X-ray diffraction (Linstead and Robertson 1936).

Four short colour documentaries, filmed at the time at the request of ICI in the Linstead laboratory at Imperial College, give us a flavour of the atmosphere of this research (*Imperial College* 1936). One retraces the different stages in characterising magnesium phthalocyanine. The others show us the synthesis of a copper phthalocyanine, a rather violent reaction taking place in an ordinary test-tube, and that of a copper phthalocyanine of a more brilliant blue obtained by the dissolution of the primary phthalocyanine in a concentrated solution of sulphuric acid followed by precipitation in hot water. What strikes the current observer most is the extreme simplicity of the means used to study this new family of compounds which was to become extremely important for the colour industry.

From the laboratory to industrial production

As problems appeared, work alternated between Imperial College and Grangemouth. The former suggested variants for colouring powders; the latter evaluated their qualities as pigments. Between 1933 and 1942, twenty-six patents were submitted. The phthalocyanines had an interest other than academic!

The manufacture of copper phthalocyanine started in 1935 at ICI. All that was left was to find a commercial name for the new pigment. 'Monastral fast blue' made its first public appearance during an exhibition in November 1935 in London. Many other names would soon be attached to this pigment and its variants (see Table 8.1).

During that time, Linstead evaluated the ability of this new structure to host the most diverse metals. Prior work had shown it could accommodate iron, magnesium, copper, nickel and platinum. Now it was the turn of sodium, potassium, beryllium, calcium, zinc, cadmium, lead, barium, aluminium, tin, vanadium, chromium, manganese and cobalt (Barrett *et al.* 1936). Most phthalocyanines obtained were blue; a few were green. Colours were more often dull rather than bright, like those obtained from cobalt. With aluminium, Linstead had to chlorinate the phthalocyanine to obtain a compound with a 'pure blue' colour. He repeated this practice with tin and observed variations in tints. Here lay the roots of the research which would lead to green pigments obtained by halogenation with chlorine and bromine.

Manufacture of phthalocyanines in Germany was started by I.G. Farben in 1936. In the United States, Du Pont de Nemours supplied the same product under various names as early as 1937. The qualities of this new product were such that its use spread rapidly. As early as October 1938, its original version, referenced in the *Colour Index* under number 74160 and name PB 15, was available in France in the Lefranc catalogue of artists' colours under the more poetic name of *bleu Hortensia* (Hydrangea blue). From 1936, under the influence of expanding syntheses, competition and trade, the number of commercial names under which this blue pigment was sold multiplied. Due to the

universal use of this pigment, this phenomenon has not ceased developing, until today (see Table 8.1).

Table 8.1 Commercial names for copper phthalocyanine in the USA.

Accosperse cyan blue GT	Graphtol blue BL	Permanent blue BT 398
Aqualine blue	Helio blue B	Phthalo blue B base
Arlocyanine blue PS	Helio fast blue B	Phthalocyaninato copper
Bahama blue BC	Heliogen blue and others	Phthalocyanine light blue VK
Bermuda blue	Hostaperm blue AFN	Phthalogen brilliant blue IF 3GK
Blue GLA	Irgalite blue BCA	Phthalogen turquoise IFBK
Blue phthalocyanine α-form	Irgalite blue LGLD	Pigment blue 15
Blue pigment	Irgalite fast brilliant blue BL	Pigment blue Ciba 376S
Blue toner GTNF	Irgaplast blue RBP	Pigment fast blue BN
BT 4651	Isol fast blue B	Pigment sky blue Phthalocyanine VK
Calcotone blue GP	Isol fast blue toner BT	Plastol blue B
Ceres blue BHR	Isol phthalo blue B	Polymo blue FFG
Chromatex blue BN	Japan blue 404	PV fast blue A 2R
Chromofine blue 4920	LBX 5	PV fast blue B
C.I. 74160	Leophoton	Ramapo blue
C.I. pigment blue 15	Lioconductor ERPC	Renol blue B 2G-H
Congo blue B 4	Lionol blue E	Resamine fast blue B
Copper (II) phthalocyanine	Liophoton blue ER	Resanine blue B 4703
Copper phthalocyanin	Liophoton ERPC	Resino blue F
α-copper phthalocyanine	Liophoton TPH 278	Rubber blue BKA
β-copper phthalocyanine	Lufilen blue 70-8100	Sandorin blue 2GLS
Copper phthalocyanine blue	Lumatex blue B	Sanyo cyanine blue BN
Copper	Lutetia fast cyanine R	Segnale light turquoise BDS
Cromofine blue 4950	Lutetia percyanine BRS	Siegle fast blue BS
Cromophtal blue 4G	Microlith blue 4GA	Siegle fast blue LBGO
Cupric phthalocyanine	Monarch blue G	Skyline blue B4712
Cyan blue BNC 55-3745	Monarch blue toner NCNF X 2810	Solastral blue B
Cyanine blue BB	Monastral blue	Solfast sky blue
Cyan peacock blue G	Monastral blue B	Sumkiaprint cyanine blue GN-O
Dainichi cyanine blue B	Monastral fast blue	Sumitone cyanine blue HB
Daltolite fast blue B	Monastral fast paper blue B	Sunfast blue
Duratint blue 1001	Monolite fast blue BNVSA	Suprapal green 3X4A041
EM blue NCB	No 2712 cyanine blue B	Synthaline blue
Euvinyl blue 702	Nyastral blue BC	Tetor blue
Fastogen blue 5007	Nylofil blue BLL	Tetrabenzoporphyrazine
Fastolux blue	Ocean blue	Thalo blue no.1
Fastolux peacock blue	Palomar blue B 4773	Turquoise blue base G
Fenalac blue B disp	Peacoline blue	Unisperse blue G-E
Franconia blue A 4431	Permaline blue	Versal blue A

Linstead continued exploring the properties of phthalocyanines, on which he would publish no less than twenty-four articles including one he co-published in 1939 concerning the halogenation of phthalocyanines, which would turn out to be rich with

industrial applications for it opened the way to the manufacture of a series of green pigments much prized by industry (Barrett *et al.* 1939). Indeed, the total chlorination of the molecule, i.e. the replacement of all the hydrogen atoms by chlorine atoms, led to a molecule the crystallised form of which constitutes the blue-green pigment PG 7 in the *Colour Index*. The replacement of a few atoms of chlorine with bromine allowed for a series of more yellow hues to be obtained (PG 36). These green pigments are greatly used in the paint industry today.

A very particular molecular structure

In parallel with the work of Linstead, the study of the structure of phthalocyanine molecules was pursued by Robertson (1935, 1936). Phthalocyanine molecules are of organic structure, square and plane, very stable, and able to host an atom of a metallic element. The dimensions of the crystalline mesh vary slightly with the nature of this hosted element. Phthalocyanines are now classified in the family of porphyrins, to which belong compounds as important for life as the chlorophylls, and the haems which carry oxygen in our blood (Figure 8.3).

Like them, phthalocyanines can host a metal atom which establishes links with four nitrogen atoms participating in an extended system of conjugated bonds. However, phthalocyanines are set apart from porphyrins, both by the fact that twice as many nitrogen atoms are implicated in the system of conjugated bonds and by the more important dimensions of the latter, which involves eighteen π electrons (Figure 8.4).

In either case, such a system is ideally suited to absorb certain wavelengths of the light spectrum selectively, here, mainly in the yellow range. Those which correspond to the more interesting colours for the colourist are those of copper phthalocyanines. With some atoms from metal elements, the unit formed is not a monophthalocyanine (Figure 8.4) but a biphthalocyanine, a molecule formed of two stacked phthalocyanines surrounding the atom of the metal element, a little like an oyster enclosing its pearl. The first known example was obtained with tin. These systems have interesting optoelectronic properties, and are much studied (Cadiou 2000). The use of phthalocyanines seems equally promising for the treatment of prion diseases; a journal, *Journal of Porphyrins and Phthalocyanines*, has been dedicated to them since 1997.

α and β copper phthalocyanines

The molecules of phthalocyanines tend to stack and form crystals. Those of copper phthalocyanines are no exception to the rule. These were the crystals studied by Linstead and Robertson. They made up Monastral fast blue. However, it was not until 1968, thirty years after the studies of Linstead and Robertson, that it was discovered that these molecules could be stacked and ordered in different ways. The blue variety studied by Linstead and Robertson was then baptised α, and the new one, which is of a rather unattractive dull green, β (PB 15:3 in the *Colour Index*). Other varieties would be discovered afterwards, but their industrial applications are little developed.

The important fact is that variety α – with the colour we are seeking – is less stable than variety β, and it tends to turn into β, in particular when it is dissolved in a solvent, which is almost unavoidable during manufacture. It is therefore necessary to stabilize

the molecule of variety α, which is done by replacing a hydrogen atom by a chlorine atom. The molecule thus obtained is referenced in the *Colour Index* under the name PB 15:1. Various further treatments improve its ease of use, for example by preventing flocculation. This molecule is referenced as PB 15:2. These treatments sometimes have an influence on colour. We thus have at our disposal a very complete range extending from blue to green.

Exceptional qualities

As soon as Monastral fast blue was introduced, publicity presented the discovery of the new pigment as equally important in the history of blue pigments as those of Prussian blue and artificial ultramarine. In spite of specifications becoming more rigorous all the time, the new pigment was, in fact, far superior to all the blue pigments which we have reviewed. Monastral fast blue is the one which comes closest to the ideal for a blue pigment. Its very particular colour does not exhibit any red component. It is almost the ideal cyan colour and is employed as such in four colour printers. Monastral blue is endowed with a strong colouring power, twice as strong as that of Prussian blue and twenty to forty times higher than that of ultramarine. Its stability in light is excellent. It resists heat as well as chemical environments, be they acidic or basic. Its density is conveniently close to that of the organic binders used in most paints. Monastral blue is also non-toxic.

The only possible difficulty in the future is the necessity of stabilising the molecule and opposing its tendency to flocculate, particularly when in the presence of titanium dioxide, the white pigment most commonly used in paints.

With such an assortment of qualities, it is easy to understand why these blues have almost wholly dominated in many fields (Figures 8.5 and 8.6) – paints, printing inks, plastics, wallpapers, floor coverings and cements. Copper phthalocyanines are everywhere, the most manufactured blue pigments in the world today, forcing the other blue pigments into specific niches.

REDISCOVERING
FORGOTTEN BLUES

9
The rediscovery of Egyptian blue

A missed opportunity

From the Renaissance onwards, in Italy as well as in France, Vitruvius' *De Architectura* had always remained in print – rather poorly, in fact, for the text of the manuscripts had been badly corrupted by successive copyists, and, furthermore, it was hard to translate from Latin. During the sixteenth and seventeenth centuries a translation into French by the humanist Jean Martin, published for the first time in 1547, was circulating in France. It was illustrated by various artists, among whom was Jean Goujon. Very few of its readers would have paid attention to the recipe for caeruleum. However, in 1635, the painter Pierre Lebrun noted in his manuscript collection of *Essays on the marvels of paint* (Lebrun 1967 [1635]: 805):

> The *cérulée* called blue or *turquin* [Turkish blue] is made by grinding sand with the nitre flower, so fine that it becomes like flour. Cyprus bronze filings are then gathered and sprinkled so as to incorporate into it, balls are then rolled between hands, put in a vessel and into the furnace, bronze and sand exchanging their sweats under the force of fire change nature, and reduce into a ceruleous colour.

What motive did he have to copy Vitruvius' recipe? Perhaps it was the scientific rationalism of the eighteenth century French Encyclopédistes. Nobody had made Egyptian blue for a very long time and, so far, none has ever been found in a painting from the fifteenth, sixteenth or seventeenth centuries.

Under Colbert's instigation, Claude Perrault embarked upon a new translation of the *De Architectura*. A gifted jack of all trades, doctor, anatomist, physiologist and theorist of architecture, Perrault (1673) studied the text in depth, translated, illustrated and commented on it. Concerning Book 7, Chapter 11, *Of blue preparation*, in which Vitruvius gave the recipe for caeruleum (see Chapter 1) and wrote: 'the invention thereof is admirable', Perrault noted:

Vitruvius means to say that it is a wonderful thing that art should so happily be able to imitate nature as it does in artificial azure [blue ashes], which is made of those materials which natural azure [azurite] is believed to be made of. For natural azure, growing in copper mines, is thought to materialize when a hot vapour rising from the bottom of the earth melts, dissolves & mixes together the minerals ready to turn into copper, in other words an earth which is neither copper nor earth but derives from both; this the copper filings mixed with crushed sand seem to supply, just as the hot vapour is made up for by the nitre heated in the furnace, which induces the fusion & mixture of these materials.

The preparation method for the natural azure called Lapis, of which the Ultramarine colour is made, is a thing hardly less ingenious than the preparation of the artificial blue by the Ancients; & its colour is incomparably more beautiful; for the blue of the Ancients, the natural as well as the artificial, being made of copper which is a metal much susceptible to rust, it is impossible that its colour should not change, & indeed it soon turns green & blackish; whilst the Lapis of which ultramarine is made is a precious stone which does not change its natural colour, & as it is obtained from gold mines it draws upon the nature of this metal not to be susceptible to rust. (…)

Not for one instant did Perrault imagine that Vitruvius' recipe might concern a blue material unknown at his time. Based on its being blue and containing copper, he associated the 'ancients' artificial blue' with azurite, natural or artificial. He endowed it with the same type of changes due to ageing which lead to green copper salt or black copper sulphide, and therefore advocated the use of ultramarine rather than this pigment.

At a time when the French economy was attempting to rid itself of imports of foreign-made blue pigments, neither Perrault nor any of his readers took any notice of this recipe as an alternative blue pigment, which at the time, in view of its physical properties and production cost, could very well have rivalled existing pigments. This was a missed opportunity which, due to the improvements in quality of the blue pigments progressively appearing on the market, would never present itself again.

The rediscovery of the 'ancients' artificial blue pigment' did not therefore occur due to economic impetus, but from intellectual curiosity. It is, indeed, impossible to dissociate it from the constant interest accompanying the discovery of Roman wall paintings as well as that of Egyptian tombs. In summary, we may say that it resulted in equal parts from the Pompeii excavations and from the 1798 French Egyptian expedition under the command of Bonaparte. Hence the appellations of 'Vestorian blue' and 'Egyptian blue' given to it at the time. Of these two names, only the latter endured.

The discovery of Pompeii

In Perrault's time, ancient Roman painting had long been a topic of wonderment. In fact, this was the case ever since the fortuitous discovery in 1509 of the buried lower levels of Nero's *domus aurea* in Rome, the rooms of which, decorated with wall paintings, were at the time referred to as *grottoes*. Popularised by the painter Raphael, these decorations had led to a general vogue for the 'grotesque' style. However, this vogue would rise to much larger proportions with the rediscovery of Pompeii, Herculaneum and Stabiae, and their extraordinary painted mural decorations. Buried since the eruption

of Vesuvius in AD 79, these cities had been completely erased from the memory of the Campania inhabitants; not only had their exact locations been lost, but they had been covered up again by the great eruption of 1631. This was why the first finds by Prince d'Elbeuf in 1712, three intact marble statues, had become famous throughout Europe. One of the buried cities had been found, of which only ancient texts had retained the memory!

But when Charles III of Bourbon, King of Naples and the Two Sicilies, resumed the recovery operations, he behaved like a jealous collector. He intended to keep to himself the results of his excavations, and imposed total secrecy over their outcome. While certain visiting dignitaries were admitted, they were forbidden to draw or even sketch the finds. The rule was rigorous, and barely did Venuti, Antiquary to the King, allow himself to write to a friend in 1739 (Corti 1951: 114):

> While proceeding with searches around Naples, we discovered the most beautiful thing in the world: a wall painted with life-size figures, wonderful and strikingly true to reality, much better than those of Raphael!

In the same year, Charles de Brosses (known as President de Brosses), who had the chance to go down into the web of tunnels through which the site was being plundered, reports (Brosses [1739] 1858: 422–3):

> For I was not shown everything: at any rate, I did not preserve any notion; we were shown these rooms with such rapidity that, sometimes, I hardly had the opportunity to catch a glimpse. The painting of which I have the most vivid memory deserves to be ranked first among the most curious things found in that place; it is a fresco, roughly of the size of a chimney mirror in height: it is therefore without contradiction the largest antique painting in existence. We pulled out and separated the whole stretch of wall without damaging it: we framed the wall with beams held by long iron keys; this Italian workers know how to do with infinite skill.

Indeed, the technique for transferring wall paintings perfected by the sculptor Canart enabled the Neapolitan sovereigns to assemble an incomparable collection of ancient wall paintings at the *Villa Reale* in Portici, a collection of which very few people had heard. Soon new decorations, of neo-Pompeian style, would appear in royal palaces (Figure 9.1). The fashion would spread all the way to St. Petersburg immediately after the appearance of the first volume of the *Antichita di Ercolano* (1757) resulting from the work of the Herculaneum Royal Academy. The publication of the dissertation read in Paris by Charles de Brosses in front of the Académie des Inscriptions in 1748 and published in 1750, *Letters on the current state of the underground city of Herculée* (Brosses 1750), was what drew French attention to the active excavations in Pompeii, which were mistaken at the time for Herculaneum.

In spite of the political upheavals which followed the campaign led by Bonaparte in Italy, this royal collection was continually enriched. As early as 1808, in particular, the new King of the Two Sicilies, Joachim Murat, and Queen Caroline (Napoleon's sister), both smitten with archaeology, gave renewed vigour to the excavations. However, none of the carefully vetted visitors, whether they denigrated the Portici collection (as

Stendahl had done) or admired it (like Taine), worried about the nature of the pigments employed by ancient painters. Nor did the restorers, who attempted to prevent the surface of the exhumed frescoes from whitening, concern themselves with these pigments. The initiative of Empress Josephine to call in Chaptal, whom she knew personally, to analyse samples of dry pigment is therefore a testimonial to an exceptional curiosity. Nothing prevents us from thinking that the request may have actually emanated from Queen Caroline. 'H.M. the Empress and Queen honoured me by handing over to me seven samples of colours found in Pompeia, in the shop of a colour merchant.' Thus begins the *Sur quelques couleurs trouvées à Pompeïa* (one of the first published accounts of the analysis of ancient pigments) by Jean-Antoine Chaptal (1809), Comte de Chanteloup, former Minister of the Interior and renowned chemist.[1]

French analyses

Practised in Europe in those countries perpetually in search of minerals to exploit, the young science of chemistry developed efficient analytical techniques to qualitatively and quantitatively determine the elementary composition of numerous rocks under the term 'docimasy'. It was necessary to have at one's disposal sufficient quantities to carry out the tests – something which was hard to achieve in the case of ancient colours. This is the reason why the first analyses practiced on samples taken from paint layers led to qualitative results only, e.g. 'presence of copper'. Only analyses carried out on raw pigments, those found in pellet form as yet unused, would be able to lead to the determination of a relevant quantitative composition, provided no foreign matter was mixed up with the samples. Another discipline, mineralogy, applied itself simultaneously to perfecting the classification of rocks, and then discovered and studied the structure of crystals. The combination of these two bodies of knowledge concerning composition and structure would lead to ever more precise identification of minerals. The characterisation of Egyptian blue would benefit from these somewhat haphazard advances in knowledge.

In order to analyse these colours, Chaptal made good use of the methods of the time: recording the reactions with acids or bases followed by precipitation and attempts at fusion with borax causing the formation of coloured glass beads, the hue of which would reveal the nature of the metals present in the sample. He thus identified a Verona earth[2], yellow and red ochres, and, by intuition (for he did not have the analytical tools needed), a pink madder lake. Among these colours, there was one which intrigued him particularly: 'A beautiful blue, intense and full (…) the colour of which shines more and with more vivacity than the most beautiful blue ashes' (Chaptal 1809). It was not a

[1] The first documented pigments analysis seem to have been carried out in 1800, by J. Haslam and published in 1807 (Smith 1807: 223–6). They concerned the wall paintings from St Stephen's chapel in Westminster Palace, London (see Rees Jones 1990).

[2] Green earth of a bluish green found on the Monte Baldo, near Verona. It is made of celadonite. Concerning green earths used in Roman wall painting, see Delamare *et al.* (1990).

carbonate (hence neither azurite nor blue ashes). It was neither ultramarine nor a smalt. This blue matter stood apart from all blues known up to that time by its great chemical inertness. Chaptal showed it was composed of silica, copper oxide, lime and alumina: 'It seemed to be the result, not of a precipitation, but the effect of a beginning of vitrification, or rather a veritable frit'[3] (Chaptal 1809).

With remarkable intuition, he brought these results together with an unpublished analysis carried out by a young chemist whom he had met during the French Expedition to Egypt (1798–1801): 'M. Descotils[4] observed a colour of a vivid blue, bright and vitreous on the hieroglyphic paintings of an Egyptian monument, and he was sure that that colour was due to copper' (Chaptal 1809). Then, more farsighted than Perrault, and adopting the point of view of the necessity of applying science to industry, he compared the colour of the Pompeian pigment with those of the blue pigments available on the market, and concluded:

> Starting from the nature of the principles constituting this colour, we can only compare it with the blue ashes of recent times; considering it from the point of view of its utility to the arts, we can favourably compare it with ultramarine and azure [cobalt blue], particularly since M. Thénard made known a preparation for the latter allowing it to be used with oil[5]. But blue ash has neither the shine nor the fastness of the Ancients' colour; and azure and ultramarine are of a price much higher than that of a composition of three elements of little value each. It would therefore be very interesting to search for the manufacturing process of this blue colour.

This opinion carried all the more weight as Chaptal was also a keen industrialist, and had set up various very prosperous factories manufacturing chemical products around Montpellier, some of which made pigments.

[3] Frit: a term which has long belonged to glass technology, where it is defined as the 'result of submitting a vitrifiable material to an early stage of fusion'. It would be better to replace the word 'fusion' by 'softening', since glass never melts. Frits constitute materials easy to manipulate. Indeed, handling the various pulverulent oxides entering into the composition of glass is awkward, and even possibly dangerous. It is a lot easier to manipulate them dissolved in glass reduced to a powder, i.e. in the guise of a frit.

[4] Hippolyte-Victor Collet-Descotils (1773–1815), sometimes spelt Descostils, was an engineer who graduated from the École des Mines, and was a specialist in mineral analysis. He was one of these young chemists, sponsored by Chaptal, who would frequent the Société d'Arcueil, founded in 1807 by Berthollet and Laplace. This chemical analysis seems to be the very first to have been carried out on Egyptian blue. It was published neither in the *La décade égyptienne*, the journal of the Institut d'Égypte (1798–1801), nor in the *Description de l'Égypte*, nor in the *Mémoires de Physique et de Chimie de la Société d'Arcueil*. Rather it was alluded to by a direct witness, the Chief Army Pharmacist, J-P. Boudet (1818: 249).

[5] See Chapter 6.

English analyses

Upon recovering their throne in 1815, the Bourbons of Naples resumed control over the excavations in Pompeii and Herculaneum. The issue of preserving archaeological objects found during the excavations arose very quickly, in particular that of unrolling carbonised papyrus scrolls. In order to solve their problem, they too drew upon a renowned chemist, but, because of the political reversal, they looked to England. Thus Humphrey Davy was sent to Italy by the English Prince Regent. There he developed a passion for ancient pigments, and profiting from his stay in Rome analysed those with which his friend the sculptor Canova supplied him. As for Chaptal, most of these pigments bore no mystery for him. Only the blues evaded him. He observed them in the paint layers (Davy 1815: 105–6):

> These blues are pale or darker, according as they contain larger or smaller quantities of carbonate of lime, but when this carbonate of lime is dissolved by acids, they present the same body colour, a very fine blue powder similar to the best smalt or to ultramarine, rough to the touch (...)

Davy was intrigued by this blue mineral which could endure for millennia without losing the brightness of its colour. Using analytical methods similar to those of Chaptal, he found that these blues consisted of 60% by weight of silica, copper oxide, 'a considerable quantity of alumine, and a small quantity of lime' (Davy 1815: 106). He also provided evidence for the presence of sodium, the new metal which he himself had discovered and named in 1807. He concluded that these blues were 'a frit made by the means of soda, and coloured by oxide of copper' (Davy 1815: 107). Apart from the identification of soda, this was a confirmation of Chaptal's work.

Once familiar with the world of Roman antiquities, Davy broadened the field of his investigations. In Rome he examined numerous Roman wall paintings (among which was the famous *Aldobrandini Wedding*, which at that point belonged to a private individual), gathered a few samples[6] and noticed the use of this very same blue pigment in the blue, purple and green paint layers.

He was the first to establish a link between this unknown blue pigment and those mentioned in the ancient technical texts. He thus identified this blue as the prepared *kuanos* of Theophrastus (Περί λιθων VIII: 55) and Vitruvius' *caeruleum*. Furthermore, since the latter had mentioned that *caeruleum* was made in Alexandria, he named it 'Alexandria frit'. Like Chaptal, but by other means, he therefore also linked the Roman blue to Egypt, but he went further. Since Vitruvius had given the recipe for *caeruleum*, why not attempt to make it? He rediscovered, by trial and error, the proportions, temperature and duration of heating. Starting from twenty parts (by weight) of powdered

[6] 'When the preservation of a work of art was concerned, I made my researches upon mere atoms of the colour, taken from a place where the loss was imperceptible: and without having injured any of the precious remains of the antiquity, I flatter myself, I shall be able to give some information not without interest to scientific men as well as to artists, and not wholly devoid of practical applications.' (Davy 1815: 100).

opaque flints, fifteen parts of soda ash and three parts of copper filings, he obtained after two hours of 'strong heat' a solid 'of a fine deep sky blue' which seemed to him to be similar to the Alexandria frit. That this recipe did not call for alumina did not bother him. In fact, as Vitruvius' recipe was incomplete – calcium is missing (Delamare 2003; cf. Chapter 1) – he did not make Egyptian blue, but a soda glass tinted by copper and, perhaps, Hubert blue (see below). Fontenay (1874b), repeating this attempt sixty years later, found that the blue material obtained was vitreous and that, while its colour was indeed that of *caeruleum*, it differed from it by its solubility in hot water and acids.

Davy was the first of a long list of scientists and colour enthusiasts to attempt the synthesis of this seductive blue material. Having the same preoccupations with applying science that Chaptal did, and coming from one of the nations which specialised in the production and trade of blue ashes, he dreamt of bringing back to life the manufacture of this *caeruleum* which had so valiantly stood the test of time: 'The azure, of which the excellence is proved by its durability for seventeen hundred years, may be easily and cheaply made' (Davy 1815: 120). But, being inventive, he also hoped to extend the principle (Davy 1815: 121):

> The principle of the composition of the Alexandrian frit is perfect; namely, that of embodying the colour in a composition resembling stone (…) This is a species of artificial lapis lazuli, the colouring matter of which is naturally inherent in a hard siliceous stone.

> It is probable that other coloured frits may be made, and it is worth trying whether the beautiful purple given by oxide of gold [Cassius' purple], cannot be made useful in painting in a densely tinted glass[7].

The consequences of Bonaparte's expedition to Egypt

While it had not had the expected political results, the French Egyptian expedition had brought back a considerable wealth of knowledge concerning modern Egypt as well as the astonishing monuments left by antiquity. During these few years, while criss-crossing the country, the French scientists had marvelled at the mural decoration of temples and tombs, which the artists in the expedition reproduced to their best abilities with pencil or water colour. As in Italy, the extraordinarily fresh appearance of the colours after so many millennia did not cease to fascinate[8], nor did the nature of the blues, as witnessed by the analyses of the chemist Descotils, probably the first attempts at identifying this ancient blue pigment. However, the results, which do not appear to have been

[7]The idea is to go from a material which can only be made in thin layers to a bulk material which could be ground into a pigment.
[8]This effect was not of recent origin. Pliny the Elder, who wrote around AD 77, had already commented: 'We know there still subsists to our day in sanctuaries in Ardee paintings older than the city of Rome [they date from the sixth century BC] and which, more than any other, arouse my personal admiration: after such a long period, they remain as if recently finished, without having been protected at all' (*Naturalis historia* XXXV: 6).

published, were probably not out of the enclosure of the Société d'Arcueil, a coterie of scientists into which Chaptal had introduced the young Descostils (Crosland 1997).

Scientists remained active in the exploitation of documents brought back from Egypt at the end of the expedition. As far as the blues were concerned, they mostly directed their attention to the copper-coloured ceramic glazes. Various members of the expedition had brought back small ceramic objects (such as *chouabtis*, figurines left in tombs to serve the deceased in the underworld) with a turquoise-blue glaze. This glaze was of the greatest interest to the porcelain manufacturers of Meissen in Saxony and Sèvres near Paris. It was a race as to who would be the first to discover its formulation. This was the perspective from which, in 1812, Vivant Denon entrusted the *chaouabtis* he had brought back to the laboratory of the Sèvres factory. From the attempts dating back to that period, only a lead-glazed facsimile *chaouabti* remains (in the collection of the Musée National de Céramique in Sèvres), the colour and thickness of which were not satisfactory (cf. Humbert 1994: 243).

On the pigment side, on the other hand, research was at a standstill. Thus, when Belzoni, an Italian adventurer who prospected and dug in Egypt between 1815 and 1819 on behalf of the English, examined the blues on the wall paintings in the tombs, he did not imagine they might be anything other than indigo in which sand glistened[9] (Belzoni 1820: 175):

> As I observed before, I am of opinion, that these colours were from the vegetable kingdom, and think I can produce a pretty strong proof of the fact. The present natives of Egypt, who manufacture indigo, make it up in cakes of the size of a sea biscuit, in a very rough manner. Not knowing how to extract the colour from the plant without mixing it with sand, the cake glitters all over, the light being reflected from every particle. The ancient Egyptians were no better, for whenever there is blue in any of their paintings, which is evidently indigo, the same sparkling sand is to be seen as in the modern cakes.

In 1824, a former Italian consul in Egypt, Passalacqua, who resided in Paris and had assembled an important collection of Egyptian antiquities, asked two chemists, Le Baillif and Vauquelin, to perform analyses on various objects in his collections, in particular on unused blue pigments. Le Baillif was treasurer of the *Préfecture de Police* in Paris, but he also played at being a chemist during his free time. Like Descotils, he detected the presence of copper in the two blues which had been entrusted to him[10], but did not know how to proceed further (Le Baillif 1826: 242). Louis-Nicolas Vauquelin, a highly talented chemist, was a member of the Institut. He only analysed one sample, an unused pigment coming from the Valley of the Kings[11], but the results he obtained went

[9] That which glistens like sand is the quartz sand used as surplus in Egyptian blue (cf. Chapter 1).

[10] 'A little of blue azure, taken from the fourth of seven boxes of the color box, weighing one-eighth of grain, was tested with a torch. Protoxide, a beautiful blood red, which stains the middle of the small clay cup shows that copper is the basis of this kind of Egyptian azure' (Le Baillif 1826: 242)

[11] Passalacqua's catalogue, n°561: 'A fairly large amount of powdered blue colour' (Mérimée 1826).

far beyond those of his challenger as they were both qualitative and quantitative. The results are given below, counted as a percentage of weight (Vauquelin 1826: 238–9):

> This blue colour is a combination of copper oxide and silica, lime, a little iron and alkali. This blue is rather fusible, and when heated with a blow torch over a piece of coal with a little tartar, it yields metallic copper.

> Here are the approximate results of the analysis I submitted it to: out of a hundred parts, to wit:

1.	silica	70
2.	lime	9
3.	copper oxide	15
4.	iron oxide	1
5.	soda mixed with potash	4.

		99 parts

> I do not know whether this colour was obtained via the dry or the wet method; but it is definite that its elements are intimately combined, for concentrated acids only take away traces of copper oxide and lime, and a second application dissolves nothing more.

This was the first time that a composition of Egyptian blue (here, *hsbd iryt*) approximating to reality had been published. Alumina is absent – that found by Chaptal and Davy was probably due to contamination from the surrounding clay. Furthermore, the proportion of fluxes, soda mixed with potash, is much too low to interpret this composition as that of glass (where it would be around 17%). Familiar with chemical industries, Vauquelin added: 'I believe I should mention here a blue colour, absolutely identical, which formed on the floor of a kiln where copper had been melted at the Romilly factory; it is of the same chemical composition.'

This result, which does not seem to have been published elsewhere, probably reached a certain audience, for the fame of Egyptian blue continued to grow. In his treatise *De la peinture à l'huile* [*Of oil paint*], in the chapter dealing with colour preparation, Mérimée (1830: 170–74) dedicated four pages to the '"Egyptian blue" used by the ancients'. He recalled the works of Chaptal and Davy on *caeruleum*, and drew a parallel between this pigment and the copper-coloured glass Venetians knew how to make. He too agreed that this pigment would be 'of great utility for distemper painting and decoration'.

Darcet blue as an imitation of Egyptian blue

The desire to recreate Egyptian blue was put forth as a recurring theme each time a chemist became aware of Egyptian blue. This would finally be realised by the chemist d'Arcet *fils*[12]. Probably made familiar with this type of chemistry by his father, who did a great deal of research on glazes and colours fired at high temperatures, he undertook

[12] Jean, Pierre, Joseph d'Arcet (1777–1844). Often spelt Darcet (*Révolution oblige...*). He was a member of the Académie des Sciences, a chemist and an industrialist. He was the son of

research on Egyptian blue. He was successful with a laboratory synthesis, and then following successful synthesis on a pilot scale, around 1830, he commercialised 'a Darcet blue in the likeness of Egyptian blue' (Fontenay 1874b: 471). The formula remained a well-kept secret, but it seems that it was Egyptian blue. For, much later, H. de Fontenay (1874b) would analyse a sample of known provenance, supplied by the chemist Péligot: its composition was indeed that of flux-rich caeruleum. D'Arcet presented his blue pigment in 1834 at the *Exposition des Produits de l'Industrie Française* in Paris. As he was a member of the exhibition's central jury, his blue was not entered in the competition, but this pigment was judged to be one of the two striking innovations in the field (Moléon *et al.* 1835–1838: 320): 'Here stand out two new colours, of which we have been enriched by Messrs Guymet [sic] and D'Arcet.'

To set the commercial career of the new pigment in motion, d'Arcet found a customer in the wallpaper industry, an industry which had a pressing need for a very cheap sky blue. He sold his new pigment to the Drouard Establishment in Paris. They surmounted the technical difficulties arising from the large grain size of the pigment, obtained a sort of quality certification and sent samples of this new product to the Société d'Encouragement pour l'Industrie Nationale. According to its experts (Gaultier de Claubry 1837):

> This matter [d'Arcet blue] is a frit coloured by copper oxide; its application to the preparation of wallpaper presented many difficulties, which M. Drouard very successfully surmounted. In May, 1834, he presented you with samples of wallpaper coloured with this blue, which were featured at the exhibition of industrial products and are now kept at the ceramic museum established at the Sèvres royal porcelain factory under the care of M. Brongniart.

> From this time on, M. Drouard has made a certain amount of papers with remarkable graduation of tints but, as the coloured matter could not be brought to the trade, this production could not continue; it had required the use of particular means, the application of which left nothing to be desired.

D'Arcet seems to have met with technical problems in transitioning from pilot to industrial scale, and seems not to have been able to solve them. This is very likely, considering the real difficulty in controlling temperatures in industrial kilns with sufficient accuracy to 950°C ± 50°C. The industrial use of Egyptian blue was of short duration: barely three years.

In spite of his lack of wisdom, we can only admire Drouard's appetite for risk. He jumped into this adventure when artificial ultramarine was already widely available to the trade and presented nothing but advantages over Egyptian blue, except perhaps for its price. Unfortunately, we have no information about the price at which d'Arcet sold his blue pigment, but considering the low price of the raw materials and the simplicity of its manufacture it must have been rather lower than that of ultramarine, which was then still in its infancy. For a wallpaper manufacturer, the price of a pigment is

the chemist Jean d'Arcet who succeeded Macquer at Sèvres and directed that manufacture for around twenty years.

an overarching criterion. In 1831, the lowest quality ultramarine sold for 16 francs per pound, but this price went down very quickly. Thus, in 1837, Ferrand was selling his ultramarine for wallpaper at 3.50 francs per kilogramme, and the colouring power of that pigment was much greater than that of Egyptian blue.

A very French enthusiasm

It would be tedious to quote all of the chemists who took some interest in Egyptian blue in the years 1840–80, be it to identify archaeological objects on pellets or fragments of wall decorations found in Gaul – Girardin (1846, 1852), Chevreul[13] (1850), Pisani (1880) – or on a continuing basis – like Brongniart[14] (1877: vol. 2, 771), then director of the Sèvres factory, who attempted in vain to find the secret of the blue glaze of the *chaouabtis*. This work was resumed successfully in the 1870s by Salvetat, then chief chemist at the Sèvres factory, who published his results on 'Babylonian enamel'. Around 1880–90, having optimised both the clay and the glaze, Sèvres produced several blue statuettes. These were the forebears of the turquoise-blue glazed Egyptian ceramic replicas currently sold to tourists in the Musée du Louvre and the British Museum.

Some chemists had the good fortune to be able to analyse raw *caerulea*. Thus Delesse, a young engineer with the Corps des Mines, who later became a famous geologist and a future member of the Académie des Sciences, analysed one of these 'balls of a beautiful celestial blue' found in Rome in 1842, in a shop adjoining the baths of Titus. The composition he gave for it, in weight percentage, was (Delesse 1843):

silica	16.5	lime	28.8
alumina	10.7	magnesia and alkali	10.0
copper oxide	10.0	water, carbonic acid and foreign matters	24.0

This is an atypical composition, which leads one to wonder if there had been an error or if the composition of the ball was not greatly modified by the earth surrounding it.

Girardin had the good fortune of being entrusted with 'a vase which a worker's pick had broken, and which contained several kilogrammes of a light blue substance, which had probably been a powder, but which humidity had gathered into a solid' (Girardin 1846). This vase had been found in 1843 during excavations on the site of a Roman villa located near Routot, in the Brotonne forest (Eure). Girardin recognised its content as *caeruleum*, and gave a composition, in weight percentage, which appears more credible:

silica	49.4	lime with traces of magnesia and iron	19.4
soda	15.5	cupric oxide	9.3
alumina	4		

[13] He identified Egyptian blue several times in blue paint layers and in green paint layers, where it accompanied green earths.
[14] Brongniart (1770–1847) was the son of the architect of the St Louis d'Antin church and the Bourse in Paris. The Musée du Louvre preserves a remarkable clay bust of him at the age of seven by Houdon.

Therefore, at that stage of the research, scientists are able to recognize Egyptian blue on monuments of ancient Egypt as well as on those of Rome or Roman Gaul. It was known through Vitruvius that it was not a natural product, and that it was obtained via synthesis. Its global composition was known, but not its structure. But the repeated use of the word 'frit' to describe it led to the assumption that it was a vitreous material. In fact, no one had yet made a pronouncement on the exact nature of this material. This was the problem which chemists and mineralogists would now confront.

From frit to crystal

In 1874, Fontenay published the work he had done in Paris in the laboratory of Peligot, at the Conservatoire des Arts et Métiers. He had quantitatively analysed numerous Egyptian blue balls and pellets from various origins (Fontenay 1874a, b, c). Some, brought back by the duc de Luynes in 1865 after his journey to Palestine, belonged to the ceramic museum in Sèvres. They came from tombs in the Nile valley and the ruins of Thebes (Fontenay 1874b: 466):

> These samples were perfectly round, of the size of a small orange, and presented a curious peculiarity: in order to preserve their mixture from browning, the Egyptians wrapped it all around in a layer of clay which contracted less through calcinations than its content, so that the azure ball rattled freely inside its envelope, like a dry nut in its shell.

Others came from Cumae and Pompeii via the Passalacqua collection or were Gallo-Roman pigments found in Autun and at Mount Beuvray, at the site of the ancient city of Bibracte, capital of the Eduan people.

Fontenay analysed one of the pellets coming from Autun or Mount Beuvray 'using the methods usually applied for silicate analysis'. He found, as a weight percentage (Fontenay 1874b: 464):

silica	70.25	lime	8.35
copper oxide	16.44	soda	2.83
iron and alumina	2.36		

On the basis of the texts of Theophrastus, Vitruvius and Isidore of Seville[15], he too attempted to rediscover the manufacturing process. In his experimentation, he modified Vitruvius' recipe according to the results of his analyses and, in the laboratory of the Sèvres factory, he perfected the second modern synthesis of Egyptian blue. He mixed 70 parts by weight of white sand (i.e. pure silica), 25 parts of chalk, 12 parts of black copper oxide (CuO) and six parts of soda (sodium carbonate) as flux. The mix did not include iron, which he viewed (with good reason) as an impurity. He heated the mixture to temperatures ranging from 900°C to 1000°C, which he maintained for two to

[15] Isidore of Seville was a bishop and writer of numerous works, among which an encyclopaedia of ancient knowledge written around 630, where a variant of the recipe for *caeruleum* related by Vitruvius can be found: Cf. Chapter 1, note 29.

three hours, depending on the size of the pellets. He noted that: 'The colouration first develops at the surface of the balls and penetrates progressively toward the centre, but extremely slowly; it is therefore necessary in most instances to repeat the operation twice to colour the whole mass' (Fontenay 1874c).

The formation of Egyptian blue is, indeed, mostly driven by phenomena of volume diffusion, the kinetics of which are a function of $t^{1/2}$, t being the heating duration. Fontenay also noticed that if the temperature goes too high, the end product turns black; while if the temperature remains too low, it is green. Temperature and duration of heating were therefore important parameters.

In any case, the 'secret' behind the manufacture of Egyptian blue (and of Darcet blue) had now been published.

A big step forward would be taken in 1881 by the mineralogist Bertrand (1881) who, in a comment in response to an insignificant note of a colleague in *Couleurs anciennes obtenues par l'emploi des oxydes de cuivre* [*Ancient colours obtained through the use of copper oxides*], affirmed that Egyptian blue was of a crystalline nature, that it crystallised in square prisms and that under polarised light this crystal had a negative axis. To take all of the elements necessary to make a copper-tinted blue glass and be told that the result had a crystalline structure must have raised a few eyebrows in the scientific community. These results were fully confirmed in 1889 by the remarkable study of Fouqué (1889a, 1889b, 1889c), a specialist in the synthesis of minerals and rocks. Reverting to the recipe of Fontenay, Fouqué studied the synthesis of Egyptian blue (Figure 9.2). He determined its composition precisely, classified it among the family of silicates and attributed to it the formula $CaO.CuO.4SiO_2$.

He noted that 'no trace of alkali enters this product. It can be obtained through the use of substances rigorously devoid of soda and potash'. There followed a complete study of the optical properties of crystals made under polarised light which confirmed and completed the observations of Bertrand. A birefringence of 0.031 was measured. From then on, one could characterise these crystals more easily and more precisely with an optical microscope than chemists had ever done. Furthermore, the method was non-destructive. The study of the reactivity of this silicate to chemical agents confirmed the excellent resistance of Egyptian blue. Fouqué confirmed that the synthesis took place only within a fairly restricted range of temperatures, between red and red-to-white heat. 'It is in maintaining the optimal temperature that the whole difficulty of its manufacture resides'. He also discovered that the presence of a small amount of flux helps with the formation of crystals. Of all the fluxes he tried, he advised sulphate of potash. Fouqué tried to synthesise analogous silicates by replacing calcium by either magnesium, or one of the other alkaline earths (barium and strontium). He failed (Fouqué 1889b).

Towards an industrial production of Egyptian blue

Fouque did not escape the lure of an industrial production of Egyptian blue. He too could not avoid ending his note to the *Comptes Rendus* with the following note (Fouqué 1889b):

The beauty and fastness of this colouring matter, which is unaffected by air, humidity, light, or most chemical agents, the ease of its manufacture, and the very low price for which it can be produced, leave one to wish that it take its place again in industry.

Nevertheless, in 1889, the market for blue pigments was firmly held by artificial ultramarine. Fouqué was probably unaware of the unfortunate previous experience of the Drouard Establishment with Darcet blue. In any case, he ignored the importance of colouring power among the qualities required of a coloured powder to be usable as a pigment. Pursuing his idea with the active support of the Deschamps Establishment, manufacturers of ultramarine in Bar-le-Duc, Fouqué perfected the production of Egyptian blue on a pilot scale. For the Deschamps Establishment, this was probably more an historical reconstruction than a production with commercial intent. No one would be more convinced of the insufficient colouring power and covering power of Egyptian blue when compared with ultramarine than an ultramarine manufacturer.

Of this production, as opposed to that of d'Arcet, we do have a direct testimony from the former technical director of production for the Deschamps Establishment, a German named Bock. In the middle of World War I, from Germany where he had returned at the start of the hostilities, he took the trouble to write to correct an English publication which had wrongly minimised the role of French scientists in characterising Egyptian blue. Retracing the work of Fouqué at the Deschamps Establishment, he wrote (Bock 1916):

> For the manufacture of Egyptian blue, we used as raw materials quartz, chalk, copper oxide and soda ash[16]. It was important to pay attention that there would be no iron. Very finely ground quartz was used. As a precaution, it was very finely sifted, for after several attempts it was clear that successful fusion hinged on the fineness of the silica. The soda ashes, which served solely as flux, were 98% ammonia soda. The other ingredients in the mixture also had to be very finely ground. The mixture (copper oxide 24.4 parts; quartz 50.0; chalk 21.0; soda 4.6) was made either by grinding together under the wheel, or in a rotary drum.

> This raw mixture was placed in a crucible identical to those used for manufacturing ultramarine, and placed in a kiln, the temperature of which, ranging from 900 to 950°C, was measured with a Le Chatelier pyrometer[17].

> Once the kiln cooled, one found a uniform blue mass of vitreous aspect. The latter was broken into fragments the size of a walnut which were ground. The finer the grinding, the paler the colour gets. (...)

> The powder, still warm, was washed in hydrochloric acid, then rinsed abundantly in hot water until it was rid of excess copper and acidic remnants. Thus was obtained a

[16] This was soda ash made by the Solvay process (ammonia soda), i.e. sodium carbonate Na_2CO_3, used as a flux in the glass industry.

[17] A very recently invented apparatus. It was in 1887 that Le Chatelier perfected his thermoelectrical pyrometer using the platinum – 10% rhodium platinum junction, much superior in terms of reliability to all those proposed before. Together with a new generation of galvanometers (aperiodic, of the Deprez-d'Arsonval type) and periodic calibration based on the melting points of pure metals, it enabled the measurement of high temperature with accuracy and reliability for the first time.

product chemically and physically identical to the antique Egyptian blue with formula $CaO.CuO.4SiO_2$.

The temperature range had now been narrowed down. Only the duration of the high temperature heating was missing, which should have been that used for ultramarine production, hence several days. The importance of this little known text should be emphasised: it is the only one (to the best of our knowledge) which allows us to imagine the workings of the ancient workshops producing *hsbḏ iryt* in Alexandria, or *caeruleum* in Pozzuoli, and then the rest of the Roman Empire.

Samples of this production were presented for curiosity's sake at the Chicago International Exhibition in 1893. They were noticed, as witnessed by the official account (Adrian 1894: 246–7):

> A product which particularly draws visitors' attention is an Egyptian or Vestorian blue, a new colouring agent which Messrs Deschamps were the first, and are the only ones to manufacture for industry. This is the blue with which M. Fouqué entertained the Académie des Sciences during its session of February the 18th, 1889, which had been studied by Chaptal in 1809, in 1815 by Davy, in 1874 by M. de Fontenay, but of which the learned professor at the Collège de France [Fouqué] is the only one to have been able to give the chemical composition. It is on the basis of his advice that Messrs Deschamps have been able to reproduce in all its brightness this beautiful colour from antiquity.

The claim that they 'manufacture for industry' was without doubt an error on the reporter's part (whose enthusiastic report was not exempt from inexactitudes) since Bock (1916), a specialist in pigments, remarked: 'This colour has no hiding strength, and only a low colouring power. Which, from our point of view, excludes any practical application.' However, this reporter was not the only one to believe in this production. For when, Le Chatelier (1899) patented a new material analogous to Egyptian blue (see Chapter 10), the text of the descriptive memoir read: 'Today, the manufacture of this [Egyptian] blue exists, but is little developed.'

Fouqué under attack

Around 1890, the Egyptologist Flinders Petrie entrusted several chemists with the analysis of various objects found in excavations in Meidum and Armana. Among them were colours, in particular Egyptian blue. Between 1892 and 1894, W.J. Russell published the result of his research on ancient blues originating from Egypt (Russell 1892, 1893–95, 1894). He knew of the recent findings of Fouqué, but was dubious about them. He did not in fact attempt to check them, by studying for example the crystalline character of the blues entrusted to him. He was content with submitting them to a gravimetric analysis. He recognised the presence of 3–10% by weight of copper, and of 10% sodium and potassium carbonates. He then studied the synthesis of silicates and glass tinted blue by copper. Using an alkali content of 10%, he noted that concentrations of copper as well as lime had to be brought up to 20–30% to obtain deep blues. He prepared a master compound made of silica, copper oxide and alkaline fluxes. Then

by adding calcium carbonate and bringing it to a high temperature, he obtained real Egyptian blue. However, if he added sodium carbonate and raised the temperature high enough, he obtained blue soda glass.

Shortly thereafter, Spurrell (1895) published a synthesis of his research on coloured materials used in Egypt, and devoted a rather long section to Egyptian blue. He gathered the excavation data he was aware of, the texts from the ancient authors on coloured materials and the work done by other chemists before him. The identification made by Fouqué of Egyptian blue as a double silicate of calcium and copper evidently appeared faulty to him, since it was in disagreement with Vitruvius' recipe. According to Spurrell there was an additional proof: a microcrystalline powder is not vitrifiable and therefore could not yield a frit. The disagreement between these authors and Fouqué was due mostly to the fact that they could not conceive of Egyptian blue being a mixture of a crystallised phase and a vitreous matrix of slightly different composition, each being susceptible to variations in composition according to production, location and time period. The proportion of vitreous matrix was particularly important in the case of samples found in Egypt.

Fouqué vindicated

This quarrel would end in 1914 with the appearance of the remarkable study by Laurie *et al.* (1914). These authors began by checking in great detail the observations of Fouqué on various Egyptian blue samples of Egyptian, Cretan and Roman origin: blue balls and wall paintings from the Palatine in Rome and from Viriconium in Shropshire (UK). They confirmed the validity of Fouqué's work, in particular the presence of crystals answering to the empirical formula $CaO.CuO.4SiO_2$. They then obtained the archaeological samples studied by Dr. Russell, as well as his laboratory notebooks and the samples he had made. They checked that he had indeed synthesised two families of samples: Egyptian blue with the calcium carbonate, and blue glass when he omitted it. They also checked on a blue made by Fouqué to show that it was indeed Egyptian blue. They noted that Russell had clearly shown one could synthesise this silicate at a temperature below its melting point by starting from quartz and copper and calcium carbonates.

Apparently ignoring the development of industrial production for Egyptian blue by Fouqué at the Deschamps Establishment, Laurie *et al.* also tackled the systematic study of the conditions for the formation of Egyptian blue. They were actually the first to explain how they measured the reaction temperature. The problem is technically not easy. On the one hand, temperature is never homogeneous in a kiln, and, on the other, the thermocouple material changes at high temperatures, thereby giving erroneous readings, hence the need to recalibrate frequently. However, they determined an optimal temperature range of $850°C \pm 20°C$ (a temperature currently viewed as much too low), and confirmed that the role of the flux was to speed up the reactions, potassium being equivalent to sodium for that purpose.

Once Egyptian blue had been synthesised, it was necessary to separate it from its glassy matrix in order to measure precisely the properties of the crystalline phase. To this end, the authors centrifuged a mixture of the powdered product in two different liquids of differing densities. Firstly, the powder was centrifuged in bromoform (d=2.88), then the heavy residue was centrifuged in a mixture of methylene iodide and benzene (d=2.948). The crystalline phase (d=3.04) settled. Having recovered it, they could then accurately measure the ordinary (1.6354) and extraordinary (1.6053) refractive indices, the difference between which (0.0301) was close to that measured by Fouqué (0.031). It was as a consequence of the publication in England of a book mentioning only these English contributions that Bock claimed precedence for the knowledge of the exact conditions of Egyptian blue manufacture, perfected at the Deschamps Establishment with the help of Fouqué.

From Egyptian blue to Han blue

Studies were not at a standstill in France. Le Chatelier (1907), a chemist who specialised in cement, hence in silicates and high temperatures, studied ancient ceramic clays and their blue glazes in order to answer questions put to him by the curators of the different departments of the Musée du Louvre. He also analysed three pellets found in Egypt (without mentioning their provenance or their date). He experimented with the pellets by heating and cooling them to observe the sensitivity of the blue colour to heat, and whether they would return to their original colour once they had turned black or green. He carried out these same experiments, mixing Egyptian blue with glass as if he wanted to recreate the conditions of use for this material when making large ceramic objects (animals figures, basins, vases) or turning it into glazes.

He also verified that powdered Egyptian blue makes a poor pigment for oil paint, while its qualities are unsurpassed when it is employed *a fresco*. Criticising the difficulty of manufacturing Egyptian blue industrially, as well as its low stability at high temperatures when one wants to use it in the ceramics industry (where the chemical environmental conditions are such that it is hard to prevent it from changing), Le Chatelier advised the use of the equivalent of the $CaO.CuO.4SiO_2$ silicate, in which calcium was replaced with barium (cf. Chapter 10).

In spite of all these difficulties, Egyptian blue was produced. Indeed, in France in 1930, the artists' colours manufacturer Lefranc-Bourgeois had Egyptian blue manufactured, and, in 1938, sold it as a pigment for frescoes under the name of 'Pompeii blue'.

Invention of cuprorivaite

In 1938, an Italian mineralogist, Minguzzi, was studying a mineral found on the side of Mount Vesuvius by one of his colleagues. Made of small azure blue grains, it was mixed with quartz and calcium carbonate. Its density, birefringence and pleochroism were measured. Analysis showed the presence of a little sulphur, carbon, iron, aluminium

and 3.5% alkali, sodium and potassium. Minguzzi thought he had discovered a new mineral. He baptised it 'cuprorivaite', from 'rivaite', which is the double silicate of calcium and sodium. He attributed to it the empirical formula (Minguzzi 1938): $2(Ca, Na)$ $(Cu, Al) (Si, Al)_4 (O, OH)_{10}.H_2O$. The formula lacks in precision, but, as the mineralogist Frémy (1877) once taught:

> That mineral which seems the purest almost always contains, as inclusions, foreign bodies which were in the medium that formed it: analysis is then powerless to determine the true composition of the mineral, while a synthetic reproduction will enable one to distinguish the constitutive elements from those which are but accidental.

However, there was no lack of opponents, who doubted the novelty of this mineral.

At the same time, Ivanov *et al.* (1938) noticed (as Fontenay had) the formation of Egyptian blue on the floor of copper-melting furnaces. He described the crystals as lamellar, and indexed the crystal planes visible on the surface. He managed to synthesise Egyptian blue, researched the optimal conditions for the process and claimed to be ready to consider a move into industrial production. The study of this silicate was taken up by Belov (1942), who claimed it was a phyllosilicate. The conclusion of the study left an impression of *déjà vu*. It recommended industrial production of Egyptian blue so that painters would have at their disposal a pigment guaranteeing real durability to the monumental wall paintings dear to the political regime then ruling the USSR.

Characterisation of the structure through X-ray diffraction

At the end of a short note recalling the main results already published on Egyptian blue, Jope and Huse (1940) devoted five lines to the identification of a blue material found in a pot at Armana. However, the identification was by way of the description of an X-ray diffraction pattern (which they did not publish). According to Jope and Huse, it was not Egyptian blue, but a copper aluminate ($CuAl_2O_4$). This identification would remain unique. The striking fact of this identification is that this was the first time anyone thought of characterising a blue pigment through its crystalline structure instead of its composition. Indeed, the use of X-ray diffraction in the field had a bright future, but this première had the effect of sowing the seeds of doubt and confusion. Thus Forbes (1955) described Egyptian blue as an aluminate amenable to synthesis 'via Laurie's method'. Impressed by the 'modern' character of the technique employed, various commentators tended to give this result much greater importance than it deserved.

This was why Schippa and Torraca (1957), using Jope and Huse's own method, attempted to resolve the issue. They published the first X-ray diffraction spectra obtained on various Roman ancient samples, a well as a table of distances between crystalline planes, the corresponding peaks, and their relative intensities. They confirmed that the crystalline system was quadratic, and determined the three parameters of the crystal lattice. The study of optical properties showed the existence of birefringence and pleochroism; they gave the values already found by Fouqué and confirmed by Laurie. They too then studied the synthesis of the material. They started from a silica gel, and copper

and calcium carbonates to which they added a little sodium and potassium carbonate. They studied the influence of the proportions of CuO, CaO and SiO_2 on the colour of the silicate obtained by heating at 840°C, and on its crystalline character. In summary, they found that the product obtained was blue if the ratio of molecular concentrations of copper and calcium oxides (CuO/CaO) was slightly larger than unity. Furthermore, they studied the reaction kinetics qualitatively by following the evolution of the X-ray diffraction spectra as a function of reaction time. They recommended long durations (thirteen days) and the use of silica gel rather than quartz powder. Finally, they were the first to make a *rapprochement* between Egyptian blue and cuprorivaite, and to suggest a comparative study.

A few years later, Pabst (1959) published a fundamental study of the crystalline structure of Egyptian blue ($CaCuSi_4O_{10}$)[18] and its homologues obtained by replacing calcium with barium or strontium. The study, carried out by optical microscopy and X-ray diffraction on crystals obtained by synthesis, is considered a standard reference. Pabst was the first to mention that he achieved the synthesis of this silicate by sintering[19]. He started with copper oxide, calcium carbonate and silica mixed in stoichiometric proportions. He used X-ray diffraction to check that Egyptian blue synthesis had indeed taken place. The addition of 10% by weight of borax ($Na_2Ba_4O_7.4H_2O$) as flux led to larger crystals (100 x 30 µm; Figure 9.3) after 24 hours at 800°C and the presence of a glassy phase.

Pabst determined the characteristics of each crystal structure, deduced its optical properties and checked that they matched experiments. From the standpoint of crystalline structures, they were phyllosilicates crystallising in the quadratic system and in the space group P4/ncc-D^8_{4h} with a particularly well-developed (001) crystal plane. He computed the electronic density map, and attributed the exceptional chemical inertia of Egyptian blue to the coordination number 4 benefiting the Cu^{+2} ion, the four ligand oxygen anions being coplanar. From then on, cuprorivaite was classed as belonging to the sub-family of phyllosilicates, with formula $MCuSi_4O_{10}$ (M standing for calcium, barium or strontium), the structure of which is identical to that of gillespite, $BaFeSi_4O_{10}$.

Pabst ended by regretting not having been able to study the cuprorivaite sample, this mineral corresponding in his view to the Egyptian blue crystals. This void was filled in 1962 (Mazzi and Pabst 1962). Using the very sample studied by Minguzzi, Mazzi and Pabst demonstrated beyond possible doubt, through the study of its optical properties and X-ray diffraction, that cuprorivaite and the crystalline phase of Egyptian blue are identical. They carried out the same programme on blue crystals formed on the sides of copper-melting furnaces, and confirmed that they were indeed also cuprorivaite. The

[18] $CaO.CuO.4SiO_2$ and $CaCuSi_4O_{10}$ are two equivalent empirical formulae.

[19] Production of a compact material from a powder without going through the liquid state. The operation takes place at high temperature (although below the melting point), and often under pressure. The physical mechanisms involved are volume and surface diffusions. The process appeared in the years 1826–29 with the production of platinum ingots by Wollaston and Sobolewski. Fick's first law, the basis for work on diffusion, was published in 1855, but the study of the physical processes involved in metal and ceramic sintering dates from the 1940s only. Ashby (1974) wrote an interesting synthesis.

article ended on a list of the best values obtained for the crystallographic and optical properties of this mineral. Bearing number 12-512 in the ASTM (American Society for Testing of Materials) card of crystallographic characteristics, it is referenced – this is remarkable – under the name 'Egyptian blue' with the formula for the double silicate $CaCuSi_4O_{10}$ and, prudently, mentions: 'may be equivalent to cuprorivaite'.

However, the electron structure of planar metallic complexes, particularly those of copper (II) complexes, intrigued some researchers. Ford and Hitchman (1979) published their work on prepared cuprorivaite crystals which they carefully characterised, confirming the values of the various refractive indices measured by Pabst. They then studied the d orbitals of copper through electronic paramagnetic resonance. Then, some years later, the structural characterisation of cuprorivaite was undertaken anew and refined by Chakoumakos et al. (1993), who studied each of the terms of the sequence $MCuSi_4O_{10}$ by neutron diffraction. Interatomic distances were determined up to a thousandth of an angstrom unit. Figure 9.4 gives an idea of the sheet structure of these phyllosilicates.

Back to Egypt

In 1968, W.T. Chase (1971) became interested in the manufacture of large Egyptian blue objects. He wished to better understand the conditions of the formation of cuprorivaite and so tried out several different starting formulations, among which that of Laurie satisfied him completely. By identifying the reaction products by X-ray diffraction, he confirmed the optimal temperature for the formation of Egyptian blue to be 850°C. At 1000°C, the blue colour disappeared and a glassy phase formed. Chase discovered the importance of the oxidising character in the atmosphere in which the reaction takes place: a reducing atmosphere led to the formation of tenorite (CuO) and cuprite (Cu_2O). He then compared the result of his syntheses with the blue materials of ancient Egyptian objects. In order to reproduce the glassy phase he observed in these, he had the idea of adding a soda-lime glass to his preparation, an idea he justified at length with arguments of the historical–technical type. He succeeded in narrowing the temperature range for the formation of Egyptian blue, but was not able to produce large objects by sintering. Following this work, the synthesis of Egyptian blue became part of the demonstrations regularly carried out by P. Vandiver in the course of his teachings at the Massachusetts Institute of Technology.

A few years later, Saleh et al. (1974) analysed the pigments found in the tomb of Keruef, in Thebes, among which were seven cylindrical cakes of Egyptian blue weighing 7.86 kg in total. The nature of the pigment was confirmed by X-ray diffraction and its composition by wet analysis completed through various techniques. Some elements were detected by X-ray fluorescence spectrometry (Fe, Ni, Sr, Sn, As). There was not a glassy phase, a rare state of affairs. The marked presence of iron and aluminium (7% by weight) was interpreted as being due to the impurities in the silica used, which would correspond in Egypt to the use of quartz sand rather than flint stone or quartz pebbles. This sand being low in alkali would explain the low sodium and potassium content of

this Egyptian blue. No additional alkaline elements were added. The authors checked the possibility of synthesising cuprorivaite without the addition of alkali (one hour at 1000°C). Their analyses led them to doubt either the exactness of the empirical formula for cuprorivaite or the fact that the pigment had the stoichiometric composition. They also found several differences between their X-ray diffraction spectra and those published by Pabst.

In 1976, Bayer and Wiedemann (1976) published their work on the colours present on Nefertiti's bust, and in particular the blue in her hair. They noted the presence of another mineral, a double silicate of copper and calcium, cinoite, also blue, the formula for which can be written: $2CuO.2CaO.3SiO_2.2H_2O$. Its structure is close to that of cuprorivaite. They also observed that the intensity of the colour of Egyptian blue increased with the size of the crystals. The use of alkali during synthesis led to a more intense blue under given conditions. According to Bayer and Wiedemann, the optimum colour would be reached for crystals measuring between 5 and 50 µm. They then moved on to the synthesis reactions. The originality of their approach consists in having followed the reactions occurring through thermogravimetry and differential enthalpy analysis. The first method showed the loss of weight (the decomposition of carbonates) as a function of the temperature to which the reactants were brought, and the second the variations in specific heat indicating the phase transitions. They started from the stoichiometric mix, made from carbonates (calcite and malachite), to which they added as flux alkali carbonates or sulphates, borax or lead oxide, a new ingredient. They located the range of Egyptian blue formation at between 850°C and 1000°C in an oxidising atmosphere. At 1000°C, Egyptian blue decomposed. They indicated the thermal thresholds for carbonate decomposition: copper carbonate as low as 300°C and calcite around 650°C. The main criticism which may be directed at this study is that it only showed the preliminary decompositions, which are in fact different from the true reactions which result in Egyptian blue. Linked to diffusion processes, the latter occur without any weight loss. For the first time, energy dispersion X-ray elementary microanalysis (EDXS) was used to show the presence of copper, calcium and silicon in the synthesised blue crystals. The study was extended to silicates of the same family, in which calcium was replaced by barium or strontium.

The first thesis dedicated to Egyptian blue

D. Ullrich (1979) published the first large-scale academic study devoted to Egyptian blue synthesis. It differs from other attempts by having a much more in-depth bibliography and a much more detailed inventory of Egyptian blue usage, as well as the possibility of finding all the experimental details necessary to fully understand the results. The initial material was a mixture in stoichiometric proportions of silica, malachite and calcite, to which sodium was added.

In the first part of the study, experiments covered the 700–1300°C temperature range. Products were characterised by X-ray diffraction, and, for the first time, by visible light absorption spectrometry, a technique which not only gives information on the

presence of certain chemical links, but also characterises colour. Cuprorivaite seemed absent at 850°C, but formed at 900°C. The reaction was then followed by thermogravimetric analysis, with results much like those observed by Bayer *et al.*

The second part was a study of the reaction kinetics as a function of temperature and the presence of a flux. Egyptian blue which had formed in a given time was separated by density in bromoform and weighed. With the flux, kinetics were determined for 1000°C, 950°C, 900°C and 850°C over ten-day periods (Figure 9.5). The curves show the fraction transformed as a function of reaction time. The optimal temperature seems to be 900°C, with the fraction transformed reaching 44% in 240 hours. As temperature goes down, we approach a sigmoid curve showing the existence of an initial incubation period, which increases as the temperature gets lower (Figure 9.6). This incubation period results from the germination process preceding the growth of cuprorivaite crystals within the vitreous matrix. At 950°C, when varying the amount of flux, Ullrich observed that the fraction transformed was greatest for a 4.3% weight of Na_2O.

Both figures show that for a temperature held over two days – which, considering the cost of fuel, must be rather close to the truth for ancient productions – the optimal temperature was 950°C, not 850°C as numerous authors had published.

Polyphase Egyptian blues at last

M. Tite *et al.* (1981) analysed ancient Egyptian blues made of the double silicate immersed in a glassy phase. They noted that the cuprorivaite crystals preferentially surrounded the remaining silica crystals. They studied the synthesis, using for the control of his products X-ray diffraction and scanning electron microscopy, retaining as a quality criterion the hardness of the product. They observed that the reaction took place between 900°C and 1000°C, and made it a rule to split this thermal treatment into several stages separated by grinding. They also observed the positive role of the compacting pressure on the green[20]. The use of quartz sand instead of amorphous silica led to silica grains covered with cuprorivaite crystals, as in the archaeological samples.

Jaksh *et al.* (1983) worked on a large sample of Egyptian blues recovered from Egyptian tombs, the dates of which ranged from the Fifth Dynasty to the Roman period. They characterised them by X-ray diffraction, then examined polished slices by optical microscopy followed by scanning electron microscopy equipped with elemental microanalysis. All of these blues were made of cuprorivaite immersed in a vitreous phase. The authors concluded that there was no sintering, but that there was fusion due to the presence of fluxes (the presence of phosphorus suggested the use of ashes of vegetal origin). The presence of titanomagnetite suggested the use of desert sand as a source for quartz and the presence of stannic oxide (SnO_2), from the reign of Thutmosis III onwards, indicated bronze as a source for copper.

In 1984, Tite *et al.* (1984) published some important results. They determined via atomic absorption (after having dissolved fragments from samples) the global

[20] Green: powder with a binder added intended to undergo sintering.

composition of numerous ancient Egyptian blues (some of Roman provenance). None was of the stoichiometric composition: all were too rich in silica. On the ternary diagram CuO-CaO-SiO_2, the points representing the compositions regroup about the line joining pure silica and the stoichiometric composition (cf. Chapter 1, Figure 1.10). The phases present and their hardness were characterised. They observed two correlations: the first between the sodium and potassium contents, and the second between the content in alkali (>1% in weight) and the quantity of glassy phase present. In the second part of the work, Tite and his colleagues turned particularly to the polyphase aspect of the blue material. In the laboratory they tried to reproduce synthesis conditions to match the morphologies observed. This led them to use two heating periods separated by a homogenising grinding. An examination of a polished slice with an optical microscope showed the dimensions and distributions of cuprorivaite, quartz and tridymite crystals, and of the occasional glassy phase consolidating the material. When it was present, they confirmed their earlier observations: cuprorivaite was preferentially distributed at the surface of the quartz grains present.

In 1985, Guineau (1987) characterised Egyptian blue by Raman spectrometry. In the same period, three articles appeared which completed the publication of Tite's work (Tite 1986, 1987; Tite *et al.* 1987). He revisited the theme of ancient materials, the blue colour due to copper which contained varying amounts of alkali, and lime. Egyptian blue was explicitly considered as a sintered material. The study was based on ancient Egyptian samples. Polished slices were examined under a scanning electron microscope to bring out the different phases. Global elementary microanalyses were carried out by energy dispersive X-ray spectroscopy (EDXS). The global alkali contents ranged from 5% to below 1% (by weight); the glassy phase would appear from 1% onward. The more glassy the phase there was, the more coherent and hard the synthesised product would be. Below that threshold, the absence of a vitreous phase gave a porous material, easier to grind. An excess of lime with respect to copper oxide provoked the precipitation of wollastonite $CaSiO_3$, and the formation of a copper-tinted glass. A mineral, devitrite ($Na_2O.3CaO.6SiO_2$), was identified within the vitreous phase (Tite 1987).

That same year, while analysing ancient blues, Onoratini *et al.* (1987) published a note intended to clarify Egyptian blue terminology. They first distinguished sodium copper silicate or Hubert blue $Na_2CuSi_4O_{10}$ and its calcium homologue $CaCuSi_4O_{10}$ (analogous to cuprorivaite) for which – like many others – they reserved the name of Egyptian blue. They next distinguished the blue materials made of the single silicate phase from those which are multiphase, and contain besides mostly quartz and a blue glassy phase. They suggested naming that which derives from *bleu égyptien, bleu antique*. This suggestion would be overlooked. Onoratini *et al.* synthesised these various blues, again finding, as far as Egyptian blue is concerned, an initial mix composition, a temperature and a heating duration in line with those of their predecessors. The reaction products were characterised by X-ray diffraction. Taking the temperature of reaction (from 600°C to 850°C) into account, they distinguished three reactions which, according to them, form the reactive stages leading to Egyptian blue:

[around 650°C] $$CaCO_3 \rightarrow CaO + CO_2$$
around 750°C $$CaO + SiO_2 \rightarrow CaSiO_3$$
around 850°C $$CaSiO_3 + CuO + 3SiO_2 \rightarrow CaCuSi_4O_{10}$$

The first reaction is indisputable, but of little interest. The others are only balances and do not represent the reactive mechanisms which obviously involve the alkali elements (the action of which was here termed 'catalytic') and which, in some cases at least, take part in the solid state diffusion phenomena. Synthesising *des bleus antiques*, they obtained materials similar to the *caeruleum* balls coming from the excavations in Villeneuve-Aiguières (near Fréjus, France) or from the Roman wrecks he had at his disposal. The green colour of some of these materials would be either due to too low a heating temperature, or an excess of sodium or copper. His conclusion insists (with reason) on the *ceramic* aspect of these materials.

In 1988, Schiegl showed, on the basis of numerous blue samples from ancient Egyptian origin dating from a wide array of periods, that the source of the copper element was never a copper salt, but always a copper alloy. The nature of the alloy varied according to the date – arsenical bronze as early as the Ancient Kingdom, and then tin bronze from Thutmosis III onwards (Schiegl *et al.* 1990). The same year, Schvœrer *et al.* (1988) studied the thermoluminescence of cuprorivaite to evaluate the possibility of dating the production of that pigment. The idea was seductive, but has proven to be difficult to achieve.

Gallo-Roman blues

In 1992, Guineau studied several dozen coloured materials found in the Argentomagus excavations (St Marcel, Indre, France) (Guineau *et al.* 1995). Among them were twenty *caerulea*, including five pellets found in three different locations. The study combined X-ray diffraction, EDXS microanalysis and visible light absorption spectrometry using diffuse reflection. This wealth of samples made it possible to show that the points representing the colours lay on a single geodesic curve in the CIE 1931 colour space. These results were fully backed by the global study of the unused *caerulea* recovered in Pompeii (cf. Chapter 1, Figures 1.13–1.15) (Delamare *et al.* 2004).

In 1997, in order to elucidate the reaction mechanisms, the author studied the composition gradients in the grains of quartz, cristobalite and cuprorivaite in formation, obtained from Gallo-Roman *caerulea*. Depending on the high or low alkali content, two reactive mechanisms were suggested as giving rise to cuprorivaite: a liquid phase reactive sintering when the alkali content is above 1–2%, or a solid phase sintering when the alkali content is below 1% (Delamare 1997, 1998). Various diffusion mechanisms then come into play, volume diffusions as well as surface diffusions. The alkali elements probably play the role of surface diffusion accelerators (Delamare and Rhead 1971; Delamare 1974).

In 1998, Etcheverry (1998) devoted her thesis to the study of ancient Egyptian blues of various origins and the synthesis of cuprorivaite. She observed the formation of cuprorivaite lamellar domains within a quartz crystal. This thesis was closely followed,

by that of Pagès-Camana (1999), dealing with an 'Egyptian green', a copper-tinted glassy material prepared between 950°C and 1150°C. The raw materials, atmosphere and temperature control techniques were the same as those required to make *hsbd iryt*, but the proportions of the materials as well as the temperature of synthesis were different. This was therefore a specific production, and not a result of errors in preparing blue. That same year, Guineau narrowed down the measurement of light absorption by cuprorivaite in the visible range (Figure 9.7) (Delamare *et al.* 2004). In 2000, Pozza *et al.* (2000) studied the infrared photoluminescence of Egyptian blue.

A blue fungicide

During their examination of Queen Nefertiti's bust, Bayer and Wiedemann remarked that, in most painted areas, the painted layer hardly adhered to the substrate anymore, and that this lifting was due to the presence of lichens. The only exceptions were those areas painted blue with *hsbd iryt* (Lamprecht *et al.* 1997). The same observations were made on the *Berolina* papyrus and on the famous *Ebers* medical papyrus preserved in the library of Leipzig University, where it was thought that this effect could be due to the copper contained in *hsbd iryt*. One might be tempted to think that a silicate as chemically unreactive as cuprorivaite, which has withstood thousands of years, would be totally chemically inert and therefore completely insoluble in water. Such is not the case. Although the solubility of Egyptian blue in water is very low, it can be measured and has a value of 3.10^{-7} mole per litre[21]. The anti-algae and anti-fungi properties of copper are well known and have been used for a long time. We know that copper acts within the cells themselves, modifies the protein structure, blocks the oxidative phosphorylation, and modifies the metabolism and the growth of microorganisms.

Experiments carried out showed that the presence of Egyptian blue does indeed have an effect on the growth of cultures of lichens, algae and mushrooms. However, given the very low solubility of this silicate, its effect can be observed only when the growth of the living organism is very slow. This is always the case with lichens, but more rarely with algae and mushrooms. Egyptian blue therefore owes its everlasting character not only to its chemical inertia, which has long been recognised, but also to its ability to protect the support onto which it has been laid against living organisms that might feed upon it. In this respect it is not unique. Numerous pigments known since antiquity for their toxicity toward man but used because of a lack of substitutes, such as arsenic sulphides (orpiment, realgar), mercury sulphides (cinnabar) or lead salts (white lead) also possess, *a fortiori*, these fungicidal and bactericidal powers.

Such is the history of the rediscovery of Egyptian blue, a history which unfolded over two centuries (see Table 9.1). Is such a delay in time the rule in this domain? In fact its duration depends on the match between the state of scientific knowledge at the time when the study begins and the complexity of the material to be identified. For Prussian

[21] A figure which we may compare with that for the solubility of copper sulphate ($CuSO_4.5H_2O$), a salt which was long employed as fungus killer in vineyards: 1.27 mole per litre.

blue, a complex material, the research began very early and took three centuries. The opposite is the case in the rediscovery of Han and Maya blues.

Table 9.1 A chronology of studies containing the synthesis of Egyptian blue. Dates are those of publication. Asterisks point to those experimenters who were not published. In a way, the abundance of such syntheses testifies to the fascination this pigment has exerted over researchers in the course of nearly two centuries, a scientific variation on the theme of Egyptomania (*Egyptomania* 1994). The list remains open.

Author(s) of study	Date(s) of study	Author(s) of study	Date(s) of study
[H. Davy]	1815	A. Pabst	1959
J. d'Arcet *fils**	1830	R.H. Brill	*c.* 1963
J. Girardin	1846	W.T. Chase	1971
H. de Fontenay	1874	P. Vandiver	1971
F. Fouqué	1889	S.A. Saleh *et al.*	1974
W.J. Russell	1894	G. Bayer *et al.*	1976
F.C.J. Spurrell	1895	D. Ullrich	1979
H. Le Chatelier	1899	R.J. Ford *et al.*	1979
A.P. Laurie *et al.*	1914	R. Bouchez*	1979
X*, for Bourgeois	1930	M.S. Tite	1981, 1984
L. Hodgson	1936	G. Onoratini *et al.*	1987
B.V. Ivanov *et al.*	1938	B. Perdikatsis	1991
C.L. Peterson	1950	M.-P. Etcheverry	1998
G. Schippa *et al.*	1957	S. Pagès-Camagna	1999
L. Nicolini *et al.*	1958	F. Perego*	1999

10
The rediscovery of Han blue

Han blue constitutes a very special case, since it was first discovered for simple theoretical reasons long before its existence was noticed in an archaeological context. This discovery was motivated by the study of Egyptian blue and the presence of calcium in cuprorivaite ($CaCuSi_4O_{10}$).

A systemic mind

Calcium belongs to a group of chemical elements having very similar properties, the alkaline earths. Among them we find calcium, strontium, barium and radium (in order of lighter to heavier). The existence of such 'families' led to the building of various classifications of chemical elements which found their ultimate evolution in that of the periodic table of Mendeleyev (1869). Magnesium, although located ahead of calcium in the same column, has a particular chemical behaviour which does not really belong to this family.

Several chemists who were studying Egyptian blue toward the end of the nineteenth century asked themselves: what would happen if calcium were replaced with another alkaline earth? Would one obtain an analogous silicate? Would it be coloured? What would be its colour?

The first among them appears to have been Fouqué, who was also the first to suggest an exact empirical formula for Egyptian blue. In his note in the *Comptes Rendus de l'Académie des Sciences de Paris*, he briefly said: 'It is in vain that I tried to replace lime with magnesia in Egyptian blue' (Fouqué 1889b: 327). Indeed, nobody would succeed with this substitution. Fouqué also attempted to synthesize a double silicate by replacing lime with strontium and barium oxides, strontia (SrO) or baryta (BaO). Furthermore, as we were told by Le Chatelier (1899, 1899/1900, 1900), who rubbed shoulders with Fouqué at the École des Mines, Paris, Fouqué's attempts also failed (Le Chatelier 1899, 1899/1900, 1900).

Several years later, the idea was taken up again by Le Chatelier. This time, the results were so satisfactory that he took out a patent in the name of his brother. There we can read:

> We succeeded in finding the appropriate conditions to prepare baryta and strontia blues. We have recognised that *baryta blue*, unknown before our research, presented qualities in terms of colouration, speed of formation and stability which differentiated it totally from lime blue [Egyptian blue]. But, beyond this, we recognised the existence of violet compounds, without any analogy with the lime compound, and answering to the formulae:
>
> SiO_2 (0.5 BaO. 0.5 CuO) [i.e. BaO, CuO, $2SiO_2$]
>
> 1.5 SiO_2 (0.5 BaO. 0.5 CuO) [i.e. BaO, CuO, $3SiO_2$]
>
> 2 SiO_2 (0.5 BaO. 0.5 CuO) [i.e. BaO, CuO, $4SiO_2$]
>
> In general, in the preparation, violet is mixed with blue (…).

There follow detailed prescriptions for several manufacturing variants, with or without flux, with or without clay. The temperatures to be reached and maintained were in the 1000–1200°C range.

> The qualities of the blue-violets thus obtained are: intensity of colouration; variety of colours, which may range from green to blue or from blue to violet, depending on the composition used, and the baking conditions; finally, stability which enables them to be incorporated in pastes of very varied compositions without destroying colouration.

> The uses to which baryta blue-violets may be put are, among others: colour manufacture for all kind of oil paint, distemper, watercolour paint, etc. The colouration of ceramic pastes and vitreous or semi-vitreous matters employed either alone or as a glaze on ceramic pastes of all kind.

The patent also covered a special working procedure applicable to these new products, which consists in adding barium as anhydrous barium silicate, 'and using the property this product has of setting when in contact with water, like plaster'.

Was this patent ever exploited? We do not know, but, in 1906, a patent in the same area was taken out by a German chemist, Barth (n.d., 1906). It dealt with obtaining coloured silicates by precipitation of a metallic salt solution through addition of a solution of alkaline earth silicates. This may be the reason why Le Chatelier reverted to this topic in 1907 in a German publication. This new article was a synthesis of his work in the field of ceramics and glazes with potential applications for archaeology. A paragraph dealt with 'baryta blue' (Le Chatelier 1907: 522), then nothing but silence. These works fell into oblivion. It took forty-three years before someone showed renewed interest in these double silicates.

In 1950, Peterson (1950) presented a thesis in chemistry on the topic of Egyptian blue and similar silicates at Ohio State University. Starting from the work of Le Chatelier, he synthesised the sequence of double silicates of copper and alkaline earths, and studied the influence of temperature, intermediate grindings and soda flux, and iron contents. His results confirmed those of Le Chatelier, but must have remained confidential.

It was the progress in work concerning Egyptian blue which, in 1959, pushed Pabst, a specialist on phyllosilicates, to study the structure of the crystallised phase of Egyptian blue by X-ray diffraction, a phase which was not yet called 'cuprorivaite' (cf. Chapter 9). Very naturally, he compared its structure with that of homologous silicates in which strontium or barium replaced calcium (Pabst 1959). The similarity was perfect. Belonging to the spatial group P4/ncc, the three silicates have the same structure as gillespite ($BaFeSi_4O_{10}$).

In 1976, while examining the paint layers present on the bust of Queen Nefertiti preserved at the Ägyptisches Museum in Berlin, Bayer and Wiedemann (1976) turned their attention to Egyptian blue and its synthesis, then to the homologous silicates $MCuSi_4O_{10}$ (where M = Ca, Sr or Ba) studied by Pabst and their synthesis. This study confirmed the results of Pabst as to the identity of their structure and their optical properties. All three have a very similar blue colour, and all three show strong pleochroism; in other words, in these silicates, light absorption depends on crystalline orientation.

Without being aware of them, these authors confirmed the results of Le Chatelier, who had shown that the thermal stability of these silicates increases when going from calcium to barium. Barium silicate is the only silicate able to reform after having been decomposed by excessive heat. It is this thermal stability which was at the heart of the patent submitted by Le Chatelier.

Chinese blue and purple

In 1983, the results of E. West FitzHugh appeared. A specialist in the characterisation of materials used in Far Eastern arts, associated with the Freer Gallery of Art of the Smithsonian Institution, she identified combinations of the double silicate of barium and copper in coloured sticks and blue paint layers found on Chinese archaeological objects (West FitzHugh and Zycherman 1983). The sticks formed a sequence of objects of octagonal cross section, probably ink sticks, dating from the Warring States period (475–221 BC). One is blue; the others are purple of varying darkness. Their colour seems to result from the relative proportions of blue and purple grains that can be distinguished using an optical microscope. The same blue can also be observed on painted tiles dating from the beginning of our era, as well as on the painted decoration of two pottery Hu vases dating from the Han dynasty (206 BC–AD 220). The analysis of this blue by X-ray diffraction and microanalysis showed it was the double silicate $BaCuSi_4O_{10}$ studied by Pabst, then by Wiedemann. However, the purple material, also a double silicate of barium and copper, could not be identified for lack of a reference sample. Lead was observed in the impurities. The work of Le Chatelier still had not been unearthed.

Following up this earlier work, a number of syntheses of barium and calcium double silicates with copper were produced in laboratories which had links with the Smithsonian Institution. In 1982, W.T. Chase (Freer Gallery)[1] and later, in 1987, J.G.

[1] W..T. Chase, unpublished results. Quoted in West FitzHugh and Zycherman (1992).

Douglas (Sackler Gallery)[2] carried out these syntheses starting from barium chloride, copper carbonate or silica, and using artificial natron[3] as a flux. The former performed the synthesis at 870°C; the latter at 1000°C (West Fitzhugh and Zycherman 1992). They ended up with a combination of both silicates, the blue and the purple.

Independently, at the Corning Museum of Glass, Brill studied the composition of the most ancient Chinese glass available in the American and Canadian collections (Brill *et al.* 1991a, b, c; Fenn *et al.* 1991). That made in Northern China, as early as the Warring States period, shows an extraordinary peculiarity: it is rich in barium and lead oxides, and very poor in calcium and alkaline metal oxides. The presence of lead can be accounted for by its role as a flux. That of barium is the cause of a certain opalescence in the glass, giving it the appearance of jade, which was very probably viewed as a desirable quality by Chinese glassmakers. Examination of this glass under high magnification by optical and scanning electron microscopy shows the cause for this opalescence: the presence of microscopic blue and purple crystals that Brill christened 'Chinese blue' and 'Chinese purple'. For the latter, he suggested the empirical formula $CuO.BaO.2SiO_2$. Having familiarised himself with West FitzHugh's results, he synthesised these two silicates in an original manner, as he had already done for Egyptian blue, through devitrification of a glass of a particular composition. Starting from a glass with global composition $CuO.BaO.4SiO_2$, he provoked its crystallization by imposing repeated heating during forty-eight hours at 1080°C followed by grinding. He thus obtained both silicates, the blue tetrasilicate ($CuO.BaO.4SiO_2$) and the purple disilicate ($CuO.BaO.2SiO_2$), both perfectly distinguishable through their X-ray diffraction spectra. This work confirms and complements that of West FitzHugh.

Having obtained a combination of both silicates, Brill remarked that the formation of one or the other could be encouraged by playing with the proportions of reactants and/or temperature. The optimal temperature for the formation of purple lies between 1035°C and 1080°C. Blue forms at a higher temperature (1080–1160°C).

We have seen that the Chinese blues and purples which come from archaeological objects contain a little lead. A determination of the isotopic ratios for this lead shows a marked similarity with those of contemporary lead and barium glass manufactured in the same regions. There is therefore a real link between the production of this opalescent glass and that of Chinese blue and purple pigments (Brill *et al.* 1991a).

From this point, two different types of scientists would study these silicates. The first would be those interested in their use as pigments in China, and the reconstitution of the manufacturing processes. The second would comprise crystallographers and solid-state physicists establishing the structure of crystals, particularly that of disilicate, and trying to profit from its particularities.

[2]J. G. Douglas, unpublished results. Quoted in West FitzHugh and Zycherman (1992).
[3]Natural natron is essentially natural sodium carbonate with small quantities of other sodium salts.

From Chinese purple to the Bose-Einstein condensate

The task of identifying Chinese pigments might indeed have gone no further if physicists, for academic purposes, had not shown an interest in this type of material. It was by looking for structures able to behave like 'high temperature' superconductors (over 40 K or -233°C) and focussing their attention on those containing a copper atom linked in four co-planar bonds that Finger *et al.* (1989) discovered by chance, in 1989, two silicates containing simultaneously barium and copper. While heating a complex mixture of oxides containing thallium, barium, copper and calcium at high temperature in a silica boat, they observed the formation of two coloured compounds at the junction between boat and oxide. One was of a turquoise colour. The other was magenta, a bright reddish violet. They attributed the formula $Ba_3CaCuSi_6O_{17}$ to the former. It is therefore a silicate different from those we know, since it simultaneously contains two alkali earths, barium and calcium. They then determined its crystalline lattice and its spatial group.

To the latter silicate, that of magenta colour, they attributed the formula $BaCuSi_2O_6$. It was therefore the disilicate we had before denoted $CuO.BaO.2SiO_2$. They determined its crystalline structure via X-ray diffraction and Raman spectroscopy. Figure 10.1 shows two views of the crystalline mesh.

In 1992, independently from one another, Lin and Janczak published more detailed studies of the structure of the tetrasilicate, the name of which would be 'Han blue' from then on (Lin *et al.* 1992; Janczak and Kubiak 1992). The following year, it was B.C. Chakoumakos' turn to publish his determination of the structure of double tetrasilicates $MCuSi_4O_{10}$ (with M = Ca, Sr or Ba) by neutron diffraction (Chakoumakos *et al.* 1993). Figure 10.2 shows two views of this crystalline mesh. Then, in 2000, Pozza's study on the photoluminescence of double barium and copper silicates appeared (Pozza *et al.* 2000). Studying light emission in the infrared range resulting from the excitation of these silicates in the visible range, these authors experimented with what might become a new method for characterizing these pigments from microsamples.

In 2004, the magnetic properties of Han purple were the object of a study conducted by a large international team (Jaime *et al.* 2004). At the heart of the interest shown by researchers was, once again, this very peculiar crystalline structure, whereby copper ions are spread in parallel planes in which they are strongly bound, while they are bound very weakly with those in the other homologous planes.

These results show that a critical threshold exists (depending on the magnetic field and temperature) above and below which this material, in a sense, changes dimension. In the normal state, the disilicate behaves like a planar (two-dimensional) material. In the presence of a magnetic field, in each of the planes containing copper ions, the spins of electrons compensate for one another. But at a temperature nearing absolute zero, when one increases the magnetic field beyond the considerable value of 23 teslas, the disilicate behaves like a three-dimensional material, and all the spins become oriented in the same direction. The disilicate Han purple is therefore also an extraordinary instance of a 'Bose-Einstein condensate'. This very particular state of matter, in which atoms are all in the same quantum state, was hardly known except for gases, and only

since 1995. It is hoped that the discovery of its existence in the case of solids will help us understand the phenomenon of high temperature superconductivity. Certain authors think it might be the basis for the realisation of a new generation of so-called 'quantum' computers.

The official birth of Han blue and purple

Let us now return to the researchers preoccupied with characterising and preparing the ancient Chinese pigments. In 1992, the work of Finger enabled West FitzHugh to formally identify the purple pigment found on archaeological objects (West FitzHugh and Zycherman 1992). She worked this time with a more extensive selection of objects belonging to American and Canadian museums: potteries and bronzes bearing traces of paints, and ink sticks. The comparison of X-ray diffraction spectra with those obtained by Finger and Eysel, mineralogist at Heidelberg University (West FitzHugh and Zycherman 1992), was conclusive: the purple pigment was indeed the $BaCuSi_2O_6$ disilicate. The presence of lead salts, carbonates and phosphates, was confirmed and attributed to the manufacturing process.

As for nomenclature, West FitzHugh recommended that the names 'Han blue' and 'Han purple' be used to name these silicates, and that the terms Chinese blue – one of the many names of Prussian blue – and Chinese purple be avoided. As a subsidiary story, the German patent of Le Chatelier reappeared in the bibliography at the time, but its contents do not seem to have been taken into account.

In 1994, a mineral with the composition and structure described for the synthetic tetrasilicate $BaCuSi_4O_{10}$ was discovered in a mine of Cape Province, South Africa. It was named 'effenbergerite' in honour of an Austrian mineralogist (Giester and Rieck 1994). That same year, Rhône-Poulenc Chimie requested a patent for a manufacturing process for Han blue, Han purple and various other silicates (Chopin and Macaudière 1996). The list of economic justifications for this invention recalls those developed almost one hundred years before by Le Chatelier, simply brought up to date: the needs of industry for blue and violet pigments, above all pigments not containing heavy metals; the difficulty of obtaining coloured materials with sufficient colouring power to constitute a pigment; the innocuousness and polyvalence of these pigments.

The patent covered the manufacture not only of Han blue and purple, but also of families of homologous silicates obtained by replacing the alkaline earth by a rare earth, or copper by zinc, nickel, cobalt, manganese or even an alkali metal. It also covered the formation of triple silicates containing the above mentioned elements and titanium. Its originality lies in the fineness of the reactant particles used: starting from a silica sol, i.e. a suspension in water of ultra-fine particles of silica (with a diameter of between 10 and 50 nm), the other constituents are added in a water soluble form, as nitrates for example. The mixture is dried (100–300°C), then the dry residue is roasted at between 900°C and 1100°C depending on the nature of the silicate to be obtained. The granulometry of the resulting silicate is of the order of 2 to 3 μm. These silicates 'possess a very good colouring power and very good opacifying strength and, therefore,

they are suited for the colouration of numerous materials such as plastics, paints and ceramics'. Due to their chemical inertia, they are suitable for all families of polymers used as plastics or as binders for paints. They are also possible colouring matters for rubber, paper and ink, as well as for cosmetics.

In 1997, Wiedemann's results on the synthesis of double copper and barium silicates appeared (Wiedemann and Bayer 1997; Wiedemann *et al.* 1998), showing that due to the great thermal stability of the barium salts used, the result is always a combination of $BaCuSi_4O_{10}$ and $BaCuSi_2O_6$. Since baryte ($BaSO_4$) decomposes with great difficulty into barium oxide, its use as a source of barium favours the formation of the former, Han blue. On the other hand, the choice of witherite ($BaCO_3$), which decomposes more easily, leads to the synthesis of the latter, Han purple. In 2007, the publication of the results of Berke (2007) extended the preceding work (see also Berke and Wiedemann 2000; Berke 2002). This author showed that the addition of lead salts was probably deliberate, for they catalysed the decomposition of barium salts, and also served as a flux, replacing the alkaline metals in that role. He also showed that Han purple, far from being as chemically stable as the blue, tends to decompose, giving Han blue again and red cuprite (Cu_2O). Its hue would therefore have evolved with time.

From a historical point of view, Berke was enthralled by the idea of a possible transfer of technology from the Egyptian blue manufacturers to the Chinese over the Silk Road. The idea is hard to defend for various reasons. The first is that the acceptance of a technology is usually preceded by that of the product. However, in this case, Egyptian blue has never – so far – been found in China. The second reason is that Han blue appeared in Northern China several centuries before the Silk Road, which existed since at least the second century BC. The third has to do with a change in composition. How would the idea of replacing calcium oxide, very likely lime coming from a lime kiln, with barium oxide have arisen? And what about that of substituting alkaline fluxes with lead oxide? The similarity in chemical behaviour between the calcium and barium elements, which is well known to us, may have been partly recognised in practice, but was it sufficiently conceptualised to lead to these formula adaptations?

However, one may wonder what the interest might have been in carrying these changes out. Why bother to replace a cheap lime with a certainly more expensive baryte, and to heat the reactants up to 900–1100°C rather than to 800–900°C to obtain seemingly identical products, with the same colour and the same chemical properties? As we can see, the hypothesis of a technological transfer does not really withstand examination. In any case, the deep similarities between the chemical compositions and the crystalline structures of cuprorivaite ($CaCuSi_4O_{10}$) and effenbergerite ($BaCuSi_4O_{10}$) could only have interested a scientist from the mid-nineteenth century onwards.

Analyses by Berke of dated archaeological pigments show that the first uses discovered date back to the period of oriental Zhou, around 800 BC. After the Warring States period, Han blue and purple reappear under the Qin dynasty (220–207 BC). The corresponding documentation deals mostly with pigments used to paint terracotta statues of warriors found in the Xi'an Imperial tombs. The purple colour is realised with Han purple. Strangely, the blue pigment used by the painters was not Han blue, but

azurite. The use of these silicates as pigments, as we have seen, continued under the Han dynasty (206 BC–AD 220) and seems to have ceased thereafter.

A Taoist technology ?

The study carried out by Liu *et al.* (2007) is made up of two very different parts. In the first, they confirmed the analytical results obtained by Berke on the characterisation of Han purple present in the paint layers partly covering one of the terracotta warriors discovered in Xi'an. In the second part, far from believing in the West–East technological transfer put forth by Berke, they offered an explanation for the originality in the composition of the Han blue and purple as well as for the particular chronological period during which they were made. They rested their case on the similarity in observed composition between glass that looks like jade and the two pigments involved. They underlined the exceptional symbolic value jade had in Taoism, where it was the symbol of immortality, and put forward the hypothesis that it was Taoist monks who perfected the manufacture of this very particular glass. To back up this assumption, various ancient texts could be cited such as that of *Lun Heng* (a text dating from the Han dynastry written by Wang Chong), which claimed that 'the Taoist monks used to make five-coloured jade with five stones' (Forke 1907: 27–97). Another affirmed that the appearance of this artificial jade changed with the additions made during manufacture. Adding malachite or azurite may well have led to the discovery of Han blue and purple.

It is remarkable that the temperatures required to make Han purple are exactly those required to fire pottery. Freshly manufactured Xi'an warriors, for example, were fired at 800–1000°C. It is therefore likely that they were painted with the mixture of reactants, and that it was during the firing of clay that the purple colour appeared, its shade depending strictly on the firing temperature. This would explain why the blue used was not Han blue, but azurite, deposited after firing. The progressive displacement of Taoism during the Han dynasty by a Confucianism turned more toward Man than toward Nature and Matter would have provoked both a decline in the taste for jade (natural and artificial) and increasing difficulties in carrying out complex operations such as Han blue and Han purple manufacture.

Conclusions

Faced with the rarity of materials which were able to supply blue pigments, the Chinese found a solution of their own, which has much in common with the solution found millennia before in Mesopotamia and Egypt. They too made a *pâte-de-verre* tinted blue by copper. However, this time, the dispersed phase was not cuprorivaite, but effenbergerite.

As we saw with Brill's studies, Han blue and Han purple bear close ties with opalescent glass made in Northern China: the presence of barium and lead, and the same distribution of lead isotopes. No one knows the geographical origin of the barium salt used, but barium sulphate and carbonate were the object of active trading in China until

at least the twelfth century AD. As was the case for Egyptian blue, Han blue therefore seems to have had a rather close relationship with glass production.

11
The rediscovery of *yax*, the Maya blue

Whereas Egyptian blue has been the source of many dreams, it only retains its mystery for aficionados of ancient Egypt. There is however another blue which competes with it in terms of evocative power: Maya blue. The history of Maya blue extends over at least sixteen centuries. With Egyptian blue and ultramarine, it ranks as one of the great, classic blue pigments. In spite of its complexity as a material, the time needed to pierce its secret, to determine its composition and molecular structure on the one hand and its production mode on the other, was comparatively short. Materials science had come of age when the study of Maya blue was undertaken.

The discovery of Maya painting

In the ninth century AD, Maya cities, abandoned by their populations, were progressively reconquered by the forest and erased from the memories of men. Certain sites were sporadically discovered by travellers, who were only interested in architecture and sculpture. In spite of observing some wall plaster fragments or painted pottery shards, no one envisaged the existence of a 'Maya art'. However, in 1944, an American photographer, Giles Healey, befriended the Lacandon Indians, a Maya ethnic group from the Chiapas, and was shown their traditional places of worship. In 1946, the Indians took him to one site which was out of the ordinary: high pyramids supporting temples. In one of them, three rooms were still decorated inside with exceptionally well-preserved polychrome wall paintings. This was the first time Maya painting could truly be judged, as only much degraded samples had been known before.

Although the climate there (extremely hot and humid) does not lend itself to the preservation of wall paintings, the painting technique had nevertheless been designed to meet these constraints. These wall paintings were rather particular frescoes, made by painting *a fresco* over a fresh mortar, consisting of a mixture of lime, limestone sand and a vegetal gum. The latter conferred a certain plasticity to this preparatory

layer. The vegetal species from which this gum was extracted has not been formally identified by analysis, but various sixteenth century documents list the plants used for this purpose, including *holol* (*Belotia campbelli* Sprague), *chucum* (*Havardia albicans* Britton & Rose), *chacte* (*Caesalpinia platyloba* S. Watson), *chacah* (*Bursera simaruba* Sarg) and *jabin* (*Piscidia communis* Harms) (de Landa [1560] 1994; *Del modo* 1548).

This painted site, named Bonampak (literally 'painted walls' in the Yucatec language), was published in 1955 by Morley *et al.* (1955). The depiction of a procession of King Chan Muán and his dignitaries on a blue background became famous worldwide (Figure 11.1).

Even though the existence of this blue colour had already been known by a few specialists, this was its first and most spectacular appearance in front of the eyes of the whole world. This caused some people to wonder about the nature of the blue pigment employed – was it ultramarine, azurite, Egyptian blue or cobalt blue?

First steps toward identification: an unknown pigment

It seems that E. Merwin (1931) was the first, in 1931, to undertake the analysis of a blue substance found during the excavations at the Warriors' Temple in Chichen Itzà (Yucatán). They had only identified a type of clay, beidellite. But why was it blue? A comparison with naturally blue clay had not yielded any convincing result. Merwin had suggested that the blue colour was due to the presence of iron (a return of an old idea – see the end of Chapter 2) or possibly chromium. He had in any case been thinking of a pigment of mineral origin. This thesis had been reported in 1942 by Gettens and Stout (1942: 130–31) in their dictionary of painters' materials. Believing that this pigment was characteristic of the Maya civilisation, they had called it Maya blue, under which name it is now internationally known. However, this name is ill-deserved; we shall see that this pigment had been made and used by more ancient Meso-American civilisations.

The discovery of the Bonampak wall paintings gave rise to the collection of samples. X-ray diffraction analysis of these samples was carried out by Shepard (Shepard and Gotlieb 1962), who confirmed that Maya blue was indeed made of clay. But it was a very special clay belonging to the palygorskite family, attapulgite[1], a clay which was normally white. Since elemental analysis detected no copper, cobalt or iron – i.e. none of the metals classically associated with the colour blue – the reasons behind its blue colour still needed to be determined. In 1962, Shepard suggested the presence of an organic dye, a compound undetectable via the methods previously used. He suspected the presence of a dye coming from Campeche wood (*Haematoxylon campechianum* L.). This dye, used in pre-Hispanic times under the name of *hitzquauitl* or *quamotcitl*, forms a blue lake with aluminium, one of the constituents of attapulgite. However, attempts at reconstituting production in the laboratory were not convincing as none of the blues could compete with Maya blues (Shepard and Gotlieb 1962). Gettens (1962)

[1] Attapulgite is a type of clay with very low density. It often turns up as sheets which look like vat-made paper.

demonstrated the presence of another palygorskite, sepiolite, in another archaeological sample by X-ray diffraction[2].

Where indigo enters the fray

A decisive turn of events occurred when van Olphen published his preparation of a blue pigment resembling Maya blue. He obtained it by heating attapulgite with an indigo precursor, indoxyl acetate, in an alkaline environment (van Olphen 1966). Furthermore, he perfected a test intended to recognise true Maya blue. Having noticed genuine Maya blue was insensitive to an attack by boiling nitric acid, he subjected the blue pigments, which he had produced by heating various types of clay with his indoxyl acetate, to this test. Only the blue obtained from attapulgite passed the trial with success. It seemed established from then on that only palygorskites were able to give Maya blue. This probably had to do with their very special structure: instead of consisting of sheets piled on top of each other (bi-dimensional structures) like most types of clay, palygorskites are made of bundles of adjacent nanotubes (one-dimensional structures). The openings of the central channels measure 0.64 x 0.37 nm for attapulgite, and 1.06 x 0.37 nm for sepiolite. Did indigo molecules enter through these openings? Van Olphen did not think so. In his opinion, the indigo molecules were attached to the surface of palygorskite, and at the entrance to the nanotubes.

In 1967, an important article appeared which was written by Kleber *et al.* (1967), researchers at the Institut Royal du Patrimoine Artistique, Brussels. After having attempted several production methods by heating attapulgite with indoxyl, the reduced form of indigo, the authors identified the presence of indigo in the resulting products through Fourier transform infrared spectrometry (FTIR spectrometry). They therefore assigned the colour to the presence of indigo, and suggested a model for the dye fixation mechanism. Since attapulgite loses its zeolitic water at around 150°C, they postulated that indigo penetrates the nanotubes and replaces it. This would explain the need for heat to obtain a blue clay somewhat similar to ancient Maya blues.

In 1977, De Yta (1977) identified two types of supporting clay, attapulgite and a montmorillonite, nontronite, in new archaeological samples. In 1982, Littmann (1982) was the first to attempt and succeed in making a blue pigment from attapulgite and leaves from the Mexican indigo bush. Thus the reconstruction of the Maya blue production process progressed, step by step.

However, this was not the case for the analysis of paint layer samples taken from the sites. While characterisation of the supporting clay posed hardly any problem, that of the dye – in all likelihood indigo – kept everybody waiting. It could not be extracted by solvents (it is true that indigo is insoluble in almost all liquids), and the most common non-destructive micro-characterisation methods identified the chemical elements present and not the molecules. This was the context in which, in 1984, using

[2] Sepiolite is white clay of very low density which, in solid form, constitutes the 'meerschaum' of which pipe bowls are made.

Raman microspectrometry, B. Guineau (1987: 286, Fig. 19b) demonstrated the presence of indigo in two samples of archaeological origin. One of these samples came from Dzibilnocac, the other from Coba 1 (Figure 11.2).

The circle was now complete. There was proof of the need for blue pigments made from indigo and its derivatives in order to form Maya blue. Furthermore, the true nature of these pigments – highly original – had been determined: indigo-dyed palygorskites. How could the genesis of such pigments be imagined?

Maya blue and indigo dye

We know that the civilisations of Meso-America practiced indigo dyeing, in particular using the leaves from the Mexican indigo bush (*Indigofera suffructicosa Miller*; see Figure 11.3). How did that indigo vat meet palygorskite clay? Indigo dyeing is done at a temperature no higher than 50°C, as opposed to most dyeing done with vegetable or animal dyes. How then did the idea arise to carry out this thermal treatment?

To answer the first of these questions, three hypotheses were put forth. C. Reyes Valerio (1993) suggested that the water used to prepare the indigo dye vat might have contained clay. After the elimination of the indigo leaves by filtration and the oxygenation of the bath to bring out indigo, a blue sediment would then have settled at the bottom of the vat: a sort of indigo lake[3]. Rather than the dyeing operation *per se*, M. Garcia thought of wool fulling (M. Garcia, Association Couleur Garance, Lauris, France, personal communication, 2006). This was done to eliminate excess dye, not fixed to the fibres, which would have coloured skin through contact, as is the case for the Tuareg people. Wool was repeatedly brought into contact with a type of clay (Fuller's earth) which absorbed the excess dye. The blue lake thus formed separated from fibres and could be recovered. For Dominique Cardon (1990, 2003, 2007), a historian of dyeing, the so-called 'primitive' traditional indigo dyeing techniques made use of holes dug in the ground to receive the fresh leaves from the indigo plants (D. Cardon, personal communication, 2006). It would have been enough, had these pits been dug into a clay soil, for clay and indigo to have met very simply. In all three cases, the inventors would have used the lake thus formed, and would have learnt to fix indigo through heating.

Geographical and temporal spread of the use of Maya blue

From this moment on, one knew how to recognise a Maya blue without error. One could therefore attempt to pinpoint its area of use as well as its evolution over time. Maya blue had been identified on fragments of Maya wall paintings, hence its name. In Mexico, Maya sites are spread through the Yucatán peninsula, in the regions of Campeche and Chiapas. They range in date from AD 600 to 1500. But, as early as 1962, Gettens

[3]Lake: a white or colourless mineral powder coloured by fixing a dye, often in the form of a complex.

pointed out that the use of this pigment was not limited to the Maya zone. It was also found in El Tajin, Tamuin, Cacaxtla, Tenochtitlan (*Templo Mayor de México*), Zaachila, Tula and many other Central American locations. The oldest occurrence identified so far is in Oaxaca (Mexico), a site which harks back to the Zapotec civilisation and dates from the third century AD. However, the identification of the civilisation which would have invented this blue pigment is as yet uncertain.

Production and use of Maya blue did not stop – as one might think – with the Spanish conquest; much to the contrary. The Spaniards set up a large scale Indian evangelisation programme, which included erecting numerous churches and convents. On their walls the large surfaces decorated with wall paintings were produced in large part by missionary-educated Indians, using traditional Mexican techniques and pigments (Figure 11.4). The surface area decorated between 1540 and 1580 is estimated at 300,000 m^2 (Gruzinski and Mermet 1994: 24): a gigantic task! Assuming only 20% of the surfaces were painted blue, and taking the average thickness of those cross sections of ancient paint layers (10–50 µm), i.e. 30 µm, this implies a production of around 4 tons of Maya blue. The sixteenth century was therefore one of intensive use – hence intensive production – of Maya blue. Little else is known. No contemporary text mentions the pigment.

We may wonder whether Spain, which, as so many other Western countries, lacked blue pigments and had to procure them abroad at a high price, did not realise the profit it could derive from Maya blue and import some, if only for its own use. The issue has never been investigated. The recent identification of Maya blue on a religious painting in Spain, during restoration, would seem to prove it. However, no one knows whether the canvas was painted in Spain or in Mexico and then imported into Spain. In any case, we have the proof of the attention Spain paid to the cost of importing its blue dyes thanks to a letter written in 1558 by King Philippe II to request information on 'the herb or earth' with which Indians dyed wool and cotton blue (Sanchez 1976: vol. 1, 32). Clearly his intention was to put an end to imports of pastel (*Isatis tinctoria L.*, woad) coming from France. In any event, it does not seem that Spain traded Maya blue.

Maya blue was barely heard of during the seventeenth century. It reappeared in Cuba in the mid-eighteenth century. It was used for interior or exterior wall decoration of houses (Tagle *et al.* 1990). It was used alone, or mixed with yellow ochre to get a wider range of colours. This practice extended into the nineteenth century, and lasted until around 1860. This blue stood out for its excellent resilience under the climatic conditions. It was so common then in the decoration of houses in Havana that it ended up being called 'Havana blue'. Of course, nobody could establish a link with a Meso-American blue, long vanished from everyone's memory. Where did the Cubans obtain it? It was not indigenous, but imported. Archives show that, during the eighteenth century, pigment dealers got all of their supplies of colours from Spain, England, Holland, and, more surprisingly, from New Spain, i.e. Mexico (*Autos de proceso* n.d.). More precisely, we know that Havana enjoyed tight commercial links with the town of Campeche in the Yucatán. Indeed, a recent examination of these Havana blues show that they were true Maya blue made with sepiolite (Tagle *et al.* 1990). Maya blue was therefore still being made in Campeche at that time.

Maya blue or Maya blues?

In the 1990s, cultural and scientific studies such as those of Reyes Valerio (1993) and Magaloni (1998, 2001; Magaloni *et al.* 1991, 1995, 1996) appeared. The latter was dedicated to the study of Maya painting techniques. It was the first to show that there was not a Maya blue of a single hue, but of varying hues belonging to the family of blue-greens. This family of hues was designated by the Mayan word *'yax'*, which also designated the corresponding materials. This plurality of blue tints can be easily checked on objects kept in museums, such as the Palenque incense burners (Figure 11.5). We observe in their decoration three blues: one dark, one medium and one light; in fact, these are simply three different saturation levels of the same blue. We might therefore think that they were produced by mixing increasing amounts of white pigment to the same blue pigment, but an examination of the paint layers shows that such was not the case: no matter what enlargement is selected for its examination, or the microanalysis technique used, the paint layers prove homogeneous (Figure 11.6). A combination with a white pigment is never detected. Each one of these blues was therefore a pigment specially made, with its own specific recipe.

What then was the range of the Maya painters' palette in blue-green hues? This was the question Sonia Ovarlez answered by travelling to twenty-two Maya sites from the classical periods: Calakmul (200–600), Palenque (600–1000), Bonampak and Chacmultun (800–1000), Chichén Itzà (900–1000); and post-classical periods: Chichén Itzà (1000–1100), Mayapan (1000–1300), Xel-Ha (1100–1550), Rancho Ina and Tulum (1400–1550). She measured on-site the trichromatic coordinates of colours on the paintings in-situ (Ovarlez 2003a, 2003b, 2004; Ovarlez *et al.* forthcoming).

During the classical period, the painters' palette first expanded, then became more restricted. Thus all the *yax* are blue-green at Calakmul. True saturated blues (low x and y trichromatic coordinates) do not appear until Palenque. The number of shades employed reaches a maximum with Bonampak, then decreases with Chacmultun and Chichén Itzà (classical period).

The result of the investigation cannot be challenged: the indigo dyeing of palygorskite led to a multiplicity of low saturation tints in the blue-green range. Saturated blues could also be obtained. However, whether they were hard to make or did not meet the chromatic codes prevalent at the time, their presence at Palenque remains an exception. Since each tint was obtained using a specific preparation, how did the Mayas obtain such a multiplicity of tints?

Reconstitution of the *yax* palette

Attempts have already been made at reconstituting *yax* production. Thus in 1988 Torres made a Maya blue from Mexican earth, *sak lu'um* (or *sacalum*), a mixture of attapulgite, sepiolite and kaolinite – originating from the deposit which is believed to have been the main source of palygorskite used by the Mayas to make the blue pigment (Arnold 1967; Arnold and Bohor 1975) – with a decoction of leaves from the Mexican indigo

plant. The resulting pigments successfully underwent the boiling nitric acid resistance test (Torres 1988). The production principle consisted of putting palygorskite in contact with indigo, and heating at around 150°C [4]. To modify the colours obtained, one can therefore imagine toying with the nature of the palygorskite, the amount of indigo, the temperature and the duration of the thermal treatment. Such was the basis for the study carried out by Ovarlez by letting each parameter vary individually.

Let us consider a mixture of *sacalum* clay and synthetic indigo [5]. A sample is placed in an oven at 180°C, and withdrawn once every minute. Figures 11.7 and 11.8 show the kinetics of colour appearance as a function of the quantity of indigo and temperature. If we increase the temperature, the reaction is faster, and we obtain more saturated colours. We shall also see that they are more stable. Figure 11.9 translates into figures the visual impression left by Figures 11.7–8. To this end, the trichromatic coordinates of each nuance were measured and translated into the *Lch* system, where 'c' stands for 'chroma' [6]. We see that maximal saturation is reached in a very short time, three or four minutes, and that its level increases with the initial concentration in indigo. For this *sacalum* clay, maximal saturation of the colour is reached at as low as 2% indigo concentration. There is no point in adding more indigo to the initial combination.

The range of tints obtained with *sacalum* clay is represented in the CIE 1931 colour space (Figure 11.10). The representative points lie on a curve originating from point S, representing the colour of *sacalum* clay (slightly yellowish). If there was a simple mixture between clay and indigo, this curve would go toward point I, representing the colour of pure indigo. The fact that the curve obtained differs proves that there is not just an ordinary mixture, but the formation of chemical bonds between clay and indigo. These bonds modify the electron levels of the molecular entities able to absorb visible light.

The important point of this study is that, for the first time, the temperature range from 150°C to 350°C was explored, a range which proved crucial to recovering the quality of ancient Maya blues. Until then, Maya blues reconstituted in the laboratory were made by heating the indigo and palygorskite mixture for several hours at around 150°C, but only through heating at around 300°C can one obtain the blues with the highest saturation which were observed at Palenque.

[4] For millennia, various combinations of dyes have been extracted from indigo-carrying plants, all having in common two isomers, indigotin, of a dark-blue colour, and indirubin, reddish in colour. Indigotin is usually the more abundant. This is the reason why it is the one generally chosen as a model molecule to study the structure of Maya blue in the laboratory. It is designated in scientific publications by the generic term of 'indigo'.

[5] The contact between palygorskite and indigo can be achieved in one of two ways, the dry way or the wet way. The dry way used here allows the quantity of indigo used to be easily controlled, which is not the case with the wet method. The wet method uses clay mixed with a decoction of indigo leaves. The results presented come from Ovarlez (2003b, 2008).

[6] Chroma differs from saturation in that it quantifies by how much a coloured stimulus differs from an achromatic stimulus of the same brightness (cf. Wyszecki and Stiles 1982: 487).

Figure 11.11 shows, in the same portion of the colour space, how the range of these *yax* is situated with respect to the other blue pigments which are the topic of this book. The *yax* are greener (high y) and less saturated (high x).

The secret of Maya blue: a computational approach

There still remains the fact that the key to understanding the physicochemical phenomena which govern the formation of these blues lies at the molecular level. It is a level for the characterisation of matter which is difficult and expensive to reach, but the ceaseless perfecting of analytical techniques makes it more and more accessible. The first attempts were made via high resolution electron microscopy. In 1994 and 1996 the articles of Yacamàn appeared. He studied the blue paint layers deposited on statuettes coming from Jaina Island (Campeche) using this technique. He observed the attapulgite nanotubes and their organisation. Having discovered the presence of iron nanocrystals, he concentrated his studies on them. He attempted to show that the colour of Maya blue was due not to indigo, but to the presence of these nanoparticles which would have preferentially diffused blue light, a last revival of the old idea that there is a link between the colour blue and iron (Yacamàn and Serra Puche 1995; Yacamàn *et al.* 1996).

In 2001, another much more productive approach appeared. It was no longer experimental, but was carried out by computational techniques based on quantum mechanics by Chiari and his team (Chiari *et al.* 2003; Giustetto *et al.* 2005). Making the hypothesis that the indigo molecules penetrate the central channel of the nanotubes, these authors showed that they could find stable configurations in which the carbonyl group of indigo binds (weakly) to the dehydrated attapulgite. When the channels are filled with water, indigo can no longer enter to form these bonds. Similar computations were simultaneously carried out by Polette *et al.* (2002) and Fois *et al.* (2003). These authors both considered the type of reaction in which the notions of volume and surface, or of absorption and adsorption, merge the origin of the chemical stability of Maya blue. Refined progressively and tested in numerous configurations, these models show the indigo molecules displacing the water molecules which are least bound to attapulgite in the channels. Such water is known as zeolitic water (Figures 11.12–11.14). The model seems to be corroborated by experimental studies using infrared and NMR spectrometry. These models do not, however, take temperature into account.

The secret of Maya blue: the experimental approach

In 2003, Hubbard *et al.* (2003) examined Maya blues obtained from attapulgite and sepiolite heated at 120°C and 150°C, using thermogravimetric and nuclear magnetic resonance (NMR) analysis, and concluded that indigo attaches, adsorbs, to the surface of the clay and not inside the channels. On this point, they sided with van Olphen. Where do the indigo molecules attach? Inside the channels, as Chiari and his colleagues suggest on the basis of their computations, or on the surface of the clay as suggested

by Hubbard and various experimenters? The answer was published in 2006 by Sonia Ovarlez *et al.* (2006), who explored the indigo/sepiolite reactions between 100°C and 550°C (see also Ovarlez 2008; Ovarlez *et al.* 2009). The temperatures at which the various water molecules leave sepiolite were determined: at 130°C, zeolitic water is completely gone; at 300°C, one of the two coordinated water molecules bonded to magnesium has left the surface; at 550°C, the other is totally gone. At higher temperatures, the crystalline structure collapses. Ovarlez *et al.* (2006, 2009; Ovarlez 2008) then reacted indigo with sepiolite in each of these thermal ranges. The result was observed by Fourier transform infrared (FTIR) spectroscopy, solid NMR and a surface molecular analysis technique (ToF-SIMS).

When the thermal treatment took place in a temperature range lower than 130°C, infrared analysis showed that indigo in contact with sepiolite had the same characteristics as pure indigo. The molecules are therefore combined in threes (trimers) or twos (dimers), forming cumbersome structures which diffuse in the canals with difficulty and which are not chemically bonded to sepiolite. The reaction is reversible; the blue, of little stability, is not a true Maya blue. It did not actually pass the boiling nitric acid test. Analyses carried out by ToF-SIMS, which detects only the composition of the top layer at the surface of materials, showed the presence of indigo at the surface of sepiolite.

When the thermal treatment took place between 130°C and 300°C, indigo broke its bonds with molecules of the same kind: it became a monomer. The molecule, smaller, diffuses much more easily into the channels. It can, furthermore, set up bonds between its nitrogen atoms and those sepiolite magnesium atoms which have lost their coordinated water. The reaction is irreversible. This blue is stable, and is a true Maya blue. ToF-SIMS analyses detected hardly any indigo on the surface of sepiolite.

When the thermal treatment took place between 300°C and 550°C, the carbonyl group of indigo was seen to set up an additional bond with sepiolite. At these temperatures, the indigo/sepiolite complex is even more stable. ToF-SIMS analyses did not detect any indigo at all at the surface of sepiolite. Under these conditions, the sepiolite structure no longer collapsed above 550°C. The presence of indigo inside the nanotubes prevents this from happening. The sepiolite still retained its structure at 800°C.

In short, while indigo attaches to the clay surface and does not penetrate it at the low temperatures uniformly chosen by most experimenters, as Hubbard thought, this is not the case when the temperature is increased. Under these conditions, indigo molecules dissociate, diffuse into the nanotubes and bond with even more host palygorskite molecules as there are fewer water molecules present at the higher temperatures. The reaction is irreversible, and the indigo molecules are protected from any action coming from the outside world. Such is the secret of the amazing durability of Maya blues.

Appendix
The CIE 1931 colour space chromaticity diagram

For the physicist, a colour is defined by its light emission or absorption power spectrum within the range of wavelengths visible to the human eye – between 400 nm (blues) and 700 nm (reds). This distribution, linked to the structure of the coloured material and to the chemical bonds between the atoms composing it, is specific for each material and may be used to identify it. Thus the normalised spectrum shown in Figure A.I.1 characterises ultramarine and may be used for its identification.

For the colourist, a colour is defined by three parameters: brightness, hue and chroma. It can thus be represented by a point in a three-dimensional mathematical space, a colour space. Which colour space, however, should we choose?

We may note that the concept of colour can be divided into two: brightness (i.e. the proportion of the incident light reflected toward the observer) and chromaticity (hue and chroma). For example, the colour white is a bright colour, while the colour grey is considered to be a less bright version of that same white. In other words, the chromaticity of white and grey are the same while their brightness differs.

In 1931, the Commission Internationale de l'Éclairage (CIE) defined a colour space:

- in which the performances of a normal human eye, said to be a standard observer, are described;
- in which brightness and chromaticity are decoupled.

Taking into account the fact that the retina of the human eye contains three types of colour sensors (cells or photoreceptors, cones), sensitive to blue, green and red light respectively, the CIE defined a standard observer as one whose vision is characterised by its sensitivity to the detection of these three colours (Figure A.2). These curves are called colour matching functions.

Let a colour be characterized by its spectral power distribution $I(\lambda)$ (Figure A.1). Using the colour matching functions we may compute the tristimulus values (X, Y, Z) of the colour as seen by the standard observer:

$$X = \int_0^\infty I(\lambda)\,\bar{x}(\lambda)\,d\lambda$$

$$Y = \int_0^\infty I(\lambda)\,\bar{y}(\lambda)\,d\lambda$$

$$Z = \int_0^\infty I(\lambda)\,\bar{z}(\lambda)\,d\lambda$$

This CIE colour space was deliberately designed so that the Y parameter would be a measure of the brightness of the colour. Chromaticity was then specified by the two derived parameters x and y:

$$x = \frac{X}{X+Y+Z}$$

$$y = \frac{Y}{X+Y+Z}$$

Since a complete three-dimensional (xyY) chromaticity diagram is not easy to interpret (see Figure 1.13), the two-dimensional graph representing only chromaticity (xy) is currently used. Its general form is shown in Figure 1.1.

Bibliography

Some of the texts in this bibliography are now available online. Where an online version of the text is available, this is denoted after the reference by the symbols below corresponding to where the text can be found online. All online references were accurate as of December 2012.

‡ Archives.org
‡‡ CNUM book
‡‡‡ American library

† Gallica
†† Free online library
††† Persée

* Google Books
** Biodiversity Heritage Library
*** Pre-Columbian Art Research Institute book

Abot de Bazinghen, F. (1764) *Traité des monnoies et de la juridiction de la cour des monnoies en forme de dictionnaire.* Paris: Guillyn.

Achard, F.K. (1784) 'Rapport concernant la dissertation de M. le Chevalier Landriani sur le bleu de Prusse', in *Nouveaux Mémoires de l'Académie Royale des Sciences et Belles Lettres, année 1782.* Berlin: Decker, 35.

Adam, E. (2011) *Itinéraire d'un marchand de couleurs à Montparnesse.* Paris: Chêne.

Adrian, L.A. (1894) 'Rapport du comité 19', in *Exposition Internationale de Chicago en 1893, Produits chimiques et pharmaceutiques, matériel de la peinture, parfumerie, savonnerie. Chap. III, Matières colorantes et couleurs.* Paris: Imprimerie nationale, 250.

Albis, A. d' (1999) 'Les ressources d'un art décoratif', *Dossier de l'Art, Sèvres, histoire inédite de la manufacture au XVIII^e siècle* 54: 62–89.

Albis, A. d' (2003) *Traité de la porcelaine de Sèvres.* Dijon: Faton.

Anaç, S. and Tamzok, N. (2007) 'The Mining Industry of Turkey', in Slobodan Vujic (ed.), *Proceedings of the 2nd Balkan Mining Congress*, 37–43.

Andreau, J. (1983) 'A propos de la vie financière à Pouzzoles: Cluvius et Vestorius', in *Les "bourgeoisies" municipales italiennes aux IIᵉ et Iᵉʳ siècles av. J.-C.* Paris/ Naples: Centre National de la Recherche Scientifique, 9–20.

Andreu, G., Rutschowscaya, M.H. and Ziegler, C. (1997) *L'Égypte au Louvre*. Paris: Hachette.

Andronicos, M. (1984) *Vergina, the royal tombs and the ancient city*. Athens: Ekdotike Athenon.

Andrussow, L. (1935) 'The catalytic oxydation of ammonia-methane-mixtures to hydrogen cyanide', *Angewandte Chemie* 48: 593–5.

Annales (1824) *Annales de l'Industrie Nationale et Étrangère ou Mercure technologique*. Paris: Bachelier.*

Annonces concernant les Mines (1801) 'Annonces concernant les Mines, les Sciences et les Arts. Société d'Encouragement pour l'industrie nationale. Extrait des Programmes des Prix proposés dans l'Assemblée générale de la Société, le 9 nivôse an 10', Journal des Mines 64: 365–8. [id. *Bulletin de la Société d'Encouragement pour l'Industrie Nationale* (1st series) 1(1) (Vendémiaire an XI, Septembe 1802): 6.]

Apperçu de l'extraction (1794) 'Apperçu de l'extraction et du Commerce des substances minérales en France avant la Révolution', Journal des Mines I(1) (Vendémiaire an III): 55–93.

Apted, M.R. and Hannabuss, S. (1978) *Painters in Scotland 1301–1700*. Edinburgh: The Edina Press.

Arago, F. (1828) 'Sur le nouveau système d'éclairage des phares adopté en France. Extrait d'une réclamation que le Dr Brewster vient de faire à ce sujet', *Annales de Chimie et de Physique* XXXVII, 392–409.

Arclais de Montamy, D.F. d' (1765) *Traité des couleurs pour la peinture en émail et sur la porcelain*. Paris: Cavelier. [New facsimile edition 1981, Hildesheim and New York: Olms.]*

Arnold, D. (1967) 'Sak Lu'um in Maya culture and its possible relation to Maya Blue', doctoral thesis, Department of Anthropology, University of Illinois.

Arnold, D. and Bohor, B. (1975) 'Attapulgite and Maya blue: an ancient mine comes to light', *Archaeology* 28(1): 23–9.

Arsenne, L.C. (1833) *Manuel du peintre et du sculpteur*. Paris: Roret. [Reprinted 1986, Paris: LVDV Inter-livres.]*

Art de la verrerie (1752) *Art de la verrerie, de Neri, Merret et Kunckel, auquel on a ajouté le "Sol sine veste" d'Orschall, l'"Helioscopium videndi sine veste solem chymicum", le "Sol non sine veste", le chapitre XI du "Flora saturnizans" de Henckel sur la vitrification des végétaux, un Mémoire sur la manière de faire le saffre, le Secret des vraies porcelaines de la Chine et de Saxe, ouvrages traduits de l'allemand par M. D**** [P. Thiry, baron d'Holbach]. Paris: Durand et Pissot.*

Ashby, M.F. (1974) 'A first report on sintering diagrams', *Acta Metallurgica* 22: 275–89.

Aufrère, S. (1988) 'L'Univers minéral dans la pensée égyptienne', doctoral thesis, Lyon II University.

Aufrère, S. (1991) *L'Univers minéral dans la pensée égyptienne*, vol. 1. Cairo: Institut Français d'Archéologie Orientale.

Augusti, S. (1967) *I colori Pompeiani*. Rome: de Luca.

Autos de proceso (n.d.) *Autos de proceso seguido contra el pardo Pedro Munoz*, Archivo Nacional de Cuba, Legajo 114, nº11.

A very proper treatise (1573) *A very proper treatise, wherein is briefly sett forthe the arte of Limming etc.*, Tottill (ed.). London.

Balfour-Paul, J. (1998) *Indigo*. London: British Museum Press.

Baraldi, P., Fagnano, C., Scagliarini, D., Tinti, A., Taddei, P. and Zannini, P. (2002a) 'Pigments from bowls and walls of Pompeii', in J. Mink, G. Jalsovszky and G. Keresztury (eds), *Proceedings of XVIII^th International Conference on Raman Spectroscopy*, 25–30 August 2002, Budapest, Hungary. London: John Wiley and Sons, Ltd., 821–822.

Baraldi, P., Fazioli, V., Benedetti, A., Baraldi, C. and Zannini, P. (2002b) 'Caratterizzazione dei contenuti cosmetici nei balsamari di Oplontis', in *Atti del XVI^e Convegno Nazionale, Divisione di Chimica Farmaceutica Società Chimica Italiana*, Sorrento, 2002. Naples, 57.

Barbet, A., Fuchs, M. and Tuffreau-Libre, M. (1997) 'Les diverses utilisations des pigments et leurs contenants', in H. Bearat, M. Fuchs, M. Maggetti and D. Paunier (eds), *Proceedings of the International Workshop on Roman Wall Painting, Fribourg, 1996*. Fribourg: Institute of Mineralogy and Petrography, 35–61.

Barbet, A., Delamare, F., Monier, F., Vindry, G. and Wallet, M. (1999a) 'Les peintures romaines de Lero au musée de la Mer dans l'île Ste Marguerite (Iles de Lérins)', *La Revue du Louvre et des musées de France* 3: 37–46.

Barbet, A., Tuffreau-Libre, M. and Coupry, C. (1999b) 'Un ensemble de pots à peinture à Pompéi', *Rivista di studi Pompeiani* X: 71–81.

Bardiot, N. (2001) *Du sale au propre, Marseille au siècle des lumières*. Paris: Association pour le développement de l'histoire économique.

Barrandon, J.-N. and Irigouin, J. (1979) 'Papiers de Hollande et papiers d'Angoumois de 1650 à 1810. Leur différenciation au moyen de l'analyse par activation neutronique', *Archaeometry* 21(1): 101–6.

Barrett, P.A., Dent, C.E. and Linstead, R.P. (1936) 'Phthalocyanines. Part VII. Phthalocyanine as a co-ordinating group. A general investigation of the metallic derivatives', *Journal of the Chemical Society*: 1719–36.

Barrett, P.A., Bradbrook, E.F., Dent, C.E. and Linstead, R.P. (1939) 'Phthalocyanines and related compounds. Part XVI. The halogenation of phthalocyanines', *Journal of the Chemical Society*: 1820–28.

Bart, M. (2008) 'Les carnets de voyage de Malesherbes, étude et édition critique', thesis, École Nationale des Chartes, Paris.

Barth, G. (n.d.) Deutsches Reichspatent 167934.

Barth, G. (1906) *Jahresbericht der Chemischen Technologie* 52: 524.

Bartoll, J., Jackisch, B., Most, M., Wenders de Calisse, E. and Vogtherr, C.M. (2007) 'Early Prussian Blue, blue and green pigments in the paintings by Watteau, Lancret and Pater in the collection of Frederick II of Prussia', *Technè* 25: 39–46.

Barton, D.H.R., Rydon, H.N. and Elvidge, J.A. (1968) 'Reginald Patrick Linstead, 1902–1966', *Biographical Memoirs of the Fellows of the Royal Society* 14: 308–47.

Bass, G.F., Pulak, C., Collon, D. and Weinstein, J. (1989) 'The Bronze Age shipwreck at Ulu Burun: 1986 campaign', *American Journal of Archaeology* 93: 1–29.

Bauer, G. [known as Agricola] (1530) *Bermannus, sive de re metallica.* Basel: Frobenius. [French translation: Halleux, R. and Yans, A. (tr.) (1990) *Bermannus, un dialogue sur les mines.* Paris: Les Belles Lettres.]†

Bauer, G. [known as Agricola] (1556) *De re metallica.* Basel. [French translation: France-Lanord, A. (tr.) (1987) *De re metallica.* Thionville: Klopp.]

Baumé, A. (1773) *Chymie expérimentale et raisonnée.* Paris: Didot.*

Baunach (1778) 'Observations chymiques sur la préparation du Bleu de Prusse, usitée en Allemagne dans les Fabriques en grand', *Journal de Physique* 1: 312–18.

Bayer, G. and Wiedemann, H.-G. (1976) 'Ægyptisch Blau, ein Synthetisches Farbpigment des Altertums, Wissenschaftlich Betrachtet', *Sandoz Bulletin* 40: 19–40. [French version: 'Le bleu égyptien, pigment synthétique de l'antiquité examiné sous l'angle scientifique'.]

Beckmann, J. (1846) *A history of inventions, discoveries and origins*, W. Johnston (tr.), 4th edn., vol.1. London: H. Bohn.*

Belokoneva, E.L., Gubina, Y.K. and Forsyth, J.B. (2001) 'The charge density distribution and antiferromagnetic properties of azurite $Cu_3[CO_3]_2(OH)_2$', *Physics and Chemistry of Minerals* 28: 498–507.

Belov, N.V. (1942) *Doklady Akademii Nauk SSSR (Proceedings of the USSR Academy of Sciences)* 27: 132.

Belzoni, G.B. (1820) *Narrative of the operations and recent discoveries within the pyramids, temples, tombs and excavations in Egypt and Nubia, and of a journey to the coast of the Red Sea, in search of the ancient Berenice and another to the oasis of Jupiter Ammon.* London: J. Murray.

Bergeon, S. (1988) 'Fragonard administrateur au Louvre de 1793 à 1800', *Science et Technologie de la Conservation et de la Restauration des œuvres d'art et du patrimoine* 1: 8.

Berger, J.E. (n.d.) [c. 1730] *Kerrn aller Fridrichs Städtschen Begebenheiten*, Berlin, Staatsbibliothek zu Berlin, Preußischer Kulturbesitz, Handschriftenabteilung, MS Boruss. quart. 124.

Bergman, T.O. (1787) *Opuscula physica et chemical*, vol. 4. Leipzig.

Berke, H. (2002) 'Chemistry in ancient times: the development of blue and purple pigments', *Angewandte Chemie International Edition* 41(14): 2483–7.

Berke, H. (2007) 'The invention of blue and purple pigments in ancient times', *Chemical Society Reviews* 36: 15–30.

Berke, H. and Wiedemann, H.G. (2000) 'The chemistry and fabrication of anthropogenic pigments Chinese Blue and Purple in ancient China', *East Asian Science, Technology, and Medicine* 17: 94–120.

Berrie, B.H. (1997) 'Prussian blue', in E. West FitzHugh (ed.), *Artists' Pigments: A Handbook of their History and Characteristics*, vol. 3. Washington, DC: National Gallery of Art, 191–217

Berthollet, C.L. (1789a) 'Description du blanchiment des toiles et des fils par l'acide muriatique oxygéné et de quelques autres propriétés de cette liqueur relative aux arts', *Annales de Chimie* 2: 151–90.

Berthollet, C.L. (1789b) 'Mémoire sur l'acide prussique', in *Histoire de l'Académie Royale des Sciences, année 1787, avec les Mémoires de Mathématique & de Physique, pour la même année, tirés des registres de cette Académie*. Paris,148–62.

Berthollet, C.L. (1791) 'Observations sur les combinaisons des oxides métalliques avec les alcalis et la chaux', *Mémoires de l'Académie Royale des Sciences de l'année 1788*. Paris, 728–41.

Bertrand, E. (1881) 'Commentary on the note of V. Micault "Couleurs anciennes obtenues par l'emploi des oxydes de cuivre"', Bulletin de la Société Minéralogique de France IV: 82–4.

Berzelius, J.J. (1812) *Lärbok i Kemien* [Textbook in Chemistry], vol. 2. Stockholm.

Binder, D. (2004) 'Giribaldi et la complexité des sociétés néolithiques', in *Un chantier archéologique à la loupe, Giribaldi*. Nice: Nice musées, 70–74.

Biringuccio, V. (1540) *De la Pyrotechnia*. Venice. [English translation: C. Stanley Smith and M. Teach Gnudi (tr.) (1942) *The Pirotechnia of Vanoccio Biringuccio*. The American Institute of Mining and Metallurgical Engineers. New edition 1990, Dover: Mineola.]

Biron, I., Dandridge, P. and Wypyski, M.T. (1995) 'Le cuivre et l'émail: techniques et matériaux', in *L'Œuvre de Limoges*. Paris: Réunion des Musées Nationaux, 48–62.

Blet, M. (1994) 'Analyse d'échantillons de bleu égyptien', Mémoire de Diplôme d'Etudes Approfondies, Bordeaux III University.

Blet, M., Guineau, B. and Gratuze, B. (1997) 'Caractérisation de boules de bleu égyptien: analyse par absorption visible et par activation avec des neutrons rapides de cyclotron', *Revue d'Archéométrie* 21: 121–30.

Bleu Vossen (1986) 'Bleu Vossen pour la coloration de fongicides', *Technical Bulletin Pigments* 50: 1–17.

Bock, L. (1916) 'Über Ägyptischblau', *Zeitschrift für Angewandte Chemie* 29(1): 228.

Boece de Boot, A. (1609) *Gemmarum et lapidum historia*. Leyde: Maire.*

Boece de Boot, A. (1644) *Le parfait joaillier ou histoire des pierreries: où sont amplement descrites leur naissance, juste prix, moyen de les cognoistre, & de se garder des contrefaites, Facultez medecinales, & proprietez curieuses*, J. Bachou (tr.). Lyon.

Bonnard, A.H. de (1815) 'Essai géognostique sur l'Erzgebirge, ou sur les montagnes métallifères de la Saxe', *Journal des Mines* 38(227): 339–82.

Bonnard, D. (2005) *L'outremer Guimet*, Mémoire de DEA en Histoire des Techniques. Paris: CNAM/CDHT.

Borelli-Vlad, L. (1987) 'Tecnica e conservazione della pittura murale etrusca', in F. Delamare, T. Hackens and B. Helly (eds), *Datation-Caractérisation des peintures pariétales et murales, PACT 17*. Ravello / Louvain-la-Neuve, 71–3.

Borghini, R. [1584] (1730) *Il riposo*, M. Nestenus and F. Moücke (eds), 2nd edn. Florence.

Born, I. de (1780) *Voyage minéralogique fait en Hongrie et en Transilvanie par M. de Born, traduit de l'Allemand avec quelques notes par M. Monnet, etc*. Paris.*

Boudet, J-P (1818) *Notice historique de l'art de la verrerie né en Égypte, in Description de l'Égypte ou Recueil des observations et des recherches qui ont été faites en Égypte pendant l'expédition de l'armée française, Antiquités, Mémoires*, vol. 2. Paris: Panckoucke.*

Boudriot, J. (1973–1977) *Le vaisseau de 74 canons*, 4 vols. Grenoble: Les Quatre Seigneurs.

Bouillet, M.N. (1864) *Dictionnaire universel d'histoire et de géographie*, 20th edn. Paris: Hachette.

Boutet, C. (1679) *École de la mignature, dans laquelle on peut aisément apprendre à peindre sans maître, avec le secret de faire les plus belles couleurs, l'or bruny et l'or en coquille*, new edn. Lyon: Du Chesne.*

Bouvier, J. (1960) *Les Rothschild*. Paris: Le Club Français du Livre.

Bouvier, B. and Fossier, F. (2006) *Procès-verbaux de l'Académie des Beaux-Arts*, vol. 4 (1826–1829). Paris: École nationale des chartes. Special session of December 13, 1828.

Bowles, G. (1776) *Introduction à l'histoire naturelle et à la géographie physique de l'Espagne*. Paris. [Spanish original version: Bowles, G. (1775) *Introduccion á la Historia natural y geografia-fisica del reyno de España*. Madrid. Some parts of this book have been translated in English: Talbot Dillon, J. (tr.) (1780) *Travels through Spain*. London.]

Boyer, R., Bel, V., Tranoy, L., Grévin, G., Mourey, W., Barrandon, J.-N., Binant, C., Bui-Thi-Mai, M., Girard, M., Gratuze, B. and Guineau, G. (1990) 'Découverte de la tombe d'un oculiste à Lyon (fin du IIᵉ siècle après J.-C.). Instruments et coffret avec collyres', *Gallia* 47: 215–49.

Boyle, R. [1661] (1744) 'Concerning the Unsuccessfulness of Experiments', in T. Birch (ed.), *The Works of the Hon. Robert Boyle*, 5 vols. London.

Braine, D. and Welford, P. (1991) 'Composite capital', in L. Webster and J. Backhouse (eds), *The making of England: Anglo-Saxon art and culture AD 600–900* (catalogue of an exhibition at the British Museum). London: British Museum Press, 34–5.

Brandt, G. (1735) 'Dissertatio de Semi-Metallis', *Acta literaria et scientiarum Sueciæ* 4: 1–12.

Brandt, G. (1742) 'Cobalti nova species examinata et descripta', *Acta Societatis regiæ scientiarum upsaliensis*: 33–41.

Braun, A. and Tcherniac, J. (1907) 'Über die Produkte der Einwirkung von Acetanhydrid auf Phthalamid', *Berichte der Deutschen Chemischen Gesellschaft* 40: 2709.

Brécoulaki, H. (2000) 'Sur la techné de la peinture grecque ancienne d'après les monuments funéraires de Macédoine', *Bulletin de Correspondance Hellénique* 124(1): 189–216.

Brill, R.H., Barnes, I.L. and Joel, E.C. (1991a) 'Lead isotope studies of early Chinese glasses', in R.H. Brill and J.H. Martin (eds), *Scientific Research in Early Chinese Glass*, Proceedings of the Archaeometry of Glass Sessions of the 1984 International Symposium on Glass, Beijing, 1984. Corning, NY: Corning Museum of Glass, 65–83.

Brill, R.H., Meiguang, S., Joel, E.C. and Vocke, R.D. (1991b) 'Addendum to chapter 5', in R.H. Brill and J.H. Martin (eds), *Scientific Research in Early Chinese Glass*, Proceedings of the Archaeometry of Glass Sessions of the 1984 International Symposium on Glass, Beijing, 1984. Corning, NY: Corning Museum of Glass, 84–9.

Brill, R.H., Tong, S.S.C. and Dohrenwend, D. (1991c) 'Chemical analyses of some early Chinese glasses', in R.H. Brill and J.H. Martin (eds), *Scientific Research in Early Chinese Glass*, Proceedings of the Archaeometry of Glass Sessions of the 1984 International Symposium on Glass, Beijing, 1984. Corning, NY: Corning Museum of Glass, 31–58.

Brongniart, A. (1877) *Traité des Arts céramiques*, 3rd edn. [revised, corrected and augmented]. Paris: Salvetat.*

Brosses, C. de [1739] (1858) Lettre XXXIII, *Mémoire sur la ville souterraine d'Ercolano*, in *Lettres familières écrites d'Italie*, Paris, an VII (1798–99), 3rd edn. Paris: Didier.* [Critical edition: Brosses, C. de (1991) *Lettres familières*, 3 vols. Naples: Centre Jean Bérard.]

Brosses, C. de (1750) *Lettres sur l'état actuel de la ville souterraine d'Herculée et sur les causes de son ensevelissement sous les ruines du Vésuve.* Dijon.* [Reprinted 1973, Geneva: Minkoff.]

Brown, J. (1724) 'Observations and Experiments upon the foregoing Preparation', *Philosophical Transactions* XXXIII(381): 17–24.

Brown, S. and O'Connor, D. (1991) *Medieval craftsmen: Glass-Painters.* London: British Museum Press.

Bruchmüller, W. [1897] (1913) 'The early history of the cobalt industry in Saxony' [original title: *Der Kobaltbergbau und die Blaufarbenwerke in Sachsen bis zum Jahre 1653*], G.R. Mickle (tr.), in *Report of the Bureau of Mines*, 4th edn., vol. 19, part 2. Toronto, 234–51.

Brunner (1846) *Technologiste ou Archives des progrès de l'industrie française et étrangères* etc. Paris: Roret.

Büchner, E. (1878) *Chemiker Zeitung* (April 1878).

Buck, R.D. (1949) 'Adriaen van der Werff and Prussian Blue', *Bulletin of the Allen Memorial Art Museum* 7(1): 74–6.

Buffon, G.L. Leclerc, comte de (1783–1788) *Histoire naturelle des minéraux*, 5 vols. Paris: Imprimerie royale.†

Bunsen, R.W. and Lyon Playfair, H. (1846) 'Report on the gases evolved from iron furnaces, with reference to the theory of the smelting of iron', in *Report of the British Association for the Advancement of Science.* London: Murray.**

Bur, M. (1991) *Suger.* Paris: Belin.

Burmester, A. and Krekel, C. (1998) 'The relationship between Albrecht Dürer's palette and fifteenth/sixteenth century pharmacy price lists: the use of azurite and ultramarine', in A. Roy and P. Smith (eds), *Painting techniques: history, materials and studio practice.* London: International Institute for Conservation of Historic and Artistic Works, 101–5.

Bussy, A. (1837) 'Rapport sur des draps teints au bleu de Prusse, par MM. Merle, Malartic, Poncet et compagnie, à Saint-Denis, par M. Bussy', *Bulletin de la Société d'Encouragement pour l'Industrie Nationale* (1st series) 36(398): 329–30.

Bussy, A. (1849) 'Rapport fait par M. Bussy, au nom du comité des arts chimiques, sur l'outremer artificiel de MM. Zuber et comp., à Rixheim (Haut-Rhin)', *Bulletin de la Société d'Encouragement pour l'Industrie Nationale* (1st series) 48(543): 386–8.

Byrne, G.T., Linstead, R.P. and Lowe, A.R. (1934) 'Phthalocyanines. Part II. The preparation of phthalocyanine and some metallic derivatives from *o*-cyanobenzamide and phthalimide', *Journal of the Chemical Society*: 1017–22.

Cadet de Gassicourt, L.C., Lavoisier, A.L. de and du Chanoy (1778) 'Rapport fait à la Société libre d'Émulation sur une teinture en bleu', *Observations sur la Physique, sur l'Histoire naturelle et sur les Arts* 11: 526–36.

Cadiou, C. (2000) 'Synthèse et applications de bisphtalocyanines de lutétium portant des chaînes hydrophiles ou hydrophobes', doctoral thesis, Bretagne Occidentale University.

Campbell Thompson, R. (1925) *On the chemistry of the ancient Assyrians*, London: Laizac and Co.

Cardon, D. and Du Chatenet G. (1990) *Guide des teintures naturelles*. Neuchatel and Paris: Delachaux et Niestlé.

Cardon, D. (2003) *Le monde des teintures naturelles*. Paris: Belin.

Cardon, D. (2007) *Natural dyes: sources, tradition, technology and science*. London: Archetype Publications.

Casey, R.S. (1940). 'Prussian blue writing inks', *Industrial and Engineering Chemistry* 32(12): 1584–5.

Cavassa, L. (2004) 'Production et diffusion du bleu de Pouzzoles', Mémoire de DEA, Aix-Marseille I University.

Cavassa, L., Delamare, F. and Repoux M. (2010) 'La fabrication du bleu égyptien dans les Champs Phlégréens (Campanie, Italie) durant le Ier siècle de notre ère, *Revue Archéologique de l'Est, Supplément* 28: 235–49.

Cennini, C. [*c.* 1420] (1991) *Il libro dell'Arte*, C. Déroche (French ed. and tr.). Paris: Berger-Levraut. [English translation: Thompson, D.V., Jr. (1933) Yale. Reprint edn., 1960, New York: Dover.]

Chakoumakos, B.C., Fernandez-Baca, J.A. and Boatner, L.A. (1993) 'Refinement of the structures of the layer silicates $MCuSi_4O_{10}$ (M = Ca, Sr, Ba), by Rietveld analysis of neutron powder diffraction data', *Journal of Solid State Chemistry* 103(1): 105–13.

Chandelon, M. (1864) 'Sur les manufactures de produits chimiques', *Moniteur Scientifique* 6: 266–74.

Chaperon, P.R. de (1788) *Traité de la peinture au pastel, du secret d'en composer les crayons, et des moyens de le fixer; avec l'indication d'un grand nombre de nouvelles substances propres à la peinture à l'huile, & les moyens de prévenir l'altération des couleurs*. Paris: Defer de Maisonneuve.

Chaptal, J.-A. (1781a) 'Mémoire sur un bol jaune propre à donner du brun rouge supérieur à celui d'Angleterre ou de Hollande', in *Mémoires de Chimie*. Montpellier: Martel aîné, 86–90.

Chaptal, J.-A. (1781b) 'Mémoire sur la partie colorante du bleu de Prusse', in *Mémoires de Chimie*. Montpellier: Martel aîné.

Chaptal, J.-A. (1790) *Élémens de chymie*. Montpellier: Picot.

Chaptal, J.-A. (1807) *Chimie appliquée aux Arts*. Paris: Déterville.*

Chaptal, J.-A. (1809) 'Sur quelques couleurs trouvées à Pompeïa', *Annales de Chimie* LXX (1st series) B4: 22–31.

Chaptal, J.A. (1819) *De l'industrie française*. Paris: Renouard. [Reprinted 1993, Paris: Imprimerie Nationale.]*

Charpentier, J. de (1823) *Essai sur la constitution géognostique des Pyrénées*. Paris: Levrault.*

Chase, W.T. (1971) 'Egyptian blue as a pigment and ceramic material', in R.H. Brill (ed.), *Science and Archaeology*. Cambridge: MIT Press, 80–90.

Chevreul, M.-E. (1826) 'Procédé pour dégrader les nuances de la teinture en bleu de Prusse sur soie, par M. Chevreul, directeur des teintures de la manufacture royale des Gobelins', *Bulletin de la Société d'Encouragement pour l'Industrie Nationale* (1st series) 25(267): 286–7.

Chevreul, M.-E. (1850) 'Recherches chimiques sur plusieurs objets d'archéologie trouvés dans le département de la Vendée', *Mémoires de l'Académie des Sciences de Paris* 22: 181–207.

Chiari, G., Giustetto, R. and Ricchiardi, G. (2003) 'Crystal structure refinements of palygorskite and Maya Blue from molecular modelling and powder synchrotron diffraction', *European Journal of Mineralogy* 15(1): 21–33.

Chobaut, H. (1977) *Prix-fait du couronnement de la Vierge, Enguerrand Quarton, 1453*. Nîmes: Private edn.

Chomel, N. (1743a) 'Blanchi', in *Supplément au dictionnaire œconomique contenant divers moyens d'augmenter son bien et de conserver sa santé avec plusieurs remèdes assurez et éprouvez pour un très grand nombre de Maladies & de beaux Secrets pour parvenir à une longue & heureuse vieillesse* etc. Paris: Estienne.*

Chomel, N. (1743b) 'Bleu', in *Supplément au dictionnaire œconomique contenant divers moyens d'augmenter son bien et de conserver sa santé avec plusieurs remèdes assurez et éprouvez pour un très grand nombre de Maladies & de beaux Secrets pour parvenir à une longue & heureuse vieillesse* etc. Paris: Estienne.*

Chopin, T. and Macaudière, P. (1996) French patent EP0743923 *Silicates à base d'alcalino-terreux, de cuivre et éventuellement de titane, pigments bleus ou violets à base de ces silicates, leur procédé de préparation et leur utilisation*, Rhône Poulenc Chimie, application 11 February 1994, granted 27 November 1996.

Cobalt monograph (1960) Brussels: Centre d'information du cobalt.

Colbert, J.B. (1669) *Règlement Général des Manufactures et Teintures du 13 août 1669, comprenant l'Instruction générale pour la teinture des laines & Manufactures de laine de toutes couleurs, & pour la culture des drogues ou ingrédiens qu'on y employe, et l'Instruction générale donnée de l'ordre exprès du Roi, par M. Colbert Conseiller de Sa Majesté en tous ses Conseils & aux Commis envoyés dans toutes les Provinces du Royaume pour l'exécution des Règlemens généraux des Manufactures*

& *Teintures, registrés en présence de Sa Majesté au Parlement de Paris le 13 août 1669.*

Colinart, S. (1988) 'Les pigments et les colorants de la boutique "A la Momie"', in M. Jaoul and M. Romano (eds), *Des teintes et des couleurs*. Paris: Réunion des Musées Nationaux, 55–60

Collin (1806) *Rapport et tableaux sur l'Administration des Douanes* [relatifs à l'an XIII], March the 3th, 1806. Paris: Imprimerie Impériale.

Corbier, M. (1985) 'Dévaluations et évolution des prix (Ier-IIIe siècles)', *Revue Numismatique* (6th series) 28: 69–106.

Cordier, L. (1819) 'Mémoire sur les cristaux de cuivre carbonaté rédigé d'après les dernières observations de M. l'abbé Haüy', *Annales des Mines* (1st series) 4: 3–20.

Corti, E.C. (1951) *The destruction and resurrection of Pompeii and Herculaneum.* London: Routledge and Kegan Paul.

Cothren, M.W. (1986) 'The infancy of Christ window from the Abbey of St Denis: a reconsideration of its design and iconography', *The Art Bulletin* 68(3): 398–420.

Cotte, M. (2007) *Le choix de la révolution industrielle. Les entreprises de Marc Seguin et ses frères (1815-1835).* Rennes: Presses universitaires.

Coup-d'œil (1825) 'Coup-d'œil sur l'état actuel de l'industrie manufacturière en France', *Bulletin de la Société d'Encouragement pour l'Industrie Nationale* (1st series) 24(252): 186–91.

Coupry, C. (1999) 'Les pigments', in C. Sapin (ed.), *Peindre à Auxerre au Moyen Âge, IXe – XIVe siècles: 10 ans de recherche à l'abbaye Saint-Germain d'Auxerre et à la cathédrale Saint-Étienne d'Auxerre.* Auxerre: Centre d'Etudes médiévales d'Auxerre & Editions du Comité des Travaux Historiques et Scientifiques, 58–61.

Coural, C. (1980) in J. Courcel (ed.) *Inventaire des collections publiques françaises, Paris, Mobilier National, Soiries Empire.* Paris, 230–32 and 237–40, n°71.

Coural, C. (1987) 'Étoffe fond bleu prussiate, à dessin d'ornements' in *Sublime indigo.* Marseille/Fribourg: Musées de Marseille: Office du Livre, 162, n°181.

Crell, L. von (1786) 'Extrait d'une lettre de M. Crell à M. de la Métherie sur le bleu de Prusse', *Observations sur la Physique* 28: 365–366.

Cronstedt, A.-F. and Wiedeman, G (1771) *Essai d'une nouvelle mineralogy.* Paris: Didot le jeune.*

Crosland, M. (1997) 'La Société d'Arcueil, un creuset pour physiciens et chimistes', *La Recherche* 300: 54–7.

Curaudau, F.R. (1803a) 'Sur la nature et les nouvelles propriétés du radical prussique', *Annales de Chimie* XLVI: 148.

[Curaudau, F.R.] (1803b) 'Extrait d'un mémoire du Cit. Curaudau, sur le radical prussique', *Bulletin de la Société d'Encouragement pour l'Industrie Nationale* (1st series) 1(11): 209–11.

Cuvier, G. (1810) *Rapport historique sur les progrès des Sciences naturelles depuis 1789, et sur leur état actuel, présenté à Sa Majesté l'Empereur et Roi, en son Conseil d'État, le 6 février 1808, par la classe des sciences physiques et mathématiques de l'Institut conformément à l'arrêté du gouvernement du 13 Ventôse an X.* Paris: Imprimerie impériale.

Da Cunha, C. (1989) *Le lapis lazuli, son histoire, ses gisements, ses imitations*. Monaco: Editions du Rocher.

Daclin (1828) 'Industrie étrangère. Rapport sur la correspondance de M. le baron de Fahnenberg', *Bulletin de la Société d'Encouragement pour l'Industrie Nationale* (1ˢᵗ series) 27(288): 214–18.

Dandrau, A. (1999) 'La peinture murale minoenne, I. La palette du peintre égéen et égyptien à l'Âge du Bronze. Nouvelles données analytiques', *Bulletin de Correspondance Hellénique* 123(1): 1–41.

Daniele, D. (1999) 'I pigmenti romani e la tecnica della loro applicazione nella pittura parietale. Ricerca archeometrica mediante indagini mineralogico petrografiche', doctoral thesis, Pisa University.

Darcet, J. *fils* (1839) *Exposition des produits de l'industrie française en 1839. Rapport du jury central*, vol. 2. Paris: Bouchard-Huzard.*

Darmstaedter, E. (1926) 'Nochmals babylonische "Alchemie"', *Zeitschrift für Assyriologie und Vorderasiatische Archäologie*, 37(3): 205–13.

Daubuisson, J.F. (1801–1802) 'Mémoire sur la partie économique et administrative des mines de la Saxe', *Journal des mines* XI: 63–90.

Davy, H. (1815) 'Some experiments and observations on the colours used in painting by the Ancients', *Philosophical Transactions* 105: 97–124. [French translation: Davy, H (1815) 'Expériences et observations sur les couleurs dont se servaient les anciens dans la peinture', *Annales de Chimie* XCVI(6): 72–95; id. *Annales de Chimie* XCVI(13): 193–212.]

Dayton, J.E. (1981) 'Geological evidence for the discovery of the cobalt blue glass in the Mycenaean times as a by-product of silver smelting in the Schneeberg area of the Bohemian Erzgebirge', *Revue d'Archéométrie* supplément: 57–61.

Dayton, J.E., Bowles, J. and Shepperd, C. (1978) '"Egyptian blue" or "kyanos" and the problem of cobalt', in *Minerals, metals, glazing and man*. London: Harrap, 451–62.

De Criscio, G. (1881) *Notizie istoriche archeologiche di Pozzuoli*. Naples.

De Landa, D. [1560] (1994) *Relacion de las cosas de Yucatán*. México: CHCA.

De Yta, A. (1977) 'Estudios termicos del azul maya', thesis in Maestria en Ciencia de Materiales, Escuela Sup. de Fisica y Matemáticas, IPN, México.

Del modo (1548) 'Del modo como hacian sus pinturas los indigenas de la zona maya y otras noticias', archives of the *Centro de Estudios de Historia de México*, Condumex (unpublished manuscript).

Delamare, F. (1974) 'Increase of the surface self-diffusion of silver in the presence of chemisorbed iodine', *Scripta Metallurgica* 8: 991–4.

Delamare, F. (1987) 'Les terres vertes et leur utilisation en peinture murale romaine', in F. Delamare, T. Hackens and B. Helly (eds), *Datation-Caractérisation des peintures pariétales et murals, PACT 17*. Ravello/Louvain-la-Neuve, 345–76.

Delamare, F. (1997) 'Sur les processus physiques intervenant lors de la synthèse du bleu égyptien. Réflexion à propos de la composition de pigments bleus gallo-romains', *Revue d'Archéométrie* 21: 103–19.

Delamare, F. (1998) 'De la composition du bleu égyptien utilisé en peinture murale gallo-romaine', in S. Colinart and M. Menu (eds), *La couleur dans la peinture et l'émaillage de l'Égypte ancienne*. Bari: Edipuglia, 177–93.

Delamare, F. (2003) 'La recette du cæruleum de Vitruve. Le point de vue de la science des matériaux', *Archives internationales d'Histoire des Sciences* 53/150–151: 3–18.

Delamare, F. (2009) 'Aux origines des bleus de cobalt, les débuts de la fabrication du saffre et du smalt en Europe occidentale', *Comptes Rendus de l'Académie des Inscriptions et Belles-Lettres* 9: 297–315.

Delamare, F. and Guineau, B. (1991) 'Roquepertuse. Analyse physico-chimique des couches picturales', *Documents d'Archéologie Méridionale* 14: 83–6.

Delamare, F. and Guineau, B. (2006) 'La boîte de couleurs dite "de Fragonard". Analyse du contenu des flacons', in *J.-H. Fragonard, peintre de Grasse*. Paris: Somogy, 24–31.

Delamare, F. and Monasse, B. (2005) 'Le rôle de l'alun comme mordant en teinture. Une approche par la simulation numérique. Cas de la teinture de la cellulose à l'alizarine', in P. Borgard, J.-P. Brun and M. Picon (eds), *L'alun de Méditerranée*, Proceedings of the Colloquium in Naples and Lipari, June 2003. Naples/Aix-en-Provence: Centre Jean Bérard and Centre Camille Jullian, 277–90.

Delamare, F. and Repoux, M. (2005) 'Studying dyes by time-of-flight secondary ion mass spectrometry', in J. Kirby (ed.), *Dyes in History and Archaeology 20*. London: Archetype Publications, 39–50.

Delamare, F. and Rhead, G.E. (1971) 'Increase in the surface self-diffusion of copper due to the chemisorption of halogens', *Surface Science* 28: 267–84.

Delamare, F., Delamare, L., Guineau, B. and Odin, G.-S. (1990) 'Couleur, nature et origine des pigments verts employés en peinture murale gallo-romaine', in B. Guineau (ed.), *Pigments & colorants de l'Antiquité et du Moyen-Âge*. Paris: Centre National de la Recherche Scientifique, 103–16.

Delamare, F., Monge, G. and Repoux, M. (2004) 'A la recherche de différentes qualités marchandes dans les bleus égyptiens trouvés à Pompéi', *Rivista di studi Pompeiani* XV: 89–107.

Delesse, A.J. (1843) *Journal de l'Institut historique* (1st section) (30 November 1843): 416.

Demande du comte de Beust (1785) *Demande du comte de Beust de prendre dans la forêt de Bagnères-de-Luchon le bois nécessaire à ses fabriques de potasse et de cobalt*, Paris, Centre historique des archives nationales, série K, Monuments historiques, titre VII: législation, économie, finances, shelf-mark 909, 35 à 40.

Demeulenaere-Douyère, C. and Sturdy, D.J. (2008) *L'enquête du Régent 1716–1718. Sciences, techniques et politique dans la France pré-industrielle*. Turnhout: Brepols.

Dent, C.E. and Linstead, R.P. (1934) 'Phthalocyanines. Part IV. Copper phthalocyanine', *Journal of the Chemical Society*: 1027–31.

Dent, C.E., Linstead, R.P. and Lowe, A.R. (1934) 'Phthalocyanines. Part VI. The structure of the phthalocyanines', *Journal of the Chemical Society*: 1033–9.

Déré, A.-C. and Emptoz, G. (2000) 'Les pièges de la médiation: la légende du bleu Thénard', in J.-P. Courtial (ed.), *La médiation*. Nantes: Maison des sciences de l'homme Ange Guépin, 63–71.

Desalme, J. and Pierron, L. (1910) *Couleurs, peintures et vernis*. Paris: Baillière et Fils.

Desbat, A. (1984) *Les fouilles de la rue des Farges à Lyon: 1974–1980*. Lyon: Groupe lyonnais de recherche en archéologie gallo-romaines.

Description d'un Procédé (1814) 'Description d'un Procédé inventé par M. Raymond, professeur de chimie à Lyon, pour teindre la Soie avec le Bleu de Prusse, d'une manière égale, solide et brillante', *Bulletin de la Société d'Encouragement pour l'Industrie Nationale* (1st series) 13(116): 29–41.

Desormes, C.B. and Clément, N. (1806) 'Mémoire sur l'outremer', *Annales de Chimie* 57: 317–26.

Dictionary of Fiber and Textile Technology (1990). Saint-Hyacinthe: Hoechst Celanese Corp. [4th edn. 1999, Charlotte, USA: KoSa.]

Dictionnaire de l'Académie Françoise (1694). Paris: Coignard.*

Dictionnaire technologique (1822) *Dictionnaire technologique ou nouveau diction-naire universel des arts et métiers et de l'économie industrielle et commerciale par une société de savants et d'artistes*, vol. 1. Paris: Thomine and Fortic.*

Diderot, D. [1765] (1970) 'Remarques sur le bleu tiré du cobalt', in D. Diderot, *Œuvres complètes*, vol. 5. Paris: Club Français du Livre, 567–70.

Diesbach, H. de and Weid, E. von der (1927) 'Quelques sels complexes des o-dinitriles avec le cuivre et la pyridine', *Helvetica Chimica Acta* 10(1): 886–8.

Dietrich, P.F., baron de (1786) *Description des gîtes de minerai des forges et des salines de Pyrénées, suivie d'observations sur le fer Mazé et sur les mines de Sards en Poitou*. Paris: Didot.

Dietrich, P.F., baron de (n.d.) [c. July 1786] *Rapport de la visite de M le B de Dietrich à la manufacture d'Azur des Pyrénées*, Paris, Centre historique des archives nation-ales, série K, Monuments historiques, titre VII: législation, économie, finances, shelf-mark 909, 41.

Dippel, J.P. (1854) *Die Ultramarin-Fabrikation*. Cassel.

Döbereiner (1823) *Jahrbuch der Chemie und Physik* 1.

Dossie, R. (1758) *The Handmaid to the Arts*. London: Nourse.*

Douglas, J. (1986) *20th Century Scottish Banknotes*, vol. 2. Carlisle: Banking Memorabilia.

Dralet, E.F. (1813) 'Manufacture d'Azur', in *Description des Pyrénées considérées principalement sous les rapports de la Géologie, de l'Économie politique, rurale et forestière, de l'Industrie et du Commerce*. Paris: Arthus Bertrand, 152–3.*

Dubois, C. (1907). *Pouzzoles antique (histoire et topographie)*. Paris: Fontemoing.*

Dubois, U. and Bernard, E. (1881) *La cuisine classique. Études pratiques, raisonnées et démonstratives de l'École Française*, 9th edn. Paris: Dentu.*

Dufour, L. (1820) 'Lettres à M. Palassou, correspondant de l'Académie royale des sci-ences, sur des excursions tentées vers les montagnes maudites des Pyrénées', in Bory de St-Vincent, Drapiez and Van Mons (eds), *Annales générales des sciences physiques*, vol. 7. Brussels: Weissenbruch, 224–42 .*

Dufraisse, R. (1971) 'L'industrialisation de la rive gauche du Rhin', *Revue du souvenir napoléonien* 257: 28–33.

Duhamel, *fils* [probably Guillot-Duhamel, J.-B.] (1801) 'Mémoire sur la fabrique de noir de fumée de la Rushutte, département de la Sarre, canton de Sarrebrück', *Journal des Mines* LV (Germinal an IX): 487–506.

Dulin, L. (1994) 'Étude de surfaces colorées par spectrométrie électronique en réflexion diffuse et traitement statistique des données colorimétriques. Application aux études archéologiques et codicologiques', doctoral thesis, University of Orleans.

Dumas, J.-B. (1837) 'Rapport sur le concours relatif à la description de la préparation de l'outremer factice', *Bulletin de la Société d'Encouragement pour l'Industrie Nationale* (1st series) 36(402): 496–7.

Dumas, J.-B. (1844), *Rapport du Jury central* de l'*Exposition des produits de l'industrie française en 1844*, vol. 2. Paris: Fain and Thunot.‡‡

Dupin, C., baron (1836) *Rapport du jury central sur les produits de l'Industrie Française exposés en 1834*. Paris: Imprimerie royale.‡‡

Dupin, C., baron (1856) 'Discours de M. le baron Charles Dupin [sur l'Exposition universelle de 1855 à Paris]', *Bulletin de la Société d'Encouragement pour l'Industrie Nationale* (2nd series) 55: 136–9.

Dürer, A. (1987) *Lettres à Jacob Heller*, W. Halberstadt (tr.). Caen: L'échoppe.

Duval, C. (1959) 'Sels et complexes du fer', in P. Pascal (ed.), *Nouveau Traité de Chimie Minérale*, vol. 18. Paris: Masson, 175–359.

Egyptomania (1994) *Egyptomania, l'Égypte dans l'art occidental 1730–1930*. Paris: Réunion des Musées Nationaux.

Eikelenberg, S. (n.d.) 'Aantekeningen over schilderkunst', Alkmaar archives, collection no. 390–394 (unpublished manuscript).

Emmenegger, O. (1986) 'Deterioration and preservation of Carolingian and medieval mural paintings in the Müstair convent (Switzerland) – Part III: techniques and materials used and past restorations', in *Case Studies in the Conservation of Stone and Wall Paintings*, Proceedings of the International Institute for Conservation Congress, Bologna, 1986. London: International Institute for Conservation of Historic and Artistic Works, 197–9.

Encyclopédie (1751–1765) *Encyclopédie ou Dictionnaire raisonné des Sciences, des Arts et des Métiers, par une société de gens de lettres*, 35 vols. Paris: Briasson, David l'aîné, Le Breton and Durand, and Neufchastel: Société typographique.

Endter, F. (1958) 'Die technische Synthese von Cyanwasserstoff aus Methan und Ammoniak ohne Zusatz von Sauerstoff', *Chemie Ingenieur Technik* 30(5): 281–376.

Engel, N. (1996) 'Der mittelalterliche und frühneuzeitliche Bergbau Wallerfangens nach den schriftlichen Quellen', Part 1, *Unsere Heimat: Mitteilungsblatt des Landkreises Saarlouis für Kultur und Landschaft* 21: 150–58.

Engel, N. (1997) 'Der mittelalterliche und frühneuzeitliche Bergbau Wallerfangens nach den schriftlichen Quellen', Part 2, *Unsere Heimat: Mitteilungsblatt des Landkreises Saarlouis für Kultur und Landschaftrt* 22: 82–92.

Eraclius (n.d.) *De coloribus et artibus Romanorum (On the Colours and Arts of the Romans)*, Avranches, France, Bibliothèque municipale, MS 235.

Ercker, L. (1580) *Beschreibung allerfürnemisten mineralischen Ertzt und Bergk wercksarten* , 2nd edn. Frankfurt-am-Main: Sigmund Feyrabend. [English translation: A.G. Sisco and C.S. Smith (tr.) (1951), *Treatise on ores and assaying.* Chicago: The University of Chicago Press.]

Erman, A. and Grapow, H. (1927) *Wörterbuch der Aegyptischen Sprache*, vol. 5. Berlin: Akademie Verlag.

Etcheverry, M.-P. (1998) 'Étude physique du bleu égyptien: caractérisation, mécanismes de formation, altération', doctoral thesis, Bordeaux III University.

Eudel, P. (1908) *Trucs et truqueurs, altérations, fraudes et contrefaçons dévoilées.* Paris: Librairie Molière.

Exposition des produits de l'industrie française en 1839 (1839). Paris: Bouchard-Huzard.‡‡

Exposition des produits de l'industrie française en 1844 (1844) *Exposition des produits de l'industrie française en 1844. Rapport du jury central.* Paris: Fain and Thunot. ‡‡

Exposition Universelle de 1851 (1854) *Exposition Universelle de 1851, Travaux de la Commission française sur l'Industrie des Nations*, published by Emperor's orders, 3rd group, 2nd section, XVIIIth jury, *Les tissus imprimés*, vol. 5, Paris: 34–5.

Exposition Universelle de 1855 (1856) *Exposition Universelle de 1855. Rapports du Jury mixte international publiés sous la direction de S. A. I. le Prince Napoléon*, Xth class, *Arts chimiques, teintures et impressions.* Paris: Imprimerie imperial.‡‡

Extrait d'une instruction (1814) 'Extrait d'une instruction relative aux manufactures de bleu de Prusse, publiée par le conseil de salubrité de la ville de Paris, le 21 avril 1812', *Bulletin de la Société d'Encouragement pour l'Industrie Nationale* (1st series) 13(119): 119–23.

Extrait des Registres (n.d.) *Extrait des Registres de la Classe des Sciences physiques et mathématiques de l'Institut du 26 Frimaire an 13*, Paris, Archives du Conseil d'État, 2054, section de l'intérieur, n°23906.

Fabrication perfectionnée (1840) 'Fabrication perfectionnée du bleu de Prusse, du prussiate de potasse et du prussiate de soude par M. Swindells', *Bulletin de la Société d'Encouragement pour l'Industrie Nationale* (1st series) 39(438): 477. [According to the *London Journal of Arts*, September 1840.]

Fenn, P.M., Brill, R.H. and Meiguang, S. (1991) 'Addendum to chapter 4', in R.H. Brill and J.H. Martin (eds), *Scientific Research in Early Chinese Glass*, Proceedings of the Archaeometry of Glass Sessions of the 1984 International Symposium on Glass, Beijing, 1984. Corning, NY: Corning Museum of Glass, 59–64.

Filippakis, S.E., Perdikatsis, B. and Paradellis, T. (1976) 'An analysis of blue pigments from the Greek Bronze Age', *Studies in Conservation* 21(2): 143–53.

Finger, L.W., Hazen, R.M. and Hemley, R.J. (1989) '$BaCuSi_2O_6$: a new cyclosilicate with four-membered tetrahedral rings', *American Mineralogist* 74: 952–5.

Flourens, P. (1860) *Éloge historique de Louis-Jacques Thénard.* Paris: Firmin Didot.

Fois, E., Gamba, A. and Tilocca, A. (2003) 'On the unusual stability of Maya blue paint: molecular dynamics simulations', *Microporous and Mesoporous Materials* 57: 263–72.

Fontenay, H. de (1874a) 'Note sur le bleu égyptien', *Annales de Chimie et de Physique* (5th series) 2: 193–9.

Fontenay, H. de (1874b) 'Note sur les couleurs antiques trouvées à Autun et au mont Beuvray', *Mémoires de la Société Éduenne* (new series) 3: 451–77. [Reprint page numbers: 5–38.]

Fontenay, H. de (1874c) 'Sur le bleu égyptien', *Comptes Rendus de l'Académie des Sciences*: 908–10.

Forbes, R.J. (1955) 'Paints, pigments, inks and varnishes', in *Studies in ancient Technology*, vol. 3. Leiden: E.J. Brill, 202–55.

Forbes, R.J. (1966) 'Glass', in *Studies in ancient technology*, vol. 5, 2nd edn. Leiden: E.J. Brill, 112–241.

Ford, R.J. and Hitchman, M.A. (1979) 'Single crystal electronic and EPR spectra of $CaCuSi_4O_{10}$, a synthetic silicate containing copper (II) in a four-coordinate, planar ligand environment', *Inorganica Chimica Acta* 33: L167–70.

Forke, A. (tr.) (1907) *Lun-Heng*, Part I: Philosophical Essays of Wang Ch'ung. London: Luzac.

Fouqué, F. (1889a) 'Sur le bleu égyptien ou vestorien', *Bulletin de la Société Française de Minéralogie* XII: 36–8.

Fouqué, F. (1889b) 'Sur le bleu égyptien ou vestorien', *Comptes Rendus de l'Académie des Sciences de Paris* CVIII(7): 325–7.

Fouqué, F. (1889c) 'Sur le bleu égyptien ou vestorien', Procès verbaux du Conseil d'Administration, *Bulletin de la Société d'Encouragement pour l'Industrie Nationale* (4th series) 4: 244–5.

Fouqué, F. and Lévy, M. (1882) *Synthèse des minéraux et des roches*. Paris: Masson.

Fownes G. (1841) 'On the Direct Formation of Cyanogen from its Elements', *British Association Reports*, part ii, 52–3. [Also in: C. and J. Watt (eds) (1841) *The Chemist or Reporter of chemical discoveries and improvements*, vol. 2. London: Hastings, 261–2.]*

Foy, D. (1989) 'Le décor des verreries méditerranéennes', *Dossiers de l'archéologie* 143: 10–15.

Frémy, E. (1877) *Comptes Rendus de l'Académie des Sciences de Paris* LXXXV: 1029.

[Frisch, J.L.] (1710) 'Notitia Coerulei Berolinensis nuper inventi', in *Miscellanea Berolinensia* I. Berlin: Papenii: 377–8.*

Frisch, J.L. (1896) *Briefwechsel mit Gottfried Wilhelm Leibniz*, L.H. Fischer (ed.). Berlin: Stankiewicz. [New edition 1976, Hildesheim/New York: Georg Olms Verlag.]

Fritz, F. (1954) '250 Jahre Berlinerblau. Warum Pariserblau an Stelle von Berlinerblau', *Deutsche Farben-Zeitschrift* 8: 7–8.

Fuchs, R. and Oltrogge, D. (1990) 'Utilisation d'un livre de modèles pour la reconstitution de la peinture de manuscrits', in B. Guineau (ed.), *Pigments et colorants de l'Antiquité et du Moyen Âge*. Paris: Centre National de la Recherche Scientifique, 309–23.

Fürstenau, C. (1864) *Die Ultramarin-Fabrikation: Enthaltend die fabrikmässige Darstellung des gewöhnlichen, salinirbaren und alaunhaltigen Ultramarins, des Nr. 6 und der Ultramarinblaukugeln*. Coburg: Riemann.*

Gadd, C.J. and Campbell Thompson, R. (1936) 'A middle-Babylonian chemical text', *Iraq* 3(1): 87–96.

Gaetani, M.C., Santamaria, U. and Seccaroni, C. (2004) 'The use of Egyptian blue and lapis lazuli in the Middle Ages: the wall paintings of the San Saba church in Rome', *Studies in Conservation* 49(1): 13–22.

Gallo, D. and Sandron, D. (2008) *Le Traité d'Antoine de Pise* [facsimile and transcription of the manuscript], in C. Lautier and D. Sandron (eds), *Antoine de Pise: Le vitrail vers 1400, Corpus Vitrearum* – France, Études VIII. Paris: Comité des Travaux Historiques et Scientifiques, 67–78.

Garçon, J. (1901). *Répertoire général, ou Dictionnaire méthodique de bibliographie des industries tinctoriales et des industries annexes depuis les origines jusqu'à la fin de l'année 1896.* Paris: Gauthier-Villars.

Gargiulo, P. (1998) 'Contenitori con depositi di colore blu egiziano e officine vetrarie nell'area dell'antica Liternum e nel territorio Flegreo. Aspetti tecnologici e prospettive di studio', in *Il vetro dall'antichità all'età contemporanea: aspetti tecnologici, funzionali e commerciali,* Atti delle 2e giornate nazionali di studio AIHV – Comitato Nazionale Italiano, Milano, 14–15 dicembre 1996. Milan, 61–5. and plate 5.

Gauld Bearn, J. (1923) *The chemistry of paints, pigments & varnishes.* London: Benn.

Gaultier de Claubry, H. (1837) 'Rapport sur les travaux de M. Drouard, fabricant de papiers peints, rue de Beauveau, n°10, faubourg Saint-Antoine', *Bulletin de la Société d'Encouragement pour l'Industrie Nationale* (1st series) 36(398): 321–3.

Gay-Lussac, L.J. (1815) 'Recherches sur l'acide prussique', *Annales de Chimie* XCV: 136–231.

Gay-Lussac, L.J. (1828) 'Observations de M. Gay-Lussac, following C. Gmelin, Note de M. Gmelin de Tubingue, du 22 mars 1828, sur la Préparation de l'outre-mer artificiel', *Annales de Chimie et de Physique* XXXVII: 413–15.

Geoffroy, C.-J. (1746) 'Différens moyens de rendre le Bleu de Prusse plus solide à l'air & plus facile à préparer', in *Mémoires de Mathématique et de Physique tirez des registres de l'Académie Royale des Sciences de l'Année 1743.* Paris: Imprimerie royale, 33–50.†

Geoffroy, E.-F. (1727a) 'Observations sur la préparation du bleu de Prusse ou de Berlin', in *Mémoires de Mathématique et de Physique tirés des registres de l'Académie Royale des Sciences de l'Année 1725.* Paris: Imprimerie royale, 153–72.†

Geoffroy, E.-F. (1727b) 'Nouvelles observations sur la préparation du bleu de Prusse', *Mémoires de Mathématique et de Physique tirés des registres de l'Académie Royale des Sciences de l'Année 1725.* Paris: Imprimerie royale, 220–37.†

Gérando, baron M.J. (1825) 'Rapport sur les divers concours relatifs aux prix à décerner en 1825', *Bulletin de la Société d'Encouragement pour l'Industrie Nationale* (1st series) 24(256): 305–9.

Gerber, M. (1864) *Die Sächsischen Privat-Blaufarbenwerke.* Dresden.

Gerhard, K.A. (1781) 'Nouvelle méthode d'extraire le Bleu royal de toutes sortes de cobalt, à l'usage des fabriques de Porcelaine', *Nouveaux Mémoires de l'Académie Royale des Sciences et Belles Lettres, classe de Philosophie expérimentale, année 1779.* Berlin: Decker, 12–19. [id. 1782, *Observations sur la Physique, sur l'Histoire naturelle et sur les Arts,* 21: 314–19.]

Gettens, R.J. (1937–1938) 'The materials in the wall paintings of Bâmiyân, Afghanistan', *Technical Studies in the Field of the Fine Arts* 6: 186–93.

Gettens, R.J. (1962) 'Maya blue: an unsolved problem in ancient pigments', *American Antiquity* 27(4): 557–64.

Gettens, R.J. and Stout, G.L. (1942) *Painting Materials, a short Encyclopaedia.* New York: Van Nostrand. [Reprinted 1966, New York: Dover.]

Gettens, R.J. and West Fitzhugh E. (1993) 'Azurite and Blue Verditer', in A. Roy (ed.), *Artists' Pigments: A Handbook of their History and Characteristics*, vol. 2. Washington, DC: National Gallery of Art, 23–35

Giester, G. and Rieck, B. (1994) 'Effenbergerite, $BaCu[Si_4O_{10}]$, a new mineral from the Kalahari manganese field, South Africa: description and crystal structure', *Mineralogical Magazine* 58(4): 663–70.

Girardin, J. (1846) 'Analyse de plusieurs produits d'art d'une haute antiquité', *Journal de Pharmacie et de Chimie* (3rd series) 10: 321–39.

Girardin, J. (1852) 'Analyses de plusieurs produits d'art d'une haute antiquité', 2nd Memoir, in *Précis analytique des travaux de l'Académie des Sciences, Belles Lettres et Arts de Rouen pendant l'année 1851–1852.* Rouen: Péron, 142–80.*

Giustetto, R., Llabrés i Xamena, F.X., Ricchiardi, G., Bordiga, S., Damin, A., Gobetto, R. and Chierotti, M.R. (2005) 'Maya blue: a computational and spectroscopic study', *Journal of Physical Chemistry B* 109: 19360–68.

Glanzer, I., Bracht, E. and Wijnberg, L. (2001) *On the restoration of Barnett Newman's "Cathedra".* Amsterdam: Stedelijk Museum.

Gmelin, C.G. (1822) 'Vergleichende Untersuchung eines Fossils vom Kayserstuhl in Freyburg, und des grünen Elaeoliths von Laurvig in Norwegen', *Jahrbuch der Chemie und Physik* 6(1): 74–86.

Gmelin, C.G. (1828a) 'Extrait d'une Note de M. Gmelin de Tubingue, du 22 mars 1828, sur la Préparation de l'outre-mer artificiel', Liebig (tr.), *Annales de Chimie et de Physique* XXXVII: 409–13.

Gmelin, C.G. (1828b) 'Künstliche Darstellung des Ultramarins', *Hesperus* 76: 301–303.

Gmelin, C.G. (1828c) 'Ultramarin. Ueber die künstliche Darstellung einer dem Ultramarin ähnlichen Farbe', *Jahrbuch der Chemie und Physik* 24: 360–80.

Goethe, J.W. (1962), *Italian Journey (1786-1788)* [in German: *Italienische Reise*], W.H. Auden and E. Mayer (tr.). London: Collins.

Goris, J.-A. and Marlier, G. (1970) *Le journal de voyage d'Albert Dürer dans les anciens Pays-Bas, 1520-1521.* Brussells: La Connaissance.

Graeve, V. von and Helly, B. (1987) 'Recherches récentes sur la peinture grecque', in F. Delamare, T. Hackens and B. Helly (eds), *Datation-Caractérisation des peintures pariétales et murales, PACT 17.* Ravello / Louvain-la-Neuve, 17–33.

Graham T. (1852) *Exhibition of the Works of Industry of All Nations 1851, Reports by the Juries*, vol. 1. London: Clowes, lxxix-lxxxii and 44–50.*

Gratuze, B. and Blet-Lenormand, M. (2002) 'Étude de l'origine des pigments à base de cobalt utilisés par les céramistes et les verriers', in Actes du Congrès du groupe français de céramique, Le Creusot, mars 2002.

Gratuze, B., Soulier, I., Blet, M. and Vallauri, L. (1996) 'De l'origine du cobalt: du verre à la céramique', *Revue d'archéométrie* 20: 77–94.

Gruzinski, S. and Mermet, G. (1994) *L'aigle et la sybille, fresques indiennes du Mexique*. Paris: Imprimerie Nationale.

Gueymard, E. (1838–1840) 'Sur les gîtes d'argent de la montagne de Chalanches, près d'Allemont', *Bulletin de la Société scientifique du Dauphiné, Société de statistique des sciences naturelles et des arts industriels du département de l'Isère, Société scientifique de l'Isère*, session of 5 January 1839 (1ère série) 1: 26–31.

Guichard, V. and Guineau, B. (1990) 'Identification de colorants organiques naturels dans des fragments de peintures murales de l'Antiquité', in B. Guineau (ed.), *Pigments et colorants de l'Antiquité et du Moyen-Âge*. Paris: Centre National de la Recherche Scientifique, 245–54.

Guimet, E. (1877) *Note sur les outremers*. Lyon: Association typographique.

Guimet, E. (1878) 'Mémoire sur la formation des outremers et leur coloration', *Bulletin de la Société d'Encouragement pour l'Industrie Nationale* (3rd series) 5: 562–8.

Guimet, J.-B. (1830) 'Communication sur la baisse du prix de l'outremer artificiel', *Bulletin de la Société d'Encouragement à l'Industrie Nationale* (1st series) 29(313): 291–2.

Guimet, J.-B. (1831) 'Lettre de M. Guimet à M. Gay-Lussac, sur la Fabrication de l'outremer', *Annales de Chimie* XLVI: 431–4.

Guimet, J.-B. (1849) 'Lettre de M. Guimet à M. le président de la Société d'encouragement', *Bulletin de la Société d'Encouragement pour l'Industrie Nationale* (1st series) 48: 388–9.

Guimet, J.-B. [1856] (1879) 'Lettre à MM. Zuber, à Rixheim, du 26 janvier 1856', in A.J. Loir, *Notes historiques sur la découverte de l'outremer artificial*. Lyon: Association typographique, 3.

Guineau, B. (1987) 'L'étude des pigments par les moyens de la micro spectrométrie Raman', in F. Delamare, T. Hackens and B. Helly (eds), *Datation Caractérisation des peintures pariétales et murales, PACT 17*. Ravello/Louvain-la-Neuve, 259–94.

Guineau, B. (1989) 'Collyres secs gallo-romains', *Bulletin de la Société Nationale des Antiquaires de France*: 132–40.

Guineau, B. (1993) 'Du bleu pâle au blanc azuré. Aux origines de l'azurage optique', *Bulletin de la Société Nationale des Antiquaires de France*: 79–94.

Guineau, B. (2005) *Glossaire des matériaux de la couleur et des termes techniques employés dans les recettes de couleurs anciennes*. Turnhout: Brepols.

Guineau, B. and Vezin, J. (1990) 'Nouvelles méthodes d'analyse des pigments et des colorants employés pour la décoration des livres manuscrits; l'exemple des pigments bleus utilisés entre le IXe siècle et la fin du XIIe siècle, notamment à Corbie', in *Actas del VIIIe Coloquio del Comité Internacional de paleografiadios y ensayos joyas bibliogràficas*. Madrid, 83–94.

Guineau, B. and Vezin, J. (1994) 'Recettes et couleurs de l'Antiquité et du Moyen Age. Étude d'un extrait du livre III d'Héraclius "De coloribus et artibus romanorum" d'après trois manuscrits', in D. Jacquart, *Comprendre et maîtriser la nature au Moyen Age*. Geneva: Droz, 227–54.

Guineau, B., Coupry, C., Gousset, M.-T., Forgerit, J.-P. and Vezin, J. (1986) 'Identification de bleu de lapis-lazuli dans six manuscrits à peintures du XIIᵉ siècle de l'abbaye de Corbie', *Scriptorium* 40: 157–71.

Guineau, B., Dulin, L., Vezin, J. and Gousset, M.-T. (1993) 'Analyse, à l'aide des méthodes spectrophotométriques, des couleurs de deux manuscrits du XVᵉ siècle enluminés par Francesco Antonio del Chierico', in M. Maniaci and P.F. Munafó (eds), *Ancient and medieval book materials and techniques* (*Studi e Testi* 357–358), vol. II. Città del Vaticano: Biblioteca Apostolica Vaticana, 121–55.

Guineau, B., Fauduet, I. and Biraben, J.-M. (1995) 'Étude de fragments de couleurs recueillis sur le site d'Argentomagus', *Germania* 73(2): 369–401.

Guineau, B., Villela-Petit, I., Akrich, R. and Vezin, J. (1998) 'Painting techniques in the Boucicaut Hours and in Jacques Coene's colour recipes as found in Jean Lebègue's *Libri colorum*', in A. Roy and P. Smith (eds), *Painting techniques history, materials and studio practice*, Proceedings of the International Institute of Conservation, Dublin, 1998. London: The International Institiute for Conservation of Historic and Artistic Works, 51–4.

Guitard, H. (1963) *Vos billets de banque*. Paris: Editions France Empire.

Guyton de Morveau, L.-B., Lavoisier, A.L. de, Berthollet, C.L. and Fourcroy, A.F. (1787) *Méthode de nomenclature chimique*. Paris: Cuchet.*

Halleux, R. (1969) 'Lapis lazuli, azurite ou pâte de verre? A propos de *kuwano* et *kuwanowoko* dans les tablettes mycéniennes', *Studi micenei ed egeo-anatolici* 9: 47–66.

Halleux, R. and Yans, A. (1990) 'Introduction' in G. Bauer [known as Agricola] *Bermannus, un dialogue sur les mines*, R. Halleux and A. Yans (tr.). Paris: Les Belles Lettres.

Hammer, P. (2004) 'Das Sächsische Blaufarbenwesen und der Handel mit Kobaltfarben – nach Unterlagen der Bücherei der Bergakademie Freiberg', *Scripta Geologica* (special issue) 4: 108–17.

Harley, R.D. (1982) *Artists' Pigments c. 1600–1835: a study in English Documentary Sources*, 2ⁿᵈ edn. London: Butterworth Scientific.

Hartwig, J. (2001) 'De la fabrication et de l'utilisation du Safre ou Zaffera (cobalt) et du Smalte, par les verreries du XVIᵉ au 18e siècle', *Verre* 7(4): 40–48.

Hassal, A.H. (1855) *Food, its adulterations, and the methods for their detection, comprising the reports of the analytical sanitary commission of "the Lancet" for the years 1851 to 1854 inclusive*. London: Longman, Brown, Green and Longmans.††

Hassal, A.H. (1876) *Food, its adulterations, and the methods for their detection*. London: Longman, Brown, Green, Longmans and Roberts.††

Hassenfratz, J.H. (1786) 'Lettre de M. Hassenfratz à M. de la Metherie sur la matière colorante du Bleu de Prusse', *Observations sur la Physique* 28: 453–5.

Hassenfratz, J.H. (1788) 'Extrait d'un second mémoire sur la combinaison de la base de l'acide phosphorique avec les prussiates (Bleu de Prusse), quelques plantes des marais, différentes mines de fer et plusieurs espèces de fer', *Observations sur la Physique* 33: 303–309.

Hassenfratz, J.H. (1789) 'Extrait d'un second mémoire sur la combinaison de la base de l'acide phosphorique avec les prussiates (Bleu de Prusse), quelques plantes des marais, différentes mines de fer et plusieurs espèces de fer', *Chemische Annalen* 1: 106.

Haustein (1869) 'Sur l'utilisation de l'acide sulfurique etc.', *Bulletin de la Société d'Encouragement pour l'Industrie Nationale* (2nd series) 16: 191–2.

Hautecœur, L. (1953) *Histoire du Louvre, Le château, le palais, le musée des origines à nos jours*, 2nd edn. Paris: SNEP.

Haüy, R.J. (1801) *Traité de minéralogie*. Paris: Louis.*

Heaton, N. (1910) 'The mural paintings of Cnossos', *Journal of the Royal Society of Arts* 58: 206–12. [Reprinted 1924, *Journal of the Society of Painters in Tempera* 2: 13–21.]

Hellot, J. (1740) 'Seconde partie du Mémoire sur l'encre sympathique ou teinture Extraite des Mines de Bismuth, d'Azur & d'Arsenic', *Histoire de l'Académie Royale des Sciences avec les mémoires de Mathématique et de Physique pour la même année tirés des registres de cette Académie, année 1737*. Paris: Imprimerie royale: 228–47.

Hellot, J. (1742) 'Théorie chymique de la teinture des étoffes', First Memoir, *Du bleu*, année 1740, in *Mémoires de Mathématique et de Physique tirés des registres de l'Académie Royale des Sciences*. Paris, 126–48

Hellot, J. (1744) 'Théorie chymique de la teinture des étoffes', Second Memoir *Du rouge et du jaune*, année 1741, in *Mémoires de Mathématique et de Physique tirés des registres de l'Académie Royale des Sciences*. Paris, 38–71.

Hellot, J. (1750) *L'art de la teinture des laines et des étoffes de laine en grand et petit teint avec une instruction sur les débouillis*. Paris: Pissot and Herissant.*

Héricart de Thury, vicomte L.E., Migneron (1824) *Rapport sur les produits de l'industrie française présenté au nom du jury central à S. E. M. le Comte Corbière*. Paris: Imprimerie royale.†

Héricart de Thury, vicomte L.E., Migneron (1828) *Rapport sur les produits de l'industrie française présenté au nom du jury central à S. E. M. le Comte de Saint-Cricq*. Paris: Imprimerie royale.†

Héron de Villefosse, A.M. (1819) *De la richesse minérale. Considérations sur les mines, usines et salines de différents Etats, présentées comparativement*, vol. 1. Paris: Imprimerie royale.*

Herrmann, G. (1968) 'Lapis lazuli: the early phases of its trade', *Iraq* 30(1): 21–57.

Hewitt, V.H. and Keyworth, J.M. (1987) *As good as gold: 300 years of British bank note design*. London: British Museum Press.

Hilliard, N. [n.d.] (1981) *A treatise concerning the Arte of Limning together with A More Compendious Discourse concerning ye Art of Limning by Edward Norgate*, R.K.R. Thornton and T.G.S. Cain (eds). Manchester: Mid Northumberland Arts Group and Carcanet New Press.

Hoefer, F. (1852–1866) *Nouvelle biographie générale depuis les temps les plus reculés jusqu'à nos jours*, 23 vols. Paris: Firmin-Didot.

Hofmann, A.W. (1863) *International Exhibition 1862, Reports by the Juries* etc., Class II, section A, *Chemical Products and Processes*. London: W. Clowes and Sons, 70–73, *Ultramarine* entry.

Holbach, P. Thiry, baron d' (1752) 'Mémoire sur la manière dont le Saffre ou la Couleur Bleue tirée du Cobalt se fait en Saxe', in *Art de la verrerie, de Neri, Merret et Kunckel*. Paris.

Holbach, Thiry, P., baron d' (1753) 'Cobalt', in *Encyclopédie, ou dictionnaire raisonné des Sciences* etc., vol. 3. Paris: Briasson, David, Le Breton and Durand, 556–7.

Holbach, Thiry, P., baron d' (1765a) 'Lapis lazuli', in *Encyclopédie, ou dictionnaire raisonné des Sciences* etc., vol. 9. Neufchastel: S. Faulche, 286–7.

Holbach, Thiry, P., baron d' (1765b) 'Mines', in *Encyclopédie, ou dictionnaire raisonné des Sciences* etc., vol. 9. Neufchastel: S. Faulche.

Holbach, Thiry, P., baron d' (1765c) 'Safre', in *Encyclopédie, ou dictionnaire raisonné des Sciences* etc., vol. 14. Neufchastel: S. Faulche, 490–93.

Howard, H. (2001) 'An analysis of the painted plaster', in J. Mitchell and I. Hansen (eds), *San Vincenzo al Volturno 3: the findings from the 1980–86 excavations*. Spoleto: Centro italiano di studi sull' alto Medievo, 287–95.

Howard, H. (2003) *Pigments of English medieval wall painting*. London: Archetype Publications.

Hubbard, B., Kuang, W., Moser, A., Facey, G.A. and Detellier, C. (2003) 'Structural study of Maya Blue: textural, thermal and solid-state multinuclear magnetic resonance characterization of the palygorskite-indigo and sepiolite-indigo adducts', *Clays and Clay Minerals* 51(3): 318–26.

Hughes, G.B. (1954) 'The development of Cobalt Blues', *Country Life* CXV: 1824–7.

Humbert, J.-M. (1994) 'Notice 140', in *Egyptomania, l'Égypte dans l'art occidental 1730–1930*. Paris: Réunion des Musées Nationaux, 243–4.

Hunter, D. (1978) *Papermaking, the history and technique of an ancient craft*. New York: Dover.

Imperial College (1936) Department video-clip 'Patrick Linstead and the discovery of phthalocyanine', Imperial College London (www.ch.ic.ac.uk/video/FagX.m4v, accessed 2012)

Isidore of Seville (2006) *Origines (Etymologies on the origins of certain things)*, XIX: 17.14. English translation. Cambridge.

Ivanov, B.V., Zvetkov, A.I., Shumilo, I.M. (1938) 'Egyptian Blue and Refractories for Copper Smelting Furnaces', *Doklady Akademii Nauk SSSR* 20: 685–7.

Jacqué, B. (2005) *Quand flamboie le bleu. Les papiers peints et le bleu outremer 1830-1870*. Rixheim: Musée du Papier Peint.

Jacqué, B., Jacqué, J. and Roland, D. (2002) *Comme un jardin, le végétal dans les étoffes imprimées et le papier peint*. Aix-en-Provence: Edisud.

Jacques, J. (1987) *Berthelot, autopsie d'un mythe*. Paris: Belin.

Jaime, M., Correa, V.F., Harrison, N., Batista, C.D., Kawashima, N., Kazuma, Y., Jorge, G.A., Stern, R., Heinmaa, I., Zvyagin, S.A., Sasago, Y. and Uchinokura, K. (2004) 'Magnetic-field-induced condensation of triplons in Han Purple pigment $BaCuSi_2O_6$', *Physical Review Letters* 93: paper 087203.

Jaksch, H., Seipel, W., Weiner, K.L. and El Goresy, A. (1983) 'Egyptian blue-cuprorivaïte, a window to ancient Egyptian technology', *Die Naturwissenschaften* 70: 525–35.

Janczak, J. and Kubiak, R. (1992) 'Refinement of the structure of barium copper silicate $BaCuSi_4O_{10}$ at 300K', *Acta Crystallographica Section C* 48: 1299–1301.

Johnson (1859) English Patent 891, granted 9 April 1859. [Published in *London Journal* (February 1860): 81.]

Jope, E.M. and Huse, G. (1940) 'Examination of 'Egyptian Blue' by X-Ray Powder Photography', *Nature* 146: 26.

Jugie, S. (2000) 'Les carreaux de faïence de Philippe le Hardi, duc de Bourgogne', in J. Rosen and T. Crépin-Leblond (eds), *Images du pouvoir: les pavements de faïence en France du XIIIᵉ au XVIIᵉ siècle*. Paris: Réunion des Musées Nationaux/Musée de Brou, 63–73.

Kaczmarczyk, A. (1986) 'The source of cobalt in ancient Egyptian pigments', in J.S. Olin and M.J. Blackman (eds), *Proceedings of the 24ᵗʰ International Archaeometry Symposium*. Washington, DC: Smithsonian Institution Press, 369–76.

Kahn, D. (1986) 'Recent discoveries of Romanesque sculpture at St Albans', in S. Macready and F.H. Thompson (eds), *Art and Patronage in the English Romanesque*. Society of Antiquaries of London. Occasional Papers (new series), VIII, 71–89 and plate 29a.

Kamrodt (1857), Preuss, Verhandlungen, 153.

Kamrodt (1858) 'Mémoire sur la fabrication du prussiate de potasse', *Bulletin de la Société d'Encouragement pour l'Industrie Nationale* (2ⁿᵈ series) 57(5): 771–82.

Kapff, F. (1792) *Beyträge zur Geschichte des Kobalts, Kobaltbergbaus und der Blaufarbenwerke*. Breslau.

Kellenbenz, H. (ed.) (1974) *Handelsbräuche des 16 Jahrhunderts. Das Meder'sche Handelsbuch und die Welser'schen Nachträge*. Wiesbaden.

Kirby, J. (1993) 'Fading and colour change of Prussian blue: occurrences and early reports', *National Gallery Technical Bulletin* 14: 62–71.

Kirby, J. and Saunders, D. (2004) 'Fading and colour change of Prussian blue: methods of manufacture and the influence of extenders', *National Gallery Technical Bulletin* 25: 73–99.

Kleber, R., Masschelein-Kleiner, L. and Thissen, J. (1967) 'Étude et identification du bleu maya', *Studies in Conservation* 12(2): 41–56.

Krafft, M. (1855) 'Emploi d'une nouvelle substance pour la fabrication du bleu de Prusse', *Bulletin de la Société d'Encouragement pour l'Industrie Nationale* (2ⁿᵈ series) 54(2): 49–51.

Kuhlman, K.F. (1829) 'Sur la production de l'Outremer artificiel', *Annales de Physique et de Chimie* 40: 439–41.

Kunckel, J. (1689) *Ars vitraria experimentalis*. Frankfurt and Leipzig. [Facsimile edition 1992, Hildesheim, Zürich and New York: G. Olms.]*

La Fontaine, J.H. de (1679) *L'Académie de la peinture, nouvellement mis au jour pour instruire la jeunesse à bien peindre en huile et en mignature*. Paris: B. Loyson.†

La Hire, P. de [1694] (1730) 'Traité pratique de la Peinture', in *Mémoires de l'académie royale des sciences depuis 1666 jusqu'à 1699*, vol. 9. Paris: Imprimerie royale.

Laboulaye, C. (1857) *Dictionnaire des Arts et Manufactures et de l'Agriculture formant un traité complet de technologie*. Paris.

Laboulaye, C. (1891) *Dictionnaire des Arts et Manufactures et de l'Agriculture formant un traité complet de technologie*, 7th edn., suppl. Paris.

Lafaurie, J. (1953) 'Catalogue des émissions officielles françaises de papier-monnaie, I – Billets de la Banque de France et du Trésor (1800–1952)', in *Bulletin de la Société d'Étude pour l'Histoire du Papier-Monnaie, No. 8*. Auxerre: Imprimerie modern.

Lalouette, C. (1986) *Thèbes*. Paris: Fayard.

Lamicq, P.C. (1990) 'Les voyages de "Monsieur Guillaume". Malesherbes dans les Pyrénées en 1767', *Pyrénées* 163–164: 247–81.

Lamprecht, I., Reller, A., Riesen R. and Wiedemann, H.G. (1997) 'Ca-oxalate films and microbiological investigations of the influence of ancient pigments on the growth of lichens', *Journal of Thermal Analysis* 49: 1601–7.

Landois, P. (1751a) 'Azur', in *Encyclopédie ou Dictionnaire raisonné des sciences, des arts et des métiers*, vol. 1. Paris: Briasson, David, Le Breton and Durand, 912–3.

Landois, P. (1751b) 'Blue Ashes', in *Encyclopédie ou Dictionnaire raisonné des sciences, des arts et des métiers*, vol. 1. Paris: Briasson, David, Le Breton and Durand, 284.

Landriani, M. (1783) 'Dell' azzurro di Berlino e dell' alkali flogisticato', in *Atti della Società patriotica di Milano diretta all' avanzamento dell' agricoltura, delle arti e delle manifatture*, vol. 1. Milan, 210–11.

Lapierre, N. (1990) 'La peinture monumentale de l'Asie centrale soviétique: observations techniques', *Arts asiatiques* 45: 28–40.

Larousse, P. (1866–1879) *Grand Dictionnaire Universel du XIXe siècle*. Paris: Administration du Grand Dictionnaire Universel.*

Laurie, A.P. (1935) 'Materials in Persian miniatures', *Technical Studies in the Field of the Fine Arts* 3: 146–56.

Laurie, A.P., Mc Lintock, W.F.P. and Miles, F.D. (1914) 'Egyptian Blue', *Proceedings of the Royal Society of London A*, 89(612): 418–29.

Lauth, C. (1881) 'Rapport sur les produits chimiques et pharmaceutiques. Section 4: Matières colorantes et couleurs', in *Exposition universelle internationale de 1878 à Paris. Rapports du jury international*, 73 vols., Groupe V, classe 47. Paris, *Outremer entry*, 222–39.

Lauth, C. (1882) 'Exposition Universelle Internationale de 1878 à Paris – Matières colorantes et couleurs – Couleurs minérales – Outremer', *Bulletin de la Société d'Encouragement pour l'Industrie Nationale* (3rd series) 9: 152–66.

Lautier, C. (2005) 'St Denis et la monarchie', in *La France romane*. Paris: Réunion des Musées Nationaux, 338–41.

Lavagne, H. (1988) 'Operosa Antra. Recherches sur la grotte à Rome, de Sylla à Hadrien', in *Bibliothèque des Écoles Françaises d'Athènes et de Rome* 272. Rome: Ecole française de Rome, 430–36.

Lazzarini, L. (1982) 'The discovery of Egyptian blue in a Roman fresco of the mediaeval period (ninth century A.D.)', *Studies in Conservation* 27(2): 84–6.

Le Baillif (1826) 'Lettre à M. Passalacqua contenant plusieurs procédés chimiques sur l'examen des couleurs, du blé, du pain et des cordes d'instrumens de musique de sa Collection par M. Le Baillif, trésorier de la Préfecture de police', in J.-F. L. Mérimée, *Catalogue raisonné et historique des Antiquités découvertes en Égypte par M. J Ph Passalacqua de Trieste (...)*. Paris: A la galerie d'Antiquités égyptiennes, 242.‡

Le Brun, J.-B. (1793) *Observation sur le Museum national*. Paris: Charon.† [New edition, Paris: Réunion des musées nationaux.]

Le Brun, J.-B. (1794) *Quelques idées sur l'agencement et la décoration du musée national*. Paris: Didot jeune.

Le Brun, J.-B. (1798–1799) *D'un musée national et de la nécessité de son établissement pour la conservation des chefs-d'œuvre conquis par nos armées*, an VII. Paris: Imprimerie du Journal de Paris.

Le Chatelier, A. (1899) French patent 292947 *Demande d'un brevet d'invention de 15 ans pour une nouvelle matière colorée*, granted 30 September 1899.

Le Chatelier, A. (1899/1900) Deutsches Reichspatent 112761 *Verfahren zur Herstellung von grünen, blauen und violetten Mineralfarben aus Kieselsaüre und Baryum- und Kupferverbindungen*.

Le Chatelier, H. (1900) *Jahresbericht der Chemischen Technologie* 46: 470–73.

Le Chatelier, H. (1907) 'Archäologisch-keramische Untersuchungen', *Zeitschrift für Angewandte Chemie* 20: 517–23.

Le Normand, L.-S. (1822) 'Azur', in *Dictionnaire technologique, ou Nouveau dictionnaire universel des arts et des métiers, et de l'économie industrielle et commerciale par une société de savans et d'artistes*, vol. 2. Paris: Thomine, 399–404.*

Le Normand, L.-S. and Moléon, J.-G.-V. de (1824) *Description des expositions des produits de l'industrie française, faites à Paris depuis leur origine jusqu'à celle de 1819 inclusivement; renfermant les noms et les adresses de tous les exposants tant nationaux qu'étrangers*, vol. 3. Paris: Bachelier.‡‡

Le Pileur d'Apligny, P.A. (1770) *Essai sur les moyens de perfectionner l'art de la teinture*. Paris: L. Prault.

Le Pileur d'Apligny, P.A. (1776a) *Cultures du pastel, de la gaude et de la garance*. Amsterdam and Paris: Moutard.*

Le Pileur d'Apligny, P.A. (1776b) *L'Art de la teinture des fils et étoffes de coton*. Paris: Moutard.*

Le Pileur d'Apligny, P.A. (1776c) *L'Art de la Teinture des Fils et Étoffes de Coton; précédé d'une Théorie nouvelle des véritables causes de la fixité des couleurs de bon teint; suivi Des cultures du pastel, de la gaude et de la garance, à l'usage des cultivateurs et des manufactures*. Paris: Moutard.*

Le Pileur d'Apligny, P.A. (1779) *Traité des couleurs matérielles et de la manière de colorer relativement aux différents Arts et Métiers*. Paris: Saugrain and Lamy.*

Lebègue, J. (1431) *Libri colorum*. Paris, Bibliothèque nationale de France, MS latin 6741.

Lebrun, P. (1635) *Recueuil des essaies des merveilles de la peinture*, chap. VII *Des couleurs*, Brussels, Royal Library, MS 15552. [Published in: M.P. Merrifield (1849)

Medieval and Renaissance treatises on the arts of painting. London. Reprinted 1967, New York: Dover, 767–841.]

Lécrivain, L. (1987) 'Céramiques', in *Les techniques de l'Ingénieur* A 7 290. Paris, 1–23.

Ledé, B. (2005) 'Étude d'une nouvelle méthode de synthèse des pigments outremers', doctoral thesis, University of Lille.

Lefort, J. (1855) 'Bleu de montagne', in *Chimie des couleurs pour la peinture à l'eau et à l'huile: comprenant l'historique, la synonymie, les propriétés physiques et chimiques, la préparation, les variétés, les falsifications, l'action toxique et l'emploi des couleurs anciennes et nouvelles.* Paris: Masson, 275–84.*

Lehman, C. (1770) 'Nachricht, von Auskunft der Blaufarbenwerke, in dem Obererzgebuerge', in Klotzsch (ed.), *Sammlung vermischter Nachrichten zur Sächsischen Geschichte*, vol. 4. Chemnitz: J.C. Stossel, 363–7.*

Lehman, C. (2012) 'L'art de la teinture à l'Académie royale des sciences au XVIIIe siècle', *Methodos* 12. [Available online at: methodos.revues.org]

Leveto, P.D. (1985) 'Castel Seprio, architecture and paintings', doctoral thesis, Indiana University.

Lichtenberger, G.-E. (1865) *Die Ultramarinfabrikation.* Weimar: B.F. Voigt.

Liebig, J. (1830a) 'Methode zur Darstellung von arsenikfreiem Kobalt und Nickel', *Annalen der Physik* 94: 164–7.

Liebig, J. (1830b) 'Note sur la préparation de l'oxyde de cobalt et de nickel', *Annales de Chimie et de Physique* 43: 204–8.

Lin, H.C., Liao, F.L. and Wang, S.L. (1992) 'Structure of $BaCuSi_4O_{10}$', *Acta Crystallographica Section C* 48: 1297–9.

Linquette, J.-L. (2002) *Un siècle à Saint-Ouen-l'Aumône.* Saint-Ouen-l'Aumône: du Valhermeil.

Linstead, R.P. (1934) 'Phthalocyanines. Part I. A new type of synthetic colouring matters', *Journal of the Chemical Society*: 1016–17.

Linstead, R.P. and Lowe, A.R. (1934a) 'Phthalocyanines. Part III. Preliminary experiments on the preparation of from phthalonitrile', *Journal of the Chemical Society*: 1022–7.

Linstead, R.P. and Lowe, A.R. (1934b) 'Phthalocyanines. Part V. The molecular weight of magnesium phthalocyanine', *Journal of the Chemical Society*: 1031–3.

Linstead, R.P. and Robertson, J.M. (1936) 'The stereochemistry of metallic phthalocyanines', *Journal of the Chemical Society*: 1736–8.

Liou, B and Zuinghedau, M. (tr.) (1995) *Vitruve, De l'Architectura: Livre VII.* Paris: Les Belles Lettres.

Lippolis, E. (1986) 'Kommotike techne', in *Les ors hellénistiques de Tarente.* Milan: Mondadori, 348–9.

Littmann, E.R. (1982) 'Maya blue. Further perspectives and the possible use of indigo as the colorant', *American Antiquity* 47: 404–8.

Liu, Z., Mehta, A., Tamura, N., Pickard, D., Rong, B., Zhou, T. and Pianetta, P. (2007) 'Influence of Taoism on the invention of the purple pigment used on the Qin terracotta warriors', *Journal of Archaeological Science* 34(11): 1878–83.

Loir, A.J. (1879a) 'Notes historiques sur la découverte de l'outremer artificiel', *Bulletin de la Société d'Encouragement pour l'Industrie Nationale* (3rd series) 6: 537–50.

Loir, A.J. (1879b) *Notes historiques sur la découverte de l'outremer artificiel*, reprint. Lyon: Association typographique, Lyon.

LRMF (1999) 'Cézanne et van Gogh', *Dossiers de l'art* 55: 54–61.

Ludi, A. (1988) 'Berliner Blau', *Chemie in unserer Zeit* 22(4): 123–7.

Macquer, P.J. (1753) 'Mémoire sur une nouvelle espèce de Teinture bleue, dans laquelle il n'entre ni pastel, ni indigo', in *Mémoires de Mathématique et de Physique tirés des registres de l'Académie Royale des Sciences de l'année 1749*. Paris: Imprimerie royale, 255–65.†

Macquer, P.J. (1756) 'Examen chymique du bleu de Prusse', in *Mémoires de Mathématique et de Physique tirés des registres de l'Académie Royale des Sciences de l'année 1752*. Paris: Imprimerie royale, 60–77.†

Macquer, P.J. (1763) *Art de la teinture en soie*. Paris: Servières.*

Macquer, P. (1773) 'Verrier', in *Dictionnaire raisonné universel des Arts et Métiers contenant l'histoire, la description, la police des fabriques et manufactures de France et des Pays Étrangers, ouvrage utile à tous les citoyens, nouvelle édition revue et mise en ordre par M. l'abbé Jaubert*, vol. 4. Paris: Didot jeune, 389–91.

MacTaggart, P. and MacTaggart, A. (1980) 'Refiners' Verditers', *Studies in Conservation* 25(1): 37–45.

Magaloni, D. (1998) 'Materiales y técnicas de la pintura mural maya', in Leticia Staines Cicero (coord.), *La pintura mural prehispánica en México: área maya. México, UNAM, Instituto de Investigaciones Estéticas*, vol. II, tomo III. 155–98

Magaloni, D. (2001) 'El arte en el hacer, técnica pictórica y color en las pinturas de Bonampak' in *La pintura mural prehispánica en México*. México: Instituto de Investigaciones Esteticas, Universidad Nacional Autónoma de México, 49–80.

Magaloni, D., Aguilar, M. and Castaño, V. (1991) 'Electron and optical microscopy of Prehispanic mural paintings', in P.B. Vandiver, J. Druzik and G.S. Wheeler (eds), *Materials Issues in Art and Archaeology II*. Pittsburgh: Materials Research Society, 145–50.

Magaloni, D., Pancella, R., Fruh, Y., Cañetas, J. and Castaño, V. (1995) 'Studies on the Mayan mortar technique', in P. Vandiver, J.R. Druzik, J.L. Galván Madrid, I.C. Freestone and G.S. Wheeler (eds), *Materials Issues in Art and Archaeology IV*. Pittsburgh: Materials Research Society, 483–9.

Magaloni, D., Newman, R., Banos, L., and Falcon,T. (1996) 'Los pintores de Bonampak', in *8th Palenque Round Table, 1993, San Francisco, Pre-Columbian Art Research Institute*, X. 158–68. ***

Mairinger, F. and Schreiner, M. (1986) 'Deterioration and preservation of Carolingian and medieval mural paintings in the Müstair convent (Switzerland) – Part II: materials and rendering of the Carolingian wall paintings', in *Case Studies in the Conservation of Stone and Wall Paintings*, Proceedings of the International Institute for Conservation Congress, Bologna, 1986. London: International Institute for Conservation of Historic and Artistic Works, 195–6.

Malesherbes, G. de (n.d.) [*c.* 1775] *Journal du chancelier G. de Lamoignon, seigneur de Blancmesnil et de Malesherbes*, Paris, Archives nationales, section 'archives privées', Journaux, shelf-mark FR CHAN 399AP/9.

Mallet, A. (1891) 'Prussiates', in C. Laboulaye, *Dictionnaire des Arts et Manufactures et de l'Agriculture formant un traité complet de technologie*. Paris: Comon.

Malouin, P.J. (1751) 'Bleu de Prusse', in *Encyclopédie ou dictionnaire raisonné des Sciences, des Arts et des Métiers, par une Société de Gens de Lettres*, vol. 2. Paris: Briasson, David, Le Breton and Durand, 283–4.

Maret (1807) *Rapport, projets d'avis, de décrets et tableaux relatifs à la Division et Concession des Terrains houilliers dans le département de la Sarre et dans une partie de celui de la Moselle*, September the 24th, 1807. Paris: Imprimerie Nationale.

Marggraf, A.S. (1758) 'Rapport de quelques expériences faites sur la pierre qu'on nomme lapis lazuli', in *Mémoires de l'Académie de Berlin*. Berlin: Haude and Spener, 10–19.*

Marggraf, A.S. (1762) *Opuscules chymiques de M. Marggraf*, vol. 2. Paris: Vincent.*

Marggraf, A.S. (1783) 'Expériences sur la Mine du Cobald calcinée', *Nouveaux Mémoires de l'Académie Royale des Sciences et Belles Lettres, classe de Philosophie expérimentale, année 1781*. Berlin: Decker, 3–8.

Margueritte, F. and Sourdeval, A.L. de (1860) French patent 1171, granted 11 May 1860.

Marsan, F. de (1929) 'La manufacture de bleu d'azur de Saint-Mamet (Luchon)', *Bulletin de la Société Ramond*: 79–83.

Martin, E. and Bergeon, S. (1996) 'Des bleus profonds chez les Primitifs italiens', *Technè* 4: 74–89.

Matthew, L.C. (2002) 'Vendecolori a Venezia: the reconstruction of a profession', *Burlington Magazine* 144(1196): 680–86.

Mazzi, F. and Pabst, A. (1962) 'Reexamination of cuprorivaite', *The American Mineralogist* 47: 409–11.

Médailles d'or (1846) 'Médailles d'or', *Bulletin de la Société d'Encouragement pour l'Industrie Nationale* (1st series) 45: 72.

Medals (1862) *Medals and Honourable Mentions awarded by the International Juries*, 2nd edn., class II, section A: *Chemical Products*. London, 28–40.

Mein, R. (n.d.) 'A brief history of the Backbarrow Blue Mills' (www.coltonparishcouncil.org.uk/a_brief_history_of_the_backbar.htm, accessed 2012).

Meissner, B. (1925) *Babylonien und Assyrien*, vol. 2. Heidelberg: C. Winter.

Melzer (1684) *Berglauftige Beschreibung der Stadt Schneeberg*.

Ménon, F. (1750a) 'Mémoire sur le bleu de Prusse', in *Mémoires de Mathématique et de Physique, Présentés à l'Académie Royale des Sciences, par divers Sçavans, & lûs dans les Assemblées*, vol. 1. Paris: Imprimerie Royale, 563–72.

Ménon, F. (1750b) 'Second mémoire sur le bleu de Prusse', *Mémoires de Mathématique et de Physique, Présentés à l'Académie Royale des Sciences, par divers Sçavans, & lûs dans les Assemblées*, vol. 1. Paris: Imprimerie Royale, 573–92.

Mérimée, J.-F.L. (1803) 'Rapport sur les prix proposés en l'an X, pour la fabrication du blanc de plomb et pour celle du bleu de Prusse par le Citoyen Mérimée, peintre',

Bulletin de la Société d'Encouragement pour l'Industrie Nationale (1st series) 1(6): 113–14.

Mérimée, J.-F.L. (1818) 'Rapport fait au nom du Comité des arts chimiques, sur des échantillons de bleu de Prusse présentés par M. Drouet, demeurant rue Saint-Denis, n°.188, à Paris', *Bulletin de la Société d'Encouragement pour l'Industrie Nationale* (1st series) 17(163): 27–8.

Mérimée, J.-F.L. (1826) *Catalogue raisonné et historique des Antiquités découvertes en Égypte par M. J Ph Passalacqua de Trieste (...)*. Paris: A la galerie d'Antiquités égyptiennes.‡

Mérimée, J.-F.L. (1828) 'Rapport sur le prix proposé pour la fabrication d'un outremer artificiel', *Bulletin de la Société d'Encouragement pour l'Industrie Nationale* (1st series) 27(293): 346–9.

Mérimée, J.-F.L. (1830) *De la peinture à l'huile ou des procédés matériels employés dans ce genre de peinture depuis Hubert et Jean Van-Eyck jusqu'à nos jours*. Paris: Huzard. [Facsimile reprint 1981, Puteaux: EREC.]

Mérimée, J.-F.L. (1831) 'Note sur les perfectionnemens apportés par M. Guimet à la fabrication de son outremer', *Bulletin de la Société d'Encouragement pour l'Industrie Nationale* (1st series) 30(322): 227–9.

Mérimée, J.-F.L. (1834) 'Rapport fait au nom du Comité des Arts chimiques', *Bulletin de la Société d'Encouragement pour l'Industrie Nationale* (1st series) 33(358): 166–8.

Merret, C. (1662) *The Art of Glass, wherein are shown the wayes to make and colour Glass, Pastes, Enamels, Lakes and other Curiosities*. London: O. Pulleyn.

Merrifield, M.P. (1849) *Medieval and Renaissance Treatises on the Arts of Painting*, London: J. Murray. [Reprinted 1967 and 1999, New York: Dover.]

Merwin, E.H. (1931) 'Chemical analysis of pigments' in E.H. Merwin, J. Charlot and A.A. Morris (eds), *The Temple of the Warriors at Chichén Itzà, Yucatán*. Carnegie Institution of Washington Publication 406. Washington DC: Carnegie Institution of Washington, 355–6.

Meurdrac, M. (1666) *La chymie charitable et facile, en faveur des dames*. Paris: L. d'Houry. [New edition 1999, J. Jacques (ed.). Paris: Centre National de la Recherche Scientifique.]

Micault, V. (1881) 'Couleurs anciennes obtenues par l'emploi des oxydes de cuivre', *Bulletin de la Société Minéralogique de France* IV: 82–4.

Milanesi, G. (1864) *Dell arte del vetro per musaico tre tratelli*. Bologna.

Minguzzi, C. (1938) 'Cuprorivaite: un nuovo minerale', *Periodico di Mineralogia* 3: 333–45.

Moléon, J.G. de, Cochaud A. and Paulin-Desormeaux, A.O. (1835–1838) *Musée industriel, description complète de l'exposition des produits de l'industrie française faite en 1834, ou Statistique industrielle, manufacturière et agricole de la France à la même époque*. Paris: Bureau de la société polytechnique et du recueil.*

Morley, S.G., Ruppert, K., Thompson, E.S. and Proskouriakoff, T. (1955) *Bonampak, Chiapas, Mexico*. Carnegie Institution of Washington Publication 602. Washington DC: Carnegie Institution of Washington.

Mortari, R. and del Caldo, M.A. (1971) 'Risultato delle analisi dal Laboratorio tecnico della Giunta dei Musei archeologici dell'Università di Roma su campioni di probabili colori provenienti dal riempimento del vano C del santuario', in M. Torelli, F. Boitani, F. Rasmussen, G. Lilliu, R. Mortari, M.A. del Caldo, *Gravisca (Tarquinia). Scavi nella città Etrusca e Romana, campagne 1969-1970*, Notizie degli scavi, 8, XXV, 195–299.

Moyret, M. (1880) 'Couleurs et teintures en usage dans l'antiquité comparées à celles en usage de nos jours', *Le teinturier pratique* 2: 15–18.

Mühlethaler, B. and Thissen, J. (1986) 'Smalt', in A. Roy (ed.), *Artists' Pigments: A Handbook of their History and Characteristics*, vol. 2. Washington, DC: National Gallery of Art, 113–130.

Mulsant, E. (1893) *Notice sur J.-B. Guimet*. Lyon: Association typographique.

Navas, J.R. (2003) *Monografía sobre recursos minerales de cobalto en España*. Madrid: Instituto Geológico y Minero de España.

Neri, A. (1612) *L'Arte vetraria, distinta in libri sette*. Florence.*

Nicholson, P.T. (1995) 'Glassmaking and glassworking at Amarna: some new work', *Journal of Glass Studies* 37: 11–19.

Nomenclature des manufactures (1814) *Nomenclature des manufactures, établissemens et ateliers répandant une odeur insalubre ou incommode, ou dont l'exploitation peut causer des incendies* (25 March 1814). Paris: Imprimerie Impériale. Paris, Archives du Conseil d'État, 3053 bis, nº40818.

Note sur les dégradations (1785) *Note sur les dégradations des bois de Saint-Mamet et de Bagnères-de-Luchon*, Paris, Centre historique des Archives nationales, série K, Monuments historiques, titre VII: législation, économie, finances, shelf-mark 904, 55.

Notice des principaux tableaux (1798–1799) *Notice des principaux tableaux recueillis dans la Lombardie par les commissaires du Gouvernement Français* etc. Imprimerie des sciences et des arts, an VII.†

Official catalogue (1851) *Official catalogue of the Great Exhibition of the Works of Industry of All Nations*. London: W. Clowes.*

Omoto, K. and Macouin, F. (1990) *Quand le Japon s'ouvrit au monde*. Paris: Gallimard.

Onoratini, G., Conrad, G. and Michaud, L. (1987) 'Identification de deux silicates de cuivre de synthèse, confondus sous l'appellation générique de "bleu égyptien", et définition des céramiques "bleu antique" retrouvées dans les fresques', *Comptes Rendus de l'Académie des Sciences de Paris* (2nd series) 304(12): 651–4 (with a plate).

Ovarlez, S. (2003a) 'Aportacion de la colorimetria al estudio de las recetas antiguas de fabricacion de los azules mayas', in Boletin informativo *La pintura mural prehispanica en México*, Instituto de Investigaciones Esteticas, Universidad Nacional Autonoma de México, IX, 19, 35–42.

Ovarlez, S. (2003b) 'Yax. Fabrications et utilisations des bleu-vert mayas', Mémoire de fin d'études, École d'Art d'Avignon.

Ovarlez, S. (2004) 'Comentarios respecto al estudio del azul maya', in Boletin informativo *La pintura mural prehispanica en Mexico*, Instituto de Investigaciones Esteticas, Universidad Nacional Autonoma de México, X, 21, 65–71.

Ovarlez, S. (2008) 'Le bleu maya et ses secrets: réactivité indigo-sépiolite et son influence sur la couleur du nanocomposite obtenu. Vers l'élaboration de couleurs inspirées du modèle maya', doctoral thesis, Nice University.

Ovarlez, S., Chaze, A.-M., Giulieri, F. and Delamare, F. (2006) 'Indigo chemisorption in sepiolite. Application to Maya blue formation', *Comptes Rendus de l'Académie des Sciences, Chimie* 9(10): 1243–8.

Ovarlez, S., Giulieri, F., Chaze, A.-M., Delamare, F., Raya, J. and Hirschinger, J. (2009) 'The incorporation of indigo molecules in sepiolite tunnels', *Chemistry–A Europeran Journal* 15: 11326–32.

Ovarlez, S., Falcon Alvarez, T. and Delamare, F. (forthcoming) 'The evolution of Mayan artists' blue and greenish-blue palette. A colorimetric and experimental study', in *Dyes in History and Archaeology 23*. London: Archetype Publications.

Pabst, A. (1959) 'Structures of some tetragonal sheet silicates', *Acta Crystallographica* 12: 733–9.

Pagès-Camagna, S. (1999) 'Propriétés physico chimiques d'un pigment vert synthétique égyptien. Couleur, structure, recherche des techniques d'élaboration', doctoral thesis, Marne-la-Vallée University.

Pastoureau, M. (1983) 'Et puis vint le bleu', *Europe* 654: 43–50.

Pastoureau, M. (1989) *Couleurs, images, symboles*. Paris: Le Léopard d'or.

Pastoureau, M. (1997) *Jésus chez le teinturier*. Paris: Le Léopard d'or.

Pastoureau, M. (2000) *Bleu, histoire d'une couleur*. Paris: Seuil.

Payen, A. (1823a) *Dictionnaire technologique, ou nouveau dictionnaire universel des arts et des métiers, et de l'économie industrielle et commerciale, par une société de savans et d'artistes*, vol. 3. Paris.

Payen, A. (1823b) 'Rapport fait par M. Payen, au nom du Comité des arts chimiques, sur le prussiate de potasse de M. Vincent', *Bulletin de la Société d'Encouragement pour l'Industrie Nationale* (1st series) 22(233): 305.

Payen, A. (1836) 'Rapport fait au nom du Comité des arts chimiques sur plusieurs questions de prix à mettre au concours pour les années 1837 et 1839', *Bulletin de la Société d'Encouragement pour l'Industrie Nationale* (1st series) 35(390): 465.

Payen, A. (1845) 'Rapport fait par M. Payen, au nom du comité des arts chimiques, sur la fabrique d'outremer de M. Courtial', *Bulletin de la Société d'Encouragement pour l'Industrie Nationale* (1st series) 44(495): 387–8.

Payen, A. (1862) 'Bleu de Prusse et prussiate de potasse. Nouveaux procédés de fabrication', in *Aperçu général sur l'exposition de 1862*, Annales du Conservatoire Impérial des Arts et Métiers (1st series), vol. 3. Paris: E. Lacroix, 48–54.

Péligot, E.M. (1844) *Exposition des produits de l'industrie française en 1844. Rapport du jury central*, vol. 2. Paris: Fain and Thunot.*

Pelletier, B. (1792) 'Extraits d'un mémoire sur les cendres bleues', *Observations et mémoires sur la Physique, sur l'Histoire naturelle et les Arts et Métiers* XL(1): 320.

Pelletier, B. (1798) 'Examen chimique des cendres bleues, et procédé pour les préparer', in *Mémoires et observations de chimie de Bertrand Pelletier recueillis et mis en ordre par C. Pelletier et Sédillot jeune*, vol. 2. Paris: Imprimerie de la République, an VI, 1–21.*

Pelletier, C. (1798) 'Éloge de Bertrand Pelletier', in *Mémoires et observations de chimie de Bertrand Pelletier recueillis et mis en ordre par C. Pelletier et Sédillot jeune*, vol. 1. Paris: Imprimerie de la République, an VI, vii-xxvii.

Pelouze, E. (1828) *Art de fabriquer les couleurs et vernis, de préparer les huiles, les colles, etc., pour tous les genres de peintures*. Paris: Audot.

Perego, F. (2005) *Dictionnaire des matériaux du peintre*. Paris: Belin.

Perfectionnements (1847) 'Perfectionnements dans la fabrication des ferro-cyanures de potassium et de sodium, patente accordée à M. James Laming, de Londres, le 18 novembre 1848', *Bulletin de la Société d'Encouragement pour l'Industrie Nationale* (1st series) 46(511): 61–5.

Péronnet, M. (ed.) (1988) *Chaptal*. Toulouse: Privat.

Perrat, M.-J. (1995) 'L'or et l'azur: les manuscrits de la famille Rolin', in *Regards sur les manuscrits d'Autun, VIe – XVIIIe siècle*. Autun, 128–47.

Perrault, C. (1673) *Les dix livres d'architecture de Vitruve, corrigez et traduits nouvellement en François, avec des Notes & des Figures*. Paris: chez Jean Baptiste Coignard.

Persoz, J. (1846) *Traité théorique et pratique de l'impression des tissus*. Paris: Masson.

Persoz, J. (1854) *Les tissus imprimés* in *Exposition Universelle de 1851. Travaux de la Commission française sur l'Industrie des Nations, publiés par ordre de l'Empereur*, vol. 5, 3rd group, 2nd section, XVIIIth jury. Paris: Imprimerie impériale, 1–74 and sp. 33–35.*

Peterson, C.L. (1950) 'Egyptian blue and related compounds', Master's thesis in Science, n°854858, Ohio State University.

Petit, J., Roire, J. and Valot, H. (1999) *Encyclopédie de la peinture, formuler, fabriquer, appliquer*. Puteaux: EREC.

Petrie, W.M.F. (1894) *Tell el Amarna*. London: Methuen and Co.

Peyret, S. (1994) *Les billets de la Banque de France*. Paris: Médailler.

Pinault, M. (1987) 'Savants et teinturiers', in *Sublime indigo*. Fribourg: Office du livre, 135–64.

Pinet, G. (1913) *Léonor Mérimée (1757–1836)*. Paris: H. Champion.

Pisani, F. (1880) 'Substance bleue provenant d'un ancien atelier gallo-romain', *Bulletin Société Minéralogique de France* 3: 197–8.

Pitoiset, S. and Grichois, M.C. (2002) 'Les produits d'entretien et papeterie', in *Questions d'étiquettes (mille et une étiquettes de 1830 à nos jours)*, catalogue from the *Bibliothèque Forney* exhibit in Paris. Paris: Adam Biro, 188–213.

Plicque, J.F. (1878) 'Expériences relatives à la formation de l'outremer artificiel', *Bulletin de la Société d'Encouragement pour l'Industrie Nationale* (3rd series) 5: 255–7.

Pliny the Elder [*c.* 50–70] (1857) *Naturalis Historia*, Bostock and Riley (English tr.). London: H. Bohn.*

Pliny the Elder [*c.* 50–70] (1983) *Naturalis Historia*, book XXXIII, H. Zehnacker (French ed. and tr.). Paris: Les Belles Lettres.

Pliny the Elder [*c.* 50–70] (1997) *Naturalis Historia*, book XXXV, J.-M. Croisille and P.-E. Dauzat (French eds. and tr.). Paris: Les Belles Lettres.

Poggendorff, J.C. (1858) *Biographisch-literarisches Handwörterbuch zur Geschichte der exacten Wissenschaften* etc. Leipzig: J.A. Barth.

Polette, L.A., Meitzner, G., Yacamàn, M.J. and Chanelli, R.R. (2002) 'Maya blue: application of XAS and HRTEM to materials science in art and archaeology', *Microchemical Journal* 71: 167–74.

Possoz and Boissière (1845) *London Journal of Arts*: 380.

Pozza, G., Ajò, D., Chiari, G., De Zuane, F. and Favoro, M. (2000) 'Photoluminescence of the inorganic pigments Egyptian blue, Han blue and Han purple', *Journal of Cultural Heritage* 1: 393–8.

Premiums offered in the Year 1801 (1801) '*Premiums offered in the Year 1801*', in *Transactions of the Society for the Encouragement of Arts, Manufactures and Commerce*, vol. XIX. London: W. and C. Spilsbury.*

Premiums offered in the Year 1812 (1813) 'Premiums offered in the Year 1812', in *Transactions of the Society for the Encouragement of Arts, Manufactures and Commerce*, vol. XXX. London: R. Wilks.*

Preusser, F., Graeve, V. von and Wolters, C. (1981). 'Malerei auf griechischen Grabsteinen', *Maltechnik-Restauro* 87: 11–34.

Procédé de fabrication (1842) 'Procédé de fabrication du prussiate de potasse et du prussiate de soude par M. Delaunay', *Bulletin de la Société d'Encouragement pour l'Industrie Nationale* (1st series) 41(460): 419–21.

Procès verbal (1849) 'Procès verbal de la séance du 4 juillet 1849', *Bulletin de la Société d'Encouragement pour l'Industrie Nationale* (1st series) 48(541): 325–6.

Programmes des prix (1824) 'Programmes des prix', *Bulletin de la Société d'Encouragement pour l'Industrie Nationale* (1st series) 23(236): 6–7.

Programme d'un Prix (1810) 'Programme d'un Prix proposé par ordre de S. M. L'EMPEREUR et ROI, pour remplacer l'indigo dans les teintures, tant par les produits du sol français que par ceux de l'industrie', *Bulletin de la Société d'Encouragement pour l'Industrie Nationale* (1st series) 9(72): 155–9.

Programmes, Arts chimiques (1825) 'Programmes, Arts chimiques', *Bulletin de la Société d'Encouragement pour l'Industrie Nationale* (1st series) 24(VII): 12–13.

Programmes, Arts chimiques (1826) 'Programmes, Arts chimiques', *Bulletin de la Société d'Encouragement pour l'Industrie Nationale* (1st series) 25(XV): 24–5.

Programmes, Arts chimiques (1827) 'Programmes, Arts chimiques', *Bulletin de la Société d'Encouragement pour l'Industrie Nationale* (1st series) 26(XII): 22.

Programme XIII (1836) 'Programme XIII: Prix pour la description exacte de la préparation de l'outremer factice', *Bulletin de la Société d'Encouragement pour l'Industrie Nationale* (1st series) 35(379): 18.

Proust, L.J. (1799) 'Recherches sur le bleu de Prusse', *Journal de Physique* 6: 241–51.

Proust, L.J. (1806) 'Sur les mines de cobalt, nickel et autres', *Journal de Physique* 63: 566–8.

Prückner, C.P. (1844) *Journal de Chimie pratique d'Erdmann* 33: 257. [French translation: Debette, M. (tr.) (1845) 'Sur la fabrication en grand de l'outremer artificiel en Allemagne', *Bulletin de la Société d'Encouragement pour l'Industrie Nationale* (1st series) 44(480): 263–6.]

Pulak, C. (1998) 'The Ulu Burun shipwreck: an overview', *International Journal of Nautical Archaeology* 27: 188–224.

Pulak, C. (2001) 'The cargo of the Ulu Burun ship and evidence for trade with the Aegean and beyond', in L. Bonfante and V. Karageorghis (eds), *Italy and Cyprus in Antiquity, 1500–450 BCE*. Nicosia: The Costakis and Leto Severis Foundation, 13–60.

Quarré, P. (1955). *Les carreaux de pavement de l'oratoire ducal à la chartreuse de Champmol*, Mémoires de la Commission des Antiquités de la Côte d'Or, t. XXIII, 1947–1953.

Rabanus Maurus (1988) *De laudibus sanctæ crucis*, M. Perrin (tr.). Paris: Berg International [Translation, annotation and presentation M. Perrin.]

Raby, J.-A. (1833) 'Sur le gisement des divers minerais de cuivre de Sain-Bel et de Chessy', *Annales des Mines* (3rd series) 4: 393–408 and plate IX.

Rapport fait à la Classe des Sciences physiques (n.d.) *Rapport fait à la Classe des Sciences physiques et mathématiques d'après la demande de S. Exc. le ministre de l'intérieur, sur la question de savoir quel parti on doit prendre, par rapport aux Fabriques dont le voisinage peut porter préjudice aux particuliers (par la Section de chimie)*, Paris, Archives du Conseil d'État, 2054, section de l'Intérieur, n°23906.

Rapport, projet de décret et projet d'avis (n.d.) *Rapport, projet de décret et projet d'avis, relatifs à la Translation d'une Fabrique de bleu de Prusse, située rue Saint-Nicolas, à Paris*, Paris, Archives du Conseil d'État, 2764, section de l'Intérieur, n°36182.

Rapport, projet de décret et projet d'avis (1813) *Rapport, projet de décret et projet d'avis, relatifs à une demande en établissement d'une Fabrique de Bleu-de-Prusse, rue des Bourguignons, à Paris* (20 April 1813). Paris: Imprimerie Impériale. [id. Paris, Archives du Conseil d'État: 9978.30. Paris, Archives de l'Ordre des avocats de Paris, vol. 28, pièce 69. Paris, Archives du Sénat, vol. 41, pièce 2878. Paris, Archives de l'Assemblée nationale, vol. 35, pièce 2878. London, British Library, 5403.b.4. (40). Paris, Archives Nationales: BB 30 1150.]

Rapport sur le Prix du Bleu de Prusse (1803) 'Rapport sur le Prix du Bleu de Prusse', *Bulletin de la Société d'Encouragement pour l'Industrie Nationale* (1st series) 2(13): 16–19. [Reprinted 1810, page numbers 110–11.]

Raymond, J.M. (1811) *Description raisonnée d'un Procédé sûr et facile pour teindre la Soie en bleu de Prusse d'une manière égale, solide et brillante, dans les nuances les plus foncées, sans lui ôter aucune de ses qualities*. Paris: Imprimerie impériale.

Raymond, J.M. (1814) 'Description d'un Procédé inventé par M. Raymond, professeur de chimie à Lyon, pour teindre la Soie avec le Bleu de Prusse, d'une manière égale, solide et brillante', *Bulletin de la Société d'Encouragement pour l'Industrie Nationale* (1st series) 13(116): 29–41.

Raymond, P. (1828a) 'De la teinture des Laines au moyen du bleu de Prusse', *Annales de Chimie et de Physique* 39: 44–77.

Raymond, P. (1828b) 'Extrait d'un Mémoire sur la teinture des laines au moyen du bleu de Prusse par M. Raymond fils', *Bulletin de la Société d'Encouragement pour l'Industrie Nationale* (1st series) 27(292): 312–16.

Raymond, P. (1828c) 'On the dyeing of Wool with Prussian Blue', *The Quaterly Journal of Science, Literature and Art, London*: 427–8.

Rees Jones, S. (1990) 'Early experiments in pigments analysis', *Studies in Conservation* 35(2): 93–101.

Régnier (1781) 'Minutes from June the 2nd, 1781', archives of the Sèvres Manufacture. [Quoted in: d'Albis, A. (1999) 'Les ressources d'un art décoratif', *Dossier de l'Art, Sèvres, histoire inédite de la manufacture au XVIIIe siècle* 54: 62–89.]

Reinen, D. and Lindner, G.-G. (1999) 'The nature of the chalcogen colour centres in ultramarine-type solids', *Chemical Society Reviews* 28: 75–84.

Reyes Valerio, C. (1993) *De Bonampak al Templo Mayor: el azul maya en Mesoamérica*. Mexico: Siglo XXI editors.

Riederer, J. (1968) 'Die Smalte', *Deutsche Farben-Zeitschrift* 22(9): 386–95.

Robertson, J.M. (1935) 'An X-ray study of the structure of phthalocyanines. Part I. The metal free, nickel, copper and platinum compounds', *Journal of Chemical Society*: 615–21.

Robertson, J.M. (1936) 'An X-Ray study of phthalocyanines. Part II. Quantitative structure determination of the metal free compound', *Journal of the Chemical Society*: 1195–1209.

Robertson, J.M., Linstead, R.P. and Dent, C.E. (1935) 'Molecular weight of phthalocyanines', *Nature* 135: 506–7.

Robiquet, P. (1823) *Dictionnaire technologique, ou nouveau dictionnaire universel des arts et métiers, et de l'économie industrielle et commerciale, par une société de savans et d'artistes*, vol. 3. Paris: Thomine.

Robiquet, P. (1832) 'Procédé pour fabriquer à bas prix une couleur analogue à l'outremer naturel', in *Académie des Sciences, Procés-verbaux des séances*, vol. XI, 1832–1835, séance du 31 décembre 1832. Paris: Firmin-Didot, 173

Rodari, F. (1996) 'Jacob Christoph Le Blon, l'œil trichrome', in *Anatomie de la couleur. L'invention de l'estampe en couleurs*. Paris: Bibliothèque nationale de France, 52–90.

Roger, P. (2007) 'Étude des couleurs et de la pratique picturale', *Art de l'enluminure, L'évangéliaire de Charlemagne* 20: 46–64.

Roger, P. and Vezin, J. (2007) 'Étude des matériaux de la couleur dans les manuscrits médiévaux. Emploi inédit de bleu égyptien dans trois manuscrits des VIIIe et Xe siècles', *Comptes-Rendus de l'Académie des Inscriptions et Belles-Lettres, Paris, AIBL* 151(1): 67–87.†††

Roger, P., Barrandon, J.-N. and Bos, A. (2004) 'Discovering of the Egyptian blue employment for the decoration in a 10th century manuscript, characterised by absorption in diffuse reflectance spectrometry', in J. Pérez Arantegui (ed.), *34th International Symposium on Archaeometry, Saragossa, 3–7 May, 2004*. Saragossa: Institución Ferrando el Católico, 341-5.

Rolley (2003) *La tombe princière de Vix*. Paris: Picard.

Romé de Lisle, J.-B. (1783) *Cristallographie ou description des formes propres à tous corps du règne minéral dans l'état de combinaison saline, pierreuse ou métallique*. Paris: Imprimerie de Monsieur.*

Rosen, J. (2000) 'L'avènement du bleu sous les Valois, in La faïence française du XIIIe au XVIIe siècle', *Dossier de l'art* 70: 16–19.

Rosenquist, A.M. (1959) 'Analyser an skerd og skjold fra BØfunnet', *Viking* 12: 33–4.

Rotondi Terminiello, G. (1978) 'IV. Il restauro della lunetta del portale maggiore, in La facciata della cattedrale di San Lorenzo, Genova', in A. de Floriani, G. Fusconi, E. Mazzino, P. Melli and A. Surace (eds), *Restauri in Liguria*. Genoa: SAGEP, 224–8.

Roy, A. (2007) 'Cobalt blue', in B.H. Berrie (ed.), *Artists' Pigments: A Handbook of their History and Characteristics*, vol. 4. Washington, DC: National Gallery of Art and London: Archetype Publications, 150–77.

Rufino, P.-G. (1991) *Le pastel, or bleu du Pays de Cocagne*. Drémil-Lafage: D. Briand.

Ruska, J. (1926) 'Kritisches zu R. Eislers chemiegeschichtlicher Methode', *Zeitschrift für Assyriologie und Vorderasiatische Archäologie* XXXVII(IV): 273–82.

Russell, W.J. (1892) 'Egyptian colours', in W.M.F. Petrie, *Medum*. London: D. Nutt, chap. VIII, 44–7.

Russell, W.J. (1893–1895) 'Ancient Egyptian Pigments', *Proceedings of the Meetings of the Royal Institution of Great-Britain* 14: 67–71.

Russell, W.J. (1894) 'Ancient Egyptian Pigments', *Nature* 49: 374–5.

Sage, B.G. (1777) *Éléments de minéralogie docimastique*. Paris: Imprimerie royale.†

Sage, B.G. (1789) 'Note sur le bleu de Prusse', *Observations sur la Physique* 34: 333–4.

Sage, B.G. (1791) 'Analyse d'une Mine de Cobalt sulfureuse & arsenicale recouverte d'une efflorescence rougeâtre de Vitriol de Cobalt, de la vallée de Giston dans les Pyrénées Espagnoles', *Journal de Physique* XXXIX: 53–8.

Saint-Jean-d'Angely, R. de (1810) *Rapport et projet de décret relatifs aux Manufactures et Établissemens qui répandent une odeur insalubre ou incommode* (30 June 1810). Paris: Imprimerie Impériale. Paris, Archives du Conseil d'État, 2054, section de l'intérieur, n° 23906.

Saleh, S.A., Iskander, Z., El Masry, A.A. and Helmi, F.M. (1974) 'Some ancient Egyptian pigments', in A. Bishay (ed.), *Recent advances in Science and Technology of Materials*, vol. 3. New York: Plenum Press, 141–55.

Sanchez, M.R. (1976) *Historia del Añil o Xiquilite en Centroamérica*, 2 vols. El Salvador: Ministerio de Educación.

Santrot J. and Corson, S. (2012) 'Pigments, cosmétiques ou médicaments? Dans la tombe gallo-romaine de Saint-Médard-des-Près (Vendée)', in J.-P. Brun, D. Frère and L. Hugot (eds), *Les huiles parfumées en Méditerranée occidentale et en Gaule, (VIIIe s. av.-VIIe s. ap. J.-C.)*, actes du colloque de l'École française de Rome, 16–18 novembre 2009. Presses universitaires de Rennes, 191–215 and 30 plates.

Sapin, C. (ed.) (1999) *Peindre à Auxerre au Moyen Âge IXe – XIVe siècles*. Auxerre: Comité des Travaux Historiques et Scientifiques and Centre d'études médiévales d'Auxerre.

Scheele, C.W. (1782) 'Försök, angående det färgande amnet i berliner blå' [Essays concerning the colouring matter of Berliner blue], *Öfversigt af Kongl. Vetenskaps Akademiens Förhandligar* 3: 264. [French translation in: (1785) *Mémoires de Chymie de M. C. W. Schéele, tirés de l'Académie Royale des Sciences de Stockholm, traduits*

du suédois et de l'allemand, vol. 2. Dijon, Causse and Paris: T. Barrois, 141. English translation: (1786), *The chemical essays of C.W. Scheele*. London: J. Murray.]

Scheele, C.W. (1783) 'Försök, angående det färgande amnet i berliner blå' [Essays concerning the colouring matter of Berliner blue], *Öfversigt af Kongl. Vetenskaps Akademiens Förhandligar* 4: 33.

Schiegl, S., Weiner, K.L. and El Goresy, A. (1990) 'Zusammensetzung und Provenienz von Blau- und Grünpigmenten in Altägyptischen Wandmalereien: Ein Beitrag zur exakten Chronologie der Bronzetechnologie in Altägypten', *Erzmetall* 43(6): 265–72.

Schippa, G. and Torraca, G. (1957) 'Contributo alla conoscenza del "bleu egiziano"', *Bollettino dell'Istituto Centrale del Restauro* 31–32: 97–107.

Schreiber, J.G. (1784) 'Observations sur la montagne des Chalanches près d'Allemont en Dauphiné, et sur les gîtes de minerai d'argent qui s'y trouvent, adressées par M. Schreiber, directeur des mines de Monsieur, à M. le baron Dietrich, secrétaire général des Suisses et Grisons, le 19 décembre 1783; lues à l'Académie royale des sciences le 28 avril 1784, et approuvées le 1er mai suivant', *Observations sur la physique, sur l'histoire naturelle et sur les arts*: 380–87. [id. 1838–1840, *Bulletin de la Société scientifique du Dauphiné, Société de statistique des sciences naturelles et des arts industriels du département de l'Isère* (1st series) 1: 114–22.]

Schvœrer, M., Delavergne, M.-C. and Chapoulie, R. (1988) 'The thermoluminescence of Egyptian blue', *International J. of Radiation Applications and Instrumentation, part D, Nuclear Tracks and Radiations Measurements* 14(1/2): 321–7.

Séance du 14 juillet 1830 (1830) 'Séance du 14 juillet 1830', *Bulletin de la Société d'Encouragement pour l'Industrie Nationale* (1st series) 29(313): 291–2.

Sear, F.B. (1977) *Roman wall and vault mosaics*, Mitteilungen des Deutschen Archeologischen Instituts. Heidelberg: F.H. Kerle Verlag.

Secrets concernant les Arts et Metiers (n.d.) [c. 1750] *Secrets concernant les Arts et Metiers, Nouvelle Édition, revûë, corrigée & considérablement augmentée*. Nancy.

Secrets concernant les Arts et Metiers (1819) *Secrets concernant les Arts et Métiers*, vol. 2, new augmented edn., *Art de la Teinturerie*. Lyon, 1819.

Shepard, A.O. and Gotlieb, H.B. (1962) *Maya blue: alternative hypothesis*. Notes from a ceramic laboratory 1. Washington DC: Carnegie Institution of Washington.

Slitine, F. (2005) *Histoire du verre. L'Antiquité*. Paris: Masson.

Smith, J. (1730) *A short and direct method of Painting in Water-colours*. London: privately printed.

Smith, J.T. (1807) *Antiquities of Westminster*. London: Bensley.‡‡‡

Société d'Encouragement (1891) 'Société d'Encouragement pour l'Industrie Nationale', in C. Laboulaye, *Dictionnaire des Arts et Manufactures et de l'Agriculture formant un traité complet de technologie*, 7th edn. (suppl.). Paris: Librairie du Dictionnaire des Arts et Manufactures.

Spring, M., Higgitt, C. and Saunders, D (2005) 'Investigation of pigment-medium interaction processes in oil painting containing degraded smalt', *National Gallery Technical Bulletin* 26(1): 56–70.

Spurrell, F.C.J. (1895) 'Notes on Egyptian Colours', *The Archaeological Journal* LII (2nd series) 2: 222–39.

Stahl, G.E. (1731) *Experimenta, observationes, animadversiones, CCC numero chymicæ et physicæ*, n°231. Berlin: A. Haude, 280–83.

Stas, J.S. (1856) *Exposition Universelle de 1855. Rapports du Jury mixte international publiés sous la direction de S. A. I. le Prince Napoléon*, X^th class, *Arts chimiques, teintures et impressions*. Paris: Imprimerie imperial, *Outremer artificial* entry, 600–608.

Stege, H. (2004) 'Out of the blue? Considerations on the early use of smalt as blue pigment in European easel painting', *Zeitschrift für Kunsttechnologie und Konservierung* 18: 121–42.

Sublime indigo (1987) Fribourg: Office du livre.

Suetonius (1913) *The lives of the Twelve Caesars*, J.C. Rolfe (tr.), vol. 1. London: Loeb Classical Library.

Suger (1867) 'De administratione', in Lecoy de La Marche (tr.), *Oeuvres complètes de Suger*. Paris: Vve Renouard.†

Summary abstracts (1789) 'Summary abstracts of the Rewards bestowed by the Society from the Institution in 1754, to 1782, inclusive; with observations on the effects of the Rewards etc.: Cobalt', in *Transactions of the Society for the Encouragement of Arts, Manufactures and Commerce*, vol. I. London, 14–16.

Sur la fabrication des cyanures (1848) 'Sur la fabrication des cyanures par l'azote de l'air par MM. Possoz et Boissière', *Bulletin de la Société d'Encouragement pour l'Industrie Nationale* (1^st series) 47(527): 275–6.

Sur la préparation du bleu de Prusse (1762) 'Sur la préparation du bleu de Prusse', in *Histoire de l'Académie Royale des Sciences, année 1756*. Paris: Imprimerie royale, 53–9.

Tagle, A.A., Paschinger, H., Richard, H. and Infante G. (1990) 'Maya blue: its presence in Cuban colonial wall paintings', *Studies in Conservation* 35(3): 156–9.

Talbot Dillon, J. (1780) *Travels through Spain*. London: G. Robinson.

Tarlier, C. (2007) 'L'entreprise Guimet de bleu d'outremer: de Jean-Baptiste à Jean (1826–1920)', Master's thesis in History, Contemporary World specialty, Séminaire d'Histoire Économique et Sociale, Paris IV Sorbonne University.

Tavernier, J.-B. (1679) *Voyages en Perse*. Paris: G. Clouzier. [New edition 1964, Paris: Les Libraires Associés.]

Taylor, J.R. (1977) 'The origin and use of cobalt compounds as blue pigments', *Science and Archaeology* 19: 3–15.

Tchernia, A. (1968) 'Premiers résultats des fouilles de juin 1968 sur l'épave 3 de Planier', *Études classiques* III(70): 51–82.

Tchernia, A., Pomey, P. and Hesnard, A. (1978) *L'épave romaine de la Madrague de Giens*, 34^th suppl. to Gallia. Paris: Centre National de la Recherche Scientifique.

The Art of Drawing (1731) *The Art of Drawing and Painting in Water-Colours*. London: J. Peele.

The Artist's Repository and Drawing Magazine (1784–1786) London.

Thenard, L.-J. (1803–1804) 'Considérations générales sur les couleurs, suivies d'un procédé pour préparer une couleur bleue aussi belle que l'outremer', *Journal des Mines* 15(86) (Brumaire an XII): 128–36.

Thenard, L.-J. (1813) *Traité de chimie élémentaire théorique et pratique*. Paris: Crochard.

Theophilus (1961). *De diversis artibus*, book II, C.R. Dodwell (ed. and tr.). Edinburgh and London: Thomas Nelson & Sons Ltd. and New York: Oxford University Press.

Theophrastus (1956) *Περί λιθων (On stones)*, E.R. Caley and J.F.C. Richards (tr.). Columbus: Ohio State University.

Thompson, L. (1837–1838) 'Preparation of Prussian blue', *Transactions of the Society for the Encouragement of Arts, Manufactures and Commerce* LII(I): 24–7.

[Thompson, L.] (1840) 'Préparation du bleu de Prusse par M. L. Thompson', *Bulletin de la Société d'Encouragement pour l'Industrie Nationale* (1st series) 39(433): 266.

Tiremois, de (1842a) 'Procédé pour faire du bleu d'outremer', *Bulletin de la Société d'Encouragement pour l'Industrie Nationale* (1st series) 41: 236–7.

Tiremois, de (1842b) 'Procédé pour faire du bleu d'outremer', *Annales des mines* II: 165–6.

Tite, M.S. (1986) 'Egyptian blue, faience and related materials: technological investigations', in R.E. Jones and H.W. Cotting (eds) *Science and Archaeology*. The British School of Athens. Fitch Laboratory Occasional Papers, 2. London: Leopard's Press, 39–41.

Tite, M.S. (1987) 'Characterisation of early vitreous materials', *Archaeometry* 29(1): 21–34.

Tite, M.S., Bimson, M. and Meeks, N.D. (1981) 'Technological characterisation of Egyptian Blue', *Revue d'Archéométrie* (suppl.): 296–301.

Tite, M.S. and Shortland, A.J. (2003) 'Production technology for copper- and cobalt-blue vitreous materials from the New Kingdom site of Amarna – A reappraisal', *Archaeometry* 45(2): 285–312.

Tite, M.S., Bimson, M. and Cowell, M.R. (1984) 'Technological examination of Egyptian Blue, in J.B. Lambert (ed.), *Archaeological chemistry III*. Advances in Chemistry Series no. 205. Washington, DC: American Chemical Society, 215–42.

Tite, M.S., Bimson, M. and Cowell, M.R. (1987) 'The technology of Egyptian blue', in M. Bimson and I.C. Freestone (eds), *Early vitreous materials*. British Museum Occasional Papers, 56. London: British Museum Publications, 39–46.

Tolstikov, V.P. and Treister, M.Y. (1996) *Le trésor de Troie. Les fouilles d'Heinrich Schliemann*. Paris: Gallimard.

Tomlinson, C. (1852) 'Introduction essay on the Great Exhibition of the Works of Industry of All Nations, on the ultramarine', in *Cyclopædia of useful arts, mechanical and chemical, manufactures, mining and engineering*, vol. 1. London: G. Virtue, cxxxvi–vii.

Torres, L.M. (1988) 'Maya blue: how the Mayans could have made the pigment', in *Materials Research Society Symposium Proceedings*, Fall Meeting, 1988, vol. 123. Pittsburgh: MRS, 123–8. [Online doi: 10.1557/Proc-123-123]

Transactions (1832) *Transactions of the Society for the Encouragement of Arts, Manufacture and Commerce, for the session 1831-32*, vol. XLIX. London, part I, 18.

Tuffreau-Libre, M. (1999) 'Les pots à couleur de Pompéi: premiers résultats', *Rivista di studi Pompeiani* X: 63–70.

Tuffreau-Libre, M. (2003) *Un atelier de peintres à Pompéi (I, 9, 9)*, Excavation Report. Naples: CNRS/Centre Jean Bérard.

Turgan, J. (1865) 'Teinturerie de soie. Guinon, Marnas et Bonnet à Lyon', in *Les grandes usines de France*, études industrielles en France et à l'étranger, vol. 4. Paris: M. Lévy, 257–72.‡‡

Turgan, J. (1882) 'Fabrication de l'outremer artificiel. Usine Guimet à Fleurieu-sur-Saône', in *Les grandes usines, études industrielles en France et à l'étranger*, vol. 18. Paris: Calmann-Lévy, 1–19.‡‡

Turquet de Mayerne, T. [*c.* 1620] (1974) *Pictoria Sculptoria & quae subalternarum artium*, manuscript, London, British Library, MS Sloane 2052. [Faidutti, M. and Versini, C. (eds) (1974) *Le manuscrit de Turquet de Mayerne*. Lyon: Audin.]

Ullrich, D. (1979) 'Ägyptisch blau ($CaCuSi_4O_{10}$): Bildungsbedingungen und Rekonstruktions-versuch der antiken Herstel-lungstechnik', Diplomarbeit, Freien Universität Berlin.

Ultramarines (1964) *Ultramarines. Their history and characteristics*. Hull: Reckitt's Colours Ltd.

Ungerer, C. (1990) 'Le blanchissage à Paris au XVIIIe siècle', doctoral thesis, Paris I Sorbonne University.

Valmont de Bomare, J.C. (1767–1768) *Dictionnaire raisonné universel d'Histoire naturelle contenant l'histoire des animaux, des végétaux et des minéraux*, etc. Paris: Lacombe.

van Eikema Hommes, M. (2004) *Changing pictures: Discoloration in 15th–17th century oil paintings*. London: Archetype Publications.

[Van Gogh, V.] 1960. *Correspondance complète de Vincent van Gogh enrichie de tous les dessins originaux* [translated from Dutch into French]. Paris: Gallimard/Grasset.

Van Olphen, H. (1966) 'Maya Blue: a clay mineral-organic pigment?', *Science* 154: 645–6.

Van Schendel, A. (1958) 'Simon Eikelenberg's experiments on the preparation of varnishes', *Studies in Conservation* 3(3): 125–31.

Varone, A. and Béarat, H. (1997) 'Pittori Romani al lavoro. Materiali, strumenti, tecniche: evidenze archeologiche e dati analitici di un recente scavo pompeiano lungo via dell'abbondanza (Reg. IX, ins. 12)', in H. Béarat, M. Fuchs, M. Maggetti and D. Paunier (eds), *Proceedings of the International Workshop on Roman Wall Painting, Fribourg, 1996*. Fribourg: Institute of Mineralogy and Petrography, 199–214.

Vasari, G. [*c.* 1550] (1996) 'Pietro Vanucci' [known as Pietro Perugino] in *Le Vite delle più eccellenti pittori, scultori, e architettori* [Lives of the most excellent painters, sculptors, and architects]. Everyman's Library.

Vauquelin, L.N. (1813) 'Analyse de deux variétés de carbonate de cuivre de Chessy, près Lyon', *Journal des Mines* 202(34): 241–52.

Vauquelin, L.N. (1814) 'Note sur une couleur bleue artificielle analogue à l'outremer', *Annales de Chimie* LXXXIX: 88–91.

Vauquelin, L.N. (1826) 'Examen d'une couleur bleue trouvée dans un tombeau égyptien, et déposé dans une coupe 561', in J.-F.L. Mérimée, *Catalogue raisonné et historique*

des Antiquités découvertes en Égypte par M. J Ph Passalacqua de Trieste (...). Paris: A la galerie d'Antiquités égyptiennes, 238–9.‡

Velut, C. (2005) *Décors de papier, Production, commerce et usages des papiers peints à Paris, 1750–1820*. Paris: éd. du Patrimoine.

Vezin, J. and Guineau, B. (1998) *Les pigments des peintures murales de la villa San Marco de Stabies*, in *Étude physico-chimique et colorimétrique des pigments bleus et verts et de leur emploi en peinture pendant l'Antiquité et le Moyen-Âge*, unpublished Report on ATP CNRS *Développement d'approches nouvelles en archéologie par les méthodes de la Physique, de la Chimie, des Mathématiques et des Sciences de la Terre*, September 1988.

Villela-Petit, I. (1995) 'La peinture médiévale vers 1400. Autour d'un manuscrit de Jean Lebègue. Édition des "Libri colorum"', thesis, École Nationale des Chartes, Paris.

Villela-Petit, I. and Guineau, B. (2003) 'Le Maître de Boucicaut revisité. Palette et technique d'un enlumineur parisien au début du XVe siècle', *Art de l'enluminure* 6: 2–33.

Vincendeau, C. (1998) *Les opalines*. Paris: Les editions de l'amateur.

Watin, J.-F. (1773) *L'Art du peintre, doreur, vernisseur, et du fabricant de couleurs*, 2nd edn. Paris: Durand.† *

Watin, J.-F. (1808) *L'Art du peintre, doreur, vernisseur, et du fabricant de couleurs*, 6th edn. Paris: Belin.

Watin, J.-F. (1823) *L'Art du peintre, doreur, vernisseur, et du fabricant de couleurs*, revised by C. Bourgeois, 10th edn. Paris: Belin-Prieur.

Weger (1845) Technologiste.

West FitzHugh, E. and Zycherman, L.A. (1983) 'An early man-made blue pigment from China: barium copper silicate', *Studies in Conservation* 28(1): 15–23.

West FitzHugh, E. and Zycherman, L.A. (1992) 'A purple barium copper silicate pigment from early China', *Studies in Conservation* 37(3): 145–54.

Wiedemann, H.-G. and Bayer, G. (1997) 'Formation and stability of Chinese barium copper silicate pigments', in N. Agnew (ed.), *Conservation of ancient sites on the Silk Road*. Los Angeles: Getty Conservation Institute, 379–87.

Wiedemann, H.-G., Bayer, G. and Reller, A. (1998) 'Egyptian blue. Production technologies and applications of two historically important blue pigments', in S. Colinart and M. Menu (eds), *La couleur dans la peinture et l'émaillage de l'Égypte ancienne*. Bari: Edipuglia, 195–203.

Williams, W. (1787) *An Essay on the Mechanic of Oil Colours*. Bath: S. Hazard.

Winckler, A.F. (1959) 'Das Sächsische Blaufarbenwesen um 1790 mit Bildern', in *Freiberger Forschungshefte* D 25. Akademie Verlag.

Wood, J. (1841) *A personal narrative of a journey to the source the river Oxus by the route of the Indus, Kabul and Badakhshan performed under the sanction of the suprem government of India, in the year 1836–1837 and 1838*. London: J. Murray.

Woodward, J. (1724) 'Præparatio Cærulei Prussiaci ex Germaniâ missa ad Johannem Woodward', *Philosophical Transactions* XXXIII(381): 15–17. [English translation: (1809) *Philosophical Transactions* (abridged series) VII: 4–6.]

Woulfe, P. (1788) 'Manière de préparer le Bleu de Prusse pour éprouver le Fer, en sorte qu'il ne devient ni bleu ni verd avec les Acides', *Observations sur la Physique* 32: 374–5.

Woulfe, P. (1789) 'Mémoire sur le bleu de Prusse', *Observations sur la Physique* 34: 99–105.

Wyart, J., Bariand, P. and Filippi, J. (1972) 'Le lapis-lazuli de Sar-e-Sang (Badakhshan, Afghanistan)', *Revue de Géographie physique et de Géologie dynamique* 2(14): 443–8.

Wyszecki, G. and Stiles, W.S. (1982) *Colour science: concepts and methods, quantitative data and formulae*, 2nd edn. New York: John Wiley and Sons.

Yacamàn, M.J. and Serra Puche, C.M. (1995) 'High resolution electron microscopy of Maya blue paint', *Materials Research Society Proceedings* 323(3) [Online doi: 10.1557/Proc-352-3]

Yacamàn, M.J., Rendon, L., Arenas, J. and Serra Puche, M.C. (1996) 'Maya blue paint: an ancient nanostructured material', *Science* 273: 223–5.

Young, A. (1792) *Travels, during The Years 1787, 1788 and 1789 undertaken more particularly with a view of ascertaining the cultivation, wealth, resources and national prosperity of the kingdom of France*. London: W. Richardson.*

Zarzycki, J. (1982) *Les verres et l'état vitreux*. Paris: Masson.

Zimmermann, C.F. (1746) *Ober-sächsische Berg-Academie in welcher die Bergwercks-Wissenschaften nach ihren Grund-Wahrheiten untersuchet und nach ihrem Zusammenhange entworffen werden. Alles in abgesonderten Abhandlungen ausgefertiget von Carl Friedrich Zimmermann*. Dresden and Leipzig: Hekel.

Zimmern, H. (1925) 'Assyrische chemisch-technische Rezepte, insbesondere für Herstellung farbiger glasierte Ziegel, in Umschrift und Ueberzetzung', *Zeitschrift für Assyriologie und Vorderasiatische Archäologie* XXXVI(III–IV): 177–208.

Zuber, H. (2003) *L'éducation d'Ivan et Alfred Zuber (1834-1849)*, Nouveau cahier Zuber no. 3. Maison-Laffitte: H. Zuber.

List of colorants, colours, minerals and blue pigments mentioned in the text

Monthiers blue	147	turquoise	2	
mountain blue	128			
		uknû merku	2	
Napoleon blue	183	ultramarine	99	
natron	1	ultramarine ashes	107	
natural ultramarine	99	ultramarine azure		
palygorskite	306	verditer	133	
paranitraniline red	204	*verditer bis*	133	
Paris blue	147	*verditer grene*	133	
pâte-de-verre	1	vert de composition	163	
pearl ash	63	vert de terre	133	
Péligot blue	144	vestorian blue	19	
Portugal blue	101	Vossen blau	190	
Prussian blue	145			
		weld lake	124	
Quamotcitl	306	woad	108	
		wollastonite	101	
realgar	17			
Reckitt blue	255	*yax*	305	
Royal blue	78	yellow ochre	30	
sacalum	310	zaffre	37	
Sanders blue	136			
sapphirum vitreum	44			
Saxe blues	164			
sea green	163			
sepiolite	307			
silica	7			
silver	1			
skuttertide	41			
sky blue	162			
smalt	37			
smaltite	41			
sodalite	100			
starch blue	47			
steel blue	147			
steel grey	163			
sulpho-arsenide	40			
sulphur dioxide	90			
tender blue	162			
tenorite	120			
Thenard's blue	195			
Turkish blue	101			

Milton Keynes UK
Ingram Content Group UK Ltd.
UKHW051948071123
432161UK00005B/45